THE
GROUP *of* SEVEN

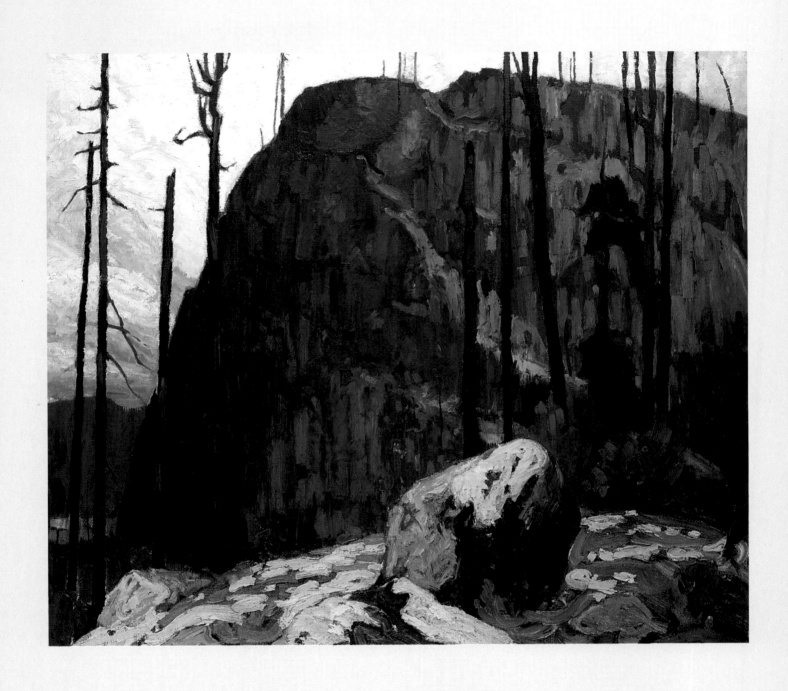

FIG. 1. LAWREN S. HARRIS, *Algoma Hill* (cat. 35)

THE GROUP *of* SEVEN

· ART FOR A NATION ·

CHARLES C. HILL

Curator of Canadian Art, National Gallery of Canada

M&S

Published in conjunction with the exhibition *The Group of Seven: Art for a Nation*, organized and circulated by the National Gallery of Canada.

Itinerary

National Gallery of Canada, Ottawa
13 October – 31 December 1995

Art Gallery of Ontario, Toronto
17 February – 5 May 1996

Vancouver Art Gallery
19 June – 2 September 1996

Montreal Museum of Fine Arts
3 October – 1 December 1996

Produced by the Publications Division of the National Gallery of Canada
in collaboration with
McClelland & Stewart Inc.
The Canadian Publishers
481 University Avenue
Toronto, Ontario
M5G 2E9

Serge Thériault, Chief, Publications Division, National Gallery of Canada
Susan McMaster, Editor, National Gallery of Canada
Colleen Evans, Picture Editor, National Gallery of Canada
Kong Njo, Art Director, McClelland & Stewart
Typeset in Centaur and Gill Sans by M&S, Toronto
Film by Lasersharp Inc., Toronto
Printed on Stirling Litho Satin, 80 lb.
Printed and bound in Canada by D.W. Friesen, Altona, Manitoba

Canadian Cataloguing in Publication Data

Hill, Charles C., 1945–
The Group of Seven: Art for a Nation

ISBN 0-7710-6716-x (hardcover)
ISBN 0-88884-645-2 (paperback)

Issued also in French under title: Le Groupe des Sept. L'émergence d'un art national
Copublished by McClelland & Stewart.
Exhibition catalogue.
1. Group of Seven (Group of artists) – Exhibitions.
2. Painting, Canadian. 3. Painting. Modern – 20th century – Canada.
I. National Gallery of Canada. II. Title.
ND245 G76 H54 1995 759.11 CIP 95-986004-5

As a relative newcomer to Canada, I am still awestruck by the vastness and grandeur of the landscape so familiar to Canadians. This landscape is as diverse as the people who inhabit it. Each region represents a richness and vitality that help define the Canadian mosaic.

In the seventy-five years since the first public exhibition of the Group of Seven's work, much has changed. What remains, however, are the images of a group of talented artists who defined how Canadians view their land. Their paintings are timeless and represent the collective strength of a nation and its people.

As this exhibition travels across the nation, Canadians will continue to share in the images of regions far from their own. We will again understand the role that our geography plays in the development of the Canadian identity. People from the east will see images of the Rockies. Westerners will examine paintings from Quebec and Ontario. All Canadians will view artwork that represents virtually every inch of the Canadian landscape.

Thanks to the Group of Seven, however, these images are not foreign to most of us. We have had the opportunity to see our nation through their eyes for seventy-five years.

Chubb Insurance Company of Canada proudly supports this exhibition and its Canadian tour. The exchange of images and ideas gives us all the opportunity to reflect on the essence of who we are and what we have accomplished.

Enjoy the exhibition!

Janice M. Tomlinson
President
Chubb Insurance Company of Canada

Lenders to the Exhibition

Public Institutions

Agnes Etherington Art Centre, Queen's University, Kingston, Ont., 99, 108
Art Gallery of Greater Victoria, 115
Art Gallery of Hamilton, 9, 10, 83, 94, 148, 167, 168
Art Gallery of Ontario, Toronto, 12, 13, 20, 37, 45, 53, 92, 93, 96, 113, 135, 139, 146, 149
Art Gallery of Windsor, 5, 34
Beaverbrook Art Gallery, Fredericton, 171
Canadian War Museum, Ottawa, 31
Dalhousie Art Gallery, Halifax, 24
The Edmonton Art Gallery, 38, 98, 127
Faculty Club, University of Toronto, 27
Gallery 1.1.1., University of Manitoba, Winnipeg, 15
Gallery Lambton, Sarnia, Ont., 71, 105, 122
Glenbow Museum, Calgary, 32, 137
Hart House, University of Toronto, 29, 40, 57, 59, 91, 112, 121, 123, 166
Heritage Collection, Cultural Affairs Division, Department of
Education and Culture, Government of Nova Scotia, Halifax, 80
Kenderdine Art Gallery, University of Saskatchewan, Saskatoon, 79, 117
London Regional Art and Historical Museums, London, Ont., 28, 44, 110, 119
Macdonald Stewart Art Centre, Guelph, Ont., 143
McMichael Canadian Art Collection, Kleinburg, Ont., 63, 75, 84, 88, 126, 142, 164, 165
Montreal Museum of Fine Arts, 25, 86, 107, 144, 153, 178
Musée d'art de Joliette, Que., 150
Musée du Québec, Quebec City, 33, 145
National Gallery of Canada, Ottawa, 1, 2, 3, 4, 6, 7, 14, 17, 19, 23, 26, 30, 39, 41, 42, 43,
46, 47, 48, 49, 51, 62, 69, 70, 72, 73, 74, 77, 78, 81, 82, 87, 100, 132, 134, 136, 140, 141, 147,
151, 154, 156, 158, 162, 163, 169, 172, 175, 177
Orillia Public Library, Orillia, Ont., 90
The Ottawa Art Gallery, 106
Robert McLaughlin Gallery, Oshawa, Ont. 58, 114, 138, 176
Tate Gallery, London, England, 36
Tom Thomson Memorial Art Gallery, Owen Sound, Ont., 129
University College, University of Toronto, 65, 66, 67, 95, 116, 159
University of Alberta, Edmonton, 101, 109
Vancouver Art Gallery, 8, 52, 68, 160, 161
Victoria University (In the University of Toronto), 16
Winnipeg Art Gallery, 85, 120

Private Collections

André Biéler Inc., 157
Estate of Carl Schaefer, 128, 131, 179
John Hartman, 133
Power Corporation of Canada, 61, 102, 118
Toronto-Dominion Bank, 125
The Toronto Hospital, Western Division, 35
Anonymous lenders, 11, 18, 21, 22, 50, 54, 55, 56, 60, 64, 76, 89, 97, 103, 104, 111, 124, 130,
152, 155, 170, 173, 174

Contents

Foreword

The public debates about the work of the Group of Seven in the 1920s recall current discussions about contemporary art. C.W. Jefferys defined two aspects of the issues in 1911: "To some artists as well as laymen art stands for a sort of sheltered garden, a sanctuary wherein to seek refuge from the work-a-day outside world, and forget for a time its crudeness and its cruelty ... But there are some turbulent souls whom this sheltered monastic life fails to satisfy. They ... are interested in life as much as in art ... They are the experimenters of art, the questioners of life, and to them art must, in the end, look for progress."

The National Gallery of Canada has striven to further progress in the arts since its foundation in 1880. On numerous occasions this support has come under attack, most notably in 1926 when the Gallery purchased Arthur Lismer's *September Gale*. Public meetings were held to protest against "artistic perverts" and "the greatest abortion of a work of art ever seen in our fair city" and to plead for the maintenance of the "rules" and "principles" of "Truth" and "Beauty." One complainant argued that "the Canadian public is paying the piper ... and ... I very much question if the public is really demanding jazz." Another writer responded vigorously, "Do we continually want to hear tunes we know? Is it not exhilarating to hear a new tune occasionally? One we could not possibly call for?"

Progress in art was the Group of Seven's gift to all Canadians. They opened up an avenue for a broader appreciation of modern painting. They affirmed that there was such a thing as Canadian art. They encouraged their fellow citizens to understand that art was not merely a prideful affair of wealthy collectors but the birthright of all. They argued with conviction, generosity, and wisdom that "art is not a professional practice but a way of life ... a universal and not a specialized quality of human consciousness."

Art museums are the keepers of our past and chroniclers of our present, but they can only fulfil their role in a constantly renewed dialogue with their various audiences. To be effective, the lessons learned within their walls must be continually realized in all aspects of our daily lives, in an appreciation and care for our urban and natural environments, and in a growing understanding of the social forces that animate our society. The artists whose works fill the halls enlarge our vision of life, explore contemporary realities in their many facets, and in many instances radically alter our perceptions of ourselves and of the world around us. They define who we are and how the past interacts with the present. They give us glimpses of the future. The patron of modern art Katherine Dreier stated it well when she spoke in Toronto in 1927: "The creative artist is the custodian of the future fame of his [and her] own country. According to its Art is the life of a nation, and the nations that have vanished from the globe are the nations without an Art."

Over the last twenty-five years scholars have continued to study the ideas and careers of the members of the Group of Seven, but there has been no general survey of its history as a movement since that organized by Dennis Reid for the National Gallery in 1970. That ground-breaking study and the work of many other researchers all have contributed to this exhibition and book. With a retrospective look at the development of the Group's ideas before, during, and immediately following the First World War, and a focus on the years of their cooperative activity in the 1920s, this study analyses the Group's exhibitions, their influence in stimulating poets, writers, dramatists, and musicians, and the full scope of their ambition to radically change both Canadian art and the thinking of all Canadians.

The National Gallery is privileged to have the opportunity of presenting this major reexamination of the Group of Seven, an art movement with which the Gallery has been intimately linked since before the First World War. Our first Director, Eric Brown, and the first

Chairman of our Board of Trustees, Sir Edmund Walker, both recognized the importance of the artists' work and vision of Canada and purchased their paintings for the national collection. They persisted in their support of the Group's projects through the 1920s in the face of virulent opposition. The result is the finest permanent collection of the work of Tom Thomson and of the Group of Seven anywhere, a collection supplemented for this occasion by loans from individuals and institutions from Halifax to Victoria.

No exhibition of this scope can be realized without the kind support of research institutions across the country, the generous sharing of ideas among fellow scholars and art lovers, and the enthusiastic aid of other collecting institutions. The National Gallery is grateful to all the lenders who have made *The Group of Seven: Art for a Nation* possible. I would especially like to thank those private collectors who have, at some personal sacrifice, agreed to share their loved works of art with the larger public for an extended period. I am certain that the opportunity to see so many remarkable paintings and drawings by Canada's leading artists, some for the first time in over half a century, will nurture a growing appreciation of Canadian art among all visitors. I am especially pleased that this exhibition will be seen in Toronto, the home base of the Group of Seven, as well as in Vancouver and Montreal, where they were active and influential. I thank the directors and staffs of these institutions for their support of this project.

Our partner in presenting the exhibition is Chubb Insurance of Canada. We are deeply grateful for their enthusiastic participation in *The Group of Seven: Art for a Nation*; without the help of patrons like Chubb the world of the arts would be much poorer.

In their day the work of the Group of Seven was considered by many to be a crude reflection of the ugliest aspects of Canadian life. In 1927, an English sculptor working in Canada, Dorothy Dick, announced to the press that, "comparing the Group's work with the products of Britain's and the Continent's traditional solid culture reminds one of the difference between canned heat and Johnnie Walker." The Board of Trustees and the staff of the National Gallery of Canada join with me in saying, here's to an invigorating draught of our own home-grown and distilled spirit – the intoxicating love of the land and its people that infuses the art of these quintessential Canadian artists.

Dr. Shirley L. Thomson
Director
National Gallery of Canada

Acknowledgments

Any publication and exhibition of this scale results from the work of numerous individuals and institutions across the country and abroad. In tracing the Group's energetic exhibiting activities in the United States I have been helped by Maureen Melton, Boston Museum of Fine Arts, Deborah Wythe, Brooklyn Museum, Janice Lurie, Albright-Knox Art Gallery, Althea H. Humber, Art Institute of Chicago, Kelly Bahmer-Brouse, Cleveland Museum of Art, Amy McGee, Columbus Museum of Art, Jennifer Moldwin, Detroit Institute of Arts, Rachael Sadinsky, Arnot Art Museum, Carolyn J. Metz, Indianapolis Museum of Art, Josephine D. Gordon, Nelson-Atkins Museum of Art, Deonna Ard, Kansas City Public Library, Marilyn Masler, Memphis Brooks Museum of Art, Ruta Schuller, Milwaukee Art Museum, Harold Peterson, Minneapolis Institute of Arts, Rosalie Meyer, Muskegon Museum of Art, Stephen C. Jones and staff, Beinecke Rare Book and Manuscript Library, Yale University, Debra Pelletier, Rhode Island School of Design, Lucy Björklund Harper, Memorial Art Gallery, Rochester, Norma Sindelar, Saint Louis Art Museum, Victoria Stratton, Seattle Art Museum, Mary D. Iversen, Everson Museum of Art, Judith M. Friebert and Anne Morris, Toledo Museum of Art, Judy Throm, Archives of American Art, Smithsonian Institution, Marison Keller, Corcoran Museum of Art, and Stephen B. Jareckie, Worcester Art Museum. My thanks to them all.

Colleagues from across Canada have been of constant assistance. In Vancouver my thanks go to Ian Thom, Teresa Healy, and Monica Smith, Vancouver Art Gallery, Scott Watson, U.B.C. Fine Arts Gallery, Gaye Farrell, Pacific National Exhibition, Heather Chan and staff, Vancouver City Archives, Peter Ohler, Peter Ohler Fine Art, and Robert Heffell and David Heffell, Heffell Gallery. In Victoria, my thanks to Patricia Bovey and Ann Tighe, Art Gallery of Greater Victoria, and the B.C. Archives and Records Service; in Banff, to Katherine Lipsett and Lena Goon, Whyte Museum of the Canadian Rockies; in Calgary, to Christopher Jackson and Patricia Ainslie, Glenbow Museum, and Rod Green, Masters Gallery; in Edmonton, to Alf Bogusky, Elizabeth Kidd, and Bruce Dunbar, Edmonton Art Gallery, and Helen Collinson, Jim Corrigan, Brian Hobbs, and Brian Corbett, University of Alberta; in Regina, to Andrew Oko, Cindy Richmond, Timothy Long, and Betty Stothers, Mackenzie Art Gallery, and Shelley Sweeney, University of Regina; in Saskatoon, to Sylvia Tritthardt, Mendel Art Gallery, Tim Nowlin and Donna Volden, Kenderdine Art Gallery and the Archives of the University of Saskatchewan, and special thanks to Ron Bernston and Gordon Shuttle, Nutana Collegiate Institute. In Winnipeg, I would like to thank Judith Hudson Beattie, Manitoba Provincial Archives, Garry Essar and Margot Rousset, Winnipeg Art Gallery, David Loch, Loch Mayberry Fine Art, Michael Moosberger and Richard Bennett, University of Manitoba, Dr. Ken Cavalier, Dale Amundsen, Donalda Johnson, and staff, FitzGerald Study Centre, for their kindness in allowing me access to the FitzGerald papers, and Gallery 1.1.1. In Cambridge, Ontario, my thanks to Jim Quantrell, City of Cambridge; in Guelph, to Judith Nasby, Tiffany Gennich, and Steve Robertson, Macdonald Stewart Art Centre; in Hamilton, to Ted Pietrzak, Ihor Holubizky, Tobi Bruce, Joan Weir, and Corinne Fairbanks, Art Gallery of Hamilton; in Kingston, to Dorothy Farr, Agnes Etherington Art Centre, and the Queen's University Archives; in Kleinburg, to Barbara Tyler, Megan Bice, Susan Gustavison, Kathy Stewart, and special thanks to Sandra Cook and Linda Morita, McMichael Canadian Art Collection; in London, to Nancy Poole and Barry Fair, London Regional Art and Historical Museums; in Niagara-on-the-Lake, to James Campbell, formerly of the Samuel E. Weir Collection; in Orillia, to Paul E. Blower, Orillia Public Library; in Oshawa, to Joan Murray and Linda Jansma, Robert McLaughlin Gallery;

in Ottawa, to Laura Brandon, Danielle Allard, and Fred Gaffen, Canadian War Museum, Madelaine Palko, Department of Foreign Affairs and International Trade, Anne Goddard and her staff, National Archives, the staff of the National Library, and Mela Constantinidi and Pierre Arpin, Ottawa Art Gallery; in Owen Sound, to Margaret Mitchell, Brian Meehan, and Rhona Wenger, Tom Thomson Memorial Art Gallery; in Sarnia, to Howard Ford, David G. Taylor, and Lisa Daniels, Gallery Lambton; in Thunder Bay, to Betty Braaksma, Brodie Resource Library; in Toronto, to Mary-Anne Nicholls, Anglican Church of Canada, Dennis Reid, Christine Boyanoski, Michael Parke-Taylor, Maia Sutnik, Faye Van Horne, Karen Mackenzie, Randal Spellar, and above all special thanks to Larry Pfaff for his assistance, Art Gallery of Ontario. To Raymond Peringer, Arts and Letters Club, a special thanks for allowing me access to the invaluable resources in the Club's papers. Thanks also to Linda Cobon, the C.N.E. Archives and the Archives of the City of Toronto, Judith Schwartz and Sam Harris, Hart House, Susan Young, Imperial Oil Limited, Geoffrey Joyner, Joyner Fine Art, Mira Godard, Mira Godard Gallery, Allan McCready, McCready Galleries, the Ontario Archives, Christine Orobetz and Erin Prendergast, Sotheby's, Gail Gregory, Toronto Board of Education, Natalie Ribkoff, Toronto-Dominion Bank, and Dr. Stanley Epstein and Marie DunSeith, Toronto Hospital. At the University of Toronto, I would like to thank the United Church Archives, Dr. David Rifat, Dr. Elizabeth Legge, and Dr. Douglas Richardson, University College, the Thomas Fisher Rare Book Library and University Archives, and Dr. Alice Rathé and staff, Archives, Victoria College. Thanks also to Ronald McLean, Waddington, McLean and Co., and the York University Archives. In Waterloo, a special thanks to Susan Bellingham, University of Waterloo; in Windsor, to Nataley Nagy, Catherine Mastin, and Betty Wilkinson, Art Gallery of Windsor. In Hull, Quebec, a most sincere expression of gratitude to Benoît Thériault, Canadian Museum of Civilization, who was of enormous help in researching Marius Barbeau's papers. In Joliette, thanks to Danielle Lord, Musée d'art de Joliette; in Montreal, to Virginia Watt, Canadian Guild of Handicrafts, for her great assistance, Judith Nefsky and Ludek Stipl, Canadian Pacific Archives, Michel Moreault and Michael Barnwell, Galerie Dominion, Mr. A. Rogazinsky, Empire Auctions, Walter Klinkhoff, Eric Klinkhoff, and Alan Klinkhoff, Galerie Klinkhoff, Conrad Graham and Pamela Miller, McCord Museum of Canadian History, Dr. David Covo, School of Architecture, McGill University, Monique Gauthier, Musée d'art contemporain, Mayo Graham, Elaine Tolmatch, Juanita Toupin, Yves Lacasse, Marie-Claude Saia, Brian Merrett, and, especially, Gilbert Caron, all Montreal Museum of Fine Arts, and Serge Joyal and Paul Maréchal, Power Corporation of Canada; in Quebec City, to Pierre Lallier, Claude Thibault, Lise Nadeau, and Nathalie Thibault, Musée du Québec; in Fredericton to Ian Lumsden and Tom Smart, Beaverbrook Art Gallery; in Saint John, to Regina Mantin, New Brunswick Museum; in Sackville, to Gemey Kelly, Owens Art Gallery, Mount Allison University; in Halifax, to Bernard Riordon and Judy Dietz, Art Gallery of Nova Scotia, Peter Kirby, Department of Education and Culture, Province of Nova Scotia, and Mern O'Brien, Susan Gibson-Garvey, and Michelle Gallant, Dalhousie Art Gallery.

Many individuals have been most generous in sharing knowledge and allowing me access to their collections. I extend my personal thanks to Mrs. Anna Ackroyd, the late Mrs. John B. Aird, Franklin Arbuckle, John Band, Beatrice Bazar, Faith Berghuis, Beth Bertram, Molly Lamb Bobak, Marjorie Bridges, Qennefer Browne, Ina Buday, Dr. Ann Compton, Mary Challice, Elizabeth and Andrew Collard, Louise Comfort, Lisa Desilets, Richard A. Daly, Paul Duval, Fraser Elliott, M.F. Feheley, Alexandra Forbes, Dr. Donald Fraser, Barbara Gunn, Margaret Hall, Anne Harris and the late Lawren P. Harris, Barbara Heward, Chillian Heward, Mark Holton, Jacqueline Hunter, Ruth Jackson, Neil Kernaghan, Margaret Knox, Peter Larisey, J. Blair MacAulay, Mrs. John A. MacAulay, Anne McDougall, Isabel McLaughlin, Reta and Max Merkur, Cheryl Meszaros, Mrs. P.M. Morley, and Ann Morrison. To John Sabean a special thanks for generously offering access to Doris Speirs's papers and his research on Thoreau MacDonald. My gratitude to the late Carl Schaefer, Mark Schaefer, Paul Schaefer, Fred and Beverley Schaeffer, Sandra Shaul, Catherine Shelly, Frances Smith, Phyllis Brooker Smith, Joyce K. Sowby, Dr. Murray Speirs, Robert Stacey, Freeman and Rosita Tovell, Chris Varley, Peter Varley, Dr. Anton Wagner, Rachel Warrener, Dr. Paul Walton, Jennings D. Young, Mr. and Mrs. Maurice Young, and Joyce Zemans. Your kindness and support are greatly appreciated.

Closer to home at the National Gallery, it is almost impossible to select specific individuals to thank, for this project has involved staff from all areas of the institution. I must, however, identify certain key participants: Anne Hurley and Greg Spurgeon, Kate Laing and Ceridwen Maycock, Registration, Maija Vilcins, Bonnie Bates, and Michael Williams, Library, and Cindy Campbell, Archives. Anne Ruggles has done a masterful job in Conservation, and my thanks also to Geoffrey Morrow, Anne Maheux, and Marion Barclay, Restoration and Conservation Laboratory. Jacques Naud, Laurier Marion, Claude Saumure, Louis Poulin, and Rolly Bernard, Technical Services, have been a great support, as has Calvin Franklin, who restored and replicated numerous frames. Rob Fillion, Clive Cretney, and Meva Hockley, Photographic Services, raced against impending deadlines; a special thanks to Charles Hupé, who worked miracles in the final rush to complete photography for the publication.

In my initial research I was ably assisted by Heather Webb, Charmaine Nelson, Madelaine Palko, Christina Martinez, and Sarolta Gyoker. I would like to extend special thanks to Sandra Dyck, who researched and organized material with great thoroughness, assembled the bibliography and bibliographic references for the works in the exhibition, and was a stimulating colleague throughout the project. My sincere gratitude to Kathy Stone, who handled correspondence, typed the manuscript, and assisted in all aspects of loans and preparation. My thanks to all my staff, who tolerated the highs and lows of research and writing. Karen Oxorn and Martha King of Exhibitions ably handled the logistics of getting the show on the road and Ursula Thiboutot coordinated the communications program. Alan Todd, patiently and with superb sympathy, designed the Ottawa presentation of the exhibition, and Richard Lachapelle and Suzanne Lacasse organized the Education program. I would like to extend my sincere gratitude to the National Gallery's publications department, ably headed by Serge Thériault. Susan McMaster worked miracles with my text and Claire Rochon and Myriam Afriat with the editing of the French translation. Usher Caplan, Jacques Pichette, and Colin Morton chipped in as the deadlines advanced. To Colleen Evans, Photo Editor, we owe the coordination of the massive last-minute photography and quality control. I am in their debt and thank them all for making the book what it is. I am likewise grateful to McClelland and Stewart, especially Krystyna Ross, Jonathan Webb, and Kong Njo, assisted by Margaret Allen and Scott Mitchell, whose enthusiasm and support have made this publication possible.

This book is dedicated to three remarkable women. The late Norah McCullough taught children with Arthur Lismer at the Art Gallery of Toronto in the 1930s and in South Africa during the war, returning to Canada to work for the Saskatchewan Arts Board and then as western liaison officer for the National Gallery. In her retirement she prepared a catalogue raisonné of the paintings of Arthur Lismer, which she generously donated to the National Gallery. Dr. Naomi Jackson Groves, scholar and specialist in the work of Ernst Barlach and of her uncle A.Y. Jackson, has always been a great supporter of the arts and a generous donor to institutions across the country. Her catalogue raisonné of the work of A.Y. Jackson will be a basic resource for all researchers. To her I owe a great debt. Finally, Evelyn McMann, former fine art librarian at the Vancouver Public Library, on her own and as a service to researchers, indexed the art exhibitions of the Royal Canadian Academy 1880–1979, and the Spring Exhibitions of the Art Association of Montreal 1880–1970, and has prepared a reference guide to biographies of Canadian artists. We are all indebted to these scholars for their great public spirit and commitment to Canadian art.

A last, but certainly equal, thanks to the families of the artists, to the lenders who have so generously agreed to allow their works to be included in this exhibition, and above all to the artists themselves. They have made the greatest contribution.

Undoubtedly I have omitted a number of people who have assisted in this project. Let me just say thank you to all.

Charles C. Hill

To

Naomi Jackson Groves

Norah McCullough

Evelyn McMann

for their contributions to Canadian art

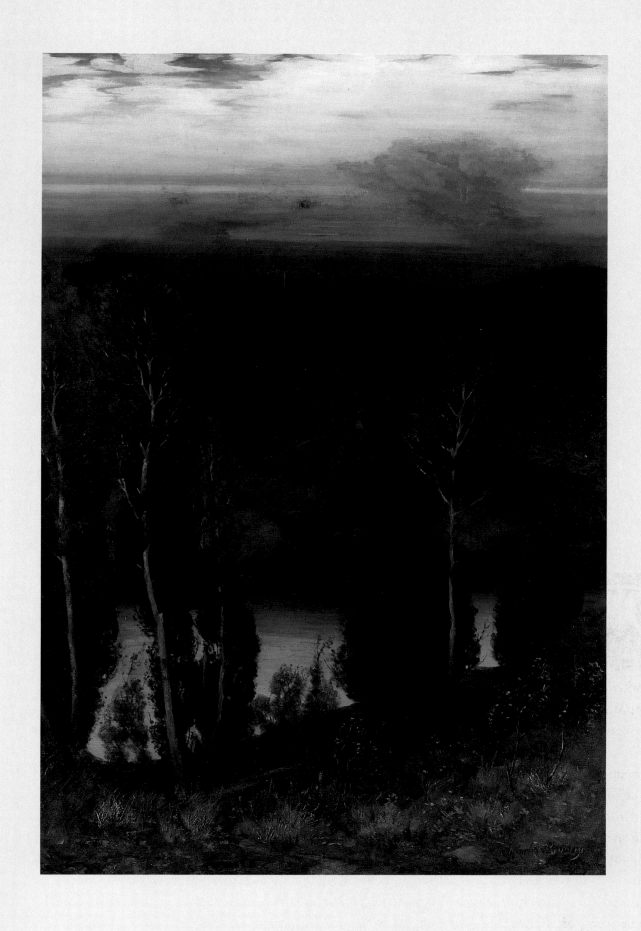

FIG. 2. ARCHIBALD BROWNE, *Benediction* (CAT. 1)

Introduction

he artists of the Group of Seven remain the most celebrated in Canadian history. Their enormous success in attaining this reputation began in the 1920s and was considerably enhanced by the distribution of silk-screen reproductions during the Second World War. These prints hung in schoolrooms, offices, and other public spaces for decades. More recently, the widespread commercial reproduction of Group of Seven paintings has maintained and confirmed their popularity.

This success was not achieved without struggle, however. During the 1920s the Group were vociferously opposed by a number of fellow artists, artists with more solid reputations in their day and considerably more commercial success. In the 1930s, John Lyman in Montreal, attempting to redefine Canadian art within an international, French-derived context, identified the Group's work as a focus of opposition. As late as 1955, the Toronto artist Graham Coughtry would complain that every tree in Canada had been painted.[1]

More recently, scholars have questioned the Group's ideology for its mythologizing of the wilderness, its evasion of and co-option by northern development. The appropriation of Native culture by associates of the Group has been criticized, and their depiction of an unpeopled landscape described

as a weapon in the cultural genocide of the aboriginal population. One writer has questioned whether their paintings of Algoma were not intended to assist Sir Edmund Walker and the Canadian Bank of Commerce, which had considerable investments in the Algoma Central Railway. Recently, Robert Fulford called the Group of Seven's story of opposition and struggle a "Great Canadian Myth."[2]

In another strain of scholarship, some writers have studied the nationalism of the Group in light of an earlier tendency to identify Canada with the land and the North, and in relation to parallel developments in literature, politics, and poetry, and have analyzed some of the reasons for their continuing popularity.[3] Exhibitions and publications have examined the paintings of the Group as compared to the art of other northern cultures, especially the Scandinavian ones, and have traced the sources of their ideas to the writings of Henry David Thoreau, Walt Whitman, Ralph Waldo Emerson, and of the theosophist movement.[4] Such studies highlight the complexity of the Group's work and its use, and reflect the powerful influence their art and history have had on our perception of Canada.[5]

There is a recurrent problem in some of these critical discussions, which this book attempts to address. Writings about art too often build on other writings about art, so that a selected quotation, for example, takes on a life of its own quite different in meaning from the original intent. An idea expressed by an author writing about an artist is quoted as if it were the artist's own idea. This has been especially true of Fred Housser's book *A Canadian Art Movement: The Story of the Group of Seven*, published in 1926, which has been frequently cited as articulating in a pure form a common ideology of each of the artist members. Yet Housser was a regular writer on theosophic subjects, and his book is therefore imbued with theosophic concepts interpreted in his own language; in many instances, these do not reflect the views of all the artists of the Group of Seven.

In general, it is far too easy to emphasize the word "Group" in discussing the work and ideas of this collaboration of artists, submerging the individuals into a common identity. Certainly, cooperative effort in the form of mutual support, intellectual stimulation, and sharing of ideas was at the core of the Group experience. Yet each artist had his own history, which coloured his art and intentions. The current project looks at their common activities, but also examines their individual contributions.

This publication and exhibition propose to examine the history and development of the Group's ideas and exhibitions during the 1920s, based as much as possible on contemporary documents, and thus, it is hoped, lay a new groundwork for debate. Their goals were much broader than has been acknowledged by their supporters. The opposition to their work and the campaign to achieve recognition for modern Canadian art were more bitter than has been recently admitted, and their support was more tenuous. As individual artists and together, they had a major and constructive influence on the development of Canadian art.

In the articulation of their personal goals, the Group of Seven effectively consisted of five artists: J.E.H. MacDonald, Lawren Harris, A.Y. Jackson, Arthur Lismer, and Fred Varley. Frank Johnston's association was too brief to have much effect, and his commercial needs would lead him to oppose the Group in the late twenties. Tom Thomson, always identified with the Group, died even before the loose collaboration of painters gave itself a name.

The seventh of the seven in 1920, when the Group held their first show in Toronto, was Frank Carmichael, who was, however, the silent partner in the Group. He alone of the original members continued to work in commercial art full-time. His paintings, although at first indebted to Tom Thomson and later owing much to Lawren Harris, were always personal in their interpretation and reflect a delicate and refined sensibility. He never participated in the larger campaign to depict the other regions of Canada but remained a painter of Ontario. It was in his watercolours and his portrayals of the northern mining region that he made his most original contribution.

Of the active and outspoken participants, J.E.H. MacDonald was the oldest, and his roots lay in rural, late-nineteenth-century Ontario. A lover of the writings of Thoreau and Whitman, he was attracted by their keen sensitivity to nature, their down-to-earth practicality combined with fervent idealism, their democratic spirit, and their poetry. The writings of the English socialist artist William Morris provided guidelines for the translation of his love of nature, plants, animals, birds, and natural phenomena into design and decoration; Morris also spoke of the necessity of a social role for art, which accorded with MacDonald's own keen sense of justice. Above all, MacDonald was the poet of the Group, vehement but reasoned in his defence of their ideals. In his published articles, first written in reaction to criticism, he would speak as both a nationalist and a working artist for the furtherance of Canadian art.

Lawren Harris was the enthusiast and initiator of the Group. It was he who assured the construction of the Studio Building in Toronto, bringing the artists together in a concrete and practical way. It was he who planned the trips to Algoma and spurred the movement on to higher goals. He had studied in Germany and was the only member to have attended university; as a theoretician and intellectual, he shared his ideas, stimulating the others. His nationalism was fuelled by his readings of the Irish nationalist George Russell (AE) before the First World War,[6] and his idealism and broad conception of his mission were strengthened by his study of theosophy. Harris also believed that the artist had a social role: to speak of human injustice and clarify the highest ideals of the nation. Those whom he called his "Christ figures"[7] were AE, Mahatma Gandhi, Whitman, Thoreau, Annie Besant, and other theosophists, all idealists who translated spirit into action. His published articles were inspirational, providing not prescriptions but an enlarged framework for growth.

A.Y. Jackson was an adventurer who delighted in physical challenge and effort and always wanted to see what was over the next hill. He had left school when he was thirteen to work, but was a voracious reader and thus largely self-educated. The bachelor of the Group, he had fewer commitments and, by living frugally, was able to paint full-time and travel widely. He was the only member to have worked extensively in France and retained an ongoing appreciation of French art. A fervent nationalist, he saw Canada as defined by the breadth of its geography and by its inhabitants. His affection for his subjects is evident in his paintings. He was gregarious and deeply interested in people, a scrapper who delighted in a scrimmage in the press and a champion of patriotism and modern art. As a Montrealer, he would play a key role in uniting the artists of his home town with Toronto.

Both Arthur Lismer and Fred Varley came from Sheffield, England, and their initial delight in the new country was as much a reflection of the opportunity it offered immigrants as a reaction to camaraderie among artists with a purpose. Lismer was the teacher of the Group, first in Halifax from economic necessity, and then in Toronto, where he demonstrated an increasing commitment to his students and later to the children in his art classes at the Art Gallery of Toronto. His teaching in an art school and his understanding of the ideas of William Morris and the English reformist Edward Carpenter led him to articulate a holistic vision of art as permeating all aspects of life and having a profoundly constructive influence in society. The writings of the art critics Roger Fry and Clive Bell reinforced his understanding of the works of Cézanne and informed his own painting. And his study of Benedetto Croce's aesthetics confirmed his belief that "art is a universal and not a specialized quality of human consciousness"[8] with a necessary social role in breaking down the imitative and opening up the creative forces in the individual and society at large.

Fred Varley was somewhat of an outsider in the Group, although his inclusion from the start bears witness to their larger intent beyond the depiction of the Canadian landscape. Primarily a figure painter, he would really come into his own in Vancouver after 1926. In Toronto, his career was characterized by spurts of activity and cooperative ventures alternating with periods of inaction. His commission as a war artist gave him his first opportunity to paint full-time; stimulated by the grandeur and horror of the subject, he produced his first major canvases. The enthusiasm this engendered carried him through the early years after his return to Toronto. He worked as a portrait painter, but his work was not conventional enough and he was unable to attract enough clients. He moved to Vancouver, taking with him the prestige and notoriety of his association with the Group, which now for the first time had a member outside Toronto. There, inspired by the new environment, he painted his most important landscapes. Varley's paintings and letters speak of a romantic, poetic spirit, of a sensualist in love with an ideal that he found in nature and in the spiritual and physical beauty of women.

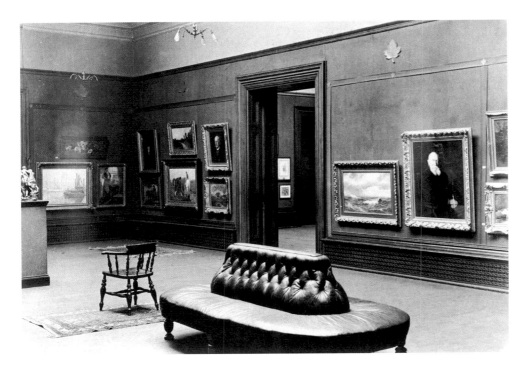

FIG. 3
Canadian Art Exhibition, Walker
Art Gallery, Liverpool, July 1910.

~

The Group of Seven held their first exhibition in May 1920 at the Art Gallery of Toronto. Yet Housser's book *A Canadian Art Movement* begins the story ten years earlier in Liverpool, England, in 1910 (fig. 3), the year an exhibition of Canadian art organized by the Royal Canadian Academy of Arts (R.C.A.) was shown in that city. A writer in the *Art Chronicle* reviewed the show: "Canadian painting has not yet grown beyond the assimilative stage of youth; its painters still look to Europe for initiative, its students go to London and Paris for the training and the inspiring associations that the artist-life of the Old World alone can provide. The sapling, however, is a vigorous one, and all that is now being grafted on it will in due season bear rich fruit. The Art of Canada must ere long become a distinct factor in the Art of the world, in spite of the poor encouragement given to it at home, where, as elsewhere, there is little real taste for Art among those who have money to spend on pictures; and, as a result, large sums are lavished on the acquisition of 'old masters'."[9] The *Liverpool Morning Post* expressed a similar reaction: "At the moment observation of physical fact is strong, but the more immutable essence of each scene is crushed out by a foreign-begotten technique."[10]

Four years later, Harris and Jackson would proffer both an explanation and a solution for the current situation, which reflected their agreement with these remarks. They touched on the same three factors: subject, technique, and support for Canadian art. In response to the consternation expressed by British publisher John Lane at the paucity of Canadian art in Canadian collections,[11] they explained that, as long as foreign-trained Canadian artists painted European or Canadian subjects in "the dark tones proper to European art" or "bleared fog-tones of Corots," collectors would naturally prefer European

subjects painted by Europeans. The new subject to be painted was "all the sunlight, the height of sky, the freedom of windy space that is Canada. Landscape predominates over figure work in Canadian art because Canada is all landscape so far — at least, landscape is all that is national yet. Her people and her cities are not characteristic … But Canada's physical appearance is distinctive and our artists are aiming to catch the illusive appearance of its face, to see in it what virtues, what natural qualities it has to breed into the Canadian people … The Canadian people, seeing in these pictures something distinctly Canadian [and] feeling a sympathy for what is caught on the canvas, will buy them."[12] The sub-theme was the people, whose identity, following the writings of the French philosopher Hippolyte Taine,[13] was informed by the environment. The artist must probe the landscape to understand the Canadian psyche and thus realize an art that would truly reflect both. "The new fields, fresh motives, original subjects that are at hand on every side, the sane and healthy outlook of Canada, neither academic nor super-refined and erotic, both of which extremes are upsetting European art; and the enthusiasm that accompanies the growth of a national spirit, are all important factors whose existence presages much for the future of Canadian art. There is a certain puritanism about Canada … with her breadth of spirit, her great distance of growth yet to come, [she] may maintain her puritanism, and then any art not puritan would not be an expression of the national spirit. Certain it is that an austerity, almost a puritanism of spirit has dominated the truer Canadian art so far."[14]

Two definitions of European art are provided in this article as the foils for the new art, a Barbizon or Hague School mistiness, and a commercial, highly academic salon style of painting, both of which flooded the Canadian art market. In contrast, Harris proffered an art more closely aligned to his own sympathies, the art of Scandinavia that he had seen in Buffalo the previous year. "In subject, in treatment there was a pronounced affinity with his own aspirations and with the aims of his colleagues in the younger ranks of Canadian artists."[15]

The goals of the artists who would form the Group of Seven in 1920 were idealistic and nationalist in intent, and their prime audience was English Canada. They set out to throw off the colonial attitude which denigrated all Canadian creative ventures and slavishly imitated or worshipped all things British or European. In such an environment, they would argue, no Canadian artist could live and grow. The large number of expatriate artists in the late nineteenth and early twentieth century was a telling comment on the lack of patronage at home. What was necessary, the Toronto-based Group contended, was to realize an art that was distinctly Canadian and thus that Canadians would recognize and support.

They were not the first artists to work towards these goals. Subject matter, technique, and aesthetics had been part of the debate since the 1870s. In a

speech given at the opening of the new Art Association of Montreal building in 1879, the Marquis of Lorne called upon Canadian painters to portray "the features of brave, able, and distinguished men of your own land, of its fair women, and ... the scenery of your country ... the magnificent wealth of water in its great streams ... the foaming rush of their cascades, overhung by the mighty pines or branching maples and skirted with the scented cedar copses."[16] Such were already the subjects of Lucius O'Brien, John Fraser, F.A. Verner, and certain other charter members of the R.C.A., whose works were praised by the British Royal Academy's secretary, J.E. Hodgson, in a lengthy assessment of the Canadian art displayed at the Colonial and Indian Exhibition in London in 1886. Amid frequent digressions on the writings of the Americans Washington Irving and James Fenimore Cooper, Hodgson admired the work of the Canadians primarily for their subject matter: "The pictorial resources of nature appear to be boundless, whilst the life of the people so much less removed from primitive simplicity than is the case in our world, supplies that element of picturesqueness for which we are compelled to search far and wide and often in vain."[17] Much of his report was devoted to denouncing the modern, academic French tendencies apparent in the work of Paul Peel and William Brymner – the very qualities praised by the noted British critic R.A.M. Stevenson. In his 1886 review, Stevenson commended those artists' "texture and brushwork," "simplicity of workmanship and the broad truth of its effect," and "purely sensuous beauty and decorative quality of surface."[18] Yet the two elements – specifically Canadian subject matter and pictorial effect as defined in French terms – were not incompatible, as could be seen in George Reid's paintings of his country boyhood and in his murals for the new Toronto Municipal Buildings illustrating the early history of the area; the latter were inspired by the civic murals being painted in France, and by the work of Puvis de Chavannes.[19] It was in the history of Canada and in rural life that Reid defined his Canadianism in the 1890s, an interest he shared with a group of graphic artists known as the Toronto Art Students' League.

∽

The Toronto Art Students' League was formed in 1886, at first to provide artists with an opportunity to study from the live model. On summer trips the members, both men and women, sketched in the small villages surrounding Toronto, the Quebec City area, the Niagara Peninsula, and the Richelieu River valley, sites intimately associated with great moments in Canadian history. Both Reid and the League members found inspiration in their readings of history, and at the turn of the century history was an important medium for the interpretation of a national landscape.[20] Rural villages also identified the origins of European settlement and thus the artists' own roots in this country. In an age when urban centres were slowly growing and streetcars extending into former farm lands, the transitions over time and in society were expressed by

the artists through depictions of the sites, lifestyles, customs, and events that defined their own history. Reid's *Mortgaging the Homestead*, Homer Watson's *The Flood Gate*, Marc-Aurèle de Foy Suzor-Coté's *Blessing of the Maples*, and Maurice Cullen's *Ice Harvest*, to name just a few, all portray elements of a Canadian experience that was slowly disappearing.[21]

Of the future members of the Group, only MacDonald had living links with this period, and his own history paintings and landscapes of Thornhill, a small farming village north of Toronto, show an affinity with the earlier movements. He would transmit his love of the landscape of the pioneer farm to his son, Thoreau, who would visually document the implements, fences, and buildings being cast aside and torn down in the late twenties and replaced by gas stations.[22]

If the nation's human history was not seen by the Group as being a field for the development of a Canadian art, nor, by and large, were the cities. Photographer and Group supporter Harold Mortimer-Lamb, writing in 1922, explained: "The spirit of Canada is not to be found in the settled portions of the country, in the vicinity of the cities. There it has been tamed, or re-clothed with the commonplace garb of civilization, so that its individuality is destroyed."[23] Harris alone of the Group would depict the older Victorian homes of Toronto, now abandoned by their former owners and awaiting demolition or occupied by more recent immigrants. For him, the city was a realm not of nostalgia, but of change, a stage on which contemporary society was being modified. While on occasion he would delight in the picturesque, his urban paintings, in which beauty and squalor are contrasted, speak of poverty and human suffering. Harris saw Canada as a youthful country, a land of equality and potential in contrast to a Britain and Europe weighed down by history, class distinctions, and ancient enmities. For new immigrants who lived in the more impoverished areas downtown in the Ward or on the fringes of the city, the hopes had temporarily turned sour, and these homes spoke to Harris of a failed ideal. In a text on his paintings that he wrote for the 1911 exhibition of the Ontario Society of Artists (O.S.A.), he contrasted the silence, dignity, and cleansing force of nature with the squalor and carelessness of humanity.[24] And it was above all in nature that Harris and the other future members of the Group would base their optimistic beliefs for Canada.

The Group of Seven's ideas were defined in the immediate prewar period, at the tail end of an era of rapid expansion, immigration, and development that saw the formation of the provinces of Alberta and Saskatchewan in 1905. By 1911, Saskatchewan had a population as large as that of Nova Scotia, the most populous of the Atlantic provinces. More than 60 per cent of Canadians still lived in Quebec and Ontario, however. Greater Montreal, which included Verdun, Outremont, Westmount, and Lachine, was the largest city in Canada,

with over 530,000 people in 1911 compared to Toronto's 381,833. By 1931 the populations of Greater Montreal and Toronto would be, respectively, more than a million and 630,000. Toronto, the smaller city, had no real art traditions save those initiated by the artists themselves. Montreal, on the other hand, was older, with an established, moneyed elite who took pride in their art possessions. What they largely possessed was European, specifically Dutch, art. This legacy weighed heavily on the art community in the city and perpetuated false values.

Most of the population of Canada in the early part of the century lived along coast lines and rivers in the eastern provinces, along the St. Lawrence, in southern Ontario, around the Great Lakes to Sault Ste. Marie, from Winnipeg to Edmonton and Calgary, and in the southern part of British Columbia. Vast areas were sparsely inhabited, and the 1915 *Atlas of Canada* would still show significant parts of the southern half of the country with a density of one person per square mile. One thing Canada did have was an immense natural presence. Yet as early as 1893, the Province of Ontario had felt it necessary to establish a natural reserve in Algonquin Park to inhibit settlement and control the exploitation of lumber.[25]

In 1919, Jackson described Algonquin Park as he found it in 1914: "Round Canoe Lake is a ragged piece of Nature, hacked up many years ago by a lumber company that went broke. It is fire-swept, damned by both man and beaver, and overrun with wolves. Most of [Tom] Thomson's sketches were painted about Canoe Lake, which was his starting point and virtually his home. Early spring and autumn seemed to inspire his finest efforts, and the intimate charm with which he endows his waste of rock and swamp, friezes of ragged spruce, the slim birch which clings to the meagre soil on the rocks, are but an expression of his love for the country."[26]

The rough wildness of the landscape, its raw, dramatic austerity, coupled with breathtaking colour and light, spoke far more directly of Canada for these artists than anything to be found in the cities or settled areas. For them, the north, a constant motif in earlier discussions of Canadian identity, found its first expression in the rocks, burnt land, trees, colour, and light of Algonquin Park. It was this same roughness, described as crudity, that many writers said characterized the Canadian people, who were perceived as lacking the refinement of the Old World. Or, as C.W. Jefferys stated, we were virile, full of exuberance, and rash with the curiosity of youth.[27]

Though industrialization would expand considerably during the early twentieth century, the resource industries remained major components of the Canadian economy. Agriculture, forestry and logging, fishing, and mining symbolized Canadian production, and the logger, the fisherman, and the rural worker came to symbolize the Canadian type. "What Canada needs most is a painter who will touch the heart of the nation with subject pictures which reveal and translate the life of the people," exhorted the *Canadian Courier* in 1907: "The river-driver, the bushman, the hunter, the grower of wheat, the

fisherman, the miner ..."[28] In his murals for Dr. James M. MacCallum's cottage on Georgian Bay, MacDonald would paint the hunter, the fisherman, and the lumberjack.[29] And throughout the twenties, Harris and Lismer would argue that their art was as much an expression of the Canadian character as of the landscape that formed it.

≈

In the foreword to the catalogue of the 1922 Group of Seven exhibition, the artists wrote: "New material demands new methods and new methods fling a challenge to old conventions. It is as impossible to depict the autumn pageantry of our northern woods with a lead pencil as it is to bind our young art with the conventions and methods of other climates and other ages."

The new methods evolved over two decades. Both Lismer's *Guide's Home, Algonquin Park* and Jackson's *Frozen Lake, Early Spring, Algonquin Park* of 1914 are essentially Impressionist paintings in paint application and concern for light and colour. The dappled foreground shadows and light of the latter are clearly indebted to Jackson's study of the paintings of Renoir. By 1915, Harris and MacDonald had incorporated the lessons learned from the Scandinavian exhibition into their work; these would remain a strong influence on Harris's paintings up to 1919, on Tom Thomson's mature canvases, and on Carmichael's paintings of the early twenties. Jackson, with the most experience of painting in France, had a clear understanding of the influence of French Post-Impressionist painting on the Scandinavian work. In 1921, he confirmed that "Cézanne, Van Gogh and other moderns" were their "gods."[30] It was from the art of the European Post-Impressionist painters that the Group derived the language to deal with the new subject matter. The rough paint surface, the brilliancy of purer colour, the synthesis of design, and the rawness of expression were appropriate formal elements to depict the wild Canadian landscape. Theirs was an experimental art: the artists understood that each painting and each subject posed new challenges and required new approaches. Their critics could only understand "experiments" as unfinished and untested results.

While recognizing their roots in Post-Impressionism and in Scandinavian, Symbolist landscape painting, the artists differentiated their work from that being done in the United States, which they perceived as overly imitative of French art. In an article referred to by Jackson, the American critic James Rosenberg reviewed an exhibition of The New Society. "What, then, in the large, is the essence of this representative show? Ghosts are speaking, it seems to me. Ghosts of France. Shades of Manet, Monet, Cézanne, Renoir, and a dozen lesser men lurk cynically on these American walls."[31] As Bertram Brooker later pointed out, an essential difference had to be understood: "Those who 'stem' from Cézanne do not imitate him; they learn from him not to imitate anybody."[32] The Toronto artists were well aware of their antecedents, but the lessons learned would be considerably modified by the

subjects treated. "Sketching [in Algoma] demanded a quick decision in composition, an ignoring or summarizing of much of the detail, a searching-out of significant form, and a colour analysis that must never err on the side of timidity. One must know the north country intimately to appreciate the great variety of its forms," wrote Jackson.[33] Lismer later expanded: "the typical qualities of such places as the Georgian Bay, Lake Superior, the Laurentians, the Northwest prairies, Rocky Mountains, and the foothills: what grand pictures these call to mind, and what a background for the elemental forces of nature to sport in. The aspects of winter and the fall; the green riot of spring, storm and sunshine, against and on such a setting, are truly of epic grandeur – no timid play of subtleties, but bold and massive design."[34] Experimentation and constantly renewed response to the landscape were essential to the vitality of the Group's art, and throughout the teens and twenties their work would continue to grow.

Certainly, the Group of Seven's "modernism" was conservative compared to much that was being done in Europe, and the Toronto artists repeatedly reminded their critics of that fact. Yet their art was perceived by most Canadians in relation to the work of other Canadians, and in this context their paintings were advanced. As the critic Hector Charlesworth noted: "The chief grudge that one has against these experimental pictures is that they almost destroy the effect of very meritorious and sincere pictures which are hung on the same walls."[35] In 1915, the painter Wyly Grier went on a canoe trip to Algonquin Park with artist Franklin Brownell and the National Gallery director Eric Brown and his wife Maude. There Grier painted *Noon* (fig. 4), a study of a nude model, which was purchased by the Gallery that fall.[36] Comparing *Noon* with Thomson's 1915 canvas *In the Northland* (fig. 6), the difference between the bold, bright, decorative language of the newer artists and the timidity of the old school is clearly evident. The one speaks of light, colour, clear atmosphere, and nature directly experienced, while the other speaks of the convention of the studio where the sole indication of place is confined to the background.

The criticism of the paintings of individual members of the Group focussed on two principal issues. The first was the crude, broad manner of painting – "that rough, splashy, meaningless, blatant plastering and massing of unpleasant colours in weird landscapes ... the same blustering spirit of Post-Impressionism, all conveying the same impression that the artist didn't know how to do it, and wasted considerable good pigment in a disastrous attempt," as Samuel Morgan-Powell of the *Montreal Daily Star* succinctly put it.[37] The fact that such attacks could be mounted against the Group as late as 1932 says more about the conservatism of certain segments of the Canadian art community than about the relative modernism of their work.

The other main criticism was that their paintings were too "realistic," that they depicted only the ugliest aspects of the Canadian landscape. "The school evidently sees only rocks, ice and snow, some timber but mostly burned,

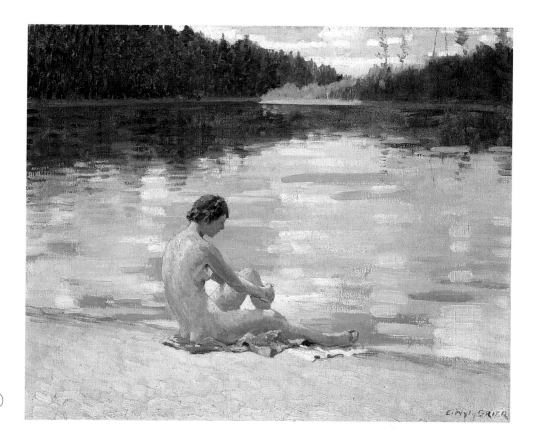

FIG. 4
WYLY GRIER
Noon 1915
Oil on canvas, 58.7 × 71.1 cm
National Gallery of Canada, Ottawa (1178)
Purchased 1915

they do not see the beauteous scenery of this country, scenery which is comparable with the best in the British Isles or on the continent and which has inspired some of the greatest landscape painters. If we are to encourage and attract immigration to this country our federal government would be well advised to prevent some of the hideous paintings that are supposed to represent Canadian scenes from being shown abroad," wrote a Toronto lumberman.[38]

The absence of sound criticism was a serious problem for the artists. Morgan-Powell spewed forth repetitive vituperation echoed in numerous letters to the editor from self-described "Lovers of Real Art." The only conservative critic with a considered point of view was Hector Charlesworth. Unlike some others who demanded "fine draughtsmanship" and finish and clarity of form and message, Charlesworth understood Émile Zola's definition of art as "Nature seen through a temperament"[39] (fig. 5). The personality he wished to see expressed was evident in the paintings of the two artists whose work he most admired, Archibald Browne (fig. 2) and Carl Ahrens (fig. 7). Of the former he wrote: "Mr. Browne has long been noted for his poetic treatment of landscape, and his exquisite intuitions in the handling of atmosphere; but his later work shows a richer feeling, a deeper grasp of the mysteries of colour, and a quality of luminosity truly wonderful."[40] And of Ahrens: "The Swiss thinker, Amiel, laid down the dictum that landscape is a state of the soul, which I take to mean that landscape increases in beauty in accordance with the

soul, the perception of beauty … Ahrens [is] an impressionist in the best sense, because he is also a sincere and able workman … To him trees have a spiritual fascination, which accounts for the real soul that pervades all his pictures."[41] For Charlesworth, painting should reveal a personal, subjective vision and an atmospheric and poetic image, and he judged the work of the Group from this position.

In the face of opposition, MacDonald and Jackson exhorted the critics to recognize the ideas behind the works of art and encourage the artists to aim for a higher ideal instead of violently denouncing their paintings. "If the function of the artist is to see, the first duty of the critic is to understand what the artist saw … a ribald and slashing condemnation, without justifying analysis, of any picture … is rarely, if ever, necessary to the public interest … The artist is not paid to exhibit his picture. It is his stock in trade and certainly should not be flippantly lowered in the estimation of the public."[42]

The Group did have vocal supporters; a number were associated with newspapers or periodicals, and so the debates about their painting and about Canadian art received extensive journalistic coverage. One early enthusiast was Augustus Bridle, from 1916 the editor of the *Canadian Courier* and later a writer for the *Toronto Daily Star*. Harold Mortimer-Lamb, a pictorialist photographer and sometime art dealer, also wrote in support of modern art, allying himself with the Group in the heat of conflict, first in Montreal before the war and then in the 1920s in Vancouver. Barker Fairley, a professor of German at the University of Toronto, was an articulate spokesman for the ideals of the

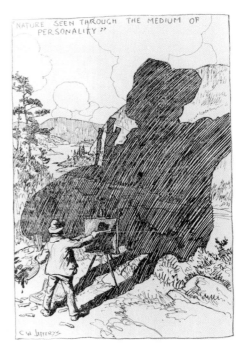

FIG. 5
C.W. Jefferys: "Nature Seen through the Medium of a Personality," *The Rebel* IV:6 (March 1920), p. 278.

FIG. 6
TOM THOMSON
In the Northland 1915
Oil on canvas
101.7 × 114.5 cm
Montreal Museum of Fine Arts
Purchased by subscription, 1922

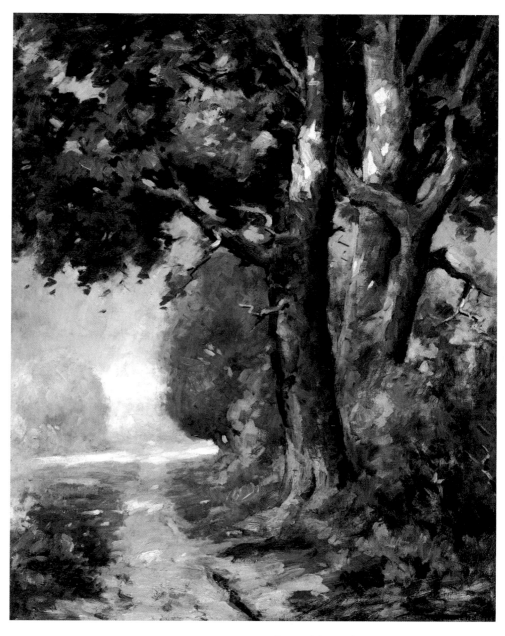

FIG. 7. CARL AHRENS, *The Road* (cat. 4)

artists, although he was not uncritical; he especially had reservations about the work of Lawren Harris.

The Group's supporters were often more conservative than the artists, however, as evidenced by Fairley's objections to Paul Nash's painting *Void* (fig. 23) and William Roberts's *Gas Attack* in the Canadian War Memorials exhibition in 1919. "Nash and Roberts have expressed the emotional reaction of war on their own natures, but they have done so at the expense of general intelligibility. Their work is esoteric and will probably remain so. It will speak to a few only."[43] The same paintings were received with praise by Jackson and Lismer.[44]

A certain puritanism characterizes many of the writings of critics favourable to the Group. Modernism was tainted with moral laxity and degeneracy in the eyes of many, a prejudice hardly countered by the Montreal art dealer William Watson when he attempted to explain the work of Gauguin and

Van Gogh in 1912. He defined Post-Impressionism as a "primal-academism," a primitivist desire. "Gauguin went to savage life, and was in his marrow barbaric, yet his works betray a knowledge of art which is singularly incongruous and this is the inimitable paradox of civilized man essaying to return to the savage." Van Gogh's ear and "lunacy" were also brought into the argument to demonstrate the sincerity of the originators of modern art and the "mannerism and inane imitation" of their followers.[45]

Eric Brown, the National Gallery's director, was also an active proponent of the ideals of the Group; he took pains to distance the Canadian manifestations of modernism from the "decadence" or "immorality" of its European expressions. "Modern art is not to be confounded in any way with Futurism because all movements which degenerate art into ugliness and distortion have just the same relation to true art that Bolshevism has to true government. The obvious purpose of art is to do good; it must bless the world if it is to be a force. When we begin to distort the human figure, a tree, a landscape or anything else, the result is degeneration, and that is not art. In Canada the new art is coming to life in an extraordinarily sane and beautiful way. There has not been the slightest attempt at degeneracy."[46] The Group's critics might have countered that distortion was in the eye of the beholder, but despite Brown's attempts to sell his clean, national modernism he would increasingly come under attack for his support of their painting.

The National Gallery and the Group of Seven shared common goals — to further an awareness of art and of the importance of Canadian art for the development of Canada as a nation. "There never was a great country that did not have a great art," declared Brown.[47] Through a system of loans circulated throughout the country, the Gallery brought paintings from its collection to communities otherwise devoid of art of any importance, Canadian and foreign, according to the wishes of the recipient. Responding to criticism from Mortimer-Lamb about the quality of the loans, Brown asserted, "Strictly speaking it is neither any part of the duty of the National Gallery, nor its intention, to keep the walls of city galleries hung with pictures from the National collection. The loans are for purposes of stimulating and encouraging public interest in the fine arts, to the point of establishing municipal galleries and schools of art which will carry on their own work for the good of Canadian taste and development."[48]

It was with a similar intent that the Group circulated their paintings across the country during the 1920s. As early as 1914, Harris had ensured that a "Little Pictures" exhibition that he was instrumental in organizing was shown in Fort William, Ontario.[49] While the Royal Canadian Academy — which received an annual government grant — pleaded that lack of funds prevented it from extending its exhibiting activity, the Group, largely at their own expense, and sharing costs with the recipient institutions, presented shows in almost every town of any size, especially in western Canada. They wanted not just a Toronto audience for Canadian art but a national one, and to stimulate local artists, collectors, and critics.

The ambitions of the Group of Seven went far beyond winning a market for their own painting, a goal they had hardly achieved by the time they disbanded in 1933. What they set out to do was considerably more: to foster a distinctive Canadian expression in painting, design, and manufacturing; to train designers and artisans to use Canadian motifs; to reform art education to counter academic teaching and instil a freer, more creative spirit into younger artists across the country; to convince collectors to take an active interest in the art being produced around them and to reject "the parasitic traffic of the picture sale room"; to see public collections of Canadian art established in schools, libraries, and galleries across the nation; and to attain for Canadian art and for Canada an international audience. To these ends, they not only exhibited and circulated their own paintings, but consistently included the work of other artists whom they respected and wished to support in their shows. Their establishment as a Group was the catalyst for the formation of the Beaver Hall Group in Montreal and of the Ottawa Group,[50] and while both soon disbanded, the Group of Seven continued to play a crucial role in fostering modern artists during the 1920s when they were under severe attack from conservative critics.

Nor did the Group members confine their interests to easel painting. They illustrated Canadian books, published portfolios, designed stage sets, decorated public buildings, painted murals, wrote poetry, worked with musicians, participated in folk festivals, and inspired writers, dramatists, musicians, poets, and a whole generation of younger artists.

As well, the artists wrote numerous articles articulating their ideas for an art inspired by a love of their country. The controversies about their painting and philosophy were published in newspapers across Canada, usually stimulated by their opponents, and — second only to the widespread distribution of their paintings — did much to bring their work and ideas to public attention.

The Group stood in opposition to "the possessive instinct … inflating the personality … looking always to other peoples, other times for all created works and ignoring or decrying all native endeavor … In brief, the way of the plutocrat and incipient plutocrat to self-glorification," declared Lawren Harris.[51] "The modern Art Gallery has moved out of the narrow exclusive possessive atmosphere of a few who desire to see art retain the element of pride of possession in a few chosen works — into a sphere of service," Arthur Lismer agreed.[52]

The Group's intent was populist, as recognized by Emma Griesbach, writing as "Diana" in the *Farmers' Sun*, the newspaper of the United Farmers of Ontario. She proposed covering the exhibitions at the Art Gallery of Toronto: "The Art idea has never been brought to the people, at least not in this country. The artists are too busy painting to have time to do it, and connoisseurs of Art seem in general to think that the Art idea — including the appreciation of pictures — is so sublimated that it is not for the ordinary people."[53]

After visiting MacDonald at the Studio Building she declared, "It is because I like sturdy Canadianism in any field, that I am drawn to the work of the Group of Seven … it is because I am profoundly convinced that our people (not only urban, but certainly also rural) need a broader conception of what the true destiny of Canada and Canadian development includes that I make this presentation of the aims and work of a group of Canadian artists … As a rural people, should we stand apart from any phase of national development? We rural people are reaching out in many directions … Let us with serious and conscientious minds, as Canadians with the broader vision, determine in the future to include in our self-education, some knowledge of art, an interest in its forms, an enjoyment of its beauties."[54]

~

If the Toronto artists found that English Canadians suffered from insufficient national pride, their confreres in Montreal protested against the inward-looking, conservative nationalism based on religion and rural life that was expressed in the Québécois ideology known as *le terroir* [the soil]. These writers and artists, who gathered around the publication *Le Nigog*, rejected an art defined by the Canadianism of its anecdotal subjects, with all the accompanying moral and nostalgic implications. For these Montrealers, the advance of art in Canada required openness to contemporary urban life and to French art – the Symbolists, Degas, and Cézanne, in particular. They felt the intrinsic, formal qualities of art were more important than subject matter. "I have seen countless Montreal 'art critics' display a narrowly patriotic point of view when giving their impressions of the salons, admiring only those works whose subject matter is totally Canadian!" wrote Fernand Préfontaine in *Le Nigog*. "Art, like science, is universal. We wouldn't dare suggest that a philosophy or a branch of physics or chemistry is purely Canadian. It wouldn't make sense. Yet we expect our art to limit itself to depicting Canadian scenes, so that artists totally unmoved by anecdotal, agrarian subject matter, who wish to create without having to deal with the patriotic sentiments of their fellow citizens, are completely powerless to do so. This sentiment may give rise to some masterpieces but surely cannot inspire them all."[55]

His statements were virulently attacked and, in response, he cried, "Let us not quibble with our artists about their source of inspiration, but rather encourage them in every possible way to produce works of art."[56] The problems were the same in Montreal as in Toronto: lack of intelligent criticism, lack of support for artists, and lack of interest in art in the general population. What Préfontaine proposed as a solution, however, was not a campaign to elicit a greater awareness, but the creation of a limited audience. "Until an artistic elite is formed, it is useless, I believe, to speak of art in our country. The public isn't interested, and those who attempt to discuss it are immediately branded as worrisome and slightly ridiculous figures … Instead, we are striving to form an elite ready and willing to take an interest in art and artists.

But considering the reception we have been given, I think it will be quite some time before this goal is achieved."[57]

The position taken by writers like Préfontaine was bitterly criticized by Marius Barbeau, an ethnologist at the Victoria Memorial Museum in Ottawa and researcher of the traditional folk cultures of Quebec. "Some members of a small, contemporary Montreal clique quite ingeniously draw inspiration from the least known works of French Impressionist or ultramodern poets. This is because subjects, formulas, and models are imported to Canada the same as wine, olive oil, and silk. Imitating foreign trends hinders the virile and independent surge of creativity. Certain of our literary hacks would attain the glory that eludes them if they dispassionately viewed the variety of themes their own country offers them, instead of rehashing universal platitudes."[58] Barbeau was in a curious position. Although lauded by supporters of *le terroir* for his role in preserving and validating traditional culture,[59] he saw this music and art not as an anchor to control the future but as a source for a contemporary expression which would incorporate many of the formal innovations proposed by the writers of *Le Nigog*. Later, Léo-Pol Morin, *Le Nigog*'s music writer, worked on several occasions with Barbeau in composing music derived from traditional folk melodies.

Barbeau worked as well with Jackson, Lismer, and Edwin Holgate, among others, on various projects related to his research on the traditional cultures of Quebec and of the Tsimshian people in British Columbia. Jackson consistently identified the predecessors of the new movement as being Ernest Lawson, J.W. Morrice, and Tom Thomson, but through Barbeau's research the lineage was expanded to include Cornelius Krieghoff, Louis Jobin, and the carvings and totem poles from the Upper Skeena River. All were seen to reflect the character of the land.

~

Subject matter as a prerequisite for a Canadian art was an issue much debated in the late twenties. In the foreword to the catalogue for their 1926 exhibition, the artists wrote: "The Group of Seven realize that subject is not necessarily an ingredient of a work of art. Nevertheless it also feels that Canadian environment is the most potent stimulus to Canadian creative genius." Lawrence Mason of the *Globe* understood this to mean that the key to approaching the paintings was to appreciate their "'significant form', rhythm, power, freedom from conventional limitations, new colour effects, vitality, personality, imagination, larger aspects, generalizations, line and composition, spiritual values and the light that never was"[60] – effectively the formal qualities and intentions of a work of art. While the Group had no argument with this position, they insisted that Canadian art must derive from Canadian experience.

A similar view was expressed by a writer in the *Canadian Forum* in December 1922. "I contend that art is divided into two distinct but closely

related categories, the one national, the other international or rather universal. National art represents the virile forward movement of a country, expressing its national intensity, aspirations, and characteristics, ever forward in its outlook, seeking to uplift the spiritual side of the nation, and, as such, being an integral and vital factor in its aesthetic advancement. To become an enduring factor, national art must be based upon the great stream of international art as it comes through the centuries. National art cannot, however, break suddenly away from this stream; it cannot deflect or modify the stream. That stream fundamentally supplies its aesthetic nourishment, and national art must accept the precepts of the men who compose that stream and apply these precepts to its own development. International art enunciates eternal and traditional principles, common to universal art-development … National art can only aspire to enter the universal category after it has proved its worth in a national sense and begins, at a further stage, to break new ground of universal aesthetic import. The 'Group of Seven' for me, therefore, is in a national stage. It represents Canada and its spiritual aspirations in a pictorial sense as nothing has represented it before."[61]

FIG. 8. LAWREN S. HARRIS, *Beaver Swamp, Algoma* (cat. 53)

1

A Canadian Art

 he Group of Seven was the product of three decades of debate surrounding Canadian art before the First World War. Responding to this debate, the Group offered a consistent vision that won wide support by articulating the issues in terms with which the public could identify, and thus laid the groundwork for the future of Canadian art.

Opening the first exhibition of the recently founded Canadian Art Club in February 1908, Daniel Wilkie, the Club's president, clearly stated the problems facing Canadian artists: "Heretofore each artist returning to his native land from his studies abroad has experienced a shock in realizing the lack of sympathy with his aims and objects, the lack of artistic facilities of every kind, the lack of intelligent critics, the lack of suitable buildings where works of art can be properly shown, and, above all, the lack of any apparent desire to see things change for the better."[1]

Confronted by this absence of support, in a "country so provincial and imitative in its tastes,"[2] artists made their living through commercial work, poorly paid illustrating for Canadian publications of limited circulation, portrait painting (the most lucrative option), or teaching. The preference of collectors for European or British art, no matter how inferior, "retarded the

advancement of native art" and resulted in poverty for Canadian artists, and their loss to the country as many left "to gain the recognition that they felt was their due."[3] Henry Sandham, John Fraser, Paul Peel, Wyatt Eaton, Blair Bruce, James Kerr-Lawson, J.W. Morrice, Ernest Lawson, Ernest Thompson Seton, Palmer Cox, Phimister Proctor, and Tait McKenzie — our early history is replete with names of artists who left Canada to further their careers or merely to earn a living. Those who did remain had to establish a structure of art organizations that would advance an awareness of Canadian art and support for artists. Starting in the nineteenth century, a number of such organizations were formed, and slowly had an increasing influence on the cultural climate of the country.

Societies of Artists

The senior Canadian art group was the Ontario Society of Artists (O.S.A.), formed in 1872. While its membership was limited to Ontario residents, both men and women, it actively solicited works from other provinces, organized exhibitions for cities outside Ontario, and for decades was the principal exhibiting organization in Toronto. In 1876, the O.S.A. formed the Ontario School of Art, but only eight years later severed its association with the school over the provincial government's interference and attempts to turn it into an institution for teaching industrial rather than fine art. The society continued to organize annual shows and assist with the art exhibitions at the annual agricultural fair known as the Toronto Industrial Exhibition (later the Canadian National Exhibition, or C.N.E.). In 1890, it resumed direction of the school, now called the Central Ontario School of Art and Design.

The Royal Canadian Academy of Arts (R.C.A.) was the most prestigious of the Canadian art organizations. Founded in 1880 by the governor general the Marquis of Lorne, after years of work by Canadian artists, it included architects and designers as well as sculptors and painters and was an exclusive organization with a hierarchical structure composed of forty academicians and an unlimited number of associates. A vacancy was required before an associate could be elected to full status by his or her peers. In fact, although Charlotte Schreiber was a charter academician in 1880, no other woman was elected to the rank until Marion Long in 1933.

The Academy's primary activity was the organization of annual exhibitions that took place on successive years in Montreal, Ottawa, and Toronto. Attempts to expand this circuit were hampered by the lack of facilities in other cities as well as by the costs of transportation. The Academy received an annual operating grant from the Dominion government, money which was also used to subsidize life classes for artists and art students in cities where there were resident academicians. This work was later extended to include Winnipeg and Saint John.

The headquarters of the Academy moved according to the city of residence of the current president, and thus efforts to construct an Academy

building and school, which would have consolidated its identity and facilitated its work, were frustrated by conflicts among the members in the various cities, as well as by the fact that the educational systems were under provincial control. The annual exhibitions were, however, major events, and brought the work of most leading Canadian artists to the different cities. It was also through the Academy that Canadian art was represented at important international exhibitions, from the Colonial and Indian Exhibition in London in 1886 to the Universal Exposition in St. Louis in 1904.

Museums of Art

Upon being elected an academician, the artist was required to donate a work to the Dominion government. These Diploma Works formed the nucleus of the collection of the National Gallery in Ottawa, which opened its doors in 1882 under the care of a staff member of the Department of Public Works, who, during the early years, was also an academician. Under a regime of not-always-benign neglect, the Gallery's collections grew through the lobbying efforts of particular artists or political colleagues, through the donation of new Diploma Works and the occasional purchase, and through gifts from the Academy. The Academy continued to take an interest in its somewhat orphaned child, and in 1907, under the presidency of George Reid, petitioned the Liberal government of Sir Wilfrid Laurier (through its patron the governor general, Lord Grey), to set up an "advisory Council of the Fine Arts composed of painters, sculptors, and architects, such Council to be appointed by the Royal Canadian Academy" to "systemize and control," through a section of Fine Arts in the Department of Public Works, "all efforts on the part of the Federal Government in connection with the Fine Arts," including the care and development of the "National Gallery of Art."[4]

To obtain advice and support for its petition, the Academy approached Byron Walker, the president of the Art Museum of Toronto and of the Toronto Guild of Civic Art, and a well-known Liberal. Both Walker and Lord Grey realized that the government would not accept control of a state institution by a professional body of limited membership. They did succeed, how-ever, in obtaining the creation of an Advisory Arts Council composed of three people, two from Montreal and one from Toronto, "who have made a special study of art and have interested themselves in the collections of objects of art and have also displayed an interest in public efforts to promote art and its culture in this country."[5] These were the Council's chairman, Sir George Drummond, the Honourable Arthur Boyer, and Byron Walker. Understandably, there was considerable dissatisfaction on the part of some of the artists who had worked so hard for the establishment of the Council only to find themselves excluded from its control.[6]

Over the years, the O.S.A. rented various premises to show its work and hold exhibitions, and from 1896 on, paintings by members were displayed on an annual basis in a gallery in the Toronto Normal School. In 1895, the society

proposed the establishment of an art association "to elevate the quality of Canadian art; to bring artists together; to provide a building for a permanent collection of pictures and for exhibitions of art societies and schools."[7] It was only in 1900, however, under the presidency of George Reid, that the O.S.A. was able to found the Art Museum of Toronto for what one commentator called "the most philistine city in the Dominion."[8]

The first exhibitions, organized jointly by the society and the Art Museum, were held in a gallery in the new public library on College Street. Even after the Art Museum received the property known as The Grange by bequest from Mr. and Mrs. Goldwin Smith, the larger shows of the R.C.A., the O.S.A., the Museum, and the Canadian Art Club from 1911 continued to be held in the library, while The Grange was used for smaller displays.

Montreal in the early twentieth century had no organization of working artists, although it did have the oldest art gallery in Canada. Artists had been active in the formation of the Art Association of Montreal in the 1860s, however, and for the next two decades there was considerable private and commercial support for local artists through the influence of Art Association members and the Canadian Pacific Railway. The Art Association established Montreal's leading art school, directed by William Brymner from 1886 to 1921, and a Spring Exhibition of Canadian art was held each year, first in the Association's building on Phillips Square, and then, from 1912, in the newly constructed art gallery on Sherbrooke Street. Certainly the most palatial building devoted to art in Canada, it had all the appearance of wealth and benevolent support for the arts.[9]

Yet the early support for Canadian art slowly disappeared during the 1890s. Active in the Art Association were Canada's richest and most adventuresome collectors, Sir William Van Horne, James Ross, and Sir George Drummond; they gathered the most significant private collections of European art in Canada prior to the First World War.[10] A younger generation aggressively collected modern Dutch art, the Montrealer E.B. Greenshields writing two books on the work of the Hague School, a derivation of French Barbizon painting.[11] The activities of these collectors came in for some scathing comments from A.Y. Jackson: "In buying pictures you have to follow the fashion set by the Van Hornes, the Angus, Greenshields, Drummond, and Hosmer outfits, and as they only buy the work of dead artists, it's kind of hard on the ones still living. Old Greenshields is the leader of the gang. His slogan is: 'The painting doesn't begin to mature until the artist begins to ferment.' They jump and rave over some old brown varnish – 'what glorious colour, what depth and feeling – a real Rousseau in the master's best manner.' Then they find out it's a fake, and leave it in a hurry, all of its beauty gone."[12]

Even Walker expressed reservations about Drummond's role. "As he owns such rare and expensive works he finds it difficult to sympathize in the work of struggling Canadian artists."[13] By 1913, the Art Association of Montreal, after fifty-three years of existence, listed 625 works in its collection, of which only thirty-three were by Canadian artists – all, except for nine, gifts.[14]

The Market for Canadian Art

The whole issue of purchases of Canadian art was of crucial importance for artists, yet in spite of all the effort put into the organization of exhibitions by the various societies, private sales were few. The problems were outlined in a petition to Laurier from the Academy in 1903: "The patronage of Canadian Artists by their fellow countrymen is certainly not large, notwithstanding the fact that many of them produce works of genuine merit. It is certain also, that those who do good things, are capable of performing work of much greater importance than they generally exhibit. The more important the work, the more time, thought, and expense its production has involved, and unfortunately the more important it is, the smaller the chance there is of its author being able to dispose of it in Canada ... It is a great thing for Artists to be incited to do their best, to be able to dare and to take the risk of producing important things without feeling that there is not even a chance of reward. Happy indeed is the man who need not consider this end; but there are very few artists in Canada who even after the exercise of great self-denial, are not forced to regard this consideration." The problem was aggravated by "the steady influx of comparatively bad and utterly worthless works ... Canada has ... for some time been made a dumping ground for certain classes of inferior work to the serious injury of native artists' chances."[15]

Artists turned to governments for minimal support, and the O.S.A. was able to obtain from the province an annual grant of $1000 for the purchase of paintings by artist members, the works being hung in the Normal School in Toronto until 1912, when they were distributed to Normal Schools across Ontario.[16] In addition, the Toronto Industrial Exhibition Association made

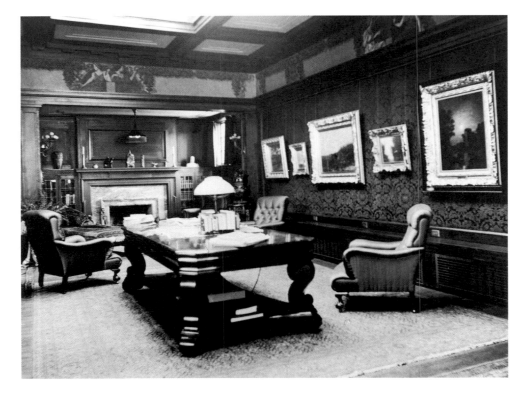

FIG. 9
The art gallery in the home of Chester Massey, Toronto, around 1910. The collecting of Barbizon and Dutch Hague School paintings was not confined to Montreal. The decorations on the frieze were painted by Gustav Hahn in 1908.

yearly purchases from its own annual art displays. These works were donated to the City of Toronto from 1902, and from 1911 deposited with the Art Museum. But, increasingly, these purchases were of non-Canadian art.[17] While the formation of the Art Museum of Toronto did provide a structure and focus for art activities in the city, it did not result in financial support for artists through sales. No work by a living Canadian artist was bought by the Museum until 1926.

The lack of sales made the Academy's success in having the federal Advisory Arts Council appointed in 1907 all the more important; the Council immediately allocated $10,000 a year for the purchase of works of art. In 1913, Byron — now Sir Edmund — Walker, the chairman of the Council since the death of Drummond in 1910, was able to have the Academy's grant raised from $2000 to $5000, the National Gallery's budget doubled, and a scholarship established funded by the Gallery and awarded by the Academy.

The increased purchasing power of the National Gallery was to be of great significance for Canadian artists, and a memorandum of understanding was drafted with the Academy by which purchases of Canadian works of art would be made by the trustees "with the collaboration of the President of the Royal Canadian Academy … mainly from the annual exhibition of the … Academy, but generally from all exhibitions of Canadian Art." Those works not hung in the National Gallery would be "distributed on loan to any provincial, public, or other art body or society approved by the Trustees which may possess the proper facilities for their public exhibition." The purpose was to "encourage the art of Canada in the following ways: It will directly benefit the artist whose work is purchased. It will benefit the exhibition from which the work of art is purchased, in that it will encourage the artist to send his best work there. It will benefit the National Gallery by allowing a greater number of the works of an individual artist to be acquired and so enable a better choice to be made for his representation in the National Gallery. It will stimulate the formation and expansion of art societies and bodies throughout the country by providing them with the nucleus of a representation of the work of Canadian artists. It will benefit the individual who is able to see the work of art thus distributed by giving him some knowledge of the art of his country, and so inspire him with the desire to collect it for himself."[18]

The institution of government aid for the visual arts was of crucial importance to Canadian artists, and would bring the Gallery into repeated public debate about the nature and limitations of its support. However, if the basis and principle were established by 1913, the definition of what should be supported was not.

~

By 1907, the groundwork for the furtherance of art in Canada was well laid, although the structure was still fragile and the support it offered artists was

still very weak. A few commercial galleries operated, most notably in Montreal with its larger and wealthier population, and itinerant dealers crisscrossed the country peddling their wares. Art clubs or societies existed in most towns and cities, some, such as the Women's Art Associations of Canada, formally interconnected, but their histories were often marked by sporadic bursts of energy followed by periods of inertia. The Nova Scotia Museum of Fine Arts was established in 1908, and the Winnipeg Art Gallery in 1912, and both would organize their own exhibitions as well as receive loans from the central Canadian societies. Artists' societies would remain for the next two decades the primary means by which artists would bring their work to public attention and advance their careers.

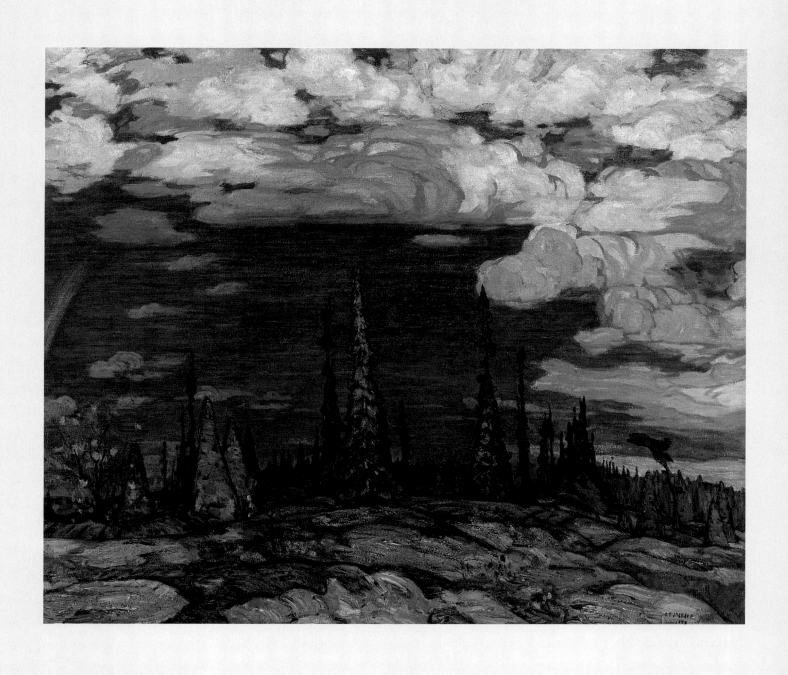

FIG. 10. A.Y. JACKSON, *Terre Sauvage* (cat. 17)

2

The Beginnings

ith the formation of the Canadian Art Club in 1907, a new professionalism was brought to the visual arts in the country, furthering a growth out of a limited parochialism into a larger, international context. The Club provided a stimulus and a model for the artists who would later come together to form the Group of Seven.

Canadian Art Club

In 1907, F.M. Bell-Smith, the president of the O.S.A., protested on procedural grounds the selection of works purchased with the Ontario government grant. As a result, a number of artists, including Edmund Morris, Curtis Williamson, W.E. Atkinson, Homer Watson, and the creators of the offending paintings, Archibald Browne and Franklin Brownell, resigned and formed a new organization called the Canadian Art Club. They immediately canvassed for non-professional members, including journalists, to provide financial support and publicity, rented premises in the County of York Municipal Building on Adelaide Street, and held their first exhibition in February 1908 (fig. 11).

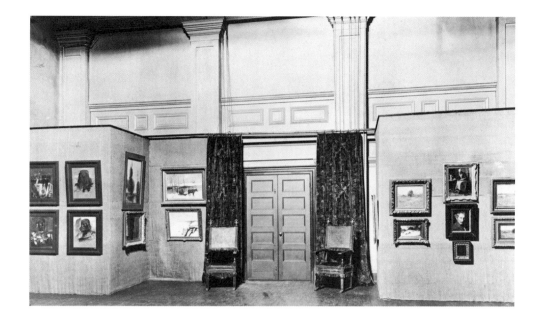

The formation of the Club highlighted certain problems endemic to Canadian art societies. E.F.B. Johnston, a lawyer and non-artist member, spoke at the opening of the first exhibition: "Small bodies of artists are created under somewhat imposing names, and for a time a real effort is made to maintain a high standard. The history of art in this country, however, shows that the laudable objects actuating the members soon vanish and the control of art societies passes into the hands of the commercial majority ... Every now and again ... secessions take place, and younger and more vigorous bodies ... spring into existence ... and now there is the Canadian Art Club in Toronto, formed of several independent and progressive artists ... who, growing restless under the yoke of the so-called rulers, finally broke away, and are making an effort to breathe the free air of their profession, untrammelled by personal consideration and unrestricted by the self-satisfied opinion of men set in judgment over their work."[1]

While Daniel Wilkie, the Club's honorary president, took great pride in the fact that it was formed of artists who "are Canadian born, men whose outlook has been broadened by association with the art of the Old World, all working together with one common aim, to produce something that shall be Canadian in spirit, something that shall be strong and vital and big, like our Northwest land,"[2] Newton MacTavish, editor of the *Canadian Magazine* and an active supporter of the Club, raised a pertinent question that needed to be answered: "Could a picture of a Dutch landscape, painted by a Canadian in Holland, be described as Canadian art? Could a novel based on Canadian social life and customs with the scenes all laid in Canada, and written by a Frenchman in New York, be accepted as Canadian literature?"[3]

One main objective of the Club was to exhibit the work of such noted expatriates as J.W. Morrice, Horatio Walker, James Kerr-Lawson, Ernest Lawson, and Phimister Proctor. Canadians could point with pride to the

success of these artists abroad, and their inclusion in the Club's exhibition in their home country revealed the high standards Canadian artists had attained. MacTavish's question was answered: subject matter was not the criterion for an invitation to exhibit, but rather a "kindred sympathy" and an individuality of expression. Dutch, Scottish, English, French, West Indian, and American landscapes and genre subjects rubbed shoulders with waterfalls in Algonquin Park, winter sunsets over the Cove Fields at Quebec City, panoramic views of the Newfoundland coast, and landscapes from the Saskatchewan prairies, Cobalt, Ontario, and the woods of Doon, near Kitchener, Ontario. But in the work of the Canadian resident artists Watson, Williamson, Cullen, Suzor-Coté, Morris, and Brownell, MacTavish saw a new national spirit. "A few artists … began to paint Canadian subjects with the vigour and breadth that is characteristic of the country, and instead of going abroad for motives, they began to look about them at home … After the national spirit of the country had been aroused, the attainments of Canadian artists abroad began to have significance. The people commenced to take interest in these artists because they were Canadians, and they in turn began to evince more interest in the country because it was Canada. And although this new impulse was felt some years before it was realized, it was with amazing spontaneity that it material-ized … in the formation of the Canadian Art Club."[4]

Elsewhere he wrote, "a number of our most distinguished painters who went away to gain the recognition they felt was their due, are now, if not com-ing back themselves, sending their work and selling a fair portion of it."[5] Yet the fact was that the Club had already abandoned its premises because of lack of funds and, as the expatriate Morrice wrote: "Nothing is sold … nobody understands them — and it involves a great expense. I have not the slightest desire to improve the taste of the Canadian public."[6] The death of Edmund Morris, one of the leading forces in the Club, a declining economy, and infighting among the members hastened its demise, and the last exhibition was held in October 1915.

Lawren Harris was among those who recognized that the Canadian Art Club had made a contribution: "The secession, as it was temporarily dubbed, has been of undoubted benefit to Canadian art. It has provided the needed stimulus."[7] Harris himself would provide the stimulus for the next stage of growth.

Arts and Letters Club

Lawren Harris returned to Toronto early in 1908 at the same time as a new association was being formed. The Arts and Letters Club was established to bring together musicians, writers, architects, and artists with a minority membership of non-professionals "with artistic tastes and inclinations" to "propagate an appreciation of art."[8] It was there that Harris met C.W. Jefferys, W.W. Alexander, Robert Holmes, and J.E.H MacDonald, all former members

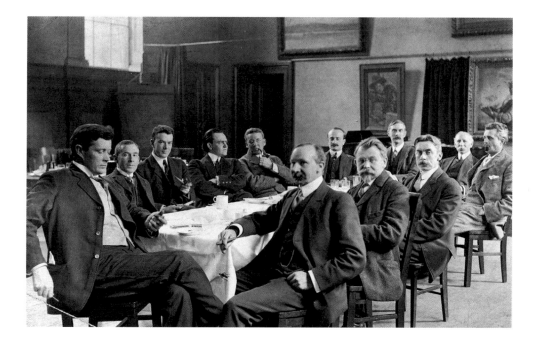

FIG. 12
The Arts and Letters Club in the
County of York Municipal Buildings,
57 Adelaide Street East, Toronto, c. 1910.
Left to right: Augustus Bridle, R.L.
Defries, Fergus Kyle, Roy Mitchell,
Bob Pigott, W.W. Alexander, Jan
Hambourg, Gustav Hahn, George Locke,
C.W. Jefferys, Wyly Grier, Eden Smith.

of the Toronto Art Students' League. It was MacDonald who designed the club crest, a "Viking ship with the sails full spread before the rising sun, to remind us of the open sea and the great adventure."[9] The first issue of the Club's newsletter, *The Lamps* (for Literature, Architecture, Music, Painting, and Sculpture), appeared in January 1910, and the membership, restricted to men, grew rapidly to include almost every male active in cultural journalism, writing, publishing, visual arts, architecture, music, and theatre in Toronto. In September of that year the Club took over the premises vacated by the Canadian Art Club on Adelaide Street (fig. 12).

The Arts and Letters Club offered a unique opportunity for people active in the arts to meet, and it became a vital factor in the development of the arts in Toronto.

Ontario Society of Artists Exhibition, 1911

It was at the Arts and Letters Club that Harris suggested a means of bypassing the usual reviewers by publishing the artists' own statements on their work for the 1911 spring exhibition of the O.S.A.[10] The statements were published in pamphlet form as well as in the *Toronto News* and *MacLean's* magazine, bringing more attention to the show than usual and resulting in the sale of sixteen works. With the support of Wyly Grier and J.W. Beatty, Harris was elected a member of the O.S.A. even before he exhibited his work for the first time in Toronto at this show.[11]

The exhibition prompted fellow Club member Augustus Bridle to note a new development in Canadian art. "The O.S.A. is slowly getting a real grip on Canadian life. Painters in Canada are beginning to break away from Dutch imitations," he wrote in the *Canadian Courier*.[12] The following year Bridle let out

a whoop of joy. "Beatty — who used to revel in Laren and Bruges and Paris — heaven be thanked that he has ultimately and almost completely turned his masterful brush to the depicture of Canadian landscapes, especially the north ... now that he has decided to use Europe as but a means to a Canadian end, we may expect him to continue proving ... that the north-land of America contains all the material he will ever be able to utilize."[13]

This spirit was echoed in Harris's review of an exhibition of illustrations by Arthur Heming. "The subjects which inspired them are truly of this country ... The incident of the Northland, the cold crispness of its snows, the suggestion of mystery and bigness ... is done in a perfectly simple and masterly way."[14] And Jefferys responded in his review of MacDonald's paintings at the Arts and Letters Club: "Mr. MacDonald's art is native — as native as the rocks, or the snow, or the pine trees, or the lumber drives that are so largely his themes. In themselves, of course, Canadian themes do not make art, Canadian, or other; but neither do Canadian themes expressed through European formulas or through European temperaments. In these sketches there is a refreshing absence of Europe, or anything else, save Canada and J.E.H. MacDonald and what they have to say; and so deep and compelling has been the native inspiration, that it has, to a very great extent, found through him, a method of expression in paint as native and original as itself."[15]

The Scandinavian Model

Both Jefferys and fellow Toronto Art Students' League member C.M. Manly had for years encouraged Canadian artists to turn away from the depiction of Old World subjects and to look at their native land, "teeming with splendid possibilities for the painter"; they saw in the work of Scandinavian painters a possible direction for artists here. "Judged by their work they love their land and are putting forth notable expressions of it, in most courageous and original ways," wrote Manly in 1905.[16] In a talk given at the Arts and Letters Club in November 1911, Jefferys summed up his perception of the recent tendencies in art as "a tendency towards order and a tendency towards disturbance. The one preserves, the other progresses. The one is necessary for harmony, for beauty, for complete expression; the other for vigour, strength, creative power — the thrill that makes art. To some — artists as well as laymen — art stands for a sort of sheltered garden, a sanctuary wherein to seek refuge from the work-a-day outside world, and forget for a time its crudeness and its cruelty ... But there are some turbulent souls whom this sheltered monastic life fails to satisfy. They ... are interested in life as much as in art. They regard art as a sort of militant order ... They are the experimenters of art, the questioners of life, and to them art must in the end, look for progress ...

"One feature which ... has immensely strengthened the militant group within recent years has been the emergence of what I may call the Racialists: those painters whose work has been mainly inspired by their local environment

and their racial temperament ... We have seen the rise of a group of most virile painters among the Scandinavian peoples ... The modern German and Austrian painters have brought into the secluded garden some strange plants which ... seem to be thriving fairly well ... Has the wave yet reached Canada? In a new country like this, where life is crude, and regardless of little beyond material things, it is natural that the first conception of art should be that of the sheltered garden ... But we are too virile, too full of the exuberance, the rashness, the curiosity of youth, to linger there long, and already I fear, the disturbers are among us."[17]

Jefferys's linkage of the "militant" movement with a native (or, to use his term, "Racialist") inspiration was very acute, as the arguments for Canadian art increasingly focussed on the stimulus provided by the local environment, a characteristic of other nationalist European art movements, including those of Spain and Scandinavia.

Primed by these discussions, in January 1913 Harris and MacDonald visited the large touring exhibition of Scandinavian art at the Albright Art Gallery in Buffalo. Harris "was deeply impressed by the sympathies it awoke in him. In subject, in treatment, there was a pronounced affinity with his own aspirations and with the aims of his colleagues in the younger ranks of Canadian artists."[18] Some years later MacDonald expressed similar sentiments: "We were full of associated ideas. Not that we had ever been to Scandinavia, but we had feelings of height and breadth and depth and colour and sunshine and solemnity and new wonder about our own country, and we were pretty pleased to find a correspondence with these feelings of ours, not only in the general attitude of the Scandinavian artists, but also in the natural aspects of their countries. Except in minor points, the pictures might all have been Canadian, and we felt, 'This is what we want to do with Canada.'"[19]

MacDonald was especially attracted to the simplicity of subject matter and presentation ("Some of the pictures even had red frames or plain wooden frames"), which reflected for him an honesty of intent, a distancing from rarefied aesthetics, and a grounding in national life. "These artists seemed to be a lot of men not trying to express themselves so much as trying to express something that took hold of themselves. The painters began with nature rather than art."[20]

What Harris and MacDonald learned from seeing the Scandinavian show was not the concept of an art rooted in native soil, to which they were already committed, but a language to enlarge their interpretation of those ideas. In the decorative and symbolic landscapes of the Scandinavians they found a Post-Impressionist vocabulary for their message.

The Militant Group

By 1913, nearly all the principal actors in the new movement had arrived in Toronto. MacDonald had met Thomson, Lismer, Carmichael, and Johnston

while working in the commercial art firm Grip Limited. In August 1912, all save MacDonald, who had left to freelance, followed Grip's art director, Albert H. Robson, to another firm, Rous and Mann,[21] where they were shortly joined by Fred Varley, recently arrived from Sheffield, England.

A pattern of sketching trips had been established, the canvases being painted up in the artists' Toronto studios. In 1912, Thomson made a canoe trip with his co-worker W.S. Broadhead up the Spanish River to the Mississagi Forest Reserve, north of Manitoulin Island, sketching and photographing,[22] and spent the summer of 1913 in Algonquin Park. Lismer painted his "wilderness" images, *The Clearing* and *Road through the Bush*, in York Mills and "five miles north of Toronto City Hall," where new building lots were being cleared.[23] By 1913, Haliburton, Mattawa, the Laurentians, and Georgian Bay had all been visited.

Around this time, A.Y. Jackson emerged as a force in the new movement, and his influence, joined with that of Lawren Harris, became a crucial element in the growth and development of the Group of Seven. There was nothing in Jackson's early career to suggest that he would end up as one of the prime spokesmen for a nationalist school of landscape painting. In fact, he seemed to be following the path of other students of William Brymner, working within various manifestations of Post-Impressionism with primarily aesthetic concerns and no articulated ideology. From September 1907 to January 1913, Jackson was in Europe studying and travelling, or working in Montreal as a commercial artist with little opportunity to paint. Of the canvases he did exhibit, by far the majority were of European subjects, save for some resulting from sketching trips in 1910 to Georgian Bay and Sweetsburg, Quebec. One of the latter was *Edge of the Maplewood*, first shown at the exhibition in Liverpool in 1910, and subsequently at the O.S.A. in Toronto in March 1911; there it was admired by MacDonald, who began to correspond with the artist.[24] The painting was purchased by Harris in March 1913 at the very moment when Jackson, financially strapped and discouraged by the apathy of the Montreal artists, was considering leaving Canada for the United States.[25] As he wrote to his cousin Florence Clement, "[There is] no end of grandmotherly advice. The young should follow their elders, etc. To which the young hopefuls reply, that as the old ones have won neither fame or wealth, why follow them to oblivion?"[26]

To Harris he wrote: "MacDonald tells me you are a real enthusiast, a good live artist; one who can practise and preach and wallop the Dutchmen when occasion calls, and judging by your letter, I strongly suspect that MacDonald is right. Those poor Dutchmen! If they were not already dead I would shed a few tears for them.

"It really looks as though the sacred fires were going to burst into flame in Toronto by the faithful efforts of yourself and MacDonald and the modest millionaire. We once had some smouldering fires in Montreal which might have blazed up if they hadn't fanned them with bricks and wet blankets and built walls of pot-boilers about, cutting off the air and light. But when they

FIG. 13
ARTHUR LISMER
Lawren Visits the Studio 1915
Graphite on paper
McMichael Canadian Art Collection,
Kleinburg, Ont. (1981.217.5)
Gift of Marjorie Lismer Bridges

Harris, the enthusiast and stimulator,
arrives in Tom Thomson's studio.

built a new half-million-dollar gallery to house the crumbs and leavings of
Europe, the poor fires petered out and died. Sad, isn't it?

"Yes, I am quite in accord with you. You have only to look over the cata-
logues of our exhibitions and you will see trails crawling all over Europe;
'Winter in Holland' – 'Spring in Belgium' – 'Summer in Versailles' – and
'Autumn on the Riviera' – Ye Gods! – Monet pottering around Jamaica;
Picasso hard at it in Japan; Renoir out in the Canadian Rockies; Sisley in Sicily
– and the French Impressionists would never have existed."[27]

In May 1913, Jackson met MacDonald, Lismer, and Varley for the first
time and, shortly after, Harris. He later commented: "To Lawren Harris art
was almost a mission. He believed that a country that ignored the arts left
no record of itself worth preserving. He deplored our neglect of the artist in
Canada and believed that we, a young, vigorous people, who had pioneered
in so many ways, should put the same spirit of adventure into the cultivation
of the arts … After the apathy of Montreal it was exciting to meet such a
man"[28] (fig. 13).

That autumn Jackson moved to Toronto with an offer of financial assis-
tance from Harris's friend Dr. James M. MacCallum, and temporarily shared
a studio with Harris. There he painted *Terre Sauvage* (fig. 10), his largest canvas
to date. In this ambitious work, the rainbow may not have promised a pot of
gold, but it did signal a new era in Canadian art.

Jefferys's "disturbers," Harris and MacDonald, now worked on two
fronts, the Arts and Letters Club, where ideas were debated and alliances
forged, and the Ontario Society of Artists, which they stirred up with revived
energy. Club members included Frank Johnston, Arthur Lismer, J.W. Beatty,
Curtis Williamson, Fred Varley, and Arthur Heming, as well as supporters
James MacCallum, George Locke (head of the Toronto Public Library),
Vincent Massey, theatre director Roy Mitchell, Albert Robson, C.W. Jefferys,
Wyly Grier (president of the O.S.A. from 1908 to 1913 and of the Club from
1910 to 1912), and art critics Hector Charlesworth (*Saturday Night*), Augustus
Bridle (the *Canadian Courier*), and M.O. Hammond (the *Globe*). Harris and
MacDonald wrote for the Club publication, and Harris headed the picture
committee for 1911–12 and 1913–14, organizing exhibitions of fellow artists
including MacDonald, Lismer, Beatty, Williamson, T.G. Greene, Heming,
and Jefferys.[29]

The overlapping membership of the Club and the O.S.A. was of great
benefit, and in February 1913 Harris and a committee consisting of Locke,
Heming, Beatty, Williamson, and MacDonald organized a surprisingly suc-
cessful exhibition of "Little Pictures" at the Toronto Public Library's gallery,
an outreach that would be repeated again the following year with MacCallum
on the committee.[30] Both Harris and MacDonald served on the executive com-
mittee and hanging committee of the O.S.A., and they brought new blood
into the society: T.G. Greene, T.W. Mitchell, Lismer, Johnston, Thomson,
Varley, and Jackson – all artists working in a sympathetic direction, painting
Canadian subjects with a fresh, new spirit.[31]

That these artists won the respect of their colleagues and were attracting attention was evidenced by the O.S.A.'s purchase for the province of MacDonald's *By the River, Early Spring* in 1911, and the Ontario government committee's purchase of MacDonald's *Morning Shadows* in 1912 and Lismer's *The Clearing* and Thomson's *Northern Lake* in 1913. Beatty had paintings selected for the Ontario collection every year from 1909 to 1913, when he resigned from the O.S.A.[32] MacDonald was also elected an associate of the R.C.A. in November 1912, together with C.W. Jefferys.[33]

In 1913, with the help of MacCallum, Harris financed the construction of the Studio Building on Severn Street in the Rosedale Ravine near Bloor and Yonge streets (fig. 14). This was the first building in Canada constructed specifically for artists' studios, and its erection consolidated certain elements of the new movement, which at this point included a diverse group of artists selected for their commitment to painting and their will to further Canadian art.[34]

Curtis Williamson was the oldest tenant, an artist of great virtuosity who had painted extensively in Holland. An obstreperous member of the Canadian Art Club, he had abandoned Holland for the coast of Newfoundland, the city streets of Toronto, and portraits. Harris praised his work in the Arts and Letters Club *Year Book of Canadian Art* in 1913 as being "full of strength and half-subdued fire. It is eloquent of ability and an almost arrogant mastery of technique."[35] J.W. Beatty was probably the best known of the artists, and a public and recent convert from Dutch to Canadian art, a born-again prophet of the new nationalism.[36] Arthur Heming was an adventurer, the painter of "the trail and the out-of-doors and the 'back of the beyond,'" a black-and-white artist who had illustrated the tales of W.A. Fraser and written his own book, *Spirit Lake*, based on his travels near Hudson Bay.[37] And then there were Harris, MacDonald, Jackson, and Thomson.

The artists reiterated their stance against "art for art's sake" and precious objects in gilt frames, asserting that the new building was a "workshop ... not a place for pink teas or tango," a place to produce "pictures which partake of the larger, bigger feeling which abounds in Canada — conveying to the minds of people something broader, grander, more noble, even, of the aspects of life which come to artists who are permeated with the virility and enthusiasm of the freer atmosphere of a new country — freed from the conservatism and staid ways of older countries of Europe."[38]

It was Thomson who introduced the artists to Algonquin Park in 1914. Of all those in the group, possibly only Harris had visited the park before.[39] Having arrived in the dead of winter, Jackson wrote to MacCallum that it was "The way it ought to be. Heming up in the Barren Lands. Thomson West Ungava. MacDonald Georgian Bay Islands. Beatty Rocky Mountains. Harris those Godforsaken Laurentian Hills. I'll look after the Labrador Coast and Williamson can keep house so Bohemian that no one will need to ask where the Studio Building is. Then we would have a Canadian School for sure."[40] In the fall of 1914, Jackson, Thomson, Lismer, and Varley all worked together in the park (fig. 15). Sketches painted on that trip resulted in Lismer's *The Guide's*

FIG. 14
The Studio Building, Severn Street, Toronto, April 1938. Private collection.

FIG. 15
Algonquin Park, October 1914.
Clockwise from left front: Fred Varley,
Tom Thomson, A.Y. Jackson, Arthur
Lismer, Marjorie Lismer, Esther Lismer.

Home, Algonquin Park and Jackson's *Red Maple*, and the following spring Thomson exhibited his famous *Northern River*. The life of the woods and the canoe was the inspiration for the newly focussed Algonquin School, and Thomson, the burgeoning painter, was the role model.

Although published almost two years later, Peter Donovan's article "Arting among the Artists" caricatured well the new identity of the Canadian artist. "When your up-to-the-moment artist decides to wreak his soul on the canvas, he puts on a pair of Strathcona boots, rolls up his blanket and beans enough to last three months, takes a rifle and a paddle, and hikes for the northern woods. He can't work this side of the Height of Land. The only rivers worth painting, from his point of view, are those which run down to Hudson's Bay. He can't work in peace unless he has a bear trying to steal his bacon or a moose breathing heavily down his neck. That's why the coming Canadian artist is such a husky beggar … Old style painters used to be sparing of colour – probably on account of the expense. But these modern chaps bring joy to the hearts of dealers in artists' supplies. They seem to mix their paint on a big flat rock and throw it on with a scoop-shovel. It's a great way to get unpremeditated effects."[41]

As the group slowly coalesced in its new identity, evolving from the Severn Group into the Algonquin School, the artists renewed their efforts to win over supporters for Canadian art. One of the prime objects of their attention became the National Gallery of Canada.

Eric Brown and the National Gallery of Canada

When Sir Edmund Walker was appointed chairman of the Advisory Arts Council in 1910, he brought to Ottawa as curator of the Gallery a young Englishman from Nottingham, Eric Brown, brother of the noted painter

Arnesby Brown.[42] Brown first arrived in Toronto via Montreal early in 1910, where he worked briefly as a canvasser for the Art Museum of Toronto and came to know Walker. It was through Wyly Grier that Brown obtained an entrée to the Toronto art scene. Both were Christian Scientists and wrote on Canadian art for the Boston-based *Christian Science Monitor*. In July 1915, Grier and the Ottawa artist Franklin Brownell introduced Brown and his wife, Maude, to Algonquin Park.[43]

Brown moved to Ottawa in 1910, and the National Gallery opened in the recently constructed Victoria Memorial Museum in 1912. He wrote numerous articles in Canadian publications and in *The Studio* magazine, publicizing the work of the Gallery and articulating its policies. "There is no doubt that Canada has growing along with her material prosperity a strong and virile art which only needs to be fostered and encouraged in order to become a great factor in her growth as a nation. No country can be a great nation until it has a great art ... [However] this encouragement of our national art in its broadest and best sense is not achieved by the exclusive purchase of Canadian works of art ... and as a knowledge and understanding of art is only to be gained by the comparison of one work of art with another ... we needs must have in addition to our own Canadian pictures the best examples we can afford of the world's artistic achievements, by which we may judge the merit and progress of our own efforts."[44]

Jackson first wrote to Brown from Montreal in March 1913 regarding the Gallery's role. "Personally I have no faith in a system which appoints three laymen who are not in touch with either Canadian or European art or artists to guide our destinies. If our present Director were given wider powers and put in full control with say J.W. Morrice and perhaps Sir Claude Phillips or one of the prominent English critics as an Advisory Council we might have a National Collection which would inspire the Canadian artist and show him the way and not suffocate him with all the old traditions which Europe herself is trying to shake off ... We want Ottawa to help us along and light up the way. Now that a paternal government has mollycoddled her railroads and protected her manufactures and the Lord knows that not a blessed one of them could have stood on their own legs. Art alone has been chopping her own way, fighting against Dutch potboilers and fake Barbizon masterpieces buried in varnish, she is pretty well damaged and half starved but she hasn't gone to Ottawa for thirty-three per cent protection yet. Our self-made millionaires can't say that."[45]

Writing under the pseudonym "Cadmium," Jackson returned to criticize the Gallery's purchase policies in May 1914. "In art there are two sorts of collectors, the one who gathers names and the other who collects works of art for the sheer love of the thing ... In the National Museum are many famous names, and yet the artist does not travel to Ottawa for inspiration. A dozen Whistlers or a few Sargents, a collection of Cézanne's still-life paintings or a room devoted to Winslow Homer, Monet, or Pissarro, and the museum at

Ottawa would be famous, but one can have an example of every artist from Giotto to Picasso and possess no work at all ... The native artist is blazing his own trail, not much concerned with their narrow outlook, and 'tis the artist and not the collector who is responsible for most of the progress made in art generally during the past twenty years."[46]

The Gallery's response was to announce the arrangement worked out with the Academy the previous year regarding purchases, distribution of paintings, and scholarships.[47] To which Harris responded by pointing out the discrepancy between the moneys spent on foreign and Canadian art and the incongruity of situating a gallery in Ottawa rather than distributing the funds directly to art societies in other cities, and reaffirming that "the artist always has been and always will be the final authority on art." Echoing Jackson's criticisms, he continued: "A far-sighted commission might have arranged that the Scandinavian exhibition, the Zuloaga exhibition, the Sorolla exhibition, and several other fine exhibits of modern paintings shown in many American cities be shown in Canada, but instead of studying what we lack, they merely add to what we are overburdened with. Their whole policy is a stupid and useless effort to keep us on the beaten track, which, so far as the artist is concerned, leads to oblivion ... As for the one thousand dollar scholarship, why hold out such an inducement to the student? It will probably be the first and last time in his life that he will clean up that much out of art. It is very doubtful if there are seven artists in Canada who sell one thousand dollars' worth of work in a year."[48]

The timing of the criticisms was somewhat curious, as the Gallery had just purchased works by Arthur Lismer, T.G. Greene, C.W. Jefferys, and Tom Thomson from the O.S.A. exhibition.[49] The urgency with which these views were expressed may have been occasioned by the recent departure for the United States of Frank Johnston. With a deepening recession, the situation for artists was grave, and would become far worse within a few months with the declaration of war.[50]

The Critics

In his speech of 1908, Daniel Wilkie had identified "the lack of intelligent critics" as one of the severe problems facing the Canadian artist.[51] There were a number of individuals who wrote regularly for various periodicals and newspapers, including Newton MacTavish, editor of the *Canadian Magazine*,[52] and Augustus Bridle, associate editor and then editor of the *Canadian Courier*.[53] M.O. Hammond, who wrote for the *Globe*, was an amateur pictorialist photographer as well as a journalist,[54] but the "art beat" was more commonly given to journalists whose primary interests lay elsewhere. Hector Charlesworth of *Saturday Night*,[55] Fred Jacob of the *Mail and Empire*,[56] and Samuel Morgan-Powell of the *Montreal Daily Star*[57] were all drama critics and book reviewers who wrote art reviews. Harold Mortimer-Lamb, who wrote on

Montreal exhibitions for the British magazine *The Studio*, was also a pictorialist photographer and a professional associate of Alfred Stieglitz.[58]

The Toronto artists of the Severn Group were favourably treated by the press during their early years, as journalists recognized the importance of their contribution to exhibitions and the increasingly large role they were playing within the community. But there was inevitably a reaction to these and other experimenters. Taking its cue from the journalistic circus around the Armory Show in New York in February 1913,[59] the backlash would first flare up that spring in Montreal. John Lyman would be the prime victim. The tone of the debate, which would involve A.Y. Jackson, would set the example for many reactionary criticisms over the next decade.

Confrontation in Montreal

As early as March 1912, Montreal critics had denounced the "liberal" policies of the Art Association of Montreal. "The hanging committee has completely abdicated all its functions as a director of public taste, as a critic of the work of young artists and experimental schools, as Montreal's chief artistic authority … Let [the Art Association] be not intolerant but severely critical of experimental tendencies" wrote the *Herald*, specifically condemning the work of John Lyman, who "is indulging in some experiments which do not seem to have yet reached a stage to need the endorsement of the Art Association."[60]

The exhibition of "Post-Impressionist" paintings by A.Y. Jackson and Randolph Hewton in the new Art Association building on Sherbrooke Street in February 1913 passed unscathed, and indeed was lauded.[61] However, the presence of the work of these two artists together with four works by John Lyman in the Association's Spring Exhibition in March whipped up a press battle of letters to the editors that would go on for several months. The *Herald*'s writer denounced the "Infanticist School," works that "do not possess, and do not profess to possess, any merits according to the accepted canons of any existing school of painting. They are as contemptuous of all precedent as the most advanced of the futurist creations." The writer queried "whether the paintings of Mr. John G. Lyman are or are not 'painted for the future'; it is open to anybody to believe that in 1933 the principles by which he is working will be the accepted canons of art and those of Messrs. Brymner, Harris, Cullen, Hammond, and the rest of the Canadian Academy will be extinct and disregarded."[62]

The writer for the *Montreal Daily Witness* added a few more swipes at Lyman, at Hewton's *Queen Aholibad* — "The whole scene is a riot of incongruous colours, and a final slap at the conventions is the presence of a nude male figure at this private bathing function" — and at Jackson's *Assisi from the Plain* for its "prodigality of paint and studied carelessness of handling."[63]

Morgan-Powell of the *Star* entered the fray somewhat tardily, having already published a noncommittal article on the exhibition, but he then

topped everyone with his entrance line: "Post-Impressionism is a fad, an inartistic fetish for the amusement of bad draughtsmen, incompetent colourists, and others who find themselves unqualified to paint pictures." He slammed Lyman's works and denounced Hewton's, but of Jackson he wrote: "He has carried Impressionism as far as the limits of sanity permit . . . Set his best pictures . . . beside the works mentioned above, and you get a clearer perception of the wide gulf that separates the genuine Impressionist from the self-styled Post-Impressionist."[64]

Mortimer-Lamb responded, searing Morgan-Powell for his "deliberate attack on the work of some younger men who have yet to win recognition" and who "are probably dependent on their art for a livelihood." Defining the responsibility of the critic as guiding "public opinion to a clearer conception of the significance of art," he continued: "So far Canadian art has been badly handicapped in every possible direction. One handicap may be removed if the newspapers will refrain from publishing the futile dogmatism of self-opinionated and generally incompetent scribblers."[65] Morgan-Powell's reply linked the personalities of the "raving maniac" Van Gogh, the "patent savage" Gauguin, and the "Post-Impressionist mountebank" Matisse with "a gospel of stupid licence and self-assertion."[66] The debate expanded, pitting Camille Mauclair, Maurice Denis, Émile Bernard, George Moore, and Roger Fry against the conservative New Yorker Royal Cortissoz and the art critic of the Paris *Temps*, with Leo Stein and Julius Meier-Graeffe being called on to support both sides.[67]

Lyman's own responses to Morgan-Powell were argued from historic precedent; he pointed out the repeated errors of critics who attacked innovation in art, errors of fact and terminology in the reviews, and the critical and commercial success of modernist movements in London, Paris, and New York.

Only Mortimer-Lamb and one writer in the *Witness* raised the issue of the importance of this debate to Canadian art and its development. The latter criticized local collectors for their lack of patronage of Canadian artists, for being "merely collectors of foreign pictures and 'old masters' . . . Now, supposing our rich men took the pride that they should take in the encouragement of Canadian art. Their homes, instead of being decorated at fabulous cost with 'old masters', genuine or faked, would be decorated largely with pictures by Canadian artists. Instead of being faint duplicates of historic museums, such homes would be living repositories of a virile national art."[68]

The conservative writers limited their appreciation of a particularly Canadian character to the "sane Impressionism" and subject matter of Maurice Cullen and Suzor-Coté.[69]

All this publicity resulted in the highest attendance figures ever for a Spring Exhibition, and the Art Association attempted to have the Armory Show brought to Montreal to enable Montrealers to see the work of real "Cubists, Post-Impressionists, and Futurists."[70] When it was unable to book the show, it held a five-year retrospective exhibition in May 1913 of the work

of John Lyman, newly returned to Montreal from Paris. A preface in the catalogue written by Lyman's wife Corinne articulated the futility of any definition of art, while at the same time stating what art is not: imitation of nature. "Art is not a description of what we see, but it's what lies between expression and the object that inspires it: imagination, organizational ability, personality ... Those who want art to be a mere narcotic providing a vague, gentle drowsiness, or a tasty tidbit to delight their barren spirit, must not stop here, for they will only find a beverage that is bitter with the corrosive juices of life."[71]

And that is exactly what the critics found. Morgan-Powell refrained from reviewing the exhibition, but his replacement could find no intrinsic worth in Lyman's art. "At no period of Mr. Lyman's career, as far as the present exhibition goes, did he have anything to say in paint which required the invention of a new dialect ... Mr. Lyman need not think he is accused of insincerity or immorality. What his work shows rather is a lack of imagination and a facility of imitation which is perilous where personality is lacking."[72] Unable to restrain himself, Morgan-Powell wrote a letter to the editor of the *Star*: "Mr. Lyman dabbles mostly in greens of offensive hues. His colours are smeared on the canvas. His drawing would shame a schoolboy. His composition would disgrace an artist of the stone age — the paving stone age. Crudity, infelicitous combinations of shades, unharmonious juxtaposition of tints, ugly distortion of line, wretched perspective, and an atrocious disregard for every known canon of sane art, are here. They leap out of the frames and smite you between the eyebrows. They simply ruin the neutral tint of the Art Gallery's well-kept walls ... They are not works of art. They are travesties, abortions, sensual and hideous malformations."[73]

The outcome of all this mud-slinging was that John Lyman left Montreal, effectively abandoning the field to the conservatives.

Confrontation in Toronto

Rumblings of the goings-on in Montreal hit Toronto that same month in the *Canadian Courier*, which reprinted part of the May review from the *Montreal Daily Witness*.[74] Grier had already voiced in the *Courier* his astonishment and finally disgust at the "artificiality" and "primitivism" of the modern work seen by him at the Armory Show,[75] and later that summer *Saturday Night* reprinted a *New York Times* interview with the American "arch reactionary" painter Kenyon Cox. Speaking from a "lifetime given to the study of art and criticism [and] in the belief that painting means something," Cox reiterated the ideas expressed earlier in Montreal, namely that Post-Impressionism, Cubism, and Futurism were the result of an exaggerated individualism and lack of discipline and respect for tradition, combined with a keen sense of publicity and commercialism. For Cox, the reviewers, frightened by "the critical blunders of the last few generations," refused to see that the emperor had no clothes.[76]

Like Lyman, Jackson too considered leaving Montreal; he intended to go to the United States. He was disgusted at the level of invective and keenly aware of how destructive such journalism was to artists. It was only the invitation from Harris and MacCallum to move to Toronto that stopped him from leaving Canada. In Toronto, the debate would be renewed.

At the Arts and Letters Club luncheons the discussions about the future of Canadian art continued. Jackson, articulate and with strong opinions, must have added a more aggressive note, and the propagandizing for modern art irritated two fellow members, Henry Franklin Gadsby and Peter Donovan, the authors of weekly satirical columns in Toronto newspapers. In a long article in the *Toronto Daily Star* titled "The Hot Mush School, or Peter and I," Gadsby took the viewpoint of his painter friends "who can and do draw" to satirize the exhibitions at the Club of the work of "the younger set, the Advanced Atomizers who spray a tube of paint at a canvas and call it *Sunshine On The Cowshed*." The article paraphrased the same conservative criticism of modernism as had been heard in Montreal: the synthesis and reduction of expressive elements, specifically the purification of colour and broad design, resulted in an unidentifiable image, "the net result being more like a gargle or a gob of porridge than a work of art."[77] As the exhibitions of the Club were not open to the public, and as the satirical article had none of the viciousness of the earlier debate in Montreal, MacDonald's reply was equally good-humoured and low-key, encouraging Gadsby to listen to the artist, to have "an open eye and perhaps a little receptivity of mind" and "to support our distinctly Native Art ... So you fellows who push the pen, push it for the highest good of your Country's Art, wake up the Sleepy Connoisseur!, put the Smart Alec Critic in his place, and try to get the Indifferent Mob expecting something ... The artist does not plead for your backing. If you cannot honestly give it, he'd rather have your opposition, because indifference kills his feeling and ambition quickest."[78] Nonetheless, the joy Gadsby expressed in his article at winning over "a prospective purchaser" to the conservative position must have hit close to home.

Cries for the realization of a distinctly Canadian art were coming from all directions now. "I believe that our art will never hold a commanding position ... until we are stirred by big emotions born of our landscape; braced to big, courageous efforts by our climate; and held to patient and persistent endeavour by the great pioneer spirit which animated the explorers and soldiers of early Canada," wrote Wyly Grier in the *Year Book of Canadian Art* for 1913.[79] Carl Ahrens, an artist "who has consistently through the past ten years or more, argued for a Canadian art entirely freed from alien influences, who, indeed, insisted that Canadian artists should not even educate themselves abroad," called for "a group of pioneers who will ignore foreign influences, paint what there is in Canada and so set a national standard ... there must be less of the studio and more of the forests!"[80] Yet, said Grier and Ahrens, this new Canadian art was to be free of "the graveyard tendencies of

Post-Impressionism," the "blight of Futurism,"[81] and "the various luminarists, Post-Impressionists and other queer fowl in France."[82] The occupants of the Studio Building stated the issue somewhat differently, calling for: "pictures … [produced by] artists who are permeated with the virility and enthusiasm of the freer atmosphere of a new country — freed from the conservatism and staid ways of older countries of Europe."[83] Where Grier and Ahrens saw in Europe a three-headed hydra of modernism, the Studio Building artists saw only Dutch potboilers and pastoral English watercolours.

By 1914 the new movement had coalesced, and with remarkable energy set out to win over an audience and to radically alter the situation for Canadian artists. At the same time voices of opposition to more modern art had been raised, and their arguments would be repeated on numerous occasions over the next two decades.

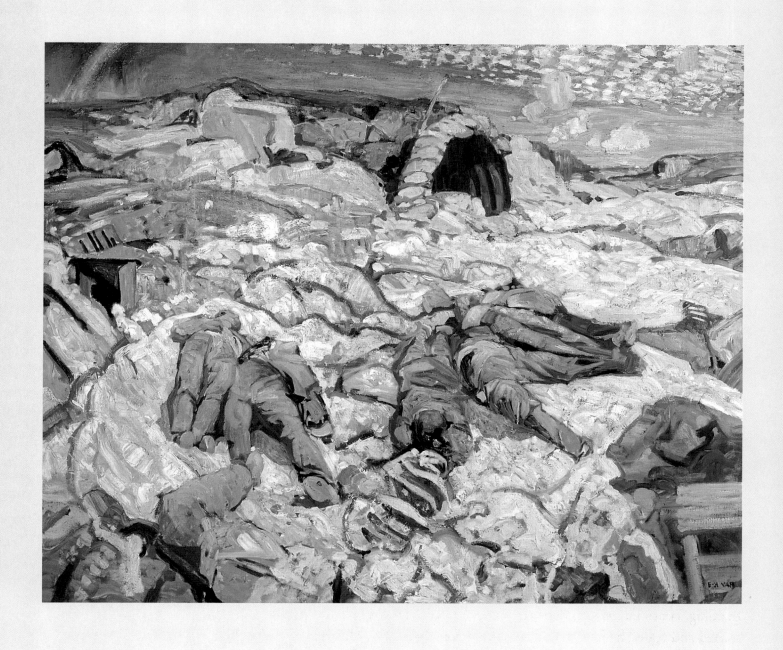

FIG. 16. F.H. VARLEY, *The Sunken Road — August 1918* (cat. 31)

3

The First
World War

The declaration of war in August 1914 affected all Canadians, but few were so devastated as the artists. Those in Belgium at the outbreak of hostilities had to flee. Frank Carmichael had been studying in Antwerp since September 1913; he returned to Toronto to share a space with Tom Thomson in the Studio Building. James L. Graham had left Antwerp for London just before the war started and feared he had lost all his studio contents. G.W. Hill, who was in Brussels supervising the casting of his statues of Thomas D'Arcy McGee and Sir George Étienne Cartier for Ottawa and Montreal, wouldn't know until the end of the war whether they had been melted down for munitions.[1]

The artists of Montreal, Ottawa, and Toronto rallied to raise money for the Canadian Patriotic Fund, donating paintings and sculptures that were exhibited from Halifax to Winnipeg and sold to the highest bidders for a combined total of more than $10,000.[2]

In December 1914, Jackson returned to Montreal. Encouraged to enlist by Hewton, now a corporal in the 24th Battalion, and by the example of his brother, W.H. Jackson of the 14th Battalion, he finally enlisted in June 1915 as a private in the 60th Battalion.[3] A year later he was wounded in the hip and

shoulder at Maple Copse near Ypres and transferred to England.[4] Captain Ernest Fosbery of Ottawa was wounded at the Second Battle of the Somme, and Lieutenant Kenneth Forbes was twice wounded and gassed just four months before the Armistice.[5] Numerous other artists enlisted: James L. Graham joined the United Arts Corps in Britain; W.S. Broadhead returned from the States to become a dispatch rider with the King Edward Horse; Carmichael's friend the etcher W.J. Wood enlisted as a private in the 157th Battalion; and J.W. McLaren, a private in the Princess Patricia's Canadian Light Infantry, would achieve renown as one of the vaudeville group, The Dumbbells. Harris enlisted in July 1916 as an instructor in musketry at Toronto and Camp Borden, and the Montreal artists Edwin Holgate and Robert Pilot (Cullen's stepson) both enlisted in 1916.

A number of artists went to England to be near family in the forces or to assist in the war effort. Florence Carlyle worked in a British munitions factory, Clara Hagarty and Lilias Torrance for the Red Cross. In France, Katherine Wallis worked as a nurse and John Lyman as an ambulance driver.[6] The losses were enormous and no one was spared. Maurice Cullen lost a stepson, Jack Pilot, Lawren Harris lost his brother, Howard, Anne Savage her twin brother, and Lilias Torrance two brothers.[7] In Canada, both Emily Carr and Albert Robinson stopped painting for the duration of the war, the former forced to put all her energy into running a boarding house to survive the financial crisis, and the latter to work in a munitions factory.[8]

For those with families in Canada, the financial situation was devastating. At the first Academy exhibition in 1914, private sales totalled $100, and the Academy's grant was later halved. The Ontario government cancelled its purchase grant in 1915, and the National Gallery's budget was slashed from $100,000 in 1914 to $8000 in 1918. Recognizing the importance of its support, the Gallery allocated almost its entire purchase budget to works by Canadian artists. In February 1916, the National Gallery vacated its premises in the Victoria Memorial Museum to accommodate the members of the Senate and House of Commons, who needed a place to meet after the Parliament Buildings were destroyed by fire.

In Toronto, both Lismer and MacDonald had been relying on freelance commercial work, which started to collapse in 1913. During the winter of 1914 to 1915, MacDonald made no more than twelve dollars a week. Lismer and his wife and daughter moved in with MacDonald, his wife, and his son, Thoreau, in the summer of 1915, working the Thornhill farm to raise cash crops.[9] The Lismers moved into their own house in Thornhill that fall, and left Toronto for Halifax the following autumn, where Lismer assumed direction of the Victoria School of Art and Design. There he resurrected the fledgling Nova Scotia Museum of Arts, organized loan exhibitions from the National Gallery and the O.S.A., and increased school attendance from two to seventy-two students in the first year. After the Halifax explosion in December 1917, however, the school was temporarily closed to store coffins.[10]

The Death of Tom Thomson

An unexpected tragedy in the middle of the larger losses of the war changed the direction of the developing Group significantly. Tom Thomson sketched and worked as a fire ranger and guide from spring to autumn in Algonquin Park, returning to Toronto in the winter to complete his exhibition canvases. After a painting career of only five years, he was found drowned in Algonquin Park in July 1917, just short of his fortieth birthday. Thomson's death was a severe blow to his friends, who were already devastated by the dislocation of the war. From Halifax, Lismer wrote, "We've lost a big man – both as an artist & a fine character … When one recalls the few years that he had been painting, it is remarkable what he achieved. He has put a new note into all his associates just as he has made his art sing with a lively Canadian note. He was the simplest soul & most direct worker I ever knew. Whilst we others speculated as to how it should be done, Tom did it with that amazing freshness that was always an inspiration to look at. He had no preconceived notions like the rest of us. He never tackled a canvas like anybody else. Everything he produced grew out of his experience & he painted himself into it all."[11]

FIG. 17
Photographs (above and below) taken by J.E.H. MacDonald, September 1917, of the cairn constructed by himself and J.W. Beatty to the memory of Tom Thomson at Canoe Lake, Algonquin Park. National Gallery of Canada, gift of Marjorie Lismer Bridges, 1983.

From England, Jackson heard of the "cruel news," and wrote, "I could sit down and cry to think that while in all this turmoil over here … the peace and quietness of the north country should be the scene of such a tragedy … without Tom the north country seems a desolation of bush and rock. He was the guide, the interpreter and we the guests partaking of his hospitality so generously given … my debt to him is almost that of a new world, the north country and a truer artist's vision."[12]

Tom Thomson died within a week of the fiftieth anniversary of Confederation, a period rent by conflicts over conscription. Not only did it seem that Canada was being destroyed by disunity and its children killed in an imperial war, but now a leading figure in the new movement – the artist who had focussed the vision of the fledgling group and given it a new identity – had gone. Intimations of suicide and suspicions of foul play did not lessen the magnitude of the loss to Canadian art, and Beatty, MacDonald, and MacCallum immediately made arrangements to design and construct a tablet and cairn to Thomson's memory at Canoe Lake (fig. 17).[13]

Canadian War Memorials: The War Front

One ray of light did appear on the horizon: Canadian artists were to be engaged to paint for the Canadian War Memorials Fund, set up by Lord Beaverbrook in London in November 1916 to provide "suitable Memorials in the form of Tablets, Oil Paintings, etc., to the Canadian Heroes and Heroines in the War."[14] The first artist engaged had been the English painter Richard Jack. The following August, at the recommendation of Captain Fosbery, a Canadian artist was assigned to the project, Private – now Lieutenant – Jackson.[15] Two

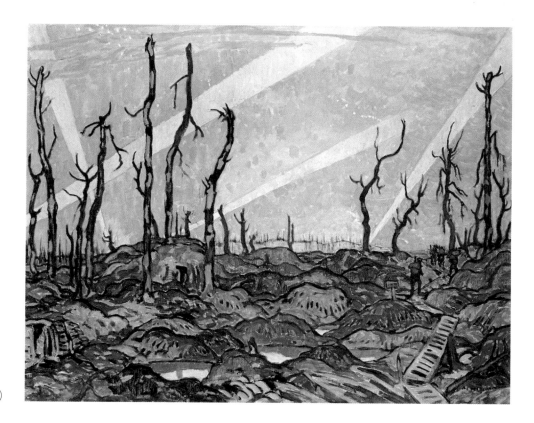

FIG. 18
A.Y. JACKSON
A Copse, Evening 1918
Oil on canvas, 86.4 × 111.8 cm
Canadian War Museum, Ottawa
Canadian War Memorials Collection (8204)

other Canadians were subsequently engaged in England, Lieutenant Cyril Barraud of the 43rd Winnipeg Battalion, and James Kerr-Lawson. All the others commissioned were British.

There was increasing pressure for Canadian artists to receive commissions, and in December 1917 five more were notified of their selection: J.W. Morrice in Paris, Maurice Cullen and Charles W. Simpson of Montreal, and J.W. Beatty and C.W. Jefferys of Toronto. The latter, unable to go abroad, was replaced by Fred Varley.[16] The four Canadian residents were nominated by a joint committee of the O.S.A. and the R.C.A., and it is to the credit of his fellow artists that Varley was proposed, for he had worked for the past five years as a commercial artist for Rous and Mann, had exhibited little, and had been elected to the O.S.A. only the previous year.[17] The war would launch Varley's career.

Jackson visited the French front in the autumn of 1917 and in March 1918.[18] He worked up his canvases in London, and by July had already completed twenty-three paintings, including three portraits.[19] Having been in the midst of battle before, the front held few surprises for him — "same old war, in nearly the same old places, same old soldiers sticking it out, fed up but cheerful and doing impossible things, same old mud and shell holes,"[20] — but to MacDonald he wrote, "You would be proud of the Canucks if you could see them. They have developed a wonderful army, more Canadian and independent than it used to be."[21]

Given the opportunity to paint after more than two years in the army, Jackson realized one of the largest bodies of work of any of the Canadians working in Europe, ranging from landscapes of camouflaged huts — "peace pictures with war motives introduced"[22] — to severe images of battle-scarred

terrain with blasted stumps silhouetted against the night sky. When the Canadian War Memorials were shown in London in January, Jackson's contribution was well received. Of his *A Copse, Evening* (fig. 18), the *Nation* wrote: "Do the mothers and wives think it hard to know that their men are dead? Let them look at this picture ... and know that it is lucky for them, but unfortunate for the living world, that they do not know how and with what thoughts their men *lived* for some time before they escaped from a *Copse, Evening*. It was not death they dreaded. Sometimes that was welcomed. It was the mutilation of the mind."[23] The *Christian Science Monitor* called "Lieut. A.Y. Jackson ... one of the most successful artists of the whole exhibition ... One feels the sense of adventures dared and even enjoyed in the doing of his work and a justified feeling of triumph at its success. It is encouraging to find work like this officially recognized and it surely justifies the hopes of a more world-wide appreciation of the aims of the artist freed from the traditions of the academies."[24]

Varley arrived in England with an honorary commission as captain in April 1918, and was sent to the Canadian army camp at Seaford. In July he was assigned two portrait commissions and four Seaford subjects – *Gas Chamber at Seaford*; *Chynton Farm, S. Camp, Seaford*; *The Seven Sisters, Seaford*; and *Tents in Cuckmere Valley, Seaford* – of which he painted only the first.[25] Finally, in late August, he was in France following the Allied armies in the last major advances. Thrilled and awed by the brutal reality and destruction he saw here, he wrote home, "You in Canada ... cannot realize at all what war is like. You must see it and live it. You must see the barren deserts war has made of once fertile country ... see the turned-up graves, see the dead on the field, freakishly mutilated – headless, legless, stomachless, a perfect body and a passive face and a broken empty skull – see your own countrymen, unidentified, thrown into a cart, their coats over them, boys digging a grave in a land of yellow slimy mud and green pools of water under a weeping sky. You must have heard the screeching shells and have the shrapnel fall around you, whistling by you – Seen the results of it, seen scores of horses, bits of horses lying around, in the open – in the street and soldiers marching by these scenes as if they never knew of their presence – until you've lived this ... you cannot know."[26]

Among the five works he completed in England and exhibited at the Royal Academy in January 1919 were two of the most emotionally charged images realized by any Canadian artist for the War Records: *Some Day the People Will Return* and *For What?* (fig. 19). Again the writer of the *Nation* singled out this work for comment. "*For What\ ...?* who can say? Who dares to put that question, not to the world, but to himself? ... it may be that we would rather not know 'for what?' because we are still merely determined to accuse, as being the easiest way of solving the riddle ... The question of the soldier artists is rarely as direct as Capt. Varley's."[27]

In April and May, Varley returned to France, and in August 1919 he arrived back in Toronto, visiting Lismer in Halifax on the way.[28]

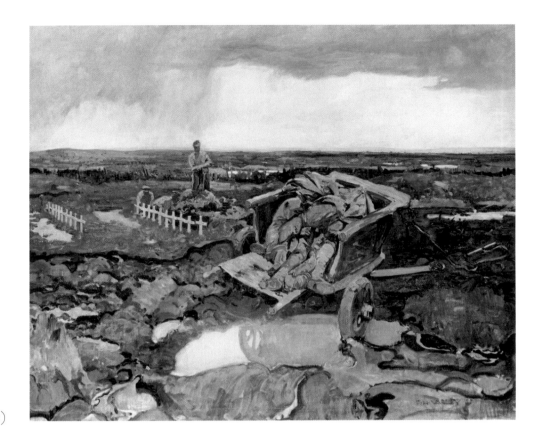

FIG. 19

F.H. VARLEY

For What? 1918

Oil on canvas, 148 × 183.5 cm

Canadian War Museum, Ottawa

Canadian War Memorials Collection (8911)

Canadian War Memorials: The Home Front

Funds were provided by the Canadian War Memorials in London early in 1918 to engage artists to document war activities in Canada.[29] Sir Edmund Walker and Eric Brown were to coordinate the program on the home front, and they requested from Jefferys and Grier the names of artists who could carry out the work.[30] Harris wrote to Brown of the stimulus the program provided: "Most of the artists were there [at the Arts and Letters Club]. They were happy — had a new lease of life … they were busy or about to be busy on war memorial work … it means so much to them — has benefited them in every way and the enthusiasm the idea has engendered will, I am certain, be productive of the best work they have ever done. It is very gratifying … to see them all so content and busy (young and old, particularly the old)."[31]

Among the artists recommended by Grier and Jefferys was Lismer, who had already written to the Gallery requesting assistance in getting permission to "gather material here in Halifax … Halifax is of vital interest as a war city & there is a tremendous amount of activity that I'd like to record — the departure & arrival of troopships, convoys, hospital ships, troopships from Australia & New Zealand & the States — camouflaged men-of-war of different nationalities — it's intensely interesting & graphic & no one is painting it." Lismer had printed one lithograph of a transport ship the previous year, but with the temporary disorganization of the art school and gallery because of the explosion, he had time on his hands and did not want to miss a great opportunity, "for I think it will have a great deal to do with the development

of our art in Canada." Lismer did receive the required permits and in spite of repeated suspicions of being a spy, he was able to sketch the ships in harbour and paint three large canvases: *Mine Sweepers and Seaplanes off Halifax, The "Olympic" with Returned Soldiers*, and *Convoy in Bedford Basin*. As well, he printed sixteen more lithographs, which were published in an edition of approximately 100 each and put on sale for the benefit of the Canadian War Memorials Fund.[32]

Jackson arrived back in Montreal in October 1918, awaiting transportation to the new war front in Siberia. After a quick trip to see family in Kitchener and old friends in Toronto, and after hearing that he would not be sent abroad, he went to Halifax at Lismer's encouragement to paint for the War Records.[33] The reunion was stimulating for both men. "You may guess Alex & I have been having some great old 'chins' on all kinds of subjects — He is of course just as stubborn an old knocker as ever & every blessed individual & subject that comes under his consideration gets either a raking or a wee modicum of praise. He has a gentle way of making one feel like a slacker — quite unintentional. He certainly has no use for a pacifist. It's fine for me to have him with us."[34]

The troop ships had been diverted to Saint John and Portland, Maine,[35] although both artists continued to produce paintings of the remaining ships in harbour in the hope that the War Memorials would buy them. Jackson wanted to exchange his for some of his first Records canvases, with which he was dissatisfied.[36] The Fund had no further money, however, and none of the remaining works was purchased.

Jackson's visit only aggravated Lismer's sense of isolation. "It does seem down here that painting is a matter of stolen time & sending to exhibitions a matter of packing cases & much expense & putting on shows much unappreciated work & lost effort — & selling the rarest chance imaginable."[37] Through MacDonald, he was offered a position at the Ontario College of Art.[38] Before he left Halifax he organized an exhibition of Ernest Lawson's paintings, six of which were bought for the Nova Scotia Museum.[39]

The Critics

During the war, modernism took on an increasingly menacing character in the eyes of some writers. Even Augustus Bridle proposed that "Modern art as exemplified most successfully in Germany was but one outcropping of the conditions which brought about the war."[40] Ahrens, in an implicit attack on Lismer, MacDonald, Thomson, and Harris, told a journalist from the *Toronto Daily Star* that, "All these new schools, so-called, had their beginnings in France … With France these experiments were legitimate but France knew where to begin and where to stop … but the so-called new art has no excuse, and bespeaks only of a hermaphroditic condition of mind and an absolute lack of the knowledge of drawing, colour, and design. I feel that these young persons who are indulging in these pastimes would gain a much higher standing before men if they gave their now mis-spent efforts to the destruction of the Hun."[41]

FIG. 20

A.Y. JACKSON
The "Olympic" in Halifax Harbour 1919
Oil on canvas
Dimensions unknown
Photograph private collection

This painting was not purchased by the War Memorials, and Jackson later destroyed it.

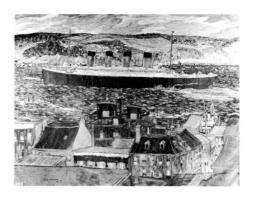

The occasion for Ahrens's comments was the 1916 annual spring exhibition of the O.S.A. The day after the opening, all the Toronto newspapers reacted in unison at the "use of strong, even violent colour – colour that makes the quieter toned canvases look weak by comparison."[42] With journalistic hyperbole, the terms Impressionism, Futurism, and Cubism were thrown around in consternation at the "intense blues," "broad lines and blobs of colour," and "lines and colours that seem to have little relation to nature." All writers identified MacDonald's paintings as the most incomprehensible. For Helen Ball, *The Elements* was "things gone mad," for M.O. Hammond "A grotesque formation of clouds, rock and waters," and for Margaret Fairbairn, "a whirl of chaotic shapes, where the clouds are as rocks, and the rocks and vegetation and humans are in one convulsive whirl." *The Tangled Garden* (fig. 21) was likened to "a huge tomato salad" and an "incoherent mass of colour."[43]

MacDonald responded in a letter to the *Globe*, pointing out the obvious, that "there are no 'Futurist' or 'Cubist' pictures in the exhibition," and proposing that "the 'blaze of colour', the 'shrieks', the 'daring contrasts' that startled critics have found in the show [may] be merely the result of this increased perception on the part of the artist [resulting from the war]. Canada will surely find herself artistically, as well as nationally, through the trial of the present times."[44]

To respond to Ahrens's accusations, he drafted another angry letter that was probably never sent. "One fails to see why the experiments of Canadian artists should not be as 'legitimate' as those allowed artists in France. We have a new country and a country practically unexplored artistically and it would seem therefore that courageous and thorough experiment is not only 'legitimate' but vital to the development of a living Canadian art ... But if this Canadian new 'school' so-called were attempting nothing but to follow the lead of French innovators, Mr. A. could not consistently object as his own style is founded on that of the Barbizon school. Certainly he does not, himself, experiment. His art is one of multiplication not addition." In response to the stinging accusation of lack of patriotism, MacDonald charged Ahrens with being a "fireside critic of the war," pointing out that one of his fellow artists (Jackson) was with the army in France, one (Harris) was undergoing military training, and the others had family obligations "as legitimate and binding as their critic."[45]

Charlesworth of *Saturday Night* entered the fray a week after the first reviews appeared, opening with, "Applied or 'quasi-futurism' has gotten hold of the hanging committee of the Ontario Society of Artists this year with a strangle clinch." In the works exhibited he found "no sincere passion for beauty, hidden or revealed, but [the pictures] rather savour the idea of the vaudeville manager whose motto is 'hit 'em in the eye.'" In a Ruskinian analogy he accused MacDonald of throwing "his paint pots in the face of the public," and of infecting "a number of other talented young artists, who seem to think that crudity in colour and brushwork signify the vaunted qualities

'strength' and 'self-expression.'" In a much-quoted slander he caricatured *The Elements* and *Rock and Maple* as "Hungarian Goulash" and "Drunkard's Stomach."[46] Unlike the Montreal newspapers in 1913, none of the Toronto papers reproduced any of the offending works so that the public might understand the cause of the critics' indignation.

MacDonald's second published response to this "gas attack" from the critics repeated Mortimer-Lamb's counsel to Morgan-Powell on "the right relation of artist and critic. If the function of the artist is to see, the first duty of the critic is to understand what the artist saw," and quoted Goethe's caution that "a genuine work of art usually displeases at first sight, as it suggests a deficiency in the spectator." At the same time he expected critics "to know the distinctive character of their own country" and to recognize it in works whose "nationality is unmistakable ... *Tangled Gardens*, *Elements*, and a host more, are but items in a big idea, the spirit of our native land."[47]

War Memorials Exhibitions, 1919, 1920

On obtaining his discharge from the army in April 1919, Jackson returned to Toronto, continuing to paint for the War Memorials, and spending part of August at Georgian Bay.[48] Both he and Lismer were back in Toronto for the first Canadian exhibition of the first phase of the War Memorials realized in Britain.

The collection had previously been shown in London and New York, and a number of works had been reproduced in various periodicals,[49] but this was the first opportunity for Canadians to see them. They were displayed at the Canadian National Exhibition in August and at the Art Association of Montreal from 27 October to 20 December. Inevitably, the preferences of the reviewers split along academic and modernist lines, the former praising Richard Jack's *Second Battle of Ypres* (fig. 22), Alfred Bastien's *Over the Top*, Kenneth Forbes's *The Defence of Sanctuary Wood*, and Byam Shaw's allegory *The Flag*, and the latter William Roberts's *The First German Gas Attack at Ypres*, Paul Nash's *Void* (fig. 23), and Wyndham Lewis's *A Canadian Gun Pit*. Both sides praised Varley's *For What?* (fig. 19), although Charlesworth proposed a more pedestrian title, *Burial Party*.[50]

The scale of the venture impressed all reviewers. It was the largest art project in Canadian history, and all recognized the importance of the collection both as a memorial to the hundreds of thousands of Canadians who had fought and more than 60,000 who had died, and as a collection of diverse art forms which would remain in Canada. Morgan-Powell could, therefore, justify the "strange distortion of composition" by referring to the paintings' intended use as decorations for a war memorial "Pantheon" to be constructed in Ottawa. Charlesworth took the position that "the experimental schemes of the up-to-the-minute painters are unsuitable to heroic themes," and criticized Roberts's *Gas Attack* for "its immensity [which] so emphasizes the crudity of the painter's mind and talent, as to make ludicrous a very tragic episode."[51]

FIG. 21. J.E.H. MACDONALD, *The Tangled Garden* (cat. 26)

The C.N.E. exhibition attracted record crowds; almost 120,000 people came out to see an art show, one which included some of the most advanced art ever seen in Canada.[52] For MacDonald, "the war memorials are not only national records, they are family records for most of us and as such they will have a sure interest handed down from generation to generation. We can feel certain of the pride of coming Canadians in these pictures. We may hope that they will read the moral of them truly, and so order the national affairs of their world that their youth may not need to be sacrificed to that monster of war which we allowed to grow up among us."[53]

So important did he feel the collection was for Canadians that he proposed the works not be sent for "internment" in "the official backwaters of Ottawa," but be housed in Toronto where they would be seen by "fifty times more people" and could be shared "with our good cousins across the border to the advantage of all,"[54] a position echoed by Lismer.[55] For Lismer, apart from its unique subject, the exhibition "had given the public an opportunity to view the work of artists of diverse outlook. The value of modern art, and of academic tradition here have an opportunity of demonstrating their respective claims."[56] To the great delight of Jackson, "even such advanced abstractions as Lieut. Turnbull's *The Red Air-Fighter* were received [by the public] without protest."[57]

Jackson took the opportunity to castigate the academic paintings for "the futility of fine craftsmanship used without passion or dramatic conception."[58] Lismer saw in them only "posthumous pictures of battlefields, frozen in action, with all the traditional impedimenta strewn around … but the spirit is still the same … detail without fervour – incident without intensity … a very polite performance."[59] In the modern work they found the true expression of experience lived and a denunciation of war, "just the stark naked fact that war is here, bereft of all glory, and that its aftermath is misery and filth."[60]

Lismer was the most enthusiastic about the British modern paintings but Barker Fairley, of the University of Toronto, was more reserved. "There is but one painter in the whole group who has succeeded in conveying an intense human emotion concerning warfare in an outright manner that does not break outright with traditional forms of expression. That man is F.H. Varley … *For What?* and *Some Day the People Will Return* are a thing apart in the collection … They are executed in an impersonal way, neither laboured nor mannered; they are not the product of a passing fashion. They will never become widely popular, but neither will they ever be appropriated by a clique. As time goes by they will simply be found standing where they now stand – in the forefront of Canadian paintings." Fairley was equally complimentary towards Jackson. "His work is detached and excessively scrupulous. His subtle keying and habitual understatement stand in the way of popularity or even of easy appeal … his *Copse, Evening* … must be one of the most enduring pictures in the collection. It stands in point of technique somewhere between the extremists and the moderates, avoiding the pitfalls of the former and the timidities of the latter."[61] Finally, Jackson wrote, "This exhibition is a justification of those who have had faith in the future of Canadian art. That this collection will

influence contemporary art in Canada seems obvious enough. In the ordinary course of events many of these types of modern work would not have been acquired by private or public collections for twenty years to come."[62]

The exhibition of the "home-front" paintings at the Art Gallery of Toronto in October 1919 was met with neither the same popular interest nor the same public debate as the first show. Patriotism and curiosity to see depictions of European battles as well as the work of renowned British artists must have fuelled the initial enthusiasm. Paintings by Canadian artists showing more familiar events did not elicit the same response.[63]

The final works of art commissioned by the Canadian War Memorials were shown at the C.N.E. and the Art Association of Montreal in the fall of 1920, together with a selection from the home-front works. The most commented upon were Paul Nash's *Night Bombardment*, David Bomberg's *Sappers at Work: A Canadian Tunnelling Company*, Turnbull's *Air-Fight*, and David Milne's watercolours (the first Milnes shown in Canada, they were enthusiastically received). The *Mail and Empire* took exception, however, to "the inclusion among the memorial paintings of works by the extreme radicals … Why should artists whose theories have not yet been tested and found to be sound and enduring be given an opportunity to experiment in a collection that is intended definitely to be permanent and enduring?"[64] Other critics were less condemnatory, disarmed by the patriotic character of the project and diversity of style and treatment in the paintings.

The works of art belonged to the Canadian War Memorials Fund, and Lord Beaverbrook hoped the government would build the "Pantheon" he had had designed. It was not willing to spend public funds to construct a memorial gallery, however, and nothing was done. MacDonald's and Lismer's fear that the works would not be available for art students and the general public proved to be justified. The paintings, sculptures, prints, and drawings, totalling more than 900 works, were transferred to the Canadian government by the Fund in

FIG. 22
RICHARD JACK
Second Battle of Ypres
23 April–4 May 1915 1918
Oil on canvas, 370.8 × 595.6 cm
Canadian War Museum, Ottawa
Canadian War Memorials Collection (8179)

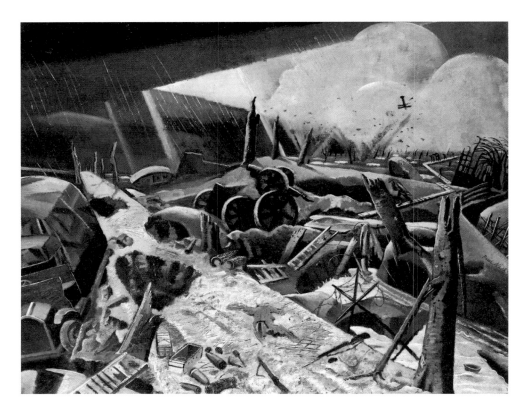

FIG. 23
PAUL NASH
Void 1918
Oil on canvas
71.1 × 91.8 cm
National Gallery of Canada, Ottawa
Canadian War Memorials Collection (8650)

April 1921 and stored at the still homeless National Gallery. While there was no possibility that Beaverbrook would have allowed them to remain in Toronto, the paintings by Lewis, Nash, Roberts, Bomberg, and Turnbull were thus effectively removed from the discussion about modern art in Canada, nor did they stimulate any collecting of Vorticist art in the country. It wasn't until September 1921 that the Gallery reopened and, save for eight large paintings installed in the newly constructed Senate, the War Records collection would not be seen again outside Ottawa until exhibited at the Art Gallery of Toronto in October 1926.[65]

∾

More than 60,000 Canadians had died during the First World War, and there had been another 173,000 non-fatal casualties. After the optimism of the Laurier era, the war was a brutal blow. Yet the very devastation and suffering strengthened the artists' resolve and clarified their intentions. The Canadian War Memorials program provided unprecedented funds for Canadian artists to work, and their relative critical success abroad produced new international recognition for their art. They had proved they could stand on their own beside their British peers. The Vorticist paintings in the collection had, as well, fuelled the debate about modern art and once again enlarged the context for growth.

FIG. 24. J.E.H. MACDONALD, *The Wild River* (cat. 27)

4

*Defining
the Program*

n the immediate postwar years, the artists came together once
again in Toronto and set off to make new discoveries (fig. 25).
Tom Thomson's life and painting remained a potent image for
them as they articulated their goals and defined themselves as a
group. The war years had challenged and strengthened the
national identity of many Canadians and instilled a new urgency into argu-
ments for reform.

The Rebel

The years from 1914 to 1918 were exceptionally difficult for J.E.H. MacDonald.
The absence of Jackson, Lismer, and Harris, the battle with the critics fol-
lowed by Thomson's death, the construction of the cairn, and finally the move
with his family from Thornhill to York Mills resulted in his suffering a stroke
in November 1917, from which it took him months to recover.[1]

During his convalescence, MacDonald wrote poetry,[2] and also, through
Barker Fairley of the University of Toronto, published a number of articles in
The Rebel, a student publication that soon became the mouthpiece of the staff

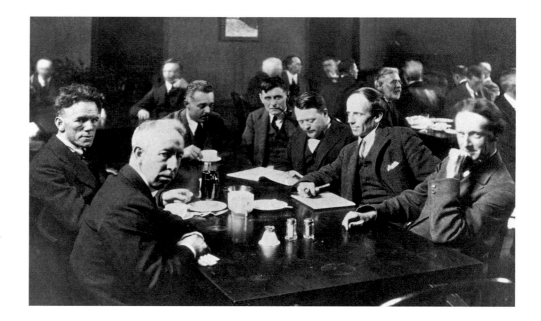

FIG. 25
Arthur Goss: Luncheon at the Arts and Letters Club, 57 Adelaide Street East, c. 1920. Clockwise from left front: A.Y. Jackson, Fred Varley, Lawren Harris, Barker Fairley, Frank Johnston, Arthur Lismer, J.E.H. MacDonald.

and their associates. His first article, "A Landmark of Canadian Art," was about the cairn constructed at Canoe Lake to the memory of Tom Thomson.[3]

Barker Fairley, the man who had encouraged MacDonald's writing, was a German scholar and critic who became one of the strongest promoters and supporters of the Group of Seven. He was born in Yorkshire, England, in 1887, and studied at the University of Leeds. He taught for three years at the University of Jena, before coming to Canada in 1910 to teach at the University of Alberta in Edmonton. In 1915 he moved to Toronto, where he assumed the position of professor of German literature at the university and in May 1917 joined the Arts and Letters Club. There he met MacDonald.[4]

MacDonald's stroke must have made him all the more aware of the fragility of the nascent Group's accomplishments to date. The lack of patriotism he saw around him, the war profiteering, the political indecision which continued to kill so many Canadian soldiers, the condescension towards Canadian art, the impoverishment of the country's artists, and the slavish acceptance of all that was foreign led MacDonald to write some of the most articulate and heated articles he would ever publish.

In "Art and Our Friend in Flanders," he linked the development of Canadian art and patriotism. Quoting a letter from A.Y. Jackson, he wrote "[a distinctive Canadian Art] ... has waited long enough ... We have always had a ready inspiration in our country. We have accumulated talent. Surely the national spirit will be strong enough now to prompt our people to do the necessary part. It only needs ... the deliberate and conscientious encouragement of Canadians (and not necessarily wealthy Canadians) to flourish like any other natural Canadian industry. Canada has a good soil for Art as for wheat, and when our people decide that Art had better be grown at home than imported from Holland, they'll find that they'll get a better article at a lower price, with a distinct broadening in national living as an accompaniment ...

"The duty of the patriotic connoisseur ... is to recognize the existence of Art by not only encouraging the artist who lives and works near him after the work is produced but by requiring as a necessity of life the production of such work in his own country ... The aim of patriotism is a full expression of the beneficent spirit of a particular people, and this expression is stunted without a native Art."[5]

The collectors of and speculators in foreign art, MacDonald argued in another article, "are solid people, well entrenched, financiers, newspaper critics, the conservative, the sentimental, the ignorant – elements of society who want always to do the proper thing. On the other side lie the real Canuck trenches held by a handful of enthusiasts, painters, a writer or two, a few professional men who have declined to accept common prejudice, and a number of healthy minded Canadians free from cant and snobbery who love Canada greatly."[6]

In an article for another Toronto publication, *The Statesman*, MacDonald called upon Canadians to leave behind their condescension and indifference and work to appreciate artists' efforts. The example lay in Canadian soldiers. "We can proudly say that our men have gone over the top of our expectations. In initiative, energy, and stamina, they have established a distinctive Canadian character. They have made new inroads of achievement in a no man's land of tradition and precedent ... their actions are an indication of the worth, form and possibilities of that Canadian national character which we, as a people, are daily building in labour, in business, in religion and government, in social life and all forms of art ... our Art movement is now steady and conscious of its aims. We have been driven towards perfection by the suffering of the war. The emotional interest of Canadians in their homeland has been increased and our Art has received, to some extent, the prophet's honour, through Canadian artists who have had opportunities to work officially in the War Zone. Some of these, though practically unknown to their own people, have been found, by discerning citizens abroad, to be worthy of comparison with leading British artists doing the same work."[7]

Lismer, too, recognized that a small victory had been won in the recognition accorded Canadian artists who had worked for the War Records. "The war has proven that artists may be useful as well as ornamental. Some fought, some recorded, pretty nearly all of them contributed in some way." But the problem remained that, at the core of Canadian society was an almost "complete misunderstanding of the meaning of Art."[8] It was essential to first eradicate the idea that art was solely a matter of "a gilt frame on the walls of the Art Gallery," he wrote.[9] "The parasitic traffic of the picture sale-room noised in the public press as important art news, the palatial appearance of the homes of connoisseurs of art convinces the bewildered and would-be appreciator that art is only co-existent with wealth and big business and only accessible to those who can afford to pay big money for it. Add to this the modern abstract methods of ultra-modernist schools of painting with their representations of

crude contortions of line and form and their intellectual synthetic principle of painting, and the beholder is forced to take refuge in the contemplation of the safe and sane variety of mediocre pictures as a shelter from the disturbance of thought brought about by visits to art galleries and War Records exhibitions."

As a result, Lismer continued, "there is not enough appreciation to go round amongst more than a dozen or so of portrait painters, landscape painters, and sculptors. By sheer force of circumstances the Canadian painter is bound to do something for his living beside paint. Were it not for the kindly offices of a very few interested people who impress the Government with the necessity of providing sustenance to Canadian Art by the occasional purchase of a picture from one of the annual shows, Canadian Art would inevitably go under, or succumb to the popular forms of picture-making, usually known as 'pot-boilers.'"[10]

"The art of picture-making for a living has become more or less ridiculous," echoed Jackson. "The supply exceeds the demand twenty times over and talents which might be employed in definite work of decoration are wasted on productions which are piled up in basements or attics ... The average painter would be better employed at a carpenter's wage designing house decoration and doing his easel pictures for his own pleasure, instead of working on speculation, constantly wavering between his individual tastes and those of an inartistic clientele."[11]

For Lismer, the solution lay in developing a recognition that art and aesthetics permeated all aspects of life – in posters designed for the war effort, in industrial and interior design, in urban planning, and so on. "If we are to offset this absurd and popular fallacy that art is only for the well-to-do and is only a matter of picture-painting, there must be a complete reform of our standards of aesthetics and appreciation, or at any rate, a realization that a sense of beauty is as necessary to the nation as a sense of morality."

Essential to this program was a radical change in the educational system, which either ignored art entirely or strove to turn out artists rather than to develop an art consciousness and appreciation of art "as an economic, industrial and aesthetic factor in the life of the community ... The system of Art Education, what there is of it, in Canada, changes not. It is still labouring under difficulties of small financial support and totally inadequate accommodation, out of date, out of touch, a sort of mill known only to a few, where Artists may be turned out according to a traditional system, on the principle that so much technical practice leads to artistic perfection, so many months at drawing from the cast, a little at the principles of Design, some Parisian studio practice, and then a diploma of proficiency and the young student is chucked out into an unappreciative world to sink or swim. The 'education of an artist' has left him with a little knowledge of everything, except his appreciation of the beauty of nature, his capacity for detecting in nature the laws of beauty and growth, and the necessary powers of observation and ability to apply them to the serious purpose of adding to the beauty of the world, or even to the, perhaps, even more serious purpose of earning his living ... The

expression of beauty is not a separate department of life. Art is a mode of living, a quality of consciousness."[12]

Algoma

Lawren Harris also suffered a form of breakdown, after the death of his brother, Howard, in February 1918; he obtained a medical discharge from the army in May.[13] That same month, MacCallum and Harris travelled by car and ferry to Manitoulin Island by way of Owen Sound. According to Housser's *A Canadian Art Movement*, Harris found the country disappointing, so they took the Algoma Central Railway up to Stop 123 and then back down to Michipicoten on Lake Superior.[14]

Harris now resumed his role as initiator in the nascent Group, and in August organized a second trip to Algoma with MacCallum, MacDonald (fig. 26), and Frank Johnston, the latter working on commissions for the Canadian War Records at the School of Aerial Gunnery at Beamsville, Ontario. They travelled up the Algoma railway in a freight car, stopping at Canyon, 113 miles north of Sault Ste. Marie, Hubert, and Batchawana.[15] MacDonald was enthralled. "The country is certainly all that Lawren and the Dr. [MacCallum] said about it. It is a land after Dante's heart. The canyon is like a winding way to the lower regions and last night, when the train went through just after dark, with the fireman stoking up, the light of the fire shining on the smoke clouds, it was easy to imagine his Satanic majesty taking a drive through his domain ... The great perpendicular rocks seemed to

FIG. 26
J.E.H. MacDonald painting in Algoma in 1918 or 1919. Photograph from A.Y. Jackson's scrapbook. Private collection.

FIG. 27
J.E.H. MacDonald: "Ars Longa,
Vita Brevis," 1919, *The Lamps*, December
1919, p. 39. The monogram is formed
from the initials of MacDonald,
Harris, Jackson, and Johnston.

overhang as though they might fall any minute and the dark Agawa moving quietly through it all had an uncanny snakiness. On a fine day, such as this, the canyon seemed to lead *upwards* and has all the attributes of an imagined Paradise, excepting, perhaps, anything in the way of meadows. There are beautiful waterfalls on all sides, and the finest trees — spruce, elm, and pine."[16] Johnston was equally enthusiastic, and painted thirty-three sketches.[17]

Algonquin Park, the site of the catalytic events of 1914, belonged to Tom Thomson. Only Lawren Harris and Bill Beatty would return there to paint. The focus had moved north to Algoma and eventually to Lake Superior.[18] A third trip was organized in September 1919, this time to include Jackson. Painted on boxcar 10557 of the Algoma Central Railway was a moose skull topped with evergreen and red berries over the motto *Ars Longa, Vita Brevis* [art is long, life is short], and a monogram of the artists' initials[19] (fig. 27). Jackson was delighted with the country. "From a hill nearby one can look over miles of primeval forest, not a clearing in any direction. Here and there is a beaver meadow, but rough stuff. They seem to be big, tough guys and delight in making the country look like hell ... The colour is disappearing very fast. The reds were gorgeous when we first came, but now it is all orange and yellow ... spruce and balsam and pine as high as the big pine at the Portage grow here all over the place, and birches you couldn't get your arms around. In spite of the bad weather ... we have done a lot of work, got soaked pretty often too, but the box car is very cosy and one can soon get dried out ... The other chaps are all out sketching under umbrellas. They are all trying to turn out four a day, and can't stop if it rains. MacDonald and Johnston are Christian Scientists and Harris a theosophist, and they don't see much difference between rain and sunshine."[20]

Ontario Society of Artists Exhibition, 1919

The first paintings resulting from the Algoma trips were exhibited by MacDonald at the O.S.A. in March 1919. That show was held in the newly constructed Art Museum of Toronto (fig. 28), which had opened the previous year with a joint exhibition of the Academy and the O.S.A. The small Neo-Classical building, the first phase of a larger project designed by Frank Darling, was situated just north of The Grange and consisted of only three galleries with a corridor connecting it to the old house. Visitors entered through The Grange. Access to Dundas Street was impeded by the still standing houses, which would be demolished over the next year.[21]

Given the small space available, the 1919 hanging committee, consisting of Grier, Johnston, and Harris, were compelled to reduce 500 entries to an exhibition of 214.[22] Farquhar McGillivray Knowles protested to the press on behalf of his wife, Elizabeth, the author of two of the refused paintings, that works previously shown at the National Academy of Design in New York were rejected in her home town. Harris explained in response that the jury had to

"consider the exhibition as a whole and reject work which might have been individually good, but out of harmony with the exhibition ... The only possible way for artists to avoid squabbles is to hold two exhibitions, one for the work which the older men consider meritorious and another for what pleases the younger men, which latter may be neither so safe nor so sane but is much more likely to produce something really significant."[23] While Harris would continue to exhibit with the O.S.A., he never served on any of its committees again.

MacDonald's *The Wild River* (fig. 24) displeased everyone. The *Evening Telegram* called it "a large colour riot,"[24] the *Star* "a particularly chaotic composition difficult for the ordinary onlooker to understand as it calls up no suggestion of nature at all,"[25] and the *Mail and Empire* noted, "the figure, the trees, and the landscape bear little relation to one another, but seem rather to fit into a generally distorted colour scheme. Everything is disproportionate, even the curly river, suspended in midair in a manner that suggests Japanese art."[26] The *Toronto Daily News* complained, "The river is wild, so wild you would never dream it was a river unless the catalogue vouched for the fact. Not only the river but the trees, the rocks, everything is equally wild and all look as though they were badly in need of sorting out and tidying up."[27]

Eric Brown didn't find the painting "successful,"[28] and even Barker Fairley had reservations. "I find it difficult to reconcile the flat planes of the picture with its unrestful texture. There is strength in this uneasy tapestry with the two giant pines clamped across it but there is not that intense hold on reality that MacDonald's admirers cannot help looking for. Not, of course, the literal photographic reality that some would have, but that deeper reality of his own experience out of which the picture grew. A painter who can saturate his pictures with weather as MacDonald can, crinkling them with blown air, drenching them with moonlight, or smearing them with fierce sun, creates an impatience, which is itself a tribute to his ability, when he works on more hasty and impartial lines. The stones at the foot of *The Little Fall* (fig. 29), however, are a quiet monument to the fact that he is growing in power."[29]

FIG. 28
The newly completed Art Museum of Toronto, 1918. The building consisted of three galleries linked to The Grange.

FIG. 29. J.E.H. MACDONALD, *The Little Fall* (cat. 28)

Peter Donovan had been won over to the cause by this time. "Personally, we thought it was a very good show – full of modernity and hit-em-in-the-eyeness, so to speak. Of course, some of it was rather advanced – these modern chaps always keep about three jumps ahead of our comprehension – but we like their daring and enterprise ... 'The old masters?' we said sneeringly. 'Why, they're deader than the fellows that used to do the hieroglyphics for Rameses. What art requires is vibration and voltage. Let the ecstatic supervene on the static! Dynamism is the thing.'"[30]

MacDonald wrote to Lismer in Halifax: "The O.S.A. show is closed, and never *will* be missed by the great majority of *un*-righteous Torontonians. No pictures were bought by Govt. – I haven't time to tell you about the real old-fashioned O.S.A. *row* we had at the last meeting over the action of the hanging committee. You really must write that resignation and get back to the front line trenches here."[31]

Algoma Sketches and Pictures, 1919

While the artists had made their arrangements before the O.S.A. confrontation, the exhibition of Algoma paintings and sketches by MacDonald, Johnston, and Harris at the Art Museum of Toronto in late April 1919 turned out to be the appropriate response to the criticism launched at *The Wild River*. The works from the fall 1918 trip were shown in the long centre gallery, and the artists displayed the same aggressive spirit that animated their writings in *The Rebel*. In the foreword to the catalogue they described the impetus for

the larger canvases: "The large pictures shown were painted at home after the trip, some of them as efforts to reproduce, with deeper truth of feeling or character, a representative scene sketched and studied on the spot. Others were painted as imaginative summaries of impressions made by the country on the mind of the artist." They challenged their audience to recognize that the whole collection was evidence that Canadian artists were interested in the discovery of their own country. "Too often the work is ridiculed by the ignorant, and criticized adversely by an unsympathetic narrowness of mind, as though it had no traceable connection with nature."[32]

The sketches were arranged chronologically and geographically, from Canyon to Hubert to Batchawana following the advance of the autumn colour. In the corners of the galleries were displayed "Algomaxims" — "some piquant aphorisms calculated to disarm the critic."[33]

FIG. 30. FRANK JOHNSTON,
Algoma (cat. 21)

The great purpose of landscape art is to make us at home in
our own country.
The blue glasses of Prejudice spoil all colour-schemes.
The artistic survey of Canada is in its beginning, and is undertaken
entirely at the artists' own expense.
Get the habit of looking at the sky. It is the source of light and art.
Co-ordinate your ideas so that you are advanced by all of them.
If you are fond of good music why have a rag-time ideal in painting?
Canada consists of 3,500,523 square miles mostly landscape. It is
apparently intended for the home of a broadminded people.
A critic is known by the comparisons he keeps.
If you never saw anything like that in nature do not despair.
Even the artist has not seen all there is.
The old masters were young servants once.
The more you know the less you condemn.
Do not take the paintings too seriously, rather let them take you.

FIG. 31. FRANK JOHNSTON,
Autumn, Algoma (cat. 22)

The critics were indeed disarmed and the show received positive reviews. "The work of these young artists deserves enthusiastic recognition and support," wrote the *Mail and Empire*, seeing it as the successor to the landscape poetry of Archibald Lampman and Bliss Carman. "In their work the spirit of young Canada has found itself … It is not commercial and it is pursued for pure love. It is not ostentatious. It is highly intellectual and poetic and without any debasing appeal to the senses. It is neither gross nor vulgar. It possesses the charm of out-of-doors and the grandeur and dignity of nature remote and supreme."[34] Even Charlesworth deigned to comment favourably, though offended by the artists' challenge to the viewer in the foreword. "Of the three, Mr. Johnston has most poetic feeling, and Messrs MacDonald and Harris are skilled draughtsmen. Though self-conscious, they are undoubtedly clever."[35]

There were no sales; however, the critical success of the show confirmed that focussing their presentation as a group was the direction to take in future

exhibitions. In November they applied to the Museum, now renamed the Art Gallery of Toronto, for an exhibition of the work of nine modern artists for the following May.[36]

The Legacy of Tom Thomson

Although he had died in 1917, Tom Thomson remained a key figure in the development of the artists' ideas. His paintings and oil sketches were stored at the Studio Building. MacDonald designed a stamp to authenticate the sketches and MacCallum assumed responsibility with the family for sales and loans to exhibitions.

A number of articles published on Thomson in the years immediately following his death defined his image and clarified the lessons learned from his life and painting. MacDonald contrasted intellectual theorizing about "Post-Impressionism, Cubism, Vorticism, [and] Synchronism" with direct experience of nature. He identified Thomson with the natural environment of Algonquin Park that was his first love. "Leaving Toronto before the break-up in Spring and not returning to his studio until after the setting-in of Winter, he practically stood waiting on his chosen ground for every inspirational opportunity. This concentration of purpose, and his natural genius and knowledge and sympathy with his subject are shown in over 300 sketches and pictures left by him. They present the skies, woods, lakes, and rapids of the Northland in intimate aspects rarely seen by the casual visitor. And they do this in a simple direct way, obviously inspired by the essential character of the subject."[37]

Sharing Lismer's appreciation of the directness of Thomson's painting methods, MacCallum further developed MacDonald's insistence on the primacy of nature as the stimulation for his art. "He was not concerned with any special technique, any particular mode of application of colour, with this kind of brush stroke or that. If it were true to nature, the technique might be anything … He proved the theory that the technique should harmonize with the nature of the painting, should never overpower or dominate the idea or emotion expressed, and should appear to be the best or the only technique to adequately express the idea."[38]

By identifying the inspiration for Thomson's art in nature and in life, specifically in his immediate environment in Canada, these writers implicitly separated him from academic precepts. On the one hand was Thomson, who, save for some basic study of commercial art, was effectively self-taught, and who had preserved his "appreciation of the beauty of nature" and "his capacity for detecting in nature the laws of beauty and growth."[39] On the other hand were the schools which "turn out scores of art students who, having learned a method of expression, then start out on a vague hunt for subjects, and mostly prove that they have acquired only the method, with no inner experience to express. Thomson was fortunate in that, finding a means of expression, he was able to interpret what had been to him the passion of his life."[40]

On his return from England, Jackson had made a brief trip to Toronto before going to Halifax. There, for the first time, he saw the work Thomson had painted since Jackson left Toronto in December 1914. The paintings must have been an exhilarating confirmation of his early faith in the artist. With Mortimer-Lamb, he made arrangements for the first memorial exhibition of Thomson's paintings to be held at the Arts Club in Montreal in March 1919, and subsequently at the Art Association of Montreal.

Jackson didn't see the show until he returned from Halifax in April;[41] it reanimated all his old frustrations about Montreal. "I thought the Thomson exhibition would wake them up. It has been a revelation to many of the younger artists but rather frowned upon by the academics who call it crude and fail to see its tremendous vitality ... The Spring show is very tame. After being on the train all the previous day passing through ripping country, hills and plains, rushing streams and departing snows, it looked in the show as though there must be [a] reward for the least typical Canadian landscape. It was mostly Dutch and the Dutchier they were the better they sold, with that awful Learmont collection of junk by well known artists and its ridiculous pretensions to money values, always open alongside. It's no wonder they never sell a modern work. To my mind the Canadian artists should drop the Montreal Art Association and let it stand on its own legs as the champion of the art dealer and the Dutchmen. They are only using the Canadian artist as a convenient camouflage. If they had one room of twelve Morrices, twelve Ernest Lawsons, and twelve Thomsons it would make all the rest of their stuff look sick. If one went to Amsterdam and found no Dutch paintings in their galleries one would naturally conclude there was no Dutch art and that is the conclusion the M.A.A. try to advertise regarding Canadian art."[42]

FIG. 32. FRANK JOHNSTON, *Fire-swept, Algoma* (cat. 23)

5

Formation of the Group

he Group's program was ambitious: to develop an unacademic, Canadian art in which the nation could take pride and which would be materially supported by collectors, to show Canadians that art permeated all aspects of their lives, and to reform the educational system so it would train designers and artisans for employment in industries that would manufacture distinctively Canadian products, generating economic and social benefits for the whole of society.

The artists discussed forming an independent art school and producing a Canadian art magazine,[1] though in the end they would work through an established institution, the Ontario College of Art, and publish in the *Canadian Courier*, the *Canadian Bookman* (published by the Canadian Authors Association), *The Rebel*, and the latter's successor, the *Canadian Forum*. They also continued to exhibit with the R.C.A. and the O.S.A. Jackson, Lismer, and especially MacDonald were active in the latter society throughout the 1920s, and in 1919 Jackson was elected a full member of the Academy, and Johnston and Lismer became associates.[2] Harris alone never accepted nomination.

It is not clear whether the artists conceived the idea of forming a separate group when they applied for the May 1920 exhibition at the Art Gallery of Toronto. In all their statements they assured the public that the formation of

FIG. 33
ARTHUR LISMER
Sketches for a Group of Seven Logo March 1920
Charcoal on paper, 25.5 × 20.2 cm
Art Gallery of Ontario,
Toronto (83/264.2)
Gift of Mrs. R.M. Tovell, 1983, transferred
from the Edward P. Taylor Reference
Library, September 1983

The logo, composed of initials, may
be read as Lismer, Lawren, MacDonald,
Johnston, Jackson, Varley.

the Group of Seven was not a secession from the older societies, a fact verified by their continuing involvement in them. However, the possibility of organizing a group to promote their ideas had been considered for some years.[3] Reactionary critics had often complained that the work of the modern artists violated the harmony of the larger exhibitions; indeed, the effectiveness of more focussed exhibitions had been confirmed by the recent Algoma show. Harris's conflict over the jurying of the O.S.A. exhibition and Lismer's desire to see the art societies do more than organize shows were also contributing factors.[4] Jackson summarized the societies' exhibitions as "largely trade shows where samples are shown, but are not sold; originality and experiment are not over welcome."[5]

By calling themselves a group rather than a society, the new association avoided any potential conflict or appearance of opposition. Unlike the Canadian Art Club, they made no effort to rent space for a clubhouse or gallery, solicited no support from lay members, elected no officers, and sought no representation on the councils of the Art Gallery of Toronto or Art College. It was merely a cooperative group of like-minded artists joined together to articulate their ideas for the advancement of Canadian art.

Nor is it clear who were the nine artists being considered for the May exhibition. Already, in Mortimer-Lamb's article on Tom Thomson written in the spring of 1919,[6] the Toronto group was identified as consisting of Jackson, MacDonald, Lismer, Varley, Johnston, and Carmichael, curiously omitting Harris. Heming, Beatty, and Williamson had not participated in any of the common ventures since 1914 and were no longer associated with the goals of the group.

In February 1920, Jackson left Toronto for Georgian Bay, visiting Harris at his family's summer home at Allandale on Lake Simcoe en route.[7] From Franceville, he sent instructions to collect works by Robert Pilot, Randolph Hewton, and Albert Robinson, and Lismer invited W.J. Wood of Midland to contribute to "a special group show in May ... about six of us with one or two specially invited ones."[8] Finally, some time in March, a meeting was held in Harris's home to confirm arrangements. Drawings by Lismer document the event and include portraits of Harris, MacDonald, Varley, Carmichael, and Johnston. Jackson, still at Georgian Bay, is absent. Inscriptions on the drawings identify Johnston as responsible for a poster (which, if produced, has not survived), Carmichael for the design of the catalogue, and Barker Fairley for writing the foreword and for advertising. A commission of 15 per cent was to go to the Group on all sales to cover costs. There would be no hanging committee. The whole group would jointly select the works and earlier paintings could be included. About seventy canvases in all would be hung, with ten sketches by each artist. On one sheet (fig. 33) a logo formed of the artists' initials, similar to that on boxcar 10557, was drafted, to be abandoned for a simple number 7. Thus was the Group of Seven born after ten years of cooperative effort.[9]

First Group of Seven Exhibition, 1920

The foreword to the catalogue of the first exhibition (fig. 34), held at the Art Gallery of Toronto in May 1920, was written by Lawren Harris but recapitulates the ideas MacDonald, Lismer, and Jackson had been articulating for two years: that art was essential for national identity, and that faith in Canada and in the significance of Canadian creativity was essential for national growth. Quoting AE, Harris wrote, "No country can ever hope to rise beyond a vulgar mediocrity where there is not unbounded confidence in what its humanity can do ... if a people do not believe they can equal or surpass the stature of any humanity which has been upon this world, then they had better emigrate and become servants to some superior people." He lashed out at auction-room collectors and foreign standards, challenged the critics, and affirmed that "the artists here represented make no pretence of being the only ones in Canada doing significant work. But they do most emphatically hold that their work is significant and of real value to the country."[10]

The show consisted of 121 catalogued works (see cat. 11–33) including fifty-four canvases and forty-four oil sketches by Group members, sixteen temperas by Johnston, and five canvases and two pastels by the invited contributors from Montreal, Hewton, Pilot, and Robinson[11] (fig. 35). The two small works sent by W.J. Wood were not included in this inaugural exhibition.[12]

The first presentation as the Group of Seven was a statement about both their somewhat tempestuous history and their current activities and goals. Sixteen canvases had been exhibited before. Jackson's *Terre Sauvage* (fig. 10), exhibited in the first Group show as *The Northland*, had been painted in that crucial month when he committed himself to the Toronto movement. It had been shown once before, at the 1918 R.C.A. in Montreal, where Morgan-Powell had slammed both Jackson's paintings and MacDonald's, and Mortimer-Lamb had written that the work was "one of the most important paintings of landscape yet produced by a Canadian artist, and more clearly expresses the spirit and feeling of Canada than anything that has yet been done."[13] MacDonald's *Tangled Garden* (fig. 21) was already well known from the 1916 controversy at the O.S.A. exhibition, and *The Wild River* (fig. 24) from the 1919 O.S.A. In addition to these landmarks of the Group's recent history were a number of canvases and studies painted for the War Records, the program that had done so much to further the recognition of Canadian art: Jackson's *Spring in Liévin* (fig. 37), Lismer's *Halifax Harbour* (fig. 36) and *Camouflage*, and Varley's *The Sunken Road — August 1918* (fig. 16).

MacDonald exhibited the largest number of earlier works, including one from 1914 and three from 1916. Jackson and Lismer presented Nova Scotia paintings, and Harris, Johnston, and MacDonald Algoma subjects. Jackson showed two early Georgian Bay canvases and four painted since his return from Franceville in late March.[14] Carmichael, the youngest, displayed four decorative landscapes from the rural areas surrounding Toronto and his home at Lansing.

FIG. 34
Logo from the catalogue of the first Group of Seven exhibition, May 1920.

FIG. 35
First Group of Seven exhibition at the Art Gallery of Toronto, May 1920.

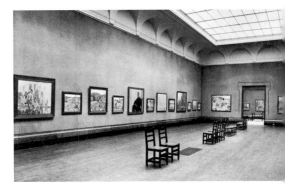

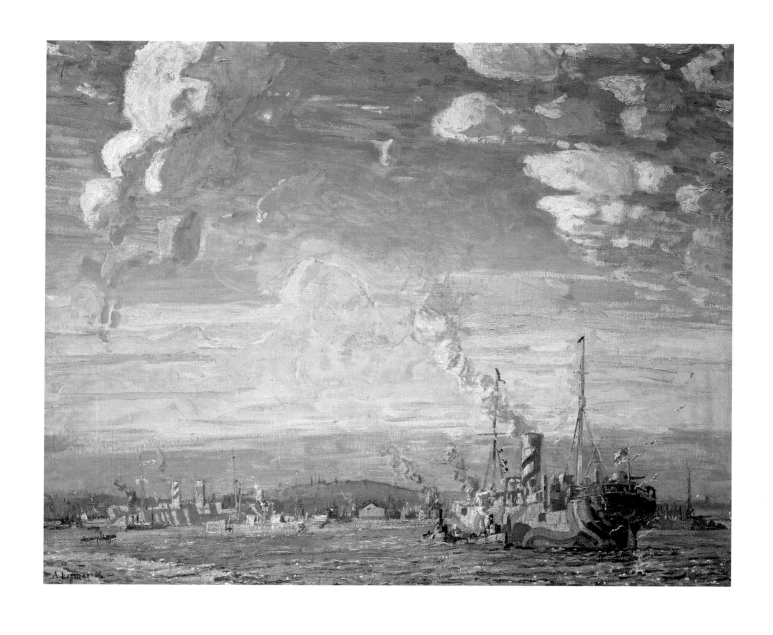

FIG. 36. ARTHUR LISMER, *Halifax Harbour, Time of War* (cat. 24)

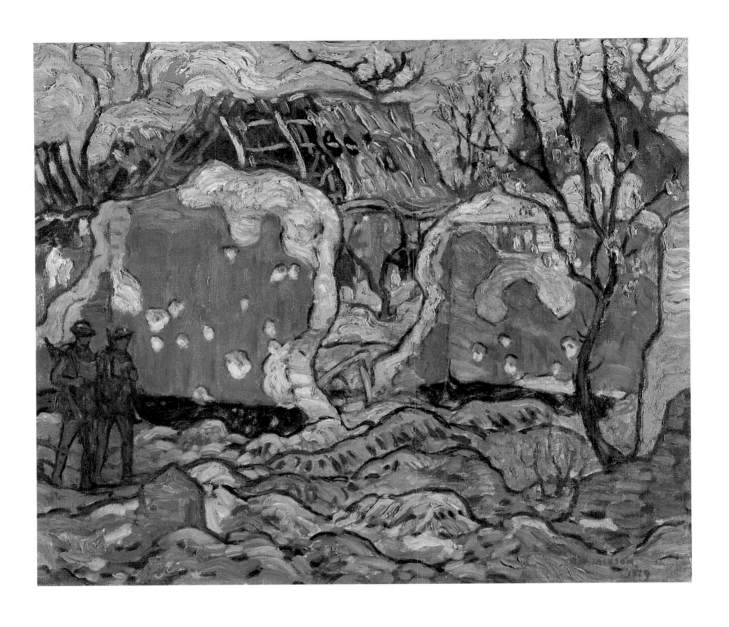

FIG. 37. A.Y. JACKSON, *Springtime in Picardy* (cat. 20)

FIG. 38. F.H. VARLEY,
Character Sketch – Prof. Barker Fairley
(cat. 30)

Harris alone exhibited urban subjects, five house paintings of the Ward and Toronto surrounds. Both Varley and Harris showed portraits, the latter for the first time. Harris's sitters included Bess Housser (fig. 40), wife of his old friend Fred Housser, a fellow student of theosophy; Eden Smith, architect of the Studio Building; and Mrs. Oscar Taylor, a Christian Scientist and co-owner of the land at York Mills where the Arts and Letters Club had their wartime farm adjacent to the MacDonald's home. Varley's portrait of Vincent Massey (fig. 102) was a recent commission for Hart House at the University of Toronto, and his others were a portrait of Winifred Head, an art teacher at Havergal College,[15] and character sketches of Barker Fairley (fig. 38) and J.E.H. MacDonald.

While landscapes predominated, the exhibition did not present a unified image of a northern ideal. Halifax harbour in wartime, Nova Scotian villages, Laurentian valleys, rural Ontario gardens, and English and French landscapes as well as the portraits comprised the show. The intent was to present the best work of Canadian artists inspired by the varied national experience.

The selection of invited artists confirms this. Hewton and Robinson were both old, prewar friends of Jackson, neither in any way connected to the Toronto artists. Hewton had been the object of attacks by Morgan-Powell, and Robinson was a home-front war artist who had already exhibited several bold, decorative, Quebec winter landscapes (fig. 44).

Robert Pilot, only twenty-one years old, was the stepson of Jackson's fellow war artist Maurice Cullen, and on his return from his military duties in England had been fêted at the Arts Club in Montreal with Jackson and Thurston Topham, "all returned heroes."[16] Pilot had then continued his studies at the Art Association of Montreal on scholarship, only finishing in the month of the Group show. Jackson's intent, beyond encouraging the young artist, was possibly to pay a tribute to Cullen himself, an artist Jackson respected. In spite of Pilot's meagre contribution (only two pastels), Jackson continued to have faith that he would "do good stuff too when he cuts loose."[17]

The exhibition was reviewed in the *Globe*, the *Mail and Empire*, the *Toronto Daily Star*, the *Sunday World*, and the *Canadian Courier*, this last notice being partly rewritten for the *Christian Science Monitor*.[18] The anonymous author who had proposed an auto-da-fé as a solution for the "abominations" by Mac-Donald, Lismer, and Harris at the O.S.A. the previous March[19] apparently did not review the show. Nor did the *Evening Telegram*, the *Canadian Magazine*, or *Saturday Night*. To the Group's challenge that "the artists invite adverse criticism. Indifference is the greatest evil they have to contend with," Charlesworth responded with silence.[20] Both the *Globe* and the *Mail and Empire* published laudatory articles, specifically noting the earlier works by Jackson and MacDonald. Fred Jacob took umbrage at the tone of the foreword and, on viewing the work of all the members together, queried whether the artists did not risk losing their individual identities. Nonetheless, he found much

FIG. 39. RANDOLPH S. HEWTON, *On the Bank of the Seine* (cat. 32)

to praise in a show which made the work of the Montreal exhibitors seem "conventional enough" in comparison. M.O. Hammond's review continued with the results of an estate auction.[21]

The most enthusiastic article was written by the Group's friend Augustus Bridle, who alone identified the show with the Canadian "North." Headlined "Are These New-Canadian Painters Crazy?," the article began in bold print: "Seven men go the record limit interpreting north-country landscapes in colours that make the rainbow look like the wrong side out. Symbolism mixes with Jazz, Realism with old-fashioned Beauty. Individualism with Collectivism. Is this Radical Eruption the Canadian Art of the Future? Nobody knows. But it is the work of men who act on the belief that Canada has a colour scheme and subject interest entirely her own," and continued, "The Seven-Group show contains tumbling rivers, cataracts, waterfalls, and fish villages; tangled gardens and beaver dams; lone, weird rocks and lakes on high levels; plateaus of brulé and Laurentian hills; battlefields and dead men; Hebrew shacks and Italian cottages; old barns and ploughed fields; spring blossoms and gorgeous autumn; cold winterscapes and trails; ships and harbours; woodland tapestries and rainbows. In colours — everything. Jungles and jangles of iridescence. Stacks of blues — from mauve and violet to ultramarine and deep indigo. Reds — from super-scarlet and vermilion to the sulky burnt umber that is almost a smudge. Yellows — from pale lemon to deep orange, sometimes in the same picture. Greens — from the

FIG. 40. LAWREN S. HARRIS, *Portrait* (Bess Housser) (cat. 13)

pale tint of an apple-tree bud to the glooms of age-old mosses." Lauding almost every major work in the show, he characterized each artist's contribution: Harris, "all so different they might have been done by four individual painters ... Harris paints with a sort of ecstasy of ideas, none of which are necessarily the same yesterday, to-day, and forever"; "MacDonald goes at a thing from the inside out. He seems anxious to know by the anatomical method what made the Creator fashion such big things and how He felt when He was doing it"; Johnston, the "most opulent ... has a prodigious fancy, a wonderful eye, and an imagination that is not often obsessed with metaphysical ideas." "Varley is the dour, emotional Yorkshireman, who Ibsenizes in paint"; "Lismer is as yet rather indeterminate ... Most of his work shows a struggle of ideas when the more simple statement of one idea would have been more effective"; Carmichael, "youngest of the group ... has a simple

FIG. 41. FRANK CARMICHAEL, *Autumn Hillside* (cat. 12)

enchantment with colour for its own sake"; "Jackson is different from all the rest, but somehow like every one of them … a pioneer in the group. From this quiet, almost shy man who goes out after ideas in landscape as Indians used to go after scalps, you realize that Canada is a land of unexploited bigness in paint … The Seven Group have made people think … They are not decadent, but creative. They go direct to nature. Their aim in art is greater virility – and they have got it." Total attendance was 2146 for the twenty-four days.[22]

Critical success was not translated into sales. Only three works sold, two sketches by Frank Carmichael and a pastel by Robert Pilot to H.L. Rous of Rous and Mann.[23] Eric Brown at the National Gallery had six works sent to Ottawa for consideration; however, because of opposition from a trustee, Senator Boyer, "who objects violently to them all,"[24] and the need to make purchases with a reduced budget from other exhibitions, only three were bought: Jackson's 1913 canvas *Night, Georgian Bay* for $200, Johnston's *Fire-swept, Algoma* (fig. 32) for $750, and Harris's *Shacks* (fig. 61) for $1000. Even before the show was over, Harris, Jackson, Lismer, and MacCallum left for another sketching trip to Mongoose Lake in Algoma.[25]

Beaver Hall Group

One immediate result of the show was the formation in Montreal in late May 1920 of a new association of artists, the Beaver Hall Group.[26] Once again this was no secession, as there was no existing group to secede from, but rather a

FIG. 42. A.Y. JACKSON,
A Quebec Village (cat. 41)

banding together to make visible a unified message of individual expression and quality in Canadian art. While not a direct offshoot of the Group of Seven, the Montreal group was clearly inspired by their example and by their invitation to Hewton, Robinson, and Pilot to exhibit. In recognition of the important link provided by Jackson, he was elected president, and later announced to Albert Laberge of *La Presse*: "I wish every artist would focus on painting, describing and expressing the region where he lives. In Toronto, seven or eight of us have endeavoured to depict northern Ontario. I wish they would do the same here in Quebec, and that they would strive to portray its landscapes, appearance, physiognomy, its very soul."[27]

According to Jackson it was Edwin Holgate who was the prime mover in the formation of the Beaver Hall Group,[28] whose diverse membership consisted of nineteen artists in all, ranging from Jackson, the oldest, to Regina Seiden, the youngest, and including Holgate, Hewton, and Pilot, and Jeanne de Crèvecoeur, James Crockart, Adrien Hébert, Henri Hébert, John Y. Johnstone, Mabel Lockerby, Mabel May, Darrell Morrissey, Hal Ross Perrigard, Sybil Robertson, Anne Savage, Adam Sherriff Scott, Thurston Topham, and Lilias Torrance. Albert Robinson was not a member.

While many of the artists had studied under William Brymner at the Art Association or were returned soldiers, the diversity of the membership militated against any cohesive platform or ideology. By the time of the first exhibition in January 1921 at 305 Beaver Hall Hill, Holgate had already left Montreal for Paris. Pilot left shortly after, and Adrien Hébert and Lilias Torrance Newton (now married) would follow.[29] According to Hewton, three additional exhibitions were held: compositions by students of the Art Association and decorative designs by Anne Savage's students, an exhibition of work by Adrien Hébert, and a show of sketches by members.[30] The catalyst for dissolution was lack of money; but more importantly, there was no driving force or individual to keep the Beaver Hall Group together or articulate its purpose.

FIG. 43
Catalogue of the second Group of Seven exhibition, May 1921.

Group of Seven Exhibition, 1921

The members of the Group of Seven exhibited little at the O.S.A. show immediately preceding their own 1921 exhibition, a fact noted by Eric Brown in his review for the *Christian Science Monitor*. "When it began to be whispered that [these artists] were beginning to dominate the Ontario Society of Artists' exhibitions with their pictures of large design and more brilliant colour, they decided to hold their own show each year and to contribute to the parent society only in strict moderation ... it seems something of a pity that any kind of cleavage should be admitted between those whose ideals are very similar and whose methods only differ in degree. However, the fact remains that the present exhibition was the quieter because the Group of Seven were reserving most of their work for their own show in May." There were some highlights at the O.S.A., however, and the National Gallery bought MacDonald's *The*

FIG. 44. ALBERT H. ROBINSON, *Noontime, Longue Pointe Village* (cat. 33)

FIG. 45. FRANK CARMICHAEL,
The Valley (cat. 38)

Solemn Land for $700 — "sombre in colour, almost forbidding in subject and primitively simple in execution"; Varley's portrait of his son, *John*, for $400 — the first Varley in the collection; Mary Wrinch's *Dufferin Terrace, Quebec* for $280; and W.J. Wood's *Summer Evening* for $125. Wood, whose naive and vigorous work was so admired by the Group, was seen by Brown as being of Thomson's lineage. "Canadian art always contains surprises, natural painters appear unheralded practically from the backwoods and startle everyone by marvellous knowledge which they seem to have absorbed from their loneliness and certainly have never absorbed from the schools, because they have never been inside them. They paint on holidays taken from mending motor cars or making wheel-barrows, they have to make their own etching presses and process blocks for country newspaper illustrations. Such a one is W.J. Wood."[31]

The second exhibition of the Group opened 7 May, but now they were a group of six. Frank Johnston had resigned. He had accompanied Harris, Jackson, and MacDonald to Algoma the previous fall and had mounted an exhibition of almost 200 recent and older temperas at the T. Eaton Company gallery in December that resulted in favourable reviews for its "poetry and imagination" and apparently considerable sales.[32] However, Johnston was in financial difficulty over a house he was building in North Toronto,[33] and apparently feared a negative effect from his association with the Group, so he "seceded from the secessionists." Fred Jacob had often noted the particular character of Johnston's work. "[Johnston] never got out of touch with the picture lovers who cannot quite get the viewpoint of his ultra-radical companions … The wide appeal of Mr. Johnston's work is due largely to the manner in which he has developed the decorative side of his art. He has a gift for finding

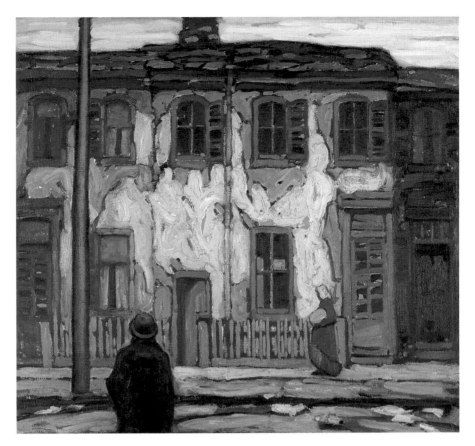

FIG. 46. LAWREN S. HARRIS, *In the Ward* (cat. 15)

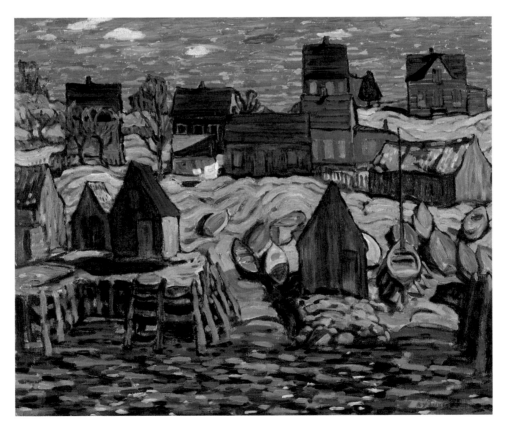

FIG. 47. A.Y. JACKSON, *Herring Cove, Nova Scotia* (cat. 18)

FIG. 48. LAWREN S. HARRIS, *Autumn, Algoma* (cat. 16)

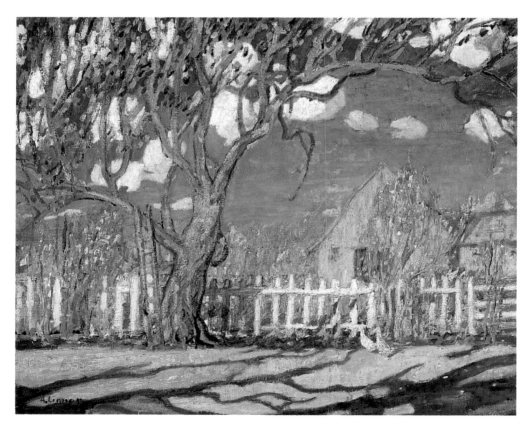

FIG. 49. ARTHUR LISMER, *Springtime on the Farm* (cat. 25)

FIG. 50. J.E.H. MACDONALD,
Batchawana Rapid (cat. 49)

FIG. 51. F.H. VARLEY,
Self-portrait (cat. 46)

subjects that appeal to the imagination and he gives them an imaginative treatment."[34] Again, Jacob noted, his work "never quite fitted with that of the other men with whom he was associated for several years."[35] In the fall, Johnston and his family moved to Winnipeg, where he became principal of the Winnipeg School of Art.[36]

The 1921 exhibition was somewhat smaller than the first, consisting of forty-eight canvases and forty-one oil sketches (see cat. 38–53). Jackson had already expressed his concern the previous November: "Varley and MacDonald are the non-producers. Lismer is pretty well tied up with the school and has to paint with a rush. Harris and I will be the big contributors."[37] In the meantime, MacDonald also had joined the staff of the College of Art to teach design and commercial and applied art. It was hoped to invite some Montreal artists to join them ("and eventually we may merge into a Canadian group");[38] however, the second Group show included no invited contributors.

The foreword to the catalogue (with its newly designed logo, see fig. 43) asked viewers to approach the works without "a preconceived notion of what a picture should be like," and reaffirmed the artists' "widely divergent aims. We have as little desire to be revolutionary as to be old-fashioned … we believe whole-heartedly in the land. Some day we think that the land will return the compliment and believe in the artist, not as a nuisance or a luxury but as a real civilizing factor in the national life."[39]

All the works had been painted within the last year; only two had been previously exhibited. They were characterized by Algoma panoramas, tangled woods, haunting beaver swamps, and magnificent Georgian Bay landscapes. Jackson for the first time exhibited Quebec winter landscapes, from his trip with Robinson to Rivière-du-Loup and Cacouna on the south shore of the St. Lawrence (fig. 42).[40] Varley exhibited portraits of Ethel Ely (fig. 52) and Margaret Fairley. Harris challenged the critics by entitling his painting of men working on a billboard *Jazz*, a term that the critics would pick up to decry "jazz in art."[41]

Reviews appeared in the *Globe*, the *Mail and Empire*, the *Toronto Daily Star* and *Star Weekly*, and a brief notice in the *Canadian Forum*, the only periodical to receive distribution outside Toronto.[42] *Saturday Night* again kept its silence.

Augustus Bridle, now writing in the *Star*, was once more the most enthusiastic, although he was somewhat dismayed by Harris's "frankly neurotic studies of colour and form, phantom trees that never grew, distorted nightmares of deadwood and much else." Jackson he found to be "swinging back to a rather more comfortable idea," MacDonald "in his Algoma tapestry period," Lismer to have made "decisive advances since last year," and Carmichael to have retained his "exquisite ecstasies of beautiful colour." He especially liked Varley's "smashing epic in bravura style, an audacious attempt to express the power of a gale on a foreground tree, a vast uneasy stretch of multi-coloured lake and a dazzling, mineralogical sky" (fig. 70).

FIG. 52. F.H. VARLEY, *Portrait of Mrs. E.* (cat. 45)

Fred Jacob was more reticent, finding that the artists occasionally "glor[ied] in ugliness" of subject and paint, preferring their more conservative paintings, and cautioning that "their most radical pictures cease to be personal and show the effect more and more of the group system."

For the first time, a writer commented on the oil sketches. M.O. Hammond wrote that they "contain from a lay viewpoint at least the very qualities absent from the larger canvases, which are really elaborations of the ideas expressed in the smaller paintings. Many of these smaller pictures are full of atmosphere and of poetic feeling and give the impression of having been painted at a moment when nature and the artists were in close familiar touch, while the larger ones suggest an imagination running riot in a city studio far away from the sane sway of the out-of-doors." Appreciating Jackson's "bits of Quebec villages nestling by the grey St. Lawrence or among the enfolding hills, showing the steep roof of the parish church, gay with the same red paint that

FIG. 53. ARTHUR LISMER, *Pine Tree and Rocks* (cat. 44)

FIG. 54. LAWREN S. HARRIS, *Island — MacCallum Lake* (cat. 52)

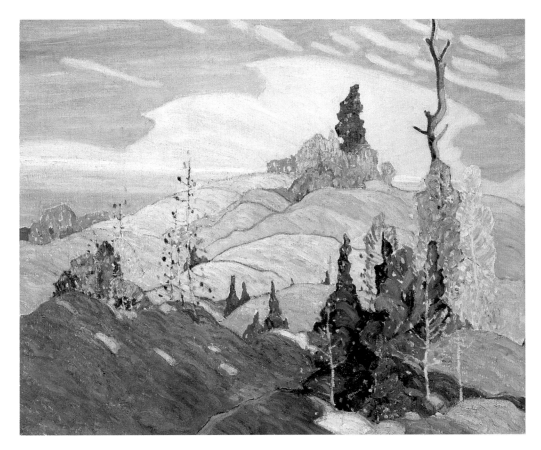

FIG. 55. FRANK CARMICHAEL, *The Hilltop* (cat. 39)

FIG. 56. A.Y. JACKSON, *Early Spring, Georgian Bay* (cat. 42)

glorifies what is apparently the presbytery near by" (fig. 42), Varley's "capital painting of Mrs. E.F. Ely," Lismer's "rocks that the laity consider too, too solid granite and … trees that show no indication of that leafiness over which the poets rave" (fig. 53), he took exception to Harris's *Island – MacCallum Lake* (fig. 54), which "suggest[s] the visit of a freakish giant with pails of liquid candy, variously coloured, with which he has iced the lakes and stately fir-trees of our remote places." Visiting the show again, save for Varley's "gorgeous Bay Wind," Harris's "Algoma lake in evg.," and MacDonald's "ploughed field at sunset," all Hammond could see were "multiples of ugliness that weary one."[43]

Fairley, always a great admirer of Varley's work, was also overtly critical of Harris's *Island – MacCallum Lake*. "It expresses to the intelligence the weirdness of the North Country, but it does not evoke the feeling of nature nor even place one out-of-doors. The point of view seems to have been dictated by the intellect and directed towards the curious and the occult." The solidity of form with "the chunkiness of candy or stalactites" conflicted with the colour "scheme of searingly hot reds … Human nature cannot cope with dreams that are more solid than reality or with ghost stories that are as boisterous as trumpets."[44]

Attendance was only slightly greater than the previous year, and despite the generally favourable reviews, the only sales were to the National Gallery.[45] Having failed to acquire Jackson's Georgian Bay canvas the previous year, it purchased his *Early Spring, Georgian Bay* (fig. 56) and his *Quebec Village* (fig. 42), for $300 each, as well as Carmichael's small *The Hilltop* (fig. 55) for $250, the first Carmichael to be acquired, and Varley's large *Georgian Bay* (fig. 70) for $750.

Once again, while their show was on in Toronto, Jackson, Lismer, and Harris left to camp on the Agawa River and Montreal Lake in Algoma.[46] Harris visited Halifax and Newfoundland in late spring, and in the autumn Lismer, Harris, and Jackson painted at Sand Lake, Algoma. Lismer then returned to Toronto to resume teaching, and Jackson and Harris went on to Franz and Rossport on the north shore of Lake Superior.[47]

MacDonald painted at Coboconk, Ontario, in the fall of 1921,[48] and the following March Jackson returned to the south shore of the St. Lawrence, painting with Albert Robinson at Levis and Bienville and then in the Eastern Townships.[49] All this provided the fuel for the paintings exhibited at the third exhibition of the Group in May 1922.

Group of Seven Exhibition, 1922

The foreword to the catalogue, once again with a newly designed logo (fig. 57), argued for a visual language suitable to the material depicted: "New materials demand new methods and new methods fling a challenge to old conventions." The artists reaffirmed the experimental and vital nature of their art, the adventurous quest for the discovery of new ideas: "Artistic expression is a spirit, not a method, a pursuit, not a settled goal, an instinct, not a body of rules … Art must take to the road and risk all."[50]

FIG. 57
Catalogue of the third Group of Seven exhibition, May 1922.

FIG. 58. F.H. CARMICHAEL, *Leaf Pattern* (cat. 54)

FIG. 59
Illustrations of paintings
exhibited in the third Group of Seven
exhibition in May 1922 from the *Toronto
Sunday World*, 28 May 1922. Clockwise
from upper left: Lawren Harris, *Shacks,
Algonquin Park*; A.Y. Jackson, *Barnston
Pinnacle*; Harris, *Early Summer Afternoon,
Barrie* and *Spring in the Outskirts*; Fred
Varley, *Character Study*; Arthur Lismer,
Islands of Spruce, Algoma.

For the first time, the artists exhibited only canvases with no oil sketches, sixty in all, the smallest number of catalogued works to date (see cat. 54-67). Again Harris, Jackson, and Lismer showed the most paintings. Almost all were being shown for the first time, and once again W.J. Wood had been invited,[51] although the seventh of the seven this year was Percy J. Robinson.

Carmichael presented some of his most luxurious canvases to date, dense, richly coloured screens of autumn saplings, owing much to Thomson's wood interiors but fuller in texture and less structured in composition, and bearing such delightful titles as *Coruscation* and *Fanciful Autumn*; the largest was *Leaf Pattern* (fig. 58).

Varley exhibited two gypsy studies entitled *Character Study* (fig. 59) and *Gypsy Blood* (fig. 193), the latter more freely brushed and sensual, a passionate work of longing and romance. Opulent in colour, it contrasted with his sketchy, intimate study of his wife, Maud, with their baby son, entitled *Rocky Shore* (fig. 60).

MacDonald offered a far greater range of canvases, from his 1914 *Winter Sun*, to his lyrical, organic *Agawa Waterfall*, 1920, to new works from 1922. Bridle summed up MacDonald's contribution: "What seems to impress [him] most in the north is colour in mass as part of landscape design. But he has one small picture of ... young trees of almost fragrant piquancy and charm of detail [fig. 107] ... His livid enormity of crimsons and carnadines entitled *October Shower Gleam* [fig. 88] ... glorifies his sensations of this twanging, clanging carnival of colour. He should have called it 'When the mists have rolled away'; for

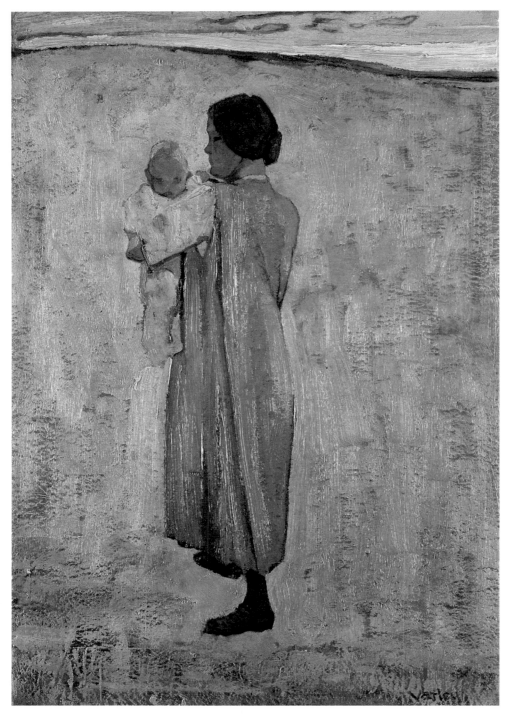

FIG. 60. F.H. VARLEY, *Rocky Shore* (cat. 56)

he has a cloud rack that no poet ever saw rolling over such reds, repeated of course in the lake. If I were a painter I would object to painting the same picture twice just because I was doing a lake. Moral: choose muddy water. But these northern painters seldom deal in mud."[52] To Jacob, the small work *Young Canada* (fig. 107) recalled "the futuristic backdrops, lavish in colour, that the radical Russian theatrical decorators are turning out."[53]

Lismer's eleven canvases were largely Algoma subjects painted after his trip to Sand Lake with Harris and Jackson, the largest being the magnificently ceremonial *Islands of Spruce, Algoma* (fig. 67) — "a few swats of symbolism

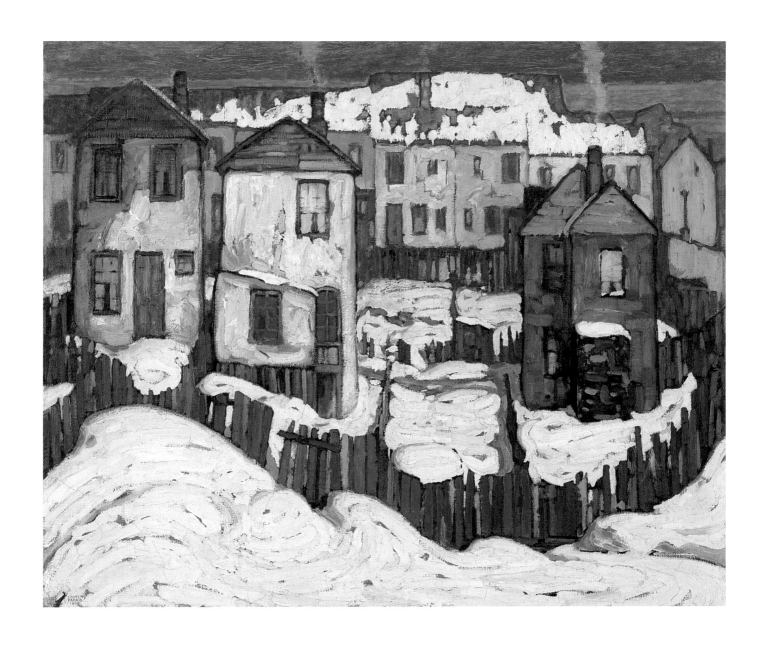

FIG. 61. LAWREN S. HARRIS, *Shacks* (cat. 14)

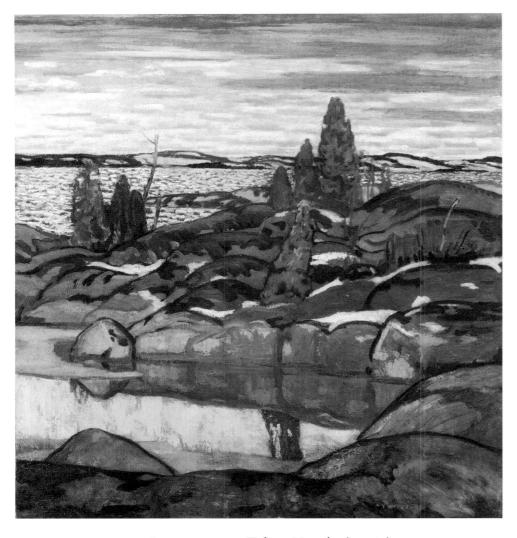

FIG. 62. A.Y. JACKSON, *Tadenac, November* (cat. 64)

masquerading as spruces." His canvas of the famous rock dedicated to Walt Whitman near the Bon Echo Inn was characterized by Bridle as a "precipitous catastrophe ... in which he rivals Harris's front rock without the sense of mass and weight, but with at least some attempt to paint in the intimate textures that rocks will insist upon having for clothes."

Harris had the greatest number of large canvases and greatest variety of subjects, ranging from the delicately coloured *Spring in the Outskirts* and the sober formalism of *Early Summer Afternoon, Barrie* (fig. 59, the critics' favourite) to the stark and dramatic *Rock, Algoma*. In both the panoramic *Algoma Country* and the glowing *Evening, Kempenfelt Bay, Lake Simcoe* (fig. 94), stark trunks are silhouetted against the landscape. For the first time, Harris exhibited an Algonquin Park subject, a winter study of houses, but his Halifax canvases disturbed reviewers. "Black Court [fig. 64] is despondent with only a note of humanity in order to show that nobody should live in such a place at all," wrote Bridle. Finally, Jackson was represented by a range of Georgian Bay canvases and Quebec landscapes, including *The Northland* (fig. 85) and *November, Georgian Bay* (fig. 62), "a large canvas with a foreground of deep quiet reflections in

FIG. 63. PERCY ROBINSON, *Untitled* (Georgian Bay, N11) (cat. 66)

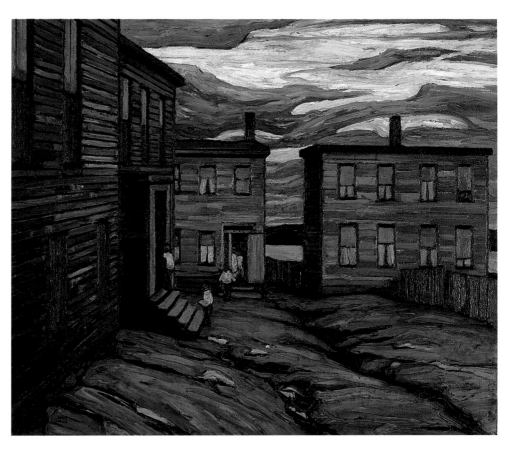

FIG. 64. LAWREN S. HARRIS, *Black Court, Halifax* (cat. 62)

FIG. 65. PERCY ROBINSON,
Untitled (Georgian Bay, N9) (cat. 65)

still-pooled water, and beyond in the distant open stretches the sweeping wrack of winds, [in which] two moods are carried and blended into a harmony of sustained power."[54]

The invited "seventh" contributor was represented by a suite of decorative pen drawings to accompany his poem *Georgian Bay* (fig. 63, 65, 66).[55] Percy J. Robinson had taught Lawren Harris at St. Andrews College and was an early member of the Madawaska Club, a cottage community of University of Toronto professors at Go-Home Bay near MacCallum's island. However, it was at the Arts and Letters Club that Robinson came to know the members of the Group, and he saw Jackson socially at Georgian Bay during the summer. Robinson had a profound love for the landscape of the Bay, and through its Ojibwa population became interested in its history, writing on the origins of local place names and later publishing the important *Toronto during the French Regime* (1933). Though an amateur artist, he exhibited with the O.S.A. from 1917 to 1923. His passion for and understanding of the Group's intent made him a sympathetic figure for the artists. His pen-and-ink drawings, though small in scale, have a vivacity and lyricism which effectively capture the effects of landscape. When published in the *Canadian Forum* in October 1922, one drawing was captioned, "One of a series of decorative sketches intended to depict moods of Georgian Bay rather than particular themes."[56]

The critics took opposite positions as to whether the Group artists were regaining their individuality or losing it. Bridle wrote: "In their search for what

lies beyond, the group are becoming rather more alike. Two years ago I could easily spot any of the painters by their pictures. Now there are times when I wonder at first glance which is a Jackson or a Lismer, at odd times a Harris and now and then a MacDonald. Even Carmichael is toning down or keying up, or whatever it may be, to catch the spirit of the group. Varley alone seems to hold out, although most of Harris's are known by their subjects, often by the technique, nearly always by the unmistakable lustre of the light." Compared to the 1921 show there was a sobriety and formality to these works, possibly, as Bridle suggested, "an inevitable reaction after the wild energy of earlier shows."[57]

The notices that appeared in the *Canadian Forum*, *Canadian Farmer*, *Toronto Globe*, *Mail and Empire*, *Toronto Daily Star*, *Star Weekly*, and *Christian Science Monitor* were positive though not enthusiastic. However, an editorial in the *Mail and Empire* was courteously grateful to the artists. "No one will deny, if he be fair-minded, that the artists have at least attempted to depict something new in a new manner, and that they have managed to work into their canvases a feeling of largeness, of optimism, of new horizons, that makes the old art seem very quiet and tame."[58] Wrote Hammond, "It is fresh, strong & curious in spots but cannot be ignored."[59] At 2805, attendance was only slightly higher than in the previous two years, and this year there was not a single sale.[60]

By the early 1920s, the Group of Seven were clearly identified as Toronto's leading modern art movement, and their annual displays were eagerly awaited by the critics – with the exception of Hector Charlesworth, who would adopt various tactics to hinder their influence. Their relative critical success was not, however, translated into sales, a problem aggravated by a continuing postwar recession.

FIG. 66. PERCY ROBINSON,
Untitled (Georgian Bay, N12) (cat. 67)

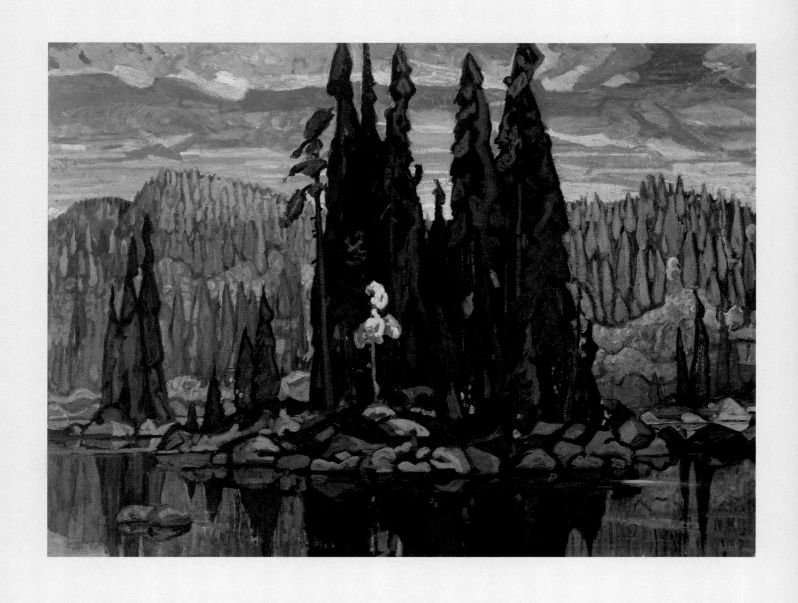

FIG. 67. ARTHUR LISMER, *Isles of Spruce, Algoma* (cat. 59)

6

*Outreach
and Alliances*

t the same time as they focussed their attention on a Toronto audience, the Group of Seven determined "to carry on an educational campaign throughout the country designed to secure the interest of the people in Canadian art."[1] The primary medium was the distribution of the works themselves. Already in their first catalogue they had appended a notice that pictures could be hired, preferably by clubs and educational institutions. This program had been started in 1919 by Doris Mills, a Christian Scientist and friend of MacDonald's wife, Joan, and of Fred and Bess Housser. Sketches rented from the artists were circulated among a private group, providing exposure and income to the artists. Mills took the initiative in bringing the "circulating picture system" to the attention of the British critic C. Lewis Hind, then writing as "Q.R." in the *Christian Science Monitor*, and further publicity was provided by the journalist and writer Ernest Hemingway, recently arrived in Toronto.[2]

Sarnia

Interest in the Toronto movement developed in a somewhat less likely community, the town of Sarnia, Ontario. During the war, the Women's

Conservation Committee had been formed to raise funds for the Red Cross. After the war, several members approached the local library board with a proposal to organize exhibitions of Canadian art and to acquire works with the funds raised as the basis for a municipal collection. The board member selected to work with them was Norman Gurd, Q.C., amateur historian and nephew of Richard Maurice Bucke of London, who had been a friend of Walt Whitman and had authored the book *Cosmic Consciousness*.[3] Gurd was active in the Ontario library circuit, and on the advice of George Locke of the Toronto Public Library, an advisory committee was formed consisting of Locke, Edward Greig, the curator of the Art Gallery of Toronto, and James MacCallum. The first exhibition was held in March 1920, and the committee, true to its word, acquired three canvases: J.W. Beatty's *Winter Scene near Toronto* for $250, Herbert Palmer's *Sawing Logs* for $200, and Jackson's *Spring, Lower Canada* of 1915 for $250. An offer to purchase Tom Thomson's *Early Spring* was refused as the painting was not for sale.[4]

The reception of the "broad" modern work shown (not limited to that of the Studio Building artists) was not unanimously positive; the main opposition came from admirers of photographic detail, and the "victims" of English picture peddlers, as described by Gurd: "For some years past, the travellers have come into town with water colours brought out from England … an English cottage with thatched roof, a flower garden in front. A good deal of colour and a smooth finish. They are *pretty pictures* and … are sold fairly reasonably. This is the sort of thing that persons whose tastes have not been educated like and this is what they have been accustomed to in Sarnia."[5] A more aggressive program was required, including laudatory articles placed in Toronto newspapers to be reprinted in Sarnia papers confirming that the committee was going in the right direction.[6] MacDonald encouraged the executors of Thomson's estate to make a canvas available to Sarnia. "We have heard that they are being strongly influenced to spend *all their money* on *two* very commonplace pictures by two of the older Canadian artists & it is to prevent this waste of money & to attempt to give a better *Canadian* character to this collection that we would like them to have this picture of Tom's."[7] Barker Fairley was invited to lecture during the second exhibition that November. The show resulted in the purchase of Thomson's *Chill November* for $600 and sketches by Harris and Lismer for the Conservation Committee, sales of seven sketches by Harris, Jackson, Johnston, MacDonald, and Palmer to private collectors, and a portrait commission for Varley.[8]

The Sarnia movement was uniquely successful not only in focussing entirely on Canadian art but also in recognizing the importance of getting these pictures into homes and winning a broader local support. The *Canadian Forum* approved: "The importance of what is happening in Sarnia is hard to exaggerate for those who care for things of the Canadian mind … We seem to have the painters and yet they have remained unknown hitherto to the country at large. Sarnia is the breach in the line. If it is followed, as it can hardly fail to be, by other small cities the credit of solving the problem of Canadian art for

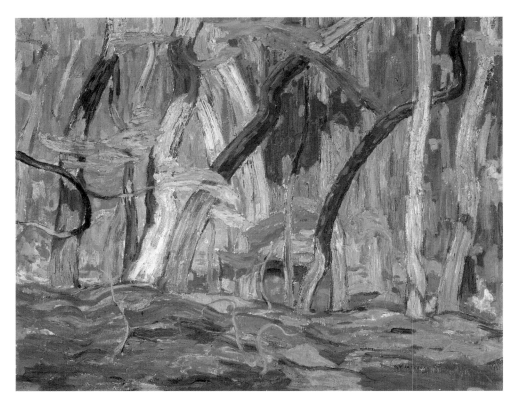

FIG. 68. A.Y. JACKSON, *Maple Woods, Algoma* (cat. 37)

Canadians will go to the small cities, and not to the big ones. Sarnia has been the first city to show that civic pride can be enlisted in this admirable cause."[9]

Western Tours, 1921–23

The Group sent paintings to Saint John, New Brunswick, and Guelph, Ontario, and in the winter of 1921 organized a tour of smaller paintings and sketches to Fort William, Moose Jaw, Edmonton, Calgary, and Brandon.[10] As Jackson commented, "the main thing is to go on painting and help out smaller towns."[11]

The reception in Edmonton was "very much divided about our show; one side very appreciative and the other quite wrathy."[12] It was the writer in the *Edmonton Journal* who was wrathy. "If those pictures are to be considered the foundation of a Canadian school of art, and are to be scattered broadcast over the world as depicting our gorgeous scenery and Canadian ideals of art, I think something should be done to reform the school, and that immediately … Now I consider that when an artist calls his picture 'Leaves in the Brook' it should at least look something like leaves in the brook, and not like a miniature barn door upon which a sign painter has tried out his colours … Tangled woods suggests such a peaceful place where Civilization has not entered in with plans for landscape gardening under her arm. I found 'Tangled Woods' [fig. 68] bye and bye … but they were too tangled for my understanding. There is not the slightest danger of Civilization ever attempting to put these woods in order … To attempt to live with such pictures would be out of the question,

although we might acquire a taste for them as some people acquire a taste for cod liver oil."[13]

The groundwork for the touring exhibitions had been laid by the National Gallery loans, as noted by Miss Mary Black of the Fort William Public Library. "We had previously had local work shows, which had been tremendously popular. Then [in 1914] the Toronto artists sent up their 'Little [Picture] Exhibition.' It was received with howls of ridicule ... The same artists were represented in it as in this collection from your gallery, Jackson and Harris, Thomson, and all of those young colourists, and yet now I am convinced that, were the two exhibitions to be held over again, there would be a general feeling that the local pictures lacked much that made the others worth living with. That change of point of view is undoubtedly due to the influence of your collection ... I remember Mr. Brown's saying in one of his letters that the pictures did not belong specifically to Ottawa, but to the people generally. At the time, I simply viewed that remark as generous, and showing breadth of vision; it has since occurred to me, that ... it is only by developing an educated public opinion as to its value that one can guarantee its being properly supported by the government." The Group of Seven show was received with great interest (attendance was seventy-five a day) and the public was "rather more modest in their expression of decided dislike than of yore!"[14] At least three sketches were sold on the tour, a Carmichael and a Harris presented to the Fort William Public Library, and a Johnston sold in Brandon.[15]

For the first time the following summer, and at the request of the western cities, the National Gallery obtained a selection of sixteen paintings from the Group to supplement its loans to the western fair circuit. The works were shown at the agricultural exhibitions in New Westminster, Vancouver, and Victoria, then in the gallery recently established by the British Columbia Art League in Vancouver. Subsequently, they were toured by the Group to Edmonton, Moose Jaw, Brandon, and Fort William.[16]

Harry McCurry, secretary of the National Gallery, accompanied the show in British Columbia and reported on the great interest expressed by artists and nascent plans to set up new municipal galleries. Local support came from the photographer John Vanderpant, of the New Westminster exhibition art committee,[17] and from Harold Mortimer-Lamb who, having returned to the coast, was now farming in Burnaby. In a long article in the Vancouver *Province* on "The Modern Art Movement in Canada," Mortimer-Lamb outlined the history of the Group, instructed his readers on the proper approach to understanding their ideas, and lauded their arrival.[18] In the general enthusiasm for increased art activity as exemplified by the Art League's new gallery, the Group's arrival on the coast was well received.

First American Tour, 1920–21

The Group of Seven did not limit their activities to Canada, but immediately sent an exhibition to the United States. Jackson explained: "Realizing that the

opinions of our critics and collectors meant nothing, that they wanted Canadian art to be a mild form of European art of thirty-five years ago, a number of our more venturesome painters started to exhibit outside of Canada where they were unknown and where their work had to hold its own with other work or sink."[19] In 1918, Eric Brown, newly elected to the American Association of Art Museum Directors, had circulated an exhibition of Canadian art to St. Louis, Muskegon (Michigan), Minneapolis, Chicago, and Milwaukee. Composed of paintings from the National Gallery supplemented by loans from artists and collectors, it asserted the Canadian identities of such expatriates as Ernest Lawson, Arthur Crisp, and Horatio Walker, as well as the strength of the new movement. Brown's foreword to the catalogue presented the works as a patriotic effort towards "genuine art reciprocity,"[20] but in Canada the show was seen as an effort to win American recognition for art which remained unappreciated at home.[21]

Foreign recognition would continue to be important in the Group's campaign to win support from Canadians. In 1920, both C. Lewis Hind and P.G. Konody, Beaverbrook's adviser for the Canadian War Memorials, visited the Canadian National Exhibition, and their laudatory opinions of the new landscape painting were published in the papers.[22]

"The best exhibition of modern Canadian painting ever seen" was offered to American museums by Brown in May 1920,[23] and a schedule arranged, with MacDonald acting as coordinator and secretary for the Group. The show opened at the Worcester Art Museum in November (fig. 69), and travelled to Boston, Rochester, Toledo, Indianapolis, Detroit, Cleveland, Buffalo, Columbus, and Minneapolis, closing at Muskegon, Michigan, in January 1922. It was presented as being a reduced version of the first Group show with the addition of "several new canvases."[24] However, as all Varley's major canvases in the May show had been commissions, they were not available, so this time the seventh artist was Tom Thomson, represented by four works.

MacDonald expressed some nervousness about the international tour. "I should judge, by comparing our own show with a fine collection of American pictures recently shown here, that we Canadians are developing a rather cold austerity of character, which may be uninviting, however noble ... Compared with our American brethren, our frames are plain & we don't put a fine glass between our raw paint surfaces & the spectator."[25] Along with the paintings, the Group forwarded copies of the 1920 catalogue, the Thomson catalogue from the Montreal Arts Club, and Bridle's article from the *Canadian Courier*, which formed the major content of the newspaper reviews during the tour. One Boston critic noted: "The work of these landscape men of 'Our Lady of the Snows' has been plausibly compared with that of the present-day Scandinavians. The comparison deems not to be altogether inapt, as one recalls the heavy-handed, strong-hued canvases of the Scandinavian exhibition at the museum six or seven years ago. Most of us in Boston did not like the exhibition, and we said so; but one has not heard that the Norse and Swedes

FIG. 69
Exhibition of Paintings by the Group of Seven Canadian Artists, Worcester Art Museum, November 1920.

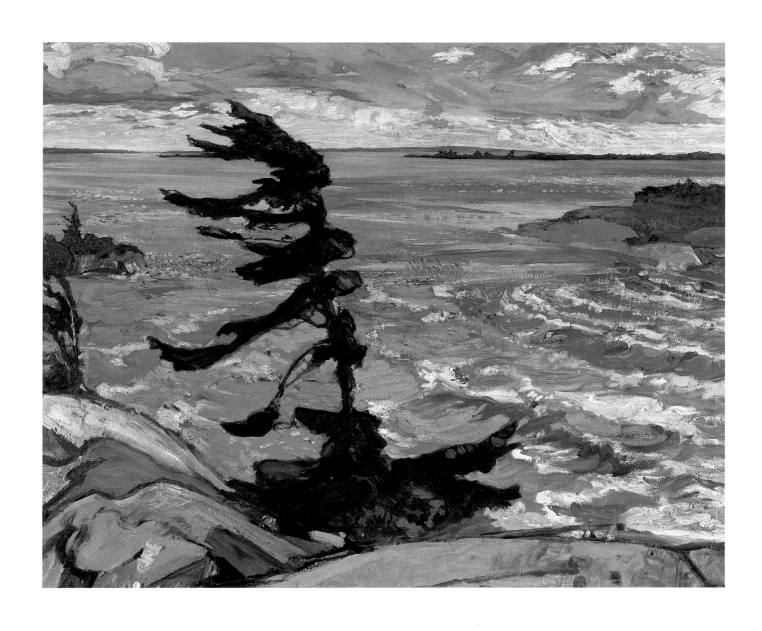

FIG. 70. F.H. VARLEY, *Stormy Weather, Georgian Bay* (cat. 47)

FIG. 71. LAWREN S. HARRIS, *January Thaw, Edge of Town* (cat. 51)

have changed their way of painting on that account. Similarly, if a Boston critic were to say that these Canadian paintings are bad and that they illustrate the degeneracy which has affected the art of painting almost everywhere in the world except Boston and a few studios of conservative New York, he probably wouldn't influence anybody outside of New England. The day has passed when from Boston one may buck the world."[26]

The reaction ranged from Boston's reserve in the face of the "bigness and ... savage grandeur" of MacDonald's *The Wild River* (fig. 24),[27] to great enthusiasm in Buffalo, where the Albright Gallery's director, Cornelia Sage-Quinton, had a long, personal relationship with Toronto collectors.[28] The Buffalo articles show the greatest familiarity with the Group, and it is possible that the artists themselves were the source of much of the information. All the writers recognized that "the 'Group of Seven' strives to paint Canada, Canada as it is – the wilds with the tangle of underbrush, the streams, the lakes and islands with their lonely wind-bent pines, and the hard, sharp distances."[29]

One sale did result from the American tour – Harris's *A Side Street* (fig. 72) to the Detroit Institute of Arts[30] – but collecting by Canadians was still almost non-existent. In two and a half years the Group had had over forty separate exhibitions in separate towns, "sales practically nil."[31]

Collecting Canadian Art

"To the visitor to Toronto or Montreal we have little to show but unimportant foreign paintings," wrote Jackson. "There is nothing to prevent any ambitious young town from becoming the art centre of Canada to-day."[32] A start had been made in Sarnia, where sales to local citizens and to the Conservation Committee would continue throughout the decade. In Kitchener an art committee was formed and the first Group show sent there in June 1921.[33] By 1926 the committee had established a core collection for the town consisting of one canvas by Jackson and one sketch each by Thomson, Carmichael, Harris, MacDonald, and Varley. That same year they purchased Thomson's *Split Rock, Georgian Bay*.[34]

In Toronto in 1921, the Art Gallery of Toronto received three canvases by Harris, Johnston, and Jackson on loan from the C.N.E.; with MacDonald's 1912 canvas *Early Evening, Winter*, these would remain the sole examples of work by the Group until 1926.[35] The Gallery acquired no works by living Canadian artists except by gift.

Greater support for Canadian art was to come from the University of Toronto, and specifically Hart House, a men's recreational facility. MacCallum and Fairley were both on the university faculty as well as the Hart House art committee. They solicited loans for exhibitions, and Fairley, in a letter to the student newspaper, the *Varsity*, encouraged staff and students "to consider ways and means of putting the right sort of picture, not hurriedly but canvas by canvas, permanently on its walls ... Hart House offers a wholly unique opportunity for the association of Canadian art with a Canadian university."[36]

FIG. 72. LAWREN S. HARRIS, *A Side Street* (cat. 34)

Paintings were borrowed from Toronto artists, but it was only in 1922, at the instigation of Fairley and the new warden, J. Burgon Bickersteth, that the first work was purchased – Jackson's *Georgian Bay, November*.[37] Thus began an annual tradition that would continue into the thirties, with a painting being given each year by the graduating class.

Prices were reduced by the artists, for, as Harris noted, "The money for purchases is collected from the students who take a real pride in the pictures, but the amount is relatively small, hence the painters are usually ready to make a sacrifice as these collections of pictures are important in that they contribute to permanent collections and are as instrumental in creating an audience for the future as anything I know of."[38] Acquisitions were complemented by a regular program of exhibitions. Fairley and members of the Group remained involved in the activities of Hart House and encouraged the extension of the program beyond Toronto. Over the next few years there would be exhibitions of paintings by the Ottawa Group, Montreal artists Emily Coonan, Sarah Robertson, Mabel May, and Anne Savage, Saskatchewan artists, and members of the British Columbia Society of Fine Arts. Regular talks by Lismer to various campus groups and debates with Wyly Grier also stimulated a greater art consciousness among students,[39] and the works acquired, as well as loaned paintings, were installed in common rooms and public spaces in Hart House. The importance of this activity, unique in Canada for the time, cannot be overestimated in developing a greater awareness of Canadian art among generations who would play influential roles in the country's future.

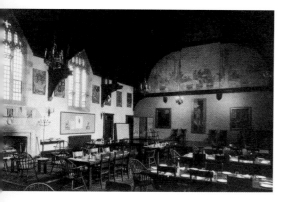

FIG. 73
M.O. Hammond: The new Arts and
Letters Club, Elm Street, Toronto,
c. 1922. The interior of the club was
designed by Henry Sproatt, architect
of Hart House at the University of
Toronto. The mural, painted by George
Reid, was unveiled 28 January 1922.

Canadian Forum

Along with their intense exhibiting activity, the artists forged new alliances and strengthened old ones. Before 1920, the main publications which supported them and through which they articulated their concepts were the *Canadian Courier* and *The Rebel*. The *Courier* ceased publication in October 1920, coincident with the publication of the first issue of the *Canadian Forum*, successor to *The Rebel*. That issue, with a cover designed by C.W. Jefferys, stated its aims: "To secure a freer and more informed discussion of public questions and ... to trace and value those developments of art and letters which are distinctly Canadian."[40] Barker Fairley, the literary editor, was the main liaison between the artists and the publication, and during the first year the *Forum* published drawings by Varley, Harris, Lismer, and MacDonald, poems by the latter, articles on the Hart House Theatre, and articles on art by Jackson and Fairley. In politics, "the early *Forum* held to a conception of civil society that was essentially voluntarist, pluralist, and populist. Intellectually it belonged to the nineteenth-century liberal-reform tradition."[41] These were the values of the Group, and the editors and artists were equally committed to the development of an independent and progressive Canadian spirit.

Although efforts were made to enlarge the scope of its coverage, the magazine, up to the mid-twenties, had a very Toronto-based content.[42] Despite this, the Group's shows before 1925 were never actually reviewed in the *Forum*; only short notices signalling their importance to readers were published, for example, "The second annual exhibition ... reveals more convincingly than any exhibition which we can recall the vigorous independent character of the best Canadian painting."[43] It was in the pages of the *Forum* that the first salvo against the Academy was launched. In an article on the first Book Week organized by the Canadian Authors Association, Fairley criticized the C.A.A. for being more concerned with sales than with writing. "We are over-conscious of our literature and under-conscious of our art. We have become over-conscious of our literature by lowering our standards till we find everything good which we readily understand. Being still under-conscious of our art we find everything bad which we do *not* readily understand ... If we are finding expression in painting and sculpture it is profoundly important that the largest number of people be aware of the fact ... The official body which is expected to guard the roots of this tradition is the Royal Canadian Academy ... To judge by the present exhibition the Academy has the same dangerous bias as the Canadian Authors Association; it is tolerant to the point of being nondescript ... The Academy is no more a guide to good painting than a public library is a guide to good literature."[44]

Basil King's response to Fairley's article was the perfect example of the patronizing attitude held by many towards Canadian culture. "A literature is the product not of an individual but of a life. Only a highly developed national life can give birth to a highly developed novel, history, play, poem, or

periodical … In other words an infant country can put forth only an infant life, and an infant life only an infant literature … Its value is not in achievement but in promise, which is precisely the value of all Canada."[45] A subsequent respondent pointed out the destructive implications of King's remarks: "If what he writes is true, every Canadian author must work under the depressing inference that it is impossible for him to attain to significant artistic work … National maturity is not the enviable period in a writer's life. Youth is the enviable period."[46] And Bess Housser went further: "The 'infancy' of our country cannot affect our Art, but rather the quality of our Art can promote and hasten the development of our country."[47]

The *Canadian Forum* would continue to take a major role in the critical discussion of modern Canadian art, poetry, and theatre throughout the twenties, and the artists of the Group of Seven would play an influential part in this debate. MacDonald had joined the board of editors by January 1923 and Harris by January 1925,[48] and they and their fellow artists submitted drawings and articles on a regular basis; and for nine years Thoreau MacDonald designed the magazine's covers. The Group were the major contributors of illustrations, but drawings also appeared by younger artists such as Graham Norwell and Carl Schaefer and by artists new to the Canadian scene such as David Milne.[49]

Art in Daily Life

In a number of projects undertaken around this time, the artists realized their postwar dream of seeing art manifest itself in all facets of life. A real art consciousness, they knew, would be developed only when Canadians recognized that art was not solely a matter of pictures on the wall but an essential factor of daily life reflected in architecture, urban and interior design, furniture, book and magazine illustration, posters, Christmas cards — in short, anything to which artists could direct their creativity.

FIG. 74
F.H. Varley: Endpapers for
The Complete Poems of Tom MacInnes
(Toronto: Ryerson Press, 1923).

FIG. 75
L.S. Harris: Endpapers for his book
Contrasts: A Book of Verse
(Toronto: McClelland & Stewart, 1922).

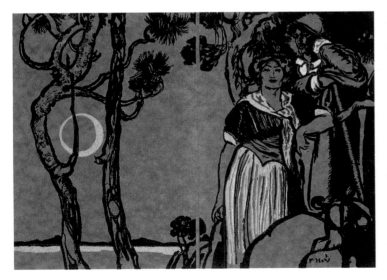

FIG. 76
J.E.H. MacDonald: Endpapers for E. Pauline Johnson's *Legends of Vancouver* (Toronto: McClelland and Stewart, 1922).

FIG. 77
A.Y. Jackson: Endpapers for Adjutor Rivard's *Chez Nous* (Toronto: McClelland and Stewart, 1924).

FIG. 78
St. Anne's Church, Toronto, 1923, showing *Saint Anne*, by Thoreau MacDonald.
Journal, Royal Architectural Institute of Canada II:3 (May-June 1925), p. 93.

Members of the Group were involved with production of some of the finest books published in Canada during the first half of the decade, mostly by McClelland and Stewart and by Ryerson Press under the directorship of Lorne Pierce. In 1923 alone, Varley illustrated books by William Arthur Deacon, George Locke, Tom MacInnes (fig. 74), and E.J. Pratt. MacDonald was the most prolific, designing and illustrating books by Marjorie Pickthall, Isabel MacKay, Pauline Johnson (fig. 76), Grace McLeod Rogers, Bliss Carman, Frances Beatrice Taylor, and Archibald MacMechan. Jackson provided end pages and illustrations for *Chez Nous* by Adjutor Rivard (fig. 77). All these books were by Canadian authors.[50]

MacDonald had long wanted to realize his decorative talents as a designer on the scale of a large mural composition.[51] In 1922 the opportunity arose when he was invited by the rector of St. Anne's Church in Toronto, Canon Skey – also a member of the Arts and Letters Club – to decorate the interior of his church. "The Rev. Paul is a good Canadian," wrote MacDonald in a semi-fictional article, "and is training his flock in the way it should go, but apparently he does not know that good Canadians do not get their mural decorating done at home. He seems never to have heard that Winnipeg, for instance, got the mural decorations for its fine new Legislative Buildings from England and New York, and that none of the important decorations of the new Parliament Buildings in Ottawa have been designed or painted in Canada, though it is true that some of them were made by Canadians living in New York."[52] Throughout Toronto, memorial windows and tablets were being erected in churches and public buildings, but they were either imported from England or manufactured by commercial firms without designs from Canadian artists. While a much longer tradition of church decoration had survived and was supported in Quebec, this initiative in Toronto was unique.

MacDonald first hoped to engage students from the Ontario College of Art to work on the project,[53] but as the work was to be done during the summer, he assembled a team of fellow artists. The church was in the Byzantine style, and MacDonald painted the dome a deep Venetian red with emblems in cream white (fig. 79). Four painted reliefs symbolizing the Evangelists by Frances Loring and Florence Wyle and four painted roundels of the prophets Moses, Isaiah, Jeremiah, and Daniel by Varley surmounted the cornice. On the pendentives were painted *The Nativity* by Varley, *The Ascension* by Herbert Stansfield (recently appointed teacher of design and crafts at the Ontario College of Art), *The Resurrection* by Herbert Palmer (fig. 80), and *The Crucifixion* by MacDonald. In the chancel were further scenes from the life of Christ by Carmichael, MacDonald, Thoreau MacDonald, Arthur Martin, and Neil McKechnie, and over the transept windows were St. Anne and St. George by Thoreau MacDonald (fig. 78).[54]

The rededication of the church was celebrated on the church's diamond jubilee, 17 December 1923, and the decorations were an enormous success and generously lauded in the press. While the original hope of including Canadian

motifs – "the trillium and other flowers … a little zoo of our own, hawk, blue jays, robins, wild ducks, orioles, deer, moose, beaver, and squirrels"[55] – was not realized, the effectiveness of the decoration should have inspired other commissions. However, it would be almost five years before MacDonald would have another such opportunity.

The artists' involvement with theatre was once again an affair of shared ideas and goals. At the Arts and Letters Club before the war, both Lismer and Harris had worked with Roy Mitchell, who directed the Arts and Letters Players. An essential element of these productions was their cooperative character; the program was controlled by the "back-stage workers, directors, artists, designers, architects, actors and writers … The Arts and Letters Players … had an absolute freedom in their choice of plays. They could do anything they felt was interesting or worth doing … Their one adamant rule was – never to produce anything that had been done in Canada before." Free from the demands of popular taste, the Players selected pieces mostly either derived from the Irish nationalist Abbey Theatre in Dublin or Symbolist plays such as Yeats's *Shadowy Waters*, Lady Gregory's *Workhouse Ward*, Synge's *Shadow of the Glen*, Maeterlinck's *Interior*, and Rabindranath Tagore's *Post Office* and *Chitra*.[56]

Plans were well advanced for the construction of a proper theatre in the Studio Building which would incorporate an art gallery when war broke out.[57] Mitchell left for New York in 1916, returning two years later to work as director of motion pictures for the wartime Department of Information under Vincent Massey.[58] With preparations to finally open Hart House at the University of Toronto almost complete, a theatre was incorporated in the plans at the last moment, designed by Mitchell and financed by the Massey Foundation. The Hart House Players launched their first productions in November 1919, *The Queen's Enemies* by the Irish writer Lord Dunsany, with sets by A.Y. Jackson, and *The Farce of M. Pierre Patelin*, with a set by Lawren Harris.[59] Modelled on the Abbey Theatre in Dublin, the Gaiety Theatre in Manchester, and Eugene O'Neil's Provincetown Players in New York, the Hart House group sought to develop a communal, amateur theatre troupe able to produce plays without being primarily driven by box office revenues. As well, they wished to counter the domination of the English Canadian theatre circuit by second- or third-rate American and British travelling companies. As Vincent Massey put it, "Our theatres are under alien influences."[60]

The Toronto painters continued to be involved, and sets for subsequent productions during Mitchell's directorship included MacDonald's for *The Chester Mysteries*; Jackson's for Ben Jonson's *The Alchemist*; Harris's for B.M. Hastings's *The New Sin*, L. Holberg's *Rasmus Montanus* (fig. 81) and George Bernard Shaw's *You Never Can Tell*; and Lismer's for Euripedes's *The Trojan Women*, Takeda Izumo's *Matsuo* and William Shakespeare's *Cymbeline* (fig. 82).[61]

But it was Merrill Denison's play *Brothers in Arms* that most stirred the admiration of Lawren Harris. Denison was the son of the noted suffragist and theosophist Flora MacDonald Denison. One of the founders of the

FIG. 79
The interior of St. Anne's Church, Toronto, 1923, decorated by J.E.H. MacDonald. On the left pendentive is *The Nativity* by Fred Varley, and on the right *The Crucifixion* by MacDonald. Above are the prophet Moses by Varley and a relief symbolizing St. Mark by Frances Loring and Florence Wyle. *Journal, Royal Architectural Institute of Canada* II:3 (May-June 1925), p. 85.

FIG. 80
St. Anne's Church, Toronto, 1923. The painting of *The Resurrection* on the pendentive is by Herbert Palmer. Above is *Jeremiah* by Fred Varley. *Journal, Royal Architectural Institute of Canada* II:3 (May-June 1925), p. 91.

FIG. 81
Lawren Harris: Stage setting for Ludwig Holberg's *Rasmus Montanus*, performed at Hart House Theatre, November 1920.

FIG. 82
Arthur Lismer: Stage setting for the cave in Shakespeare's *Cymbeline*, performed at Hart House Theatre, June 1921.

FIG. 83
Bertram Forsyth as Prospero in Shakespeare's *The Tempest*, performed at Hart House Theatre, June 1922. Sets designed by Frederick Coates.

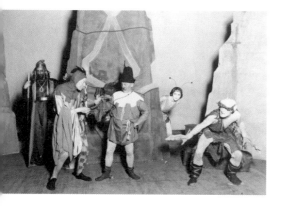

Whitman Fellowship of Canada, Flora Denison had purchased in 1910 the Bon Echo Inn on Mazinaw Lake, north of Belleville, Ontario, as "a gathering place for artists, thinkers and writers, all under the northern lights beside these great cliffs" of Bon Echo Rock. The cliff itself was dedicated to "the democratic ideals of Walt Whitman" in August 1919, with Whitman's friend and biographer, Horace Traubel, present. Denison himself had studied architecture in Toronto, the United States, and Paris, returning to Canada after the war to become art director of the Hart House Theatre.[62] His first play, *Brothers in Arms*, was written at the instigation of Roy Mitchell and performed at the Hart House Theatre in April 1921, together with two other Canadian plays, Duncan Campbell Scott's *Pierre* and Isabel Ecclestone MacKay's *The Second Lie*.[63]

Denison's plays were set in the backwoods around Bon Echo, "that tired, sparse strip of land that lies between the healthy farming country and the vast northern woods, a country of silent, drab sawmills, rotting lumber camps, stones, stumps, scrub growth and lonely rampikes."[64] One admirer identified the northern settings with the paintings of Tom Thomson,[65] but Harris went farther, perceiving in Denison's collected plays, *The Unheroic North*, "the first authentic, entirely indigenous literary work done by a Canadian." Reproaching the native critics for their deprecation of Canadian art and suppression of "the uprush of enthusiasm for new creations, the zest for living," Harris wrote, "Now if anything warrants enthusiasm it is the creation of a work of art in our midst. It is an event of the highest importance ... It means that in our land vision is being found, that conviction is being born. It means that as a people our heart begins to beat. If we imitate the style and mood of the creators in other lands, if we bow to tradition and creeds and taboos imported across the great seas, if we mumble outworn shibboleths and accept the works of other days, other lands in lieu of what we ourselves should create, we permit our powers to wither. We experience to no collective purpose. There is no real life in us."[66]

Denison had pursued an identical argument in an article published the previous month in the *Canadian Bookman*. Denouncing the intellectual's "unctuous" patronizing or utter damnation of national creative ventures, he saw the worst influence on Canadian art as "academic ennui ... that sucks away the enthusiasm, the vitality, the joy of experimentation that should be the heritage of the Canadian." Exasperated by "transplanted British mediocrity" and anti-Americanism rather than a "natural union" of the two "opposing influences ... whose product might contain something of the best of each," he argued the result was "the total lack of a positive belief in ourselves as a national entity with something to express." The example for Canadian writers lay in the Group of Seven. "They have been explorers, experimenters, influenced clearly and consciously by the country they are living in and not by the people who live in it. Their collected work is of extreme importance because it is Canadian and could have been produced in no other place than Canada. Good, bad or indifferent it reflects courage and belief."[67]

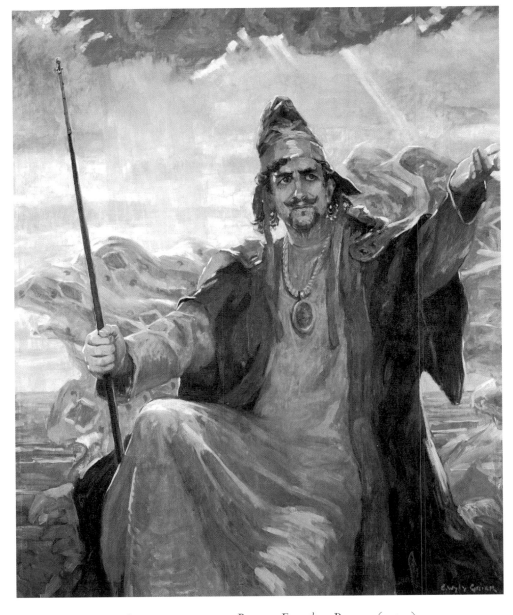

FIG. 84. E. WYLY GRIER, *Bertram Forsyth as Prospero* (cat. 5)

~

No other group of artists in Canada worked so hard to bring their art and ideas to public attention. The goal was, effectively, to change Canadian taste and values through the distribution of paintings, publication of articles, and encouragement of collectors of Canadian art. The Group of Seven defined a communality of spirit with J.W. Morrice, Ernest Lawson, and Tom Thomson, and argued for the appreciation and affirmation of Canadian creativity in all its forms. Their own art would become the means for others working in other fields to attain validation for "the creation of a work of art in our midst."

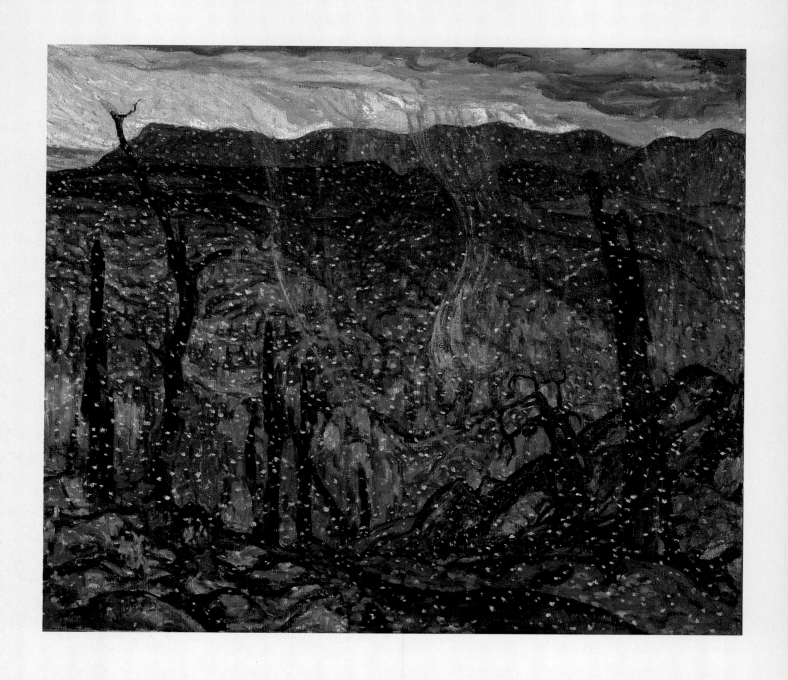

FIG. 85. A.Y. JACKSON, *First Snow, Algoma* (cat. 63)

7

The Critics

I n spite of the reputation the Group of Seven were developing in Ontario outside Toronto and throughout the west, they had not won over the opposition at home. In fact, a pattern of negative criticism had developed.

Royal Canadian Academy Exhibition, 1921

Hector Charlesworth would not review the Group shows, thus in no way abetting their development, but repeatedly attacked the movement in other articles. He posed an all-too-relevant question in a short comment on the 1921 R.C.A. exhibition. "Artists like other folk must live, but how are they to live by their work if they keep on producing stuff that people will not buy? At the show I speak of there was not a 'sold' sign ... One does not wish to live with a picture of a slum any more than he wishes to live in a slum, though at the same time such a painting, properly done, might very well make an imposing addition to a public art collection. But galleries are not buying pictures every day." Charlesworth invited the artists to paint what would sell: "horses hitched to a logging sleigh; the familiar old snake fence, with a woods in the distance," and

FIG. 86
ERNEST FOSBERY
Affy, Daughter of the Artist 1922
Oil on canvas
76.7 × 64.2 cm
National Gallery of Canada,
Ottawa (2039)
Purchased from the 1922 exhibition
of the Royal Canadian Academy
of Arts, Montreal.

castigated what would not sell: "a swamp. A repulsive, forbidding thing. One felt like taking a dose of quinine every time one looked at it." He argued that: "For sound literature and music we go back to the acknowledged masters, and we are not ashamed for so doing … Impressionists are giving us art that is not art, just as free versifiers are giving us poetry that is not poetry. If ugliness is real beauty they have yet to prove it to a very large mass of the assembled public."[1]

The only private sale from the 1921 R.C.A. show was Fred Coburn's *Over the Hill*, all others being to the National Gallery.[2]

Art Association of Montreal Spring Exhibition, 1922

In Montreal, Morgan-Powell raised the alarm about the pernicious influence of the modernists. "There has been a riot among the students. No matter in what direction you turn, you see portraits in bright colours against astonishing backgrounds. There is a row of them immediately facing the staircase — and already it has been christened 'the jazz wall' … A casual observer might almost be pardoned for thinking that they had all come from the same brush. The explanation? That is easy. They are the outcome of the influence exerted upon the students by Mr. R.S. Hewton, Art Director of the Association who succeeded Mr. Brymner … Bearing in mind that a few seasons of Post-Impressionism taught the world of art that in art truth is the pre-eminent essential, and that all forms of trickery are debasing and degrading … we may hope that this most recent experiment in portraiture will also serve to drive home the truth that no amount of clever handling of vivid pigments will ever excuse or cover up bad draughtsmanship." Ignoring a canvas by Tom Thomson, he continued: "As we have come to expect from Mr. Jackson, A.R.C.A., there is in *A Lake in the Hills*, another of those elementally drawn and crudely coloured landscapes that some people claim represent the real spirit of Canadian hills scenery. I can only say that they neither convince me nor satisfy me, nor do they seem to me to be at all illuminating. His colours are so over-laden, and so smashingly put on — almost brutally, at times."[3]

The hanging committee awarded the Jessie Dow Prize to Jackson, not for the denounced painting, but for his 1913 canvas *Morning after Sleet*, which was purchased by the National Gallery for $300. *A Lake in the Hills* was acquired by Randolph Hewton.[4]

Royal Canadian Academy Exhibition, 1922

Jackson was on the hanging committee for the 1922 R.C.A. exhibition in Montreal, and encouraged the Toronto artists to send their best. Having learned from the critical success of the Group shows, he arranged for the "modern" works to be hung in a separate room,[5] a fact noted with appreciation by the *Gazette*.[6] However, they were largely ignored by Morgan-Powell who, after a few strikes at "freak experiments," praised Carl Ahrens's painting as

FIG. 87. G. HORNE RUSSELL, *Edmond Dyonnet* (cat. 2)

"the most attractive canvas in the show," Ernest Fosbery's *Affy, Daughter of the Artist* (fig. 86) as "the finest portrait in the exhibition," G. Horne Russell's portrait of Edmond Dyonnet (fig. 87) as a "portrait that will rouse comment," and Fred Coburn's *Winter Morning at Melbourne* (fig. 90) as "surely the artist's masterpiece."[7] A letter to the *Gazette* from "Septuagenarian" of Ottawa launched a new campaign of letter writing, denouncing Lismer's *Islands of Spruce, Algoma* (fig. 67) and *September Gale* (fig. 89), MacDonald's *October Shower Gleam* (fig. 88) and *Young Canada* (fig. 107), and numerous other paintings, and praising Fosbery's *Affy* ("her boa stands out so clearly that it looks like real fur instead of a painted picture of it").[8] Among the counter-critics was Jackson, who, comparing the mixed reception accorded to the 1910 Canadian exhibition in Liverpool with the positive reception of the recent American tour of the

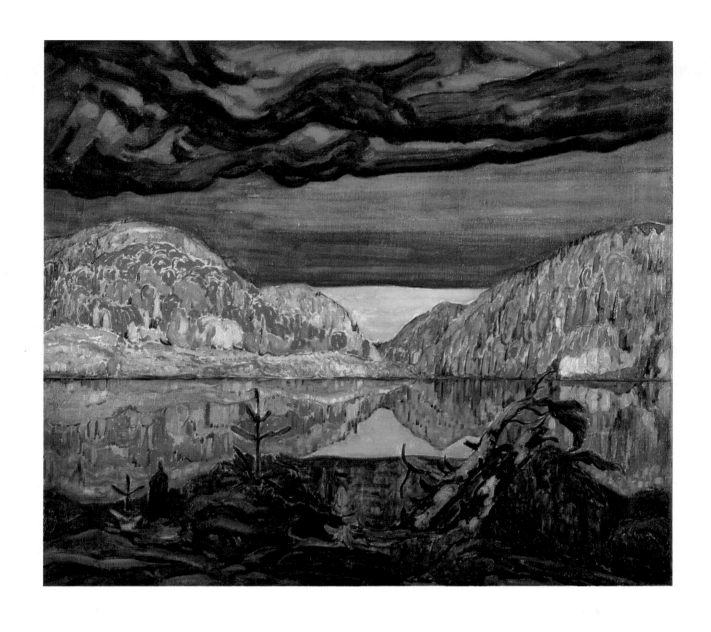

FIG. 88. J.E.H. MACDONALD, *October Shower Gleam* (cat. 57)

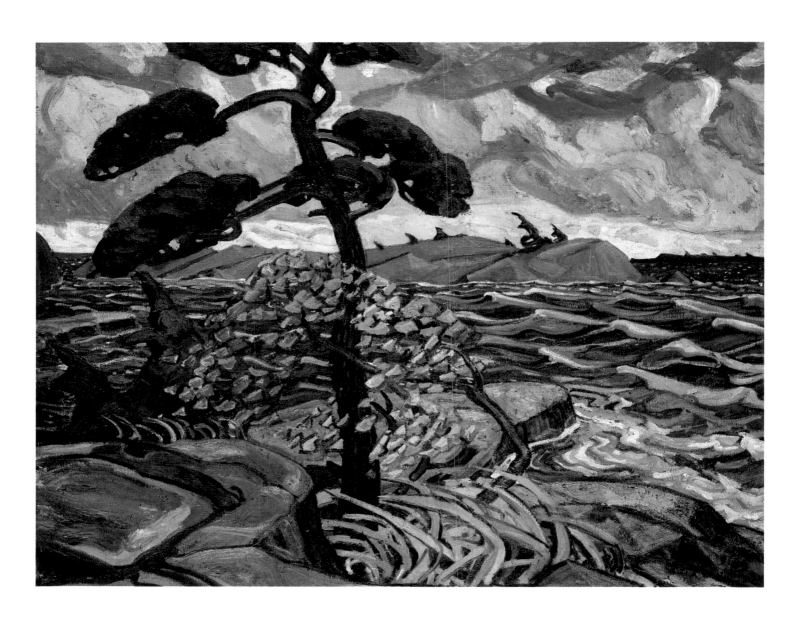

FIG. 89. ARTHUR LISMER, *A September Gale — Georgian Bay* (cat. 43)

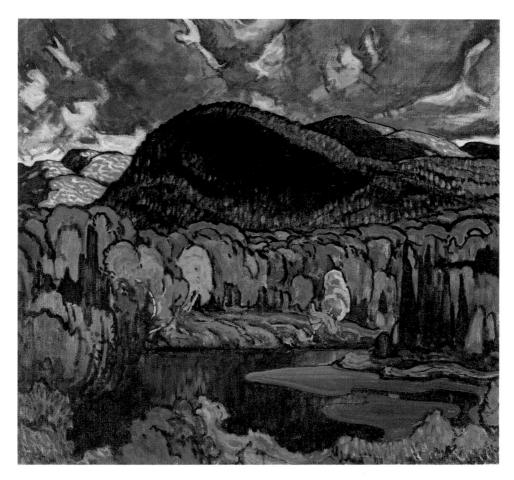

FIG. 91. J.E.H. MACDONALD, *Gleams on the Hills* (cat. 48)

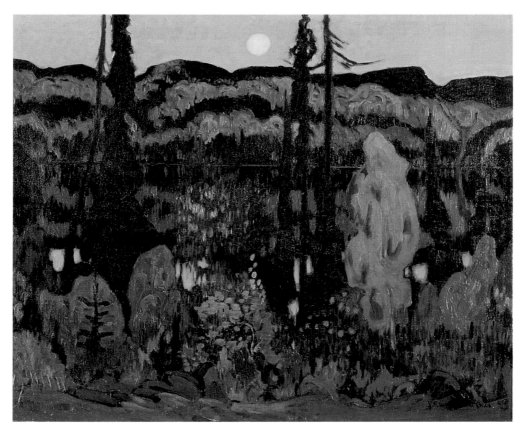

FIG. 92. J.E.H. MACDONALD, *The Lake — October Evening* (cat. 50)

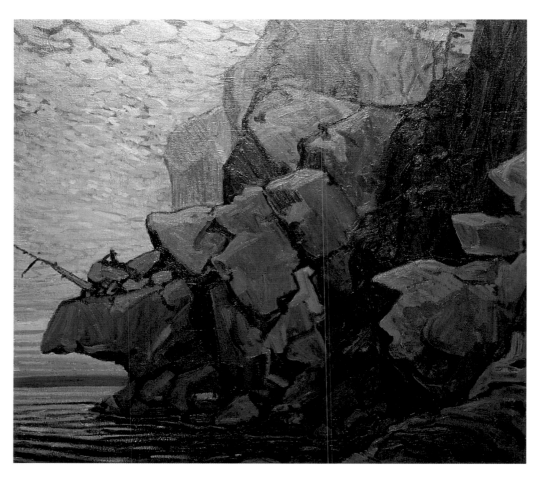

FIG. 93. ARTHUR LISMER, *The Sheep's Nose, Bon Echo* (cat. 60)

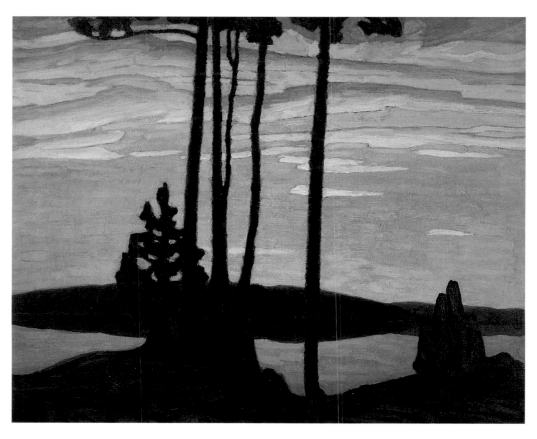

FIG. 94. LAWREN S. HARRIS, *Sunset, Kempenfelt Bay* (cat. 61)

FIG. 95
The Royal Canadian Academy of Arts Diploma Gallery and the modern Canadian gallery at the National Gallery around 1922. Hanging are the paintings Hector Charlesworth saw when he visited Ottawa in the fall of 1922.

has been in existence longer, and the Toronto Art Gallery has even the critic himself within it to help guide it, but the fact remains that practically every painter who has exhibited at all consistently in Canada is represented in the National Gallery." And to Charlesworth's criticisms of the Group, he responded, "It is rather a weakness in the force of his criticism of the Canadian modernists that it should be at such variance with the opinions of critics of worldwide reputation who have seen them."[18] The Toronto artists Jackson, Robert Gagen, and Albert Robson entered the fray, speaking as artists to a critic ignorant "of the great developments of art in the last thirty years ... The modern painters either stimulate, amuse, or cause anger, which perhaps in such a young country is better than to go to sleep so soon. After all, our most extreme work would be considered academic in Europe today ... One thing in favour of the experimental painters seems to be that, when the experiment is done, they try some other problem and sell the accomplished one for next to nothing. Most of the big canvases the National Gallery has acquired cost only from three to seven hundred dollars. The practical analytical works are much more expensive ... an art critic is entitled to his own opinions ... but when he threatens political interference from any political party, then he becomes much more of a reproach than any to be held against the National Gallery."[19]

Charlesworth in turn replied: "I am quite as familiar as anybody else with the struggles of many great artistic individualists of the past ... their difficulties came not from the critics, but from organized groups of fellow painters, who exercised a strong influence over the buying public through their control over exhibitions ... Their staunchest friends and prophets were invariably lay critics like myself – enemies of injustice like myself ... I did launch a strong protest against an apparent obsession in favour of one school of painting, which I daily see destroying the individuality of young artists in my own city. Moreover I hold that there are certain standards of poetry and beauty that are eternal and which are being allowed to languish and die, in part by official connivance."[20] The controversy was reported in the press in Toronto, Hamilton, Ottawa, Montreal, Calgary, Edmonton, and Vancouver.[21]

In January, three new trustees were appointed by the King government: August Richard of Montreal, Newton MacTavish of Toronto, and Warren Soper of Ottawa, a collector of Carl Ahrens's paintings.[22] From the O.S.A. exhibition in April the National Gallery purchased Ahrens's *The Road* (fig. 7) for $1500, reduced from $2500.[23]

Eric Brown's public support of the Group of Seven and repeated identification of it as the most important art movement in Canada had won him considerable hostility among some artists,[24] hostility which was made public when Homer Watson wrote to *Saturday Night*: "Some older members of the Academy know that there was a spirit in the old advisory board of the National Gallery and still dominant that was inimical, if not actually hostile to their work. This is well known in Academy circles and capable of proof."[25] They now had an advocate on the Gallery's Board of Trustees, Newton

MacTavish, whose career was intimately identified with the heyday of the Canadian Art Club. He immediately wrote to Homer Watson encouraging him to send his painting *The Flood Gate* to the Gallery for consideration for purchase, as "the psychological moment" had arrived.[26] *The Flood Gate* was eventually bought in 1925 for $3000, the highest price paid for a work by a living Canadian artist since Horatio Walker's *Oxen Drinking* was acquired for $10,000 in 1910. At the insistence of Mackenzie King, MacTavish also pushed through the purchase in 1924 of a portrait for the House of Commons – of Sir Wilfrid Laurier by John Russell for $5000[27] – the very form of political interference the Advisory Arts Council had been established in 1907 to prevent (fig. 96).

The enthusiasm of Eric Brown and the support of Edmund Walker did result in the purchase of a number of major canvases during the first two years of the Group's existence, including Harris's *Shacks*, Johnston's *Fire-swept, Algoma*, MacDonald's *Solemn Land*, and Varley's *Georgian Bay*. At the same time, many notable paintings were not purchased, including Jackson's *Terre Sauvage* and *October Morning, Algoma*, Harris's *Jazz* and *Island*, *MacCallum Lake*, Lismer's *September Gale*, and MacDonald's *Wild River* and *Tangled Garden*. Most markedly in the case of Jackson, his smaller and more restrained canvases were preferred. In 1920 and 1921, although a good proportion of the budget for Canadian art was expended on the Group's work – $5400 compared to $7500 for other artists – the whole process was determined by compromises. Not all the trustees shared Brown's and Walker's respect for these artists, and Shepherd, one of the Montreal trustees and president of the Art Association of Montreal, was keenly aware of the pressure from artists in that city. In 1922 and 1923, only $1050 was spent on paintings by Group members, while more than $10,000 went to other artists. Many excellent opportunities were missed and a number of unfortunate acquisitions made through the conservatism of the trustees and the necessity for continual compromise. As the opposition gained strength, the National Gallery would come under increasing pressure.

FIG. 96
Private view of John Russell's portrait of Sir Wilfrid Laurier at Jenkins Art Galleries, Toronto, 1920s. Left to right are John Russell, Newton MacTavish, Mr. Stewart of the Selgrave Institute, New York, W.L. Mackenzie King, Senator Spence, Mr. Young, and Mr. Wilkie. Private collection.

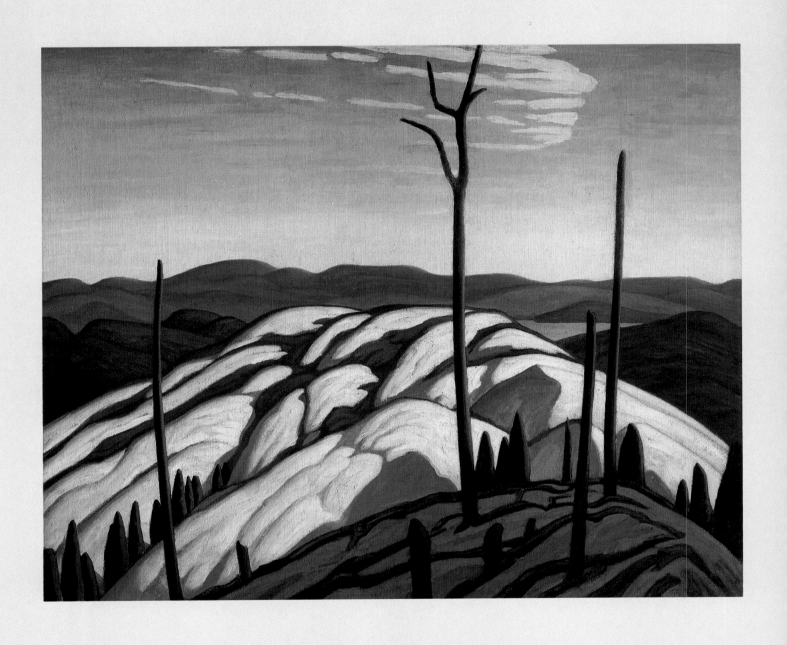

FIG. 97. LAWREN S. HARRIS, *First Snow, North Shore of Lake Superior* (cat. 68)

8

International
Recognition

rritated by the critical reaction to the work of the Group of Seven, Merrill Denison conjectured, "In all probability the members of this particular group will be forced to exhibit in the United States and forget the Canadian audience which should be here for them but which is not. Perhaps, okayed by New York, their work may wander home long after they are dead and be prized, not because it is good, or because it is Canadian, but because some other country was told that it was Canadian and said it was good."[1]

Second American Tour, 1923–24

The second American tour of *Modern Canadian Paintings* opened in Minneapolis in November 1923, and travelled to Kansas City, Omaha. Milwaukee, Providence (Rhode Island), and Worcester (Massachusetts), closing at the Brooklyn Museum in August 1924. Once again the itinerary had been arranged by Eric Brown through the American Association of Art Museum Directors, with Harris acting as coordinating secretary for the artists.[2]

Each of the six Group members was represented by five canvases; W.J. Wood, with two paintings, was the seventh of the seven.[3] In response to the

criticism the former members of the Beaver Hall Group had received in Montreal, Emily Coonan, Edwin Holgate, Lilias Newton, and Randolph Hewton were included as invited contributors, and their figure paintings were selected by the Toronto artists to complement the landscapes. The American reviews were tepid, asserting either the specific national character of the work or its lack of a unique national vision. The Midwestern writers were especially struck by the severity and restraint of the paintings, their cold, conservative expression.[4] The longest review was written by Helen Appleton Read for the *Brooklyn Daily Eagle*, who recognized in the landscapes Russian and Scandinavian affiliations and the absence of "the Cézanne-Picasso-Matisse tradition which is the special form of modern art which obsesses the young American artist to, in many places, the utter obliteration of his personality."[5]

The Americans were underwhelmed, to say the least. Charlesworth seized the opportunity to misquote Read's review and attack the Group for its purported effort "to reduce all Canadian landscape painting to one graceless and depressing formula – And the worst of it is they seem to be succeeding to some extent in spreading the belief that Canada is a land of ugliness; and its art a reflection of crude and tasteless native intelligence."[6]

British Empire Exhibition, Wembley, 1924

The recognition the Group had failed to win in the United States would come from England in 1924 at the British Empire Exhibition at Wembley. Originally conceived five years earlier as a postwar imperial economic fair, it had been postponed several times because of the recession. The R.C.A. had initiated plans for a Canadian art show for the fair in 1919 and was contacted again in 1922;[7] however, it had made no arrangements when it received notification that the National Gallery, at the request of the organizers of the exhibition, was to handle the Canadian art section. The Gallery's decision to take on this responsibility was determined by its recent experience in distributing exhibitions across Canada and the States, involvement in the Ahrens affair, and tense relations with the Academy. Brown and the trustees were convinced that if the Academy did organize the show it would be a tepid affair, dominated by senior academicians to the exclusion of the modern artists of Montreal and Toronto. The ultimate desire was "to include the finest representation of Canadian art it is possible to get together."[8]

The Academy's new president, G. Horne Russell, and its long-time secretary, Edmond Dyonnet, both of Montreal, reacted immediately, objecting to the assumption by the Gallery trustees, a body of laymen, of a prerogative of the R.C.A., a body of artists, to organize an exhibition of Canadian art abroad. This was a function the R.C.A. had carried out on all official occasions prior to 1913. They were doubly irritated that the jurying of the submissions for the Empire Exhibition would make unavailable many works for their 1923 annual show, as well as eliminating the possibility of holding their exhibition in Ottawa for the second year in a row. Dyonnet proposed that the

FIG. 98
H. Hands: The jury for the Canadian section of the British Empire Exhibition at the National Gallery of Canada, November 1923. From left to right: F.S. Challener, Arthur Lismer, Clarence Gagnon, Randolph Hewton, Florence Wyle, Franklin Brownell, Eric Brown (the director of the National Gallery but not a jury member), and Wyly Grier.

Wembley jury be composed of academicians who could select the works from their show at the National Gallery in November 1923. When Walker refused, insensitively offering, as a compromise, to ensure that works not selected for England would be available in time for the R.C.A. show, Russell and Dyonnet threatened a boycott.[9] Fuelled by old rancours from the initial creation of the Advisory Arts Council in 1907, the affair hit the press in September 1923.[10] Charlesworth warned his readers of the results should the R.C.A. "wash its hands of the whole affair" and the field be left open to those of the "blood and thunder variety … If the walls of the Canadian section are to be covered with crude cartoons of the Canadian wilds, devoid of perspective, atmospheric feeling, and sense of texture, it is going to be a bad advertisement for this country. We should advise the Department of Immigration and Colonization to intervene to prevent such a catastrophe."[11]

The affair quickly took on the character of an intercity conflict, with seven Toronto artists – Jackson, MacDonald, Jefferys, Grier, Herbert Palmer, Fred Haines, and Fred Brigden – taking on Dyonnet, Russell, and William Hope of Montreal.[12] George Reid feared the National Gallery had created a situation that would tear the Academy apart, as the Toronto artists had won the support of the associate academicians, who felt excluded from any voice in the society's activities.[13]

The National Gallery appointed a jury of five academicians, Horatio Walker, Franklin Brownell, Fred Challener, Wyly Grier, and Clarence Gagnon; and three associates, Arthur Lismer, Randolph Hewton, and Florence Wyle (fig. 98);[14] who together chose 270 works by 108 artists, many completely unknown today. Clearly the process of selection was characterized by numerous compromises. Approximately one-third of the works came from the National Gallery, with the Group members and Tom Thomson represented by only 20 canvases.[15] Among them were Carmichael's *Spring* (fig. 100) and *Autumn Hillside* (fig. 41), Harris's *Shacks* (fig. 61) and *Grey Day in Town* (fig. 101), Jackson's *The Northland* (fig. 10) and *Entrance to Halifax Harbour* (fig. 103), Lismer's *September Gale* (fig. 89), and Varley's *Vincent Massey* (fig. 102) and the retitled *Stormy Weather, Georgian Bay* (fig. 70).

The exhibition opened 24 April 1924, with the Canadian works densely installed in two galleries in the Fine Arts Pavilion (fig. 99). The conservatives and the modern artists were hung as separately as possible in adjacent galleries, with works on paper on dividing screens. Canada was the sole Dominion to produce its own catalogue, which, with *A Portfolio of Pictures from the Canadian Section of Fine Arts*, both with covers designed by J.E.H. MacDonald, was ready for the opening. Eric Brown wrote the foreword, and it took on the tone of a Group manifesto: "The Canadian fine arts are stirring, too, for which we may be devoutly thankful, for if they were not, they would be either dead or degenerate."[16]

Brown also installed the show and was present for the press day, yet it was the paintings themselves that won over the critics. The academic artists were almost entirely neglected, and all articles focussed on the more modern

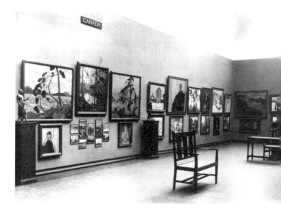

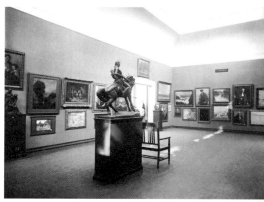

FIG. 99
The Canadian Art Section at the *British Empire Exhibition* at Wembley, 1924.

FIG. 100. FRANK CARMICHAEL, *Spring* (cat. 11)

painters. "Emphatic design and bold brushwork are the characteristics of the Canadian section; and it is here in particular that the art of the Empire is taking a new turn," enthused one writer. "There can be no question that Canada is developing a school of landscape painters who are strongly racy of the soil."[17] Recognizing Russian, Scandinavian, and French Post-Impressionist influences and parallels, the critics identified in the Canadian works a national independence of spirit, especially in comparison to the arts of Australia, New Zealand, and India.[18] "It is here, of all the Dominions, that the note is what we understand by 'modern' — very emphatic, a little crude, leaving plenty of room for refinement without loss of character. To anybody who conceives of a picture as a decorative construction in paint, the landscapes by [these Canadians] … cannot fail to give satisfaction," wrote the *Times*,[19] and the *Saturday Review* echoed: "The Canadian artists are more independent of prevailing fashions than the younger English, while they are as remote from the academic."[20] Of

FIG. 101. LAWREN S. HARRIS, *Grey Day in Town* (cat. 94)

Thomson's canvases, a British writer for the New York *Art News* commented: "Nothing could be less academic … and at the same time less freakish."[21] Formed by neither contemporary, international, modernist trends nor academic traditions, and characterized by an individual interpretation of Post-Impressionism expressive of a unique landscape, the modern Canadian paintings delighted the British critics.

Most enthusiastic was Lewis Hind in the *Daily Chronicle*. "The Canadian landscapes, I think, are the most vital group of paintings produced since the war — indeed this century. It would be a graceful and fraternal gesture if we acquired two or three for the Tate Gallery."[22] At the close of the exhibition in October, Jackson's *Entrance to Halifax Harbour* was purchased for the Tate.[23] Other works considered were Thomson's *West Wind* (fig. 134), Lismer's *September Gale*, MacDonald's *The Beaver Dam*, and Morrice's *Winter, Sainte-Anne-de-Beaupré*.[24] Charlesworth was probably correct when he wrote, "Mr. Jackson has had a distinguished career and has lately been identified with the modernist group of Toronto painters. This picture is not, however, one of the 'Georgian Bay' cartoons, but a product of Mr. Jackson's experience as one of the official artists of the Canadian War Memorials Collection."[25] British gratitude for Canada's contribution in the war may have played a determining role in the selection of this particular painting.

Horne Russell wrote to the British press, bringing to their attention the slight to the Royal Canadian Academy and the absence of "the works of many of the Dominion's best painters and sculptors";[26] however, the debate about

FIG. 102. F.H. VARLEY, *Portrait of Vincent Massey* (cat. 29)

Canadian art was not to take place in Britain, and the reviews, articles, and letters were merely fuel for the continuing struggle in Canada. As each article came out, edited selections were fed to the Canadian press, and by July the National Gallery had published a booklet of the major reviews.[27] The *Canadian Forum* and the *Canadian Bookman* – in which Bess Housser wrote and edited a monthly art column – rejoiced in the success of the Group, while the *Toronto Daily Star*[28] and *Saturday Night* continued to castigate and satirize their work, implying patronizing motives to the laudatory reviews. "Britishers, above all people, object to having preconceived opinions upset, and there is nothing in these pictures to disturb the popular belief we have all encountered among uninformed Englishmen, that Canadians are crude and commonplace in taste and ideals."[29]

From Halifax, Fredericton, Moncton, and Quebec City, to Winnipeg, Calgary, Edmonton, Vancouver, and Victoria, the English-language press reported each new step in the debate. This was no longer a skirmish limited to Toronto, Montreal, and Ottawa, but a news item of wide interest across the country.

A month before the opening at Wembley, having just returned from the concerts of the Toronto Mendelssohn Choir in New York, and on the eve of his departure for England, Sir Edmund Walker caught pneumonia; he died on 27 March 1924 at the age of seventy-five. The loss to Canada was

great. No single person had played such a creative and leadership role in so many cultural, historical, educational, and scientific ventures. As well, he had been president of the Canadian Bank of Commerce and honorary president of the Canadian Bankers' Association. His involvement had been crucial for all these institutions, and his guidance, farsightedness, and liberality of spirit had ensured their success.

The greatest tribute came from Lawren Harris. "His interest in all the arts in Canada was encompassing, vital, and far reaching ... his was a living interest in the dawn of a spiritual consciousness in his people, and a life of service to its evocation, of almost incalculable value. He was the first and only man of position to detect that in the modern movement in Canadian art the country had found the beginnings of a distinctive, significant, and bold expression. He announced the fact publicly and did all in his power to encourage and assist the artists and to further the public's understanding of the movement. Now this sort of thing takes courage. For in this one is alone and opposing the well-nigh ineradicable notion that nothing worthwhile can be created among us, so tenaciously held by our wealthy and influential individuals and by those who govern us, almost to a man."[30]

The success of the Canadian exhibit at Wembley had several repercussions, some negative and many positive. The Montreal academicians obtained the dismissal of Randolph Hewton from the directorship of the Art Association of Montreal school,[31] and the discontinuation of senior classes under the pretexts of cost and competition from the free tuition offered at the

FIG. 103. A.Y. JACKSON, *Entrance to Halifax Harbour* (cat. 36)

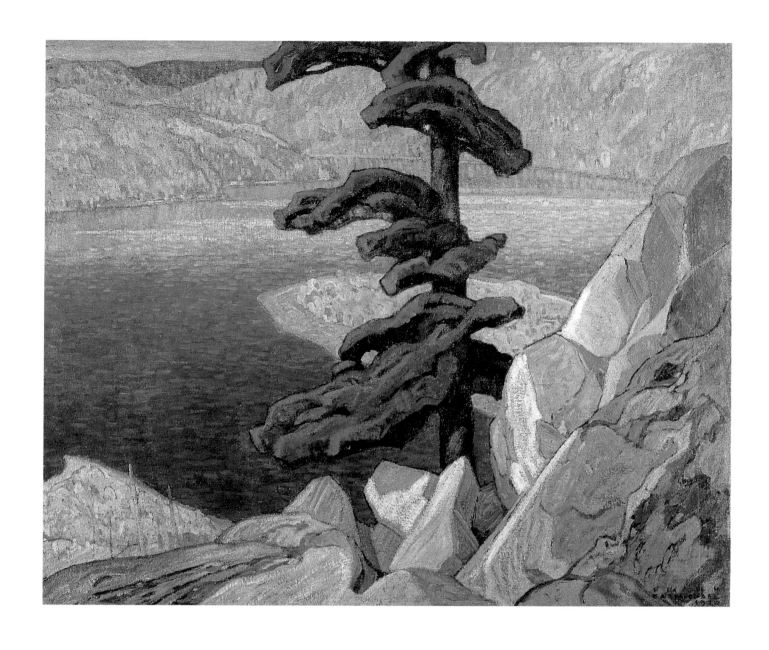

FIG. 104. FRANK CARMICHAEL, *The Upper Ottawa, near Mattawa* (cat. 69)

FIG. 105. LAWREN S. HARRIS, *Maligne Lake, Jasper Park* (cat. 72)

FIG. 108. J.E.H. MACDONALD, *Rain in the Mountains* (cat. 83)

The Second Stage

he Group of Seven held no shows in Toronto between May 1922 and January 1925, possibly because of the numerous exhibitions across Canada and in the United States and Britain. Sales were no better, and the artists were preoccupied with making a living. Lismer and MacDonald were both teaching full-time at the Ontario College of Art, and Jackson joined them for the 1924 to 1925 teaching year (fig. 109). He resigned that spring as the work interfered with his annual late winter sketching trips to Quebec. Varley replaced Jackson at the college in the fall of 1925.[1]

As Lismer also taught summer courses for Ontario art teachers, he had little time to travel, save for brief periods between classes when he usually went to Georgian Bay with his family. In the summer of 1924 he visited England to see his relatives for the first time in twelve years.[2]

Carmichael worked full-time at Rous and Mann, making short car trips to sketch in the Toronto region. In the fall of 1924 he painted on the upper Ottawa and at Wabagishik Lake, southwest of Sudbury. This was his first trip of many to the La Cloche region.[3]

MacDonald remained active in various administrative functions in the O.S.A., and was elected vice-president of the Arts and Letters Club in October

FIG. 109

Staff of the Ontario College of Art, spring 1925. Standing, left to right: Dorothy Johnston, J.E.H. MacDonald, Herbert Stansfield, Emanuel Hahn, Fred Haines, Yvonne McKague, A.Y. Jackson, Alice McMaster, Arthur Lismer, Mabel Hall. Seated, left to right: Aden Patterson, Edyth Coombs, Roselyn Hammond, G.A. Reid (Principal), J.W. Beatty. Private collection.

1923. He continued with free-lance design work and book illustration and spent the summer of 1923 working on St. Anne's Church. His first major sketching trip in years was to Lake O'Hara in the Rockies in late summer 1924 on a pass from the C.P.R.[4]

Jackson painted at Baie-Saint-Paul and Les Éboulements in March 1923 and again with Lilias Newton, Mabel May, Edwin Holgate, and Clarence Gagnon in January 1924. From there he went to Bon Echo in February, visiting with Merrill Denison and Arthur Heming.[5] After a trip to Georgian Bay, he and Harris travelled to Jasper, Alberta, in August. "I would not compare it with Lake Superior, it has not the intimate qualities nor the variety," he wrote to a friend. "Only in the upper pastures does it appeal to me very much ... Lawren has worked very hard and has a lot of good stuff." The two artists painted at Maligne Lake and in the Tonquin Valley.[6]

Fred Varley survived on the few portrait commissions he was able to obtain, mostly for educational institutions through the support of Barker Fairley. "I have come to the conclusion that Varley's prospects as a painter are just as precarious as they were ten years ago and that there seems nothing for it but to try to push him out of Canada into London or New York," wrote Fairley to Eric Brown. "The support that Varley has received here in the past two or three years ... all reduces itself to the enthusiasm of a handful of people, including yourself, whose united efforts do not seem to suffice to carry the man indefinitely ... I think he has big organic gifts which many artists have lacked who have made great names for themselves. His nature cannot serve two masters and if he had to turn again to commercial work for any length of time I believe that he would stop painting, even after all he has done. The only solution is to get him employment as a painter ... He almost invariably gives great satisfaction to his sitters. But his work is not unoriginal enough for commissions to come in unsought."[7]

Varley's major competitors for portrait commissions were Wyly Grier and Curtis Williamson, and Varley was not made for the role of court painter; as a result he was chronically impecunious. He did get work preparing illustrations

for Ryerson Press,[8] and assisted MacDonald with St. Anne's Church, but despite Fairley's promotion of his talents, he lost his house in the summer of 1923. He and his family then camped out at Bobcaygeon by the property of E.J. Pratt and his family.[9] There Varley painted some of his most tender and evocative family portraits.

That fall, he was awarded second prize ($300) for his submission *Immigrants* to an Academy competition for a mural design on "The Settlement of Canada" for the Railway Committee Room in the Parliament Buildings in Ottawa,[10] but no contract to paint the actual mural followed. In January 1924, he travelled to Winnipeg to paint a portrait of Daniel McIntyre, the city's school superintendent, then to Edmonton to paint a portrait of Chancellor Stuart of the University of Alberta and to do further work on his portrait of Principal Tory, begun the year before. He returned to Toronto via Winnipeg in April.[11]

The geographic range of the Group's painting sites was greatly extended during the second half of the decade. The Rocky Mountains became favoured by Harris and MacDonald, and Lismer also painted there in 1928. Jackson went to the Arctic in 1927, and again with Harris in 1930; in 1928, he sketched at Great Slave Lake. This expanding search reflected the artists' desire to explore the breadth of the country and to interpret its many aspects. Yet, as the decade progressed, the landscape they had first encountered was being transformed. "Wire fences, milking machines, tractors, square cows, prize pigs, and other breed stock offer nothing to the artist. But there are a couple of million square miles in the north and the west where the artist can roam undisturbed for some years to come."[12] As early as 1922, Jackson and others had signalled the impending disappearance of the landscapes they had painted. "There won't be any spruce trees left, and the wild rivers are being trained to run down pipes."[13] MacDonald and Harris retreated to the nature reserves of the Parks. "We cannot plough or pave the whole country, and if our ploughing and paving leave us with a wholesome appetite for the wild, they will be all the wiser done ... we will increase the area of our National Parks and make them easier for our city-harassed folk to reach," wrote MacDonald in 1924.[14] Yet by 1930, when the C.P.R. proposed installing a funicular to Lake Oesa, he would write in his diary, "what a pity we cannot have an idealistic contract to keep the balance true between nature and capital."[15] Increasing tourism and modernization threatened both the wild woods and hills and the picturesque old settlements. "Why don't you come home and paint Quebec before it is all turned to garages and gas stations?" Jackson wrote to Clarence Gagnon. "There should be fifty artists working to record its fast vanishing charms and then get loose on the rest of Canada."[16]

Group of Seven Exhibition, 1925

The first Group exhibition in Toronto in almost three years, and the first since their critical success at Wembley, opened on the evening of 8 January 1925 with

FIG. 110
Advertisement for the January 1925 exhibition of the Group of Seven placed in the *Toronto Daily Star*.

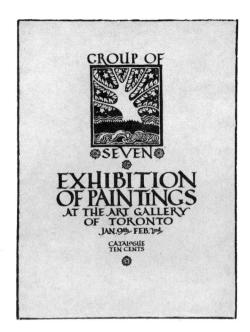

FIG. 112
Group of Seven logo from the
exhibition in January 1925.

a private viewing attended by almost 400 people (see cat. 69-89).[17] The show
was advertised in the press (fig 110), quoting denunciations of their work
from the *Star* and *Saturday Night* and praises from the London papers. The cat-
alogue, merely a list of works headed with a new logo designed by Carmichael
(fig. 112), contained no preface. Already in the foreword to the 1921 catalogue
they had warned against "subordinating painting to literature," and far too
much ink had been spilled in the interim. Because of the various responsibili-
ties that distracted the artists, this was their smallest show ever, containing
only fifty-one canvases. Jackson and Harris were the largest contributors, with
Varley exhibiting just two paintings. The seventh of the seven this year was
Albert Robinson of Montreal, who showed three Quebec City canvases and a
winter landscape of Baie-Saint-Paul. In the corridor to The Grange, Thoreau
MacDonald exhibited drawings and woodcuts.

The most novel feature of the show was the inclusion of drawings by the
Group members, together with a portfolio of reproductions. Possibly the
intent was, as the *Mail and Empire* suggested, to "provide an eloquent and com-
plete reply to those persons who assert that modernism is an artistic method
adopted by men who lack draughtsmanship."[18] Some of the drawings were
after paintings and oil sketches, and others had been published in the *Canadian
Forum*; the latter were supplemented by war drawings by Jackson and portraits
by Varley (fig. 132).[19] The portfolio contained twenty photolithographs repro-
ducing drawings in the show by Harris, Jackson, Lismer, MacDonald, and

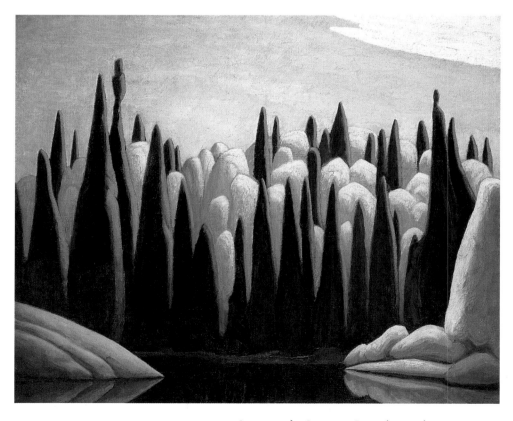

FIG. 111. LAWREN S. HARRIS, *Spring on the Oxtongue River* (cat. 71)

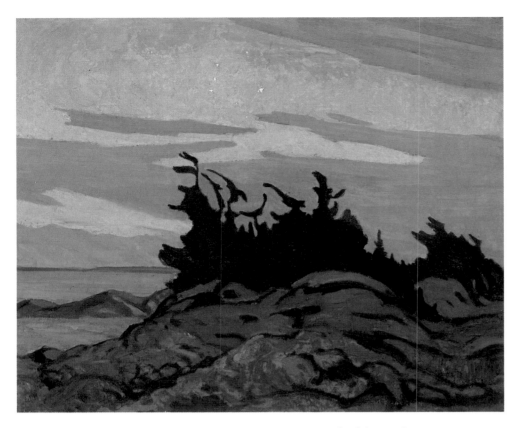

FIG. 113. A.Y. JACKSON, *Dawn — Pine Island* (cat. 75)

Varley. It was published in an edition of one hundred by Rous and Mann, and copies sold for $12, each print being signed by the respective artist.[20]

The paintings included Carmichael's *The Upper Ottawa, near Mattawa* (fig. 104), Harris's hills and rocks of the shores of Lake Superior and his brilliantly coloured *Spring on the Oxtongue River* (fig. 111), Jackson's delicate *Dawn — Pine Island* (fig. 113) and Quebec winter landscapes, and Lismer's canvas of Mossley in Lancashire painted since his return from England (fig. 117) and his 1922 canvas of the church-dominated town of Mattawa (see fig. 121). It was the Rocky Mountain paintings by Jackson, Harris, and MacDonald that attracted the greatest attention. "The painters certainly are evolving," enthused the *Star Weekly*. "They have been successively, and generally success-fully, house-haunted, tree-mad, lake-lunatic, river-ridden, birch-bedlamed, aspen-addled, and rock-cracked. This year they are mountain mad ... [Harris] does not give you a mountain but the platonic idea of a mountain, a math-ematical infinite series of mountain impressions, something gigantically pyramidical, if not veridical, a real brainstorm among the mountains."[21] *Maligne Lake, Jasper Park* (fig. 105) left the *Telegram, Star,* and *Globe* writers almost speech-less, although one suggested it be "viewed at Sunnyside from Scarborough Beach."[22] Fairley's reservations about Harris's work were even greater than in 1922. "The success of the evening was really a personal success for himself. Yet he has never painted so rigidly as now. From an aesthetic standpoint, one canvas ... says almost as much as ten. There is the same mood and the same

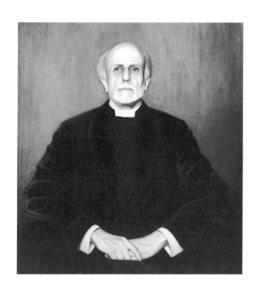

FIG. 114. LAWREN S. HARRIS,
Dr. Salem Bland (cat. 96)

handling in every one of them. It is a spacious mood somewhere between the sumptuous and the austere; the handling is thorough in its kind, and sometimes it is masterly. Yet I fear ... that Harris has taken a wrong turn. Have these violently stereoscopic effects which he is getting any real place in the painter's art? Do they not belong to the art of the theatre? ... Harris might achieve fame in either, but not by confusing the two."[23]

Not a single writer found anything to praise in Jackson's mountain canvases, and MacDonald's *Rain in the Mountains* (fig. 108) was also received with reserve. Bess Housser described the latter as mere design with colour filled in,[24] and Fairley found in it only "the same reliance on a formula, the old, flat, thin formula that he knows so well ... The better they are as 'lay-outs', the less we like them when we are asked to accept the lay-out for the finished canvas." Fairley's love of Varley's rich handling of paint prevented him from appreciating the severe designs of Harris and MacDonald, but this year it was Lismer's *The Happy Isles* (fig. 116) that stirred his admiration. "An outstanding canvas of unforeseen character," he wrote. "It is a sort of idealized Georgian Bay. No other part of the world could have helped an artist to such a result. There are the rocks, the lone pines, the channels, and all the other familiar marks of the Bay. But it is clearly not the Bay. The landscape has surrendered its epic and its objective quality altogether to the intense mood of its beholder, the artist ... This is Lismer's year."

One new voice was heard, that of Salem Bland, a social reforming, labour-supporting, anti-capitalist, anti-fundamentalist Methodist minister who had arrived in Toronto from Winnipeg in 1919 under suspicion of involvement with the Winnipeg General Strike.[25] Writing in the *Toronto Daily Star* under the pseudonym "The Observer," Bland found revealed in the work of the Group of Seven "the Canadian Soul ... in these strong and solemn and lonely landscapes ... I felt as if the Canadian soul were unveiling to me something secret and high and beautiful which I had never guessed — a strength and self-reliance and depth and a mysticism I had not suspected. I saw as I had never seen before the part the wilderness is destined to play in moulding the ultimate Canadian ... in no other country is the wilderness so close and accessible to the people. I suppose most patriotic Canadians have been disposed to quarrel with this and would have been willing to trade off our immense hinterland at the rate of 1000 square miles of rock and muskeg for 1000 acres of good farm land. But then we should have missed the 'Group of Seven' and the spirit that has created the 'Group of Seven'."[26]

The show received more journalistic attention than any preceding one, and for the first time Charlesworth felt obliged to recognize the artists' existence as a Group. He praised the work of Carmichael and Robinson for their "feeling for the subtle and evanescent moods of nature," the more delicate and atmospheric works by Harris and Jackson, and above all the drawings. "With so much basic talent in the group, the arbitrary nature of their proceedings with paint becomes the more exasperating. The keynote is over-emphasis of a

few essentials and rejection of all other elements. Articulate this or that motif; cast aside the rest. This is the method of the anatomist with a cadaver, and the result is often as gruesome." A good part of the article consisted of a denunciation of 'group systems' in politics and art. For Charlesworth, cooperativism in art was synonymous with cooperativism in politics, with "regimented opinion, pledged to fixed programs, in which it is treason to look aside at anything unrelated to the main objective, to bring up a question of realities, or to recognize validity or sincerity in other men's ideas. Something very like the same attitude of mind governs the body of painters known as 'The Group of Seven', which aspires to dominate pictorial expression in this country, despite the well established fact that all groups or schools which adhere to fixed methods and opinions are a handicap to artistic progress."[27] Overstressing the similarities in the Group members' work and wrongly accusing them of denouncing the work of others, Charlesworth failed to recognize the validity of the ideas that inspired them and the constructive influence they were having on Canadian art generally. As had been made clear in the Ahrens affair, Charlesworth's individualism was really third-generation imitation.

Total attendance for the show reached an all-time high of more than 4300 visitors, and sixteen portfolios were sold, as well as one drawing by Jackson and for the first time a canvas. MacDonald's *Morning – Lake O'Hara, Yoho Park* was sold to W.S. Greening, a long-time member of the Art Gallery of Toronto's exhibition committee. The National Gallery purchased eleven drawings.[28]

Art in Canada or a Canadian Art

With Wembley, the Group acquired a place in history, a place that had to be defined – either to affirm their claims or to question them. One dissenter amid the general celebrations at the 1924 Wembley exhibition was Newton MacTavish. "It is not correct to say that critics have discovered something different or unique or national or indigenous in the art that has been sent from Canada. Because art produced in Canada is not different from other art except as to goodness or badness ... Art is universal, and it seems to be one of the few things that cannot suffer the limitations of a boundary."[29]

This same point of view was articulated in the opening lines of his major study *The Fine Arts in Canada*, published in December 1925. "Much conflicting opinion is expressed from time to time as to nationality in art, especially in literature and the fine art of painting. For that reason the term 'Art in Canada' is used purposely in this book, in contradistinction to the term 'Canadian Art,' and also for the reason that the writer is not convinced that there is anywhere any art that is peculiarly Canadian."[30]

Dismissing any evident worth in the art of the aboriginal population[31] or of anything produced here before the mid-nineteenth century, MacTavish focussed primarily on Canadian art of the turn of the century. Colour plates

FIG. 115
Thoreau MacDonald: Endpapers for F.B. Housser's *A Canadian Art Movement: The Story of the Group of Seven*.

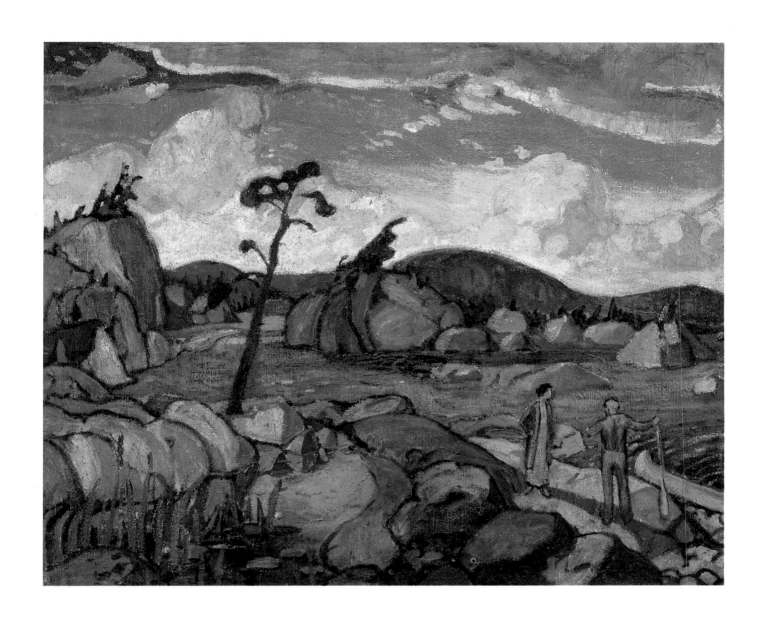

FIG. 116. ARTHUR LISMER, *The Happy Isles* (cat. 79)

FIG. 117. ARTHUR LISMER, *A Factory Town — North of England* (cat. 80)

reproduced works by the more conservative and decorative artists, thus asserting their value as the best of Canadian art.

This was the first effort to write a broad history of art in Canada, and as such the book was generally well received.[32] Yet, British reviewers were somewhat startled at MacTavish's diffidence about a Canadian art,[33] and the American writer Thomas Craven, on the basis of the works illustrated in the book, dismissed Canadian art in general as seldom exceeding "the level of conventional illustration, ranging from close imitation of sentimental English painting to a more liberal adaptation of French Impressionism. In sculpture, however, Canada can boast of a thoroughly indigenous and original art form – the totem poles of the Northwest."[34]

If MacTavish's was "a book for reference rather than inspiration,"[35] Fred Housser's history of the Group, begun in June 1924 in the wake of the critical success of the first Wembley exhibition,[36] was intended as a work of inspiration. Published one year after *The Fine Arts in Canada*, Housser's *A Canadian Art Movement: The Story of the Group of Seven* (fig. 115) set out to define the identity of a distinctly national art realized by artists "unequipped with the mental paraphernalia of academies ... inspired as the result of a direct contact with Nature herself."[37]

Housser's book was largely derived from the artists' own interpretation of their history since 1910, newspaper and magazine articles, and some letters. The guiding principles behind the thesis of the book were defined in the numerous articles published by the artists during the post-Wembley years as they clarified their intentions and raised the level of debate above the personal vindictiveness of the conflict over the British Empire Exhibition. Central to these articles were three main concepts: the determining influence of the Canadian environment on the Canadian character; the interplay between the land, the people, and the artist, which informed a distinctly national art; and the rejection of foreign academicism or other "isms" as a language for the interpretation of the Canadian spirit.

In an address to the Canadian Club, Lismer argued that Canadian art must reveal the national environment and the national "types," whose character had been formed and moulded by the Canadian "background."[38] "This design, or form, of our country is its character, the elemental nature which we recognize as one recognizes a familiar loved shape. It partakes of our own character, its virility and emphatic form is reflected in the appearance, speech, action, and thought of our people."[39] Elsewhere he wrote, "We love with a tremendous affection our natural and boundless background of lake and stream, forest and prairie, mountain and coast, each with their precious memories of pioneer, explorer, and prospector ... Commonplace picturesqueness disappears in the north country and is replaced by epical and powerfully moving shapes. Conventional paintings, easy atmospheric effects, tepid and non-committal attack has, perforce, to be discarded ... The north country is not by any means a timid painters' paradise. Gradually it was borne in on these

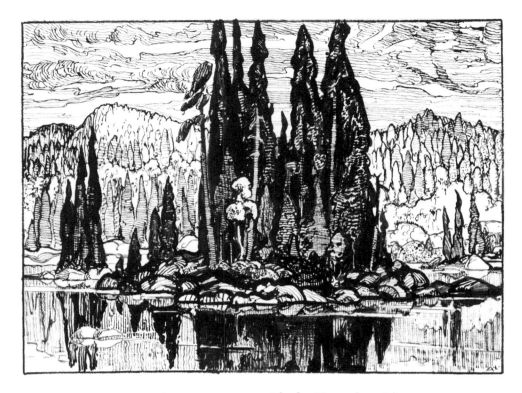

FIG. 118. ARTHUR LISMER, *Islands of Spruce* (cat. 81)

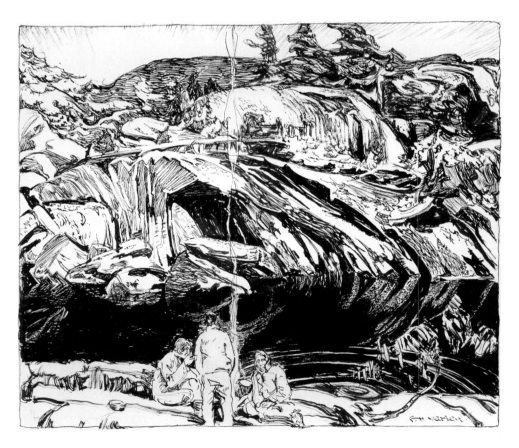

FIG. 119. F.H. VARLEY, *A Quiet Inlet, Georgian Bay* (cat. 87)

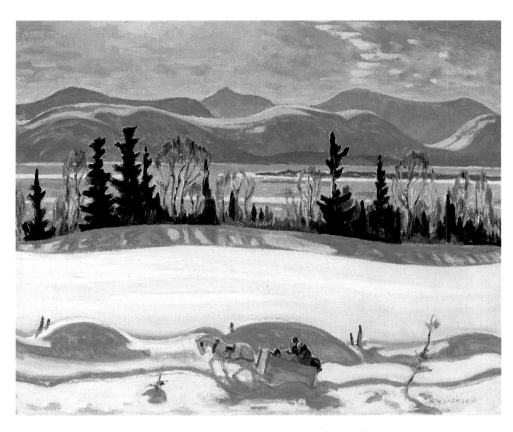

FIG. 120. A.Y. JACKSON, *Morning* (cat. 76)

FIG. 121
ARTHUR LISMER
A Northern Town 1925
Photolithograph on wove paper
28.6 × 38.7 cm
National Gallery of Canada, Ottawa

From *Canadian Drawings by Members of the Group of Seven* (Toronto: Rous and Mann, 1925), this print reproduces a drawing after the canvas of 1922 titled *A Northern Town — Mattawa* that was exhibited in the 1925 Group of Seven exhibition.

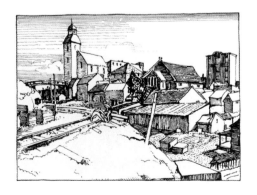

painters of a newer school that if ever this country was to receive its interpretative baptism in paint, then older theories and rules to a great extent must be discarded and a return made to the simpler forms and distinctive design common before the decay of the painters' craft into an exhibition of skill of the hand. There had to be a firm grasping of the design and rhythm of mountain and stream, of the serrated aspect of spruce and pine against skies of such glorious clarity, unsurpassed in beauty in any other country in the world ... the Group of Seven ... have moved the art of landscape painting into a more rhythmic and plastic idiom, more in harmony with the energy and quality of our national character."[40]

That the environment had a determining influence in moulding the Canadian character and thus Canadian art was a belief shared by Lawren Harris. In terms formed by his study of theosophy, he wrote, "We live on the fringe of the great North across the whole continent, and its spiritual flow, its clarity, its replenishing power passes through us to the teeming people south of us ... This emphasis on the north in the Canadian character that is born of the spirit of the north and reflects it, has profoundly affected its art, and its art in turn clarifies and enhances the quality of Canadian consciousness ... In the pioneering days whatever social fabric there was came with the settlers from Europe and was necessary to tide us over the settling period in the new land. Since then the effect of the expanse and freedom of the new environment has created new values until today, in the north, in the west, and among

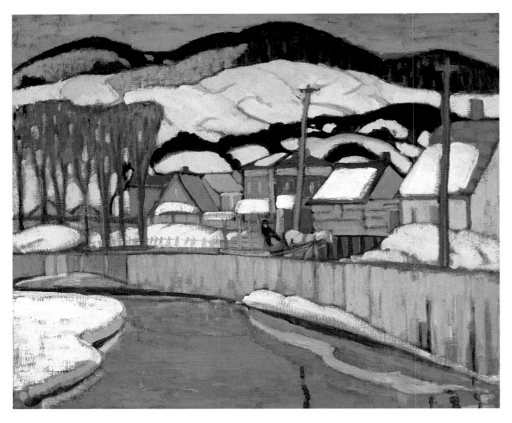

FIG. 122. ALBERT H. ROBINSON, *Winter, Baie-Saint-Paul* (cat. 86)

individuals in the older centres, grows a powerful consciousness of the Canadian spirit. This spirit is not precise; it lacks detail and finish, and is therefore considered somewhat crude by people polished with imported brushes ... We, who are true Canadians imbued with the North, are an up-start people with our traditions in the making."[41]

For Harris, the artist had a particular role in the clarification of these values: "No man can roam or inhabit the Canadian North without it affecting him, and the artist, because of his constant habit of awareness and his disci-pline in expression, is perhaps more understanding of its moods and spirit than others are. He is thus better equipped to interpret it to others, and then, when he has become one with its spirit, to create living works in their own right, by using forms, colour, rhythms, and moods, to make a harmonious home for the imaginative and spiritual meaning it has evoked in him."[42] Elsewhere he wrote: "The artist leads his audience ... summarizes, clarifies, gives precision to their hidden highest longings, however unconsciously. So that they see made clear what was vague, nebulous, almost half distrusted, and come closer thereby to a recognition of their greater selves and are rewarded by a greater sense of the fullness of life, by reassurance of their nobler intima-tions ... the artist and his audience are interdependent, as necessary one to the other for illumination as the negative and positive forces in electricity."[43]

The "decadent academicism" which hung like a pall over Canadian art was defined by Arthur Lismer in terms of nineteenth-century Parisian studio

FIG. 123. ARTHUR LISMER,
Pine (cat. 82)

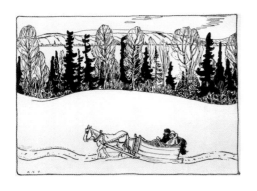

FIG. 124. A.Y. JACKSON,
Winter Scene (cat. 78)

practice, which gave primacy to technical skills, craftsmanship, and observation. "It recognizes drawing as the basis of all effort & representation as its aim – it deals with appearance & facts & not with vision in an idealistic sense – it is an excellent training for the eye & hand – the training of the mind is left to chance."[44] It dealt with values derived from the past, or, as Jackson put it, "academic bodies rush forward with their heads turned backwards to get direction."[45] For Lismer, art was "not a professional practice but a way of life ... a universal and not a specialized quality of human consciousness."[46]

The rejection of academicism and the belief in the determining character of the environment on Canadian artists led to the most problematic interpretations in Housser's book – the Group's independence from European art, and their identification as "amateurs."[47] A writer in the *Canadian Forum* criticized the book for the first error in an otherwise positive review. "It grossly overstates the native independence of these artists, identifying the English-Dutch tradition, from which they broke, with the whole of contemporary Europe and forgetting what it is easy to see, that the new Canadian technique is almost as close to Post-Impressionism as the old technique was to English watercolour."[48]

For Housser the term "amateur" had a very specific meaning. It was the definition of an artist who had abandoned or was without academic training, and who worked not from professional ambition but in a spirit of creative adventure. Bertram Brooker understood Housser's use of the term in light of the history of the Canadian movement. "In short, the movement is the opposite of 'precious' and the reverse of 'academic'. It is a movement that anyone possessed of love of country and an urge to express can join. And the more invention and originality these beginners show, the better the founders of the movement like it. Slavish imitation of their particular technical idiosyncrasies is opposed to their whole attitude. They are eager to see flourishing in this country a thoroughly amateur creative urge free of all strings – amateur because, as Mr. Housser says, 'the amateur attitude is democratic. As an attitude it distrusts divine rights whether of academies or kings, and is opposed to all forms of pontificiality and affectation associated with the old world and the past. It is creative and therefore of the new world order.' "[49]

On the other hand, Housser did feel it necessary to counter the "myth" of Tom Thomson as "the young man suddenly appearing out of the northern woods with his wild art slung behind him,"[50] as propagated in MacTavish's book and by others. "His work was an inspiration to them all, but it is not depreciating him in any way to say that he himself was a product of the movement, owing perhaps more to it than any other single member." Yet it was exactly the very "specialized quality of human consciousness" defined by Lismer that Housser perceived as the spirit of Thomson's art. "There is no trace of an intellectual philosophy, nor a theory of aesthetics; no preachment on life, no effort to impress or improve, or lift you up, or cast you down, but just pure 'being', as though nature itself was speaking to you through a perfectly attuned and seasoned medium."[51]

FIG. 125. J.E.H. MACDONALD, *Autumn Sunset* (cat. 84)

FIG. 126. FRANK CARMICHAEL, *A Grey Day* (cat. 70)

FIG. 131. A.Y. JACKSON, *Vista from Yellowhead* (cat. 77)

FIG. 132. F.H. VARLEY,
Mrs. Alexander McPhedran (cat. 89)

artists to cut a trail in the wilderness, to paint a pine tree, to sow paint-rags beyond the fringe of civilization, to climb mountains with a sketch-box ... The fact is that Mr. Housser was not grown out of boy's 'panties' in 1910, or he would have crossed the frontier of Quebec, he would have known that Cullen was tramping on snow-shoes in the Laurentians and exhibiting in Paris pine trees, frozen rivers at the Paris Salons when Lawren Harris was still at his ABC's and Gagnon was sketching and hunting back in the hinterland of Quebec, also in the Indian Reserves of the North Shore of the St. Lawrence into Ungava country. That was in 1901. If Horatio Walker could not sell a picture in Canada in those days, how could you expect Cullen or Gagnon to sell what they painted in the wilderness?"[59]

As a chronicle of the development of an idea, Housser's book is an insightful articulation of the spirit that animated the Group. Its strengths are also its limitations, however. It is a book of inspiration and only partially a history. As MacDonald noted, "It has made me realize the cynical truth of Napoleon's saying that 'all history is a lie agreed upon' ... The historian has to deal with documents or memories. The documents are the best material if *written at the time*. Memories put a haze around things which falsifies them or at all events poetizes them."[60] As the story of an idea it is too exclusive, defining the movement only in terms of a particular form of landscape painting, even to the point of excluding Varley from the inventory of paintings by Thomson and the Group members in public collections.[61] As a history, it is limited by an absence of context and a neglect of other informing factors. Gagnon was right to stress the Quebec precedents; and it was MacDonald, the oldest member of the Group, who identified other earlier, developing forces in Ontario, such as

George Reid's Toronto Municipal Buildings murals, William Cruikshank's paintings, and the Toronto Art Students' League.[62]

The book did respond, however, to those "vague, nebulous, almost half distrusted" urgings of English Canadians, and sold 2,700 copies in two years,[63] becoming, with the Wembley reviews, the most-quoted source in the defence of the Group of Seven.

∼

The studies by Newton MacTavish and Fred Housser would remain the only major English-language publications on Canadian art until Albert Robson's *Canadian Landscape Painters* in 1932.[64] The two books not only reflect two generations of critical discussion, but clearly reveal how the debate about art in Canada was transformed into a debate about Canadian art.

FIG. 133. ARTHUR LISMER, *Quebec Village* (cat. 99)

A New Prosperity

he Wembley exhibition marked a milestone in the history of the Group of Seven, for not only had the artists received international and national recognition for their work, but the event had also coincided with an upswing in the Canadian economy. After years of postwar depression, Canada would begin a five-year economic boom in 1924. At the core of this growth were three staple industries: pulp and paper, mining, and hydro-electric power.[1] The money they produced would have far-reaching effects and provide much-needed assistance for the arts.

Art Gallery of Toronto

One immediate benefit of economic growth was the construction of a major extension to the Art Gallery of Toronto. After the death of Sir Edmund Walker, R.Y. Eaton, head of the T. Eaton Company, was elected president of the gallery; immediately, he commissioned plans for an addition from the architects of the original 1918 building, Darling and Pearson. Ninety-two T. Eaton Company executives were included among the new "Life Members" in a large fund-raising campaign; Vincent Massey was selected to head the building

committee and Albert Robson the exhibition committee. Construction began in November 1924, and various committees, fuelled by additional new members, worked feverishly to organize the opening events.[2] Jackson's assistance was solicited to organize loans of works by J.W. Morrice, Helen McNicoll, Cornelius Krieghoff, and Tom Thomson, and of paintings from Montreal collectors.[3]

The new Art Gallery of Toronto opened on 29 January 1926 (fig. 135). Space in the building had been almost tripled, with a sculpture court dedicated to Sir Edmund Walker and galleries donated by H.H. Fudger in memory of his son, a friend of Lawren Harris, who had induced them to allocate this space specifically to Canadian art.[4] The opening exhibition was a major effort, including almost 500 works borrowed from Montreal, Ottawa, Toronto, and the United States, as well as strong representations of work by deceased Canadian artists as a tribute to "their contribution to the art of the country."[5] After a five-year campaign by the artists (including thwarting the National Gallery's efforts to acquire it), Thomson's *The West Wind* (fig. 134) was donated to the gallery by the Canadian Club at the instigation of Dr. Harold Tovell.[6]

The expansion of the art gallery opened up various new possibilities, and the Toronto artists recognized its importance. "One distinctly felt a new life awakening in the community; a zest and friendliness that promises the widest kind of public interest. It would seem that art is becoming a living and vital part of the life of the people, and that already the vision, enthusiasm, and

FIG. 134
TOM THOMSON
The West Wind 1917
Oil on canvas
120.6 × 137.5 cm
Art Gallery of Ontario, Toronto (784)
Gift of the Canadian Club of
Toronto, 1926

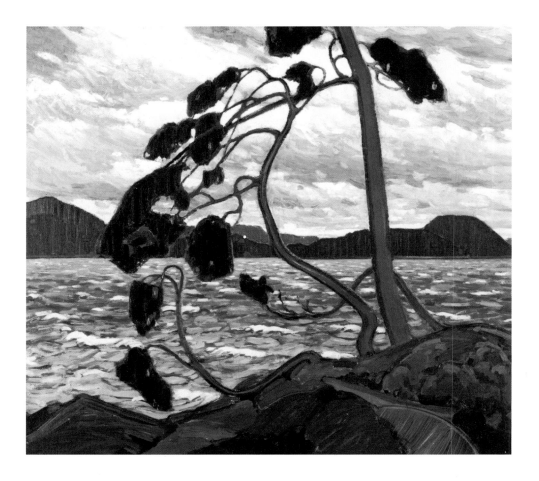

labour of those who created the gallery is being more than justified," wrote Harris.[7] Lismer contrasted the past exhibiting conditions for artists with the new purpose. "The artist of twenty-five years ago had to exhibit his work in stuffy and badly lighted galleries, the public crowded into small rooms – is it any wonder but few artists had the courage to tackle a work of gallery proportions, when their pictures were hung cheek-by-jowl in the closest possible proximity with other pictures, with never an inch of wall space between to preserve the peculiar identity of colour the artist had striven in his studio to obtain? No wonder it was the artists who were the first initiators of the movement for better conditions … The modern Art Gallery has moved out of the narrow exclusive possessive atmosphere of a few who desire to see art retain the element of pride of possession in a few chosen works – into a sphere of service, for true Art education is the elevating of creative activity or quality of human consciousness. To do this, the membership must be drawn from all classes – and the gallery must function freely as 'open house' to the public who are eager for information and enlightenment."[8]

In his article on the opening of the new gallery, Jackson counselled wisdom in the formation of the collections. "When one considers that it took us nearly ten years to make up our minds about *The West Wind*, it is clear that if we decide on the ambitious project of forming a permanent collection … a bolder policy is imperative."[9] The new and bolder policy was immediately initiated by the purchase of six watercolours by J.W. Morrice and the donation of $10,000 by Kate and Reuben Wells Leonard of St. Catharines, Ontario, specifically for the purchase of Canadian art. The first paintings acquired with the Leonard fund were by Clarence Gagnon, Laura Muntz Lyall, J.E.H. MacDonald, Albert Robinson, Mary Wrinch, and Curtis Williamson, all artists represented in the exhibition of nine Canadian artists held at the gallery in August 1926.[10] Jackson's *Barns* was purchased later that year, and further Canadian acquisitions were made in 1927. In recognition of the positive new direction, Harris donated three sketches by Tom Thomson to the gallery.[11]

For the first time in the Art Gallery of Toronto's history, it was able to direct its acquisitions, most importantly those of Canadian art, without having to rely on the selection committee of the Canadian National Exhibition. The responsibilities of the exhibition committee under the chairmanship of Albert Robson were expanded to include acquisitions, and an education committee was established chaired by Harold Tovell assisted by Arthur Lismer.[12] Lismer would become a salaried worker for the committee in February 1927, and that fall, having resigned from the Ontario College of Art over irreconcilable differences with George Reid, would direct the educational work at the Gallery under the supervision of the committee.[13] A new energy infused the gallery, as expressed in the exhibition program, the initiation of children's classes under Lismer, and the purchases of Canadian art, which would be further expanded by the formation of a subscription fund from the Friends of Canadian Art in 1930.[14]

FIG. 136. F.H. VARLEY, *Lake Shore with Figure* (cat. 103)

Folk Culture and the Railways

The upswing in the economy had an indirect effect on the two national railways as the increased use of automobiles and highway construction took away passengers. A more aggressive development of tourism was required, and both the Canadian Pacific (C.P.R.) and Canadian National (C.N.R.) railways launched into an extensive program of hotel construction and publicity, which

was most actively pursued by the C.P.R. under the direction of its general publicity agent, J. Murray Gibbon.

Gibbon, a Scot who had come to Canada in 1913 to take up his post, had studied art in London and Paris, was an author in his own right (he was the first president of the Canadian Authors Association), had a great interest in traditional folk cultures, and was keenly aware of the potentialities in the arts for the promotion of tourism.[15] In 1920, he arranged for publication of a booklet, *Chansons of Old French Canada*, to be sold to tourists at the C.P.R. hotel in Quebec City, the Château Frontenac. The booklet was illustrated by Ethel Seath and contained a preface by Marius Barbeau, an anthropologist at the Victoria Memorial Museum in Ottawa.[16]

Born in Sainte-Marie-Beauce, Quebec, Barbeau had studied at Laval University, the Sorbonne, and Oxford before joining the Geographical Survey of Canada in Ottawa in 1910. His two prime interests during his long and productive career were the traditional cultures of the aboriginal peoples and of Quebec. With great initiative and a keen sense of publicity, he worked to further knowledge of these cultures and to popularize them as part of a process of nation building.

In all of Barbeau's work, one intention was primary: to preserve those aspects of this heritage which he perceived as menaced by political, cultural, and economic changes, indifference, or hostility from a Europeanized and colonialized social elite. At the same time as he encouraged the maintenance of traditions, he saw them as a rich resource for a national, contemporary artistic expression.[17] In his introduction to a booklet commemorating the first folk festival organized at the Bibliothèque Saint-Sulpice in Montreal in 1919, he challenged his readers: "We come up against general indifference and frequently even haughty antagonism from certain intellectuals. In the eyes of these critics, it is futile, a mere amusement, to collect and publish folk tales and narratives of this country. Are not the lower classes by definition contemptible and ignorant? Are not their customs and language vulgar? At a public meeting, we were angrily reproached by a colleague from the Royal Society of Canada: 'Why do you persist in unearthing these inanities that we've been trying to discard for fifty years?' Others, literary hacks, have been asserting for decades that 'the only way to revive our literature is to closely imitate that of France, so let us immerse ourselves in modern French literature.' The fearful have warned us: 'Don't follow the example of those reckless individuals (Fréchette, Drummond, De Montigny) who have ubiquitously propagated the myth of the "French Canadian dialect," jamming colloquialisms in the mouth of their *habitants*. Don't arm our adversaries who maintain we speak like savages' . . . Instead of developing their faculties through contact with the many forms of nature, they relentlessly coat them in dogmatic precepts that lead to academic pedantry and destroy all insight. What could be more irritating than the subservience or intellectual parasitism that prompts an individual to perpetually cling to someone or something?" In the face of

indifference and hostility, he offered inspiration. "As original and suggestive as the folk document is, it is not for the exclusive use of the scholar and historian. From an artist's point of view, it is eminently suited to academic pursuit. The great European masters have constantly drawn from the popular sources of their country. Why shouldn't their Canadian disciples be inspired by their example?"[18]

Barbeau and Gibbon shared common interests and would work together on a number of mutually profitable enterprises throughout the twenties. Their first co-venture resulted from Gibbon's invitation to the young American artist Langdon Kihn to visit the Stoney reserve at Morley, Alberta, in 1922, in order to publicize the annual Indian Days celebration held at the Banff hotel. The Canadian Pacific Railway purchased eighteen of Kihn's portrait drawings and commissioned Barbeau to write *Indian Days in the Canadian Rockies*, paying for the illustrations which reproduced Kihn's drawings.[19] At the instigation of the book's publisher, Hugh Eayrs of the Macmillan Company of Canada, and through Lismer, the drawings were shown at the Arts and Letters Club in March 1924 and subsequently at the Art Gallery of Toronto.[20]

The following April, Barbeau lectured and the folk singer Philéas Bédard sang at the Empire Club of Canada in Toronto and at the Arts and Letters Club, and Barbeau announced to the press that "The artists have dared to blaze a trail ... The Group of Seven have caught something of the vitality of the real Canada. When will our musicians and poets follow suit? Soon, very soon. Canada will then come into her own."[21]

In August 1925, with passes from the C.P.R., Jackson and Lismer and his wife and daughter joined Barbeau and his family on the Île d'Orléans, where he was studying, with Ramsay Traquair, a professor of architecture at McGill University, the churches of Sainte-Famille and Saint-François.[22] After a short stay on the island, the group visited the sculptor Louis Jobin at Sainte-Anne-de-Beaupré, Barbeau's first meeting with the artist,[23] and then travelled to Baie-Saint-Paul, Île aux Coudres, and Saint-Hilarion. This was Jackson's first visit to the last village; he would return the following winter.[24] Both he and Lismer were delighted with their trip and became enthusiastic participants in Barbeau's projects. Two sculptures by Jobin were acquired for the Art Gallery of Toronto,[25] validating Barbeau's perception of their merit as works of art rather than craft, and both Jackson and Lismer wrote articles about the trip. Jackson depicted Jobin as the heir of a centuries-old tradition of Quebec woodcarving established by Mgr. de Laval at Saint-Joachim in the seventeenth century, a theory dear to Barbeau's heart, and one that would rapidly enter the narrative of the history of Canadian art. "In many of the figures there is a certain rude vigour that is in harmony with the early architecture. They both grow out of the soil. We do not feel this with the early painting. The painters studied in Europe and kept on doing as they were taught with no interest in their environment."[26]

Both Jackson and Lismer also quickly became intermediaries between the Women's Art Association of Canada in Toronto and some of the weavers on

the Île d'Orléans, at Baie-Saint-Paul, and on the Île aux Coudres. Jackson had met several of them before through Clarence Gagnon, most notably the Cimon family of Baie-Saint-Paul,[27] and by the mid-twenties there was a lively tourist trade in weaving from this region. The Canadian Handicrafts Guild, through their numerous outlets, had been encouraging and marketing the work for almost two decades,[28] and Holt Renfrew sold woven goods through its shop at the Château Frontenac.[29] But for Lismer, the weavers and their work were a great discovery, which he identified as the expression of the unacademic spirit of creativity. "In a life of toil, fraught with economic struggle, the capricious vagaries of weather and fortune of crops, the simple idea of the necessity of creation is a fundamental virtue of humanity. And work that by others is classed as decoration is, to the creators thereof, a living, vital, expression, an absolute necessity."[30]

Lismer's belief in the importance of "Canadian craftsmanship of a distinctly national type"[31] once again clarified the limitations of traditional thought. "In an academic course the useful arts have no place – Design is looked down upon – the applied arts belong to the shop & commercial art is anathema – & illustration & lettering & any imaginative form of study that might be classed as non-academic [are] excluded rigorously from academic schools … Art is a quality of human consciousness of slow growth in any nation & the problem in Canada of Art Education is how to reconcile the demands of a growing country of commercial & industrial needs & to also supply the necessary stimuli towards the growth of a love for beauty & the Fine Arts as one of the essential ways of revealing a nation's ideals."[32] Just as he had earlier argued for the appreciation of art "as an economic, industrial and aesthetic factor in the life of the community,"[33] he now asserted, "we need to develop national standards of design to utilize our wealth of natural form & weave it into the artistic expression of our people."[34]

Art in French Canada, 1926

Barbeau's invitation to Jackson and Lismer to join him that summer was always linked to the idea of a possible exhibition,[35] and in the fall of 1925 plans were completed for a show to coincide with that of the Group of Seven at the Art Gallery of Toronto in May (fig. 137).[36] Lismer's and Jackson's canvases of Baie-Saint-Paul, Île aux Coudres (fig. 139), and Saint-Hilarion (fig. 133) were included in the Group's exhibition, and *Art in French Canada* consisted of paintings by the Group's younger associates in Montreal and paintings and sculpture by more senior artists, including Maurice Cullen, Alfred Laliberté, Ozias Leduc, Robert Pilot, Marc-Aurèle de Foy Suzor-Coté, and Horatio Walker. Marius Barbeau selected textiles from the Lower St. Lawrence and Assomption sashes and carvings by Jean-Baptiste Côté, Louis Jobin, and the Levasseur family, and a further selection of rugs and 'homespuns' was loaned by the Women's Art Association. Barbeau lectured on the early arts of Quebec and Quebec folk song accompanied by Philéas Bédard.[37]

FIG. 137
Thoreau MacDonald: Cover for the catalogue *Exhibitions of the Group of 7 and Art in French Canada* (Toronto: Art Gallery of Toronto, 1926).

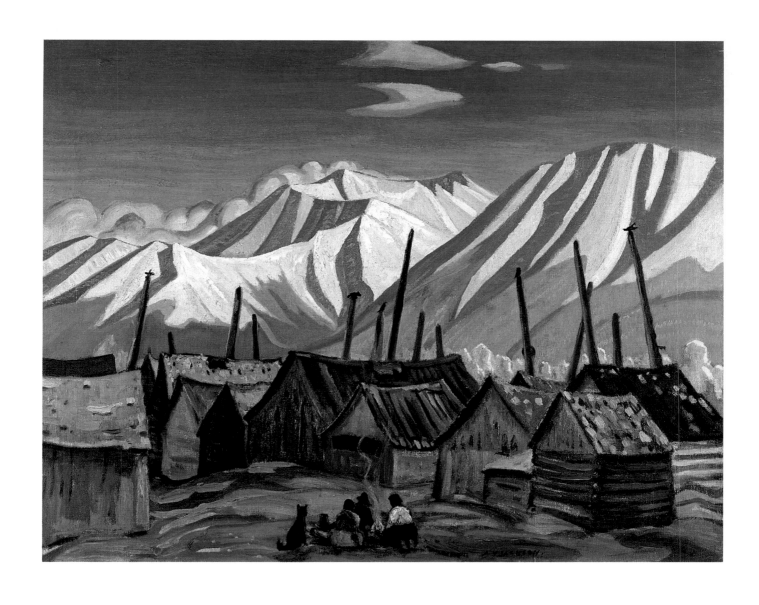

FIG. 138. A.Y. JACKSON, *Kispayaks Village* (cat. 115)

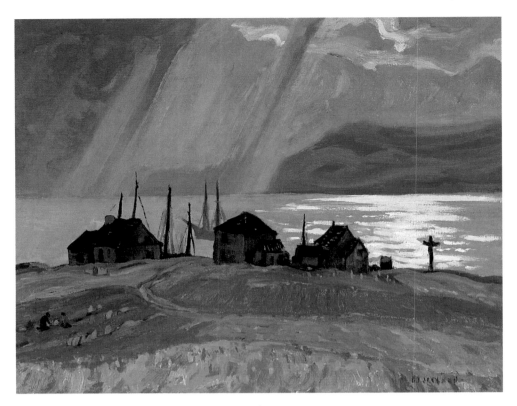

FIG. 139. A.Y. JACKSON, *Île aux Coudres* (cat. 98)

Hastily organized by Jackson and Barbeau,[38] and consisting of only fifty-five catalogued items with some painters represented by just one work, the exhibition was a somewhat awkward combination of modern, conservative, and traditional. While it was favourably received, the reviewers' attention was distracted by the Group's exhibition. Charlesworth, however, was delighted to see the return of the senior Quebec artists. "Comparisons must be odious in this instance and it is sad to have to record that the Montreal artists represented in the gallery devoted to an exhibit of the art of French Canada put Toronto's Group of Seven far into the shade even in subjects of a type which the latter claim to have made their own ... if one wants to know how a typical Septimist theme with intense azure hues can be beautifully and sincerely handled one has only to look at *Evening on the North Shore* by Clarence Gagnon," he declared. "Perfect in drawing and perspective," full of "genius in colour and atmospheric quality," the paintings by Gagnon, Walker, Leduc, and Suzor-Coté assuaged Charlesworth's spirit after the Group's show — "as weird [a show] as any reformed opium-eater craving for a momentary return to the old thrills could wish."[39]

Quebec Festivals, 1927, 1928

One planned feature of the Toronto exhibition that was not realized was a program of folk songs to be set to music by Ernest MacMillan and interpreted by Campbell McInnes.[40] Essential to Marius Barbeau's larger program was the production of contemporary works inspired by traditional art forms,

Manufacture and *L'Ordre de Bon Temps* — the latter with sets by Arthur Lismer after C.W. Jefferys. Lismer also designed sets for Campbell McInnes's musical group, the Canadian Singers, and his drawings illustrated the programs. The most ambitious production was the thirteenth-century play *Le Jeu de Robin et Marion*, with a libretto modernized by Léo-Pol Morin, produced and conducted by the Montreal-born conductor of the New York Metropolitan Opera, Wilfrid Pelletier, and with sets and singers from New York. E.W. Beatty, the president of Canadian Pacific, awarded musical prizes of $3000 in various categories.[45]

The response this year was not unanimously enthusiastic. Robert Choquette, the newly appointed literary editor of *La Revue Moderne*, queried, "when the organizers ... include country people in the program, does this help French Canadians or harm them? ... it's true that every country in the world holds these national displays for the benefit of foreigners; it's especially true that visitors, if they're not blind, need only observe artists like Plamondon, soloist at Saint-Eustache and tenor at the Opéra, the internationally renowned Albani, Wilfrid Pelletier, conductor at the Metropolitan, Alfred Laliberté, a student of Scriabin, Claude Champagne, Achille Fortier, and the young Hector Gratton ... to be convinced that the French Canadian race is not made up solely of *coureurs-de-bois* ... Songs rooted in our agrarian tradition that have been reworked, harmonized, and performed by true artists are delightful to hear ... But sung by *habitants*, these melodies, which are supposed to move us, can, in all honesty, only amuse us, and even more amuse foreigners ... Purged of all these inevitably mediocre numbers, the Quebec Festival would be the perfect occasion to present what is unanimously judged to be the annual musical bouquet of our finest talent."[46]

Choquette failed to appreciate Barbeau's admiration for the authenticity and quality of the unaccompanied songs sung by such original rural performers as Philéas Bédard. In Barbeau's mind, there was a definite difference between these and the arranged and accompanied songs performed by professionals like Juliette Gaultier.[47] Some of Barbeau's old associates in the folklore movement perceived such arrangements with a critical eye, however. "It must be rare to hear popular Scottish songs performed by Germans, or Irish songs interpreted by Italians. When the singer lacks the Anglo-Saxon's ear for the language, doesn't it seem to remove some of the ... flavour from the rendition or recital? I find something strange and inauthentic in this."[48]

The stress of organizing the festival had created problems between Gibbon and Barbeau.[49] Gibbon was not a great admirer of the newer Canadian art, as demonstrated by the artists he selected to illustrate his own books,[50] and he was suspicious of Lismer's and Barbeau's plans for the various theatrical sets. As a publicity agent for the C.P.R., his prime concern was to attract international attention to the festivals to increase tourism and hotel business. Already he had deleted from Barbeau's *Indian Days in the Canadian Rockies* the author's criticisms of the missionaries as inappropriate in a popular book,[51] and he had included French troubadour music in the festival programs to

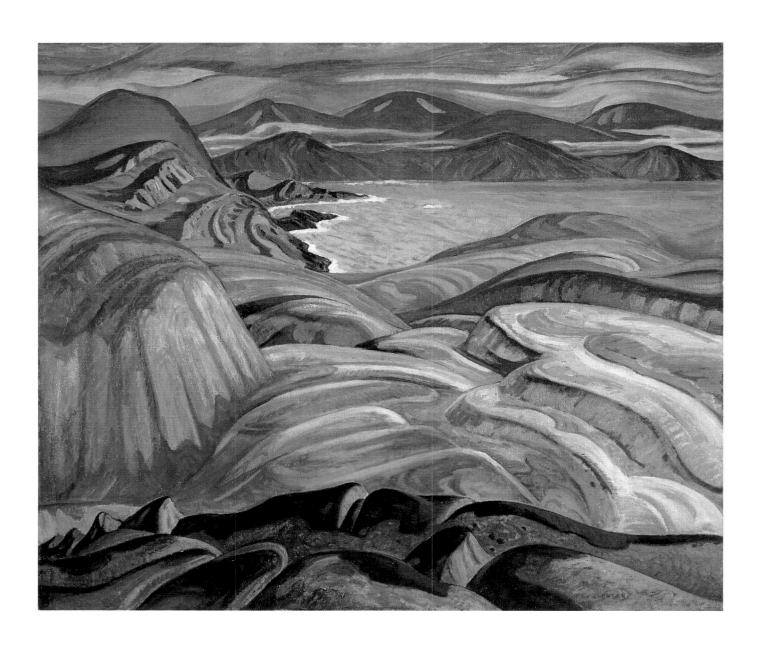

FIG. 144. A.Y. JACKSON, *Labrador Coast* (cat. 112)

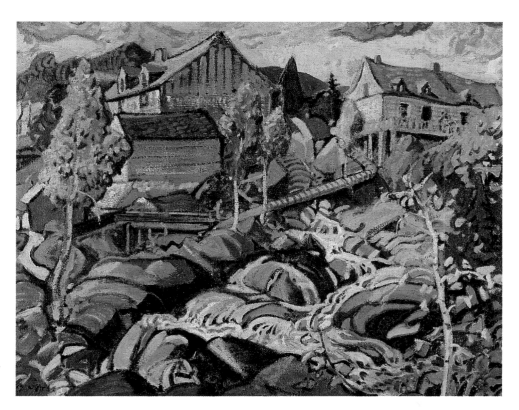

FIG. 149. ARTHUR LISMER, *The Mill, Quebec* (cat. 100)

respond to criticisms of folk music such as those articulated by Choquette. Gibbon stated his position clearly when the Toronto dramatist Herman Voaden, a great admirer of the Group of Seven, approached him about producing Voaden's play *Symphony* in 1931. "I do not see how we could make any use of [*Symphony*], as it does not appear to have the slightest relation to the Canadian Pacific Railway, which is essentially an optimistic undertaking and could not be identified with anything so gloomy and morbid ... As regards Ballad Operas ... if the music does not appeal to the audience, the production might as well be considered wasted effort ... So far as my own personal opinion is concerned, the Group of Seven and the aesthetic movement which is associated with it is no doubt interesting, but seems to represent only one phase of Canadian artistic endeavour ... Canada is not limited to the barren lands of Ontario or the high peaks of the Rockies."[52]

Barbeau's prime goal, by contrast, was "artistic presentation of our Canadian folk songs and folk crafts" to popularize and preserve them and provide inspiration for contemporary arts. Gibbon's influence had led the festival in a different and more professional direction, and Barbeau declined his invitation to participate in the 1930 Quebec festival,[53] although they would work together on other projects in the thirties.

Skeena River Project

Marius Barbeau's activities did not bind him to the concerns of the Canadian Pacific Railway, and specific projects by necessity fell into the sphere of the

Canadian National. The Skeena River, a long-time interest of his, was C.N.R. territory. Barbeau had begun research on the history, social structure, oral traditions, music, and arts of the Tsimshian in the Skeena River area in British Columbia in 1914. There he had visited the villages of Hazelton (Gitenmaks), Hagwilget, Kispayaks, Gitsegyukla, and Kitwanga, which were rich in carvings, totem poles, and unique grave houses situated in a superb natural setting. In the spring of 1924 he submitted a "petition from the residents of Hazelton" to the Canadian National Parks requesting that a national park and game preserve be established in the neighbourhood of Hazelton and that the villages in the area be declared historic sites to ensure the preservation of the houses and poles, so intimately linked to the "mythical and historical traditions of the region."[54]

The proposal was to preserve the poles in the villages to prevent their removal and export, and to encourage tourism through the promotion of the area's scenic beauty, big-game hunting, and fishing, and the revival of carving, jewellery making, and weaving. At the core of Barbeau's plan lay the story of Temlaham, a legendary "garden of Eden" or "Paradise Lost," whose site Barbeau identified as being located two miles below Hazelton, at the bend of the Skeena River below the Rocher Déboulé mountain. There, he suggested, a museum might be constructed in "the form of one of the old Indian Council Houses, built in the ancient manner, of split cedar and with carved corner posts."[55]

The C.N.R. was equally interested in the restoration and preservation of the poles *in situ* to promote tourist traffic, as the railroad line from Jasper to Prince Rupert was being run at a deficit.[56] In June 1924, a "Totem Pole Preservation Committee" was established, composed of Duncan Campbell Scott, the deputy superintendent general of Indian Affairs, J.B. Harkin of Parks, and Edward Sapir and Marius Barbeau of the Victoria Memorial Museum. The Department of Indian Affairs would finance and supervise the restoration of the poles in the villages (with the permission of the owners), siting them so as to be visible to tourists, and the C.N.R. would provide free transportation for the men and materials plus the services of one of their engineers. There appears to have been little further discussion of a park, museum, or revival of local arts. Restoration and reinstallation of the poles began in the summer of 1925 at Kitwanga.[57]

During the summer of 1924, Barbeau returned to the Upper Skeena with Langdon Kihn, and an exhibition of the season's drawings and paintings, including portraits and landscapes, was shown in the Railway Committee Room of the Parliament Buildings in Ottawa and at the Arts Club of Montreal the following spring.[58] Two of the canvases were also selected for inclusion in the 1925 Canadian art exhibition at Wembley. The intent was to publicize the importance of the work on the Skeena through representation of its people, totem poles, and landscape, and Barbeau was most concerned to keep "this unique record of aboriginal life" in Canada.[59] F.N. Southam of Montreal finally purchased twenty-seven of Kihn's Skeena works, which he

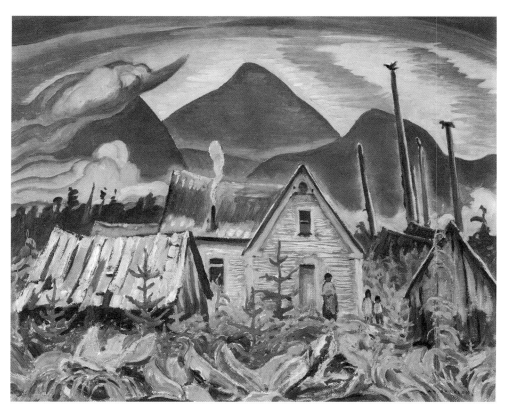

FIG. 150. A.Y. JACKSON, *Indian Home* (cat. 114)

donated to museums in Montreal, Ottawa, Toronto, Winnipeg, Vancouver, and Victoria.[60]

While in British Columbia in 1926, Jackson discovered the work of a Tsimshian artist, Frederick Alexei, and he urged the eastern galleries to take an interest in his paintings. "The picture I bought I hope to pass on to the Toronto gallery. It has decided character and all the Academy crowd in Canadian art haven't any."[61] That same autumn, while lecturing at the University of British Columbia, Barbeau was contacted by a Victoria artist, Emily Carr.[62] Carr had not been able to pursue her early ambition to depict the poles and villages of the coast, being blocked by day-to-day necessities and financial obligations, and in the 1920s when she resumed painting had confined her work to landscapes. It was only in her hooked rugs and pottery that she pursued her interest in Native arts. Soon both Carr and Alexei became part of a larger and more ambitious project.

Canadian West Coast Art: Native and Modern, 1927

Once again an exhibition of indigenous material, together with contemporary works by artists inspired by the environment would be part of a program to bring these unique Canadian art forms to public attention and to underline the necessity for their preservation.[63] Barbeau arranged for Jackson and Holgate to visit the Skeena on passes provided by the C.N.R. in the summer of 1926.[64] They worked at Usk, Port Essington (fig. 151), Kitwanga, Skeena Crossing (Gitseguklas), Hagwilget, and Hazelton, both artists sketching the landscape

FIG. 151

A.Y. JACKSON
Indian Home, Port Essington 1926
Oil on panel, 21.1 × 26.6 cm
McMichael Canadian Art Collection,
Kleinburg (1968.8.3)
Gift of S. Walter Stewart

and ports, grave houses, totem poles, and houses. Some of Jackson's drawings are clearly documentary in intent, while in others he explored motifs for paintings of the poles and villages in their landscape setting; Holgate drew large, expressive portraits, far more accomplished than Kihn's finished illustrations.[65]

Barbeau's plan, as developed with Jackson and others, was "to exhibit jointly a considerable number of West Coast Indian carvings and paintings and a certain number of modern paintings by Canadian artists, which might serve as interesting background to the Indian art motives ... the exhibition is to bear the name *Indian and Modern Art from the Canadian Rockies* ... Both the Indian carvings and the modern interpretation of their surroundings seem of unusual interest ... [The exhibition] would, besides, act as a stimulus towards the discovery of one of the most valuable artistic fields we have in Canada."[66] The modern artists selected included Kihn, Jackson, and Holgate, and "to add a touch of the eastern range of the Rockies we should have something of Lawren Harris and J.E.H. MacDonald. Mr. Varley, who now lives in Vancouver, may have something to contribute, something worth while. Miss Emily Carr of Victoria has made interesting paintings in which the West Coast scenery and totem poles are included."[67] The number of artists was further expanded when Barbeau obtained railway passes for Pegi Nicol of Ottawa to work on the Stoney reserve at Morley, Alberta, and for Anne Savage and Florence Wyle to work on the Upper Skeena.[68] Barbeau spent that summer on the Nass River with Ernest MacMillan recording songs.[69]

Linked to this project was the publication of Barbeau's own retelling of the legends of *The Downfall of Temlaham*, to be illustrated with a selection from the works by Kihn that had been purchased by Southam;[70] he hoped that the colour illustrations would be paid for by the railway. "I think Kihn's work would greatly benefit the publicity of the C.N.R. and help in the undertaking of the conservation of totem poles and the beautiful myths of Temlaham. Your company assisted in his coming to the Skeena. His work certainly was essential in our campaign for the conservation of the totem poles. I hope it may still have further influence in bringing about the establishment of an Indian National Park on the Upper Skeena," wrote Barbeau, soliciting the company's support.[71]

House poles, masks, and ceremonial objects, as well as apparel and carved chests and argillite, were borrowed from the newly renamed National Museum, the Royal Ontario Museum, and McGill University, and, together with works loaned by Barbeau and the artists, formed the exhibition *Canadian West Coast Art: Native and Modern*, which opened at the National Gallery in Ottawa in the first week of December 1927. A hastily prepared catalogue,[72] with a cover designed by Emily Carr (fig. 152), who had come east for the opening, contained a preface by Eric Brown and a short text by Barbeau. Brown asserted the importance of the work of the West Coast tribes "as one of the most valuable of Canada's artistic productions ... an invaluable mine of decorative design which is available to the student for a host of different purposes and possessing for the Canadian artist in particular the unique quality of

FIG. 152
Emily Carr: Cover for the catalogue *Exhibition of Canadian West Coast Art Native and Modern* (Ottawa: National Gallery of Canada, 1927).

FIG. 153
Installation of the *Exhibition of Canadian West Coast Art* at the Art Gallery of Toronto, January 1928. To the immediate left of the door are paintings by Emily Carr and Frederick Alexei.

being entirely national in its origin and character," and Barbeau stressed once again the importance of art in the older communities: "Their art was no idle pursuit for them or their tribesmen but fulfilled an all-essential function in their everyday life."

The objects were generically catalogued by type with no individual entries except for a short description by Barbeau. Frederick Alexei was represented by two works, including one loaned by Jackson, and listed in the "West Coast Indian Art" section, together with Emily Carr's rugs and pottery. Carr had an additional twenty-six oils, all dating from before 1914, the largest number by any single artist, listed in the section devoted to "Works by Canadian Artists."

The Ottawa reception of the show was cool and Carr, for one, was devastated;[73] however, Jackson and Lismer worked to ensure that the presentation in Toronto would be a success (fig. 153). Two films, one on the Kwakiutl and one on the Nass River were shown, Gaultier performed renditions of Native music backed by Kihn's sets to a full house, and Barbeau gave a public lecture affirming once again the essential relationship of art to life as evidenced in the culture of the West Coast peoples.[74] "Carving, painting, singing, dramatic art, and social standing in the community were all part of each other ... art was not a luxury to those people; it was the most vital necessity in life, next to food." Erroneously relegating the artistic production of the Native tribes to the past, he defined their art as their legacy to the future and a warning to other Canadians. "A people without art is devoid of self-expression, of soul. [A] materialistic people leave the country a vacuous waste in the eyes of posterity ... These West Coast nations will live long for their art. The museums of the world now treasure their works, and our artists are turning to their themes for inspiration. It has already been said by one critic abroad that the only form of art that can be called Canadian is that of the West Coast tribes. The new American nationalities have not yet come into their own ... [But] the Awakening is already with us ... our painting, as an original contribution to the history of art, is already gaining recognition abroad. Art to many Canadians is no longer a luxury, but a means of self-expression, a step towards a culture that will some day be distinctly our own.... The manifestations of Canadian art, both ancient and modern, are of vital significance. They speak of the country that is ours. They are searching and original. They express the independent personality of remarkable artists. They strive after a beauty, a truth, an expression that comes from the soul and the heart ... Something of our time will survive and there is little danger that culture, once become a vital part of ourselves, will cease to exist."[75]

Attendance was good in Toronto but poor in Montreal;[76] however, the journalists were delighted with the show, especially with the Native art works and the paintings of Emily Carr.[77]

As a result of seeing all the work together in the West Coast show, and with the encouragement of Jackson, Barbeau revised his plans for illustrating

The Downfall of Temlaham to include works by Jackson, Holgate, Carr, Savage, and Kihn.[78] Jackson designed the dust jacket, initials, and decorations, which were redrawn by Thoreau MacDonald, and the book was released in July 1928. Holgate was delighted and "pleased to think it was a Canadian affair throughout."[79]

~

Marius Barbeau would continue to encourage artists to paint on the Upper Skeena, and generations of painters would work in Charlevoix County, which he did so much to popularize. Jackson never returned to the Skeena, and though he went to the Lower St. Lawrence region for decades, was not directly involved in Barbeau's projects again. Lismer's 1925 drawings were reproduced in a number of books and articles over the years. Marius Barbeau had implanted a new perception of Canada's culture and history into receptive soil; it would now be incorporated into the histories and definitions espoused by the Group.

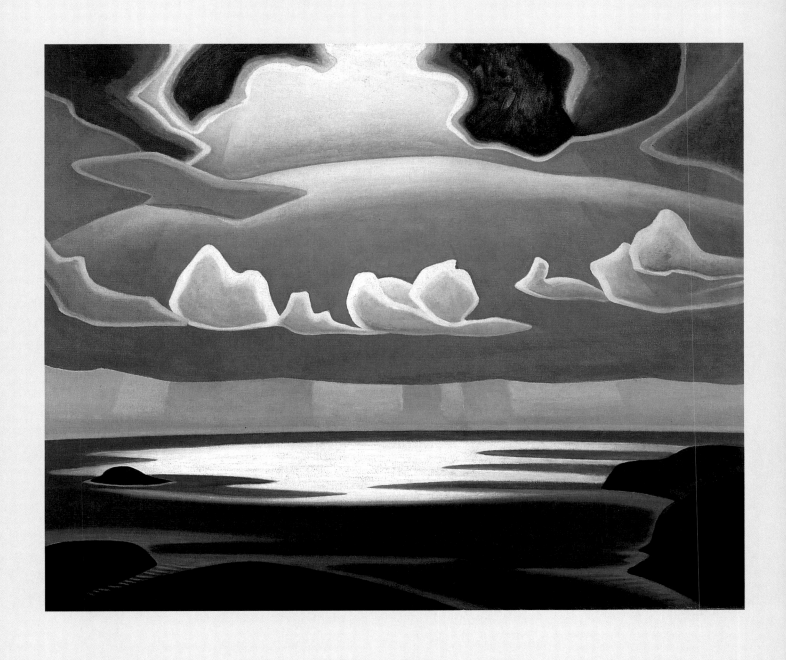

FIG. 154. LAWREN S. HARRIS, *From the North Shore, Lake Superior* (CAT. 110)

11

*At Home
and Abroad*

he latter half of the decade saw an even greater expansion of
the Group's activities and influence. Their paintings would be
exhibited in Philadelphia, Paris, New York, and across western
Canada. New relationships developed as they continued to
encourage the growth of collections of modern Canadian art,
and new battles with the conservatives would be fought. A.J. Casson became
the seventh member of the Group in 1926, and they supported an increasing
number of independent and younger artists. Finally, a private, though tenta-
tive, market for their paintings slowly appeared.

Group of Seven Exhibition, 1926

It was Lismer who exhibited the greatest number of works resulting from the
1925 trip to the Lower St. Lawrence with Barbeau – six canvases and eight oil
sketches, including the large canvas *Quebec Village* (fig. 133) and *The Mill, Quebec*
(fig. 149). Jackson, who preferred Quebec in the winter months, showed only
Summer, Baie-Saint-Paul and his storm-wracked *Île aux Coudres* (fig. 139) in the
1926 Group exhibition. He had the largest number of canvases in all, followed
by Lismer and Harris, with three new portraits, including one of Salem

FIG. 155. ARTHUR LISMER, *Evening Silhouette, Georgian Bay* (cat. 116)

Bland (fig. 114). Varley showed a number of intimate studies of his children and family, some painted at Bobcaygeon in 1923 (fig. 156). MacDonald had only one new mountain canvas, all the others having been previously exhibited, including *Solemn Land* borrowed from the National Gallery. Once again the artists presented oil sketches along with the paintings, and Carmichael showed some watercolours (see cat. 90–105).[1]

After years of informally incorporating a seventh member, the Group had finally decided who Johnston's replacement would be – A.J. Casson, Carmichael's close friend and assistant at Rous and Mann.[2] Possibly this was a last-minute decision, as he is listed in the catalogue with the invited contributors together with nine other young artists. This was the largest number of non-members ever included in a Group show, reflecting a renewed effort to support younger, non-academic talent. The artists included Thoreau MacDonald, exhibiting paintings for the first time, and four former students at the Ontario College of Art: John Alfsen, George Pepper, Tom Stone, and Lowrie Warrener. Anne Savage, already well known for her innovative teaching at the Baron Byng High School in Montreal, was the only Montrealer this year, as Holgate, Coonan, and others were included in the adjacent exhibition *Art in French Canada*. The three remaining artists were the "amateurs," Doris Huestis Mills, her sister, Marion Huestis Miller, and Bess Housser.

A handsome catalogue with a cover designed by Thoreau MacDonald was published with, once again, an introductory text (fig. 137). "The Group of Seven realize that subject is not necessarily an ingredient of a work of art. Nevertheless it also feels that Canadian environment is the most potent

FIG. 156. F.H. VARLEY, *Evening in Camp* (cat. 102)

stimulus to Canadian creative genius. Even though an artist may not necessarily look for the support of approval from his people, it is from them that he must draw his inspiration."

On the eve of the opening Jackson wrote to a friend: "Our show is mostly hung and is going to be very interesting. MacDonald has done nothing and Casson looks very mild. Thoreau, Doris and Bess all look very perky but are going to come in for a lot of criticism I expect. Carmichael has the best stuff he has done and Lawren has lots of good things."[3]

The response was immediate. Augustus Bridle's first review appeared in the *Star* the evening of the opening. In his usual breezy journalese, he opened: "The school of seven ... have reached new heights, mostly mountain heights ... The air breathes an exhilarating pictorial ozone which will give heart failure to those who are not accustomed to climb higher in the scale of Canadian landscape grandeurs than the suburban prettiness of the Don and Humber valleys or the level loveliness of the Niagara peninsula."[4] In the *Star Weekly* he

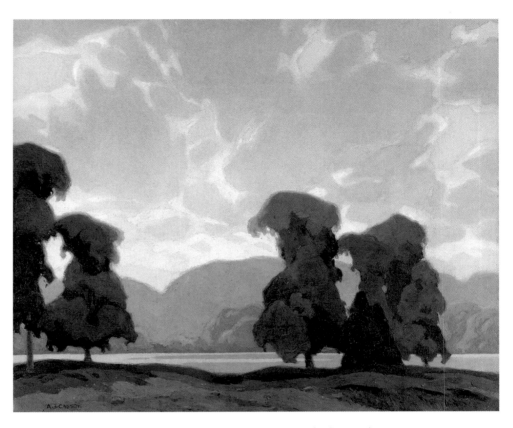

FIG. 157. A.J. CASSON, *Afternoon Sky* (cat. 92)

expanded: "I have never seen so much colour, paint, light, texture, technique with so little normal human life. Nearly all these pictures are of places in which nobody ever can live and where even trees have a hard time to hide the rocks. Nine-tenths of the rest are of shacks more desolating than the rocks ... To have painted so many dehumanized, deanimalized and unpastoral pictures without resorting to sheer symbolism is a proof that, however dead the subjects of some pictures may be the painters are very much alive ... it's the landscape of ideas more than of life [and] Harris dominates the exhibition."[5]

With his large *Mountain Forms* (157.5 × 203.2 cm) and fourteen other canvases, Harris dwarfed all the other artists to the point where one visitor proposed the removal of their work so as not to distract from his solo show.[6] "Undoubtedly, Lawren Harris is the man who will cause the most gnashing of teeth in the present exhibition," wrote Fred Jacob. "He marches steadily ahead with his process of simplification so that his pictures are more and more hard sheets of color. In their design, they frequently suggest ideas for stage sets or backgrounds, and most of his work is very remote from realism."[7] One writer compared Harris's mountains to "a hashish eater's dream,"[8] but Bridle was enthusiastic: "His mountains rise like great teeth of cosmic lime out of calm lake pedestals and are as sculptural, as enigmatically mathematical as Epstein. He achieves a remarkable structural synthesis and present[s] landscape purged of its grossness of detail in quintessential symbolism."[9]

Harris's *Miners' Houses* (fig. 161), which was exhibited in the aftermath of one of the most violent and protracted strikes ever at the British Empire Steel

Corporation (Besco) collieries in Glace Bay, Cape Breton, was identifiable to all as a "social tract done in paint"[10] and a "study of the horrors of Glace Bay. It might properly be called 'Dies Irae', and looks like a scene from Dante's *Inferno*. Two rows of thin starved houses stand like rows of sepulchral monuments along the Appian Way, or like crucifixes on the skyline of a place of skulls. The street between these rows of cottage cadavers is like a stream of lava. The greenish indigo sky is cleft with a shaft of vengeful light as if signifying the impending wrath of Heaven. It is a powerful satire on industrial peonage."[11]

FIG. 159. LOWRIE WARRENER, *Bats Fly Merrily* (cat. 105)

Harris had visited Cape Breton in the midst of one of the worst periods of the strike. From there he sent a profile to the *Toronto Daily Star* of Dr. F. McAvoy, a Baptist minister from Glace Bay who four days previously had confronted Prime Minister Mackenzie King in the House of Commons.[12] McAvoy had been instrumental in planning and organizing a relief system for the workers even before the strike began. "Only by the quickest thinking and most strenuous work could McAvoy and his committee keep one day ahead of starvation." All this took place against the background of Glace Bay, which "is really no town," wrote Harris, "but a number of huddles of box-like houses around scattered coal mines, all loosely tied together by muddy roads and a streetcar loop line to the main street of stores and amusement places. It's a sordid place, it's drab and dreary and bedraggled even on a sunny day. The miners' houses are in monotonous rows on either side of beaten earthen lanes and refuse-filled ditches, and behind them the yards are sour. There is no vegetation ... These people strain every nerve for a way out, look everywhere for a ray of hope, search all men for a solution, where perhaps there is none. They constantly face starvation, they face the sight of their wives and children suffering from squalor and privation and hunger, they face utter dejection, complete loss of faith in mankind, there is left [to] them only 'the bondage of hopelessness'."

FIG. 160. GEORGE PEPPER, *Sunflowers* (cat. 104)

While Harris's paintings received the greatest attention, reviewers did not fail to notice the change in Carmichael's work, the result of his 1925 trip to Lake Superior with Harris and Jackson. "He, too, is becoming as grim as possible ... Frank has gained in power and lost in beauty. Perhaps that's the idea." Of Lismer's palette, Bridle wrote, "At times he comes near to making the ugly beautiful. So many counter rhythms in one picture often run away with the line of melody. But his rhythms, jumbly and agitated, are never without vitality, perversity, and joy."[13] Casson was clearly the odd man out. "The newcomer to the Group of Seven does not experiment with modernism. He is a fine colourist with a feeling for Canadian landscape. To those who know and love the scenery of civilized Ontario, Casson speaks with eloquence. His canvases will form resting places for those visitors to the present show who cannot understand Lawren Harris."[14]

As predicted, the critics were hard on the "invitation-imitators"[15] in the "'salon aux croûtes' or daub room."[16] Said Fred Jacob, "The work of the younger modernists is not very encouraging. Most of them are imitative to a

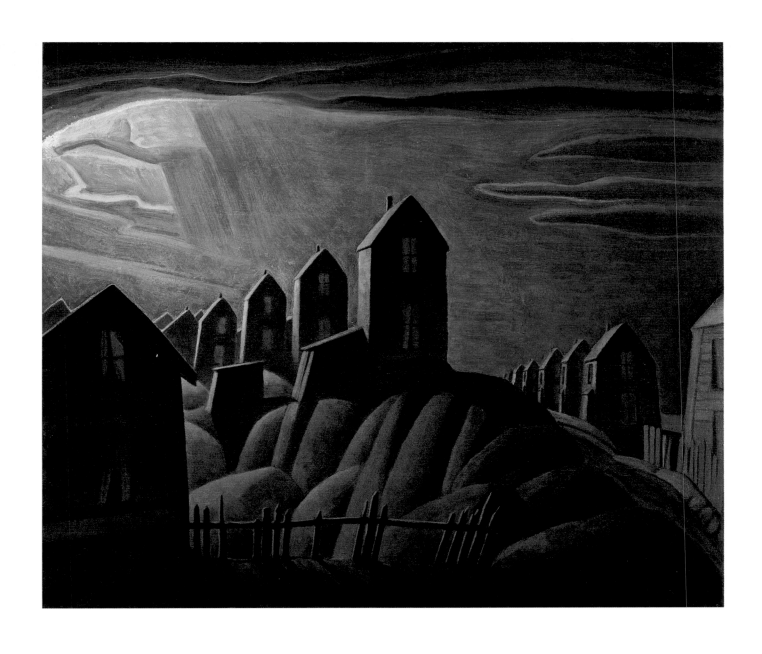

FIG. 161. LAWREN S. HARRIS, *Miners' Houses, Glace Bay* (cat. 93)

marked degree. You find disciples of Lawren Harris in considerable numbers repeating the Harris houses, snow, humble homes, and valleys, but minus the Harris virility."[17] Brooker[18] and Housser spoke up for them in response. "Their work as a whole is bold, venturesome, and with a modern snap. They have started in to make their contribution to Canadian art with the ground ploughed and harrowed by the Group of Seven. They are not imitators, as the critics would have us believe, but their intuition has apparently caused them to hold a similar philosophy of expression to the Group of Seven. Their fearless unconcern [for] the conventional essentials of humdrum painting prompts the feeling that they will carry Canadian art still further on the road."[19]

Charlesworth, true to form, came out with one of the most vicious and unjustified attacks ever against the Group. "The numeral 'Seven', whatever it meant once, is of course merely cabalistic in meaning today like the phrase 'Ku Klux Klan'. In fact the extravagances of the group suggest a certain affinity with the KuKluxers. The latter excuse their vagaries by calling themselves 100 per cent American, and the Septimists proclaim themselves 100 per cent Canadian."[20] To read ethnic purity and isolationism into the Group's goals was a complete misinterpretation of their intent. National self-affirmation was not limited in the artists' view to Canada, as evidenced by Harris's admiration for AE, the Irish nationalist, and by his review of Romain Rolland's *Mahatma Gandhi*. Harris contrasted Gandhi as a spiritual leader with the imperial attitude. "And here we have as contrast the so sad spectacle of an alien English people ruling India for their own ends, breaking pledges, fostering enmities, resorting to violence, to wholesale incarcerations, to the massacre of utterly defenceless people, for no other discoverable reason than a vague fear of losing something … Our Western way of national aggrandizement, the present-day heritage of a perverse Europe, turning religion into an endorsation of conquest and cruelty and hate, is indeed far removed from the ideals of Gandhi."[21] The Group's campaign to shake off the shackles of colonialist thinking, to validate Canada aesthetically and culturally, and to further a national expression represented Canadians' first steps towards making an international contribution in their own terms. "A people must become individualized before the universal can have any meaning for it," wrote Harris. "It must give life to its own *particular* attitude, which depends on the interplay of its time, its place on earth, and its capacity, before it can become aware of the universal spirit that informs all great manifestations and all noble living. It must create before it can hope to comprehend the creative results of other peoples and other times."[22]

Attendance for the 1926 exhibition was down from the previous year at 4196, and only a Carmichael and a Harris sketch sold.[23] Later that year, Hart House bought Carmichael's *Snow Clouds* (fig. 146) and Vincent Massey bought Jackson's *Manseau, Quebec* (fig. 140). To permit all the members of the newly expanded board of trustees to decide on acquisitions, the National Gallery no longer purchased works directly from exhibitions, but made a selection from each for an annual Canadian show held in Ottawa in January. In face of the

FIG. 162
LAWREN HARRIS
Grey Day in Town 1923
Oil on canvas, 79.7 × 95.4 cm
Art Gallery of Hamilton (69/122)
Bequest of H.S. Southam, Esq.,
C.M.G., LL.D., 1966

This photograph shows the painting before it was reworked by Harris in the early thirties.

FIG. 165. LAWREN S. HARRIS, *Ontario Hill Town* (cat. 95)

after, Dreier invited Harris to participate as the Canadian representative in the *International Exhibition of Modern Art* she was organizing to open at the Brooklyn Museum in November 1926. He sent the two paintings that had been the focus of journalistic attention in the 1926 Group show, the large *Mountain Forms* and *Miners' Houses* (fig. 161), and went to see the exhibition in Brooklyn and to meet Dreier.[33]

Harris was impressed. "I believe it to be the most representative, most stimulating, and the best exhibition of advanced modern art so far shown on this continent," he wrote to the exhibition committee of the Art Gallery of Toronto, urging them at all costs to bring the show to the city. To avoid any semblance of being self-serving, he assured them that his works would not be included. Though still nervous after the Group show of May 1926, the committee finally agreed to have the exhibition in April 1927.[34]

Founded in the spring of 1920, at the same time as the Group of Seven,[35] the Société Anonyme was a major force for public education about modern art. In words that recall the manifestos of the Group, Dreier wrote in her initial pamphlet: "We are entering a new era and the men most sensitive to the coming, new influences must, in the very nature of things, express themselves differently from the past, whether it be in art, politics, or science."[36] Many of Dreier's ideas, a combination of "the mystical teachings of theosophy, the metaphysical theories of Wassily Kandinsky (himself heavily influenced by theosophy), and the socially oriented aesthetic ideals of John Ruskin and

especially William Morris … about the social utility of art,"[37] could well define the major influences on the Group in the mid-twenties, and in Harris she found one who shared many of her beliefs.

The Société Anonyme exhibition was the most important show of contemporary international art presented to that date in Canada, its only precedent being the few Vorticist canvases in the War Memorials exhibitions of 1919 and 1920. Dreier came to Toronto to help install the paintings and sculpture, and gave a public lecture explaining the ideas behind modern art. She identified the Group of Seven as part of this international movement, and added, "it is very true what Lawren Harris stated when he wrote me that: 'To appreciate the Art of other countries, a people must create their own artistic idioms before they can become articulate as a people and commence to live in profound reality. This self-achievement of a people permits them to then comprehend and understand the work of others.' It is, therefore, very important that a public should exist that is qualified to understand creative Art, for the creative artist is the custodian of the future fame of his own country. According to its Art is the life of a nation, and the nations that have vanished from the globe are the nations without an Art."[38]

The press explained, presented, and satirized, and readers wrote letters to the editor, with the reactions ranging from dismay to delight, disgust to awe. Dreier herself impressed all. Harris, Lismer, and Kathleen Munn gave talks to the public,[39] and Harris and Johnston faced off in the pages of the *Canadian Forum*. For Frank (now Franz) Johnston, the one-time tentative rebel, the art exhibited was the product of "leprous brains" and "mental miscarriages,"[40] while Harris queried whether Torontonians had ever seen "such a wealth of ideas or so much real adventuring, or so large a proportion of stimulating and profound works … the exhibition has enlarged the vision of so many of our people, has awakened them to a greater range of ideas and new possibilities of expression and has thus enlarged the eliciting audience for our artists. This should keep them true to their own path and help clarify their particular direction."[41]

New Voices

The hosting of the Société Anonyme exhibition in April 1927 was just one manifestation of expanding interests in the thinking of Lawren Harris and other artists and collectors in Toronto. A month before, two Toronto artists, Kathleen Munn and Bertram Brooker, had exhibited semi-abstract figurative paintings at the annual O.S.A. show.

A native of Toronto, Kathleen Munn had studied extensively in New York and at the Art Students League Summer School at Woodstock, New York, with Andrew Dasburg and Max Weber. She had been exhibiting Cubist-influenced paintings since 1916.[42] In 1923, she once again startled the critics when, showing for the first time in several years at the R.C.A., she presented a painting entitled *The Dance*.[43] This work and Harris's *Above Lake Superior* were the

FIG. 166. KATHLEEN MUNN, *Composition* (cat. 127)

focus of most reviewers' curiosity about "freak art," which for some was a symptom of infantilism,[44] for others a constructive sign of liberalism in the Academy,[45] and for yet others simply a cause for dismay.[46]

By 1927, the writers were apparently intrigued by the new life evident in the Ontario Society, and set out to explain to their readers Munn's Cubism as seen in her painting *Two Figures*, and Brooker's "musical Expressionism" as evident in his paintings *Arise, Shine* and *Endless Dawn*,[47] which were considered by one writer "a remarkable thing for a man who had never painted before."[48]

Brooker had in fact been working, first in black and white and then in tempera, although he had only recently begun painting in oils,[49] stimulated by the Group-inspired milieu in which support for spontaneous creativity characterized the "amateur movement." Housser classified Brooker among a particular group of untrained amateurs, those working from a "solid intellectual base" who took up painting as "a serious realization of the philosophical and spiritual significance of the art element in life."[50] Born in England, Brooker had come to Manitoba as a youth, where he had worked in Neepawa, Portage la Prairie, Regina, and Winnipeg as a writer, promotional manager, and eventually music and drama critic for the *Free Press*.[51] He moved to Toronto in 1921 as editor and manager of an advertising journal, *Marketing*, and joined the Arts and Letters Club in 1923.[52] There he met Fred Housser and Lawren Harris, who would remain close friends for the next decade. The three shared common interests in philosophy and creativity, seeking out unifying factors amid

the various manifestations of religion, life and art – "the elusive rhythm that pours through matter and translates it into life."[53]

Bertram Brooker exhibited his paintings for the first time at the Arts and Letters Club in January 1927.[54] These canvases were painted using a method whereby the artist dissociated himself from external influences and thoughts and, listening to music, determined forms and colours through intuitive association. Owing much to the writings of P.D. Ouspensky on the "fourth dimension" and of Wassily Kandinsky, as well as to the theories behind Thomas Wilfred's "Clavilux" or colour organ, these partially abstract paintings were primarily concerned with the emotive effects of form and colour as correspondences of music.[55]

Presented at the Club without titles, Brooker's paintings provoked dismay among the members.[56] Harris's "ex-cathedra" pronouncements on the

FIG. 167. BERTRAM BROOKER, *Sounds Assembling* (cat. 120)

FIG. 172. LAWREN S. HARRIS, *Northern Lake II* (cat. 111)

FIG. 173. LOWRIE WARRENER, *Northern Night* (cat. 132)

FIG. 174. DORIS MILLS,
Mountain Sunrays (cat. 126)

Norman Harris in the conservative newspaper the *Telegram* reviewed the show favourably, including Brooker's *Sounds Assembling* (fig. 167),[69] but a week later the same paper published a vociferous attack on the Art Gallery's Council with the banner headline "Junk Clutters Art Gallery Walls while Real Paintings Are Hidden in Cellar." Accusing the Group of Seven of repeating their annual "extravagances," the writer continued: "There has been a stagnation instead of a movement. And it is not even Canadian, but following in the rut of the so-called 'modernists' who have afflicted the whole world and who were particularly virulent in Germany … Deplorable … is the effect of such exhibitions on impressionable minds of the young including those of art students … Too many of them have already gone astray after strange gods."[70]

The show had a record attendance of 7933, but there were only three sales. Jackson sold his Wembley canvas *Winter, Georgian Bay* to Albert Robinson's brother, Doris Mills bought a Varley sketch, and Hart House purchased Lismer's *Isles of Spruce*.[71]

Vancouver, 1928

In Vancouver there were several art organizations, including the Studio Club and the Palette and Chisel Club, but the most prominent was the British Columbia Society of Fine Arts. A professional artists' body, its primary function was the organization of annual exhibitions. In 1920 a new group was formed, the British Columbia Art League. This was not a professional organization, although many leading artists were actively involved in its work, but was set up to establish an art school and gallery in Vancouver. The prime movers in the founding of the League were John Radford, Bernard McEvoy, and John Innes, all former Ontarians.[72]

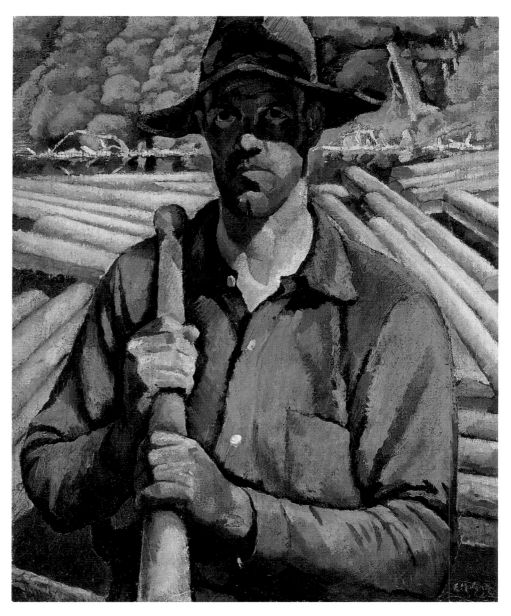

FIG. 178. EDWIN HOLGATE, *Lumberjack* (cat. 122)

modern artist does not try to paint things as they may seem to be, or rather as he may know them to be in detail, but he interprets the individual mood in which these seeming appearances, simplified into masses, are conceived. It allows him freedom to compose in colour and form for their inner values, to reflect not Nature, but the response to Nature in his vibrating mood ... Photographically it means building prints by massed formation of contrasting lights and shades instead of by deliverance of technical detail. It means the rendering of structural forms in strength and simplicity, rather than the confusion of complicated, detracting and unessential detail. It means concentration of observation and feeling in form relationship." To criticisms of a previous exhibition of his work that "it reflected so little of the Canadian spirit," he responded in terms worthy of Harris and Lismer: "One learned to see the impossibility of conveying the spirit of Canada ... by employing methods of petty representation ... Canada is not beautiful in detail, but by

the immensities of its proportions, the tragic [unfoldment] of its forms and contrasts, the dramatic struggle to turn a virgin country and community into one with a degree of culture. This rudeness, this immensity and tragic unfoldment one tries to express in extreme simplicity of composition, form strength, obvious contrast in light and shade ... designs which belong to Canada and to no other country."[94]

The controversy in Vancouver started with a letter to the *Daily Province* from the Reverend J. Williams Ogden, an artist and long-time member of the B.C. Art League, insisting that the "freak" pictures on show at the Vancouver Exhibition (fig. 177) be burned and denouncing both the exhibition's art committee and the National Gallery. "We know that these 'freakists' by political influence and press manipulation have, for the time, captured the seats of power in connection with the National Gallery of this Dominion and that good public money is being paid for the purchase of the works of these men."[95] The pictures in question were those of the Group of Seven, specifically Harris and MacDonald.

The debate in the paper touched only briefly on the issue of Canadian art,[96] dealing more with the incomprehensibility and ugliness of modern painting. The conservatives, including James Leyland, the supervisor of the Art League's gallery, denounced the pretensions of the new art's defenders and argued for tradition.[97] Another reader wrote, "nature and truth are co-eternal and never die, hence the immortal legacies of the old masters."[98] With Varley absent in Toronto, Mortimer-Lamb and Vanderpant argued for the defence,[99] and once again the dispute was reported from Vancouver to Saint John. The letters and editorials continued through November, three months after the show had left Vancouver.[100]

The exhibition was a *succès de scandale*, realizing an attendance of 65,000.[101] "A stranger coming to Vancouver during that period would have been convinced that the people of this city were more interested in art than the citizens of Florence, or Chelsea, or Montmartre ... Vancouver owes this famous group a great debt, for their pictures drew crowds to the exhibit that never would have gone there otherwise, and added zest to life by inspiring heated discussions which lasted for months."[102] The controversy hardened the differences between conservatives and moderns in Vancouver, however, as well as strengthening already existing resentments against the National Gallery. The Group's paintings, minus those from Montreal and the Gallery, were subsequently shown at the New Westminster Provincial Exhibition, and in Edmonton and Calgary.[103] No sales resulted from all this effort.

Paris, 1927

The final phase of the Wembley exhibitions took place in Paris in 1927. Clarence Gagnon, recently returned to that city, had assisted Eric Brown with the installation of the 1925 Wembley show, and it was at his instigation that negotiations were entered into for an exhibition in France. Having been

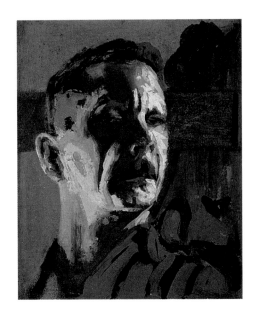

FIG. 179. W.J. WOOD, *Self Study* (cat. 133)

FIG. 180
J.E.H. MacDonald: Cover of the catalogue for the *Exposition d'art canadien*, Jeu de Paume, Paris, April 1927.

FIG. 181
Façade of the Jeu de Paume with the poster published for the exhibition designed by Thoreau MacDonald, April 1927.

FIG. 182
Exposition d'art canadien, Jeu de Paume, Paris, April 1927.

confronted with constant criticism and public attack over the National Gallery's actual or supposed role in the organization of other Canadian shows abroad, Brown was concerned that the Gallery not be seen as the prime mover behind this new project.[104] Finally, a request was sent by Charles Masson, the director of the Musée du Luxembourg, asking the Gallery to organize an exhibition consisting of a selection from the 1924 and 1925 Wembley shows (any replacements to be authorized by the Gallery), together with a retrospective of works by J.W. Morrice and Tom Thomson.[105] It was at the suggestion of Armand Dayot and Gagnon, who was then working on illustrations for the Alaska novel *Le Grand Silence Blanc*, that a small collection of masks and carvings in argillite and wood by Aboriginal artists from British Columbia was added.[106]

In an article published in *L'Art et les Artistes* preceding the exhibition's opening, Brown identified the origins of art in Canada as lying in the aboriginal art of British Columbia and in a French colonial school just now being rediscovered. More recently, he wrote, Post-Impressionist influences, denounced in Canada as decadent, had made their mark and, together with the war, had stimulated Canadian artists to new heights of ambition: "'If we adhere to tradition,' said the artists, 'we will produce nothing that has not been done before us.' The colonial spirit gave way to the national ethos." Supported by the British critics at Wembley, Brown affirmed that "the artistic ideal of young Canadian painters is expressed by a school that has no direct roots anywhere else, and that, up to a certain point at least, is indigenous and spontaneous."[107]

In his introductory essay in the catalogue, the French critic Thiébault-Sisson further linked the Native and contemporary arts in Canada through their "taste for stylization and ... decorative instinct," and differentiated Canadian landscape painting from French art: "This raw, new painting has nothing in common with our subtle art, filled with fine and delicate artistry ... but it has overwhelmingly powerful accents all its own."[108]

At the continual prodding of Clarence Gagnon, much of the dross from the two Wembley shows was omitted. Some works were added, including the three prize winners from Philadelphia, Harris's large *Mountain Forms* from the Société Anonyme exhibition,[109] and Holgate's *Lumberjack* (fig. 178), and with the Morrices and Thomsons they produced a far superior and more important exhibition than either of those at Wembley. Yet the critical reaction was poor and uninformed. Writers misquoted Brown's and Thiébault-Sisson's texts, could see Canada only through the writings of Louis Hémon or Jack London, and confused Thomson, who was supposed to have been killed by "savages" or to have been frozen in the snow, with Gagnon's new protégé, the trapper René Richard.[110] All articles claimed Morrice as a French painter, characterized the new "Canadian primitives" by their lack of French refinement, and bemoaned the absence of nudes.[111] The Canadian Press writer refused to cover the exhibition[112] and, although the National Gallery had both English and French articles translated for the first time, there was little coverage in Canada compared to that for Wembley.[113] Even the purchase of Robinson's *Open Stream* from the

show by the Musée du Luxembourg was dogged by misunderstandings and evasions, and the painting was not paid for until five years later.[114]

American Exhibitions, 1927–32

William Hekking of the Albright Art Gallery in Buffalo had hoped to tour the Canadian paintings from the *Sesquicentennial* in the United States, but the paintings were required for the National Gallery's annual show. Instead he selected an entirely new show of forty paintings by Carmichael, Harris, Jackson, Lismer, and MacDonald, together with one painting each by Bess Housser and Doris Mills. These were shown in Rochester, Toledo, Syracuse, and Buffalo in the first half of 1927.[115] Housser's book *A Canadian Art Movement* supplied the background and described the ideals that inspired the works and was the main source of information for the reviewers.[116] The following autumn Hekking organized a second show – this time including three Montrealers, Holgate, Robertson, and Robinson – which was exhibited in Buffalo and Rochester in the fall of 1928.[117]

The exhibition of Canadian paintings toured by the American Federation of Arts in 1930 was initiated by Vincent Massey in Washington and Frederick Keppel of the Carnegie Corporation, the latter financing the show.[118] The American painter Eugene Savage was engaged to visit Ottawa, Toronto, and Montreal to select the works and arrived with Newton MacTavish's history of Canadian art in hand.[119] Harris and Jackson took him around the Toronto studios, and Hewton and Robertson took him around Montreal. Savage had made his Ottawa selection before arriving in Toronto, but Jackson and Harris were determined that the exhibition should reflect their understanding of the best of Canadian art, including work by artists from Winnipeg and Victoria, and that it form a cohesive whole.[120]

Jackson justified the exclusion of the academicians on the grounds of American superiority in that field – "our only chance was the stuff that had a native flavour to it, even if it was crude or deficient in technical qualities ... the show has to stand on whether Canadians have something they say in their own way or not."[121] Despite their efforts, the unity and quality of the exhibition were compromised by the inclusion of more conservative paintings by artists not associated with the Group, including two by Horatio Walker, the Canadian with the highest reputation in the United States.

Under the patronage of Vincent Massey, the Canadian minister to the United States, the exhibition received unprecedented publicity in Washington and on the subsequent tour and was warmly received. While most reviewers praised the paintings for their "sane modernism," one Baltimore writer defined this as their prime deficiency, referring to paintings by Brooker, Carmichael (fig. 184), L.L. FitzGerald, Harris (fig. 253), Prudence Heward, and Bess Housser (fig. 185). "The Canadians have made their search too lightly and have satisfied it much too easily. They accent and insist upon 'bold' shapes 'strongly' drawn, emphatically outlined and made rather partly rhythmical.

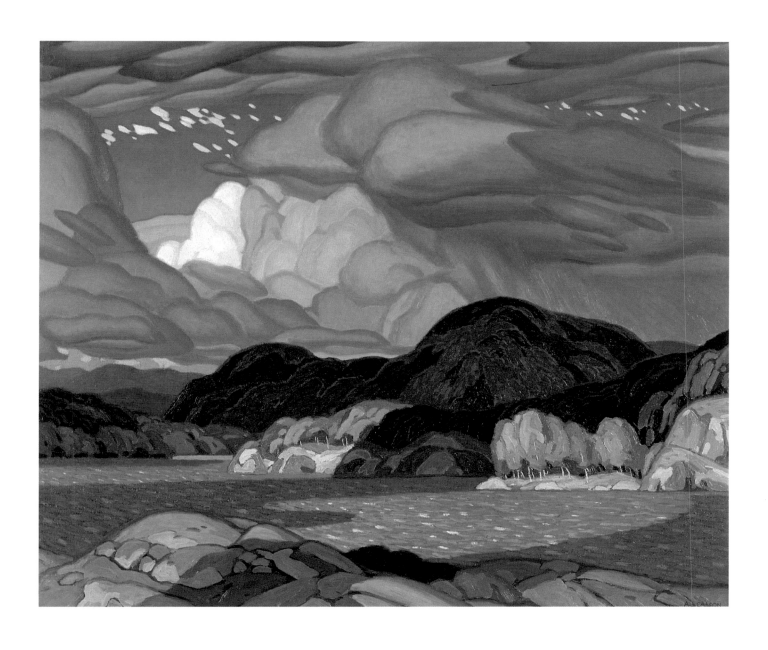

FIG. 183. A.J. CASSON, *October* (cat. 109)

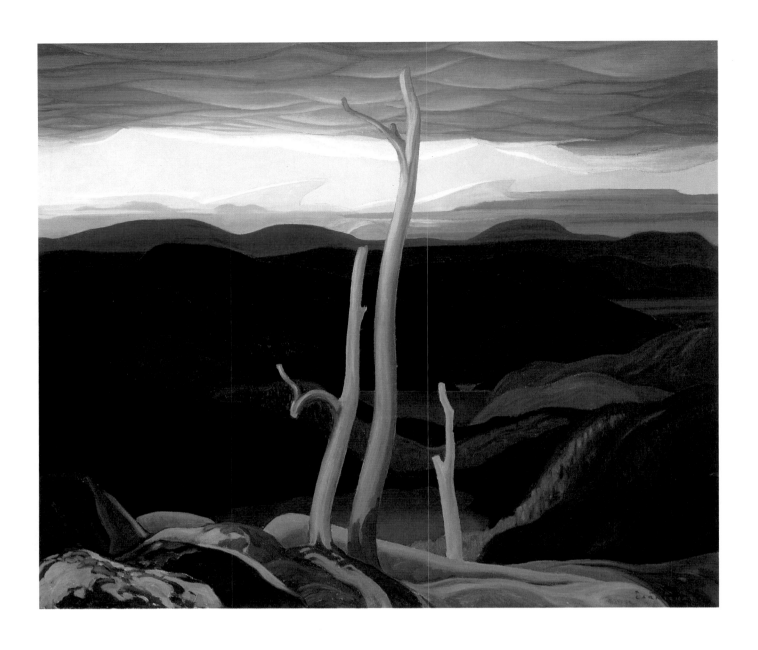

FIG. 184. FRANK CARMICHAEL, *Evening, North Shore, Lake Superior* (cat. 107)

FIG. 185. BESS HOUSSER, *Laurentian Village* (cat. 123)

However, these shapes for all their definiteness and massiveness and simplicity really do lack significance. I mean that the designs seem contrived or invented, and that the formal aspect of the painting, while it is stridently presented, is really without inevitability and life. It becomes a forced and dramatic affair, a sort of confused emotional geometry which does not seem quite logical or convincing or meaningful ... In the end I should call it a synthetic painting that overreaches itself. Nothing could be quite that neat and crisp and impressive. The submission to influence and the work of experiment has stopped too soon and both logic and emotion have been processed. Though imitations of Dutch genre painting no longer attract them they are yet unable to accept Braque and Picasso on their own terms."[122]

The exhibition received more publicity in Canada than any other Canadian show sent to the States,[123] yet the only real analysis of its contents came from Jehanne Biétry Salinger in *La Revue Populaire*. She admired several paintings greatly, and her reservations largely concerned the selection and lack of cohesion in the show. "By and large, this group of canvases is presentable and satisfactory, but it is generally far too timid to be an authentic ambassador of progressive Canadian painting ... It has committed the deadly sin of grouping together painters and canvases that are totally unrelated, while its aim should have been to coherently represent the latest Canadian art."[124]

To respond to this criticism, Harris selected the paintings for the second exhibition toured by the Federation later that year, including only Group members and associated artists, with the exception of Fred Haines, the new

curator of the Art Gallery of Toronto. Though it was a more cohesive show, the publicity efforts had been spent and it received little but local notice.[125]

As the first American Federation of Arts exhibition had been presented in New York, an invitation from the Roerich Museum in that city provided the opportunity to correct the earlier image of Canadian art. Organized by Lawren Harris, the show opened under the patronage of the new Canadian minister to the United States, Duncan Herridge. The foreword to the catalogue by Fred Housser reiterated the credo of *A Canadian Art Movement*, although correcting the identification of the painters as amateurs. "Although most of the Canadian modern painters have studied in Europe and are familiar with the works of the numerous modern schools, the Canadian movement has never passed through any of the extreme phases of modernism which ha[ve] marked the course of corresponding movements in other countries ... The awakening of Canadian artists to the esthetic effects on themselves of Canadian landscapes, space and skies has been the chief inspiration to creative effort. It has caused the modern movement in Canada to serve the idea of a higher national consciousness and a Whitmanic attitude toward art in America."[126] The paintings were mostly landscapes, with the exception of figures by Heward, Holgate, and Varley (fig. 51), and Isabel McLaughlin's *Chestnut Branch* (fig. 215). Though reservations were expressed about their theatricality and poster-like effects,[127] once again it was their tempered modernism and absence of "pseudo-French" style that reviewers noted.[128]

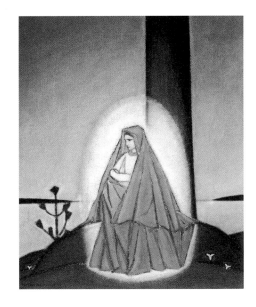

FIG. 186. THOREAU MACDONALD, *Pine Tree Madonna* (cat. 124)

In the second half of the decade, the Group of Seven maintained the earlier frenetic pace of exhibitions, reaching audiences beyond the borders of the country and beginning, at last, to make some sales. Canadian art was never so present on the international scene as during this period, and a somewhat weary Eric Brown, accused at every turn of bias for supporting the Group, wrote home: "Our problems seem to be continuous but I can't see what other course we could have pursued than the one we have. It has had good results for Canadian art, which would not have developed anything like so quickly otherwise."[129]

FIG. 187. F.H. VARLEY, *Mimulus, Mist and Snow* (cat. 119)

The Collectors

he lack of markets for works of art by Canadian artists re-mained a severe problem. This was confirmed by an article in the *Canadian Bookman* in 1924 reporting that only 2 per cent of the pictures purchased in Canada were by Canadian artists.[1] In the mid-twenties, a clientele did develop for the work of older or more conservative artists, as witnessed by the success of William Watson with his annual exhibitions of Maurice Cullen and Robert Pilot at his Montreal gallery. Suzor-Coté, Alfred Laliberté, and especially Clarence Gagnon had a market for their work during the 1920s. In January 1928, Watson declared his commitment to the furtherance of Canadian art and in a letter to Clarence Gagnon announced his ambition to be the "Macbeth of Canada"[2] (following the example of the New York dealer in American art, William Macbeth). Yet an exhibition by Albert Robinson in March 1926 sold only eight sketches.[3]

In Toronto, Jenkins Galleries and the Carroll Gallery, a subsidiary of a London dealer, sponsored the work of the most conservative local artists, including Carl Ahrens. The galleries at the Simpson and Eaton stores sold both European and Canadian art, generally of a more conservative nature, such as the works of W.J. Phillips and Herbert Palmer.[4]

FIG. 188
Home of L.S. Harris, Toronto, 1928.
On the wall is *Northern Lake II* (cat. 111).
Canadian Homes and Gardens, June 1928, p. 48.

FIG. 189
Home of the Houssers, Toronto, 1931.
Paintings, left to right: Bess Housser,
title unknown; Jackson, *Winter Road*;
Harris, two oil sketches.

FIG. 190
"Pinebrook," home of the Millses,
Toronto, 1931. Over the fireplace is
Harris's *Morning, Lake Superior*, on loan
to the Millses; other paintings by
Doris Mills. The pine-motif frieze,
lamps, tables, fireplace surround, and
wall sconces were designed by
Thoreau MacDonald. *Canadian Homes
and Gardens*, February 1931, p. 18.

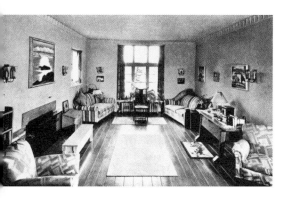

The Group artists were able to sell their sketches, yet the canvases remained in their studios. It is difficult to document their private sales, but the number of major canvases which the artists themselves loaned to exhibitions through the 1930s and into the 1950s indicates all too clearly the almost total absence of a market for their important paintings. It was only through teaching that Lismer, MacDonald, and Varley were able to support their families and continue working. Carmichael and Casson worked for commercial art firms, Harris had a private income, and only Jackson earned a living through his art, though even he on occasion did free-lance commercial work for Ford Motor Company and the Canadian National Railways.[5] Gregarious, hard-working, frugal, and a bachelor, Jackson seems to have been able to sell his smaller and medium-sized canvases, but at low prices, especially in comparison to those commanded by the more conservative academicians. Undoubtedly, part of the appeal of the Quebec paintings that dominated his output in the late twenties was their picturesque, affectionate, and very human character, somewhat the same appeal that made Gagnon so successful at considerably higher prices.

Private Sales

It was only in the mid-twenties that some of the artists' major canvases began to sell, slowly, and for the first time to private individuals. Dr. MacCallum had, of course, been a loyal supporter in the prewar years, especially of Tom Thomson. MacCallum continued to purchase Thomsons from the artist's estate and the occasional sketch by Group members; however, there was only one canvas postdating the war in his collection, Jackson's *March Storm, Georgian Bay* (fig. 194), exhibited in the Group's first show.[6]

The people who did start to collect paintings by the Group were all close associates and friends. The Houssers purchased Jackson's *Winter Road* and Lismer's *Old Pine* (fig. 53) in 1927, Harris's *Fish House, Coldwell* the year following and his *Island, Lake Superior* by 1930, and MacDonald's *The Little Fall* (fig. 29) some time after 1928.[7] Installed in the Housser's early-Ontario-style house designed by Mathers and Haldenby, the paintings had a simplicity and austerity compatible with the interior space[8] (fig. 189).

Dr. Arnold Mason, a dentist to and friend of many of the Group members, also acquired a few paintings, some in lieu of fees (fig. 60).[9] The Daly family, whose portrait Varley painted in 1924 and 1925, purchased Jackson's *Cognaschene Lake*,[10] and Ernest and Ethel Ely, the latter also painted by Varley, acquired his *Gypsy Blood* (fig. 193) and *Lake Shore with Figure* (fig. 136), the latter apparently in lieu of a clothing bill.[11] Harold and Ruth Tovell purchased Harris's *Beaver Swamp* (fig. 8) and Jackson's *Winter Morning*, the latter before 1928,[12] and Doris and Gordon Mills had an excellent collection of smaller paintings and drawings installed in their new home, which had benches, lamps, and wall sconces designed by Thoreau MacDonald[13] (fig. 190).

While acquiring astutely, none of these collectors had the funds that permitted buying on the scale that Alice and Vincent Massey did in the late twenties and early thirties. Vincent Massey knew the artists through the theatre and the sketch committee at Hart House and through the Arts and Letters Club, of which he was president in 1920 and 1921. The Masseys' first purchase consisted of fourteen oil sketches by Thomson acquired from the artist's estate in 1918,[14] and around 1925 Varley was commissioned to paint Alice's portrait. They acquired Jackson's *Manseau, Quebec* (fig. 140) in 1926, shortly before their departure for Washington where Massey was to be the first Canadian minister to the United States, and where they would remain until 1930. During these years Vincent's father died, and his collection of French, English, and Dutch academic painting was sold at auction,[15] the younger generation committing themselves to Canadian art. The Masseys decorated the Washington residence with modern Canadian paintings from their own collection, from the National Gallery, and from loans by the artists.[16] They also acquired a few additional works, and in 1930 purchased George Pepper's *Street in Hull* and Sarah Robertson's *Joseph and Marie-Louise* (fig. 192) from the exhibition of Canadian art at the Corcoran Gallery.

It was after their return to Canada that they became most active; by December 1934 they had acquired 109 works, by far the largest collection of

FIG. 191
"Batterwood," home of the Masseys, Port Hope, Ont., 1932. Paintings, left to right: Jackson, *Winter, Quebec* and *Manseau, Quebec* (cat. 97); Hewton, *Portrait of Lionel and Hart Massey*.

FIG. 192. SARAH ROBERTSON, *Joseph and Marie-Louise* (cat. 177)

FIG. 193. F.H. VARLEY, *Gypsy Blood* (cat. 55)

Canadian contemporary art formed to date[17] (fig. 191). The Masseys' collection made real the idea Jackson had been articulating for years, that a modern collection should be rooted in works by Morrice, Thomson, and Ernest Lawson. Marius Barbeau, supported by Jackson, had given new recognition to the tradition of Quebec wood carvers and the paintings of Cornelius Krieghoff. Their heirs were the members of the Group of Seven and the younger artists invited to exhibit in their shows. The Massey collection included works by all these artists and was especially strong in its representation from the late twenties and first half of the thirties. No other could match it in quality or in the number of important paintings it contained by each artist.

As in the Massey purchases, collecting during this period was not confined to works by the Group, but – as the artists had always intended – was extended to the work of their associates. The Houssers purchased a Pepper and a Robertson (*The Blue Sleigh*, fig. 195), the Millses works by Thoreau MacDonald (fig. 186) and Schaefer, and the Tovells a canvas by Brooker, *The*

FIG. 194. A.Y. JACKSON, *March Storm, Georgian Bay* (cat. 19)

Dawn of Man.[18] Brooker was less favoured than other artists in terms of purchases, yet he himself would acquire paintings by Warrener, Bess Housser, Munn (fig. 166), and FitzGerald, as well as Carmichael's *Rain Clouds.*[19]

In the late twenties, for the first time, the Group were favoured with competitive bids for their work. Sarnia and Bertram Brooker vied for MacDonald's *Gleams on the Hills* (fig. 91) at the 1927 R.C.A. exhibition, the latter acquiring it,[20] and Jackson could have sold his *Winter, Quebec* from the 1928 National Gallery *Annual* three times; the Masseys eventually purchased it (fig. 191). Jackson commented sardonically, "You see the secret of Coburn's and Cullen's success. Make the canvases all alike."[21] Both the Art Gallery of Toronto and Hart House bid on Lismer's *Isles of Spruce* (fig. 67) from the 1928 Group show.[22]

Government and Institutional Sales

Institutional buying continued slowly through the late twenties. The Sarnia Women's Conservation Committee, renamed the Women's Art Association in 1924, maintained a regular exhibition program of works borrowed from artists as well as works by Anne Savage's students at the Baron Byng High School in Montreal and by members of the Art Students' League (see chapter 13) in Toronto. Two more Thomson canvases were sold to Sarnia collectors, as well as sketches, and the Women's Art Association bought Holgate's *Lumberjack* (fig. 178) in 1927 and twelve Arctic sketches by Jackson in 1928.[23]

The Art Gallery of Toronto was now actively collecting Canadian art. Between 1927 and 1932 it acquired approximately forty works by purchase and

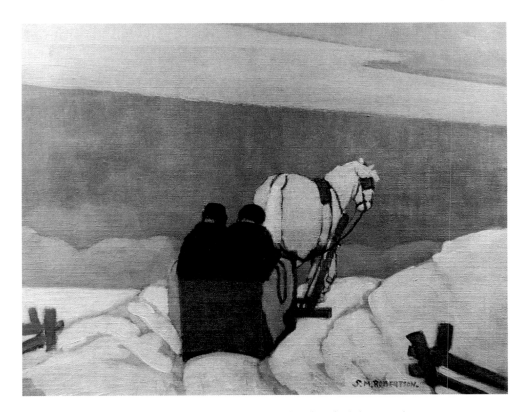

FIG. 195. SARAH ROBERTSON, *The Blue Sleigh* (cat. 129)

FIG. 196. MABEL MAY, *Winter Landscape* (cat. 125)

gift.[24] Hart House continued its annual purchases, acquiring Varley's small *Wonder Tree* from the 1925 Group show; MacDonald's 1916 canvas *Laurentian Village, October*, Holgate's *Fire Ranger*, and Carmichael's *Snow Clouds* (fig. 146) in 1926; Casson's watercolour *A Breezy Day* in 1927; Lismer's *Isles of Spruce* (fig. 67) in 1928; and Thomson's *The Pointers* in 1929. Subsequent purchases included paintings by Anne Savage, Bess Housser (fig. 185), and Charles Comfort (fig. 197), as well as Harris's *Red House, Winter* and Jackson's *October Morning, Algoma* (fig. 198) in 1932.[25]

Each one of these new all-Canadian collections sought to acquire a canvas by Thomson, now canonized as the founder of the national movement. Toronto, Kitchener, and Guelph all purchased paintings in 1926.[26] A new player in the field also set out to get a Thomson and thus turn its collection towards the modern movement. The Nutana Collegiate Institute in Saskatoon had initiated the formation of a "Memorial Collection" of Canadian art in 1919 honouring former students who had died during the war. The intent was to "formulate interest in Art among the boys and girls attending this school; to encourage, in a small way, our Canadian Artists by purchasing their pictures; and to provide a medium through which the spirit of the fallen boys might function in the building of our nation."[27] Alfred Pyke, principal of the school from 1915 to 1923 and formerly a resident of London, Ontario, solicited the assistance of an old friend from that city, David Wilkie. Wilkie had been a business associate of Paul Peel's father. The works acquired through him and after his death in 1920 were those by the most conservative artists in the O.S.A. Only one painting by a western artist was purchased, a Gus Kenderdine in 1923.[28]

Pyke was succeeded as principal in March 1923 by another Ontarian, Aldis Cameron, a graduate of the University of Toronto, who launched himself into his new role with fervour. Intrigued by the debate over the Canadian exhibition at the 1924 British Empire Exhibition at Wembley, he set out to find out about the new art, obtaining the catalogues of the annual R.C.A. and O.S.A. exhibitions, studying the reports and collections of the National Gallery, and reading art reviews in *Saturday Night* and the *Canadian Forum*. Intent on developing something more than a memorial – a municipal collection – he approached artists and dealers about purchasing works by Gagnon, Suzor-Coté, and Brownell, only to find them beyond the means of the students. His greatest desire, however, was to acquire a work by Tom Thomson. Through a mutual acquaintance, he approached MacCallum, who responded, "To me, as a friend of Thomson's, it is a question whether in justice to him, I should advise his people to place a picture of his among a collection of pictures of the most academic type – both in colour and style. They will kill him and he will kill them."[29]

Undaunted, Cameron visited the Studio Building in Toronto in 1926 and met with Maud Bowman of Edmonton, a Group supporter, and then with Varley, Charles Scott, and Mortimer-Lamb in Vancouver.[30] In the fall of 1926

FIG. 197. CHARLES COMFORT, *Prairie Road* (cat. 121)

he wrote to Jackson in Toronto, who responded: "The advice you received down here seems to have been from dull, uninformed or very prejudiced people. It has one quality your collection — consistency, it is uniformly dull and looks like a collection formed between 1900 and 1907 instead of the past seven stirring years in Canadian art . . . it seems that as a memorial to men who fought and died you have a collection of pictures with no fight in them."[31]

Jackson defined the art as being based on "old and purely local values,"[32] yet Cameron did have two more ambitious projects, which meshed with difficulty: to form a modern art collection and to support western Canadian

FIG. 198. A.Y. JACKSON, *October Morning, Algoma* (cat. 40)

artists. In 1925, he was instrumental in forming the Saskatoon Art Club, which organized annual exhibitions at the school, brought in loans from the National Gallery, and organized shows of the work of James Henderson.[33] Paintings by Henderson, Emile Walters, who had spent his youth in Saskatchewan, and W.J. Phillips were purchased.

But Cameron had not given up his second goal. To Jackson, he replied: "You have issued a challenge to a Westerner that cannot easily be ignored and at present I am inclined to call you and ask for a showdown to see whether the 7 constitutes a full house or that one of them is a *four*-flusher ... I like your suggestion that we should not touch the earlier Canadian paintings. They are not only expensive but they do not breathe the spirit of the prairie, which is not two-faced like Janus, but looks always in one direction, viz. toward the future (the next year's crop). The West is not only progressive but it is aggressive, not hide-bound because of traditions but adventurous and visionary, as witness its United Farmer movements, its grain pools, its Union of Churches, its community enterprises. However to speak seriously I may say that it is our intention to complete the Memorial Gallery as we have begun it ... This should be accomplished by next summer. After that we shall feel free to extend our collection in the way we may consider most desirable. You have bid to send us a Modern Canadian exhibition of art next fall. I have raised you to undertake to select seven paintings by the Group and a Thomson as the nucleus of a modern Canadian gallery, the first in the West if not in Canada. How many chips shall I require and how long can I stay in the game?"[34]

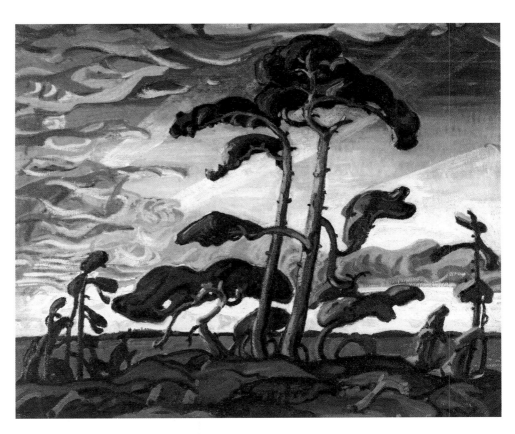

FIG. 199. ARTHUR LISMER, *Pines, Georgian Bay* (cat. 117)

The last pictures acquired for the Memorial Collection included two paintings from the famed and debated Wembley shows, a Nicholas Loveroff and Fred Challener's *Off to Flanders*. Now Cameron could establish his "Gallery of Modern Art," but fearing negative reactions, worked to raise the required money by subscription rather than from the students and graduates. In November 1927, he was able to borrow twenty-five Thomson sketches from the National Gallery, *Golden Autumn* from the estate, and ten sketches each from Thomson's two sisters who lived in Aberdeen, Saskatchewan, Mrs. William Henry and Mrs. James Henry.[35] The following April, he borrowed Thomson's *West Wind* from Toronto and twenty-eight paintings from Group members and associated Montreal artists, which were exhibited at Nutana Collegiate, while another display of Group sketches received from Calgary was shown in the Hudson's Bay store. The response, according to Cameron, was enthusiastic, but for lack of funds no works were acquired for the school. However, the University of Saskatchewan purchased Lismer's *Pines, Georgian Bay* (fig. 199).[36]

Undaunted, Cameron continued to seek support for a municipal gallery and sponsored exhibitions from the east in 1929[37] and 1930, the latter including a component sent by the Group of Seven as well as the R.C.A. and the O.S.A.[38] He continued to pursue a Thomson for the collection, and finally received on loan two sketches from the artist's sisters until such time as a gallery might be built.[39] In the end, a civic art gallery would not be established until the 1940s.

The National Gallery and the Academy

One after another, certain cities became the focus of debate about modern Canadian art as exemplified in the work of the Group of Seven. While Toronto, Montreal, and Ottawa had not been won over completely, the debate there now focussed on other issues. The reception of the paintings elsewhere was to a certain extent coloured by the strength or cohesion of art values in the community. In Sarnia, Kitchener, Saskatoon, and Fort William, where there were very few practising artists and local enthusiasts who actively promoted modern work, no negative reaction ever really coalesced. In those places where the art values were more traditional and entrenched, as in the larger cities, opposition took a very definite form. Due in large part to the relative critical success of the exhibitions of Canadian art sent abroad, and the exclusion of academic representation in those shows coordinated by the Group and its supporters, the hostility in these places between the moderns and the academics hardened and became increasingly embittered during the second half of the decade.

After the British Empire Exhibitions there was a year of respite before conflicts recommenced. The catalyst was the purchase by the National Gallery of Lismer's *September Gale* (fig. 89) in February 1926. A public meeting was held in Ottawa to protest the Gallery's apparent partiality to the Group of Seven and the acquisition with public funds of "hideous, freakish and unnatural" paintings by "artistic perverts."[40] The protest was led by the Ottawa art dealer James Wilson, at whose gallery the Ottawa Group had sponsored a Group of Seven exhibition in 1924, and Ernest Fosbery.[41] The letters of support for their position opposed the "truth and beauty" of nineteenth-century English and Canadian academic painting to "the greatest abortion of a work of art ever seen in 'our fair city'."[42] Eric Brown replied, calling for tolerance in regard to artistic judgment and defending modern Canadian art. "It expresses the country, most particularly in landscape, in a way that painting has not done before in Canada ... There are many aspects of modern Continental art which are horrible, being both hideous, colourless and formless and if the attackers could be induced to take a course in them, they might, if only in reaction, find themselves appreciating the sanity and splendour of this much abused Canadian movement."[43] Jackson took a more cynical view. "If one knew these critics asked greater things of us, more austerity and richer qualities of imagination, a better understanding of the modern developments of art abroad, there might be justification for their judgments. If they asked of us more heroic things worthy of a vast and thrilling country — great forests, swirling rivers and endless stretches of hills and plains, and the seasons working their marvellous changes of colour over all — then we could frankly admit that we have accomplished very little. But these hardy Canadians look at a painting of a hive or a spruce tree and run all the way home to write to the press about the shock they received."[44]

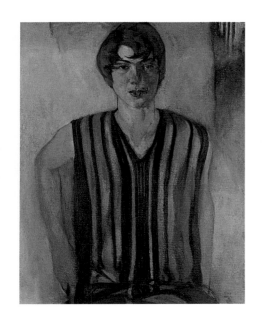

FIG. 200. F.H. VARLEY,
Vera (cat. 156)

The conflict broke out anew in the fall when Wyly Grier, just elected vice-president of the Academy, called for the dismissal of Eric Brown, "the art dictator of Canada," for his assumption of the prerogative of the Academy in organizing Canadian art exhibitions abroad, his supposed complicity in the selection of the Canadian art for the *Sesquicentennial* in Philadelphia, and his favouritism towards the Group of Seven.[45] Grier had publicly supported the artists in the Wembley affair, although irritated by the "intemperate praise lavished upon them by their panegyrists,"[46] but now expressed remorse for having sat on the Wembley jury and thus doing injury to the Academy. Hewton and Lismer immediately declared their lack of repentance for participating in the Wembley jury,[47] and Jackson, quoting Grier against himself, pointed out that "Canadian art has received more favourable comment abroad through the modern Canadian movement of the last six years than it did in the previous forty years through the efforts of the Academy."[48] Yet the conflict was not defined as one between the Academy and the Group of Seven but as one between the National Gallery and the Academy,[49] although the latter's president asserted that the artists spoke for themselves only.[50]

Housser's *A Canadian Art Movement* appeared on the market during this debate, and Fosbery's critique and Jackson's response[51] elicited another attack on Brown for his supposed partiality for the Group in the 1927 National Gallery annual exhibition, and on the Gallery trustees for presuming, as a group of non-artists, to organize an annual exhibition meant to represent "the best work produced during the year" in Canada.[52] The selection for the show in Paris, purportedly consisting of works approved by the Wembley juries but now supplemented by a few additions as well as those by Morrice and Thomson, was also attacked.[53] The affair took on the character of a cloak-and-dagger plot when Fosbery wrote to the minister of public works, "We now learn, and are prepared to prove, that a number of cases containing pictures variously estimated at from forty to forty-seven in number, addressed 'Exposition d'Art Canadien, Musée du Jeu de Paume, Paris, France', are ready for shipment from the National Gallery. By the time this reaches you they may already have been collected by the express company."[54]

The attack this time was directed by Fosbery, John Hammond, and Franz Johnston,[55] and was reported in Toronto, Montreal, Ottawa, Winnipeg, and Vancouver.[56] Not confining themselves to the press, the artists appealed to the prime minister, attacking the very source of the Gallery's funding and endangering its independence.[57] The trustees justified their decision and confirmed their approval of Brown's actions, but each skirmish in the fight left an increasingly bitter legacy.

One result of the assaults on the Gallery was a sharp decrease in its acquisitions of the work of the Group of Seven. Nothing was purchased in 1927 or 1929, and between 1928 and 1932 only two Harris canvases (*Maligne Lake, Jasper Park* [fig. 105] and *North Shore, Lake Superior*), one MacDonald (*Batchawana Rapid* [fig. 50]), one Varley (*Vera* [fig. 200]), and one watercolour each by

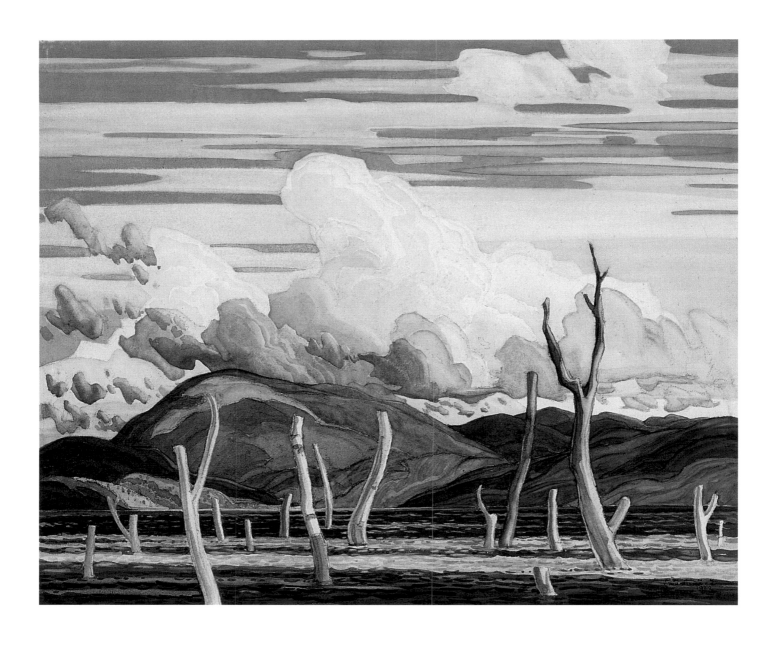

FIG. 201. FRANK CARMICHAEL, *Wabagishik: Drowned Land* (cat. 136)

FIG. 202. ERNEST FOSBERY,
James Wilson (cat. 7)

Carmichael (fig. 228) and Casson (fig. 229) were bought. The Gallery tried to avoid giving further reason for complaint, but resentment had blinded the opposition to reason, and several more years of conflict lay ahead.

What the Academy wanted was representation on the Gallery's board, a role in determining the content of exhibitions in Canada and abroad, and an increased grant.[58] The Gallery reaffirmed its procedure for Wembley in selecting juries to choose paintings for exhibitions abroad, although only one exhibition was organized after Paris, a small show sent to Buenos Aires for the British Empire Trade Fair in 1931. On that occasion, Wyly Grier, now president of the Academy, sat on the selection committee.[59] Almost all Canadian exhibitions outside Canada from 1927 to 1933 were coordinated or organized by the Group of Seven, save for the Canadian contribution to annual shows at the Imperial Institute in London from 1927 to 1930, the contents of which were selected by the Academy from its annual shows and shipped by the National Gallery.

The R.C.A. lacked the initiative of the Group in organizing and circulating its exhibitions. It argued that financial constraints prevented it from extending its activity, yet its lack of enterprise offered no justification for an increased grant. The Academy could show little presence either across the country or in Ottawa in the eyes of government, and it was rapidly losing prestige and position.[60] The Group's extensive exhibiting network and the National Gallery's loans and exhibition program were supplanting the Academy and undermining its role as the premier art society in Canada. This inaction and hardening of its position was exacerbated by the longevity of the senior members. In 1930 only Gagnon, Robinson, and Jackson were under fifty, and four were over seventy – Dyonnet, Watson, Percy Woodcock, and Hammond, who was eighty-seven years old. For a new academician to be elected, one had to die or retire. It was only the retirement of Horatio Walker that permitted the election of Ernest Fosbery to full membership in 1929. As his Diploma Work, Fosbery donated to the National Gallery his portrait of the Gallery's arch critic, the art dealer James Wilson (fig. 202).

The National Gallery also became a target for conservative opposition when it invited Fred Varley and Emily Carr to select paintings from British Columbia for its 1930 *Annual Exhibition of Canadian Art*. Protests came not from the art societies but from the B.C. Art League, specifically John Radford, now art editor of the *Vancouver Sun*, and J. Williams Ogden, the clergyman who had earlier attacked the "freak" pictures. Despite the latter's claim that the issue was not "modernism and fundamentalism in art" but rather the Gallery's discrimination against B.C. artists, his castigation of Varley as a "one-man tribunal" revealed the splits in the Vancouver community. "Then I think of the judge's own landscape picture at the last Vancouver exhibition ... The subject was either dawn or sunset on Howe Sound ... The mountains were 'without form and void,' and dirtiness was 'upon the face of the deep,' and a daub which looked like jam which had been uncovered too long, smeared across the sky did duty for the dawn or sunset."[61]

Radford ensured that any articles criticizing modern art, the Group of Seven, or the National Gallery were reprinted in the Vancouver newspapers, and when Harris's and Jackson's Arctic sketches and paintings were shown at the exhibition in Vancouver in 1931 together with contemporary British water-colours circulated by the National Gallery, he attacked the latter and Bernard McEvoy the former: "Why [Harris] should paint the Arctic landscape in the way he does, I am at an utter loss to know ... he paints mountains as if they had numbers of great cigars laid against them to dry, and icebergs of questionable shape ... I have no room to speak of A.Y. Jackson's pictures except to say that I am sorry he went to the Arctic."[62] Each confrontation elicited letters to the editor and greater publicity for the artists. Yet, contrary to the statements made by Fosbery and others that the artists were seeking publicity, it was their critics who did all the work for them.

With a few exceptions, every important modern painter working in Canada in the late twenties was encouraged by the Group of Seven and included in their exhibitions. In the face of opposition and neglect, the Group actively promoted its members' work and ensured that shows sent abroad were representative of the highest level of Canadian achievement. Once again, their endeavours and ideals would inspire others working in parallel fields.

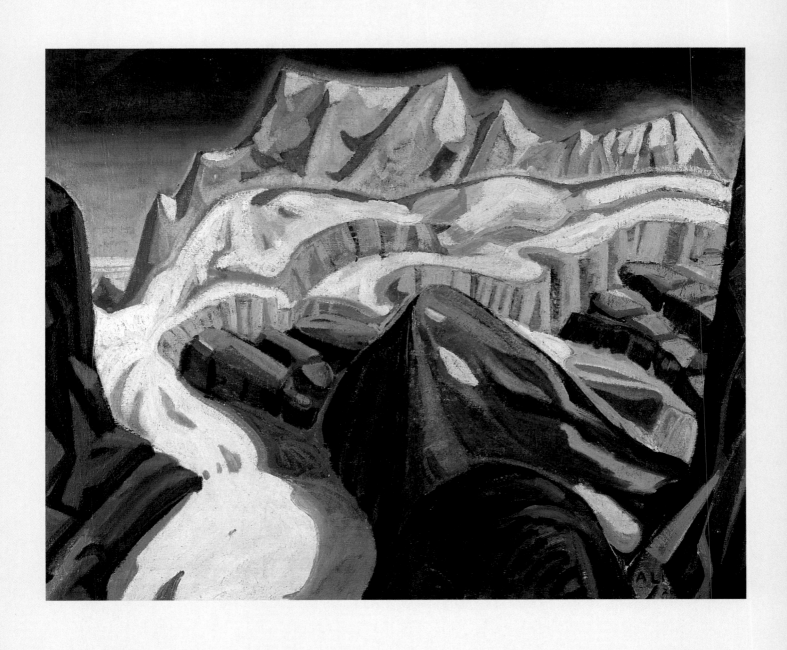

FIG. 203. ARTHUR LISMER, *The Glacier* (cat. 148)

13

Consolidation
and Growth

he evident success of the Group of Seven in attaining certain of their goals and the subsequent publicity elicited opposition from conservatives and imitation from admirers. The Group was at a crucial stage in its development; it risked becoming a new Academy, and criticisms would be expressed even by artists who were overtly supportive.

"Art redolent of our life"

"I wish that the public reaction to art could be friendlier – that art might be accepted, not as something in a gallery or a catalogue, to be looked at with critical curiosity and a sort of premeditated determination to regard all artists as crazy or, at best, fantastic; but rather as something in the home – a presence there – the embodiment of another person's experience added to our own and enriching our own."' One of the most astute observers of cultural trends in Toronto in the late twenties was Bertram Brooker (fig. 204). In a weekly "letter" syndicated through the Southam newspapers, he chronicled, analyzed, and debated the various currents in English Canadian culture. Titled "The Seven Arts," the column discussed architecture, sculpture, painting, music, poetry,

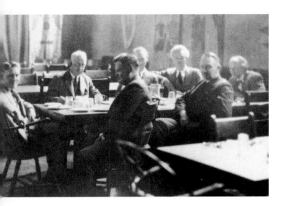

dance, and drama, and appeared in Ottawa, Calgary, Winnipeg, Edmonton, and Vancouver – but not in Toronto, the main focus of his attention.[2] Many of the subjects that recur had been treated by other writers, including Lismer and Harris: the folk festivals organized by the C.P.R.,[3] the academic mania for technique,[4] the "amateur" movement,[5] and the continuing obsession of dealers, galleries, and collectors with English and Dutch art to the exclusion of Canadian art.[6]

The main argument that ran through Brooker's writings was his belief that there were unifying factors in all forms of artistic expression, as evidenced on one level by painters who wrote poetry, writers who were musicians, or his own adventures as a painter sculpting;[7] and on another, by his efforts to translate music into colour.[8] "All the arts are recognized as channels of creative energy which, at the source, is the same kind of energy, whether it be utilized or moulded to form by the poet, the sculptor, the writer, or the musician," he wrote.[9] The artist's function was "to take all the subtle impressions and relationships that present themselves before him and somehow unify them, giving them a life of their own … not a different kind of life from what the layman experiences; it is simply more of it and a more intense sense of union with it." Art must therefore "consist in the enlargement of life, both for the artist and for the audience."[10]

For Canadian artists, as evidenced by the essays in the *Yearbook of the Arts in Canada*, which Brooker edited in 1929, the task was to develop an "art expression here that is redolent of our own life … until Canadian artists derive their forms and themes from the inspiration of their own surroundings, instead of dealing at second hand with the forms, themes, and technical methods of older civilizations … we shall produce nothing but pale and insipid imitations of something done superbly somewhere else."[11] The Group of Seven, by finding their inspiration at home, had enlarged the life of Canadians, and Brooker affirmed that "painting is the one art in which a really native expression has become thoroughly established."[12]

One subject covered in Brooker's columns was the expansion of the Little Theatre movement in the late twenties, and one of the most articulate voices for a new national and experimental drama was Herman Voaden. In the 1929 *Yearbook*, Merrill Denison had published – to Brooker's regret[13] – a severe rejection of the possibility of a national drama. "This dream of a native theatre is a product of that introspective patriotism that recognizes nationhood most easily in folk songs and native dances, an imitative creative impulse." In a curious dismissal of his own goals in *The Unheroic North*, Denison argued that English Canada lacked any clear identity or "national intentions,"[14] and was merely a provincial reflection of London or New York, to which centres Canadian dramatists would inevitably be drawn. In response, Voaden set out to espouse "the cause of the heroic north."[15]

Herman Voaden came to Toronto in September 1928 as head of the English department at the Central High School of Commerce.[16] He came to

know Lismer and Fred Housser, and in the winter of 1929 offered a course in play production at Hart House, with costume design taught by Lismer. Set design was taught by Lowrie Warrener.[17]

Born in Sarnia, Warrener had studied sculpture at the Ontario College of Art with Emanuel Hahn; fellow students included Carl Schaefer and George Pepper. With the latter, he then went on to the Académie Royale des Beaux Arts in Antwerp (as recommended by Lismer, who had studied there before coming to Canada),[18] and then returned to Sarnia in April 1925. Imbued with the idea of the "North,"[19] in the summer of 1926 he painted with Schaefer, and in 1927, with Schaefer and Pepper, on the Pickerel River (fig. 205).[20] An exhibition of Warrener's works at the Sarnia Public Library in January 1926 was a surprising success, with numerous sales. Delighted, Norman Gurd wrote, "He is the first artist that our movement has produced and naturally we all hope he will make good."[21] Moving to Toronto in the spring of 1926, Warrener rented space in the Studio Building, and he and Schaefer were invited by Lismer to exhibit at the Arts and Letters Club, immediately preceding Brooker's impressive first show.[22] Warrener had been interested in theatre in Sarnia,[23] and in Toronto he assisted Lismer with the decorations for the 1928 Quebec Festival[24] and designed sets for Hart House productions.[25] It was there that he met Herman Voaden.

Responding to Denison's article, Voaden announced a competition for one-act plays, which were "to be written for an outdoor setting and must reflect some aspects of life in Northern Ontario. Contestants may be guided as to mood or subject by the work of any painter whom they consider distinctively Canadian." The judges were J.E.H. MacDonald, Merrill Denison, and John Robins, a professor of English at Victoria College and a long-time associate of the Group.[26]

The winning authors chose, respectively, Lismer's *September Gale*, Harris's *Above Lake Superior*, MacDonald's *Solemn Land*, and Thomson's *West Wind* as inspiration, and two of the plays were presented at the Central High School of Commerce in Toronto in April 1930 with sets by Warrener. The stage set for *Winds of Life* by Dora Conover (fig. 206), with its silhouetted blown pine rising behind conical rocks, and that for *Lake Doré* by Jessie Middleton most obviously reflected Harris's work. The latter set was described in the collection of winning plays published in 1930: "To create the bleak and austere feeling of the wilderness … the hill and mountain forms seen were three dimensional, stylized pieces painted a silver grey, with cold blue and green lights thrown on them."[27] The publication of winning plays, with decorations by Warrener, included a preface by Voaden which was a manifesto for Canadian drama derived from his readings of Ralph Waldo Emerson, Walt Whitman, Lawren Harris, Fred Housser, Bertram Brooker, and Roy Mitchell. He called for a theatre inspired by the Canadian land and people. "We must feel the 'earth resonances' and spiritual emanations of our soil and natural forms. Our innate ideality should force itself on our art, changing our expression till it is in line

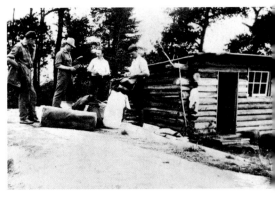

FIG. 205
Carl Schaefer, John Byers, Lowrie Warrener, and George Pepper at the Hahn cabin, Pickerel River, 1927. Private collection.

FIG. 206
Lowrie Warrener: Set for Dora Conover's *Winds of Life*, performed at the Central High School of Commerce, Toronto, 9 April 1930.

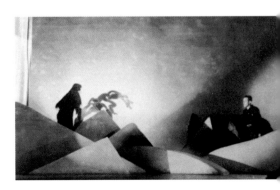

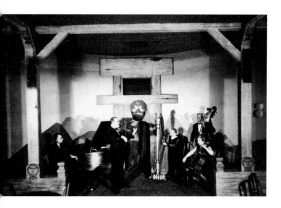

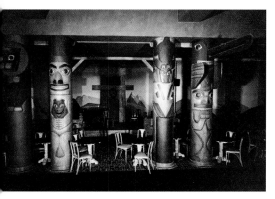

FIG. 210
Edwin Holgate: Decorations in the
Jasper Tea Room, Château Laurier,
Ottawa, c. 1929.

situation is similar. Once we get the Canadian mood into any one of our buildings by colour, design, and arrangement, the result is inevitable. We can sell our country (to use a slang phrase) to our own people as well as to visitors. Imagine a great decoration of mountains against a sky of gold – the thing could be a glory – Canadian mountains, ranges of them. The Laurentian country, the St. Lawrence, Ottawa, the Ontario North, Canadian outdoor sports, animal life. The necessary subjects and material are endless, picturesque, typical – and no one but a Canadian can get the spirit, can saturate the work with the life and mood Canadian."[38] Jackson also made proposals: "Harris could make a marvellous Rocky Mt. room for them, Kihn a West Coast, Holgate 'Quebec', MacDonald 'Northern Ontario', Jefferys 'early settlers', Comfort 'the Prairies', and so on." But the C.P.R. was not interested. "I think it is going to be done by some American firm,"[39] wrote Jackson in regret. The hotel opened with a festival of English folk music under the direction of Murray Gibbon.[40]

Marius Barbeau had more success with the C.N.R. when he approached them with the suggestion of including a Canadian room in the new extension to the Château Laurier in Ottawa.[41] "A Canadian room!" exclaimed Brooker. "Who had ever heard of such a thing? What sort of a Canadian room? What would it be like? Barbeau suggested that they make it a West Coast room."[42]

At Barbeau's instigation it was Edwin Holgate who carried out the decorations for a tea room, no longer Japanese but derived from carvings and designs from the Upper Skeena. With the assistance of Native carvers from Kitwanga and the West Coast,[43] Holgate realized a unique decorative scheme. Masks and designs decorated the corner pillars, posts carved in the manner of totem poles lined the dance floor, and tables and lamps were all carved and painted in a "Skeena River style," while the walls were covered with mountain landscapes (fig. 210). The hotel named it the Jasper Room; Jackson suggested the more appropriate Skeena Room,[44] although the suggestion was not taken. Barbeau celebrated. "The Skeena Room, with its decorative designs, its fine red cedar boards, takes upon itself a rich meaning, which reaches out far and wide. It is a symbol of our growing aspirations towards a nationhood and a culture that will be our contribution to the world at large. It will stimulate fresh outbursts of self-expression. Other hotels, other large public buildings will require their Canadian decoration. We have grown tired of the perpetual daubs of weary commercial imitators."[45] In a hotel with an Adam-style restaurant, a French Renaissance ballroom, and an English tavern grillroom, the tea room was the only space that reflected the fact that the hotel was in Canada (apart from the moose, deer, and buffalo heads hanging in the lobby).[46] When Mackenzie King visited the room, he recommended Holgate to eternal damnation.[47]

In the ongoing debate about Canadian art that ran through Brooker's column, he asserted that "most great art has sprung from a definite locale and the characteristics of a particular people,"[48] citing the examples of Japan, England, and Russia.[49] "This thing we call 'Canadianism' and look for eagerly in the art

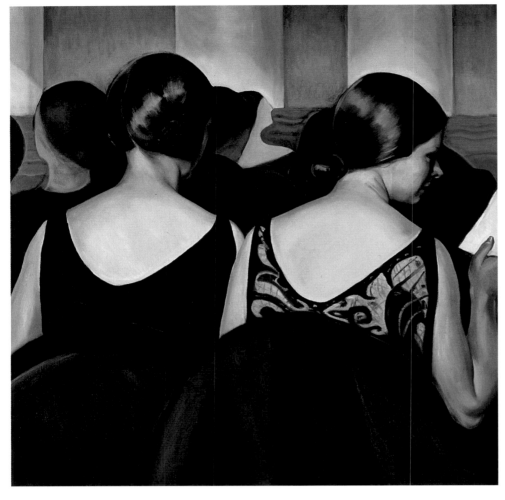

FIG. 211. PRUDENCE HEWARD, *At the Theatre* (cat. 144)

and literature of this country is resented by those who have served an apprenticeship to European principles and methods, because they think that we who talk of Canadianism are seeking to oppose something extremely local in this country to what they are fond of talking about as 'universal standards' ... although [they] really mean European standards. And the Canadian-minded artist talks a lot about Canadianism, although the thing that he wants to see in our art is wanted in every other country, namely a fresh native reaction and an aesthetic interpretation of forms, atmosphere and conditions in new terms especially created for the purpose of expressing a peculiar and limited set of circumstances ... It is something of this service that Canadian painters have done for our landscape."[50]

Art Students' League

The Group of Seven were in an ambiguous situation in the late twenties. They had wide renown without acceptance. They had influence but no security that their legacy would survive in the face of academic opposition. Conservative academicians had a higher repute and more public credibility, which was translated into a bigger market for their work. For younger artists,

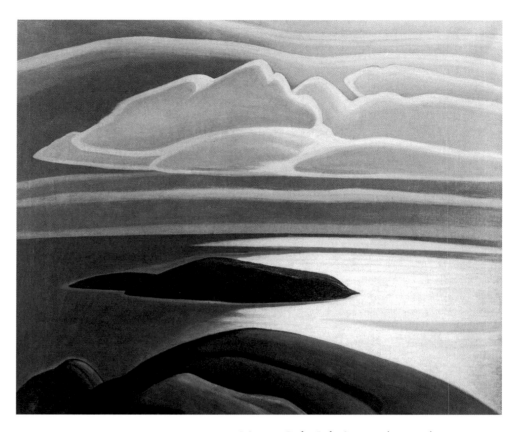

FIG. 212. LAWREN S. HARRIS, *Morning Light, Lake Superior* (cat. 143)

however, the Group *were* Canadian art. Their articulation of an ideal, their considerable reputation, and their paintings, characterized by fresh colour, aggressive rhythms, and clean form, were very attractive to students at the Ontario College of Art where both MacDonald and Lismer taught. When Lismer resigned, a group of students also left to form the Art Students' League, housed in buildings rented from the Art Gallery of Toronto on Grange property.[51]

Entirely directed by the members, the League was founded on a belief in cooperative effort in a non-academic, non-professional, and non-commercial spirit. In "an atmosphere of stimulating work [and] the association of artists & leaders in various branches of art, education & religion,"[52] they organized regular sketching trips in summer and winter. Two of the prime movers behind the formation of the League were Isabel McLaughlin and Edna Breithaupt of Kitchener; on Breithaupt's property on Georgian Bay a cabin (Wakunda) was built where members and others could work all summer.[53] There was a regular program of exhibitions at the League and the League-directed Grange Studios, where crafts were sold. Members taught children at settlement houses and at the art gallery, and made regular studio visits which gave them direct contact with most of Toronto's leading modern artists. Harris, Jackson, Lismer, Brooker, and Yvonne McKague gave criticisms and lectures; other noted speakers included Dr. Frederick Banting, Salem Bland, and Emma Goldman.

FIG. 213. LAWREN S. HARRIS, *Lighthouse, Father Point* (cat. 141)

FIG. 214. A.Y. JACKSON, *The "Beothic" at Bache Post, Ellesmere Island* (cat. 147)

FIG. 215. ISABEL MCLAUGHLIN, *Chestnut Branch* (cat. 173)

The League did provide a stimulating, self-reliant working atmosphere, but its goals were ultimately frustrated by a too-close identification with the Group of Seven. Its activities were largely focussed on landscape sketching, and the members' sense of debt to the Group inhibited individual development. Without specifically referring to the League, Jackson observed, "we have developed a lot of imitators but nothing very original or profound."[54]

It was just this influence that Brooker identified as a threat to the individuality of newer artists. "Until recently, of course, the effect of the Group and their painting was almost exactly the reverse of this. Young painters, and especially beginners and students, seeing their work, were encouraged to look at Canada with a fresh viewpoint – a viewpoint unencumbered by the atmospheric – realistic – photographic tendencies ... So long as the influence of the Group of Seven operated to release young Canadian painters from the stuffy ties of Victorian atmosphericism ... [it] can only be regarded as a healthy and helpful one. But already – although the Canadian public has by no means accepted the Seven – the influence of their work shows signs of hardening into a formula, which a good many painters are adopting as being, so to speak, the

FIG. 216. EMILY CARR, *Wood Interior* (cat. 138)

'fashionable' native school of painting. Notice, I do not say 'popular', but fashionable, a quite different thing."[55]

But extension of the Group's membership would pose other problems. By restricting their numbers they risked being perceived as exclusive and self-serving, but they retained considerable flexibility and a cohesion of ideals.

FIG. 219. J.E.H. MACDONALD, *Dark Autumn, Rocky Mountains* (cat. 151)

were the dominant force in the visual arts in that city. Not only did they control the École des Beaux-Arts, where Charles Maillard had succeeded the French painter Emmanuel Fougerat as director in 1925, but they also controlled the Art Association of Montreal. There was increasing dissatisfaction with the Spring Exhibitions,[58] on whose hanging committee Horne Russell served every year from 1919 to 1933, in addition to his regular membership on the Art Association's Council and its acquisition committee.[59]

Only two Canadian works that could be classified as modern entered the Association's collections during these years, both in 1927: Albert Robinson's *Winter, Baie-Saint-Paul* (fig. 122), a gift from his patron, Mrs. W.L. Davis, and Kathleen Morris's *After Grand Mass*, a gift from W.J. Morrice. The museum was run as a private club with a very limited understanding of its educational role. As one member noted, "it has hardly been possible for members of our Association and others in Montreal to see anything of the work of a considerable number of our Canadian artists, whose merits are recognized in great and critical centres of art, such as London and Paris ... Can we not take a page from Toronto's book of experience, agree to have differences of opinion on artistic questions, open our doors to the moderns, seek out exhibitions of Old Masters, and greatly increase the scope of our lectures and other educational activities?"[60]

Adding to the indifference or unstated hostility of the Association to non-academic art was the stifling influence of Morgan-Powell, still writing in the *Montreal Daily Star*. As Brooker commented, "To a man of his type the

FIG. 220. MABEL MAY, *From My Studio Window* (cat. 153)

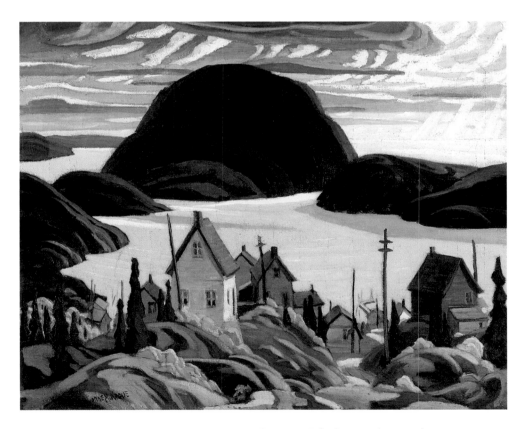

FIG. 221. YVONNE MCKAGUE, *Rossport, Lake Superior* (cat. 154)

traditional artist is always sincere; the experimental is always a charlatan."[61] He took any occasion to denounce modernism of any form for its abandonment of "recognized canons"[62] and its "craze for ugliness, for distortion, for crude and violent colouring, for deliberately bad drawing, and all sorts of eccentricities perpetrated in the name of art."[63]

The Toronto artists exhibited infrequently in Montreal during the twenties, but if their physical presence was not great, their reputation and ideas were all too present in the eyes of numerous Montreal artists, as evidenced in Jean Chauvin's 1928 book *Ateliers*. A compilation of articles printed the previous year in *La Revue Populaire, Ateliers* was published in a handsome edition by Louis Carrier with a title page lettered by Thoreau MacDonald.[64] The intent of the book was defined in a brief foreword. "Abroad and in our province of Ontario ... there reigns a very modern style of art, eloquently defended by a host of writers. But not until now has anyone ventured to bring together a number of Quebec painters, sculptors, printmakers, and architects, both English and French, in one volume."[65] The book was structured around a series of studio visits in Montreal and Quebec City with a number of leading, and mostly academic, artists. Making some insightful comments on critics, art dealers, and the paucity of support for Canadian artists, Chauvin repeatedly found himself in the awkward position of spokesperson for the artists' criticisms of modern art and specifically the Group of Seven, to the point where

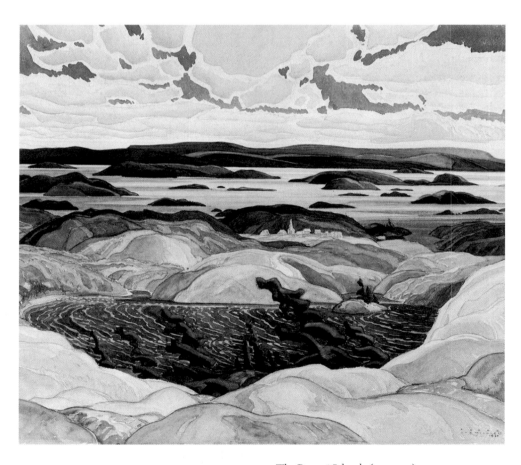

FIG. 222. FRANK CARMICHAEL, *The Bay of Islands* (cat. 135)

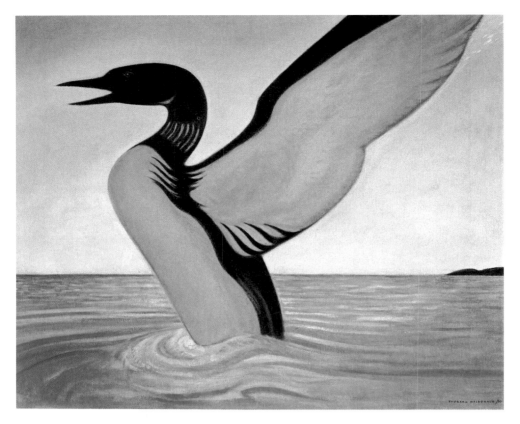

FIG. 223. THOREAU MACDONALD, *Northern Diver* (cat. 152)

he felt obliged to provide the reader with a capsule history of the Ontario movement.[66]

Indirectly, the Group of Seven and their associates in Montreal were the point of reference in most of the texts in the book, either through criticism[67] or comparison.[68] A supporter of the new movements, who recognized the need for further support for artists in general, Chauvin defined one of the sources of the problems faced in Montreal: "It is the fault of the artists themselves, unconcerned about defending their profession, acting as critics, reviewing the salons, forming associations, collaborating with magazines and newspapers, educating the public through lectures (as do the Toronto painters, most notably the Group of Seven), assisting in the creation and diffusion of art-work, and using every available means to increase the number of enthusiasts and stimulate the market."[69] Chauvin had clearly understood the effectiveness of the Group's program.

There were signs of new interest in the work of the Group of Seven and their Montreal associates among a younger coterie in the city, mostly writers and lawyers, known simply as the Group. A forum for discussion and debate on politics, art, poetry, and nationalism, the Group counted among its members Brooke Claxton and Terry McDermot (brothers-in-law of Anne Savage), Arthur Terroux, G.R. McCall, Raleigh Parkin (brother of Alice Massey), and F.R. Scott. In 1925 they formed the Leonardo Society to exhibit modern Canadian painting in Montreal. Operating first out of a bookstore and then in

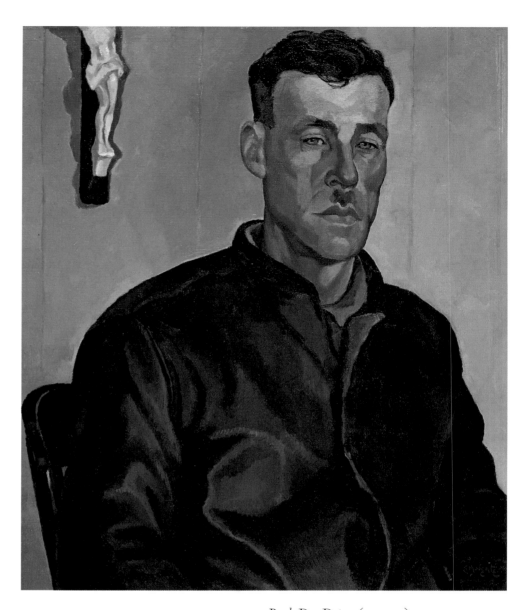

FIG. 224. EDWIN HOLGATE, *Paul, Dog Driver* (cat. 145)

Sidney Carter's gallery, they opened their own space on St. Catherine Street in 1927, where they exhibited Anne Savage's Skeena River sketches, Jackson's Arctic sketches, and paintings by Audrey Buller and Pegi Nicol, as well as reproductions of modern School of Paris paintings and group shows by Montreal and Toronto artists.[70]

Frank Scott was also a co-founder, with A.J.M. Smith, of the *McGill Fortnightly Review*, a journal of "independent opinion" in which Smith published his poem "The Lonely Land," subtitled "Group of Seven."[71] The artists' fight to make Canadians realize they could define their own culture was once again the exemplar for writers working in parallel fields. The *McGill News* would also publish articles by Jackson, Harris, and Carr in the late twenties.[72]

Without any organization of Montreal artists to counter the academic stranglehold, an alliance with Toronto was of special importance, and in March 1929 Edwin Holgate was invited to become the eighth member of the

Group of Seven.[73] The invitation to join coincided with the opening of Holgate's Jasper Room in the Château Laurier in Ottawa. By inviting Holgate to become a member, they extended their own repertoire and gave recognition to the Montreal artists. Respected as he was in the Montreal art community, Holgate was an important ally for the Group of Seven.

Modernism and Internationalism

There was a growing interest in international and specifically French modern art in Toronto in the late twenties, both among collectors and in the education programs and the exhibitions of the Art Gallery of Toronto. The Société Anonyme exhibition was the most advanced and important of these, yet there were also shows of French and American paintings from the Phillips Collection in Washington, instigated by Vincent Massey, and of modern French paintings from the Kraushaar Galleries in New York in December 1929. To the latter, the Tovells loaned works by Jacques Villon, Raymond Duchamp-Villon, and Marcel Duchamp, while H.S. Southam — the newly appointed chairman of the National Gallery's Board of Trustees — loaned a major Van Gogh.[74] Walter Pach, Katherine Dreier, Arthur Lismer, and Jehanne Biétry Salinger lectured on modern French art.[75] The Art Gallery of Toronto acquired sculptures by Ivan Městrović, Auguste Rodin, Paul Manship, and Jacob Epstein.

In the pages of the *Canadian Forum*, recent books on modern European and American art were regularly reviewed, and Bertram Brooker reported on his biannual visits to New York in his column "The Seven Arts." Contacts with that city were more frequent in general as Torontonians travelled there for business or for pleasure. At home, the department stores displayed contemporary French interior designs. The 1929 exhibition *Architecture and Allied Arts* at the Art Gallery of Toronto included furniture by Jacques Ruhlmann of Paris and silver by Georg Jensen and Jean Puiforcat. That same year, René Cera, the T. Eaton Company's designer, designed a model modern home called "The House of Today," which included sculptures by Elizabeth Wyn Wood and a painting by Lawren Harris (fig. 225).[76]

The "modernization" of daily life was more evident in architecture and the decorative arts than in painting, where collecting and exhibiting were still largely confined to prewar French art, yet it furthered the evolution from the past preference for Barbizon-derived paintings. There was a great deal of catching up to do, as Jackson noted. "If some fifteen years ago the director [of the National Gallery of Canada] had collected Cézannes, Van Goghs, Renoirs, Gauguins, and so on, there would have been such a storm of protest from art bodies, collectors, and others that he could not possibly have retained his position, and yet judging from the tremendous increase in the importance of these painters and their recognition by all the principal museums of the world, that is what a far-sighted director should have done."[77]

FIG. 225
René Cera: *The House of Today*, designed for the T. Eaton Company, 1929. On the rear wall can be seen Lawren Harris's *Morning, Lake Superior*.

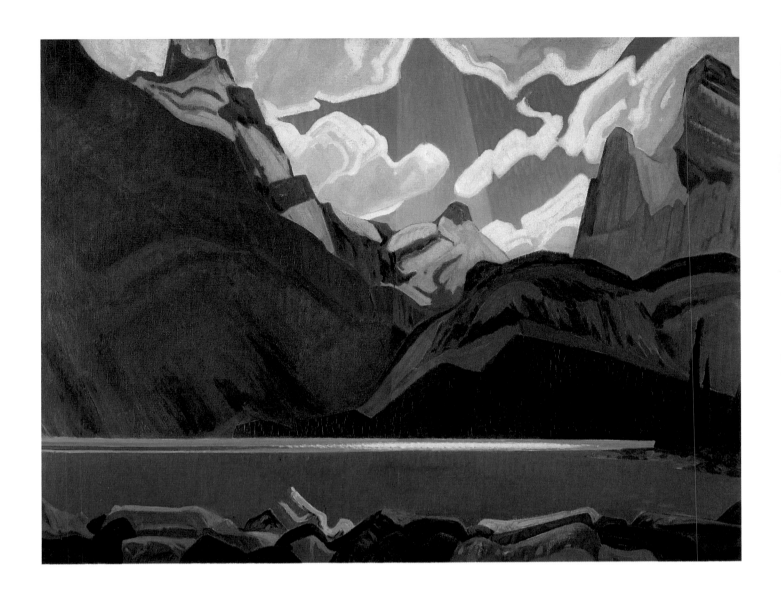

FIG. 226. J.E.H. MACDONALD, *Clouds over Lake O'Hara* (cat. 150)

FIG. 227. LILIAS TORRANCE NEWTON, *Elise Kingman* (cat. 155)

Despite the change in climate, Brooker still found among some uniden-
tified Group members and their friends an "antipathy for modern French
painting ... partly because of the strong nationalist or 'native' tendency which
prompted the Group to break away from European methods of painting in
the first place. It is also partly a reaction against the propaganda for modern
French art, which usually allows no room for anything interesting being done
in any other country. Over and above this, however, there seems to be a genuine
feeling that French painting is overrated ... I cannot see that the modern
French influence is any worse than the earlier European influence which
permeates almost all painting on this continent. Indeed, I feel, it is a more
liberating influence. And it rather surprises me that our own 'moderns' ... are
not more in sympathy with what 'moderns' are doing elsewhere."[78]

FIG. 230. EDWIN HOLGATE, *Nude* (cat. 146)

the country … [he] is constantly searching for the structure, spatial relationships and colour subtleties of the subjects he approaches."[88] For Brooker, what was most significant in the new movement was its expression of the Canadian consciousness; and its less insistent concern with the Canadian background.

The one artist Brooker did not talk about was Emily Carr, exhibiting with the Group for the first time.[89] Since her initial visit to Toronto, when she met the Group artists, she had corresponded regularly with Harris and had exhibited in the east on three occasions, and he had arranged for her to be represented in the exhibition organized by the American Federation of the Arts. The intervening years had seen a remarkable advance in Carr's paintings, and she came east to attend the 1930 show.[90]

Reviewers other than Brooker were restrained. Augustus Bridle felt all had been said of the Group, though he was no less admiring of the energy evident in the paintings of Harris, Jackson, and Lismer. Varley, by the character of his work, was too distant in spirit and had "become an honorary member," and MacDonald was almost absent.[91] Bridle gave only brief mention to the invited contributors.

The writer in the *Canadian Forum* found the work of the "outsiders" weak and "clannish," exempting the paintings by Carr, May, McKague, Pepper, and Robertson, and shared Brooker's observation that this was no longer a Group

show. "The cement which once kept all the stones of this Canadian tower together has dried out and has fallen off, the stones have been disassembled and have been scattered. For the sake of sentimentalism or conservatism, bring them together if you will, but it takes more than the desire to see them, one next to the other, to make of them a unit with a symbol, having a common significance."[92]

For the first time in its history, a Group show was exhibited in Montreal, immediately following the closing in Toronto.[93] As was to be expected, Morgan-Powell welcomed it with barbs. "The outstanding feature of the exhibition is the monotony of the pictures shown. Most of them appear to be done in the same style, and a casual observer might be excused for thinking that most came from the same brush ... The general impression made by the average canvas done by the Group of Seven and their adherents is one of gloom, creating a most unwelcome and unpleasant atmosphere of depression, from which one escapes into the open air and sunlight feeling that it is a thousand pities artists who have some ability should waste it in the effort to paint a Canada that nobody knows and nobody would want to recognize even if they did know it."[94] St. George Burgoyne in the *Gazette* was hardly more approving. "Press and platform propaganda has invested the painting of this group with an importance out of all proportion to its performance, as indicated by the present show. Beauty in form and tone seem taboo and, with a few exceptions, drawing is a superfluity."[95]

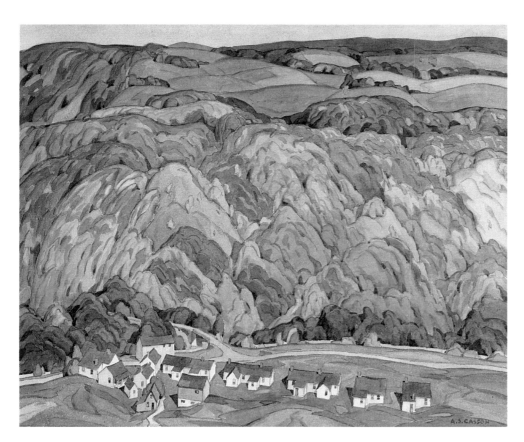

FIG. 231. A.J. CASSON, *Credit Forks* (cat. 139)

FIG. 232. LAWREN S. HARRIS, *Icebergs, Davis Strait* (cat. 165)

14

A Canadian Group

he premature announcement of the Group of Seven's demise failed to take into account the virulent hostility of their opposition and the need for alliances to protect up-and-coming painters. There was much questioning of their ideas from various sources, but disbanding at this stage would have meant effectively abandoning a number of artists across the country who continued to benefit from the Group's support. Alternatives had to be found.

Shortly after the close of the Group's April 1930 exhibition, Harris left for a brief trip to Europe, and then in August he and Jackson went north to the Arctic. The sketches and paintings from the latter trip were exhibited at Hart House, in Ottawa, Montreal, Toronto, Vancouver, and in the United States.[1] In January 1931, Harris was awarded first prize for his painting *North Shore, Lake Superior* at the First Pan-American Exhibition at the Baltimore Museum. The exhibition included paintings from Canada, the United States, and Central and South America.[2] The following summer Harris had a solo show at Dartmouth College in New Hampshire.[3]

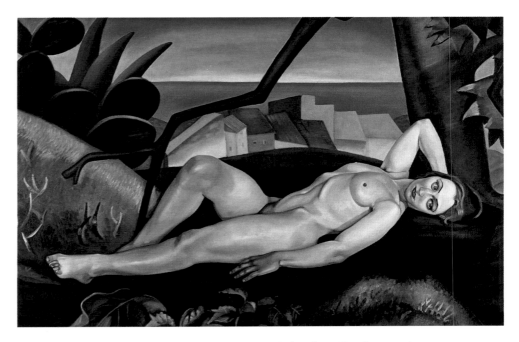

FIG. 235. PRUDENCE HEWARD, *Girl under a Tree* (cat. 167)

usual, *Doc Snyder's House* (fig. 239), the result of two winters' work. Landscapes predominated, with the exception of McLaughlin's and Brooker's still lifes, Holgate's and Newton's portraits, and Heward's large nude. Emily Carr sent in two totemic figures, *Indian Cemetery* and *Thunder Bird*, and three landscapes.

The first reviews were unenthusiastic or diffident, and there was a general perception of *déjà vu*.[11] There would be no sales from this show.

Following the opening reception, the Group met at Harris's house and decided to expand. "The interest in a freer form of art expression in Canada has become so general that we believe the time has arrived when the Group of Seven should expand and the original members become the members of a larger group of artists, with no officials or constitution, but held together by the common intention of doing original and sincere work. We hope the 1931 exhibition will mark a forward movement in art in this country."[12]

The post-mortems started immediately, some in the form of terse reviews. Thoreau MacDonald was the most critical. "The Group of Seven and their followers have always been regarded as Canadian through and through. That has been their special pride and they have never tired of praising the grandeur of the North and the great Canadian Shield. But for Canadian patriots, lovers of our Country, their present exhibit is far from cheering. For they are ever becoming more artistic, more artificial. Without any feeling for the face of our country they tiresomely express themselves in strange and unbeautiful forms, in artificially constructed scenery without life … The Group – or at least their followers – in their efforts to be modern and free are in danger of becoming more conventional than older societies. They lack life that comes from keeping their feet on the ploughed ground and eyes on the face of nature. If the Group intends to be a nursery for incompetent

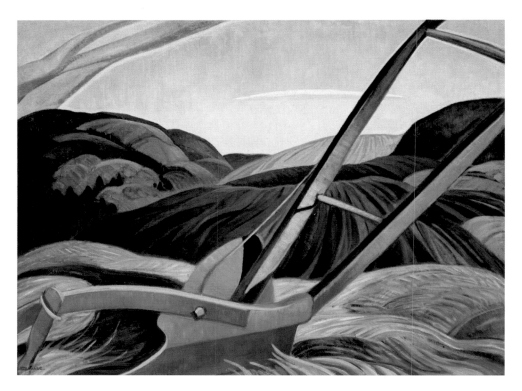

FIG. 236. ANNE SAVAGE, *The Plough* (cat. 178)

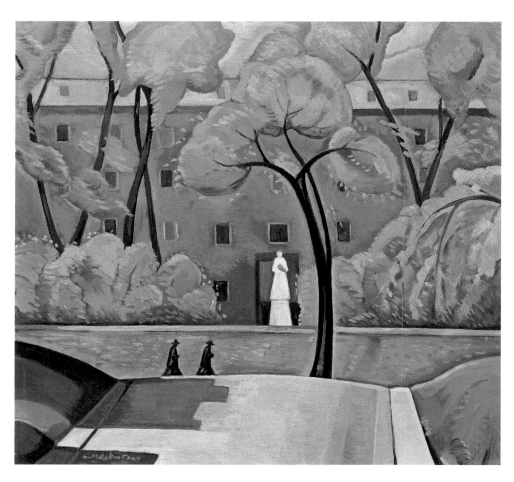

FIG. 237. SARAH ROBERTSON, *Sulpician Seminary* (cat. 176)

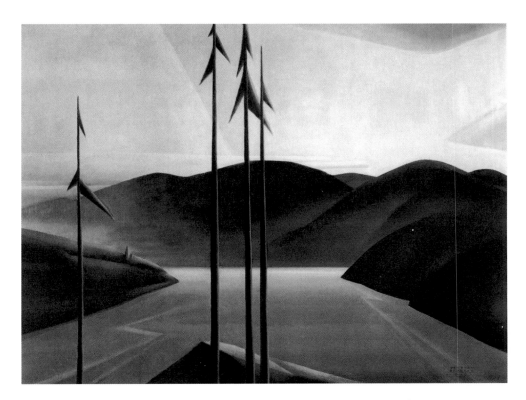

FIG. 238. BERTRAM BROOKER, *The St. Lawrence* (cat. 158)

FIG. 239. L.L. FITZGERALD, *Doc Snyder's House* (cat. 163)

painters, then all right, but if the aim is to raise the standard of painting in Canada and to increase the love and understanding of our country, then something different must be done."[13]

Blodwen Davies was willing to give them credit for their support of other artists. "The Group have volunteered the information that they will begin to add substantially to their numbers to include both men and women. The recognition already accorded women by the inclusion of their work in Group exhibitions has done more than any other single circumstance to develop the notably fine work being done by this generation of women painters. The Group have gone out of their way to encourage women whose work indicated the same vigorous attitude, the same frank and untraditional conception of the mission of the painter. This spirit of generosity, of spontaneous support, has been a dominant characteristic in their relationship to all young painters. Looking back to their own fierce struggle, not for honours, but for a fair deal, they have preferred to err on the side of open-mindedness in their contact with young aspiring painters."[14]

Jehanne Biétry Salinger also recognized their contribution to Canadian art. "There is, beyond the work of the Seven, the outcome of their work, the result of their influence, something developing, growing throughout Canada, new forms of expression, new ideas in the process of germination, fresh emotions born from a renewed viewpoint, all because the Seven did, some twelve years ago, shake the Barbizon and Dutch shackles which held Canadian art in bondage. The Group of Seven perhaps has died with this December exhibition. It has died, in the sense that each of the leaders, who were its members, has gone on by himself, that the paths of the Seven have parted, perhaps never to cross again, but their very motive for coming into existence as a group has grown so far and so wide that Canadian art has emerged from this initial Canadian art movement."[15]

John Lyman, who had returned to Canada that September, responded to Salinger's article. "Throughout what Mrs. Salinger calls 'the amazing story of this art adventure' the emphasis has been misplaced, has been put on the objective rather than the subjective element of artistic creation. The real trail must be blazed towards a perception of the universal relations that are present in every parcel of creation, not towards the Arctic circle. The association of the Seven as a means of getting a hearing from the public and in protest against the hopeless trend of art in Canada, had a favourable outward effect. On the artists themselves it had much less. The discovery that they could make pictures in hitherto unpainted regions was a stimulant to them, but the effect of stimulants does not last forever ... This is no criticism, in any sense of the word, of the painters of the group. An unsound theory will not ruin an authentic artist. The members of the group are what they are, what they were potentially, the product of their racial and epochal antecedents, a part of the ambient spirituality of their age. The Northland has not transfigured them. Their work would fit quite naturally into the ensemble of the less advanced sections of most Paris salons.

FIG. 240. FRANK CARMICHAEL, *Grace Lake* (cat. 159)

FIG. 241. EMILY CARR, *Red Cedar* (cat. 160)

FIG. 242. EMILY CARR, *The Little Pine* (cat. 161)

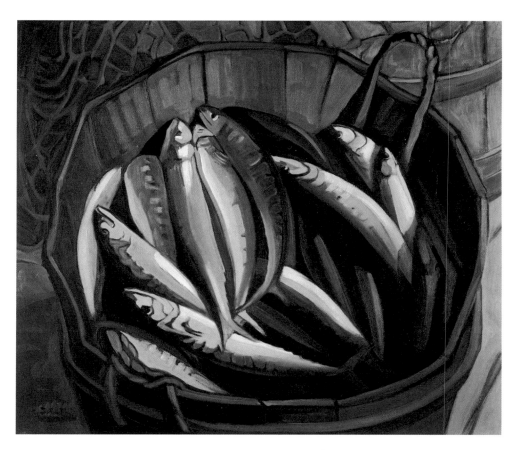

FIG. 243. KATHLEEN DALY, *Mackerel* (cat. 162)

"… In dealing with the painting of Canadians it is quite customary to create an inherent confusion in terms between the two distinct ideas of the manifestations of Canadian nature and the manifestations of nature to a Canadian, of the physical representation of Canada and the Canadianism of an artist … In the case of the group this confusion has been used to argue from personal preference to national significance … New ideals are budding without the mediation of the Seven. Probably they realize this and welcome it. Young Canada is at last becoming conscious of the spirit of the age. If in time it can put its own imprint on it, so much the better. But let us not be hasty in talking of a Canadian school. As T.M. says, it smacks already of academicism."[16]

In spite of all these eulogies, the Group's intent was not to disband but expand, and this in the manner of former inclusions — by adding individuals to a non-structured association. In May 1932, Lismer wrote to FitzGerald inviting him to join. "We have had many names under consideration but we are only unanimous about one … you. This is the wish of all of us. There are no conditions & no organization. Exhibitions are held when we feel the time is propitious. There is no president, secretary or anything like that. We shall consult you about new members, exhibitions & we hope you will keep in touch with *us*. Holgate is the 8th. You are the 9th. Our present idea is a show about next Feb."[17]

Vancouver, 1932

There were some last chapters to be written before the final demise of the Group. In October 1931, after eleven years of work, the Vancouver Art Gallery finally opened. Six years previously the unprecedented sum of $100,000 had been committed by several businessmen to be used for the purchase of works of art once the gallery opened. Under the direction of the major benefactor, H.A. Stone, not a single Canadian work of art was acquired, most being British academic paintings from the nineteenth or twentieth century.[18] The opportunity to rectify the situation came when an all-Canadian exhibition was organized the following May. The usual controversy arose, with John Radford leading the pack criticizing the Group of Seven and Varley and his pupils. "They seem to be prolific producers of artificialities, grotesque fantasies, gruesome hallucinations, morbid conceits, and these artists draw paranoiac monstrosities whose victims suffer from dropsy or locomotoc atania [locomotor ataxy] showing their bankruptcy of good taste and their kowtowing to the leprous god of ugliness."[19] Editorials and letters to the editor persisted in Vancouver and Toronto through August.[20] Exasperated, Jackson wrote to the *Mail and Empire*: "When one considers the vast quantities of mediocre junk that Canada has imported in the name of art and the one or two dozen at most serious examples of modern art which a few collectors have brought in, the menace of modernism seems far away. Now that Vancouver has an art gallery it would seem advisable that they bring in what New York or Paris would consider a modern show. Then they wouldn't get the jim-jams over an exhibit a Toronto school-girl would consider conventional."[21]

FIG. 244. A.G. BARNES, *The Grey Veil* (cat. 8)

A popularity vote was taken on the works on view. Fred Brigden's *Canyon of the Agawa* received 173 votes, Archibald Barnes's *The Grey Veil* (fig. 244) 102, and Fred Coburn's *Winter Landscape* 80. Lawren Harris's *Isolation Peak, Rockies* (fig. 253) received 28 votes and Jackson's *The Road to Saint-Fidèle* 11. MacDonald's *Autumn Colour*, the painting called a "Drunkard's Stomach" by Charlesworth in 1916, received no votes.[22] To the credit of the gallery's committee, they purchased the Jackson, Mabel May's *Autumn in the Laurentians*, and a Morrice, *On the Beach, Dinard*, even though the latter two had each received only four votes. Reflecting on the Vancouver situation, Mortimer-Lamb exclaimed, "Who ... would have believed, say, five years ago, that a responsible body of citizens acting for a civic gallery would deliberately have acquired for its permanent collection an A.Y. Jackson?"[23]

The Academy, the National Gallery, and the Group

In his denunciatory letter to the editor about the all-Canadian exhibition, Radford had accused the artists of political manipulation and control of galleries and museums "under the plea of encouraging 'modern' or 'contemporary' art." He continued: "It is alleged that Ottawa is the art mentor for the

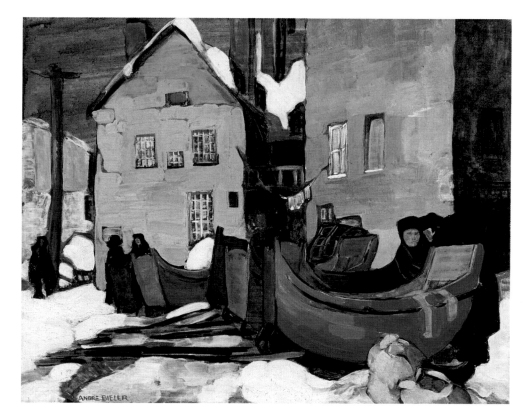

FIG. 245. ANDRÉ BIÉLER, *"Berlines," Quebec* (cat. 157)

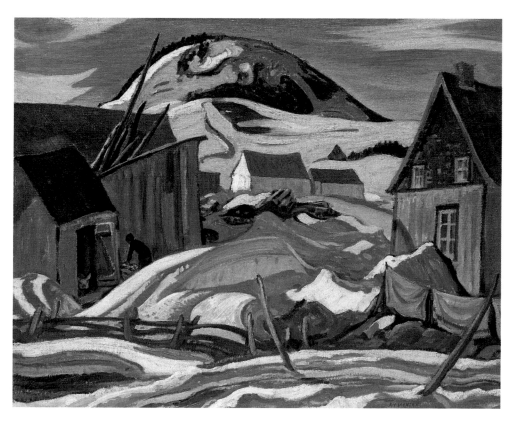

FIG. 246. A.Y. JACKSON, *Winter Evening, Quebec* (cat. 168)

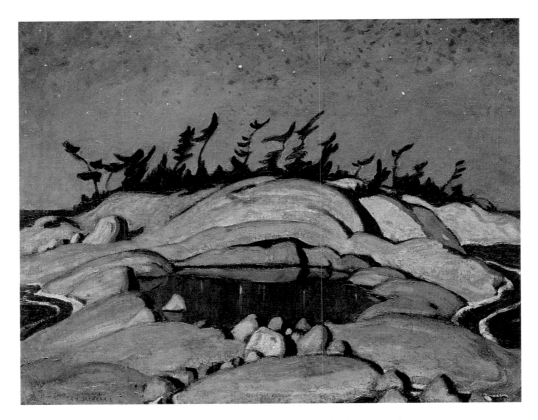

FIG. 247. A.Y. JACKSON, *Night, Pine Island* (cat. 169)

FIG. 248. A.Y. JACKSON, *Saint-Fidèle* (cat. 170)

FIG. 249
The jury for the Royal Canadian
Academy of Arts Exhibition at the
Art Gallery of Toronto, 31 October 1932.
Left to right: J.W. Beatty,
Wyly Grier, John Lyle, Emanuel
Hahn, A.Y. Jackson.

FIG. 250. KENNETH FORBES,
Girl Ironing (cat. 6)

Dominion, and that only those pictures endorsed by Ottawa should be purchased by galleries throughout the various provinces."[24] A petition was already circulating in Vancouver, under Radford's guidance, asking the government to launch an investigation of the National Gallery for "flagrant partisanship" and for the organization of exhibitions "at home and abroad that do not represent the best in Canadian art" because of their exclusion of the work of "our best artists."[25] The campaign had started the previous winter when Franz Johnston, Arthur Heming (fig. 251), and Ottawa artist Henri Fabien had written to the new prime minister, R.B. Bennett, voicing their complaints.[26] In all, 118 artists from Montreal, Toronto, Ottawa, Hamilton, Vancouver, and Victoria signed the petition, including three former presidents of the R.C.A., George Reid, Homer Watson, and Horne Russell, the current vice-president, W.S. Maxwell, and the secretary, Edmond Dyonnet.[27] Although he had been on the selection committee for the Buenos Aires show in 1931 and had assisted MacDonald and Emanuel Hahn in choosing works from the 1932 Academy exhibition for the National Gallery's *Annual*, the current president of the R.C.A., Wyly Grier, also joined the protest. J.E.H. MacDonald had been elected to full membership in the Royal Canadian Academy the previous November. At the 1932 annual meeting, none of his paintings was accepted as his Diploma Work. He died three weeks later on 26 November.[28]

Outraged, Jackson wrote to Dyonnet, charging the Academy with seeking, once again, to control the National Gallery. "I find a lot of misstatements and unsupported accusations in all this litter of publicity. I think the insinuation of Simpson, Russell, and Grier that poor old Jim MacDonald was not worthy to be trusted to help Grier pick out a few pictures to go to Ottawa is just an unbelievably sad comment on all of them. MacDonald has had nothing to do with the Group of Seven during the past five years beyond allowing us to exhibit old canvases which had been exhibited in the Academy or the O.S.A. His last three canvases, painted under great stress last summer, were done for the Academy to express his appreciation of the tardy honour conferred on him. I have come to the conclusion that my confreres in the Royal Canadian Academy will feel freer without my presence in the society and I herewith send you my resignation."[29]

While the *Vancouver Sun* had published the anti-Gallery petition in the press in May,[30] and individual artists persisted in their criticisms of the Gallery and of the Group of Seven through the summer,[31] the affair did not break until December. It was reported across the country. There followed over six months of articles, editorials, and letters to the editor. On the petitioners' side were Fosbery (fig. 202), Grier (fig. 84), Maxwell, Kenneth Forbes (fig. 250), Richard Jack (fig. 252), Heming, Radford, John Russell, William Colgate, and Canadian artists in Paris.[32] On the Gallery's side were Jackson, Harris, Lismer, Chauvin, Wyn Wood, Frances Loring, David Milne, and Arthur Crisp writing from New York.[33] A counter document in support of the Gallery was signed by 282 artists from across Canada.[34] The articles and letters dragged out all the

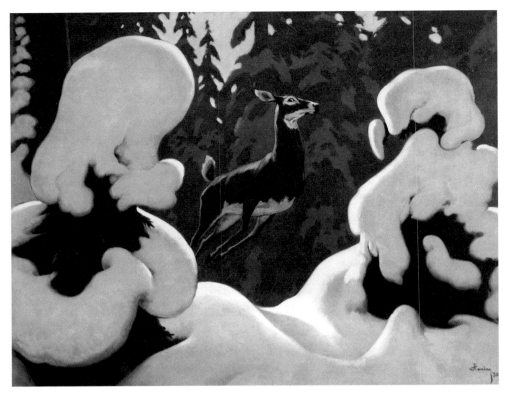

FIG. 251. ARTHUR HEMING, *In Canada's Fairyland* (cat. 9)

complaints about Wembley, Gallery purchases, and exhibitions, laying the entire blame on Eric Brown. Yet at the core of the conflict was the hostility of the conservatives to the Group of Seven and modern art, a hostility brought to the boiling point by the decline of private patronage due to the Depression. It became all the more imperative that conservative artists be able to regain their lost status and control of the little state patronage that remained.[35] "The squabble over the National Gallery continues and has run into the usual channel of condemning the Group and its pernicious influence," Harris wrote to FitzGerald. "An unusual amount of lies are loose and the boys of pique are resorting to rather smelly methods. This is dividing the sheep from the goats and will leave nearly all the up and coming painters out in the cold."[36]

Canadian Group of Painters, 1933

Harris went on to outline to FitzGerald the final stage in the development of the Group of Seven. "Last year the group decided to enlarge its membership — you were the enlargement. Now we feel that it is essential to form a society of all the so-called modern painters in the country, secure a charter and make ourselves felt as a country-wide influence in terms of the creative spirit. We propose to call the society 'The Canadian Group of Painters' thus retaining the word group and suggesting the enlargement of the idea."[37]

Before announcing the formation of the new association they issued a statement. "The members of the Group realize the futility of trying to imitate

FIG. 252. RICHARD JACK, *Arthur Heming* (cat. 10)

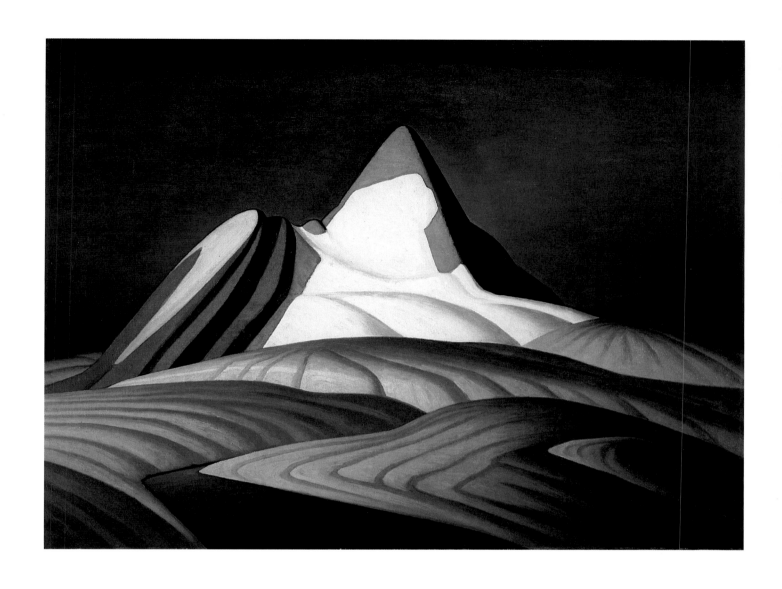

FIG. 253. LAWREN S. HARRIS, *Isolation Peak, Rocky Mountains* (cat. 166)

the great works of the past, even if such were possible, but believe we should try to apply the attitude that created those to our own day and place. While there are a great variety of idioms in art, expressive of the race and background of the different ages and peoples, the Group believe that the creative attitude that gave rise to these is essentially the same in all ages, varying only in the degree of creative power and vision. It holds that what is called the great tradition in art is not a thing housed only in galleries and museums, but is innate in all creative individuals and is evoked into life by the stimulus of time and environment.

"The Group of Seven has therefore always believed in an art inspired by the country, and that the way in which a people will find its own individual expression in art is for its artists to stand on their own feet and by direct experience of the country itself, and its inexhaustible variety of new and untried themes, to produce works in terms of its own time and place.

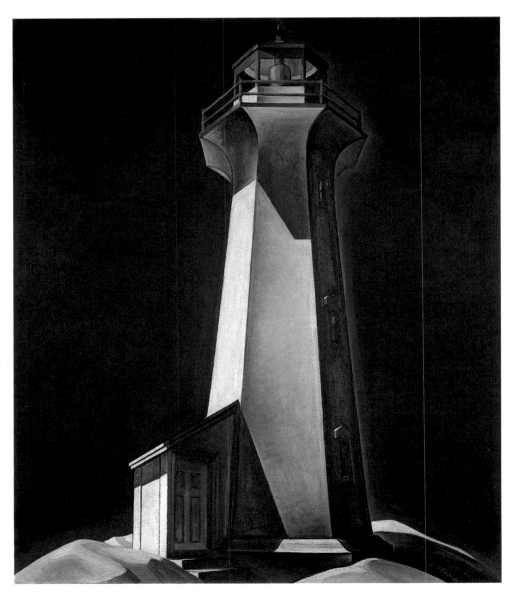

FIG. 254. GEORGE PEPPER, *Lighthouse* (cat. 175)

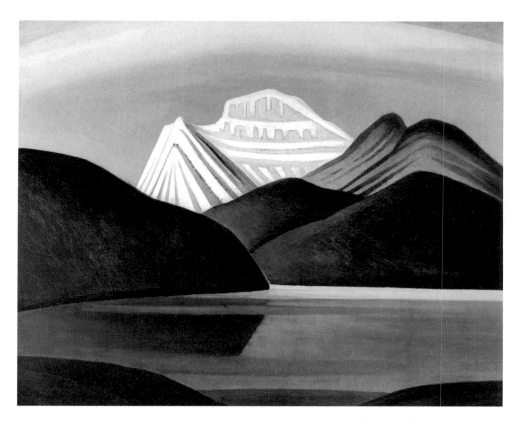

FIG. 255. LAWREN S. HARRIS, *Mountains and Lake* (cat. 142)

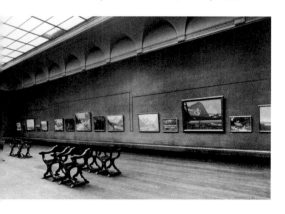

"While the works of the Group are far removed from the extreme expressions of modern art in Europe, nevertheless, their works are modern, in the sense that they are not literal imitations of nature, but are re-creations of a scene or mood or the spirit of a place inspired by a new and artistically little explored country. This means creative adventure and the consequent disregard of outworn conventions irreconcilable with the spirit of the country . . .

"The Group has always defended this attitude. It has always maintained for themselves and others the right to freedom of expression, believing that only in diversity of outlook will there ever be a widespread interest in the arts in this country . . .

"All the members of the Group appreciate the encouragement of its well wishers, and also the expressions of those who disagree with its aims. These have both been helpful in different ways."[38]

J.E.H. MacDonald Memorial Exhibition, 1933

A memorial exhibition of the work of J.E.H. MacDonald was held at the Art Gallery of Toronto in January 1933 (fig. 256). Coincidental with this show was an exhibition of French painting, *From Manet to Matisse*. Lismer wrote the foreword. "The French are the supreme experimenters in the realm of art, and France the cradle of modernism. More than any other nation, they have kept alive the torch of great art expression."[39] Jackson was on the gallery's exhibition

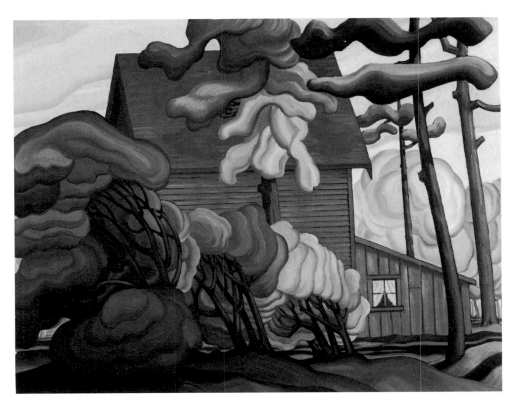

FIG. 257. CARL SCHAEFER, *House in the Wood* (cat. 179)

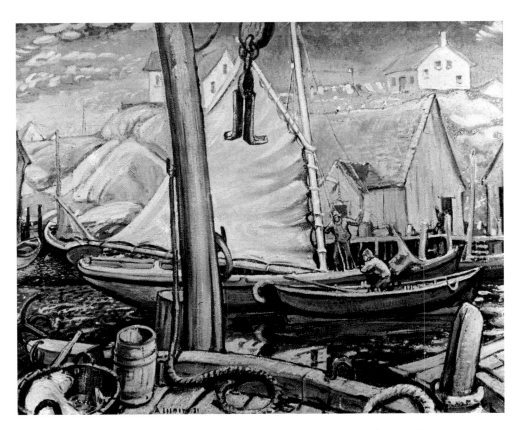

FIG. 258. ARTHUR LISMER, *Harbour Life, Nova Scotia* (cat. 171)

committee, which organized both shows, and he queried in vain: "Who owns a Derain? a Picasso? a Matisse? a Léger? a Braque? ... There are a couple of Cézannes and a Renoir in the Van Horne collection ... But who owns a Gauguin or a Seurat?" Admonishing those who saw modern painting as a menace, he added, "It is well to remember that over the same period the genius of France has dominated the whole world of art ... If the zealous guardians of our art standards are concerned about improving our tastes, they can find more effective ways of doing so than by discouraging the rare modern work that is brought in."[40] But in the height of the emotion of the memorial show, Jackson exclaimed, "Jim MacDonald means more to Canadian painting than the world-acclaimed Matisse in the next room."[41]

The insistence on an evident Canadianism was to haunt the new Canadian Group of Painters. "I am a little afraid that a strong nationalist bias, which always gets into the utterances of the old Group, either public or private, is going to continue very strong in the new Group," wrote Brooker to FitzGerald. "Comfort and I ... did stress that paintings, even by Canadians in Canada, need not necessarily be confined to any sort of nationalistic tradition."[42]

Conclusion

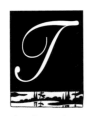he Group of Seven attracted an audience for Canadian art greater than at any previous time in our history. They affirmed the existence of artists here and proclaimed that their art merited the attention of the Canadian public. In this a major, if far from complete, victory was won in the face of colonialist self-denigration and constant adoption of external values. As Reid MacCallum observed, "The artists themselves, probably rightly, have largely refrained from explaining what they were doing, being too busy doing it. At most, in the heat of controversy, one finds politico-geographical terms such as 'Canadian Art', 'Canadianism', 'The Canadian North', or Lawren Harris's 'The North' bandied back and forth, denied or asserted to characterize the new movement in its essence. In the heat of controversy the use of terms intelligible to the public precisely because they are not art-terms served a useful purpose in drawing attention to the fact that Canada now harboured eminent painters of her own, doing excitingly original work; but the fact remains that the language of politics or geography is as unsuited as that of arithmetic to formulate the essence of an art."[1]

By defining art politically and geographically, the artists of the Group did impede the discussion of art on its own terms — what was actually happening

on the surface of the canvas – and ultimately inhibited an appreciation of Canadian art in any but those ways. Judgment came to be based on the 'Canadianism' of a painting rather than its inherent pictorial qualities, thus discouraging a wider admiration of artists such as David Milne or Goodridge Roberts, and of the movement towards abstraction.

New times demanded new methods, and the critics, while recognizing the major contribution the Group had made, called upon artists to take to new roads. "For the first time in our Canadian history we had here a body of men who were in passionate reaction against all the values of our civilization and who, in an agony of soul, were trying to tell us what they saw in Canadian life and how they felt about it," wrote Frank Underhill in 1936. "There must have been some subtle flaw in their original vision, for soon they were seeing themselves as their admiring critics saw them, as Men of the North and nothing more. Instead of using the North as an instrument through which to express their vision of Canadian life, they began to use it as a means of escape from Canadian life … the Group, being the only artists of our time with any vital energy, have attracted a host of young imitators who are imitating merely the superficial aspects of their work without any of their original creative vision … It is time that we demand from our artists that they cease to be mere escapists and that they concentrate their gaze upon the life that is actually lived by our ten million Canadians and tell us what they see here. For where there is no vision a people perish."[2]

In Toronto there would come a call for an art more overtly responsive to the social conditions of the thirties, and from Montreal, for a clearer articulation of an art developing within a European, and specifically French, formalist early-twentieth-century tradition. Reviewing Harris's selections of Canadian art for the San Francisco Golden Gate Exposition in 1939, Lyman noted that the paintings were largely by the old Group of Seven and the Canadian Group. "This slant conveys on the whole the impression that Canadian art stopped in its tracks a decade ago. In preparing exhibitions for abroad it might be to the advantage of this country to take into account the fact that the relative importance given the Group of Seven collectively at home, where the work is endowed with the romance of a pioneer saga, is not fully apparent to outsiders who judge painting by itself."[3]

FIG. 259
First exhibition of the Canadian Group of Painters, Heinz Art Salon, Atlantic City, New Jersey, summer 1933. *Saturday Night* XLVIII:50 (21 Oct. 1933), p. 16.

Just as the Group of Seven had found purpose in defining their goals in relation to the art of an earlier era, so new movements would articulate their philosophies with reference to that of the Group. They had become the new academicism.

The formation of the Canadian Group of Painters did not mean the end of painting for the individual artists. Each in his own way would continue to pursue his art, although they were increasingly dispersed. Varley remained in Vancouver, while Harris left Toronto in 1934 to live in the United States. Lismer spent considerable time out of Canada in the late thirties. Carmichael began teaching at the Ontario College of Art in 1933, and Casson continued to work at the commercial art firm of Sampson and Matthews. Jackson alone of the members remained in the Studio Building and would represent for several generations the embodiment of the original ideal.

FIG. 260. LILIAS TORRANCE NEWTON, *Albert Robinson* (cat. 174)

Despite the Group's great fame, even notoriety, their victories were fragile and tentative. After MacDonald's death, Fred Haines was appointed principal of the Ontario College of Art, and Lismer was relieved of responsibility for the summer teachers' courses after twelve years' work.[4] Varley left the Vancouver School of Decorative and Applied Arts in 1933 over a salary reduction, and established the British Columbia College of Arts with Jock Macdonald and Harry Tauber. The school closed after two years, and by 1936 Varley was destitute. The Art Students' League was absorbed into the Guild of All Arts in Scarborough, east of Toronto, in 1932.[5]

During all those years the artists sold relatively few paintings. Of the fifty canvases in MacDonald's memorial exhibition, thirty-seven came from the artist's estate. In a career that spanned almost twenty-five years, he had sold barely thirty paintings. In the 1936 retrospective exhibition of the Group at the National Gallery, Carmichael owned twenty of his twenty-four canvases, Casson eighteen of his twenty, Harris twenty of his twenty-six, and Lismer twenty of his twenty-five. Jackson exhibited the largest number of works borrowed from collectors and institutions — twenty-three out of twenty-seven. The major market for their paintings would only develop later.

The Depression clearly affected sales in the thirties, and the nascent collections in Sarnia, Kitchener, and Saskatoon would remain moribund for years.

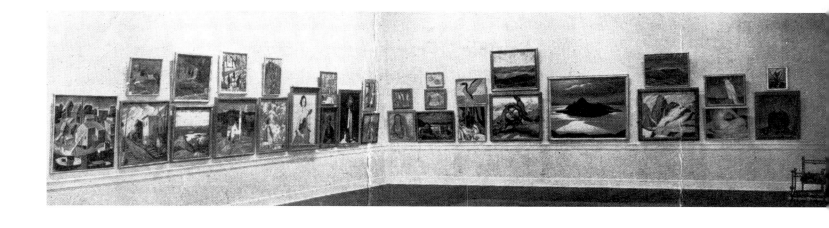

Canada has a definite part to play in the world. The artists, notably the Group of Seven, were among the first to strike out boldly. They carved new materials out of our landscape and evolved a different technique to handle them. It is probably true that the painters are the heralds always of wider and more far-reaching artistic developments. They make us artistically aware of a new scene. This new scene must produce its effect on character, and both scene and character are immediately at hand for the novelist, poet, and dramatist.

"The movement of the Group of Seven has centred in one city, Toronto … The hope of Canada lies in the development of … groups in many Canadian cities, each group inspired with a high artistic ideal and determined to give opportunity to creative talent … Canada is probably on the eve of a great renaissance in her art and literature. She is unshackled by the past. She looks only to the future. With untold wealth, power, and idealism, she is ready to create a new and important culture. All that has been done before, in prose and poetry, music, painting, and sculpture, is only a preparation for what is to come."[10]

The ideas debated and promoted by the Group of Seven have had a long life – for some, far too long. They would inform cultural policy into the 1950s and beyond; of the seventeen recipients of the prestigious Canada Council Medal from 1961 to 1964, for example, twelve had played some role in the events narrated in this text: Lawren Harris, A.Y. Jackson, Arthur Lismer, Fred Varley, Wilfrid Pelletier, Sir Ernest MacMillan, E.J. Pratt, Marius Barbeau, Brooke Claxton, and Vincent Massey. Like other major art innovators, the Group were united in their intent and cooperative action, and together they were remarkably effective in promulgating their vision across Canada and internationally. Theirs is a notable record of achievement, and their ideals have left a permanent trace on the culture of Canada.

Endnotes

INTRODUCTION

1. Quoted in Gigeroff 1955.
2. Teitelbaum 1991; S. Watson 1991, 1994; Fletcher 1989; Walton 1990; Morrison 1991; Fulford 1969, 1992.
3. Carl Berger, "The True North Strong and Free," in Russell 1966, pp. 3–26; Cole Harris, "The Myth of the Land in Canadian Nationalism," in Russell 1966, pp. 27–43; Cook 1974; Stacey, "The Myth – and Truth – of the True North," in Tooby 1991b, pp. 36–63; Davidson 1969; Vipond 1974, 1980; Djwa 1976, 1977; Grace 1984; Cole 1978.
4. The modern theosophical movement, established in the late nineteenth century, emphasizes mystical experience, esoteric doctrine, occult phenomena, and a belief that reality is constituted of one principle behind its various manifestations. It has an affinity for religious and philosophical conceptions identified with Asian thought, including reincarnation and human evolution. The International Society was based in Adyar, India. The Theosophical Society in Canada was one of the first national societies, and published the *Canadian Theosophist* from 1920. See Lacombe 1982.
5. Nasgaard 1984; Martinsen 1984; Stacey 1980; Davis 1974, 1992.
6. F.B. Housser 1926a, pp. 37–38.
7. Harris, Allandale, Ont., to J.E.H. MacDonald, Toronto, postmarked 7 July 1919, McMichael Coll. MacDonald papers; L.S. Harris, 1925a.
8. Lismer, Toronto, to Mortimer-Lamb, Vancouver, 26 June 1925, B.C. Arch., MS 2834, box 1, file 14.
9. Art Chronicle 30 July 1910.
10. Morning Post 4 July 1910.
11. G. Clark 1914a.
12. G. Clark 1914b.
13. Canadian Courier 26 Nov. 1910.
14. G. Clark 1914b.
15. G. Clark 1914b.
16. RCA Records 1883, p. 8.
17. Tupper 1887, p. 61.
18. R.A.M. Stevenson 1886, p. 519.
19. See Pepall 1986b.
20. See Colgate 1954. The League started out as a life-drawing group. Their calendars, published annually from 1893 to 1904, also illustrated northern development and rural industry. See Stacey in Tooby 1991, pp. 36–63.
21. See C.L. Sibley, "A. Suzor-Coté, Painter," in ALC 1913, p. 155.
22. See Thoreau MacDonald, Toronto, to Brown, Ottawa, 18 Feb. 1932, NGC Arch., 7.1-M. "In my present drawings I'm trying to record as much as I can of the rural life of Ontario which is so quickly passing away." See also T. MacDonald 1929b.
23. Mortimer-Lamb 1922a.
24. OSA Notes 1911.

25. Addison and Harwood 1969; Addison 1974.
26. A.Y. Jackson 1919c.
27. Jefferys 1911b.
28. Canadian Courier 19 Oct. 1907.
29. See Landry 1990.
30. Jackson, Toronto, to C. Breithaupt, Boston, 17 Jan. 1921, UWL, Breithaupt Bennett papers, corr. received.
31. Rosenberg 1920, p. lix. The article is referred to in the letter cited in n. 30.
32. Brooker 1929c.
33. A.Y. Jackson 1921, p. 175.
34. Lismer 1925a, p. 179.
35. Charlesworth 1916, p. 5.
36. Grier diary for 1915, 19 July–4 Aug. 1915, Arch. of Ont., MU8223.
37. Morgan-Powell 1918, p. 2.
38. Toronto Daily Star 10 April 1930.
39. Charlesworth 1923b.
40. Charlesworth 1918c.
41. Charlesworth 1918a.
42. J.E.H MacDonald 1916b.
43. Fairley 1919b, p. 9.
44. Lismer 1919c; A.Y. Jackson 1919j.
45. W.R. Watson 1912.
46. E. Brown 1921b.
47. E. Brown 1921b.
48. E. Brown, "Memorandum for the Honourable the Speaker of the Senate, National Gallery Loan Exhibitions," typescript, p. 2, NGC Arch., 5.1-Lamb [c. 28 Feb. 1925].
49. Fort William Daily Times Journal 21 and 14 March 1914.
50. The Ottawa Group, formed in 1923, consisted of Paul Alfred, Harold Beament, Frank Hennessey, F.H. McGillivray, Graham Norwell, Yoshida Sekido, and David Milne. They held an exhibition at Hart House at the University of Toronto in January 1924. They appear to have disbanded later that same year. See Varsity 31 Jan. 1924 and 4 Feb. 1924.
51. L.S. Harris 1924b.
52. Lismer 1926c, pp. 71–72.
53. Griesbach, Collingwood, to Greig, Toronto, 10 April 1920, AGO Arch., A3.9.5-AMT Letters 1912-20-G.
54. Griesbach 1920.
55. Préfontaine 1918a, pp. 47–48.
56. Préfontaine 1918c, p. 378.
57. Préfontaine 1918b, p. 123.
58. Barbeau 1920b, p. 2.
59. Pelletier 1918.
60. Mason 1926.
61. Turner 1922, pp. 82, 84.

1. A CANADIAN ART

1. The Canadian Art Club, p. 6.
2. Jefferys 1911a.
3. MacTavish 1910, pp. 299–300.
4. "Royal Canadian Academy of Arts Memorial Regarding the Present Conditions and Needs of Canadian Art," 7 Jan. 1907, NAC, DPW papers, R.G. 11, vol. 1653, pp. 299–300.
5. National Archives of Canada, Ottawa, Order in Council, p. c. 673, 3 April 1907, R.G. 2, vol. 297.
6. Brymner, Montreal, to Morris, Toronto, 25 April 1912, AGO Arch., Art Club papers; H. Watson, Doon, Ont., to MacTavish, Toronto, 5 May 1908, North York Libr., MacTavish papers.
7. *Prospectus of Proposed Art Association for the City of Toronto and Province of Ontario to be Established under the Auspices of the Ontario Society of Artists*, Arch. of Ont., MU2254, OSA Minute Book 1881–90, 12 March 1895.
8. Globe 16 March 1900.
9. See Reid 1979; Pepall 1986a; Trudel 1992.
10. See Brooke 1989.
11. Greenshields 1904 and 1906; see also Hurdalek 1983.
12. Jackson, Montreal, to Florence Clement, Berlin, Ont., 5 March 1913, priv. coll.
13. Walker, Toronto, to S. Fisher, Ottawa, 3 Feb. 1909, file copy, UTL, MS. coll. 1, out corr. 1905–09, box 20.
14. AAM 1913a.
15. Robert Harris, PRCA, Montreal, to Laurier, Ottawa, 20 April 1903, in NAC, Laurier fonds, vol. 261, pp. 72338–43.
16. See Bayer 1981, pp. 32–54; and 1984.
17. Figures are uncertain, but between 1912 and 1925 approximately 70 Canadian works were purchased by the CNE and approximately 173 European and American works.
18. RCA President's Report 1913, p. 12.

2. THE BEGINNINGS

1. The Canadian Art Club, pp. 8–9; see also Lamb 1988.
2. The Canadian Art Club, p. 4.
3. [MacTavish] 1908a, p. 480.
4. MacTavish 1911, pp. 322–23.
5. MacTavish 1910, p. 300.
6. J.W. Morrice, Paris, to Morris, [Toronto], 12 Feb. 1911, AGO Arch., Art Club papers.
7. L.S. Harris, "The Canadian Art Club," in ALC 1913, p. 213.
8. [MacTavish] 1908b, p. 95.
9. Jefferys 1911b. While MacDonald officially became a member only in February 1911, he designed a crest for the first publication of the Club, *A Gathering of the Arts* (copy in North York Libr., MacTavish papers), which predates the first issue of *The Lamps*. Bridle 1910 refers to MacDonald having designed the Viking crest "less than a year ago." Though listed as a charter member, Harris became a member only in November 1909. Information from the Arts and Letters Club archivist, Raymond Perringer.
10. B.B.C. 1911, pp. 64, 69. This article refers to the statements being published in the *Toronto Daily*

News and in pamphlet form as *Notes on Pictures at the O.S.A. Exhibition.* MacDonald was on the hanging committee for this exhibition. Arch. of Ont., MU2254, OSA Minute Book 1900–15, 1 Nov. 1910.

11. Arch. of Ont., MU2254, OSA Minute Book 1900–15, 7 March 1911 (nominated by Grier and Beatty) and 4 April 1911 (elected).

12. Bridle 1911, p. 12.

13. Bridle 1912a, p. 7; see also Farr 1981.

14. L.S. Harris 1911a.

15. Jefferys 1911a. Harris (chairman), Jefferys, and Beatty comprised the Club's picture committee that year.

16. OSA Annual Report 1905, p. 6.

17. Jefferys 1911b, p. 16.

18. G. Clark 1914b. See also Nasgaard 1984; Martinsen 1984; Stacey 1980.

19. J.E.H. MacDonald 1980, p. 9. This is the text of a talk he gave at the AGT, 17 April 1931. See also Fairbairn 1913; L.S. Harris 1948, p. 31.

20. J.E.H. MacDonald 1980.

21. Robson 1932, pp. 134–40; Hunter 1940, p. 11; see also Tooby 1991a.

22. Owen Sound Sun 27 Sept. 1912.

23. Canadian Courier 4 April 1914; Bayer 1984, pp. 84–85.

24. Jackson refers to MacDonald in a letter from Assisi, Italy, to his mother, Mrs. Henry Jackson, in Montreal (4 Dec. 1912, priv. coll.). Hewton and Jackson were planning their exhibition at the AAM for February and invited MacDonald to join them.

25. Jackson, Montreal, to Florence Clement, Berlin, Ont., 5 March 1913; and from Émileville, Que., to Chas. Clement, Winnipeg, 19 April 1913; both priv. coll.

26. Jackson, Émileville, Que., to Florence Clement, Berlin, Ont., 3 April 1913, priv. coll.

27. Jackson, [Montreal], to Harris, [Toronto], 26 March 1913, quoted in F.B. Housser 1926a, pp. 79–80.

28. A.Y. Jackson 1958, p. 23.

29. Jefferys 1911a. Harris was elected chair of the picture committee, see ALC Arch., Minute Book of the Executive Committee 1913–18, 28 Oct. 1913; the Scrapbook 1908–25 notes a Jackson exhibition to 13 Dec. 1913 and a J.E.H. MacDonald exhibition from 5 Dec. 1914, ALC Arch. See also Lamps Dec. 1911, p. 12, for a calendar of exhibitions, winter 1911–12. On the Arts and Letters Club, see Bridle 1945.

30. See exhibition catalogues, Little Pictures 1913 and 1914. On p. 11 of the latter, purchasers in 1913 are listed. See also Jefferys, "The Toronto Exhibition of Little Pictures," in ALC 1913, pp. 193–95; Donovan 1913; Bridle 1913; Charlesworth 1914; Canadian Courier 14 Feb. 1914. The 1914 exhibition was sent to Fort William, Ont. See Daily Times Journal 21 and 14 March 1914.

31. Arch. of Ont., MU2254, MU2255, OSA Minute Books 1901–15 and 1916–31. T.G. Greene nominated by Beatty and MacDonald 7 March, elected 4 April 1911; Lismer nominated by Jefferys and Beatty 4 March, elected 8 April 1913; Johnston nominated by Harris and H.S. Palmer 4 March 1913, not elected; T.W. Mitchell nominated by Beatty and MacDonald 1 April, elected 8 April 1913; Thomson nominated by Lismer and Greene 3 March, elected 17 March 1914; Varley nominated by Lismer and Greene 3 March 1914, not elected until 14 March 1916; Jackson nominated by Lismer and Greene, 5 May 1914, elected 16 March 1915; Beatty resigned 6 May 1913, renominated by

MacDonald and F. Haines 2 Feb. 1915, elected 16 March 1915; Johnston renominated by Jefferys and MacDonald 1 Feb. 1916 and by Reid and Grier 6 Feb. 1917, elected 13 March 1917; Carmichael nominated by Varley and MacDonald 6 Feb., elected 13 March 1917.

32. See Bayer 1981 and 1984.

33. Toronto Star Weekly 8 March 1913.

34. F.B. Housser 1926a, p. 66, notes the original plan was to incorporate a theatre and picture gallery. See also Denison 1923b and Larisey 1993, p. 29.

35. L.S. Harris in ALC 1913, p. 215.

36. Globe 15 Jan. 1914, p. 5.

37. Bridle 1912b. See also Globe 3 June 1899; Stringer 1910.

38. Toronto Daily Star 28 Feb. 1914. This article notes others who used the studios on occasion: Frank McMahon, Col. Mercer, D.A. Dunlop, and a number of professors and lecturers at the University of Toronto "who are keenly interested in the development of Canadian art."

39. Jackson, Mowat, Ont., to MacDonald, Toronto, postmarked 14 Feb. 1914, copy in McCord Arch., Jackson letters. Jackson writes, "I landed last night and found it just as Harris had said. You don't notice the cold one bit."

40. Jackson, Mowat, Ont., to MacCallum, Toronto, 8 March 1914, NGC Arch., MacCallum fonds. See also I.B. Wrenshall 1914b.

41. Donovan 1916.

42. Globe 10 Sept. 1910. See also M. Brown 1964a.

43. Wyly Grier's brother Louis Grier was a painter at St. Ives, Cornwall (L. Grier 1895, pp. 110–12), where Arnesby Brown also worked. See also Eric Brown 1911. Wyly was a witness at the wedding of Eric and Maude Brown (M. Brown 1964a, p. 18). Typescripts of Eric's articles for the *Christian Science Monitor* are in the NGC Arch., NGC fonds, 9.9-Brown, those by Grier in the Arch. of Ont., MU8227.

44. Eric Brown 1912 and 1913. Jackson refers to the latter.

45. Jackson, Montreal, to Brown, Ottawa, 12 March 1913, NGC Arch., 7.1-Jackson.

46. A.Y. Jackson 1914. That same day Harris sent an oil sketch by Jackson, *Autumn in Picardy*, donated by members of the Arts and Letters Club, to the National Gallery, much to the indignation of Brown and Walker. Walker, Toronto, to Brown, Ottawa, 15 Nov. 1913; Brown to Walker, 17 Nov. 1913; Harris, Toronto, to Brown 14 May 1914; Brown to Grier, Toronto, 4 June 1914; Grier to Brown, 5 June 1914; all NGC curatorial file, access. 6529. See also Toronto Daily News 8 Nov. 1913; Mail and Empire 8 Nov. 1913.

47. Globe 28 May 1914.

48. L.S. Harris 1914. See also Grier 1915. Clipping and identification of authorship in NAC, MG28 I126, vol. 14, Scrapbook 1915–33, p. 42.

49. NGC Arch., corr. 25 March–18 May 1914, curatorial file, access. 940.

50. Johnston, New York, to MacCallum, Toronto, 8 April 1915, NGC Arch., MacCallum fonds. Mortimer-Lamb 1915, p. 259, notes that, "for over a year before the outbreak of hostilities Canada experienced an industrial and financial depression, following and consequent on a period of exuberant and unwarranted inflation and speculation."

51. The Canadian Art Club, p. 6. See also L.S. Harris 1948, p. 37.

52. MacTavish 1938. For his papers, see North York Libr.

53. For Bridle's papers, see NAC, MG30 D354.

54. See Sutnik 1989. For Hammond's papers, see Arch. of Ont. See also Dewan 1994.

55. See Walton 1992.

56. J.E.H. MacDonald 1928b. Jacob became a member of the Arts and Letters Club in January 1920.

57. Morgan-Powell 1929a. See Johnstone 1965.

58. See Koltun 1984, pp. 321–22. By 1906 Mortimer-Lamb was in partnership in Montreal with Sidney Carter; they were photographers and agents for the Dutch art dealer E.J. Van Wisselinghe. Mortimer-Lamb worked for a good part of his life for the Canadian Mining Institute, first in Montreal and then in Vancouver. See Carter, Montreal, to James Mavor, Toronto, 3 and 13 Dec. 1906, 30 Jan. and 8 May 1907, in UTL, Mavor papers; Mortimer-Lamb 1908; Lowrey 1985.

59. Stringer 1913, p. 13.

60. Montreal Daily Herald 15 March 1912.

61. Montreal Daily Star 20 Feb. 1913; Burgoyne 1913a. See also Burgoyne 1939.

62. Montreal Daily Herald 26 March 1913.

63. Montreal Daily Witness 26 March 1913.

64. Morgan-Powell 1913a and 1913b.

65. Montreal Daily Star 7 April 1913.

66. Morgan-Powell 1913d.

67. J.G. Lyman 1913a and 1913b; Morgan-Powell 1913c; One of the Moderns 1913.

68. Sibley 1913.

69. Montreal Daily Witness 26 March 1913; Burgoyne 1913e.

70. Burgoyne 1913d.

71. AAM 1913b.

72. M.C.J. 1913c.

73. Morgan-Powell 1913e.

74. Canadian Courier 31 May 1913, p. 22, incorrectly identifying the source as the *Montreal Daily Star* rather than the *Montreal Daily Witness* (see M.C.J. 1913).

75. Grier 1913a.

76. Cox 1913. See also M. Brown 1963, pp. 132–33, 157.

77. Gadsby 1913.

78. J.E.H. MacDonald 1913.

79. Grier, "Canadian Art: A Résumé," in ALC 1913, p. 246.

80. G. Clark 1914c.

81. Grier 1913b, p. 16.

82. G. Clark 1914c.

83. Toronto Daily Star 28 Feb. 1914.

3 THE FIRST WORLD WAR

1. Mortimer-Lamb 1915b; Bridle 1916b, pp. 20, 71–72; Kerr 1916d; Jacob 1917a; R.J. Mount 1914.

2. Saturday Night 24 July 1915. Jackson, Thomson, Lismer, MacDonald, Varley, and Harris all donated paintings to the Patriotic Fund Sale. A sale for the fund was also held in Winnipeg (see *Winnipeg Industrial Bureau Eighth Annual Report Year 1914*, pp. 52–55). Artists also donated works to the Comité de Secours National de France (see exhibition catalogue for *Fonds de Secours Français* 1915).

3. Gazette 29 June 1915.

4. Jackson, Shoreham, England, to J.E.H. MacDonald [Thornhill], 10 Sept. [1916], copy in McCord Arch., Jackson letters.

5. Konody 1918, p. 39; M. Miller 1983, p. 91.

6. See note 1. Also Boyanoski, "The Paintings of W.J. Wood," in Boyanoski and Hartman 1983, p. 29; Kucheray 1978; Kerr 1916a; MMFA 1963; J.E.H. MacDonald, Toronto, to Brown, Ottawa, 15 July 1916, NGC Arch., 06.3-Studio.

7. MMFA Arch., Arts Club papers, Minute Book 1913–21, 18 July 1917; Alice Massey, Toronto, to

Vincent Massey, [Ottawa], c. 23 Feb. 1918, NAC, MG32 A1, vol. 33, file Alice Massey to Vincent Massey; McDougall 1977, p. 34. Jackson, London, to Catherine Jackson, Montreal, 1 May 1916; and to Mrs. Henry Jackson, Montreal, 21 Nov. 1917; both priv. coll.

8. Tippett 1979, pp. 115–22; Jackson, Montreal, to Brown, Ottawa, 23 Nov. [1918], NGC Arch., 5.42 J.

9. J.E.H. MacDonald, Toronto, to E.R. Greig, Toronto, 21 July 1915, AGO Arch., A3.9.5-AMT Letters 1912–1920-M.

10. See corr. with Lismer in NGC Arch., 5.11-Halifax, and in AGO Arch., A3.9.5-AMT Letters 1912–1920-L. See also Kelly 1982; Canadian Courier 29 Dec. 1917 and 8 June 1918.

11. Lismer, Halifax, to MacCallum, Toronto, 21 July 1917, priv. coll.

12. Jackson, Shoreham, England, to J.E.H. MacDonald, Toronto, 4 Aug. 1917, copy in McMichael Coll., MacDonald papers.

13. MacCallum, Toronto, to [John Thomson], 1 Sept. 1917; and J.E.H. MacDonald to John Thomson, 3 Oct. 1917; both in NAC, MG30 D284, vol. 1, files 5, 6.

14. Tippett 1984, p. 26.

15. Jackson, Shoreham, England, to Mrs. Henry Jackson, Montreal, 24 July 1917, priv. coll.

16. Arch. of Ont., MU2255, OSA Minute Book 1916–31, 15 Dec. 1917; Toronto Daily Star 24 Jan. 1918; Bridle 1918.

17. J.E.H. MacDonald 1919a, p. 206; Fairley 1922b, p. 594.

18. A.Y. Jackson 1958, pp. 39–40.

19. Jackson, Oldham, to Mrs. Henry Jackson, Montreal, 20 July 1918, priv. coll.

20. Jackson, London, to Florence Clement, Berlin, Ont., 13 Nov. 1917, priv. coll.

21. Jackson, London, to J.E.H. MacDonald, Toronto, 6 April [1918], copy in McCord Arch., Jackson letters.

22. Fairley 1919b, p. 8.

23. J.E.H. MacDonald 1919a, p. 207.

24. Christian Science Monitor 10 Feb. 1919.

25. C. Varley 1981, p. 34. Jackson, London, to Walker, Toronto, 4 July 1918, NGC Arch., 5.41-C, Canadian War Memorials General. Gas Chamber at Seaford is reproduced in Konody 1919a, pl. VIII.

26. C. Varley 1981, p. 26.

27. J.E.H. MacDonald 1919a, p. 207.

28. C. Varley 1981, pp. 46, 48.

29. Tippett 1984, p. 38.

30. Walker, Toronto, to Brown, Ottawa, 27 April 1918, NGC Arch., 01.01-Walker, corr. re: Canadian War Records.

31. Harris, Toronto, to Brown, Ottawa, 29 Oct. 1918, NGC Arch., 5.42-Harris.

32. Lismer, Halifax, to Brown, Ottawa, 22 Jan. 1918 and 25 March 1919; Brown to Lismer, 10 April 1919; Lismer, Bedford, N.S., to Brown, 14 Aug. 1919; Lismer, Toronto, to Brown, 1 Oct. 1919; all NGC Arch., 5.42-L. See Catalogue and Price List of War Etchings, Drypoints, Lithographs by British and Canadian Artists (Ottawa: Canadian War Memorials, 1920).

33. Jackson, Toronto, to Mrs. Henry Jackson, Montreal, 19 Oct. 1918, priv. coll. Lismer, Bedford, N.S., to Brown, Ottawa, 30 Dec. 1918, NGC Arch., 5.42-L.

34. Lismer, Bedford, N.S., to J.E.H. MacDonald, Toronto, 21 March 1919; NAC, MG30 D111, vol. 1.

35. Jackson, Bedford, N.S., to Florence Clement, Hermosa, Ca., 16 Feb. 1919, priv. coll.

36. Jackson, Toronto, to Brown, Ottawa, 1 Sept. [1919], NGC Arch., 5.42-Jackson.

37. See note 34.

38. Lismer, Halifax, to Brown, Ottawa, 29 April 1919, NGC Arch., 5.42-L; see also McLeish 1955, pp. 64–65.

39. Lismer, Halifax, to Brown, Ottawa, 10 June 1919, NGC Arch., 5.42-L.

40. Bridle 1916b, p. 20.

41. Toronto Daily Star 16 March 1916.

42. Fairbairn 1916.

43. Mail and Empire 11 March 1916; Bell 1916; Hammond 1916.

44. J.E.H. MacDonald 1916a.

45. J.E.H. MacDonald, Toronto, to Editor, Toronto Daily Star, 17 March 1916 (not published), McMichael Coll., MacDonald papers.

46. Charlesworth 1916, p. 5.

47. J.E.H. MacDonald 1916b.

48. Jackson, Toronto, to Brown, Ottawa, 11 Dec. 1919 and 1 Sept. [1919]; both NGC Arch., 5.42-J.

49. Konody 1918; Saturday Night 26 Oct. 1918 and 9 Aug. 1919.

50. Charlesworth 1919b.

51. Charlesworth 1919b; Morgan-Powell 1919a.

52. Lismer 1919c, p. 42.

53. J.E.H. MacDonald 1919d.

54. J.E.H. Macdonald 1919d. This letter was part of a debate about modern painting. See also Globe, 1 Sept. 1919, p. 6; MacLean 1919; Bengough 1919; Konody 1919c; Beatty 1919; Lismer 1919b.

55. Lismer 1919c, p. 42.

56. Lismer 1919b and 1919c, p. 40.

57. A.Y. Jackson 1919j, p. 77.

58. A.Y. Jackson 1919j, pp. 76–77.

59. Lismer 1919c, p. 40.

60. A.Y. Jackson 1919j, p. 77; MacLean 1919; Lismer 1919c, pp. 41, 44; Fairley 1919b, p. 10.

61. Fairley 1919b, pp. 9–10.

62. A.Y. Jackson 1919j, p. 78.

63. Greig, Toronto, to Brown, Ottawa, 1 Nov. 1919, NGC Arch., 5.41-C, Canadian War Art Loans Misc. Attendance was 4093 compared to 16,517 for the exhibition British Naval Photographs in April 1919, AGO Arch., AMT Minute Book 1900–25, 17 Nov. 1919, p. 172.

64. Toronto Sunday World 14 Aug. and 5 Sept. 1920; Canadian Courier 15 Aug. 1920; Toronto Star Weekly 28 Aug. 1920; Fairbairn 1920d; Hammond 1920c; Jacob 1920g; Rorke 1920; Charlesworth 1920; Morgan-Powell 1920a; Montreal Daily Herald 25 Sept. and 9 Oct. 1920; Burgoyne 1920a.

65. F.B. McCurdy, Ottawa, to Walker, Toronto, 12 April 1921, copy in NGC Arch., 5.41-C Canadian War Memorials General. Paintings by Leonard Richmond, Edgar Bundy, George Clausen, Algernon Talmage, Inglis Sheldon-Williams, William Rothenstein, and James Kerr-Lawson were installed in the Senate in February 1921. Paintings by K. Forbes, A. Bastien, and H. Barraud were loaned to the London Western Fair in 1922 (Advertiser 13 Sept. 1922). Much restoration had to be carried out once the paintings were transferred to the government. Over 250 works from the Canadian War Memorials were shown at the Art Gallery of Toronto in October 1926.

4 DEFINING THE PROGRAM

1. J.E.H. Macdonald 1979, p. xiii.

2. Manuscripts and typescripts of J.E.H. MacDonald's poems dating from 1915 to 1931 are with his papers in the National Archives. His poems were published in the Canadian Courier, The Rebel, Queen's Quarterly, and Canadian Forum.

3. J.E.H. MacDonald 1917a.

4. Fairley became a member of the Arts and Letters Club in May 1917, ALC Arch., Minute Book, 9 May 1917. He never met Tom Thomson. See McLaughlin Arch., Joan Murray interview.

5. J.E.H. MacDonald 1918b, pp. 183, 186.

6. J.E.H. MacDonald 1918c, p. 259.

7. J.E.H. MacDonald 1919c.

8. Lismer 1920, p. 209; and typescript, c. 1917–18, AGO Arch., Lismer papers. The manuscript is at the MMFA, in the Lismer papers.

9. Lismer 1919a.

10. Lismer 1920, p. 209.

11. A.Y. Jackson 1919b, p. 159.

12. Lismer 1920, pp. 209–11.

13. Larisey 1993, pp. 34, 35.

14. F.B. Housser 1926a, pp. 136–37. MacCallum, Toronto, to T.J. Harkness, Owen Sound, 6 May and 14 June 1918; both in NAC MG30 D84, vol. 1, file 7.

15. Harris, Allandale, to J.E.H. MacDonald, York Mills, two letters, postmarked 2 and 31 Aug. 1918; both in McMichael Coll., MacDonald papers. Harris, Toronto, to Brown, Ottawa, [before 15 Sept. 1918], NGC Arch., 5.42-H. In this letter, at the request of Brown, Harris proposes painting for the War Records at the Lake Superior Corporation, in Sault Ste. Marie, and at the Collingwood Ship Building Yards. The itinerary of the trip is given in the foreword to the catalogue of Algoma 1919.

16. J.E.H. MacDonald, Agawa, Ont., to Joan MacDonald, c. 11 Sept. 1918, quoted in Duval 1978, pp. 86–87.

17. F.H. Johnston, Toronto, to Brown, Ottawa, 22 Oct. 1918, NGC Arch., 5.42-J.

18. The Harris family summered on Canoe Lake in the 1920s, and Harris painted at least one winter canvas from there, Shacks, Algonquin Park, exhibited in the 1922 Group of Seven exhibition. See also Beatty, Toronto, to Cameron, Saskatoon, 22 May [1928], Nutana Arch.

19. J.E.H. MacDonald 1919f.

20. Jackson, postmarked Franz, Ont., to Florence Clement, Waterloo, Ont., 29 Sept. [1919], priv. coll.

21. Toronto Star Weekly 20 April 1918, p. 7; Grier 1918; Charlesworth 1918b; Greig 1919. See also OSA Annual Report for the Year Ending 28 Feb. 1917, pp. 6–7.

22. Telegram 8 March 1919.

23. Toronto Daily Star 26 March 1919. Interned, which was exhibited at the National Academy in 1918, is described: "In a wire cage out in the sunlight is a rooster … in custody probably awaiting future execution."

24. Telegram 8 March 1919.

25. Fairbairn 1919a.

26. Jacob 1919a.

27. Toronto Daily News 7 March 1919.

28. Eric Brown, "The Forty-Seventh Exhibition of the Ontario Society of Artists," typescript, 12 March 1919, NGC Arch., 9.9-B, file 11.

29. Fairley 1919a, pp. 281–82.

30. Donovan 1919a.

31. Cited in McLeish 1955, p. 65.

32. Exhibition catalogue for Algoma 1919.

33. Toronto Daily Star 3 May 1919; Jacob 1919b.

34. Jacob 1919b.

35. Charlesworth 1919a.

36. AGO Arch., AMT Minute Book 1900–25, 17 Nov. 1919.

37. J.E.H. MacDonald 1917a, pp. 45, 48.

38. J.M. MacCallum 1918, pp. 378–79.

39. Lismer 1920, p. 210.

40. A.Y. Jackson 1919c. See also Fairley 1920b, p. 245.

41. The exhibition was shown at the AAM from 25 March to 12 April 1919. Jackson was in Halifax while the show was on at the Arts Club.
42. Jackson, Montreal, to Brown, Ottawa, 17 April 1919, NGC Arch., 5.42-J.

5 FORMATION OF THE GROUP

1. Lismer, Bedford, N.S., to J.E.H. MacDonald [Toronto], 21 March 1919, NAC, MG30 DIII, vol. 1. Jackson, Toronto, to Brown, Ottawa, 30 Oct. [1919]; and Brown to Jackson, 4 Nov. 1919; both NGC Arch., 5.42-J. See also NGC Arch., 06.1-Rous and Mann.
2. Fairbairn 1919c.
3. Jackson, Oldham, England, to Lismer [Bedford, N.S.], 22 May 1918, McMichael Coll., Lismer papers.
4. Lismer, Bedford, N.S., to J.E.H. MacDonald, Toronto, 21 March 1919, NAC, MG30 DIII, vol. 1.
5. A.Y. Jackson 1919b, p. 159.
6. Mortimer-Lamb 1919b, p. 119. The manuscript was sent in March (see B.C. Arch., MS 2834, box 1, file 8) after being corrected by MacDonald and Lismer. See J.E.H. MacDonald, Toronto, to Lismer [Bedford, N.S.], 16 March 1919, McMichael Coll., Lismer papers; and Lismer to MacDonald, 21 March 1919, NAC, MG30 DIII, vol. 1.
7. Jackson, Penetang, Ont., to Florence Clement [Kitchener], [7] Feb. 1920, priv. coll.
8. Jackson, Franceville, Ont., to J.E.H. MacDonald, Toronto, 17 March [1920], NAC, MG30 DIII, vol. 1; and to Catherine [Jackson], Montreal, 27 March 1920, priv. coll. See also Lismer, Toronto, to W.J. Wood, 9 March 1920, copy in AGO Arch., Wood papers.
9. The drawings are reproduced in Thom 1985, pp. 68–73. On the terms of availability of the galleries, see Greig, Toronto, to Brown, Ottawa, 1 June 1920, NGC Arch., 5.41-C, Canadian War Art Loans Misc.
10. A copy of the catalogue annotated by Carmichael is in the McMichael Collection and lists additional works: Harris – *Winter Landscape*, Johnston – "others," Lismer – *Bedford Basin*, and Varley – *Prisoners*. It is not clear if these were being proposed for the subsequent American tour. If they were included in the first show they were not referred to by any of the critics.
11. *Noonday, Saint-Eustache* by Pilot was sold to H.L. Rous, and was then sold at Waddington's, Toronto, 29 Oct. 1976, lot 429, as *Winter Scene, Eastern Townships* (repr.), pastel, 34.3 × 45.7 cm. Information on the sale from the family of H.L. Rous.
12. See Boyanoski and Hartman 1983, p. 35.
13. Morgan-Powell 1918; Mortimer-Lamb 1918 and 1919a, p. 150.
14. Jackson, Toronto, to Mrs. Henry Jackson, Montreal, 11 May 1920, priv. coll.
15. Kirkpatrick 1986, pp. 135–37.
16. Jackson, Montreal, to J.E.H. MacDonald, Toronto, 13 Jan. 1919, copy in McCord Arch., Jackson letters.
17. Jackson, Penetanguishene, Ont., to Brown, Ottawa, c. 17 Aug. 1920, NGC Arch., 7.1-J.
18. Hammond 1920b; Jacob 1920e; Fairbairn 1920c; H.E. Wrenshall 1920b; Bridle 1920a and 1920b.
19. "Snap, Colour and Horrors," n.d., AGO Arch., exhibition file for OSA 1920. Possibly in the *Telegram*, but unlocated on microfilm.
20. Fairley had written "things are neglected unless they are written about," Fairley 1919c, p. 128.

21. Hammond noted in his journal (13 May 1920): "It is a broad, virile show with some wild drawing & broad treatment but [?] enough to be interesting. Harris's portraits a feature." Arch. of Ont., MU 1293, Hammond journal, Nov. 1919–Aug. 1920.
22. AGO Arch., AGT exhibition file, Group of Seven May 1920.
23. AGO Arch., AGT exhibition file, Group of Seven May 1920.
24. Brown, Ottawa, to Walker, Toronto, 15 June 1920, UTL, ms. coll. 1, box 15, file 21.
25. Jackson, Toronto, to Mrs. Henry Jackson, Montreal, 11 May 1920, priv. coll. They went to Mongoose Lake and were back in Toronto by 28 May: Jackson, Toronto, to Florence Clement [Kitchener], 28 May 1920, priv. coll. See also Reid 1970, p. 159.
26. Jackson, Toronto, to Florence Clement [Waterloo], 28 May 1920, priv. coll.
27. Laberge 1921. His article gives the membership, as does Gazette 18 Jan. 1921.
28. Jackson, Montreal, to Brown, Ottawa, 18 Jan. 1921, NGC Arch., 7.1-J.
29. Holgate was in France Nov. 1920 to July 1922, see NGC Arch., Davis-Holgate interview; Pilot left 29 October 1920, see Gazette 29 Oct. 1920; Adrien Hébert left for France 8 June 1922, see Ostiguy 1986, p. 21; Lilias Torrance Newton was in Paris by May 1923, see Gazette 9 May 1923.
30. Hewton, Montreal, to Brown, Ottawa, 16 Feb. 1924, copy in NGC Arch., 7.1-H.
31. Eric Brown 1921a, typescript, NGC Arch., 9.9-B, file 11.
32. Fairbairn 1920e; Jacob 1920h; Hammond 1920d. See also Arch. of Ont., MU1293, Hammond journal, 4 Aug. 1920–23 Feb. 1921, entries 1 and 6 Dec. 1920.
33. Johnston, Toronto, to Walker, Toronto, 3 Feb. 1920[1921] and 7 Feb. 1921, UTL, ms. coll. 1, box 15, file 34; Johnston, Winnipeg, to Walker, 16 Nov. 1921, box 15, file 43.
34. Jacob 1920h.
35. Jacob 1921b.
36. Saturday Night 8 Oct. 1921.
37. Jackson, Toronto, to Brown, Ottawa, 30 Nov. 1920, NGC Arch., 5.42-J.
38. Jackson, Toronto, to Brown, Ottawa, 24 April [1921], NGC Arch., 7.1-J.
39. Prices for the works exhibited are in the exhibition file in the AGO Arch. Unlike the 1920 exhibition, this catalogue did not give prices.
40. Jackson, Rivière du Loup, Que., to Lismer [Toronto], 14 Feb. [1921], McMichael Coll. Lismer papers.
41. Reproduced in colour in Bess Harris and R.G.P. Colgrove 1969, p. 33, as *Billboard*.
42. Bridle 1921a; Canadian Forum May 1921; Hammond 1921b; Jacob 1921b; B.B. 1921.
43. Arch. of Ont., MU1293, Hammond journal, 24 Feb.–23 Oct. 1921, entry 22 May 1921.
44. Fairley 1921a, pp. 276–78.
45. Attendance was 2560 compared to 8240 for *Exhibition of Paintings by Contemporary American Painters* (8 Jan.–6 Feb. 1921), 4897 for *Loan Exhibition of Chinese Paintings* (10–27 Feb. 1921), and 7928 for the OSA annual show (4 March–10 April 1921); all AGO Arch., AMT Minute Book 1900–25, 6 June 1921.
46. Jackson, Agawa River, Ont., to Mrs. Henry Jackson, Montreal, [May 1921], priv. coll.
47. MacCallum, Toronto, to C.S. Quinton, Buffalo, 21 Sept. 1921, Albright Arch., R.G. 3:1, exhibition records, box 28, folder 3. See also Reid 1970, pp. 176–81.

48. J.E.H. MacDonald, Cobocook, Ont., to Brown, Ottawa, 25 Sept. 1921, NGC Arch., MacCallum collector file.
49. Jackson, Levis, Que., to Florence Clement [Kitchener], 27 March 1922, priv. coll.; A.Y. Jackson 1922a.
50. A priced copy of the catalogue is in the exhibition file, AGO Arch.
51. Lismer, Toronto, to W.J. Wood, Midland, Ont., 4 April [1922] and 19 April 1922, copies in AGO Arch., Wood papers; Wood to Lismer, 5 April [1922], McMichael Coll., Lismer papers.
52. Bridle 1922.
53. Jacob 1922e.
54. Eric Brown 1922.
55. See P.J. Robinson 1966, with a foreword by A.Y. Jackson; G. de B. Robinson 1981.
56. Canadian Forum Oct. 1922, p. 15.
57. Bridle 1922.
58. Canadian Forum May 1922; Jacob 1922d; Canadian Farmer 27 May 1922; Hammond 1922d; Fairbairn 1922b; Toronto Sunday World 28 May 1922.
59. Arch. of Ont., MU1293, Hammond journal, 24 Oct. 1921–23 June 1922, entry 9 May 1922.
60. Compare this to 6036 for the 1921 RCA show, 6524 for *Paintings by French Artists* (7 Jan.–6 Feb. 1922), and 5728 for the *Retrospective Exhibition of the Ontario Society of Artists* (11 Feb.–12 March 1922); all AGO Arch., AMT Minute Book 1900–25, 12 April 1922.

6 OUTREACH AND ALLIANCES

1. Lloyd Harris, Brantford, Ont., to Walker, Toronto, 21 June 1920, UTL, ms. coll. 1, box 15, file 21.
2. Doris Mills, "Circulating Pictures," *Christian Science Monitor*, n.d. [1919], in Doris Mills, scrapbook, "The Writings of the English Art Critic C. Lewis Hind from the Christian Science Monitor," priv. coll; and "Circulating Pictures," *Toronto Star Weekly*, 14 Feb. 1920, in White 1985, pp. 3–4. My thanks to John Sabean for bringing both these items to my attention.
3. N. Gurd, *The Story of Tecumseh* (Toronto: William Briggs, 1912), illus. by C.W. Jefferys; G.L. Smith 1974, p. 38.
4. G.L. Smith 1974, pp. 3–6. See also Gurd, Sarnia, Ont. to Greig, Toronto, 13 and 26 March 1920; Greig to Gurd, 18 March 1920; both AGO Arch., file A.3.9.5-AMT Letters 1912–1920-G. Thomson's *Petawawa Gorges* (NGC 4723) was exhibited in 1920 as *Early Spring*: see fig. 69.
5. Gurd, Sarnia, to MacCallum, Toronto, 1 April and 6 Nov. 1920, cited in G.L. Smith 1974, pp. 6, 9.
6. Canadian Forum Dec. 1920; Globe 10 Jan. 1921.
7. J.E.H. MacDonald, Toronto, to T.J. Harkness, Owen Sound, 24 Oct. 1920, NAC, MG30 D284, vol. 1, file 9. The "older Canadian artists" were St. Thomas Smith and Florence Carlyle. See G.L. Smith 1974, p. 10.
8. G.L. Smith 1974, pp. 11–14. Gurd, Sarnia, to Walker, Toronto, 30 Nov. 1920; Walker to Gurd, and to Brown, Ottawa, 4 Dec. 1920; Brown to Walker, 6 Dec. 1920; all in NGC Arch., 05.1-Walker. Gurd to George Locke, 20 Dec. 1920, AGO Arch., A3.9.5-AMT Letters 1912–1920-L.
9. Canadian Forum Dec. 1920.
10. Exhibition catalogue for Saint John 1920 (nos. 29–72); exhibition catalogue for Group 1921.
11. Jackson, Toronto, to Brown, Ottawa, 24 April [1921], copy in NGC Arch., 7.1-J.
12. Jackson, Toronto, to Brown, Ottawa, 24 April [1921], copy in NGC Arch., 7.1-J.

13. Edmonton Journal 2 April 1921; see also Jones 1923.
14. Black, Fort William, Ont., to McCurry, Ottawa, 18 Nov. 1920, and 1 Feb. 1921, NGC Arch., 5.13-Ft. William. See also Daily Times Journal 7, 12, 15, and 18 Jan. 1921. On M.J.L. Black see Kirker 1927.
15. Black to McCurry, 19 Feb. 1921, NGC Arch., 5.13-Ft. William. R.J. Brandon, Brandon, Man., to Lismer, Toronto, 14 June 1921, AGO Arch., Lismer papers, sect. 7.
16. NGC Arch., 5.1-Group of Seven; McCurry, Ottawa, to Brown [London], 16 June 1922, NGC Arch., 9.9-Brown; Brown to Lismer, Toronto, 25 Oct. 1922, AGO Arch., Lismer papers, sect. 4. See also A.H. Gibbard, Moose Jaw, to McCurry, 10 Feb. 1923; McCurry to Gibbard, 13 Feb. 1923; both NGC Arch., 5.14-Moose Jaw. See also McCurry, "Report (on Western Trip 1922)" in NGC Arch., 9.9-Report.
17. Vanderpant is listed as a member of the fine art committee in the exhibition catalogue for New Westminster, Western Tour 1922–23. See also Hill 1976, p. 16.
18. Mortimer-Lamb 1922a.
19. Jackson, Toronto, to Cameron, Saskatoon, 29 Nov. 1926, Nutana Arch., Memorial corr.
20. Exhibition catalogue for St. Louis 1918; Art Quarterly July 1919.
21. Rebel Feb. 1919; Equity 29 May 1919.
22. Toronto Daily Star 30 Aug. 1920; Hammond 1920c.
23. Brown, Ottawa, to C.H. Burroughs, Detroit, 29 May 1920, Detroit Arch., Group of Seven.
24. Exhibition catalogue for Columbus, U.S. Tour 1920–21.
25. J.E.H. MacDonald, Toronto, to G.V. Stevens, Toledo Museum of Art, 18 Feb. 1921, Toledo Libr., Group of Seven, March 1921.
26. Coburn 1920.
27. W.H.D. 1920.
28. C.B. Sage, Buffalo, to Greig, Toronto, 22 July 1916, AGO Arch. A.3.9.6, AMT Letters 1912–1920-S; Sage Quinton to J.E.H. MacDonald, Toronto, 1 Feb. 1921, copy in Albright Arch., R.G. 3:1, exhibition records, box 28, file 3.
29. Academy Notes Jan.–June 1922; see also Haverson 1921; Buffalo Evening News 24 Sept. 1921.
30. Educational Secretary, Detroit Institute of Arts, to J.E.H. MacDonald, Thornhill, Ont., 4 Aug. 1921, Detroit Arch., Group of Seven, June 1921.
31. Lismer, Toronto, to McCurry, Ottawa, 8 Dec. 1922, NGC Arch., 5.1-Group of Seven.
32. A.Y. Jackson 1922b, p. 662.
33. Jackson, Toronto, to Brown, Ottawa, 24 April [1921], copy in NGC Arch. 7.1-J.
34. Jackson, Toronto, to Norah Thomson, [May 1926], NAC MG30 D322, vol. 1, Jackson 1926. The committee consisted of A.Y. Jackson's aunt Geneva Jackson, Mrs. S.J. Williams, who donated the Thomson with money left by her daughter Elinor Williams, Mrs. Harvey Sims, and Mrs. T.R. Cram. The collection was donated to the National Gallery in 1943 as Kitchener had no art gallery.
35. AGO Arch., AMT Minute Book 1900–25, 12 April 1922. Harris exchanged Snowfall for Old Houses, Toronto, Winter in 1942. Jackson exchanged Cacouna for Early Spring, Quebec (cat. 113). Johnston's painting was Where the Eagles Soar (AGO 134). J.E.H. MacDonald's Early Evening, Winter was a CNE purchase in 1912.
36. Varsity 28 Jan. 1920; Fairley 1920a.
37. Varsity 11 Jan. 1922; Fairley 1922a; Siddall 1987, pp. 35, 37, 98–99.
38. Harris, Toronto, to L.L. FitzGerald, Winnipeg, 28 Nov. [1932], UM FitzGerald, box 7, Harris file.

39. Hart House Ottawa Group 1924; Varsity 4 Feb. 1924; "Montreal Group of Artists Exhibiting in Hart House, Oct.–Nov. 1924," UTA, A73-0050/123-File 1; Hart House Saskatchewan 1925; corr. with lists between Greig and T.W. Fripp, 12 Dec. 1927–25 Feb. 1928, AGO Arch., A3.8.8-Jan.–March 1928. See also Siddall 1987, p. 39.
40. Canadian Forum Oct. 1920.
41. Mills 1979, p. 16; see also Davidson 1969.
42. Traquair 1920 reviewed the 1920 RCA show in Montreal but otherwise Montreal art exhibitions were not covered.
43. Canadian Forum I:8 (May 1921), p. 229.
44. Fairley 1921c, p. 462.
45. King 1922, p. 491.
46. Sharman 1922.
47. B. Housser 1922.
48. See the mastheads of the Canadian Forum III:28 (Jan. 1923), p. 103, and V:52 (Jan. 1925), p. 102.
49. Thoreau MacDonald's covers were published June 1923 to June 1932. Drawings published: Graham Norwell, April 1924, p. 211; David Milne, July 1924, p. 305; Schaefer Nov. 1926, p. 49, July 1928, p. 717, Jan. 1929, p. 127, Sept. 1929, p. 421, and regularly after that date.
50. N. Thomson 1928; Pantazzi 1966.
51. J.E.H. MacDonald, Toronto, to Brown, Ottawa, 11 Dec. 1918, NGC Arch., 5.42-M.
52. J.E.H. MacDonald 1923, p. 112. The English artist Frank Brangwyn and the American artist A.V. Tack did the decorations in the Manitoba Legislature, and the Canadian expatriate Arthur Crisp did those in the new Parliament Buildings in Ottawa. Cromer, MacDonald's fictional character in this article, was Herbert Stansfield, who had had a handicraft guild at Cromer, England, before coming to Canada. See also F.H. Brigden 1927, pp. 22–23.
53. Greenaway 1924.
54. J.E.H. MacDonald 1925a. The ceiling and chancel colours were changed in 1960. See St. Anne's Church 1987.
55. J.E.H. MacDonald 1923, p. 112. See also Bridle 1923c; Globe 17 Dec. 1923; Canadian Forum Jan. 1924.
56. Denison 1923b, p. 31. See also The Lamps I:1 (Oct. 1911), pp. 1, 3, 6, and I:2 (Dec. 1911), pp. 2–4; Usmiani 1987.
57. Denison 1923b, p. 32; F.B. Housser 1926a, p. 66; Harris, Toronto, to Carr, Victoria, 2 Dec. 1932, NAC, microfilm, MG30 D215, vol. 2, Harris 1932.
58. Usmiani 1987, pp. 151–52.
59. Eglington 1920; Rebel Oct. 1919; R.B. 1919; Dramatic Cricket 1920a; Canadian Courier 3 Jan. 1920.
60. "Introduction," in Massey 1926, vol. 1, p. v.
61. Dramatic Cricket 1920b; P.E. 1920, p. 237; Denison 1923c; Dale 1921, pp. 101, 114–16.
62. See Goldie 1977; D. MacDonald 1973; Gorham, "Flora MacDonald Denison Canadian Feminist," in Kealey 1977, pp. 47–70; Allen 1993; Canadian Theosophist 15 July 1920 and 15 June 1921. Traubel died at Bon Echo 8 September 1919.
63. Charlesworth 1921a. All three plays were published in Massey 1926, vol. 1.
64. L.S. Harris 1923.
65. Johnson 1921.
66. L.S. Harris 1923.
67. Denison 1923a.

7 THE CRITICS
1. Charlesworth 1921d.
2. Dyonnet, Montreal, to Greig, Toronto, 12 Jan. 1922, AGO Arch., exhibition file for RCA 1921. See also RCA Report 1921, p. 10.

3. Morgan-Powell 1922a.
4. Thomson's Landscape (fig. 6) was purchased by the Art Association of Montreal from the Spring Exhibition through Dr. Shepherd. In the correspondence it is referred to as Autumn in Algonquin Park. See Brown, Ottawa, to Walker, Toronto, 9 March 1922; Walker to Brown, 11 March 1922; Shepherd, Montreal, to McCurry, Ottawa, 6 May 1922; all NGC Arch., 1.12T, Oils Purchased / Canadian, Thomson. See also curatorial file for Jackson's Morning after Sleet (NGC 2000); Shepherd, Montreal, to Harkness, Owen Sound, 14 June 1922, NAC, MG30 D284, vol. 1, file 11. Hewton loaned A Lake in the Hills to the 1936 Group of Seven retrospective at the National Gallery. This is not the same painting as that by the same title in the McMichael Canadian Collection. See also A.Y. Jackson 1958, pp. 20–21. Shepherd, H.B. Walker, Hewton, Cullen, Dyonnet, and Russell formed the hanging committee, AAM Report 1921, [p. 35].
5. NAC, MG28 I126, vol. 17, RCA Minute Book 1895–1925, 19 May 1922. Jackson, Toronto, to Mortimer-Lamb [Vancouver], 19 Dec. [1922], B.C. Arch., MS 2834, box 1, file 11. The other members of the hanging committee were Archibald Browne, R.F. Gagen, and C.W. Simpson.
6. Burgoyne 1922b.
7. Morgan-Powell 1922c and 1922d.
8. Septuagenarian 1922. The other artists included Harold Beament, Randolph Hewton, Suzor-Coté, Stanley Turner, Albert Robinson, Marjorie Gass, Mabel May, and Anne Savage.
9. A.Y. Jackson 1922c. See also Burgoyne 1922c; Student in Arms 1922; Shepherd 1922; M.A. 1922. The AAM only initiated Sunday openings in 1922 after paying back the Orkney bequest (which had been given conditional on the Association maintaining Sunday closings). See AAM Report 1922, p. 5.
10. Jackson, Toronto, to Brown, Ottawa, 24 April [1921], copy in NGC Arch., 7.1-J.
11. Brown, Ottawa, to Shepherd, Montreal, 7 April 1921; Percy Nobbs, Montreal, to Walker, Toronto, 8 April 1921; Shepherd to Brown, 9 April 1921; Margaret McCaul, Toronto, to Brown, 9 April 1921; RCA to the Secretary of State, 11 April 1921; all NGC Arch., 7.2-RCA, vol. 1. See also RCA Report 1921, pp. 9–10.
12. Dominion of Canada Official Report of Debates of the House of Commons, Fifth Session, Thirteenth Parliament, vol. CXLVIII, 27 April 1921, p. 2684.
13. See note 11 and Brown, Ottawa, to Nobbs, Montreal, 4 June 1921; Nobbs to Walker, Toronto, 13 June and 1 Oct. 1921; Brown to Walker, 27 July, 7 and 12 Oct. 1921; Walker to Nobbs, 29 Sept. and 6 Oct. 1921; Walker to Brown, 6 and 11 Oct. 1921; all NGC Arch., 7.2-R.C.A., vol. 1.
14. J.H. King, Minister of Public Works, Ottawa, to Walker, Toronto, 25 Oct. 1922; Walker to Brown, Ottawa, 26 Oct. 1922; Brown to Walker, 20 Nov. 1922; Walker to J.H. King, 22 Nov. 1922; Shepherd, Montreal, to Brown, 15 and 25 Nov. 1922; Madonna Ahrens, Toronto, to Mackenzie King, Ottawa, 29 Jan. 1923 (copy); F.A. McGregor, secretary to Mackenzie King, to Soper, Ottawa, 5 Feb. 1923; all NGC Arch., 1.61-Ahrens.
15. See note 5.
16. Brown, Ottawa, to Walker, Toronto, 1 and 20 Nov. and 2 Dec. 1922, UTL, ms. coll. 1, box 16, files 15 and 16; box 27B. See also NAC, MG28 I126, RCA Minute Book 1895–1925, 17 Nov. 1922.

36. Exhibition catalogue for Group 1926.

37. Telegram 15 May 1926; Mail and Empire 14 May 1926.

38. Jackson, Toronto, to Barbeau, Ottawa, 5 and 8 May [1926], CMC, Barbeau's corr., Jackson, temp. box 19.

39. Charlesworth 1926b.

40. Barbeau, Ottawa, to Tovell, Toronto, 10 April 1926, AGO Arch., exhibition file for Art in French Canada (Group 1926).

41. Gibbon, Montreal, to Barbeau, Ottawa, 20 Jan. 1927, CMC, Barbeau's corr., Gibbon 1927, temp. box 11.

42. Program for Quebec 1927. Holgate's portrait has since been retitled The Fire Ranger.

43. Barbeau, Ottawa, to Gibbon, Montreal, 24 Jan. 1928, CMC, Barbeau's corr., Gibbon Jan.–March 1928, temp. box 11.

44. Barbeau 1928b, pp. 21–22.

45. Program for Quebec 1928b; Folk Singers and Folk Dancers Special Performance for Their Excellencies the Governor General and Viscountess Willingdon in the Jacques Cartier Room, Château Frontenac, May 24, 1928, for Quebec 1928, illustrated with drawings by Lismer. There is considerable correspondence with Gibbon and Lismer in the CMC Barbeau correspondence files regarding this festival.

46. Choquette 1928.

47. Barbeau, Ottawa, to Gaultier, New York, 24 March 1927, CMC, Barbeau's corr., Gaultier 1925–38, temp. box 10.

48. E.-Z. Massicotte, Montreal, to Barbeau, Ottawa, 4 Feb. 1929, CMC, Barbeau's corr., Massicotte 1917–47, temp. box 34.

49. Barbeau, "French and Indian Motifs in Our Music," in Brooker 1929a, pp. 126-28.

50. Gibbon 1927, illus. by Frank Johnston; Gibbon 1938, illus. by K. Shackelton, W.J. Phillips, N. de Grandmaison, E. Neumann, J. Crockart, etc.; Gibbon 1939, illus. by C.W. Jefferys, Fergus Kyle, John Innes, etc.

51. Gibbon, Montreal, to H. Eayrs, Toronto, 1 and 3 May 1923; and to Barbeau, Ottawa, 3 May 1923; both CMC, Barbeau's corr., Gibbon 1919–26, temp. box 11.

52. Gibbon, Montreal, to Voaden, New Haven, Ct., 2 Jan. 1931, YUA, Voaden papers, acc. 3, box 6, file 1930–31, Gibbon.

53. Barbeau, Ottawa, to Gibbon, Montreal, 7 May 1929, CMC, Barbeau's corr., Gibbon 1929–42, temp. box 11. See also Dance and Folk Song Festival (Quebec: Château Frontenac, 16–18 Oct. 1930).

54. Memorandum to Mr. Harkin re: National Park at Hazelton, B.C., prepared and submitted in the spring of 1924, typescript, part I, p. 7, CMC, Barbeau's corr., Harkin 1916–34, temp. box 16. See also Kihn, New York, to Barbeau, Ottawa, 12 March 1924, Kihn 1922–56, temp. box 22. The historical heritage defined in this proposal was that of the aboriginal population and of the "pioneers."

55. Memorandum to Mr. Harkin, part I, p. 7, and part III, p. 4, see note 54.

56. Barbeau, "Public Spirit in Canada," April 1927, typescript, p. 6, CMC, Barbeau's corr., Kihn 1922–56, temp. box 22.

57. See Darling and Cole 1980; Harlan Smith, Ottawa, to Duncan Campbell Scott, Ottawa, 11 Nov. 1925, CMC, Barbeau's corr., Scott 1911–46, temp. box 52. Barbeau is reported to have said in a lecture at the University of British Columbia in the fall of 1926 that he had "come to the conclusion that … the younger generation of Indians in B.C. have not the ability or the inclination to

carry on the work of their forefathers," Cianci 1927, p. 5.

58. Memorandum on "W.L. Kihn, Painter of Indian Portraits," [1925], typescript, CMC, Barbeau's corr., Kihn 1922–56, temp. box 22. In the same box are lists of works exhibited in "The Langdon Kihn Collection of Indian Portraits and Landscapes of the Upper Skeena, B.C." See Harrold 1925; A.R.M. 1925; La Presse 28 March and 6 April 1925; Montreal Daily Star 6 April 1925.

59. See note 56, p. 3.

60. F.C. Morgan, Montreal, to Kihn, New York, 9 Dec. 1926; and to Barbeau, Ottawa, 24 Dec. 1926; both CMC, Barbeau's corr., Morgan 1925–57, temp. box 38. Barbeau to C.T. Currelly, Toronto, 23 Dec. 1926, Currelly, B.184.f-32. Lists of the distribution are in Kihn, temp. box 22. Works were given to McGill University, the National Museum, the National Gallery, the Royal Ontario Museum, the Winnipeg Art Gallery, the B.C. Art League, and the Provincial Museum in Victoria. Seven Haida portraits were given by Wm. Southam and Sons Ltd. to the AAM in 1925, AAM Report 1925, p. 9.

61. Jackson, Skeena Crossing, B.C., to Brown [Ottawa], 4 Oct. [1926], NGC Arch., 7.1-J. See also Hawker 1991.

62. Barbeau, Banff, Alta., to Lismer, Toronto, 17 Oct. 1926, NAC, MG30 D184, vol. 1; Vancouver Daily Province 23 October 1926; Carr, Victoria, to Barbeau [Vancouver], 23 Oct. [1926], CMC, Barbeau's corr., Carr, box 179, file 5. A Carr exhibition was proposed for the B.C. Art League at the same time, to which she consented if the League would pay all expenses and if the show would include only landscapes (no "Indian stuff"); nor would she lecture. The League declined. Vancouver Arch., Add. MSS 168, vol. 4, B.C. Art League "Gallery Committee" Book, pp. 3, 6, 26 Oct. and 9 Dec. 1926.

63. Jackson, La Malbaie, Que., to Barbeau, Ottawa, 25 Feb. [1926], CMC, Barbeau's corr., Jackson, temp. box 19; Barbeau to Holgate, Montreal, 26 May 1926, Holgate, temp. box 18.

64. Barbeau, Ottawa, to Holgate, Montreal, 26 May 1926, CMC, Barbeau's corr., Holgate, temp. box 18; and to Jackson, Toronto, 22 May 1926, Jackson, temp. box 19.

65. See Landry 1994, pp. 138, 200–22.

66. Barbeau, Ottawa, to V. Massey, Toronto, 30 Dec. 1926, CMC, Barbeau's corr., Massey 1927–58, temp. box 34.

67. Barbeau, Ottawa, to Greig, Toronto [23 Feb. 1927], CMC, Barbeau's corr., Greig 1925–28, temp. box 14.

68. Barbeau, Ottawa, to Gibbon, Montreal, 30 May 1927, CMC, Barbeau's corr., Gibbon 1927, temp. box 11; to C.K. Howard, Montreal, 31 May 1927, Howard 1924–39, temp. box 18; and to Wyle, Toronto, 16 June 1927. Wyle to Barbeau, 31 Oct. 1927, Wyle, temp. box 65.

69. Barbeau, Ottawa, to Kihn, New York, 16 June 1927, CMC, Barbeau's corr., Kihn, temp. box 22.

70. Hugh Eayrs, Toronto, to Barbeau, Ottawa, 27 Dec. 1923, 31 Jan. 1924, 28 May 1927, and 31 May 1927 (with enclosure, John D. Robins to Eayrs) ; all in CMC, Barbeau's corr., Eayrs 1923–33, temp. box 5.

71. Barbeau [Ottawa], to C.K. Howard [Montreal], c. 10 June 1927, CMC, Barbeau's corr., Howard, temp. box 18.

72. Exhibition catalogue for West Coast Art 1927. The Ottawa catalogue omitted Kihn's works and Carr's pottery and rugs. A corrected catalogue was published in Toronto.

73. Carr 1966, pp. 11–12.

74. Barbeau, Ottawa, to Lismer, Toronto, 15 Dec. 1927; Lismer to Barbeau, 29 Jan. 1928; both CMC, Barbeau's corr., Lismer, temp. box 28. Mail and Empire 11 Jan. 1928.

75. Barbeau, "The Plastic and Decorative Arts of the North West Coast," address at the AGT, 9 Jan. 1928, in conjunction with West Coast Art 1927. Repeated at the AAM, 17 Feb. 1928, CMC, Barbeau coll., Northwest Coast files, B.33.f-Lectures on the Ethnology of B.C. (1926–27), (B-F-527).

76. At Toronto attendance was 7742, AGO Arch., AGT Minutes 1927–28, 6 March 1928. See also Jackson, Montreal, to Barbeau, c. 5 March 1928, CMC, Barbeau's corr., Jackson, temp. box 19.

77. Rhoades 1927; Toronto Daily Star 9 Jan. 1928; Brewster 1928; Canadian Forum Feb. 1928; Echoes March 1928; Leechman 1928.

78. Barbeau, Ottawa, to J. Walter Thomson, Montreal, 30 Dec. 1927, CMC, Barbeau's corr., Walter Thomson, temp. box 56. Barbeau to Jackson, Toronto, 23 Jan. 1928; Jackson to Barbeau, 30 Jan. [1928]; both Jackson, temp. box 19.

79. Holgate [Montreal], to Barbeau, 18 July 1928, CMC, Barbeau's corr., Holgate, temp. box 18.

11 AT HOME AND ABROAD

1. Brooker 1926a, p. 279; F.B. Housser 1926c, p. 179.

2. Duval 1951, pp. 17–18.

3. Jackson, Toronto, to Norah Thomson, 5 May [1926], NAC, MG30 D322, vol. 1, Jackson 1920s.

4. Bridle 1926c.

5. Bridle 1926d.

6. Telegram 29 May 1926. Mountain Forms was exhibited with Société Anonyme 1926-27 in Brooklyn, and solicited by Brown for NGC 1927, where it was catalogued but not exhibited. See Harris, Toronto, to Dreier, Danbury, Conn., 1 and 10 Sept. [1926]; Dreier to Harris, 19 Nov. 1926; both Beinecke Libr., Société Anonyme coll. (Za), K. Dreier corr., box 18. See also Harris to McCurry, Ottawa, c. Nov. 1926; McCurry to Harris, 14 Jan. 1927; both NGC Arch., 5.5-Annual Exhibition 1927.

7. Jacob 1926b.

8. Reade 1926.

9. Bridle 1926c.

10. Jacob 1926b.

11. Bridle 1926c.

12. Albert Smythe, Toronto, to Harris, [Toronto] 25 May 1925, NAC, MG30 D208, vol. 1, corr. 1925–27; Harris 1925b, p. 12; Mellor 1983, p. 288.

13. Bridle 1926d.

14. Jacob 1926b.

15. Bridle 1926d.

16. Bridle 1926c.

17. Jacob 1926b.

18. Brooker 1926a, p. 279.

19. F.B. Housser 1926c.

20. Charlesworth 1926b.

21. L.S. Harris 1925a.

22. L.S. Harris 1928, p. 2.

23. AGO Arch., AGT Minutes 1925–26, 22 Oct. 1926. Harris, Toronto, to Greig, 28 May 1926; Greig, Toronto, to Harris, Banff, Alta., 16 July 1926; both AGO Arch., exhibition file for Group 1926. Lists with prices for works are in the exhibition file.

24. Jackson, Toronto, to Norah Thomson, [23 May 1926], NAC, MG30 D322, vol. 1, Jackson 1926.

25. Jackson, Toronto, to Barbeau, Ottawa, [before 4 June 1926], CMC, Barbeau's corr., Jackson, temp. box 19.

26. AGT Bulletin Nov. 1926, p. 11. The Albright Art Gallery loaned works for the AGT Inaugural 1926, Hekking, Buffalo, to Tovell, Toronto, 17 May 1926, Albright Arch., RG 2:4, box 4, folder 14. See also Toronto Daily Star 1 Dec. 1926.

27. Exhibition catalogue for Philadelphia 1926, p. 85; Horatio Walker was in the American section, p. 62.

28. Citizen 12 Jan. 1927; McKay 1927, p. 32. In response to questions from Martin Baldwin, completed September 1947, Harris identified *Ontario Hill Town* (cat. 95) as the prize winner. No contemporary documentation has been located to confirm that. The information is in the AGO Arch., exhibition file for AGT 1948.

29. Citizen 12 Jan. 1927.

30. D.G. 1926 notes Robinson was awarded a bronze medal in painting. He had only one painting in the exhibit.

31. Grafly 1926, p. 634.

32. Dreier, Danbury, Conn., to Harris, Toronto, 26 Aug. 1926, Beinecke Libr., Société Anonyme papers, K. Dreier corr., box 18; Brinton 1926, n.p.

33. Dreier, Danbury, Conn., to Harris, Toronto, 26 Aug. and 10 Dec. 1926; Harris to Dreier, 1 Sept. [1926]; all Beinecke Libr., Société Anonyme papers, K. Dreier corr., box 18.

34. Harris, Toronto, to the exhibition committee of the AGT, AGO Arch., exhibition file for Société Anonyme 1926-27, Toronto. Harris to Dreier, [before 10 Dec. 1926], see note 33; in this letter, Harris notes he would be willing to pay half the costs. See also AGO Arch., AGT Minutes 1927–28, 4 Jan. 1927.

35. Bohan 1982, p. 27.

36. Société Anonyme 1972, n.p.

37. Bohan 1982, p. 16.

38. Dreier 1927, p. 6.

39. See Pfaff 1984. The education program is itemized in AGO Arch., A3.7.3-General corr. 1929, D-L, Education Committee, April 1927.

40. F. Johnston 1927.

41. L.S. Harris 1927a, pp. 240–41.

42. See Zemans, Burrell, and Hunter 1988; Kerr 1916h.

43. The jury for that exhibition was composed of Jackson, Robinson, Gustav Hahn, and F.M. Bell-Smith, NAC, MG28 I126, vol. 17, RCA Minute Book 1906–27, 19 May 1923.

44. Telegram 22 Nov. 1923.

45. Hammond 1923b; Jacob 1923c.

46. Fairbairn 1923c; Bridle 1923b; Charlesworth 1923e.

47. Telegram 5 and 18 March 1927; Bridle 1927b; Jacob 1927b; Burke 1927.

48. Bridle 1927b.

49. Toronto Daily Star 5 Feb. 1927.

50. F.B. Housser, "The Amateur Movement in Canadian Painting," in Brooker 1929a, p. 87.

51. See Reid 1973; Sproxton 1980; J.O. Sinclair 1989.

52. Eleanor Somers, Calvin, N. Dak., to B. Brooker, Toronto, 26 June 1923, UMA, MSS16, box 1, folder 7.

53. Brooker, Toronto, to The Editor, *The Daily Star*, Toronto, (c. 20 Aug. 1924), UMA, MSS16, box 1, folder 11.

54. Toronto Daily Star 5 Feb. 1927. Hekking of the Albright Art Gallery probably referred to Brooker when he wrote to Dreier: "I have just come back from Toronto and I want to say to you that there are a few boys up there that have great possibilities, in fact, I think there is one man who is in the forefront of the moderns. I would like to exhibit one of his pictures in this show. Mr. Harris can tell you about this man. I understand you recently met him. He, himself, is very interesting but his work is not quite as abstract as this new modern artist. Unfortunately I cannot speak his name at this time." Hekking, Buffalo, to Dreier [Danbury, Conn.], 31 Dec. 1926, Beinecke Libr., Société Anonyme papers, Dreier corr., box 19.

55. These theories were much in vogue, as evidenced by Toronto Daily Star 29 Jan. 1927; and Bridle 1927a. See also L.S. Harris 1924a; Brooker 1925, p. 210, and 1928–30, 19 Oct. 1929. Thomas Wilfred gave a performance of his Clavilux at Convocation Hall at the University of Toronto, 11 February 1924, which was attended by Harris and Roy Mitchell. See W.S.M. 1924, p. 2; Moon [Muriel Goggin], [Toronto], to Merrill Denison [Bon Echo], 12 Feb. 1924, in Queen's Arch., coll. 2056, box 32-1924.

56. Lismer was convenor of the picture committee, ALC Arch., Minute Book, 26 Oct. 1923.

57. J.E.H. MacDonald, "Notes on Whitman," Arts and Letters Club, 28 Jan. 1927, p. 2 in NAC, MG30 D111, vol. 3, file 31.

58. J.E.H. MacDonald [Toronto], to Bertram Brooker [Toronto], 28 Jan. 1927, cited in Zemans 1973, p. 65.

59. Lismer, Toronto, to Norman Mackenzie, Regina, 2 April 1927, Mackenzie Arch.. See also Sault Ste. Marie Star 2 June 1927.

60. Evening Citizen 9 Jan. 1928 lists Ottawa artists Pegi Nicol, Kathleen Morris, and George Pepper as slated to exhibit with the Group. Morris curiously never did exhibit with the Group of Seven.

61. An annotated and priced catalogue is in the exhibition file for Group 1928, AGO Arch. No prices are given for Harris's works. In addition to the catalogued works, J.E.H. MacDonald's *Wild River* is added as lent by the University. Jackson had a large *Autumn Algoma* at $750 and a small version at $300. He also exhibited *Snow Laden Spruce* and *Winter, Georgian Bay*, the latter his Wembley canvas, also previously exhibited in the 1921 Group show. The catalogue notes sales. On MacDonald's *Wild River* see also Jacob 1928a.

62. Attendance at the opening was 633 and, for the seventeen days the show was on, 7933, AGO Arch., AGT Minutes 1927–28, 6 March 1928.

63. AGO Arch., A3.7.3-General corr. 1929, D-L, Education Committee, Feb. 1928, Group of Seven; Hammond 1928b.

64. Jackson, Montreal, to Alice Massey [Washington], 5 March [1928], NAC, MG32 A1, vol. 51, Miscellaneous corr. at Washington, Alice Massey. Phillips later bought Jackson's *At Saint-Hilarion, Quebec* (reproduced in Robson 1932, p. 213). See note 62. Jackson to Norah Thomson, c. 24 Feb. 1928, NAC, MG30 D322-Jackson, n.d. Harris attended a dinner for AE at Hart House, Arch. of Ont., MU1293, Hammond journal, 11 July 1927–30 Sept. 1928, entry 24 Feb. 1928.

65. Hammond 1928a.

66. Bridle 1928a.

67. Bridle 1928b.

68. Jacob 1928a.

69. N. Harris 1928a.

70. Telegram 18 Feb. 1928. Reprinted in the *Vancouver Star*, undated copy MMFA Arch., AAM scrapbook 1903–29, p. 430.

71. See note 61. Also J.B. Bickersteth, Hart House, Toronto, to F.S. Haines, AGT, 12 April 1928; Haines to Bickersteth, 18 April 1928; both AGO Arch., A3.8.7-corr. April–June 1928. Fred Haines succeeded Greig as curator of the AGT in March 1928.

72. Vancouver Daily Province 19 Sept. 1920; Charlesworth 1921b.

73. Radford was elected to the OSA 7 January 1890, Arch. of Ont., MU2254, OSA Minute Book 1881–90, 7 Jan. 1890. See also Radford 1894 and 1907. Radford was an architect and watercolour painter.

74. McEvoy 1897. See Also Bradshaw 1921. McEvoy wrote for the *Vancouver Daily Province* as "Diogenes." His son, Dermot McEvoy, a lawyer, would also be active in the B.C. Art League.

75. W.H.K. n.d.; Porter 1923; Innes 1928.

76. McEvoy and Innes knew Charlesworth through journalism. Jefferys's illustration on p. 1 of Charlesworth 1938 includes a portrait of Radford, although he is not referred to in the text.

77. Exhibition catalogue: *B.C. Art League Souvenir Catalogue: Opening of Vancouver Art Gallery, Nov. 28th, 1921.*

78. Vancouver Daily Province 20 Sept. 1925 and 17 Feb. 1926; Vancouver Sun 2 Oct. 1925.

79. Vancouver Sun 27 Nov. 1926. Mortimer-Lamb had tried to get Lismer to join the staff of the new art school, Mortimer-Lamb, Vancouver, to Lismer, Toronto, 8 July 1926, NAC, MG30 D184, vol. 1, file 5.

80. Vancouver Star 15 Dec. 1926. See also Vancouver Sun and Vancouver Daily Province, both 15 Dec. 1926.

81. Vancouver Arch., Add. MSS 168, vol. 5, Minutes of Executive Committee, pp. 12, 16 (12 Nov. and 10 Dec. 1926). Radford rejoined 8 Jan. 1929. The NGC received Frederick Sandys's portrait of the Reverend James Bulwer by gift from Mrs. H.A. Bulwer in 1961.

82. Radford 1923; The Hook 25 May 1923. See also Mortimer-Lamb 1925a; and "The National Encouragement of Art," typescript for a lecture given at the B.C. Art League, 20 Oct. 1925, B.C. Arch., MS 2834, file 13. See also Vancouver Arch., Add. MSS 168, vol. 2, Minutes of Monthly Meetings, 20 Oct. 1925, p. 152.

83. Vancouver Daily World 28 Sept. and 26 Nov. 1923; Vancouver Arch., Add. MSS 171, vol. 1, file 1, Minute Book, 7 Feb. 1924, p. 41.

84. N. Robinson 1926 and 1927.

85. Radford 1926 and 1927a.

86. F.H. Varley 1927a; Radford 1927b.

87. See AFA 1926–27; Edmonton Journal 19 July 1927; H.O. McCurry, Ottawa, to K. Morris, Ottawa, 24 June 1927, NGC Arch., 5.4-Paris 1927.

88. Hipp 1927; Butterfield 1927; Vanderpant 1927; Nicol 1927; McEvoy 1927b; A.E.F. 1927.

89. A list of the paintings is in NGC Arch., 5.14-Loans Vancouver.

90. F.H. Varley 1927b, p. 24.

91. Mortimer-Lamb and Vanderpant entered into partnership in the Vanderpant Galleries in the spring of 1926, Mortimer-Lamb, Vancouver, to Lismer, Toronto, 28 Jan., 8 March, and 16 June 1926, NAC, MG30 D184, vol. 1, file 5. Currie 1928.

92. Vancouver Daily Province 12 June 1927; McEvoy 1928a.

93. Photographic Journal July 1928.

94. Vanderpant 1928c, pp. 448–49.

95. Vancouver Sunday Province 12 Aug. 1928; Ogden 1928.

96. Mortimer-Lamb 1928a; W. Miller 1928a; Vanderpant 1928b.

97. Leyland 1928.

98. Reader 1928.

99. Varley, CPR en route, to Cameron, Saskatoon, 1 July 1928, Nutana Arch.; Mortimer-Lamb 1928a and 1928b; Vanderpant 1928b.

100. Hamilton Herald 22 Aug. 1928; Free Press 5 Sept. 1928; Morning Citizen 22 Sept. 1928; Telegram 22 Sept. 1928; Times Globe 2 Oct. 1928; Evening Journal 8 Oct. 1928; Gazette 19 Oct. 1928; Montreal Standard 17 Oct. 1928. There are numerous other letters until 28 November 1928; see Vancouver Daily Province 28 Nov. 1928.

101. Leyland 1928.

102. New Western Tribune 29 June 1929.

103. Taylor 1928; Norbury 1928; Calgary Herald 6 Dec. 1928. In Jackson, Toronto, to Mortimer-Lamb [Vancouver], 11 Nov. [1928], priv. coll., Jackson says the exhibition is also to go to Camrose, Alta. It may also have gone to Drumheller, see A. Key, Drumheller Public Library, to Brown, Ottawa, 22 Feb. 1929, NGC Arch., 5.14-Drumheller.

104. Brown, Ottawa, to Gagnon, Paris, 22 July 1925, NGC Arch., 5.4-Paris 1927.

105. C. Masson, Paris, to Brown, Ottawa, 5 Jan. 1927, NGC Arch., 5.4-Paris 1927.

106. Gagnon, Paris, to Brown, Ottawa, 7 Jan. 1927, NGC Arch., 5.4-Paris 1927. Gagnon writes: "I was told if I am not mistaken that there are still some Indian craftsmen doing these. If so we should see that their names are included in the catalogue with those exhibits."

107. Eric Brown 1927a, pp. 190, 192.

108. Thiébault-Sisson, "La Première exposition d'art canadien," in exhibition catalogue for Paris 1927, pp. 15, 16.

109. Brown, Paris, to McCurry, Ottawa, 30 March 1927, NGC Arch., 5.4-Paris 1927. Brown writes: "I think we shan't hang Harris's Mountain Forms. Alongside the others it seemed rather overstrained and theatrical & I think would hurt the dignity and earnestness of the show." The painting was not included in the catalogue nor is it visible in installation photographs.

110. "L'Exposition de l'Art Canadien," n.s., n.d., NGC Library, clipping file for Paris 1927; Thiébault-Sissons 1927a; Fierens 1927; R.B. 1927.

111. Alexandre 1927a and 1927b; René-Jean 1927a.

112. Brown, Paris, to McCurry, Ottawa, 10 April [1927], NGC Arch., file 5.4-Paris 1927.

113. Halifax Daily Star 25 April 1927; Letondal 1927; A.M.D. 1927; Canadian Bookman June 1927; F.M. Brown 1927b; Eric Brown 1927b. A more positive selection of reviews was published in the NGC Annual Report 1927–28, pp. 7–18.

114. Gagnon, Paris, to Brown, Ottawa, 11 May 1927; Robinson, Montreal, to McCurry, Ottawa, 15 Feb. 1932; both NGC Arch., 5.4-Paris 1927.

115. See corr., NGC Arch., 5.5-Annual Exhibition 1927 and 5.14-Buffalo Loans; and Albright Arch., RG 3:1, box 34, folder 22. See foreword to exhibition catalogue for Rochester 1927, n.p.; Rochester Democrat and Chronicle and Rochester Herald 13 and 20 Feb. 1927.

116. Hekking, Buffalo, to Jaffe, Toledo Museum of Art, 22 Feb. 1927, Toledo Libr., exhibition file for Paintings by Contemporary Canadian Artists, March 1927.

117. Exhibition catalogue for Buffalo, Buffalo 1928.

118. Leila Mechlin, AFA, Washington, to C.P. Davis, St. Louis Art Museum, 16 May 1929, St. Louis Arch., exhibition file for AFA (1) 1930.

119. F. Keppel, New York, to H.S. Southam, Ottawa, 30 Dec. 1929, NGC Arch., 5.14-AFA 1930; Jackson, Toronto, to Sarah Robertson, Montreal, 1 Feb. [1930], NGC Arch., Robertson fonds.

120. Jackson, Toronto, to Sarah Robertson, Montreal, 1 and 6 Feb. [1930] and postmarked 13 Feb. 1930, NGC Arch., Robertson fonds; Jackson to McCurry, Ottawa, 9 Feb. [1930], NAC MG30

D186, vol. 1, NGC n.d.; Harris, Toronto, to Brown, Ottawa, 6 Feb. 1930, vol. 2, NGC 1930; Jackson, Fox River, Que., to McCurry, Ottawa, 29 March [1936], NGC Arch., 5.5-Group 1936.

121. Jackson, Toronto, to Robertson, Montreal, postmarked 13 Feb. 1930, NGC Arch., Robertson fonds.

122. Emmart 1930.

123. Toronto Daily Star 8 March 1930; Rainey 1930; Salinger 1930e and 1930f; Brooker 1928–30, 29 March 1930; Mechlin 1930.

124. Salinger 1930l, pp. 7, 9.

125. N.S. Mount 1931. No catalogue of this show has been located but a list is in AGO Arch., A3.8.2-1930 General corr. D-K, Exhibition American Federation of Arts 1931. See AFA (2) 1930.

126. F.B. Housser, "Foreword," in exhibition catalogue for Roerich 1932. See Jackson, Toronto, to FitzGerald, Winnipeg, 16 Feb. [1932], UM FitzGerald, box 7. See also corr. in NGC Arch., 5.5-Annual Exhibition 1932.

127. Cochrane 1932; Adlow 1932.

128. M'Cormick 1932; Hughes 1932.

129. Brown, Paris, to McCurry, Ottawa, 30 March 1927, NGC Arch., 5.4-Paris 1927.

12 THE COLLECTORS

1. Canadian Bookman Sept. 1924.

2. Watson Art Galleries sales book 1928–56, p. 1, NGC Arch., Watson Art Gallery fonds. W.R. Watson, Montreal, to C. Gagnon, Paris, 15 Aug. 1925; and 11 Nov. 1926; both McCord Arch., Gagnon additional papers file I. William Macbeth was a pioneer dealer in American art in New York. It was at his gallery that the first exhibition of "The Eight" was held in 1908.

3. Watson Art Galleries sales book 1911–27, p. 132 (15–27 March 1926), NGC Arch., Watson Art Gallery fonds. Also W.R. Watson, Montreal, to Brown, Ottawa, 23 March [1926], NGC Arch., 5.5-Annual Exhibition 1927.

4. Brooker 1928–30, 10 May 1930.

5. Jackson, Toronto, to C. Gagnon [Paris], 2 Dec. [1925], McCord Arch., Gagnon papers; to Barbeau, Ottawa, [Dec. 1925] and 8 May 1926, CMC, Barbeau's corr., Jackson, temp. box 19; to Norah Thomson, 5 May 1926 and [May 1926], NAC MG30 D322, files Jackson 1920s and Jackson 1926. See also Jasper National Park 1927, illus. by Jackson, Carmichael, MacDonald, and Casson, copy in NAC, acc. 1968–155, vol. 2707-36, no. 383.

6. See Reid 1969.

7. Jackson, Toronto, to Alice Massey, Washington, 13 Nov. 1927; Massey to Jackson, 22 Nov. 1927; both NAC, MG32 A1, vol. 51, Miscellaneous corr. at Washington, Alice Massey. Lismer, Toronto, to Norman Mackenzie, Regina, 2 April 1927, Mackenzie Arch.; Harris to Hekking, 28 Oct. 1928, Albright Arch., RG 3:1, box 34, folder 22; Jackson to Haines, Toronto, 20 June 1931, AGO Arch., A3.8.1-General corr. 1931, A-C:CNE 1931. Harris's Island, Lake Superior was loaned by Housser to the 1930 Group of Seven exhibition. See catalogue entry for The Little Fall (cat. 28). See also The F.B. Housser Memorial Collection (exhibition catalogue: London Public Library and Art Museum, 1945).

8. See Canadian Homes and Gardens June 1929, p. 31; Clive 1931a, pp. 19, 51. The house was built in 1927. Jackson, Toronto, to Norah Thomson, London, postmarked 21 Sept. 1927, NAC, MG30 D322, vol. 1, Jackson 1920s.

9. Dr. Mason loaned Varley's Sunflower Girl and Woman and Babe to Group 1936. He acquired MacDonald's Leaves in the Brook some time after the

end of the tour of Roerich 1932 and before AGT MacDonald 1933.

10. R.A. Daly loaned the Jackson to Group 1936, no. 105. The portrait is reproduced in P. Varley 1983, p. 104. Daly was president of a Toronto securities firm.

11. Ernest Ely loaned Gypsy Blood and the portrait of Mrs. Ely to Group 1936. See also the entry for Lake Shore with Figure (cat. 103). Ernest Ely was a clothier.

12. Beaver Swamp was loaned by Tovell to Group 1936 and Jackson's Winter Morning to Buffalo 1928. Dr. Tovell was a radiologist.

13. See Clive 1931a, pp. 17–19, and 1931b. Gordon Mills worked for the T. Eaton Co. in advertising and public relations. See W.G. Mills 1985.

14. Vincent Massey, Ottawa, to Alice Massey [Toronto], 25 Feb. 1918, NAC MG32 A1, vol. 53; Alice Massey to Vincent Massey, 27 Feb. [1918], vol. 33.

15. Exhibition catalogues: Chester D. Massey, Sir William Mackenzie, Sir Edmund Walker Collections (Toronto: The Jenkins Galleries, 21–24 June 1927); and The Chester D. Massey, the Late Nicholas Garland, Miss J.B. Bethune, Arthur Godden and Carter Estates (Toronto: The Jenkins Galleries, 7–8 Feb. 1928).

16. Rainey 1930 refers to an article on "Paintings in the Canadian Legation" in the Washington Post the previous June.

17. Certain acquisitions are documented in "Picture Account," 5 July 1927–31 Dec. 1935, NAC, MG32 A1, vol. 34, Savings 5712. See the exhibition catalogue for Massey 1934.

18. See Reid 1973, pp. 13, 41.

19. Warrener, Sarnia, to Schaefer, [Hanover, Ont.], postmarked 14 Dec. 1926, NAC MG30 D171, vol. 5, Warrener 1926–28. Inventory of Works in Brooker Estate, priv. coll. Brooker loaned the Carmichael to Buffalo 1928, and his FitzGerald Still Life to Group 1936.

20. See entry for cat. 48.

21. Jackson, Saint-Tite-des-Caps, Que., to McCurry, Ottawa, 3 April [1928], NGC curatorial file (acc. 15482).

22. See entry for cat. 59.

23. See Smith 1974; Gurd 1925; Gurd, Sarnia, to Cameron, Saskatoon, 30 Nov. and 19 Dec. 1927, Nutana Arch.

24. Acquisitions are listed in the AGT Bulletin issued twice a year from Nov. 1926 to March 1930 and annually from March 1931.

25. See Siddall 1987.

26. The AGT acquired The West Wind, Kitchener acquired Split Rock, Georgian Bay, and the Ontario Agricultural College in Guelph, Ont., acquired The Drive. See the program, Ontario Agricultural College Unveiling of "The Drive," A Northern Ontario Landscape Painting by Tom Thomson, in the War Memorial Hall, Friday Evening, January 8th, 1926.

27. A.J. Pyke, Saskatoon, to Homer Watson, Doon, Ont., 8 March 1922, Nutana Arch.

28. See Memorial Art Gallery, Nutana Collegiate Institute, Saskatoon, Saskatchewan, a fully illustrated catalogue published by the school in 1979. On Wilkie see N. Poole, The Art of London 1830–1980 (London: Blackpool Press, 1984), pp. 79–80. Correspondence regarding all purchases is in the Nutana Arch. Works purchased were by: in 1919, H.S. Palmer, W. Greason, A.M. Fleming, H. Britton, F. Carlyle, and W. St. Thomas Smith; in 1920, F.M. Bell-Smith, C.W. Jefferys, T.W. Mitchell, and R.F. Gagen; in 1921, T.G. Greene, G.A. Reid, F.M. Knowles, and André Lapine; in 1922, A. Browne and H. Watson; in 1923, E.W. Grier, and Gus Kenderdine.

29. Cameron, Saskatoon, to Brown, Ottawa, 24 July 1924, NGC Arch., 5.14-Saskatoon loans; Mac-Callum, Toronto, to J.W. McLennan, University of Toronto, 31 Oct. 1924, copy in Nutana Arch.

30. Cameron, Saskatoon, to Jackson, Toronto, 8 Dec. 1926 and 7 Jan. 1927, Nutana Arch.

31. Jackson, Toronto, to Cameron, Saskatoon, 29 Nov. 1926, Nutana Arch.

32. Jackson, Toronto, to Cameron, Saskatoon, received 5 Jan. 1927, Nutana Arch.

33. Meszaros 1990, p. 31; Cameron, Saskatoon, to Henderson, Fort Qu'Appelle, 4 Nov. 1924 and 14 March 1927, Nutana Arch.

34. Cameron, Saskatoon, to Jackson, Toronto, 7 Jan. 1927, Nutana Arch.

35. Jackson, Toronto, to Cameron, Saskatoon, 27 Jan., 3 April, 7 May, and 24 Sept. [1927]; Cameron to Jackson, 16 Feb. and 4 May; Cameron to George Thomson, Owen Sound, 4 Oct. and 2 Nov.; Thomson to Cameron, 2 Nov.; Brown, Ottawa, to Cameron, 8 Oct.; Cameron to Mrs. Wm. Henry, Aberdeen, Sask., 2 Nov.; all 1927, all Nutana Arch., with list of works exhibited.

36. Jackson, Toronto, to Cameron, Saskatoon, 12 Dec. [1927], 12 Feb. and 10 March [1928]; Varley, Vancouver, to Cameron, 29 Jan. and 31 March; G. Thomson, Owen Sound, to Cameron, 5 Feb.; Cameron to Varley, and to Jackson, both 22 Feb.; Haines, Toronto, to Cameron, 7 March; Cameron to Jackson, 15 March; MacCallum, Toronto, to Cameron, 15 March; Cameron to Mrs. Lorne Johnson, Regina, 16 March; Cameron to Norman Mackenzie, Regina, 29 March; Harris to Cameron, 31 March; Cameron to Harris, Toronto, 10 May; all except first 1928, all in Nutana Arch. Cameron to Greig, AGT, 23 Jan. and 22 Feb. 1928; Greig to Cameron, 1 Feb. 1928; Cameron to Haines, 13 April 1928; all AGO Arch., A3.8.8-General corr. 1921–25 [sic], Jan.–Mar. 1928. See also Saskatoon Daily Star 4 April 1928.

37. Cameron, Saskatoon, to Haines, Toronto, 19 Sept. and 16 Nov. 1929; Haines to Cameron, 24 Oct. 1929; both AGO Arch., A3.7.4-General corr. 1929, N-Z:N-Miscellaneous.

38. Exhibition catalogue for Saskatoon 1930.

39. Cameron, Saskatoon, to Blodwen Davies, Toronto, 1 June 1930; L. Henry, Saskatoon, to Davies, 11 March 1931; both NAC, MG30 D38.

40. Ottawa Journal 22 Jan. and 23 Feb. 1926; Grant 1926; W.C. Chalmers 1926a and 1926b.

41. Fosbery 1926; Wilson 1926a; Citizen 1 March 1924; Wilson 1926b.

42. Henderson 1926.

43. Eric Brown 1926.

44. A.Y. Jackson 1926d; also F.B. Housser 1926b.

45. Toronto Daily Star 20 Nov. 1926. The spokesperson is not identified in the article. C. Gagnon identifies him as Grier. See Gagnon, Paris, to Brown, Ottawa, 21 Dec. 1926, NGC Arch. 5.4-Paris 1927. Grier was elected vice-president 19 Nov. 1926, RCA Report 1926, p. 10.

46. Grier, "Lecture for National Gallery of Canada Canadian Painters," p. 27 (1925), Arch. of Ont., MU8227. Brown requested texts for a lecture on Canadian art from Grier and Lismer to be sent out with slides to art groups. Lismer did not submit a text. Grier sent his in 9 July 1925 but it was not used. Instead, the Gallery printed Eric Brown 1925. See corr. with Grier, NGC Arch., 7.1-Grier.

47. Lismer 1926b; Hewton 1926.

48. A.Y. Jackson 1926f.

49. Browne 1926.

50. Sproatt 1926.

51. Fosbery 1927a; A.Y. Jackson 1927a.

52. Fosbery 1927b and 1927c; Fosbery, Ottawa, to Shepherd, Montreal, 24 March 1927, NGC Arch., 9.9-Controversy 1927.

53. Telegram 21 Feb. 1927; Toronto Daily Star 24 Feb. 1927.

54. Fosbery, Ottawa, to J.C. Elliott, Minister of Public Works, Ottawa, 7 March 1927, copy in NGC Arch., 9.9-Controversy 1927; Brown, Ottawa, to Sproatt, Toronto, 28 Feb. 1927, NGC Arch., 7.2-RCA, file 1.

55. Fosbery 1927a; Ottawa Journal 25 Feb. 1927; "Major Fosbery Makes Reply to Gallery Board," Ottawa Citizen, 25 Feb. 1927.

56. Radford 1926 and 1927a; Telegram 21 Feb. 1927; Toronto Daily Star 24 Feb. 1927; "No Knowledge of Artists' Protest," Montreal Gazette, 23 Feb. 1927; Free Press 8 March 1927.

57. See notes 54 and 55. Petitions by artists and others in Montreal (7 March 1927), Toronto (23 March 1927), and Ottawa (31 March 1927) in support of Brown were sent to the trustees, a prelude to the larger 1932 controversy. NGC Arch., 9.9-Controversy 1927.

58. Sproatt, Toronto, to Shepherd, Montreal, 10 Feb. 1928; Shepherd to Sproatt, 10 April 1928; both NGC Arch., 7.2-RCA, file 2. The Academy's grant was reduced from $7500 to $2500 in 1924.

59. Brown, Ottawa, to Holgate, Montreal, 11 Nov. 1930; and to Grier, Toronto, 12 Nov. 1930; both NGC Arch., 5.4-Buenos Aires.

60. RCA Report 1929, pp. 10–11.

61. Radford 1930a, 1930b, 1930c; Ogden 1930; T.W.B. London, president, B.C. Art League, to trustees of the National Gallery, 4 Feb. 1930, NGC Arch., 9.9-Controversy 1930.

62. Radford 1931a; McEvoy 1931. See also Vancouver Star 29 Aug. 1931; Vancouver Daily Province 1 and 6 Sept. 1931.

13 CONSOLIDATION AND GROWTH

1. Brooker 1928–30, 17 Aug. 1929.

2. Brooker 1928–30, 31 Aug. 1929; in 16 Nov. 1929, Brooker says the column appears in six newspapers. I have found it only in the Citizen (Ottawa), Tribune (Winnipeg), Calgary Herald, Edmonton Journal, and Vancouver Daily Province. It was not in the Hamilton Spectator. Not all newspapers published the complete letter. References here are to the Citizen.

3. Brooker 1928–30, 15 Dec. 1928; and 26 Jan., 30 March, and 30 Nov. 1929; etc.

4. Brooker 1928–30, 25 May, 26 Oct., and 7 Sept. 1929; the latter elicited a response. See Pyper 1929; Brooker 1929b.

5. Brooker 1928–30, 13 July 1929.

6. Brooker 1928–30, 28 Sept. and 2 Nov. 1929.

7. Brooker 1928–30, 22 Oct. (the first letter) and 3 Nov. 1928, and 12 Jan. 1929.

8. In Brooker 1928–30, 2 and 9 March and 19 Oct. 1929.

9. Brooker 1928–30, 15 June 1929.

10. Brooker 1928–30, 8 Dec. 1928.

11. Brooker 1928–30, 23 Nov. 1929.

12. Brooker 1928–30, 17 Aug. 1929.

13. Brooker, Toronto, to Voaden, 22 Feb. 1930, YUA, Voaden papers, acc. 3, box 33, Brooker.

14. M. Denison, "Nationalism and Drama," in Brooker 1929a, pp. 52, 55.

15. Grace 1992, p. 55.

16. Wagner 1993, p. 12.

17. R.K.H. 1929.

18. Warrener, Antwerp, to Schaefer [Hanover, Ont.], 9 Dec. 1924; Warrener, Paris, to Schaefer, 24 Feb. 1925; Warrener, Sarnia, to Schaefer, 4 June 1925; all NAC, MG30 D171, vol. 5, Warrener 1924–25. See also Murray 1994b, pp. 20–21; Daniels 1990.

19. Warrener, Paris, to Schaefer, Hanover, Ont., 24 Feb. 1925, NAC, MG30 D171, vol. 5, Warrener 1924–25.

20. Schaefer 1979a; Flood 1982.

21. Warrener, Sarnia, to Schaefer, Hanover, Ont., postmarked 2 Jan. 1926, NAC, MG30 D171, vol. 5, Warrener 1925–26; Gurd, Sarnia, to Frances Flintoft, Rome, 1 March 1926, copy in Gallery Lambton Arch.

22. Warrener, Sarnia, to Schaefer, Hanover, Ont., 12 Dec. 1926, NAC, MG30 D171, vol. 5, Warrener 1925–26; J.E.H. MacDonald, "Notes on Walt Whitman: Arts & Letters Club 28 Jan. 1927," NAC, MG30 D111, vol. 3, file 31.

23. Warrener, Sarnia, to Schaefer, Hanover, Ont., postmarked 21 Jan. 1926, NAC, MG30 D171, vol. 5, Warrener 1925–26.

24. Gibbon, Montreal, to Lismer, Toronto, 15 May 1928, AGO Arch., Lismer papers 4.

25. Brooker 1929a, pp. 276–77; Brooker 1928–30, 18 May 1929.

26. Canadian Forum Jan. 1930.

27. Voaden 1930, plate opposite p. 88.

28. Voaden 1930, pp. xxiii–xxiv.

29. Gibbon, Montreal, to Voaden, Toronto, 26 May and 12 June 1930; Voaden to Gibbon, 9 June 1930; all YUA, Voaden papers, acc. 3, box 6, file 1930–31, Gibbon. Brooker 1928–30, 13 July 1929.

30. Voaden [Port Coldwell, Ont.], to Violet Kilpatrick [Toronto], 12 Aug. [1930], cited by Voaden in Wagner 1993, p. 135.

31. Voaden and Warrener, "Symphony," in Wagner 1993, pp. 137–38.

32. J.E.H. MacDonald 1929a; see also Brooker 1928–30, 23 Feb. and 2 March 1929.

33. J.E.H. MacDonald 1929a; Telegram 26 March 1929; Roberts 1929.

34. Construction March and May 1929.

35. Brooker 1928–30, 5 Jan. 1929.

36. Lismer 1927a, p. 174.

37. See Hodkinson 1992; Lismer 1933s.

38. L.S. Harris, Toronto, to Gibbon, Montreal, 19 April 1927, CP Arch., Montreal, RG 23.109019.

39. Jackson, Toronto, to Barbeau, Ottawa, 26 April [1928], CMC, Barbeau's corr., Jackson, temp. box 19.

40. Barbeau, Ottawa, to Sir Henry Thornton, Montreal, 30 Jan. 1929, CMC, Barbeau's corr., Thornton, temp. box 57. In this letter Barbeau proposed an all-Canadian festival for the opening of the new wing in the Château Laurier in Ottawa. For the opening of the Royal York, an English festival was organized. See Brooker 1928–30, 21 Dec. 1929. Also Gibbon, Montreal, to Lismer, Toronto, 1 Oct. 1929; and to Haines, Toronto, 24 Oct. 1929, list dated 12 Nov. 1929; all AGO Arch., A3.7.3-General corr. 1929, D-L:G.

41. See Holgate, Montreal, to Barbeau, Ottawa, 27 March 1927 [1928], 18 July and 24 Oct. 1928; Barbeau to Holgate, 28 July 1928; all CMC, Barbeau's corr., Holgate, temp. box 18. Barbeau to E.W. Beatty, Montreal, 9 May 1928, Beatty, B.168.f-27; Barbeau to Henry Thornton, Montreal, 30 June and 6 Aug. 1928, Thornton, temp. box 57.

42. Brooker 1928–30, 6 April 1929.

43. Canadian National Railways Magazine August 1929. My thanks to Sandra Dyck for bringing this to my attention.

44. Jackson, Montreal, to Barbeau, Ottawa, [March 1929], typed excerpt, CMC, Barbeau's corr., Jackson, temp. box 19.

45. Barbeau 1930, p. 363. This is an edited version of Barbeau 1929, in which he refers to the Jasper Room. For Brooker's reaction to the room see Brooker 1928–30, 8 March 1930.

46. See the *Canadian National Railways Magazine* for July 1929 (including Denison 1929). Almost the complete issue is devoted to the Château Laurier extension and decorations. See also Canadian Passing Show Aug. 1929; La Revue Populaire Oct. 1929; Journal, Royal Architectural Institute of Canada Nov. 1930.

47. Barbeau, Ottawa, to Holgate, Montreal, 16 May 1929, CMC, Barbeau's corr., Holgate, temp. box 18.

48. Brooker 1928–30, 21 Dec. 1929.

49. Brooker 1928–30, 14 June and 8 Nov. 1930.

50. Brooker 1928–30, 14 June 1930.

51. The most detailed history of the League is given in *Etcetera*, published by the League; see Breithaupt 1930; Canadian Bookman Dec. 1927. The League was a more informal association during the winter of 1926–27. An earlier student group known as the Art League of Toronto had been formed in 1919. See C.C.C. 1919. There is considerable documentation on the Art Students' League in the Breithaupt family papers in UWL.

52. Lismer, "The Art Students' League," ms., AGO Arch., Lismer papers, file A1182D. See also L.S. Harris 1929.

53. See advertisement in *Canadian Forum* X:117 (June 1930), p. 331; flier, "Art Students' League Sketching Camp, Open June to Nov. 1931," UWL, Edna Breithaupt coll., box 1.

54. Jackson, Toronto, to Sarah Robertson, Montreal, 3 Nov. [1928], NGC Arch., Robertson fonds.

55. Brooker 1928–30, 29 Dec. 1928. This article was a comment on the current R.C.A. exhibition. See also F.M. Brown 1927a, p. 60, on the dangers of imitation.

56. C. Gagnon, Paris, to Brown, Ottawa, 28 Nov. 1926, NGC Arch., 5.4-Paris 1927.

57. In his comments on OSA 1929, Brooker notes only two Group members who exhibited (Harris and Jackson), omitting Casson, who also exhibited, Brooker 1928–30, 6 April 1929.

58. Gazette 27 March 1926; Morgan-Powell 1926a; Jackson, Saint-Hilarion, to Sarah Robertson, Montreal, 7 April [1926], NGC Arch., Robertson fonds; Jackson, Montreal, to C. Gagnon, Paris, 20 April 1926, McCord Arch., Gagnon papers; R. Pilot, St. Andrews by the Sea, N.B., to W.R. Watson, Montreal, 25 March 1926, NAC, MG30 D310, vol. 1, Robert Pilot corr. 1926; Jackson to C. Gagnon, 20 March [1927], McCord Arch., Gagnon papers; H.P. Bell 1927.

59. See AAM Reports 1919–34.

60. Raleigh Parkin, Montreal, to Arthur Browning, Montreal, 5 March 1928; Parkin to E.L. Judah, Montreal, 27 Jan. 1932; both NAC, MG30 D77, vol. 16, AAM corr. 1928–54. Parkin resigned in 1932. The AAM acquired by gift a Lismer drawing, *The Fiddler*, in 1929, and purchased Jackson's *Les Éboulements, Early Spring* in 1931.

61. Brooker 1928–30, 8 Feb. 1930.

62. Morgan-Powell 1928b. On a copy of this clipping in his scrapbook (priv. coll.) Jackson has written "S.M.P. did not see this exhibition" (AAM Canadian 1928).

63. Morgan-Powell 1929b.

64. Chauvin 1928, [p. 267].

65. Chauvin 1928, p. 7.

66. Chauvin 1928, pp. 210, 213.

67. Chauvin 1928, pp. 78, 115, 135, 163, 184, 187, 195, 226, 230.

68. Chauvin 1928, pp. 149, 210.

69. Chauvin 1928, p. 243.

70. Djwa 1987, pp. 75–77; notes from conversation, C. Hill with F.R. Scott, c. 1974; Gazette 30 April 1928; invitation to Anne Savage exhibition, NAC, MG32 B5, vol. 128, subject file "Art." Printed program The Leonardo Society Jan.–Feb. [1928]; invitation to group show 4–16 July [1928] and printed statement in NGC Libr., file CS0.-Leonardo.

71. Djwa 1987, p. 83; Smith 1926.

72. A.Y. Jackson 1927c; L.S. Harris 1928; Carr 1929.

73. Brooker 1928–30, 16 March 1929.

74. Exhibition catalogues: *Paintings Lent by the Phillips Memorial Gallery, Washington*, 3–28 Nov. 1928; *French Paintings and Sculpture from the Kraushaar Galleries, New York and Private Collections*, 7 Dec. 1929.

75. AGT Bulletin May 1928, p. 7; April 1929, p. 12; March 1930, p. 10; March 1931, p. 13; March 1932, p. 13.

76. The folder in which the photographs are contained is inscribed: "'The House of To Day' Calgary Feb. March 1929." See also Canadian Homes and Gardens Oct. 1929; Brooker 1928–30, 5 Oct. 1929.

77. A.Y. Jackson 1926f.

78. Brooker 1928–30, 1 Feb. 1930.

79. F.B. Housser 1927c, p. 81.

80. F.B. Housser 1931, p. 384, review of Thomas Craven, *Men of Art* (New York: Simon and Schuster, 1931).

81. Samuel M. Kootz, *Modern American Painters* (Brewer and Warren 1930), pp. 7–9. Jackson, Toronto, to Barbeau, Ottawa, 26 and 29 June [1933]; Jackson, Whalen Island, Ont., to Barbeau, [Aug. 1933]; both CMC, Barbeau's corr., Jackson, temp. box 19. See also Brooker 1928–30, 2 Feb. 1929: "There is no distinctive American school for us to imitate. The traditional American painters paint like the traditional European painters, and the modernistic American painters paint like the modernistic European painters … In short, Canada is the only country where an individual and non-European school of painting has developed wholly uninfluenced by Paris, which has become the fashion centre for painting techniques … for a good many years."

82. L.S. Harris 1933c.

83. L.S. Harris 1933e, p. 288; see also 1934.

84. L.S. Harris 1933f, p. 6; see also Harris, Toronto, to Carr, Victoria, June [1930], NAC, MG30 D215, microfilm, vol. 2, Harris 1930.

85. Brooker 1928–30, 19 April 1930.

86. Brooker 1928–30, 19 April 1930.

87. Brooker 1928–30, 1 March 1930; see also 8 June 1929.

88. Brooker 1928–30, 7 Sept. 1929.

89. Carr's work had been considered for the 1928 Group show; however, it overlapped with the Montreal showing of West Coast Art 1928 in which her works were included. Brown, Ottawa, to Carr, Victoria, 14 Jan. 1928, NGC Arch., 7.1-Carr; Barbeau, Ottawa, to Carr, 15 March 1928; both CMC, Barbeau's corr., Carr, B.179.f-5.

90. Harris, Toronto, to Carr, Victoria, 2 and 25 Jan. 1930, NAC, MG30 D215, microfilm, vol. 2, Harris 1930; Daily Colonist 1 April 1930. See Tippett 1979, pp. 172–75; Blanchard 1987, pp. 215–17; Arch. of Ont., MU1293, Hammond journal, 1 Oct. 1928–30 June 1930, entry 10 April 1930. Hammond photographed Carr on that date.

91. Bridle 1930b.

92. Canadian Forum June 1930. Other Toronto articles included Salinger 1930j; Telegram 5 April 1930; Toronto Daily Star 7 April 1930; F.M. Harris 1930; C.C. MacKay 1930a; It Is To Laugh 1930; Kean 1930.

93. Correspondence regarding sales in Toronto is in AGO Arch., exhibition file for Group 1930, April. A priced list of works received from Toronto, noting Montreal sales, is in the "In and Out Exhibition Register" for May 1930, pp. 319–23, MMFA Arch. The exhibition was in Montreal for only two weeks, 3–18 May 1930. Harris's *Entrance to Coldwell* and *Morning, Tonquin Valley*, Holgate's *Indian Graves*, Bess Housser's *Hill Farms* and *Afternoon, Collins Inlet*, Jackson's *Laurentian Hills*, and Lismer's *Cathedral Mountain* were not sent to Montreal.

94. Morgan-Powell 1930.

95. Burgoyne 1930c. An article had previously appeared on the Toronto show, Salinger 1930i.

96. Girard 1930b.

97. Laberge 1930a.

98. Brooker 1928–30, 19 April 1930.

99. See Haines, Toronto, notes to Downard, AGT, 28 April and 3 and 29 May 1930, AGO Arch., A3.7.7-General corr., H-Miscellaneous. Montreal sales are noted in the exhibition register, see note 93. Total attendance was 11,704, the highest yet. See weekly attendance sheets in AGO Arch. A3.7.6-General corr. 1930, R.Y. Eaton 1930.

14 A CANADIAN GROUP

1. G.K.M. 1930; exhibition catalogue for NGC Jackson-Harris 1930; exhibition catalogue for AGT Harris-Jackson 1931; exhibition catalogue for Vancouver 1931. See correspondence regarding proposed US tour in AGO Arch., exhibition file for AGT presentation.

2. Mail and Empire 16 Jan. 1931; American Magazine of Art April 1931; Boas 1931.

3. See AGT corr. 21 May, 29 Sept., and 4 Nov. 1931 with Romeyn and Company Ltd., Toronto, AGO Arch., A3.8.2-Insurance 1931.

4. Banting's diary of this trip to St. Irenée in March 1931 is in UTL, ms. coll. 76, box 28B, transcript.

5. Jackson, Go-Home Bay, Ont., to Norah Thomson [Toronto], postmarked 17 Aug. 1931, NAC, MG30 D322, Jackson 1931; Jackson, Toronto, to Savage, Montreal, postmarked 20 Sept. 1931, NAC, MG30 D374, vol. 1., corr. 1931.

6. Lismer, Seal Cove, Grand Manan, N.B., to McCurry, Ottawa, 14 Aug. 1930, NGC Arch., 7.1-L. They visited Grand Manan, Yarmouth, Lunenburg, and Halifax. Jackson, Toronto, to Savage, Montreal, 8 Feb. [1931], NAC, MG30 D374, vol. 1, corr. 1931.

7. Brooker, Toronto, to FitzGerald, Winnipeg, 6 Aug. and 27 Nov. 1931, UM FitzGerald, box 7.

8. MacDonald, Thornhill, to FitzGerald, Winnipeg, 14 Oct. 1931, UM FitzGerald, box 7.

9. Brooker, Toronto, to FitzGerald, Winnipeg, 10 Jan. [1932], UM FitzGerald, box 7.

10. Brooker, Toronto, to FitzGerald, Winnipeg, 27 Nov. 1931, UM FitzGerald, box 7.

11. Bridle 1931b; McCarthy 1931c; Hammond 1931; Telegram 5 Dec. 1931.

12. Salinger 1931f.

13. T. MacDonald 1932. Jackson explained to Anne Savage that Thoreau's article "was to have been one of five or six terse comments for or against but they went to press too early for the others." Jackson, Toronto, to Savage, Montreal, postmarked 12 Jan. 1932, NAC, MG30 D374, vol. 1, file 1932.

14. Davies 1932, p. 13.

15. Salinger 1932a, p. 143. Her article elicited a swift response from F.B. Housser 1932a and a counter response from Salinger 1932c. See also Lismer 1932a.

16. Lyman 1932.

17. Lismer, Toronto, to FitzGerald, Winnipeg, 24 May 1932, UM FitzGerald, box 7.

18. To the Mayor and City Council of Vancouver, 2 Dec. 1925, from eleven donors, in VAG Arch. H.A. Stone offered $50,000 and the ten others $5000 each. The core collection is listed in Myers 1931a and 1931b; Radford 1931b and 1931c; Vancouver Sun 5 Oct. 1931; Milligan 1931.

19. Radford 1932b. The first reviews were Myers 1932c and 1932d; Vancouver Sun 11 May 1932.

20. Vancouver Sun 17 and 22 June 1932; Bouchette 1932a and 1932b; Vancouver Sunday Province 3 July 1932; Mail and Empire 12 July 1932; Milligan 1932.

21. A.Y. Jackson 1932b. See also Lismer 1932f and 1932g; Telegram 16 Dec. 1932; L.S. Harris 1932b.

22. A catalogue annotated with the results of the ballot is in the VAG library.

23. Mortimer-Lamb 1932b. The acquisition committee consisted of Charles Scott, Charles Marega, C. Spencer, and Mortimer-Lamb, Vancouver Daily Province 7 Nov. 1931.

24. Radford 1932b.

25. Petition signed T.W. Mitchell to R.B. Bennett, 27 April 1932, copy with letter from W.P. Weston, Vancouver, to McCurry, Ottawa, 9 June 1932, NGC Arch., 9.9-Controversy 1932–34, file 2.

26. Johnston, Toronto, to Bennett, Ottawa, 25 Jan. 1932; Heming, Toronto, to Bennett, 1 March 1932; Fabien, Ottawa, to Bennett, 23 April 1932; copies of all in NGC Arch., 9.9-Controversy 1932–34, files 1 and 2.

27. T.W. Mitchell, Toronto, to Bennett, Ottawa, 18 Nov. 1932, with list of protest petitioners, copy in NGC Arch., 9.9-Controversy 1932–34, file 2. See also Ottawa Journal 8 Dec. 1932.

28. RCA Report 1931, pp. 7–8. F. McGillivray-Knowles's placement on the retired list created a vacancy. MacDonald had been nominated for the RCA on 11 May 1929 by Jefferys and Reid but Fosbery had been elected. On 30 April 1931 he was nominated by Beatty and Cullen. See RCA Nomination Book 1903–47, NAC, MG28 I126, vol. 8. See also vol. 17, RCA Minute Book 1927–59, 5 Nov. 1932; McCarthy 1932e; Telegram 29 Nov. 1932.

29. Jackson, Toronto, to Dyonnet, Montreal, 14 Dec. 1932, copy in Jackson's scrapbook, priv. coll.

30. Vancouver Sun 31 May 1932.

31. Graham 1932e, pp. 11, 15; Toronto Daily Star 7 July 1932, 18 and 27 Aug. 1932; Lampman 1932, p. 17.

32. Fosbery 1932a, 1932b, 1933; Mail and Empire 9 Jan. 1933; Maxwell 1932b; Heming 1933; Radford 1932d, 1932e; Vancouver Sun 24 Dec. 1932; Wells 1932d; Colgate 1933a; La Presse 9 Jan. 1933. See also Grier 1933.

33. Jackson 1932c, 1933b, 1933c; L.S. Harris 1932a, 1932b; Telegram 16 Dec. 1932; Lismer 1932k–L; Chauvin 1933; Wood 1933; Loring 1933; Milne 1933a–f; Crisp 1933.

34. Petition received 27 Jan., see H.S. Southam, Ottawa, telegram to E.W. Wood, Toronto, 27 Jan. 1933, NGC Arch., 9.9-Controversy 1932–34, file 2. In Toronto the support statement was coordinated by E.W. Wood, Loring, and Louise Comfort. The document with the signatures is in the NGC Arch. The conflict would continue into 1934.

35. Varsity 12 Dec. 1932.

36. Harris, Toronto, to FitzGerald, Winnipeg, 1 Jan. 1933, UM FitzGerald, box 7.

37. See note 36.

38. Phillips 1933.

39. Exhibition catalogue for AGT MacDonald 1933, p. 3.

40. A.Y. Jackson 1932d.

41. Globe 21 Jan. 1933.

42. Brooker, Toronto, to FitzGerald, Winnipeg, 15 March 1933, copy in UMA, MSS16, box 1, folder 11.

CONCLUSION

1. H.R. MacCallum 1933, p. 243.

2. Underhill 1936.

3. Lyman 1939.

4. Lismer, Toronto, to McCurry, Ottawa, received 13 June 1933, NGC Arch., 7.1-L.

5. Jackson, Toronto, to Savage, Montreal, 21 June [1932], NAC, MG30 D374, vol. 1.

6. Girard 1934.

7. Jackson, Les Éboulements, Que., to Savage, Montreal, 3 April [1932], NAC, MG30 D374, vol. 1; Arch. of Ont., MU2255, OSA Minute Book 1931–37, 5 April 1932, 6 Dec. 1932, 3 Jan. 1933.

8. Lismer 1927b, pp. 69–71.

9. Robertson, Montreal, to Brown, Ottawa, 2 Dec. 1931, NGC curatorial file for Robertson, Joseph and Marie-Louise (acc. 15545).

10 Voaden 1928, p. 106.

production of Shakespeare's *Tempest* in June 1922. Wyly Grier's brother Monro Grier played Gonzalo, and the production was lauded in the press (Jacob 1922f; Charlesworth 1922b; Telegram 7 June 1922; Denison 1923c, 62; A. 1922, 755). This portrait has all the qualities Hector Charlesworth (1922b) admired in the show itself – lavish trappings and elaborate posturing – and may depict the very scene he praised: "Mr. Forsyth had the requisite majesty of bearing as Prospero and recited the famous 'cloud capt towers' speech with fine rhetorical fervour."

Forsyth left Toronto for New York in the spring of 1926 where he later committed suicide (Globe 17 Sept. 1927). J.E.H. MacDonald (1929b) composed "A Prologue" in his memory.

6
Kenneth Forbes (1892–1980)
Girl Ironing 1924 (see fig. 250)
Oil on canvas, 75.9 × 63.8 cm
National Gallery of Canada, Ottawa (4228), Royal Canadian Academy of Arts, diploma work, deposited by the artist, Toronto, 1934
Inscriptions: l.l., *K.K. Forbes. / 1924.*
Exhibitions: London, Royal Academy, 1924, no. 437 *An Artist's Wife*; Pittsburgh, Carnegie Institute, 15 October–6 Dec. 1925, *24th Annual International Exhibition of Paintings*, no. 100, AAM, 4–19 Dec. 1926, *Exhibition of Paintings by Kenneth Forbes*, no. 2, $800; OSA 1927, no. 35 *Girl Ironing*, $700; NGC 1928, no. 48, $800; AGT Forbes 1933, no. 51 *Ironing*, $600.
Bibliography: Burgoyne 1926; Telegram 5 March 1927.

Son of the Canadian portrait painter John Colin Forbes (1846–1925), Kenneth Forbes worked for the Canadian War Memorials in London and returned to Toronto in 1924. He was elected to the Royal Canadian Academy in 1933, and submitted his 1924 Royal Academy painting as his diploma work, required for all newly elected academicians (Burgoyne 1926). Forbes had considerable success as a portrait painter, sharing the social values of the wealthy and supplying literal likenesses marked by evident technical skill. He was a virulent opponent of modern art and fulminated to the press in 1932: "There is great beauty of an infinite variety in Canada and it is not a raw upheaval of nauseating colours with pointed rocks and dead trees stuck in at random and with an occasional live tree that reminds one of a stick with gherkins spiked on it. Real Canadian artists are ashamed of this class of work" (Toronto Daily Star 27 Aug. 1932).

7
Ernest Fosbery (1874–1960)
James Wilson c. 1930 (see fig. 202)
Oil on canvas, 86.3 × 66.3 cm
National Gallery of Canada, Ottawa (3981), Royal Canadian Academy of Arts, diploma work, deposited by the artist, Ottawa, 1931
Exhibitions: RCA 1930, no. 53, repr.; NGC 1931, no. 76.
Bibliography: Mail and Empire 8 Nov. 1930; Lyle 1931, 10, repr. 8.

Ernest Fosbery was responsible for the engagement of Canadian artists, including A.Y. Jackson, to work for the Canadian War Memorials in England (Tippett 1984, 28–30). He became a successful portrait painter in Ottawa and attacked what he perceived as the self-serving myth making of the Group of Seven

(Fosbery 1927a) and "a conscious effort to be national . . . [which] seems to lead almost inevitably to superficial mannerisms" (Fosbery 1930, 279).

He used his associations to combat Eric Brown's policies for years. The submission of this portrait of his friend and fellow combatant, the prominent Ottawa art dealer James Wilson (c. 1855–1932), was clearly intended as a slap in the face of the National Gallery.

8
Archibald Barnes (1887–1972)
The Grey Veil 1929 (see fig. 244)
Oil on canvas, 76.4 × 63.7 cm
Vancouver Art Gallery (32.9), gift of F.N. Southam, Montreal, 1932
Inscriptions: l.r., *BARNES*
Provenance: Purchased from Vancouver 1932 and donated by F.N. Southam, Montreal.
Exhibitions: RCA 1930, no. 8 repr.; NGC 1931, no. 9; CNE 1931, no. 363, $1000; Vancouver 1932, no. 4, $1000.
Bibliography: Mail and Empire 8 Nov. 1930; Lyle 1931, p. 7, repr. 6; Graham 1932b, repr. 5; Toronto Daily Star 27 Aug. 1932, repr.

Archibald Barnes was one of the many English artists who received commissions from the Canadian War Memorials. He first visited Canada in 1929, settling the following year in Toronto where he became a successful portrait painter. *The Grey Veil* received the second greatest number of popularity votes from viewers at the Vancouver Art Gallery's *All Canadian Exhibition* in 1932 and was praised by Jean Graham (1932b) in *Saturday Night*: "The austerity and grace of the subject are brought out in soft and neutral tints. It is unusual in style and severity and suggests the art of Spain. Such work is a revelation of the poetry which lies in such subtle art and is especially needed in this generation of broad effects and crude colouring."

9
Arthur Heming (1870–1940)
In Canada's Fairyland 1930 (see fig. 251)
Oil on canvas, 76.6 × 101.9 cm
Art Gallery of Hamilton (64.72.15), gift of Harold G. Smith, Esq., O.B.E., and Family in memory of Marjorie Evel Smith (1886–1948), 1964
Inscriptions: l.r., *Heming 1930 / .1*; stretcher: u.c., on label in ink, *In Canada's Fairyland / by / Arthur Heming / Price $250.00*
Provenance: T.R. Lee, Ingersoll, Ont., 1952. Harold G. Smith, Esq., O.B.E.
Exhibitions: OSA 1930, no. 74, $600; Eaton 1930, no. 32, $1000, repr.; NGC 1931, no. 108.
Bibliography: Canadian Society of Graphic Art 1931, repr.; Canadian Geographical Journal June 1931, repr. 460; Robson 1932, repr. 165; Winnipeg Saturday Review 25 Aug. 1934, repr.

Colour-blind, Arthur Heming worked in black and white and yellow until 1930 when, at the suggestion of his friend Richard Jack, he began painting in a greater range of colours (Phillips 1940, 27). Heming's paintings were touted by the Toronto *Telegram*'s art critic Kenneth Wells (1933d) as truly expressive of the Canadian north: "There is more of the north in them, more real Canadianism, as the landscape painters understand it, than in the whole lumped output of the Group of Seven. His pictures may not appeal to the sophisticates of the studio . . . Gallery

curators may not find them satisfying to that snobbism which breeds in such places . . . In a modernistic wilderness of self-expression he puts self aside to accurately describe on canvas the life of a northland that is passing and that will soon be only a dream . . . he paints the north not as a painter loving colour and design for its own sake, but as an artist loving it for his subject's sake."

10
Richard Jack (1866–1952)
Arthur Heming 1929 (see fig. 252)
Oil on canvas, 75.5 × 62.7 cm
Art Gallery of Hamilton (53.74.A), gift of Arthur Heming's sisters, Edith Heming Acres and Emma Heming Noxon, 1953
Inscriptions: l.l., *RICHARD JACK / 1929.*
Provenance: The artist; by descent.
Exhibitions: OSA 1929, no. 113 *Arthur Heming in the North Country*; AAM, 30 Nov.–15 Dec. 1929, *Landscapes and Portraits by Richard Jack, R.A., R.I., R.S., A.R.C.A.*, no. 37 *Mr. Arthur Heming.*
Bibliography: Choate 1929; Montreal Gazette 2 Dec. 1929; Graham 1932c, p. 5 repr.; J.L. Brown 1932, repr. 20; Tatler 22 March 1933, repr.

The paintings by the British artist Richard Jack realized for the Canadian War Memorials (see fig. 22) were enormously popular for their elaborate detail and heroic narrative. Jack arrived in Canada in the fall of 1927 (Montreal *Gazette* 25 Oct. 1927), and within five months had a solo exhibition of his portraits at the Art Gallery of Toronto.[1] From Saint-Tite-des-Caps Jackson wrote: "All I hear from Toronto is wails and howls about handing the art gallery over to Richard Jack and having all the boobery in the town marvelling at their own photographic likenesses."[2] Another writer complained in the *Mail and Empire* about the "inane and colourless" portraits and "the advertising which is always denied our own artists and accorded to any European painter however mediocre" (Wyte 1928).

1. *Catalogue of Portraits by Richard Jack, R.A.* (Toronto: AGT, 16 March–2 April 1928). 2. Jackson, Saint-Tite-des-Caps, to McCurry, Ottawa, 3 April [1928], NGC Archives, 7.1-Jackson.

11
Franklin Carmichael (1890–1945)
Spring 1920 (see fig. 100)
Oil on canvas, 92.2 × 76.8 cm
Private collection
Inscriptions: l.l., *FRANK / CARMICHAEL / '20.*
Provenance: Estate of the artist.
Exhibitions: Group 1920, no. 1, $350; CNE 1920, no. 23, $450; U.S. Tour 1920–21, no. 1, $350; Wembley 1924, no. 27; Philadelphia 1926, no. 1577; Rochester 1927, no. 3; AGT Canadian 1927, no cat. no., $350; Group 1936, no. 5.
Bibliography: Jacob 1920e; Bridle 1920a and 1920b; H.E. Wrenshall 1920b; M.T. 1921; Academy Notes Jan.–June 1922; Toronto Star Weekly 26 Jan. 1924.

Augustus Bridle (1920a) described *Spring* as "a gnarled old tree which he made almost human in its hunger for returning vitality and the decoration of blossoms." An exceptional work in Carmichael's oeuvre due to the predominance of sky against which the branches are arranged, *Spring* was exhibited extensively throughout the 1920s.

12

Franklin Carmichael (1890–1945)
Autumn Hillside 1920 (see fig. 41)
Oil on canvas, 76 × 91.4 cm
Art Gallery of Ontario, Toronto (L 69.16), gift from
the J.S. McLean Collection, 1969, donated by the
Ontario Heritage Foundation, 1988
Inscriptions: l.r., FRANK / CARMICHAEL / 1920
Provenance: Purchased by J.S. McLean from the
artist, Toronto, 1937; gift from the J.S. McLean
Collection, 1969.
Exhibitions: OSA 1920, no. 22 *An Autumn Landscape*,
$400, repr.; Group 1920, no. 4, $450; CNE 1920,
no. 22, $450, repr.; RCA 1920, no. 40 *An Autumn
Hillside*; Wembley 1924, no. 28; Ghent 1925, no. 573
Coteau en automne; NGC 1926, no. 18 *Autumn Hillside*,
$350; AGT Canadian 1927; Group 1936, no. 16, repr.
Bibliography: Hammond 1920a; Jacob 1920c;
Fairbairn 1920b; Bridle 1920a; Traquair 1920, p. 84,
and 1921, p. 81; NGC 1924a, repr.; MacTavish 1924,
repr. 140, and 1925a, repr. opposite p. 156; Richmond
1925, p. 19; Birmingham Gazette 30 Jan. 1925; Eric
Brown 1927a, repr. 187 as *L'Automne*.

The flattened, vertical, decorative treatment of
the background trees in *Autumn Hillside* bears
witness to Frank Carmichael's study of such
Tom Thomson paintings as *Autumn's Garland*.
The space opens at the left to a vista of rolling
hills with the curtained cloud a perfect foil to
the busyness of the rest of the canvas.

13

Lawren S. Harris (1885–1970)
Portrait (Bess Housser) c. 1920 (see fig. 40)
Oil on canvas, 112.5 × 92.2 cm
Art Gallery of Ontario, Toronto (89/113), gift of
L.S.H. Holdings Ltd., Vancouver, 1989
Inscriptions: u.r., LAWREN / 1920.; verso:
c., LAWREN HARRIS
Provenance: Estate of the artist.
Exhibitions: Group 1920, no. 15, 16, 17, or 18.

Augustus Bridle (1920b) observed in his enthusi-
astic review of the first Group show that Lawren
Harris's portraits were "all somewhat influenced
by the Whistler method of simplicity; excellent
likenesses and strong ensembles with no attempt
to flatter the subject." He also noted that
"Harris refuses to be identified solely by one
type of picture." In fact, the artist's decision to
exhibit portraits for the first time ever at the
premier exhibition of a group known for its
concentration on landscape is startling, and at
the same time shows the complexity of their
intent. In the foreword to the catalogue Harris
wrote: "Recognizing that Art is an essential
quality in human existence [the Group] will wel-
come and support any form of Art expression
that sincerely interprets the spirit of a nation's
growth." For Harris, this spirit was reflected in
its people as well as in its geography.
 Bess Housser was active in Doris Mills's art-
lending group and from 1924 to 1926 edited an
art column in the *Canadian Bookman*. Later she
began painting herself (see cat. 123). In 1934 she
married Lawren Harris.

14

Lawren S. Harris (1885–1970)
Shacks 1919 (see fig. 61)
Oil on canvas, 107.9 × 128 cm
National Gallery of Canada, Ottawa (1693)
Inscriptions: l.l., LAWREN / HARRIS / 1919

Provenance: Purchased from Group 1920.
Exhibitions: Group 1920, no. 20, $1000; Wembley
1924, no. 86; Saint John Exhibition, Aug. 1929;
Edmonton 1930, no. 9; Saskatoon Industrial
Exhibition, June–Aug. 1931; Kingston, Queen's
University, Oct. 1931; Hamilton, McMaster
University, April–May 1932; London, Western Fair,
Sept. 1932; Cornwall Art Association, February–June
1935; Group 1936, no. 64.
Bibliography: Jacob 1920e; Bridle 1920a and 1920b;
Somerville 1924d; Montreal Daily Star 10 June 1924;
R. Lee 1924, p. 339; Leicester Mail 12 Nov. 1924; F.B.
Housser 1926a, p. 217; Dick 1928c.

Some of the first paintings Lawren Harris
exhibited were of Toronto streets, including
those in the Ward, a poor district just north of
Toronto City Hall, largely populated by recent
immigrants, including Italians and Jews (Bridle
1909). After the war he began to explore the out-
skirts of the expanding city at Earlscourt and
Lambton. Bridle (1920a) wrote: "*Shacks* is a win-
ter afternoon fair on the rear end of a group [of
shacks] that shout in reds, greens and blues.
Harris exuberates in painting old paint in a high
key. He revels in gorgonesque gobs of broken
and patched roughcast. He delights to swat him-
self in the eye with pink fence-boards, yellow
windows and blue door-ways that zip out of the
naked plaster like poppies stuck in skulls."

15

Lawren S. Harris (1885–1970)
In the Ward 1920 (see fig. 46)
Oil on canvas, 86.7 × 92.7 cm
University of Manitoba, Winnipeg Collection of
Gallery 1.1.1., School of Art, University of Manitoba,
Winnipeg, gift of the Students of the School of Art
Inscriptions: l.l., LAWREN / HARRIS / 1920;
stretcher: u.l., in ink, VACANT HOUSE / IN THE
WARD, u.r., ink, LAWREN HARRIS / 1920
Provenance: Purchased from the artist 1950.
Exhibitions: Group 1920, no. 22, $400; U.S. Tour
1920–21, no. 4 *The Empty House*, $500.
Bibliography: Morehouse 1921a.

The scabrous peeling stucco and broken shutters
of this dilapidated house evoke an image of dis-
eased poverty which is belied by the pink and
pale blue of the facade. The anonymous fore-
ground figure seen from the rear (though facing
the viewer in the sketch)[1] and staring at the
house, augments the haunting quality of this
image of alienation. Lawren Harris was torn by
his condemnation of the existence of urban
poverty and his ability to see beauty in its
midst.[2]
 One American reviewer was delighted by
this work: "*The Deserted House* by Harris may be
lonely and desolate inside but its outer walls
throb with colour. Its blues have a beauty that
impress as do the deep tones of a church organ;
the old wall is lovely with shades of deep rose
and tones of pale green; the green shutters at the
windows have fallen into decay and an occasion-
al white curtain reminds that the house once was
tenanted" (Morehouse 1921a).

1. *Canadian Art* (sale catalogue, Toronto, Sotheby,
Parke Bernet [Canada] Inc., 1–2 June 1982), p. 21, repr.
2. See his poem "A Note of Colour" in L.S. Harris
1922, p. 11.

16

Lawren S. Harris (1885–1970)
Autumn, Algoma 1920 (see fig. 48)
Oil on canvas, 107.5 × 125.5 cm
Victoria University (In the University of Toronto)
Inscriptions: l.l., LAWREN / 1920
Provenance: Acquired prior to 1948.
Exhibitions: Group 1920, no. 25 *Decorative Landscape*,
$600.
Bibliography: Bridle 1920a and 1920b.

Lawren Harris exhibited only two Algoma can-
vases in the first Group show, *Waterfall* (present
whereabouts unknown) and *Decorative Landscape*,
described by Bridle (1920a) as "no place on
earth. The maple leaves in the foreground are a
swank of gorgeous colour against a shimmering
fog of phantom blue spruces and an enchanted
lake on the 20th plane." There are no violent
contrasts of colour in this work, the muted yel-
lows, browns, greens, and blues evoking a misty,
ethereal world.

17

A.Y. Jackson (1882–1974)
Terre Sauvage 1913 (see fig. 10)
Oil on canvas, 128.8 × 154.4 cm
National Gallery of Canada, Ottawa (4351)
Inscriptions: l.r., A Y JACKSON / 1913; on label
removed from old stretcher, *This canvas was painted in /
Nov. and Dec. 1913, in Harris' / studio over Bank of
Commerce– / Bloor and Yonge St. First exhibit / at RCA
Montreal 1918 called Northland, / later exhibit in First Group
Show to U S. / under the title Terre Sauvage.*; on old
stretcher, *Refused by OSA / First exhibited at RCA 1918,
(MOUNT / ARARAT), NORTHLAND, [JACK]SON,
(partly covered by label) STUDIO BLDG SEVERN ST
TORONTO, PAINTED / 1913, TERRE SAUVAGE
GROUP SHOW / RCA 1918, [RO]ERICH /
WEMBLEY / BOSTON.*
Provenance: Purchased from the artist, Toronto 1936,
in partial exchange for *Winter Afternoon*, purchased
1915.
Exhibitions: RCA 1918, no. 89 *The North Country*;
Group 1920, no. 30 *The Northland* $800; U.S. Tour
1920–1921, no. 11 *Terre Sauvage*, $300; OSA
Retrospective 1922, no. 96 ; Wembley 1924, no. 102
The Northland; [Hart House Jackson 1927, no. 21,
$800?]; Roerich 1932, no. 26; Group 1936, no. 123
Terre Sauvage.
Bibliography: Burgoyne 1918; Laberge 1918; Mortimer-
Lamb 1918 and 1919a; Hammond 1920b; Bridle 1920a
and 1920b; W.H.D. 1920; Morehouse 1921a; Hendricks
1921c; Muskegon Chronicle 14 Jan. 1922; Toronto Star
Weekly 26 Jan. 1924; Bertram 1924; F.B. Housser 1926a,
p. 91; Salinger 1932a, p. 142; A.Y. Jackson 1933a, p. 136.

The largest canvas A.Y. Jackson painted before
the 1920s, *Terre Sauvage* symbolized his engage-
ment with the new Toronto movement. Refused
by one of the OSA juries, according to the
inscription, it was first exhibited only after
Jackson's return from England when both his
and MacDonald's paintings were lauded by
Albert Laberge (1918): "They paint their canvas-
es in a fugue, in a kind of fury. It's as if, vibrat-
ing before untamed nature, savage and wild, they
can scarcely find colours strong enough, gestures
vigorous enough, to express the emotions they
feel. An atmosphere of apocalypse breathes
through the paintings of these artists. They are
the visionaries of Art." Morgan-Powell (1918)
disagreed: "Nobody visiting the exhibition is
likely to miss having his or her sense of colour,
composition, proportion and good taste violently

affronted." But for Bridle (1920a), reviewing the first Group show, "This is the bluest and most Scandinavian thing in a show where blues and Nordland predominate. A stage of superb and tremendous rocks on which a vivid line of green jackpines stand like sentinels shouting 'Watchman, what of the Night?' to a prodigious amphitheatre of turbulent white clouds with the fragment of a discouraged rainbow in one corner."

18

A.Y. Jackson (1882–1974)
Herring Cove, Nova Scotia 1919 (see fig. 47)
Oil on canvas, 63.9 × 76.7 cm
Private collection
Inscriptions: l.r., *A Y JACKSON*; stretcher: t., *A.Y.JACKSON HERRING COVE, N.S. PAINTED 1919*
Exhibitions: Group 1920, no. 34 *A Nova Scotia Village*, $250; Saint John 1920, no. 43 , $250; U.S. Tour 1920–21, no. 10 , $250; [AAM 1922, no. 147 , $350 ?]; AGT Canadian 1926, no. 18 , $300; Rochester 1927, no. 17; AGT Canadian 1927, no cat. no., $400; [Buffalo Jackson 1928, no. 8?].
Bibliography: M.T. 1921; Academy Notes Jan.–June 1922; Rochester Democrat and Chronicle and Rochester Herald 20 Feb. 1927, repr.

Arthur Lismer wrote from Bedford, Nova Scotia, to J.E.H. MacDonald in March 1919: "It's fine for me to have [Alec Jackson] with us. He is staying at our house of course except when he was at Herring Cove which has captivated him. I think you'll find that Algoma has a rival when you hear him."[1] A.Y. Jackson painted three canvases of Herring Cove, two of which were exhibited in the first Group show, *A Fishing Village* and *A Nova Scotia Village*.[2]

1. Lismer, Bedford, N.S., to J.E.H. MacDonald [Toronto], 21 March 1919, NAC, MG30, DIII, vol. 1.
2. A third canvas, shown in Group 1921, is in the Musée d'art contemporain, Montreal (repr. catalogue of Sotheby Parke Bernet (Canada) Inc., Toronto, sale 26–27 May 1981, lot 26). Installation photographs of AGT Canadian 1926 show *Herring Cove, Nova Scotia* and *A Fishing Village* (present whereabouts unknown).

19

A.Y. Jackson (1882–1974)
March Storm, Georgian Bay 1920 (see fig. 194)
Oil on canvas, 63.5 × 81.3 cm
National Gallery of Canada, Ottawa (5051), bequest of Dr. J.M. MacCallum, Toronto, 1944
Inscriptions: l.r., *A.Y.JACKSON*; stretcher u.c., *A MARCH STORM / GEORGIAN BAY*
Provenance: Dr. James MacCallum, Toronto, by 1933.
Exhibitions: Group 1920, no. 37 *A Storm in March*, $300; RCA 1920, no. 133 *Storm over a Frozen Lake*.
Bibliography: Jacob 1920e; Bridle 1920a and 1920b; Morgan-Powell 1920b.

This is the most expressive and freely brushed of the four canvases A.Y. Jackson painted between his return from Georgian Bay in late March and the opening of the first Group show 7 May. A volcano of grey and brown paint swirls up from the silhouetted, windswept pines, the snow resting in the crevices of the red-brown rocks between the cracked, black ice.
This Georgian Bay painting was the only canvas by a Group member postdating Thomson's death in the collection of Dr. James MacCallum.

20

A.Y. Jackson (1882–1974)
Springtime in Picardy 1919 (see fig. 37)
Oil on canvas, 65.1 × 77.5 cm
Art Gallery of Ontario, Toronto (2544), gift from the Albert H. Robson Memorial Subscription Fund, 1940.
Inscriptions: l.r., *A Y JACKSON / 1919*
Provenance: Purchased from the artist, Toronto 1940
Exhibitions: Group 1920, no. 40 *Spring in Liévin*, $300; AGT Canadian 1926, no. 9 *Springtime in Picardy '18*, $300.
Bibliography: Jacob 1920e; Bridle 1920a and 1920b.

Between his return from England in October 1918 and demobilization in April 1919, A.Y. Jackson continued to paint for the Canadian War Memorials. Distance from the battlefield has added clarity and colour to his memories of the spring of 1918, the pink blossoms expressive of both hope and the indifference of nature to human folly. Fred Jacob (1920e) of the *Mail and Empire* wrote: "There is plenty of variety in Mr. Jackson's work but no pictures in the gallery are harder to take than his villages and *Spring in Liévin*," while Bridle (1920b) described the painting as "a fantastic reminiscence of the artist's war experience in the shell-battered Flanders town, with a gaunt peach tree in pink bloom, before the ruined houses showing blue-tinted walls of inner rooms, and a couple of passing Tommies."

21

F. H. Johnston (1888–1949)
Algoma 1919 (see fig. 30)
Tempera on wove paper laid down on card, 61 × 50.8 cm
Private collection
Inscriptions: l.l., *FRANK H. JOHNSTON '19* (effaced); l.r., *Franz Johnston*; verso: c., *ALGOMA / painted by / Franz Johnston / ARCA OSA*; u.r., *Studio / Bldg.*
Provenance: Estate of the artist.
Exhibitions: Group 1920, no. 59, $150; Saint John 1920, no. 50, $150; U.S. Tour 1920–21, no. 16, $150; CNE 1923, no. 183, $200.

Frank Johnston was the only artist of the Group to sketch regularly in tempera, a medium he used in his commercial work. During his trip to Algoma in the fall of 1918 Johnston had painted works as large as 76 by 76 centimetres,[1] so it is probable that this was painted in Algoma in the fall of 1919 when he went there with Harris, Jackson, and MacDonald, and not worked up in his Toronto studio.

1. Johnston, Toronto, to Brown, Ottawa, 22 Oct. 1918, NGC Arch., 5.42-Johnston.

22

F.H. Johnston (1888–1949)
Autumn, Algoma 1919 (see fig. 31)
Tempera on wove paper laid down on card, 61 × 50.8 cm
Private collection
Inscriptions: l.l., *FRANK H. JOHNSTON '19*; verso: c., *AUTUMN ALGOMA / by / FRANK H. JOHNSTON / 96 KEEWATIN AVE.*, l.c., Wembley 1925 label, partially covered by OSA 1927 label, *Algoma in October $200. / 2474 Yonge St. / 19 Glencairn Ave / RETURN TO 2474 YONGE ST.*
Provenance: Estate of the artist.
Exhibitions: Group 1920, no. 61, $150; Saint John 1920, no. 49, $150; U.S. Tour 1920–21, no. 15, $150; [Wembley 1925, no cat. no. *Algoma, Arabesque* ?]; Hart House Johnston 1927, no. 1 *Algoma in October*, $200.

Fred Jacob (1920e) was especially pleased with Frank Johnston's work in the first Group show. "The finest master of decorative art in this group is Frank H. Johnston. No one has to wait for an explanation of a picture by Mr. Johnston, and that must be true of any work that will ultimately make a wide appeal. Mr. Johnston uses lovely colours, but most of all, his work is decorative because of the imaginative quality that it possesses. He has a gift for finding subjects that show nature in a fanciful, or, at times, fantastic mood, and he catches the feeling exactly."

23

F.H. Johnston (1888–1949)
Fire-swept, Algoma 1920 (see fig. 32)
Oil on canvas, 127.5 × 167.5 cm
National Gallery of Canada, Ottawa (1694)
Inscriptions: l.r., *Frank H. Johnston '1920*
Provenance: Purchased from Group 1920.
Exhibitions: OSA 1920, no. 65 *Fire Swept* $750, repr.; Group 1920, no. 64 *Fire Swept, Algoma*, $750; Vancouver Exhibition, New Westminster Provincial Exhibition, Victoria Agricultural Fair, B.C. Art League, Vancouver, August–Sept. 1923; Edmonton Art Association, Sept. 1924 –April 1925; Calgary, Women's Canadian Club April–July 1925; Boston 1926, no. 52 *Fire Swept Wood*; New Westminster Provincial Exhibition, 1927; Camrose, Alberta, Sept. 1927; Edmonton Museum of Art, Sept. 1927–Oct. 1928; Kingston Art and Music Club, Nov.–Dec. 1928; Regina Exhibition, July–Aug. 1929; London Western Fair, Sept. 1929; Walkerville, Willistead Public Library, Oct. 1929–Nov. 1930.
Bibliography: Hammond 1920a; Fairbairn 1920a; Jacob 1920c and 1920e; Bridle 1920a and 1920b; Edmonton Journal 30 Oct. 1924.

Fire-swept, Algoma was the first exhibited, panoramic Algoma canvas painted by a member of the Group. In a composition that would become familiar, burned rampikes surmount the crest of the foreground hill, set against a broad vista. The complex linear tracery of the foreground acts as a foil to the matte, flat patterning of the hills beyond, which are rendered with the treatment characteristic of tempera. Bridle (1920a) was delighted with the painting: "Two of [Frank Johnston's] biggest, *Fire-swept* and *Beaver Haunts*, are tremendous hoardings upon which the great Fire-Ranger of the eternal forest advertises Solitude for the Multitude. *Fire-swept* is a gaunt and grim plateau of brulé like a Hunswept village in the foreground, a colossal trilogy of forested rock, mountain above hill to a ribbon of sky."

24

Arthur Lismer (1885–1969)
Halifax Harbour, Time of War 1918 (see fig. 36)
Oil on canvas, 102.5 × 130 cm
Dalhousie Art Gallery Permanent Collection, Halifax, gift of the artist, Montreal, 1954
Inscriptions: l.l., *A Lismer* (date illegible)
Exhibitions: RCA/OSA 1918, no. 102 repr.; CNE 1918, no. 153 repr.; RCA 1918, no. 113; Group 1920, no. 68, $600; Saint John 1920, no. 66, $600; U.S. Tour 1920–21, no. 20, $600.
Bibliography: Hammond 1918 and 1920b; Charlesworth 1918b; Eric Brown 1918b; Burgoyne 1918; Morgan-Powell 1918; Mortimer-Lamb 1919a; Jacob 1920e; H.E. Wrenshall 1920b; Bridle 1920a and 1920b.

Painted in the expectation that it would be purchased by the Canadian War Memorials, this canvas remained with the artist until 1954. A year and a half after the end of the war, the public was losing its appetite for such subjects, yet when first exhibited at the new Art Museum of Toronto in 1918 the painting was universally admired for its "vivid effects of sunlight and positive colour, pitched in a dazzlingly high sky . . . work which lends such brilliancy to the walls may be welcomed for the cheer it brings" (Eric Brown 1918b). Fred Jacob (1920e) noted that Arthur Lismer had reworked the sky when exhibited in 1920, and Bridle (1920a) still found it one of his best: "It is a fine uplift of warships and little craft on a dazzling blue harbour with a vivid Venetian sky – and a fleet of zippy white cumulus clouds."

25

Arthur Lismer (1885–1969)
Springtime on the Farm 1917 (see fig. 49)
Oil on canvas, 66.1 × 81.3 cm
Montreal Museum of Fine Arts (1956.1124), purchase A. Sidney Dawes Fund, 1956
Inscriptions: l.l., *A. Lismer / 17*
Provenance: The artist, Montreal; Laing Galleries, Toronto.
Exhibitions: [OSA 1917, no. 85, $350 ?]; [CCE 1917, no. 106 *Spring on the Farm*, $350 ?]; Group 1920, no. 70 *Springtime on the Farm*, $300.
Bibliography: [Fairbairn 1917]; Bridle 1920a.

From Halifax in the spring of 1917, Arthur Lismer sent three canvases to the OSA exhibition, one Nova Scotian canvas and two paintings worked up from earlier studies, *Springtime on the Farm* and *Georgian Bay, Spring*, the latter acquired by Dr. MacCallum. It is not certain whether the OSA canvas is an earlier version of this work, as one review refers to a mother and child in the composition (Fairbairn 1917; see Kelly 1982, 39); yet both canvases depict the garden of the Lismers' home on John Street in Thornhill, a subject he first painted in winter in 1916.[1]

1. See *Winter Sunshine*, reproduced in the OSA 1916 catalogue. A related sketch titled *My Garden, John Street, Thornhill* is in the Art Gallery of Ontario (50/51). A related painting by MacDonald is reproduced in Robertson 1965, p. 25.

26

J.E.H. MacDonald (1873–1932)
The Tangled Garden 1916 (see fig. 21)
Oil on board, 121.4 × 152.4 cm
National Gallery of Canada, Ottawa (4291), gift of W.M. Southam, F.N. Southam, and H.S. Southam, 1937, in memory of their brother Richard Southam
Inscriptions: l.l., *J.E.H. MacDonald '16*
Provenance: Estate of the artist.
Exhibitions: OSA 1916, no. 88, $500; CNE 1916, no. 384, $500; RCA 1916, no. 147; Group 1920, no. 82 n.f.s.; OSA Retrospective 1922, no. 115; AGT Canadian 1926, no. 35, $500; Rochester 1927, no. 40; AGT Canadian 1927, no cat. no., $600; AGT MacDonald 1933, no. 116; NGC MacDonald 1933, no. 23; Group 1936, no. 172.
Bibliography: Fairbairn 1916; Ball 1916; Hammond 1916, 1922a, 1928a, and 1932c; Charlesworth 1916, 1917a, and 1926b; Kerr 1916b and 1916c; J.E.H. MacDonald 1916b; Jacob 1917b, 1920d, 1920e, and 1922a; H.E. Wrenshall 1920b; Bridle 1920a, 1931b, and 1933a; F.B. Housser 1926a, pp. 106–14, 159, repr. opposite p. 96;

Toronto Daily Star 11 Dec. 1926; Bothwell 1927; Telegram 28 Nov. 1932; Robson 1932, p. 138; Middleton 1932; Salinger 1932a, p. 143; Phillips 1932b; A.Y. Jackson 1933a, p. 138; McCarthy 1933a; Lismer 1933c; Harrold 1933b; Longstreth 1934.

The centre of the controversy surrounding the 1916 OSA show, J.E.H. MacDonald's *Tangled Garden* was destined to attract attention in the first Group exhibition. But the critics had a new focus of attention. "In the west gallery," wrote Jacob (1920e), "hangs his painting *The Tangled Garden*, round which a veritable hubbub of controversy raged when it was first exhibited some four years ago. How the stand-patters raved at Mr. MacDonald for daring to be a virtuoso in colour. And now *The Tangled Garden* does not seem radical at all. It is gorgeously decorative, and looks almost quiet when compared to the explosive landscape *The Wild River*." Bridle (1920a) argued that "the artist here was the gardener not the painter."

27

J.E.H. MacDonald (1873–1932)
The Wild River 1919 (see fig. 24)
Oil on canvas, 134.6 × 162.6 cm
Faculty Club, University of Toronto Collection
Inscriptions: l.r., *J.E.H. MacDonald '19*; stretcher: u.r., torn label, . . . INNEAPOLIS / INSTITUTE OF ARTS / L 21.1580; graphite u.r., *MacDonald*
Provenance: Purchased from the artist, 1928.
Exhibitions: OSA 1919, no. 138, $600; Algoma 1919, no. 38 *The Wild River (Montreal Falls)*; Group 1920, no. 85, n.f.s.; CNE 1920, no. 93, $650; U.S. Tour 1920–21, no. 23, n.f.s.; Hart House MacDonald 1925, no cat. no.; AGT 1926, no. 87, $650; AFA 1926–27, no. 7; Group 1928, hors cat., loaned by the Faculty Union, University of Toronto; AGT MacDonald 1933, no. 113; NGC MacDonald 1933, no. 13.
Bibliography: Toronto Daily News 7 March 1919; Telegram 8 March 1919; Fairbairn 1919a; Jacob 1919a, 1920e, and 1928a; Donovan 1919a; Fairley 1919a, p.281; Bridle 1920a and 1920b; W.H.D. 1920; Boston Post 6 Dec. 1920; Hendricks 1921c; M.T. 1921; Bulletin of the Minneapolis Institute of Arts Dec. 1921; Academy Notes Jan.–June 1922; Bridle 1925; B. Housser 1925h; F.B. Housser 1926a, pp. 142, 152, 159, 160; Edmonton Journal 19 July 1927; Hammond 1928a; Telegram 18 Feb. 1928; Cianci 1928a, 13; A.Y. Jackson 1933a, p. 138.

The focus of so much attention in the 1919 OSA, *The Wild River* could still challenge the critics. "In it," wrote Jacob (1920e), "Mr. MacDonald has done a piece so far removed from realism, from 'photography', from actual nature – rivers do not flow up hill, even climb over a hump – that one wonders if Canadian art will ever grow so much more radical that *The Wild River* will appear as conventional as *The Tangled Garden*." And Bridle (1920a) enthused: "*The Wild River* God made, never supposing that 'Jimmie' would discover it up in Algoma and do it all over again. Here we have chameleon rocks and scarlet foliage, crooked spruces that suck under the stones and a honey-like jazz of wild water halfway between ripple and foam."

When it was exhibited in the 1928 Group show, the *Telegram* (18 Feb. 1928) declared: "The painting was not worth hanging when it was painted in 1919 and is no more worth hanging now."

28

J.E.H. MacDonald (1873–1932)
The Little Fall 1919 (see fig. 29)
Oil on canvas, 71.1 × 91.4 cm
London Regional Art and Historical Museums, F.B. Housser Memorial Collection, 1983
Inscriptions: l.r., *J.E.H. MacDonald '19*
Provenance: F.B. Housser, Toronto, by 1932; Yvonne McKague Housser, Toronto, 1936; on loan to the London Public Library and Art Museum, from 1945.
Exhibitions: OSA 1919, no. 139, $250 repr.; Algoma 1919, no. 37; CNE 1919, no. 112, $250; Group 1920, no. 86, $250; Saint John 1920, no. 52, $250; U.S. Tour 1920–21, no. 22, $250; Western Tour 1922–23, no. 63; Rochester 1927, no. 38; AGT Canadian 1927, no cat. no., $300; London 1928, no. 98, £100; AAM Canadian 1928, no. 38, $300; AGT MacDonald 1933, no. 114, loaned by F.B. Housser; NGC MacDonald 1933, no. 14; Atlantic City 1933, no. 32; Group 1936, no. 159.
Bibliography: Fairbairn 1919a; Fairley 1919a, p. 282; Bridle 1920a; Hendricks 1921c; Bulletin of the Minneapolis Institute of Arts Dec. 1921; Academy Notes Jan.–June 1922, repr. 41; Mortimer-Lamb 1922a; A.Y. Jackson 1933a, p. 138.

The paintings exhibited by J.E.H. MacDonald in the first Group show were almost a retrospective of his painting career and included this work, his second canvas from the 1919 Algoma show. A reworking of two 1913 canvases, *Song of the Rapid* and *A Rapid in the North* (Robertson 1965, repr. 20), both close-cropped, intimate studies of rushing water framed by rocks, *The Little Fall* was universally admired. For Bridle (1920a) it showed "how a splotch of moose-maple reds stuck in the ribs of the rocks cavorts like blobs of fire in the blue rapids below." The sketch for this canvas, in the Art Gallery of Ontario, was painted in Algoma in September 1918 (Robertson 1965, repr. 51).

29

F.H. Varley (1881–1969)
Portrait of Vincent Massey 1920 (see fig. 102)
Oil on canvas, 120.6 × 141 cm
Hart House Permanent Collection, University of Toronto
Inscriptions: l.l., *F.H. Varley / 1920*
Provenance: Presented to Vincent Massey by his university friends upon the completion of Hart House, 1920.
Exhibitions: Group 1920, no. 102; CNE 1920, no. 135; Wembley 1924, no. 251, repr.; Group 1936, no. 182.
Bibliography: Hammond 1920b; Jacob 1920e; H.E. Wrenshall 1920b; Bridle 1920a and 1920b; Fairley 1922b, p. 596; NGC 1924a, repr.; Toronto Star Weekly 26 Jan. 1924; R. Lee 1924, p. 339; Toronto Daily Star 20 Aug. 1924; Glasgow Bulletin 29 Dec. 1924; MacTavish 1925a, repr. opposite p. 134; F.B. Housser 1926a, p. 215; Brooker 1926b, repr. 7; Saskatoon Daily Star 4 April 1928; Mortimer-Lamb 1930; Seattle Times 6 July 1930; Robson 1932, repr. 195; Davies 1932, repr. 21; Sheffield Telegraph 12 June 1933.

F.H. Varley's portrait of Vincent Massey was commissioned to honour Massey for the key role he had played in convincing the Massey Foundation to construct Hart House for the University of Toronto.[1] For Barker Fairley (1922b, 596), the Massey portrait "shows conclusively the artist's power to immerse himself in the mood of his sitter . . . Mr. Varley has cleverly endeavoured to carry the mood over the whole picture so that every square inch of canvas

speaks and breathes the sitter, and places itself in pictorial relation to the face and figure. This endeavour, if perfectly carried out, would combine the [Augustus] John idea with the Whistler idea and present that very rare thing – an organic portrait. Judged by this severe test, which there is nothing in the Canadian tradition to supply, the portrait of Mr. Massey stands as a real achievement. It is not perfect. One feels that the paint is put on with the strain of creative effort rather than with the ease of confident mastery, though even on that score the picture would lose in psychological intensity if the strain of execution were removed. One feels, too, that the bright colour of the background in the region of the head is a slightly precarious adventure into colour interpretation and not finally convincing."

1. For Varley's first university commission see Kirkpatrick 1987. He had painted Dean Cappon for Queen's University, Kingston, in 1919. See C. Varley 1981, p. 58.

30
F.H. Varley (1881–1969)
Character Sketch – Prof. Barker Fairley 1920 (see fig. 38)
Oil on canvas, 61.1 × 51.2 cm
National Gallery of Canada, Ottawa (5031), gift of Barker Fairley, Toronto, 1950
Inscriptions: l.l., *F.H. VARLEY*
Provenance: The artist, Toronto; Barker Fairley, Toronto.
Exhibitions: Group 1920, no. 105; Saint John 1920, no. 50.

F.H. Varley exhibited two smaller portraits, one of Barker Fairley and one of J.E.H. MacDonald, the latter later destroyed (Kirkpatrick 1986, 132–33). From the little one can see of the MacDonald portrait in the installation photograph of the first exhibition, they seem to be quite similar, although only that of Fairley was identified as "A Character Sketch." Fairley was a close associate of the Group during these early years, and Varley's principal champion.

31
F.H. Varley (1881–1969)
The Sunken Road – August 1918 1919 (see fig. 16)
Oil on canvas, 132.4 × 162.8 cm
Canadian War Museum, Ottawa (8912)
Inscriptions: l.r., *F.H. VARLEY*
Provenance: Canadian War Memorials Collection; transferred to the National Gallery of Canada, 1921; transferred to the Canadian War Museum, 1971.
Exhibitions: Group 1920, no. 106; War Memorials 1920, no. 235; War Memorials 1923, no. 111; War Memorials 1926, no. 238.
Bibliography: Jacob 1920e; Hammond 1920b; Bridle 1920a; Fairley 1922b, p. 594; A.Y. Jackson 1926e.

F.H. Varley would retain his military commission until March 1920, receiving his officer's salary with his materials and incidental expenses being paid for by the Canadian War Memorials Fund.[1] *The Sunken Road*, worked up from an oil sketch and photograph of the bloated corpses of German soldiers,[2] is much lighter in colour than his other war paintings. As with Jackson, the distanced memory added a new note to his work. As in *Terre Sauvage* a rainbow symbolizing rebirth occupies the upper left corner. For

Fairley (1922b, 594) this painting spoke of "the stench of corruption . . . one is amazed to find how organic it is." Bridle (1920a) wrote: "His cadaver picture, *The Sunken Road*, is an epic of necrosis; men tangled and twisted like shattered trees, trunks and heads awry – a putrefying heap of mortality with vapours flitting over the dugouts and the segment of an insolent, chuckling rainbow at one corner. Any bard who would rise and sing 'They Shall Not Die' or recite 'In Flanders Fields' in front of that picture would be a master of satire. There is no phantom lure in any of Varley's work. What is so, let it be. There is an emotional satisfaction in expressing the sometimes illogical and ugly truth."

1. E. Brown, Ottawa, to Walker, Toronto, 3 Jan. 1920, NGC Arch., 5.41-Canadian War Memorials General; and Varley to Brown, 28 April 1920, 5.42-Varley.
2. The oil sketch is reproduced in C. Varley 1981, p. 48, and the photograph in Tippett 1984, pl. 14.

32
Randolph S. Hewton (1888–1960)
On the Bank of the Seine c. 1920 (see fig. 39)
Oil on canvas, 59.7 × 72.5 cm
Glenbow Museum, Calgary (81.41.1)
Inscriptions: l.l., *Hewton*
Provenance: Zwickers Gallery, Halifax, 1981.
Exhibitions: [Group 1920, no. 117 The Pont Neuf, Paris, $200 ?]; [CNE 1920, no. 57, $200 ?].
Bibliography: Hammond 1920b.

A.Y. Jackson had met Hewton in Paris in 1912. Their joint exhibition at the Art Association of Montreal in February 1913, the press attacks at the Spring Exhibition that year, and later their common war experiences built a bond between the two artists.
Though not a war artist, Hewton had been able to sketch in the battle areas before returning to Montreal, and he had a solo exhibition of these French war sketches at the Arts Club in Montreal in March 1920.[1] Whether the three paintings he sent to the first Group of Seven exhibition, *The Barnyard*, *The White Cottage*, and *Pont Neuf, Paris*, were recent works or painted before the war is not clear. The Toronto reviewers described them as "misty landscapes" (Jacob 1920e) and "an early evening scene on the Thames [sic]" (Hammond 1920b).
By including the Montrealers, the Group confirmed their commitment to forging alliances with isolated artists working in a modern vein, as well as to fostering a national landscape art.

1. *Water Colours and Pastels by R.F.* [sic] *Hewton* (Montreal: Arts Club, 28 Feb.–26 March 1920, exhibition catalogue).

33
Albert H. Robinson (1881–1956)
Noontime, Longue Pointe Village 1919 (see fig. 44)
Oil on canvas, 76.7 × 101.8 cm
Musée du Québec, Quebec City (34.567)
Inscriptions: l.r., *ALBERT ROBINSON* 1919
Provenance: Purchased by the Government of Quebec from the 1920 AAM Spring Exhibition.
Exhibitions: AAM 1920, no. 229, $500.
Bibliography: Montreal Gazette [10] April 1920.

Albert Robinson sent two canvases to the first Group of Seven exhibition, *Returning to*

Boucherville, previously exhibited at the 1919 Spring Exhibition of the Art Association of Montreal, and *Drawing Ice*, neither of which it has been possible to identify or locate. *Noontime, Longue Pointe Village* had been exhibited a month before at the 1920 Spring Exhibition and purchased by the Quebec Government (Montreal Gazette [10] April 1920). At the instigation of the provincial secretary, Athanase David, a purchase program for a museum to be constructed in Quebec City had been initiated that year. However, the program was stopped as quickly as it was begun, for the planned jury for the 1921 Spring Exhibition did not meet and no purchases were made.[1] The cancellation did not mean the end of acquisitions, but procedures for selection during the years up to the eventual opening of the museum in 1933 are not clear.
 Broadly painted, with a wonderful, linear rhythm of shadows, trees, and poles, *Noontime, Longue Pointe Village* is a strong and expressive painting and marked Robinson as one of the boldest innovators working in Montreal at that time.

1. Dyonnet, Montreal, to Gagen, Toronto, 24 Dec. 1920 and 12 Jan. 1921, Arch. of Ont., MU2250 I–1.

34
Lawren S. Harris (1885–1970)
A Side Street 1920 (see fig. 72)
Oil on canvas, 91.4 × 111.8 cm
Art Gallery of Windsor, gift of the Detroit Institute of Arts, 1956
Inscriptions: l.r., *LAWREN / HARRIS*
Provenance: Purchased by the Detroit Institute of Arts from U.S. Tour 1920–21.
Exhibitions: OSA 1920, no. 60 Morning Sun, Winter, $300, repr.; U.S. Tour 1920–21, no. 2 A Side Street, $500.
Bibliography: Hammond 1920a; W.H.D. 1920; Toledo Blade 5 March 1921; Morehouse 1921a and 1921c; Hendricks 1921c; Bulletin of the Minneapolis Institute of Arts Dec. 1921; *Canadian Magazine*, LX:1 (Nov. 1922), repr. 19; F.B. Housser 1926a, p. 218.

The first American exhibition launched the Group onto the international scene. The purchase by the Detroit Institute of Arts of Lawren Harris's *A Side Street* must have been gratifying for the Toronto artists. One Boston reviewer (W.H.D. 1920) described this painting as being "as objective and forlorn as a description of some Five Towns Dwellings in a story by Arnold Bennett," while an Indianapolis writer (Morehouse 1921a) enthused: "*A Side Street* is a big winter street scene. The long, low house with many green shutters and red doors, the snow reflecting a warm, yellow glow, the trees casting blue shadows in lines that curve and bend gently across the snowy surface of the untravelled street, are handled in a big, masterful way by the artist."
 The oil sketch for this painting, *Toronto Houses* (now NGC 4579), was purchased by the Kitchener Art Committee before 1926.

35
Lawren S. Harris (1885–1970)
Algoma Hill 1920 (see fig. 1)
Oil on canvas, 117 × 137.1 cm
Fine Arts Committee, The Toronto Hospital, Western Division, gift of Mrs. E.R. Wood, Toronto, 1927
Inscriptions: l.r., *LAWREN / HARRIS*
Provenance: Gift of Mrs. E.R. Wood, Toronto, 1927, to Toronto Western Hospital.

Exhibitions: U.S. Tour 1920–21, no. 3, $800.
Bibliography: Hendricks 1921c; Morehouse 1921c; M.T. 1921; Academy Notes Jan.–June 1922.

Lawren Harris's paintings were distinguished by most American reviewers for special notice. "Mr. Harris is described as young, phenomenally optimistic and a prodigious worker," lauded the Indianapolis writer (Hendricks 1921b), and a Buffalo writer (M.T. 1921) saw *Algoma Hill* as the keynote of the exhibition for its "brilliant coloring, the insistence upon an adequate, underlying design, the attempt for form, the vigorous, free, yet consistent treatment, and the subject taken from the Canadian wilds."

36

A.Y. Jackson (1882–1974)
Entrance to Halifax Harbour 1919 (see fig. 103)
Oil on canvas, 65 × 80.5 cm
Tate Gallery, London (3967)
Inscriptions: l.r., *A.Y.JACKSON / 19*
Provenance: Purchased from the artist, Toronto, from Wembley 1924.
Exhibitions: RCA 1919, no. 81 *Ships Entering Halifax Harbour*; U.S. Tour 1920–21, no. 14 *Entrance to Halifax Harbour*, $300; RCA 1922, no. 108; Hamilton RCA 1923, no. 42; Wembley 1924, no. 104 (toured to Leicester only).
Bibliography: Fairley 1919c and 1920c, p. 78; Bulletin of the Minneapolis Institute of Arts Dec. 1921; Burgoyne 1922b and 1931a; Toronto Star Weekly 26 Jan. 1924; Hind 1924b, p. 250; Art News 31 May 1924, p. 10, repr. 9; R. Lee 1924, p. 339; Toronto Daily Star 20 Aug. 1924 and 25 Oct. 1924; B. Housser 1924d; Charlesworth 1924e; Canadian Forum Dec. 1924 and Jan. 1925; Topham 1924; Eric Brown 1925, p. 10; F.B. Housser 1926a, pp. 163, 204, 209, 211, 217; Bothwell 1927; The Dean 1927; Saskatoon Daily Star 4 April 1928; Hammond 1930c; Dick 1932, p. 280; Robson 1932, p. 198.

From Toronto A.Y. Jackson wrote to Eric Brown: "Just a line to let you know that I have finished the *Olympic* and will send it in to the R.C.A. I have treated it as a definite record made from many notes on the spot. Whether it would have been better if I had given my imagination free rein remains to be seen. The artists around the Studio Building all like it. I am also sending a smaller canvas of ships entering Halifax Harbour, painted from Herring Cove. You will have to decide if it is of any war interest. I painted it more as a scheme of colour and design and send it in as a work for sale."[1] Barker Fairley (1919c, 126–27) compared the two paintings in his review of the RCA show: "Jackson's '*Olympic*' in Halifax Harbour [see fig. 20] is bound to stand as a fascinating excursion in an intensely individual career. The design is for once emphatic, perhaps a little arbitrary even, and there is set against it a mosaic of more than usually explicit detail. If the intention was to convey the size of the *Olympic* it may be doubted whether the picture is completely successful; the ship certainly dominates the harbour and the houses, but this cuts both ways and it may be that the dwarfing of the houses is more pronounced than the vastness of the vessel. And perhaps as a result of the artist's having departed from his wonted ways it is difficult to pass from the stage of curiosity to the fuller contemplation that one is entitled to expect. His smaller *Ships Entering Halifax Harbour*, on the other hand,

is the real Jackson. What that means it is not easy to say but one may be assured that in a generation from now no explanation will be called for. It might be called a subtly deflected naturalism, which seems at one moment ruthless and at another unassuming." This painting received almost no recognition when exhibited in the United States but was specifically noted by C. Lewis Hind (1924b, 250) at Wembley in 1924. "Nature compelled this breezy, rough, outstretched scene. The theme dictated the technique; the entrance of Halifax harbour lives on this canvas."

The purchase of this painting for the Tate Gallery marked a turning point in the Group's history, more important than Detroit's purchase of Harris's *A Side Street*. To be represented in what was then known as the National Gallery of British Art assured the Group's recognition across Canada. "It is the recognition, in the art centre of Britain, of authentic art in Canada. It is the seal of genuine approval upon the many laudatory comments in the English press since the opening of the exhibition at Wembley. It is a justification of the so-called 'modern' work, that aims for simplification and interpretation, rather than for representation. It means encouragement to all young Canadians who are endeavouring to express something which is truly innate and to find themselves honestly native to their land, depicting their visions of that land, and of the life that moves upon it. It means encouragement to all those who are endeavouring to catch and express something of the universal rhythm in which this country is only a part" (B. Housser 1924d).

1. Jackson, Toronto, to Brown, Ottawa, 30 Oct. [1919], NGC Arch., 5.42-Jackson.

37

A.Y. Jackson (1882–1974)
Maple Woods, Algoma 1920 (see fig. 68)
Oil on canvas, 63.5 × 81.3 cm
Art Gallery of Ontario, Toronto, purchased 1981 with funds raised in 1977 by the Volunteer Committee (matched by Wintario) to celebrate the opening of the Canadian Wing
Inscriptions: l.r., *A Y JACKSON / '20*
Provenance: André Biéler, Kingston, 1946; W.A. Manford, Toronto, by 1970.
Exhibitions: Western Tour 1921, *Tangled Woods*, or Group 1921, no. 15 *Maple Woods*, $400.
Bibliography: Edmonton Journal 2 April 1921, or Jacob 1921b.

Maple Woods, Algoma is the most dense and aggressive of all A.Y. Jackson's canvases. If this work was exhibited as *Maple Woods, Algoma* in the second Group show it failed to attract any attention beyond Fred Jacob's (1921b) observation that it would merely startle the average visitor.[1] It is more probably *Tangled Woods*, to which one Edmonton writer reacted: "I don't want to discourage these artists. Far from it. Only to encourage them to use their talents to better purpose … Those who have it should … not use the talent the Lord gave them to distort His other handiwork, making it hideous in the eyes of the people" (Edmonton Journal 2 April 1921).

1. Jackson (1958, p. 25) refers to a 1913 canvas *Maple in the Pine Woods* that "roused to anger the critics of the Group of Seven." I have located no work exhibited

under that title from 1920 to 1933 and the two titles here are not appropriate to that painting, which is now in a private collection.

38

Franklin Carmichael (1890–1945)
The Valley 1921 (see fig. 45)
Oil on canvas, 109 × 91.4 cm
The Edmonton Art Gallery Collection, presented by the Edmonton Teachers' Association, 1926
Inscriptions: l.l., *FRANK / CARMICHAEL / 1921*
Provenance: Purchased from the artist, 1926.
Exhibitions: Group 1921, no. 3, $350; CNE 1921, no. 133, $450; U.S. Tour 1923–24, no. 3, $350; Edmonton 1925, no. 101, $350.
Bibliography: Telegram 17 Feb. 1924; Read 1924; Brooklyn Museum Quarterly July 1924, p. 105.

Among Frank Carmichael's paintings included in the Group's 1923 American exhibition were *Leaf Pattern* (cat. 54) and *The Valley*. The Brooklyn critic Helen Appleton Read (1924) was especially struck by his work. "Frank Carmichael, one of the strongest painters in the group, specializes in landscapes and makes lovely decorative compositions out of the most difficult of subjects, namely, wood interiors. One is a tangle of silver birches, another a dappled pattern of red and gold autumn foliage against green trees which have not yet turned. Another notable canvas by the same artist which will probably be one of the most popular in the exhibition he names *A Valley*, a glacier-green stream winding between green hills and simplified grey-green tree shapes, a wholly delightful painting, fresh, unusual, not too decorative, with nothing of stale picture-making about it, despite the evident competency of the artist."

This plunging, sculptural view of a river valley outside Toronto was exhibited in Edmonton in 1925, acquired by the Edmonton Teachers' Association and donated the following year. This was the first canvas by a member of the Group of Seven acquired for a public institution west of Fort William.

39

Franklin Carmichael (1890–1945)
The Hilltop 1921 (see fig. 55)
Oil on canvas, 76.9 × 92 cm
National Gallery of Canada, Ottawa (1811)
Inscriptions: l.l., *FRANK / CARMICHAEL / 1921*
Provenance: Purchased from Group 1921.
Exhibitions: Group 1921, no. 4, $250; Western Tour 1922–23, Victoria Fall Fair and B.C. Art League; Saskatoon, University of Saskatchewan, March–Aug. 1924; New Westminster 1924; Washington, Canadian Legation, Dec. 1927–May 1930; Regina Exhibition, July 1930; Winnipeg, T. Eaton Co., Aug. 1930; London, Western Fair, Sept. 1930; Guelph, Ontario Agricultural College, May 1931 [–Sept. 1933 ?]; London, Western Fair, Sept. 1933; Saint John Vocational School, Oct. 1933; Cornwall Art Association, Jan. 1934; Group 1936, no. 1.

Frank Carmichael exhibited four canvases in the second Group show including *A Silvery Tangle* (now collection AGO) and *The Valley* (cat. 38), yet it was the small, delicately drawn and coloured *The Hilltop* that the National Gallery's trustees purchased. This was the first Carmichael to be acquired, ensuring that each member of the Group was represented by at least one painting in the National Gallery by 1921.

Provenance: Purchased from the artist, Toronto, from NGC 1928.
Exhibitions: Group 1921, no. 58, $300; CNE 1921, no. 206, $300, repr.; Winnipeg 1921, no. 76, $300; Rochester 1927, no. 39; AGT Canadian 1927, no cat. no., $300; NGC 1928, no. 100, $350; Buenos Aires 1931, no cat. no.; Edmonton 1932, no. 25; NGC MacDonald 1933, no. 5; Winnipeg 1933, no. 51; Regina Grain Conference July 1933; Banff, Pacific Relations Conference, Aug. 1933; Edmonton 1933, hors cat.; Smiths Falls Art Association, Jan.–May 1934; Cornwall Art Association, Feb.–June 1935; Lake Couchiching Y.M.C.A., July 1935; London, Western Fair, Sept. 1935; London, Western University, Sept. 1935–March 1936; Windsor Art Association, March–April 1936.
Bibliography: Bridle 1921a; Harrold 1928.

Batchawana Rapid has many similarities to *The Wild River*, although it is considerably smaller. The flowing water, painted with thick impasto, rushes diagonally across the composition, which is bordered by pink and green rocks. The rhythmically brushed autumn foliage in the upper part of the canvas is painted in yellows, oranges, reds, and greens. Over the thinly painted foreground rocks, autumn leaves float on still pools of blue water. A related sketch was formerly in the collection of Barker Fairley (Robertson 1965, repr. 51).

50
J.E.H. MacDonald (1873–1932)
The Lake – October Evening 1921 (see fig. 92)
Oil on canvas, 53 × 66 cm
Private collection
Inscriptions: l.r., *J.E.H. MacDonald, A.R.C.A.*
Provenance: Purchased by J.S. McLean, Toronto, from AGT MacDonald, 1933; by descent.
Exhibitions: Group 1921, no. 59 *The Lake – Evening*, $100; Group 1926, no. 93 *The Lake, October Evening*, $175; Philadelphia 1926, no. 1568; NGC 1927, no. 143; AGT MacDonald 1933, no. 138 *Algoma Lake, Evening*; NGC MacDonald 1933, no. 21, loaned by J.S. McLean, Toronto.

Rich and evocative colour characterizes most of J.E.H. MacDonald's Algoma canvases. Here a screen of brilliant red, orange, and olive green foliage alternates with black, silhouetted forms. A rolling rhythm of autumn leaves crosses the black hills in the background, which are surmounted by a uniformly coloured sky accented by a full moon. This small and powerfully evocative canvas seems to have escaped the notice of the reviewers of both the 1921 and 1926 Group shows, possibly lost amid the larger paintings.
 The sketch for this canvas in the Art Gallery of Ontario (L69–31) is dated 1922, though MacDonald did not return to Algoma after 1920.

51
Lawren S. Harris (1885–1970)
January Thaw, Edge of Town 1921 (see fig. 71)
Oil on canvas, 107 × 127.2 cm
National Gallery of Canada, Ottawa (5005), gift of the artist, Vancouver, 1960
Inscriptions: l.l., *LAWREN / HARRIS / 21*; stretcher: u.c., *JANUARY / THAW / LAWREN / HARRIS*
Exhibitions: Group 1921, no. 70 *The Fringe of the City*, $700; CNE 1921, no. 175, $750; Winnipeg 1921, no. 83, $750; AFA 1926–27, no. 16; Dartmouth Harris 1931, *January Thaw*, $1000.

Bibliography: Bridle 1921a; Hammond 1921b; Jacob 1921b; B.B. 1921; Winnipeg Tribune 15 Oct. 1921.

The Fringe of the City caught the attention of all the reviewers of the 1921 Group show. "There are many people who want art always to discard realism in favour of the decorative, as distinct from the merely pretty," wrote Fred Jacob. "The only way in which the Group of Seven may satisfy them is that they are never merely pretty. But, then, they are frequently not decorative, and at times appear to glory in ugliness. Neither have they broken completely with realism. One of the most striking features in the gallery is *The Fringe of the City*, by Lawren Harris. Approach any of the shack-towns of Toronto from behind on a warm March day, and you will get something of the impression that Mr. Harris has conveyed in this painting. The dirty snow, the water-soaked earth, that can absorb no more moisture, and the mean houses, leering in their drabness at the man who said 'Be it ever so humble, there is no place like home' – all of these are faithfully indicated in the picture. One might almost say that Mr. Harris has reached the high-water mark in realism in the painting of a mud puddle. The picture is bold, and it is true, but it fills you with horror at the thought of the way in which some humans live" (Jacob 1921b).
 For Augustus Bridle (1921a), "What [Harris] calls a shack is itself a broad set of crude colour splashes capable of expressing a certain emotion peculiar to poverty." And M.O. Hammond (1921b) wrote, "In one [picture] depicting the loosening give of winter, he has caught the barren ugliness that man has created with bricks and lumber by a waterside and holds it up to scorn."
 A satirical article in the *Toronto Sunday Star* (B.B. 1921) also chose this painting for comment: "These new pictures which he had painted made you think that the houses north of the Danforth would disappear in the spring mud before the pavement reached them. They missed optimism altogether. Jenks and I almost decided to sell our Mimico lots and stay bachelors. Then Jenks got hot. 'Why doesn't he go out and paint one of those places where you can see a wooden shack being bricked in, or where a big wooden shell is going up around a little clapboard one-roomed house? Paint it on Saturday afternoon when Dad is shingling and the kids are carrying nails. The fringe of the city may be dirty and muddy but it's gay. What about Earlscourt in 1912 and the Kingston road today?'"

52
Lawren S. Harris (1885–1970)
Island – MacCallum Lake 1921 (see fig. 54)
Oil on burlap, 76 × 96.7 cm
Vancouver Art Gallery (65.23), Women's Auxiliary Provincial School Loan Scheme
Inscriptions: l., *LAWREN / HARRIS*, l.r. in graphite, *LAWREN*.
Provenance: The artist, Vancouver; Vancouver Art Gallery Women's Auxiliary Provincial School Loan Scheme, after 1948.
Exhibitions: Group 1921, no. 74, $500; AGT Canadian 1926, no. 8; Hart House 1927, no. 6, $500.
Bibliography: Hammond 1921b; Jacob 1921b; Fairley 1921a, pp. 276, 278.

Island – MacCallum Lake marks a radical departure in Lawren Harris's painting, one which was not

well received by Group associate Barker Fairley (1921a, pp. 276, 278): "[His] recent productions have pointed to a change, which has been very much in evidence at the two Group of Seven exhibitions. Hanging side by side with the work of artists who are making it clearer year by year that their work is organic, that it holds together and will yield its meaning to those who will study it without haste, his pictures as a whole have seemed disturbingly arbitrary, perspicuous enough in outward fact but in mental attitude provocative and even abnormal ... The extremist example of his present work is *Island – MacCallum Lake* ... It is a smallish canvas almost completely filled by a bizarre little island in Algoma, completely covered by a grotesque clump of trees which are quite possibly true in outline to the actual vegetation ... It expresses to the intelligence the weirdness of the North Country, but it does not evoke the feeling of nature nor even place one out-of-doors. The point of view seems to have been dictated by the intellect and directed towards the curious and the occult ... One misses the organic sense of all-round growth ... When compared with some of his contemporaries he is not a landscape artist at all; he does not penetrate nature."

53
Lawren S. Harris (1885–1970)
Beaver Swamp, Algoma 1920 (see fig. 8)
Oil on canvas, 120.7 × 141 cm
Art Gallery of Ontario, Toronto (53/12), gift of Ruth Massey Tovell in memory of Harold Murchison Tovell, 1953
Inscriptions: l.r., *LAWREN / HARRIS / '20*
Provenance: Dr. Harold and Ruth Tovell, Toronto, by 1936.
Exhibitions: Group 1921, no. 75 *Evening, Algoma*, $800; CNE 1921, no. 172, $800; Winnipeg 1921, no. 81, $800, repr.; RCA 1922, no. 91 *Beaver Swamp*; Hamilton RCA 1923, no. 36; Los Angeles 1925, no. 224; Rochester 1927, no. 5 *Beaver Swamp, Algoma*; Group 1936, no. 69 *Algoma Swamp*, loaned by Harold Tovell, M.D.
Bibliography: Bridle 1921a; Hammond 1921b; [Fairley 1921a, p. 278]; Winnipeg Tribune 15 Oct. 1921; Burgoyne 1922b; Morgan-Powell 1922d; Rochester Times-Union 25 Feb. 1927, repr.

Like the underpainting in Tom Thomson's *The Jack Pine*, blood red glows behind the black tendrils of the swamp-drowned trees. For Augustus Bridle (1921a), this work was a "bold attempt ... to dramatize the north ... a marvellous sunset sky, a hill of conventionalized tamaracks – or it may be spruces, jack pines or something else – all seen through a screen of real red-tinged trees. Here we have realism, symbolism and magnificence."
 Translating the cool tones of the oil sketch (private collection) and illuminating the rich and sombre colouring of *Algoma Hill* (cat. 35), Lawren Harris evokes the haunting beauty of Algoma. Light is the dominant subject of this painting.

54
Franklin Carmichael (1890–1945)
Leaf Pattern 1922 (see fig. 58)
Oil on canvas, 102.4 × 122.3 cm
Private collection
Inscriptions: l.l., *FRANK / CARMICHAEL / 1922*
Provenance: Estate of the artist. R.S. Waldie, Toronto, 1947.

Exhibitions: Group 1922, no. 1, $450; U.S. Tour 1923–24, no. 4, $350; Wembley 1925, no cat. no.; Buffalo 1928, no. 7; Group 1936, no. 10.
Bibliography: Hammond 1922d; Bridle 1922; Telegram 17 Feb. 1924; Read 1924; Yorkshire Observer 23 July 1926; Yorkshire Post 23 July 1926.

In *Leaf Pattern*, Frank Carmichael enhances the linearity of *Spring* (cat. 11) and the strength of texture of *The Valley* in a patterned screen of foliage in autumn colour. "In this exhibition," Augustus Bridle (1922) wrote, "[Carmichael] seems like the roving young poet who has very little time to get the big, serious things, and only time enough to snatch a few of the passing gleams as he goes. But it is a pity he cannot get the opportunity to emphasize his own rare sense of colour, which in its original purity is the finest of all the group and seems to be losing its identity. Perhaps when he gets further with the 'great adventure' into something constructive and not merely impressionistic, he may also come out as a real subject-painter of strong individuality."

55

F.H. Varley (1881–1969)
Gypsy Blood 1919 (see fig. 193)
Oil on canvas, 61.2 × 51.2 cm
Private collection
Inscriptions: u.r., *VARLEY*
Provenance: Ernest Ely, Toronto, before 1936.
Exhibitions: Group 1922, no. 8; Western Tour 1922–23, no. 71, $400; Group 1936, no. 179, loaned by Ernest Ely, Toronto.
Bibliography: Bridle 1922; Adam 1923, p. 6.

This painting was included in the Group of Seven's Western Tour, which travelled to Edmonton where Fred Varley's work was greatly admired. The show played a role in his receiving two portrait commissions (see cat. 101) from the University of Alberta. "The recent exhibition of work by 'The Group of Seven', where three of Mr. Varley's canvases were hung, was for many of us the first opportunity of appreciating the artists' powers, and the canvas of *Gipsy Blood* especially aroused lively expectations. Such a painter might be trusted to avoid the usual kind of stodgy official portrait, not far removed from a coloured photograph. Those who gave Mr. Varley this commission [to paint Dr. Henry Marshall Tory] were, at any rate, complimenting Canada's progressive school of young painters and doing something to strengthen the quickening spirit of art of which there are now welcome signs amongst us" (Adam 1923, p. 6).

56

F.H. Varley (1881–1969)
Rocky Shore 1921 (see fig. 60)
Oil on composition board, 56.8 × 40 cm
Private collection
Inscriptions: l.r., *Varley*
Provenance: Dr. A.D.A. Mason, Toronto; by descent.
Exhibitions: Small Paintings 1921, no. 153 *Woman and Child*, $100; [Group 1922, no. 11 *Rocky Shore* ?]; Group 1936, no. 185 *Woman and Babe*, loaned by Dr. A.D.A. Mason, Toronto.
Bibliography: Bridle 1922.

Augustus Bridle (1922) had reservations about Fred Varley's contributions to the 1922 Group show. "Varley has a disappointingly small number

of things," he wrote. "He does not seem to be constantly charmed as are the others. He seems moody and impatient; as though he would leave to the rest of them most of the things seen in the north and wants something unusual. Well, he has found it. His *Rocky Shore* is uncommon enough, because it does not at first strike the beholder as being a shore at all, is only by outlines and colour a picture of rocks, and has for a main motif a trim, neatly dressed maid in pink who does not seem to belong to the picture, and was obviously put there to satisfy the painter's desire for a certain blend of colour."

There is some uncertainty about the painting *Rocky Shore*, which has also been identified as being cat. 103 (Varley 1983, 95). Yet that work is dated 1922–23 and therefore unlikely to have been shown in 1922. The painting described here (cat. 56) is proffered as possibly being *Rocky Shore* based on Bridle's description above.

57

J.E.H. MacDonald (1873–1932)
October Shower Gleam 1922 (see fig. 88)
Oil on canvas, 105.4 × 120.7 cm
Hart House Permanent Collection, University of Toronto
Inscriptions: l.l., *J.E.H. MacDonald '22*
Provenance: Purchased from the estate of the artist with income from the Harold and Murray Wrong Memorial Fund, 1933.
Exhibitions: Group 1922, no. 12 *October Shower Gleam, Telegram Lake*, $500; CNE 1922, no. 274, $500; RCA 1922, no. 136 *October Shower Gleam*; Hamilton RCA 1923, no. 61; U.S. Tour 1923–24, no. 21, $500; Wembley 1925, no cat. no.; Paris 1927, no. 125 *Après une averse d'octobre*; Buffalo 1928, no. 40 *October Shower Gleam*; Calgary RCA 1929, no. 103, $500; AFA (1) 1930, no. 38; International 1933, no. 173; Group 1936, no. 158, loaned by Hart House, Toronto.
Bibliography: Bridle 1922; Burgoyne 1922b; Septuagenarian 1922; K. Clark 1930.

Though J.E.H. MacDonald did not return to Algoma after 1920, he continued to work from his earlier sketches. The artists would christen the various unnamed lakes where they sketched after their friends or opponents. Just as Lawren Harris had named MacCallum Lake in his painting of 1921 (cat. 52), so MacDonald exhibited this work as *October Shower Gleam, Telegram Lake* after the conservative Toronto newspaper the *Telegram*, which consistently decried modern art (T. MacDonald 1944, 5).
Augustus Bridle (1922) noted that: "MacDonald has the sense of design in his work that makes some of his pictures rare studies in colour and mass and a certain use of pattern. What seems to impress him most in the North is colour in mass as part of landscape design … The North challenges MacDonald to dare things that were only suggested in old Ontario. And he is having the time of his life setting them down. He has great vitality, a high constructive imagination, and a big sense of the epical that is sometimes overwhelmed by his regard for the sheer decorative element in design. Nature to him at present seems to be a vast temple with decorated walls."

58

J.E.H. MacDonald (1873–1932)
Young Canada 1922 (see fig. 107)
Oil on canvas, 52.3 × 65.8 cm

Robert McLaughlin Gallery, Oshawa, gift of Isabel McLaughlin, 1987
Inscriptions: l.l., *J.E.H. MacDonald '22*
Provenance: Purchased by Isabel McLaughlin, Oshawa, from AGT MacDonald 1933.
Exhibitions: Group 1922, no. 17, $100; RCA 1922, no. 138; U.S. Tour 1923–24, no. 22, $200; Small Pictures 1924, no. 134, $200; Kitchener 1926, no. 33, $150; AGT Canadian 1926, no. 34, $200; AAM Canadian 1928, no. 37; Kingston OSA 1929, no cat. no.; Roerich 1932, no. 39; AGT MacDonald 1933, no. 134; NGC MacDonald 1933, no. 22, loaned by Isabel McLaughlin; Group 1936, no. 161.
Bibliography: Jacob 1922e; Septuagenarian 1922; Telegram 8 Nov. 1924.

When this picture was exhibited in the OSA *Small Picture* show in 1924, the writer in the Toronto *Telegram* (8 Nov. 1924) wrote: "If you look up no. 134 in the catalogue and find it entitled *Young Canada*, don't feel discouraged. There are others who cannot recognize in this pallid fir tree rising from a vermilion bed of sofa cushions, looking rather like a Christmas tree nightmare, which might have visited Scrooge, anything to warrant its title. It should be dedicated to the authors and singers of 'O Canada!'"

59

Arthur Lismer (1885–1969)
Isles of Spruce, Algoma 1922 (see fig. 67)
Oil on canvas, 119.4 × 162.6 cm
Hart House Permanent Collection, University of Toronto
Inscriptions: l.l., *A Lismer 22*
Provenance: Purchased from Group 1928.
Exhibitions: Group 1922, no. 20 *Islands of Spruce, Algoma*, $750; CNE 1922, no. 267, $750. repr.; RCA 1922, no. 128; Hamilton RCA 1923, no. 56; U.S. Tour 1923–24, no. 17 *Island of Spruce, Algoma*, $800; RCA 1924, no. 127; Wembley 1925, no cat no. *Isles of Spruce, Algoma*; Paris 1927, no. 108 *Les Îles aux Cyprès*; Group 1928, no. 46 *Islands of Spruce, Algoma*; AFA (1) 1930, no. 34 *Isles of Spruce, Algoma*, loaned by Hart House; Group 1936, no. 128 *Isles of Spruce*.
Bibliography: Bridle 1922; Eric Brown 1922, repr.; Burgoyne 1922b; Septuagenarian 1922; A.Y. Jackson 1922c; Bulletin of the Minneapolis Institute of Arts Nov. 1923, repr. 59; Burnham 1924; Read 1924; Brooklyn Museum Quarterly July 1924, p. 108; F.B. Housser 1926a, pp. 152, 178–79, repr. opposite p. 188; The Dean 1927; J. Adeney 1928b, p. 43; Jacob 1928a; Brooker 1929a, p. 62; Rainey 1930; L. Mechlin 1930, p. 270, repr. 264; Art News 7 June 1930, p. 6; St. Louis Post-Dispatch 27 July 1930, repr.

This large, horizontal canvas must have dominated the 1922 exhibition and, together with MacDonald's *October Shower Gleam, Telegram Lake*, been one of the keynotes of the show. Once again it was Augustus Bridle (1922) who was most sensitive to the contributions of the individual artists: "Lismer has a good number, and more than usual that interest the average eye; fewer that revel in the jazzy effects of water and cloud and sky and twisted leaves. Of the group he is the most restless, and is only now toning down to a point where he can begin to size up to a really big thing on its merits … His best one is his biggest this time … an island of spruce in a lake whose gleam seen from twenty feet back is a wonderful bit of water illusion. Close up you see nothing but smudge; in perspective a marvellous sheen of still water; after which and the lift of

the spruces you do not mind that his background is just a few swats of symbolism masquerading as spruces. I think Lismer understands his art better as yet than he has been able to illustrate it. But he is becoming more clarified and simple and is gaining in strength."

60

Arthur Lismer (1885–1969)
The Sheep's Nose, Bon Echo 1922 (see fig. 93)
Oil on canvas, 101.6 × 114.3 cm
Private collection
Inscriptions: l.r., *A.Lismer / 22*
Provenance: The artist, Montreal; Laing Galleries, Toronto.
Exhibitions: Group 1922, no. 23, $600.
Bibliography: Bridle 1922.

The "precipitous catastrophe called *Sheep's Nose, Bon Echo*" was compared by Augustus Bridle (1922) to Lawren Harris's *Rock, Algoma*[1] in the same show as being "without the sense of mass and weight but with at least some attempt to paint in the intimate textures that rocks will insist upon having for clothes." While Harris's canvas was worked up from a sketch painted at Mitchell Lake in Algoma, Arthur Lismer's is one of a number of oil sketches and canvases depicting the rock face dedicated to Walt Whitman at Bon Echo on Mazinaw Lake.[2]

1. L.S. Harris: *Rocky Cliffs, Algoma*, 1922, is in the Art Gallery of Ontario (69/123). This painting and the oil sketch titled *Mitchell Lake, Batchawana* are reproduced in Adamson 1978, pp. 87, 92. 2. The National Gallery owns one oil sketch of Bon Echo Rock and two canvases (2004, 6117, 6941), and one canvas is in the Art Gallery of Hamilton (55.77.A).

61

Lawren S. Harris (1885–1970)
Sunset, Kempenfelt Bay 1921 (see fig. 94)
Oil on canvas, 82 × 102.5 cm
Power Corporation of Canada
Exhibited in Ottawa only.
Inscriptions: l.r., *LAWREN / HARRIS 21*
Provenance: Private collection, Toronto, 1928; private collection, Ottawa; Sotheby's, Toronto, 10 Nov. 1987, lot 282; Power Corporation of Canada.
Exhibitions: [Group 1922, no. 40 *Evening, Kempenfelt Bay, Lake Simcoe*, $500 ?].
Bibliography: Jacob 1922e; Bridle 1922.

Lawren Harris's family had a summer home on Kempenfelt Bay on Lake Simcoe, which he frequently visited. This is the earliest of at least three canvases of trees in front of the bay[1] and also the earliest canvas in which he defines the foreground with vertical tree trunks through which one has a panoramic view to the far distance.[2] Richly coloured and fluidly brushed with considerable texture, this work translates the fierce emotion of *Beaver Swamp, Algoma* (cat. 53) into a more tranquil mood. Fred Jacob (1922e), who took objection to Harris's shack paintings, breathed a sigh of relief: "His gift for lovely colour will out at times. Look at the beautiful design, *Evening, Kempenfelt Bay*."
 The positive identification of this canvas is complicated by Augustus Bridle's (1922) description of the trees as dead poplars. In fact the painting in the show pleased him not at all: "[Harris's] *Evening on Lake Simcoe* is a picture of dun dreary deformity; a few lone scrags of dead

poplars and a swale of dun-brown rock; absolutely devoid of beauty; chosen only because it is so queer."

1. *Pines, Kempenfelt Bay*, c. 1923, is in the Macdonald Stewart Art Centre, University of Guelph. *Pines, Kempenfelt Bay*, purchased by the National Gallery in 1924, is now in the Art Gallery of Hamilton (66.72.24). 2. The same compositional device appears in *Algoma Country* (48/9) and *Above Lake Superior* (1335), both in the Art Gallery of Ontario. The oil sketch for the former (*Algoma Lake*, AGO 2464) is traditionally dated c. 1920, but an almost identical sketch by A.Y. Jackson (private collection) is titled and dated by the artist *Sand Lake, Algoma, 1921*. I believe *Algoma Country* dates from 1922 and was first exhibited in the 1922 Group of Seven exhibition as cat. 35 *Algoma Country*. Harris exhibited a painting titled *Above Lake Superior* in the 1922 Group show (cat. 31) and at the RCA 1923 at the AGT (cat. 72). None of the reviews of the Group show enable one to equate that title to the AGO painting. One review of the 1923 RCA compares the foreground of *Above Lake Superior* to "an embossed duvet drapery" (Fairbairn 1923c), and another states, "his lichen somewhat resembles a patchwork quilt on closer inspection" (Hammond 1923b). When the AGO *Above Lake Superior* was exhibited at the 1924 OSA, all reviewers described the work as one they were seeing for the first time and a major advance in Harris's work (Hammond 1924a; Jacob 1924; Hamilton Spectator 13 March 1924). For these reasons I believe the AGO painting probably dates from 1924 rather than the usual c. 1922.

62

Lawren S. Harris (1885–1970)
Black Court, Halifax 1921 (see fig. 64)
Oil on canvas, 97.1 × 112 cm
National Gallery of Canada, Ottawa (5007), gift of the artist, Vancouver, 1960
Inscriptions: l.l., *LAWREN / HARRIS / '21*; stretcher: u.c., *LAWREN / HARRIS / BLACK / COURT / HALIFAX / $1000.00*
Exhibitions: Group 1922, no. 43, $600; Group 1936, no. 82.
Bibliography: Bridle 1922; F.B. Housser 1926a, pp. 185–86.

In 1921, probably in the early spring, Lawren Harris travelled to Nova Scotia and Newfoundland (Reid 1970, 176). Two canvases resulted from this trip, not landscapes but depictions of the urban slums of Halifax. *Elevator Court, Halifax* and *Black Court, Halifax* were both exhibited in the 1922 Group of Seven exhibition. The two paintings grow out of Harris's shack paintings, though the message is more direct, as Augustus Bridle (1922) observed: "*Black Court* is despondent with only a note of humanity in order to show that nobody should live in such a place at all."
 Fred Housser (1926a, 186) discussed these two paintings at length. "The Halifax canvases are shattering to any form of shallow idealism. A naked material fact stares us in the face presented with so much humanity that one reads clearly the experience of the painter in his work. So intense a portrayal of subject could not have been achieved without leaving scars upon the emotional nature of the artist. For the realization must have forced itself upon Harris that *Elevator* and *Black Courts* typify the daily life of more than one half of the human race. It must also have been made plain to him that it likewise symbolized a consciousness of spiritual poverty in a very large portion of the

remaining half of mankind since were man conscious that he possessed the spiritual resources with which to meet and right Black Court conditions he would do so."

63

A.Y. Jackson (1882–1974)
First Snow, Algoma 1920 (see fig. 85)
Oil on canvas, 107.1 × 127.7 cm
McMichael Canadian Art Collection, Kleinburg, Ont. (1966.7), gift in Memory of Gertrude Wells Hilborn
Inscriptions: l.r., *A.Y. JACKSON*
Provenance: The artist, Toronto; Percy and Gertrude Wells Hilborn, Preston, Ont.
Exhibitions: U.S. Tour 1920–21, no. 7 *The Northland*; Group 1922, no. 46, $800; CNE 1922, no. 250, $800; [Hart House Jackson 1927, no. 21, $800 ?].
Bibliography: J.E.H. MacDonald 1919f, p. 39; Bridle 1922; F.B. Housser 1926a, pp. 141, 191.

The sketch (private collection) for *First Snow, Algoma*, which does not include the swirling snow, was painted by A.Y. Jackson in Algoma in the fall of 1919. That trip was described by his fellow traveller J.E.H. MacDonald (1919f, 39) in an article published in *The Lamps*: "From a castle-like hill of rock which the painters favoured, the hills lifted endlessly in the purple grey of bare trees, broken only with the dark spruce. Winter began to skirmish over the land … Sometimes the frequent rain turned to light snow, and one day from the top of the castle hill, 'Amundsen' saw a strong attack by Winter, the snow sweeping every sign of Autumn from the hills in swirling white."
 Postdating Frank Johnston's *Fire-swept, Algoma*, this panoramic canvas was called *The Northland* when it was shown in the 1922 Group show on its return from the United States. Augustus Bridle (1922), confusing it with the smaller canvas *First Snow* (priced at $300), described it as "a dramatic big thing showing the restless drive of the flakes across the face of the autumn hills."

64

A.Y. Jackson (1882–1974)
Tadenac, November 1922 (see fig. 62)
Oil on canvas, 102.2 × 97.2 cm
Private collection
Inscriptions: l.r., *A Y JACKSON*; back of frame: b., *TADENAC, NOVEMBER – GEORGIAN BAY*
Provenance: Gift of the artist, Toronto, to Pickering College, Newmarket, Ont., before 1953; Sotheby's, Toronto, 29 Oct. 1985, lot 544; purchased by the present owners.
Exhibitions: Group 1922, no. 47 *November, Georgian Bay*, $1000; RCA 1924, no. 106 *Georgian Bay, November*, repr.; CNE 1925, no. 291, $600.
Bibliography: Bridle 1922; Eric Brown 1922.

A.Y. Jackson exhibited three Georgian Bay canvases in the 1922 Group show: *November, Georgian Bay* at $1000, *April, Georgian Bay* at $350, and *Grey Day, Tadenac* at $350. Augustus Bridle (1922), confusing two of the paintings, felt that *November, Georgian Bay* "lacks only more lustre in the water to match the delicately beautiful tracery of the foreground trees" and criticized *Grey Day, Tadenac* as "considerably too large for his palette." The latter comment most probably referred to *November, Georgian Bay*, and it was possible that Jackson shared Bridle's opinion and for that reason cut down the canvas to exhibit it in its

current format in 1924.[1] Bridle's (1922) identification of "the sombre, almost sullen study in solitude" is a perfect description of this moody, richly coloured canvas, and continues: "Once he grew tired of greys in conventional landscapes; now he goes back to colours almost as sober but with the element of power and ruggedness."

The painting was loaned to the 1953 A.Y. Jackson retrospective exhibition at the Art Gallery of Toronto as *Tadenac, November*. Tadenac is on Georgian Bay just north of Go-Home Bay.

1. The almost-square format is exceptional in the artist's oeuvre. A photograph of the canvas in its current format in the AGO Library is inscribed on the back: "Jackson cut right portion of this off." The painting has been lined and the tacking margins removed so it is impossible to confirm which side might have been removed.

65

Percy Robinson (1872–1953)
Untitled (Georgian Bay, N9) c. 1919–22 (see fig. 65)
Pen and ink on paper, 9.5 × 15 cm
University College, University of Toronto
Provenance: Gift of G. de B. Robinson, Toronto, c. 1981.
Exhibitions: Group 1922, no cat. no. *Decorative Drawing to Poem "Georgian Bay".*

Percy Robinson was encouraged to pursue his early interest in painting by Lawren Harris, his former pupil at St. Andrew's College, and subsequently by A.Y. Jackson. His pen and ink drawings remind one of elegant Victorian penmanship harnessed to evoke the spirit of the land. The poem which they eventually illustrated began, according to his son (Robinson 1966, 5), as "an historical epic of the Jesuit mission in Huronia," but was continually revised. Georgian Bay itself became the main theme.

66

Percy Robinson (1872–1953)
Untitled (Georgian Bay, N11) c. 1919–22 (see fig. 63)
Pen and ink on paper, 16.8 × 13.5 cm
University College, University of Toronto
Inscriptions: u.r., *P.J.R.*
Provenance: Gift of G. de B. Robinson, Toronto, c. 1981.
Exhibitions: Group 1922, no cat. no. *Decorative Drawing to Poem "Georgian Bay".*

67

Percy Robinson (1872–1953)
Untitled (Georgian Bay, N12) c. 1919–22 (see fig. 66)
Pen and ink on paper, 12 × 18.4 cm
University College, University of Toronto
Provenance: Gift of G. de B. Robinson, Toronto, c. 1981.
Exhibition: Group 1922, no cat. no. *Decorative Drawing to Poem "Georgian Bay".*

68

Lawren S. Harris (1885–1970)
First Snow, North Shore of Lake Superior 1923 (see fig. 97)
Oil on canvas, 123.4 × 153.5 cm
Vancouver Art Gallery (50.4), Founders Fund
Inscriptions: l.r., *LAWREN / HARRIS*; stretcher: t., *FIRST SNOW LAKE SUPERIOR HILLS. LAWREN HARRIS*
Provenance: Purchased from the artist, Vancouver, 1950.

Exhibitions: OSA 1923, no. 64 *Landscape*, repr.; U.S. Tour 1923–24, no. 9 *Lake Superior Country*, $2000; Wembley 1925, no cat. no.; Paris 1927, no. 58 *Paysage du Lac Supérieur*.
Bibliography: Jacob 1923a; Hammond 1923a; Charlesworth 1923a; Minneapolis Journal 11 Nov. 1923, repr.; Burnham 1924; Telegram 17 Feb. 1924; Read 1924; H.W.M.K. 1925; Winnipeg Free Press 23 May 1925; Yorkshire Post 23 July 1926; McCormick 1932.

In October 1922 Lawren Harris and A.Y. Jackson camped on the north shore of Lake Superior at Coldwell where the sketch for this canvas was painted.[1] Harris's first major Lake Superior canvases don't focus on the breadth and light of the lake but on the rolling expanse of the hills.

When it was first exhibited at the OSA in 1923, the Russian artist Leon Bakst is reported to have said: "It was sculpture rather than painting."[2] Commented Fred Jacob (1923a): "He doubtless referred to the fact everything in the picture seemed as hard as granite, even the snow and the fir trees. It suggests H.G. Wells's description of the end of the world, and even persons who quarrel with the futuristic effect will admit the powerful suggestion that it contains." Hector Charlesworth (1923a) merely found it "weird."

The painting was included in the second American tour organized by the Group. One Milwaukee reviewer objected to Harris's Canadian "rocks and barren trees ... we in Wisconsin who are fortunate to journey to the Wisconsin side [of Lake Superior] each summer like to think of the Lake Superior country as something warmer and more livable than Mr. Harris pictures it" (Foley 1924). A more analytical reviewer (Burnham 1924) was struck by the colour: "There is an undeniable sweep to the canvases *North Shore, Lake Superior* and *Lake Superior Country*, but it is held down by the very solidity of his paint. Colour there is, to be sure: intense blue hills at the horizon, then reddish brown hills, and in the foreground snow-covered mountains spread with blue shadows that give the whole canvas an ultraviolet cast. There is a wealth of colour in the pictures, but it is colour imprisoned in a medium which seems as uncompromising as clay."

But in Brooklyn, Helen Appleton Read (1924) found Harris's paintings the most dramatic: "He more than any of the others gets away from the idea that a picture is merely a decoration and gives us an emotional reaction. He paints the country about the north shore of Lake Superior and gives us a feeling of vastness and of starkness, of wilderness. His shapes are hard-edged and bold, simplified down to their essential forms, his colour cold and clean."

1. *Lake Superior Country*, dated Oct. 1922, McMichael Canadian Art Collection, Kleinburg, Ont. (1972.7).
2. F.B. Housser (1926a, 189) quotes Bakst as referring to *Above Lake Superior* (AGO 1335).

69

Franklin Carmichael (1890–1945)
The Upper Ottawa, near Mattawa 1924 (see fig. 104)
Oil on canvas, 101.5 × 123.1 cm
National Gallery of Canada, Ottawa (4271)
Inscriptions: l.r., *FRANK / CARMICHAEL / 1924*
Provenance: Purchased from the artist, Toronto, 1937.
Exhibitions: Group 1925, no. 7; Wembley 1925, no cat.

no.; Paris 1927, no. 17 *La rivière Ottawa*; [Buffalo 1928, no. 6 *Ottawa River*, $850 ?]; Group 1936, no. 20.
Bibliography: Hammond 1925a; Charlesworth 1925b; Jacob 1925a; H.W.M.K. 1925; Winnipeg Free Press 23 May 1925.

The Upper Ottawa, near Mattawa is at the same time a consolidation of Frank Carmichael's previous interests in textured form and in colour, and a great departure. Fred Jacob (1925a) enthused: "Carmichael is showing the best work that has ever come from his brush. He has toned down his tendency to indulge in orgies of colour. No longer does he live in eternal Autumn. His tones are quieter, and he has made a proportionate gain in delicate values. His largest picture, painted on the Ottawa River with its Japanesey tree, seems to us the most striking canvas that Mr. Carmichael has ever exhibited." Even Hector Charlesworth (1925b) liked these paintings: "Occasionally ... members of the group escape from the rigours of their creed and make excursions in the direction of individualistic perception and sincerity ... Four of Mr. Carmichael's pictures ... are among the best in the gallery. They are not mature work, but they give a sense of air and of a feeling for the subtle and evanescent moods of nature – sincere rather than sensational."

70

Franklin Carmichael (1890–1945)
A Grey Day 1924 (see fig. 126)
Brush, pen, and black ink on wove paper, 28.4 × 30.8 cm
National Gallery of Canada, Ottawa (3175)
Inscriptions: l.r., *F.C.* (monogram) / *Frank Carmichael*, l.l., *A Grey Day*
Provenance: Purchased from Group 1925.
Exhibitions: Group 1925, one of no. 9.

While Fred Varley's dry brush drawings were included in the portfolio launched at the 1925 Group show, *Canadian Drawings by Members of the Group of Seven*, none of Frank Carmichael's drawings appeared.

71

Lawren S. Harris (1885–1970)
Spring on the Oxtongue River 1924 (see fig. 111)
Oil on canvas, 82.2 × 102.2 cm
Gallery Lambton, Sarnia (56.1), purchased with funds donated by the Industries of Sarnia, 1956
Inscriptions: l.r., *LAWREN / HARRIS*; stretcher: u.l., on label in ink, *Spring on the Oxtongue River / Lawren Harris / Northern Painting XVII 32 ∂ 4 ...*
Provenance: The artist, Vancouver, 1956.
Exhibitions: Group 1925, no. 14.
Bibliography: Telegram 12 Jan. 1925.

The Oxtongue River runs into the southwest corner of Algonquin Park where the Harris family spent part of the summers in the mid-twenties. Brightly coloured, this canvas is a bold simplification of the oil sketch in the Art Gallery of Hamilton (55.72.5), which is painted in similar hues but with greater contrast of lights and darks and with a central windswept pine and clouds flitting in the sky. Though possibly reworked by the artist after 1924 (see cat. 94), the conical trees and reduction of form are characteristic of Lawren Harris's paintings of that year. The writer for the Toronto *Telegram* (12 Jan. 1925) suggested the artist had his tongue

in his cheek when he painted this work, yet Fred Jacob (1925a) felt Harris's paintings in the 1925 Group show characterized the whole movement: "One of the British critics, who so greatly admired the modern school of Canadian painting, summarized its characteristics as 'bold simplification, emphatic statement with a full brush in strong colour.' One could not find a better description of the work that Lawren Harris is showing in the Group's exhibition ... Nobody in the group has more powerful brush work ... One realizes that, in the sphere of aesthetics, it is dangerous to make arbitrary assertions about what is or is not beauty. For example, the present writer abominates the imitative sentimentality and the pseudo-Corots that used to figure so largely in Canadian art galleries. For him they have no beauty, but how can he prove those eyes and tastes are wrong that find them beautiful? Accordingly, one realizes that not everybody will feel beauty in the glaring, vital, rigid studies of Canadian solitudes that Mr. Harris paints, but those who do, and the number increases steadily, find in his canvases an extraordinarily impressive interpretation of nature."

72

Lawren S. Harris (1885–1970)
Maligne Lake, Jasper Park 1924 (see fig. 105)
Oil on canvas, 122.8 × 152.8 cm
National Gallery of Canada, Ottawa (3541)
Inscriptions: l.l., *LAWREN / HARRIS / 1924*
Provenance: Purchased from NGC 1928.
Exhibitions: Group 1925, no. 20; Wembley 1925, no cat. no.; Paris 1927, no. 60 *Lac Maligne, Parc National de Jasper*, repr.; NGC 1928, no. 63 *Maligne Lake, Jasper Park*; Buenos Aires 1931, no cat. no.; Edmonton Museum of Arts Sept. 1931–July 1932; Saskatoon Industrial Exhibition July–Aug. 1932; Winnipeg 1933, no. 21; Regina Grain Conference July 1933; Banff, Pacific Relations Conference Aug. 1933 (not hung); Edmonton 1933, hors cat.
Bibliography: Fairbairn 1925; Hammond 1925a; Telegram 12 Jan. 1925; London Times 25 Nov. 1925; H.B.C. 1926; Yorkshire Post 23 July 1926; Yorkshire Observer 23 July 1926; Manchester City News 4 Sept. 1926; Chavance 1927; A.M.D. 1927; R.B.F. 1928a; Harrold 1928; Dick 1932, p. 281, repr.

None of the reviewers of the 1925 Group show could miss "the cold, abrupt grandeur of those serrated peaks" (Fairbairn 1925) in *Maligne Lake, Jasper Park*, "a jangle of angles and triangles in grey-green" (Hammond 1925a).

Barker Fairley (1925) expressed strong reservations about Lawren Harris's "stereoscopic effects," and Hector Charlesworth (1925b), reviewing a Group show for the first time, was exasperated: "The perversity of Lawren Harris, who on many occasions has revealed fine aesthetic feeling for tone, is inexplicable. In his large canvases at present on display he twists the contours of nature into hard and turgid outlines; and most of his comrades show a tendency to do likewise. Angles and spirals abound as in mechanical drawings; and the rigid outlines enclose untoned masses of crude colour."

Both *First Snow, North Shore of Lake Superior* (cat. 68) and *Maligne Lake* were included in the 1925 Wembley exhibition and during their British tour were praised by a Rochdale journalist (H.B.C. 1926): "Next to the all-pervading snow one feels the sense of vast open spaces, of absolute freedom, with now and again a great

and terrible loneliness. Seldom, indeed, is there any hint of man or beast. These feelings are strongly aroused by a striking pair of works [*First Snow*] and [*Maligne Lake*]. Of these the former shows a wilderness of red rock glowing in the sunshine, with a deeper note of purplish violet in the shadowed foreground, a far-away blue distance under a greenish-golden sky. A few stark poles, the bones of dead trees, add to the sense of space and loneliness. The other picture, *Maligne Lake*, set amid towering peaks, is eerie to a degree. Nature, gaunt and grim, viewing her image in a flawless mirror amid a silence that may be felt."

73

Lawren S. Harris (1885–1970)
Rocky Mountains 1924 (see fig. 128)
Pen and black ink with white gouache on calendered wove paper, 35.1 × 39.3 cm
National Gallery of Canada, Ottawa (3169)
Inscriptions: l.l., *Lawren Harris*
Provenance: Purchased from Group 1925.
Exhibitions: Group 1925, one of no. 21.

74

Lawren S. Harris (1885–1970)
Maligne Lake, Jasper Park, Alberta 1924 (see fig. 127)
Pen and black ink on wove paper, 32.8 × 40 cm
National Gallery of Canada, Ottawa (18290)
Inscriptions: l.r., *Lawren / Harris*; verso: l.l., *Maligne Lake, Jasper Park / Alberta / Lawren / Harris / 25 Severn St. Toronto*, l.c., $35.00
Provenance: Kathleen Fenwick, Ottawa; purchased from the estate of Kathleen Fenwick, Ottawa, 1975.
Exhibitions: Group 1925, one of no. 21; Wembley 1925, no cat. no. *Maligne Lake II*; Paris 1927, no. 63 *Lac Maligne, nº 2*.
Bibliography: Canadian Drawings 1925, repr. Harris, pl. 4, *Mount Samson, Jasper Park*; Richmond 1926, repr. 247.

75

A.Y. Jackson (1882–1974)
Dawn – Pine Island 1924 (see fig. 113)
Oil on canvas, 53.5 × 66 cm
McMichael Canadian Art Collection, Kleinburg, Ont. (1977.4), gift of Miss D. Esther Williams, Toronto
Inscriptions: l.r., *A Y JACKSON*
Provenance: The artist, Toronto; Miss D.E. Williams, Toronto.
Exhibitions: Group 1925, no. 31; NGC 1926, no. 74, $350; Hart House Jackson 1927, no. 44, $500.
Bibliography: Telegram 12 Jan. 1925; Charlesworth 1925b; Jacob 1925a; B. Housser 1925a.

A.Y. Jackson returned to Georgian Bay regularly most summers during the 1920s. This delicate treatment of the silhouetted pines shows both his technical virtuosity and a sensitivity of expression not always evident in his work. The same theme is treated in *Night, Pine Island* (cat. 169), painted the same year. The painting was appreciated by reviewers for its "tender quality" (B. Housser 1925a), its "imagination" (Telegram 12 Jan. 1925), and its "decorative" qualities (Charlesworth 1925b). Fred Jacob (1925a) was the most enthusiastic: "Though Mr. Jackson is not even, and seems to revel here in baldness, and there in crudeness, he rises at his best to a subtlety that belongs peculiarly to him. Look at the atmospheric suggestion in *Dawn* and *Winter, Moonlight*, masterly bits of pale colour, and the romantic fullness of *Morning*. In each of

them is a mood of nature perfectly expressed, with refinement that does not mar the power of the conception."

76

A.Y. Jackson (1882–1974)
Morning 1924 (see fig. 120)
Oil on canvas, 53.3 × 66 cm
Private collection
Inscriptions: l.r., *A.Y. JACKSON*
Provenance: Kenneth G. Heffel Fine Art Inc., Vancouver.
Exhibitions: Group 1925, no. 35.
Bibliography: Telegram 12 Jan. 1925.

The *Telegram*'s writer observed, "It may be a token of reconciliation between the Group of Seven and those who have followed the more conventional paths that A.Y. Jackson has borrowed F.S. Coburn's famous old white horse for his picture ... entitled *Morning*. It is a delightful scene from rural Quebec in wintertime. The old horse is jogging along, pulling an old fashioned sleigh. Across the road is a snowy field, beyond which is a thin fringe of trees, through which are to be had glimpses of the broad river and the mountains beyond" (12 Jan. 1925).

77

A.Y. Jackson (1882–1974)
Vista from Yellowhead 1924 (see fig. 131)
Pen and black ink with white gouache on illustration board, 26.4 ×34.3 cm
National Gallery of Canada, Ottawa (3171)
Provenance: Purchased from Group 1925.
Exhibitions: Group 1925, one of no. 37; Wembley 1925, no cat. no.; Paris 1927, no. 90 *Vue de Yellowhead*.
Bibliography: *Canadian Forum*, Oct. 1924, repr. 15 as *A View from Yellowhead, B.C.*

78

A.Y. Jackson (1882–1974)
Winter Scene 1924 (see fig. 124)
Pen and black ink with white gouache and graphite on wove paper, 21 × 28.6 cm
National Gallery of Canada, Ottawa (3173)
Inscriptions: l.l., *A.Y.J.*, l.l. corner, *Winter Scene*
Provenance: Purchased from Group 1925.
Exhibitions: Group 1925, one of no. 37; Wembley 1925, no cat. no.; Paris 1927, no. 91 *Scène d'hiver*.
Bibliography: Canadian Drawings 1925, repr. Jackson, pl. 2, as *Winter in Quebec*; Richmond 1926, repr. 246.

79

Arthur Lismer (1885–1969)
The Happy Isles 1924 (see fig. 116)
Oil on canvas, 78 × 98.2 cm
University of Saskatchewan, Saskatoon, gift of Mr. E.E. Poole, Edmonton, 1959
Inscriptions: l.l., *A. Lismer 24*
Provenance: The artist, Toronto; H.S. Southam, Ottawa, 1937; Laing Galleries, Toronto, 1950; E.E. Poole, Edmonton.
Exhibitions: Group 1925, no. 38; Wembley 1925, no cat. no.; Paris 1927, no. 109 *Les îles heureuses*; RCA 1927, no. 123 *The Happy Isles*; Buffalo 1928, no. 34; AFA (1) 1930, no. 36, $600; AFA (2) 1930, no cat. no.; Roerich 1932, no. 32; Atlantic City 1933, no. 30 repr.; Malloney Lismer 1935, no. 7, $750; Group 1936, no. 142.
Bibliography: Bridle 1925; Hammond 1925a; Telegram 12 Jan. 1925; Fairley 1925, p. 146; H.W.M.K. 1925; R. Lee 1925, p. 368; B. Housser 1925a; F.B. Housser 1926a, pp. 176, 179–81; Brooker 1926a, pp. 278–79; Yorkshire Post 23 July 1926; Grier 1928, p. 21;

L. Mechlin 1930, p. 270; Emmart 1930; Cochrane 1932; Toronto Daily Star 10 July 1933; Bagnall 1933.

The title *The Happy Isles* comes from Tennyson's *Ulysses*:

It may be that the gulfs will wash us down:
It may be we shall touch the Happy Isles,
And see the great Achilles, whom we knew;
Tho' much is taken, much abides; and tho'
We are not now that strength which in old days
Moved earth and heaven; that which we are, we are;
One equal temper of heroic hearts,
Made weak by time and fate, but strong in will
To strive, to seek, to find, and not to yield.

It was the poetry of the canvas that struck Augustus Bridle (1925), who contrasted Lismer's work to that of Harris: "Perhaps no one else would be quite so happy there, for the islands are just clumps of colour sparkling like jewels on blue enamel, that you can't drink, and each one running up one lone leafless pine like a flag of no surrender to the commonplace. Nor does Mr. Lismer get lost in his clouds. They are the real Lismer, a truant from the school who has ducked the class in arithmetic, for the forbidden sweets of poetry." Bess Housser (1925a) delighted in Lismer's paintings: "Sensing rhythm as a fundamental, he covers his canvas in a flowing and never-ceasing movement of line and singing colour that are positive paeans of joyousness. He tosses beauty about with a carelessness that says beauty is an enduring thing and life a glorious adventure." And it was *Happy Isles* that Barker Fairley (1925, 146) singled out: "It is strange and new, as we can tell from its colour, which is the most powerful we have seen since Thomson sketched. There is, of course, no such colour in the Bay. But it is living colour throughout, from the milky green of its foreground pool, up through its red rocks and blue hills, to a blue and yellow blaze of sky capped with earthen clouds."

80
Arthur Lismer (1885–1969)
A Factory Town – North of England 1924 (see fig. 117)
Oil on canvas, 101.5 × 127.2 cm
Heritage Collection, Cultural Affairs Division, Department of Education and Culture, Government of Nova Scotia, Halifax
Inscriptions: l.r., *A Lismer /* (date illegible)
Provenance: Laing Galleries, Toronto; private collection, Burlington, Ont., 1968; Manuge Galleries, Halifax.
Exhibitions: Group 1925, no. 41.
Bibliography: Charlesworth 1925b.

Arthur Lismer exhibited two industrial subjects in the 1925 Group show, *A Northern Town* from 1922[1] and *A Factory Town – North of England*. The English canvas, unique in its inclusion in this all-Canadian exhibition, resulted from Lismer's trip with his family to Britain the previous summer. It depicts the Unitarian Church in Mossley, Lancashire, where his sister lived (Tooby 1991, n.p.). In the 1925 show only Hector Charlesworth (1925b) commented on the painting: "Most of the paintings by Messrs. Macdonald and Lismer are in harsh, unemotional moods, though in *The Factory Town* and *A Northern Town* an abundance of varicoloured detail is translated by Mr. Lismer into vivid synthesis and the light is that of nature."

1. Repr. sale catalogue, Sotheby's, Toronto, 27 May 1985, lot 794. A third canvas titled *Copper Mining Town – Ontario* from 1924 is reproduced in Donegan 1987, p. 71. See also fig. 121.

81
Arthur Lismer (1885–1969)
Islands of Spruce 1924 (see fig. 118)
Pen and black ink on wove paper, 27.8 × 35.6 cm
National Gallery of Canada, Ottawa (3176)
Inscriptions: in image, l.r., *A.L.*; sheet, l.l., in ink, *Islands of Spruce*, graphite, *The Island Macgregor Bay*; l.r., *A.L.*
Provenance: Purchased from Group 1925.
Exhibitions: Group 1925, one of no. 45; Wembley 1925, no cat. no. *Group of Trees*; Paris 1927, no. 112 *Groupe d'arbres*.
Bibliography: Canadian Drawings 1925, repr. Lismer, pl. 4; MacTavish 1925a, repr. 155; Richmond 1926, p. 246.

82
Arthur Lismer (1885–1969)
Pine 1923 (see fig. 123)
Reed pen and black ink on wove paper, 40.9 × 30.5 cm
National Gallery of Canada, Ottawa (3177)
Inscriptions: l.r., *A. Lismer / 23*
Provenance: Purchased from Group 1925.
Exhibitions: Group 1925, one of no. 45; Wembley 1925, no cat. no.; Paris 1927, no. 113 *Pin*.
Bibliography: Canadian Drawings 1925, repr. Lismer, pl. 3.

83
J.E.H. MacDonald (1873–1932)
Rain in the Mountains 1924 (see fig. 108)
Oil on canvas, 123.5 × 153.4 cm
Art Gallery of Hamilton (55.87.J), bequest of H.L. Rinn, 1955
Provenance: Estate of the artist; Mellors-Laing Galleries, Toronto. Purchased from Dominion Gallery, Montreal, with funds from the bequest of H.L. Rinn, 1955.
Exhibitions: Group 1925, no. 47; Wembley 1925, no cat. no.; Western Tour 1928–29, $700; Edmonton 1928, no. 16; RCA 1929, no. 137, $700; AGT MacDonald 1933, no. 145; NGC MacDonald 1933, no. 38; Group 1936, no. 175.
Bibliography: Bridle 1925; Jacob 1925a; Fairley 1925, p. 146; Burgoyne 1929b; H.P. Bell 1930a, p. 30; A.V. Thomson 1930, p. 129.

The predominance of mountain landscapes struck most reviewers of the 1925 show. "[Lawren Harris] has flung not a pot of paint, but whole mountains in the faces of the critics, and any audacities the rest of the seven may venture upon seem in comparison quite playful and almost conventional," exclaimed Augustus Bridle (1925). "Take J.E.H. MacDonald for instance … This year he shows us *Rain in the Mountains*. It is a picture full of parallel bands of colour. It contains several huge puffs of pigment that look like Arabian genii escaping out of a bottle. Thanks to Mr. Harris, we see at a glance that these are squalls of rain. There is a huge purple patch rising up into the sky and a year ago we might have thought it was a forest fire, or a field of heliotrope. This year, thanks to Mr. Harris, we see at once that it is a mountain, a little purple with pride, because Mr. MacDonald has chosen to paint it. On the whole, beside the Einstein intensity of Mr. Harris, Mr. MacDonald is quite simple and domestic."

84
J.E.H. MacDonald (1873–1932)
Autumn Sunset 1924 (see fig. 125)
Pen and ink on paper, 24.2 × 28.5 cm
McMichael Canadian Art Collection, Kleinburg, Ont. (1966.13), gift of Mrs. M. Speirs, 1966
Inscriptions: in image, l.r., *J.M.*
Provenance: Doris Huestis Mills Speirs, Toronto.
Exhibitions: Group 1925, one of no. 50.
Bibliography: Canadian Drawings 1925, repr. MacDonald, pl. 2; Richmond 1926, p. 246; A.Y. Jackson 1933a, repr. 137.

The two artists most closely associated with the *Canadian Forum* were J.E.H. MacDonald and his son Thoreau, both of whom had drawings and prints regularly reproduced in its pages from 1922. These drawings were the model for those included in *Canadian Drawings by the Group of Seven*, launched at the 1925 Group show. In 1928, the *Canadian Forum* published a portfolio of reproductions of twelve drawings by Thoreau (Canadian Forum Reproductions 1928).

85
J.E.H. MacDonald (1873–1932)
A Glacial Lake 1924 (see fig. 130)
Ink and gouache on paper, 20.2 × 22.5 cm
Winnipeg Art Gallery (L–1)
Inscriptions: In image, l.r., *J.M.*; below image, l.l., *A Glacial Lake*, l.r., *J.E.H. MacDonald*; sheet, l.r., *J.E.H. MacD.*
Provenance: Purchased from the CSGA 1927 by W. Scott and Sons, Montreal, and donated to the Winnipeg School of Art, 1927.
Exhibitions: Group 1925, one of no. 50; CSGA 1927, no cat. no.
Bibliography: Canadian Drawings 1925, repr. MacDonald, pl. 3 as *A Glacial Lake, Rocky Mountains*; Jackson 1925a, repr. 113; Winnipeg Tribune 22 Oct. 1927, repr.; *Winnipeg School of Art Prospectus for Session 1928–1929*, p. 20.

In 1926 the Winnipeg School of Art initiated the formation of an art collection for the benefit of students.[1] The next year it acquired this drawing by J.E.H. MacDonald from a travelling exhibition organized by the Canadian Society of Graphic Art, together with a print by Edwin Holgate and a drawing by Thoreau MacDonald.[2]
 LeMoine FitzGerald was appointed principal of the School in the summer of 1929 and he immediately put the collecting on a more consistent basis, requesting exhibitions of oil sketches and drawings from artists; on each occasion one or two works were acquired. In 1931 he wrote to Harry McCurry at the National Gallery that "We have had an exhibition of drawings by Lismer and managed to get two of them for our collection here, adding this to the ever growing group. Just now we have twenty-five of MacDonald's oil sketches, which are quite beautiful. It is our intention to have one of these also … It is the intention to have an exhibition from each of the members [of the Group] and to purchase one from each. The purchases, of course, are made through donations, as we cannot spend any of the school income on such things, so that it makes it, at times, rather difficult."[3]

1. *Winnipeg School of Art Prospectus for Session 1927–1928*, p. 20. 2. *Winnipeg School of Art Prospectus for Session 1928–1929*, p. 20; Comfort, secretary CSGA, to

to 1926 he consistently sketched during the late winter on the north shore near Baie-Saint-Paul. However the snow remained very late in 1926, and Jackson spent time in Montreal waiting for a subtenant before vacating his Toronto studio. "It's the longest steadiest winter that has happened since Jacques Cartier landed on the Île-aux-Coudres," Jackson wrote to Clarence Gagnon on 20 April. "Even in Montreal today there are snow banks all along the streets ... However it was a nice winter, lots of sunlight and not much wind ... We were all a little too serious perhaps trying to get a lot of work done."[1] Possibly Jackson made a quick trip to Manseau.

The villages of Quebec under snow were becoming familiar fare for the Toronto critics. "Once again A.Y. Jackson furnishes the high spots of the exhibition. He becomes steadily more subtle, and nobody now painting in Ontario can equal him in studies of snow, both in the open and in towns ... Without any sacrifice of originality or boldness, Mr. Jackson paints pictures that almost any discriminating gallery frequenter can understand and enjoy" (Jacob 1926b). This canvas was purchased by Vincent Massey that same year.[2]

1. Jackson, Montreal, to C. Gagnon, [Paris], 20 April 1926, McCord Arch., C. Gagnon papers. 2. Jackson, Toronto, to Brown, Ottawa, received 20 Dec. 1926, NGC Arch., 5.5-Annual 1927.

98

A.Y. Jackson (1882–1974)
Île aux Coudres c. 1926 (see fig. 139)
Oil on canvas, 53 × 66.4 cm
The Edmonton Art Gallery Collection (26.2)
Inscriptions: l.r., *A Y JACKSON*
Provenance: Purchased from the artist, Toronto, 1926.
Exhibitions: OSA 1926, no. 67 *On the Île aux Coudres*, $300; Group 1926, no. 51 *Île aux Coudres*, $250; Edmonton 1926, no. 22.
Bibliography: P.J. Robinson 1926.

Jackson first visited Île aux Coudres in the summer of 1925 with Marius Barbeau and Arthur Lismer. "It's a whale of a day," he wrote to Norah Thomson. "After a week of peevish weather. Mean east wind damp but no kick to it. It swung round to the south and everything is lovely. It's wonderful what effect winds have ... Away out the sun is shooting long bars of light across the water and yours truly has been trying to grab a lot of things all at once. We are using sketchbooks mostly. There is too much drawing and too many variations of colour to tear off sketches ... Lismer found the same difficulties and he is more accustomed to summer sketching than I am."[1]

1. Jackson, Île aux Coudres, to Norah Thomson, [Toronto], [Sept. 1925], NAC, MG30 D322, vol. 1, Jackson 1925.

99

Arthur Lismer (1885–1969)
Quebec Village 1926 (see fig. 133)
Oil on canvas, 132.7 × 162.6 cm
Agnes Etherington Art Centre, Queen's University, Kingston, gift of H.S. Southam, Ottawa, 1949
Inscriptions: l.l., *A. Lismer '26*
Provenance: The artist, Montreal; H.S. Southam, Ottawa, 1949.

Exhibitions: Group 1926, no. 68, $1000; NGC 1927, no. 126, $1000; Quebec 1927, no cat. no.; Buffalo 1928, no. 32; Atlantic City 1933, no. 29; Malloney Lismer 1935, no. 16, $850; [London 1935, no. 16 ?]; Group 1936, no. 131.
Bibliography: Brooker 1926a, pp. 278-79; Ottawa Citizen 12 Jan. 1927; Burroughs 1933; Toronto Daily Star 10 July 1933; Bagnall 1933.

On his return to Toronto in the fall of 1925, Lismer wrote to Marius Barbeau: "St. Hilarion made an excellent place to finish up a delightful trip. The rhythm of the countryside is quite exciting there & good for innumerable & varied compositions ... In all, the Province of Quebec proved wonderful & for my part, I've never had such an intimate experience ... I'm afraid that we have not fulfilled your hopes regarding pictorial records of value."[1]

In fact, this short trip to Quebec would result in a number of canvases by Lismer which would be widely exhibited. *Quebec Village*, one of two related paintings[2] depicting the village of Saint-Hilarion nestled in the surrounding landscape, is the largest of these.

Lismer later recalled the "critical ribbing" the painting received "on account of the halo round the church. It was really an attempt to get vibration of light in the rarefied atmosphere of a September day at St. Hilarion. It was interpreted as an effect or aura of sanctity around the sacred edifice, or as one put it – 'modern aberration of three dimensional expressionism'. So I got the credit of being extremist and of investing the R.C. church with a crown of pigmental glory."[3]

1. Lismer, Toronto, to Barbeau, Ottawa, 4 Oct. 1925, CMC, Barbeau's corr., Lismer, temp. box 28. 2. A smaller canvas of the same composition minus the halo, also titled *Quebec Village*, is in the Musée du Québec (45.29). 3. Quoted in Southam, Ottawa, to McCurry, Ottawa, 28 Sept. 1949, NGC Arch., 1.12-Watson.

100

Arthur Lismer (1885–1969)
The Mill, Quebec 1925 (see fig. 149)
Oil on canvas, 82 × 102.2 cm
National Gallery of Canada, Ottawa (5803)
Inscriptions: l.l., *A Lismer / 25*
Provenance: Purchased from the artist, Montreal, 1951.
Exhibitions: Group 1926, no. 69 *The Mill Stream, Baie St. Paul*, $600; Philadelphia 1926, no 1572 *Mill, Quebec*; Rochester 1927, no. 31 *The Mill, Quebec*; AGT Canadian 1927, no cat. no. *Mill Stream, Quebec*, $500; London 1928, no. 110 *The Old Mill, French Canada* £100; AAM Canadian 1928, no. 35 *The Old Mill, French Canada*; [Kingston OSA 1929, no cat. no. *Mill, Quebec ?*]; [Saskatoon OSA 1929, no cat. no. *Old Mill, French Canada ?*]; [Edmonton OSA 1930, no cat. no. *Old Mill ?*]; Eaton 1930, no. 46 *The Old Mill, Quebec*, $600; NGC 1931, no. 169 *Old French Mill*, $600; Atlantic City 1933, no. 31 *Old Mill, Quebec*; CGP 1933, no cat. no. *Old French Mill, Q.*, $500; Malloney Lismer 1935, no. 19 *Old French Mill, Q.*, $600; Group 1936, no. 137 *Old Mill, French Canada*.
Bibliography: Brooker 1926a, p. 279; Davies 1931a; Toronto Daily Star 10 July 1933.

Augustus Bridle (1926d) summed up Lismer's contributions to the 1926 Group show: "Lismer continues to paint as though an earthquake had tried to happen to his house on rocks. His pictures this year show far less of the blatant reds and much more of the softer browns, greens and

yellows ... He abominates just being simple. A merely tender episode in one of his pictures would cause him acute pain." The artist explained in a letter to Harold Mortimer-Lamb: "I mean to suggest the difference between the *imitative*, which is an academic idea arising mainly from reliance on such fetishes of verisimilitude as light & shade, perspective – impositions of the Renaissance – and the creative idea, which is more subjective & modern & arises from a desire to project the qualities & feelings of natural form from a conscious, organized understanding of the structure, movement (Rhythm) – balance of parts – architectural qualities – the things that give life."[1]

1. Lismer, Toronto, to Mortimer-Lamb, Burnaby, 26 June 1925, B.C. Arch., MS 2834, box 1, file 14.

101

F.H. Varley (1881–1969)
The Hon. Charles Allan Stuart, Late Chancellor of the University of Alberta 1924 (see fig. 145)
Oil on canvas, 144.5 × 124.4 cm
Central Collection, University of Alberta, Edmonton
Provenance: Commissioned by the University of Alberta, Edmonton, 1924.
Exhibitions: Group 1926, no. 110; AGT 1926, no. 196; Group 1936, no. 187.
Bibliography: Adam 1924, pp. 17–18, repr. 17; Edmonton Gateway 4 March and 14 May 1924; Stansfield 1925, p. 240; Bridle 1926d; Brooker 1926a, p. 278; Charlesworth 1926b; Telegram 12 June 1933.

In 1922, Fred Varley was commissioned to paint the portrait of Dr. Henry Marshall Tory (1864–1947), the president of the University of Alberta (Fairley 1922b, reprint; Reid 1970, 190; Adam 1923, front.). The contract was undoubtedly obtained through Barker Fairley, who taught at the university in Edmonton from 1910 to 1915. Varley painted the portrait in Toronto in 1923 (Adam 1923), and the following spring went to Edmonton to do further work on the hands. There he received a second commission, this time to paint the university's chancellor, Charles Allan Stuart (1864–1926) for $1000 (Edmonton Gateway 4 March and 14 May 1924). In the enthusiasm of the moment, Varley wrote to his wife in Toronto that "it is already a big success and I know myself it is the best painting I have ever done."[1]

A lawyer from Ontario, Stuart moved to Calgary in 1897 and was appointed to the Supreme Court of the Northwest Territories in 1906 and of Alberta in 1907. He was elected chancellor of the University of Alberta on its establishment in 1908. The portrait was presented to the university at Convocation, 15 May 1924 (Edmonton Gateway 14 May 1924).

1. Varley, Edmonton, to Maud Varley, Toronto, April 1924, transcription in McMichael Coll., C. Varley's research notes.

102

F.H. Varley (1881–1969)
Evening in Camp 1923 (see fig. 156)
Oil on canvas, 76.8 × 66 cm
Power Corporation of Canada
Inscriptions: l.r., *VARLEY* (with fingerprint)
Provenance: Roberts Gallery, Toronto. Laing Galleries, Toronto; Lawrence T. Porter, St. Andrews

East, Quebec 1959; Joyner Fine Art Inc., Toronto, 25 Nov. 1987, lot 31.
Exhibitions: Group 1926, no. 116, $750; [Edmonton 1926, *Camp Group* ?]; Group 1936, no. 199 *Summer Night in Camp*, $400.
Bibliography: Charlesworth 1926b.

Varley's most tender family study shows his wife, Maud, his young son, Peter, and his elder daughter, Dorothy, by a campfire. The canvas was painted while they camped out on the property next to the cottage of E.J. Pratt and his family at Bobcaygeon in 1923. Having defaulted on their mortgage payments, and with their Toronto house reclaimed, that summer they faced an uncertain future.

103
F.H. Varley (1881–1969)
Lake Shore with Figure 1922–23 (see fig. 136)
Oil on canvas, 100 × 69.9 cm
Private collection
Inscriptions: l.l., *F.H. / Varley / 22–23*
Provenance: Ernest Ely, Toronto, by 1936; by descent.
Exhibitions: U.S. Tour 1923–24, no. 30 *Landscape and Figure*, $750; Group 1926, no. 117 *Lake Shore with Figure*, $750; AGT 1926, no. 193, $750; Buffalo 1928, no. 53 *Landscape with Figure*, $600.
Bibliography: Charlesworth 1926b.

Hector Charlesworth (1926b), always reserved about the Group's landscapes, admired Fred Varley's figure works: "Varley's drawing is almost invariably effective, especially in portraiture, though he is less successful in handling accessories. This is particularly true of *Lake Shore with Figure*, in which the kneeling woman is a first-rate bit of painting." Not only is the figure wonderfully successful but the rocks and sky are painted with a gentle lyricism which effectively evokes and complements the serenity of her pose.

According to Peter Varley (1983, 95), this canvas was given to Ernest Ely to pay for a new suit when his father ripped his pants slipping off a ladder while working on the decorations at St. Anne's Church.[1]

1. The painting is reproduced in P. Varley 1983, p. 95, as *Rocky Shore*, yet Charlesworth's description accords rather to this painting. In 1935 Varley listed this painting as *Figure with Landscape*, noting that his portrait of *Vera* (cat. 156) had been stretched over it. Varley, Vancouver, to Brown, Ottawa, 7 Dec. 1935, NGC Arch., 5.5-Group of Seven 1936. See also cat. 56.

104
George Pepper (1903–1962)
Sunflowers 1925 (see fig. 160)
Oil on wood, 30.2 × 26.3 cm
Private collection
Inscriptions: l.r., *PEPPER 25*
Provenance: Acquired from the artist.
Exhibitions: RCA 1925, no. 173; Group 1926, no. 171.

The 1926 Group show was the first occasion on which such a large number of invited contributors exhibited – nine. Of the four graduates of the Ontario College of Art, John Alfsen, George Pepper, Tom Stone, and Lowrie Warrener, Pepper sent in the most works. His eight small paintings included a study of a gypsy camp in the south of France, a winter street in Ottawa or Hull, boat houses on the Ottawa river, and his small decorative study of sunflowers. Pattern and colour are the key interests.

In including the work of these artists, the Group extended support to younger painters. For Bridle (1926c) they were "the embryo school of seven Alpinists who are as yet only in the foothills." Countered Fred Housser (1926c, 179): "All of these contributors … evidently are taking art more seriously than their critics."

105
Lowrie Warrener (1900–1983)
Bats Fly Merrily 1925 (see fig. 159)
Oil on board, 27.6 × 38.1 cm
Gallery Lambton, Sarnia
Inscriptions: l.r., *Lowrie Warrener*; verso: u.r., *$50. / 1*; u.l., *Bats Fly Merrily / Nor.Ont.1925 / Bats Fly Merrily / L.L.W.1925 / French River Area*; c., *The Bats / Fly Merrilly*
Provenance: Estate of the artist.
Exhibitions: Group 1926, no. 184; Hart House, *Lowrie Warrener Exhibition*, 2–16 April 1927, no. 35, $60.

Pattern and colour characterize this small painting by Lowrie Warrener. While depicting one of the numerous cabins on the French River where Warrener camped in 1925, it is as far from a literal description as Arthur Lismer would have wished and is intended to express mood and emotion rather than place.

106
Franklin Carmichael (1890–1945)
In the Nickel Belt 1928 (see fig. 163)
Oil on canvas, 101.8 × 122 cm
The Ottawa Art Gallery, Firestone Art Collection
Inscriptions: l.r., *FRANK / CARMICHAEL / 1928*
Provenance: Laing Galleries, Toronto; O.J. Firestone, Ottawa.
Exhibitions: Group 1928, no. 5, $750; Group 1936, no. 18.
Bibliography: Jacob 1928a.

Frank Carmichael's submissions to the 1928 show were welcomed by Fred Jacob (1928a): "A steady gain in strength marks the work of Frank Carmichael. He has deliberately given up the purely decorative, in which he used to excel, and is now setting himself to the interpretation of grim features of Canadian life. He has put plenty of forbidding feeling into *In the Nickel Belt* and power in *Old Lime Kilns*. At one time, one felt that Carmichael lacked originality, both in method and subject, but he gains steadily in individuality."

The industrial subject matter of Lawren Harris's *Miners' Houses, Glace Bay* (fig. 161) and of Arthur Lismer's *A Northern Town* (fig. 121) takes on a very different character in this panoramic landscape. The smoke from the smelters near Sudbury rises up in a swirling curve against a backdrop of falling rain. The message is both ambiguous and evocative.

107
Franklin Carmichael (1890–1945)
Evening, North Shore, Lake Superior 1927 (see fig. 184)
Oil on canvas, 101.5 × 121.7 cm
Montreal Museum of Fine Arts (1959.1211), purchase, Robert Lindsay Fund, 1959
Inscriptions: l.r., *FRANK / CARMICHAEL / 1927*
Provenance: Estate of the artist; Laing Galleries, Toronto.
Exhibitions: Group 1928, no. 6 *Evening, North Shore, Lake Superior*, $750; [Saskatoon 1928, no. 56 *Evening, Lake Superior* ?]; [Buffalo 1928, no. 56 *Evening*, $850 ?]; AFA

(1) 1930, no. 3 *Evening, Lake Superior*, $850; Roerich 1932, no. 2; Group 1936, no. 22.
Bibliography: J. Adeney 1928b, p. 43; Bridle 1928a; Rainey 1930; Harrold 1933a.

The critics differed in their estimation of Frank Carmichael's new work and of the obvious influence on it of Lawren Harris's paintings. The year before Fred Jacob (1927b) had wondered if the latter gave credence to warnings about the dangers of the 'Group idea' but this year Augustus Bridle (1928a) was enthusiastic: "The world of the Group is deserted and silent. Not even a bird disturbs the solitudes. The lakes gleam into the distance, almost into infinity. Some of Carmichael's waterscapes have a wonderful silvery vibration of light. He seems to have abandoned most of his earlier opulence of colour in detail and is now, in at least two of his pictures, a near-Harris. In one he has the identical Harris motif of three weird old stubs polished to resemble elephant tusks. But he has a lovely texture in his mossy hummocks; real moss – which some day as he develops this particular stylization may become only a surface of unearthly texture."

108
A.J. Casson (1898–1992)
Mill Houses 1928 (see fig. 164)
Oil on canvas, 76.2 × 92.1 cm
Agnes Etherington Art Centre, Queen's University, Kingston, gift of Mr. and Mrs. Duncan MacTavish, Ottawa, 1955
Inscriptions: l.r., *A.J. CASSON*
Provenance: The artist, Toronto; *Canadian National Committee of Refugees (Ottawa Branch) Exhibition and Auction of Canadian Paintings* (NGC, 10 Oct. 1940), no. 15, sold to H.S. Southam, Ottawa; Mr. and Mrs. Duncan MacTavish, Ottawa.
Exhibitions: OSA 1928, no. 14, $250; Buffalo 1928, no. 8; NGC 1929, no. 22; AFA (1) 1930, no. 9, $300; AFA (2) 1930, no cat. no., $300; Malloney Jackson 1935, no. 2; Group 1936, no. 29.
Bibliography: Ottawa Evening Journal 22 Jan. 1929; Jacob 1928c; La Revue Populaire June 1930, repr. 69.

A.J. Casson exhibited six canvases in the 1928 Group show, including *Housetops in the Ward*, a bird's-eye view of patterned, snow-covered roofs (repr. Murray 1994a, pl. 85). He adopts the same perspective in this intimate scene of mill houses with a stream meandering across the canvas.

109
A.J. Casson (1898–1992)
October 1928 (see fig. 183)
Oil on canvas, 94 × 114.3 cm
Central Collection, University of Alberta, Edmonton
Inscriptions: l.r., *A.J. CASSON*
Provenance: The artist, Toronto; purchased from Saskatoon 1930; presented to the Normal School, Edmonton, by the Class of 1930–31.
Exhibitions: Group 1928, no. 7, $450, repr.; CNE 1928, no. 335, $450; AAM Canadian 1928, no. 14; NGC 1929, no. 23; AFA (1) 1930, no. 8, $400; Saskatoon 1930, no. 20, $350.
Bibliography: J. Adeney 1928b, p. 43; N. Harris 1928a, repr.; B.H.S. 1928, repr. 17; Brooker 1929a, p. 256, repr. 257; Davies 1932, repr. 22.

Reproduced in the catalogue of the 1928 Group show, *October* is one of Casson's most lyrical and luminous canvases. The play of light,

arrangement of clouds, and transparent colour evoke a spirit of delight.

110
Lawren S. Harris (1885–1970)
From the North Shore, Lake Superior c. 1927
(see fig. 154)
Oil on canvas, 121.9 × 152.4 cm
London Regional Art and Historical Museums (40.A.12), gift of H.S. Southam, Ottawa, 1940
Provenance: The artist, Hanover, N.H.; H.S. Southam, Ottawa, 1937.
Exhibitions: Group 1928, no. 20 *Lake Superior III*; Buffalo 1928, no. 18; OSA 1929, no. 98 *Lake Superior, no. 3*; Group 1936, no. 79 *Hills on Lake Superior*.
Bibliography: Choate 1929.

All the critics were struck by Lawren Harris's paintings in the 1928 Group show, though frustrated by his numerical titling. "His offerings run as follows: Mountains I; Mountains II; Lake Superior I; Lake Superior II; Lake Superior III ... but perhaps it would puzzle even the ingenuity of Mr. Harris to give his productions a more descriptive title," complained the *Telegram* (18 Feb. 1928). Fred Jacob (1928a) observed that "the person who is not in tune with the artist's spiritual conception, cannot possibly find a meaning in them." But Augustus Bridle (1928a) found in this the very strength of Harris's contribution: "Many of [his] triumphant cosmogonies of colour are mainly symbolic ... [One] of his uses the earth as only the invisible end of a cloudscape. In these beautiful masses of colour there is the gleam of what comes after death. Einstein seems to have had a hand in some of them; they suggest the fourth dimension as a reality. The catalogue titles mean nothing. Most of them might as well be called by algebraic symbols ... Space and time to Harris are the mother of colour and form."

When exhibited at the OSA the following year, the painting was described by the *Mail and Empire's* new critic (Choate 1929): "Rays of lemon yellow, streaking through three banks of clouds, gleam on a central strip of water." Like an opening blossom, the cloud-petals spread, revealing the celestial light. Harris's Lake Superior canvases of the second half of the decade reveal a new synthesis and serenity, a resolution after the turmoil of Glace Bay.

This painting, identified by Harris in 1935 as *Lake Superior I*,[1] was exhibited in the 1936 Group retrospective as *Hills on Lake Superior*,[2] catalogued as *Lake Superior III (Lake Superior Painting 9)* by Doris Mills in 1936,[3] and sold to H.S. Southam of Ottawa in 1937 as *Lake Superior III*.[4] Harris's paintings in the 1928 Group show were not priced, and the identification here of this painting as *Lake Superior III* is based on the above information. A canvas from the Massey collection in the National Gallery (15477), previously catalogued as *Lake Superior III*, was exhibited in Massey 1934, no. 110, as *Lake Superior II*.[5]

1. Harris, Hanover, N.H., to Brown, Ottawa, 9 Dec. 1935, NGC Arch., 5.5-Group 1936. 2. Confirmed by installation photograph and annotated catalogue with dimensions. 3. "The Paintings of Lawren Harris compiled by Mrs. Gordon Mills July–Dec. 1936," typescript with sketch drawings; priv. coll. 4. Outward shipping form, dated 10 Aug. 1937, NGC Arch., 9.9-Trustees Southam 1937–38 file 4. 5. See

memo of 29 June 1994, NGC curatorial file for acc. 15477.

111
Lawren S. Harris (1885–1970)
Northern Lake II c. 1926 (see fig. 172)
Oil on canvas, 81.3 × 101.6 cm
Private collection
Inscriptions: stretcher: u.l., label, *LAWREN HARRIS / NORTHERN LAKE #2 / Property ... / Return BE ... MCLAUGHLIN / 150 ...*; u.r., torn label, *... ORIOLE PARKWAY, TORONTO / NOT FOR SALE*; u.l., *CANADA / CANADIAN ART 1926*; u.r., *Northern Lake 32 × 40 / Lawren Harris / Northern Painting*; label, ART GALLERY OF TORONTO / Artist *Lawren Harris* / Title *Northern Lake, Autumn* / cat. 27 Date *Oct.Nov./48* / Collection *Miss Esther Williams, Toronto*
Provenance: The artist, Toronto; Esther Williams, Toronto, after 1936. Kenneth G. Heffel Fine Art Inc., Vancouver, by 1980; present owner.
Exhibitions: Group 1928, no. 24; NGC 1929, no. 58; Group 1936, no. 71.
Bibliography: Jacob 1928a.

Lawren Harris's constant development and logical refinement challenged the Toronto reviewers. "In the present show," wrote Jacob (1928a), "it is not easy to feel that the latest phases of Lawren Harris are his strongest phases. A few years ago he did strange luminous studies of water, the stretches of Lake Superior, that seemed to epitomize loneliness. Now he is using the same colour treatment over and over again for mountains, lakes and fantasies, and his simplification destroys almost all realism. Some of his pictures, like *Northern Lakes*, are decorative and others, like *A Fantasy*, are pure abstractions ... It may be safely said that Lawren Harris has never been more deliberately difficult. That his present phase will have justified itself in the next decade, I should not like to predict."

Northern Lake II is one of two decorative canvases that hung in Harris's house in Toronto (see fig. 188), both of which were on loan to Isabel McLaughlin in Toronto after Harris left for Hanover, New Hampshire. He described this painting as "the one in soft greys, soft yellows and brown blacks and silver grey tree tumbles running up left side ... *Northern Lake* suggests a silvery grey day with no sunlight, the design is lyrical."[1]

1. Harris, Hanover, N.H., to Brown, Ottawa, 2 Feb. 1936, NGC Arch., 5.5-Group 1936. The other canvas is in the McMichael Canadian Art Collection, Kleinburg, Ont. (1968.7.5), gift of R.S. McLaughlin, Oshawa.

112
A.Y. Jackson (1882–1974)
Labrador Coast 1930 (see fig. 144)
Oil on canvas, 125.7 × 152.4 cm
Hart House Permanent Collection, University of Toronto
Inscriptions: l.r., *AY JACKSON*
Provenance: Purchased from the artist, Toronto, with the income from the Murray and Harold Wrong Memorial Fund, 1942.
Exhibitions: AFA (1) 1930, no. 32, $1000; RCA 1930, no. 94, repr.; NGC 1931, no. 137, $800; AGT Harris-Jackson 1931, no. 348.
Bibliography: Rainey 1930; L. Mechlin 1930, p. 267; Salinger 1930p, p. 102; Comfort 1930, p. 7, repr. 4; Mail and Empire 8 Nov. 1930; C.C. MacKay 1930b, p. 2;

Brooker 1928–30, 22 Nov. 1930; J. Adeney 1931a; Lyle 1931, p. 8, repr. 6.

Worked up from a sketch painted on his 1927 trip to the Arctic with Dr. Banting, this large painting is probably not the $400 *Labrador Coast* A.Y. Jackson exhibited in the 1928 Group show. This canvas was, however, shown in the Canadian exhibition at the Corcoran Gallery in Washington in the spring of 1930,[1] and subsequently at the RCA where it was lauded by Jehanne Biétry Salinger (1930p, 102): "In landscape painting, the massively lyrical *Labrador Coast* by A.Y. Jackson gave us enough joy to make us overlook many of the sins committed in the name of art in that class of work ... There was nothing in the show to compare with the intense rhythm and majestic style of *The Labrador Coast*." The architect John Lyle (1931, 8) disagreed: "Jackson is always on the lookout for rhythm in his compositions – there is even what might be termed the music of line strongly in evidence, but why does Mr. Jackson exaggerate to the nth degree, as he does in this picture, the scheme of movement which he has adopted as his *parti*. Surely simplicity and straightness of line have also their appeal as contrasting elements to that of rhythmic line. This picture would have gained tremendously by the introduction of contrasting planes and lines ... I have another quarrel with Mr. Jackson in the monotony of his colour. The dull yellows and browns of many of his landscapes do not impress me as being either true, interesting or beautiful."

1. Size and price are given in lists in AGO Arch., A3.8.2-General Corr. 1931-Exhibition AFA 1931.

113
A.Y. Jackson (1882–1974)
Early Spring, Quebec c. 1927–28 (see fig. 148)
Oil on canvas, 53.3 × 66 cm
Art Gallery of Ontario, Toronto (135), gift from the Canadian National Exhibition, 1965
Inscriptions: l.l., *A Y JACKSON*
Provenance: Exchanged by the artist, Toronto, 1929, for *Cacouna*, purchased by the CNE, 1921.
Exhibitions: [Buffalo Jackson 1928, no. 10, $300 ?]; Group 1928, no. 33, $250; [Saskatoon 1928, no. 46 ?]; [Western Tour 1928–29, no. 22 *Early Spring*, $300 ?]; AAM 1929, no. 113 *Early Spring in Quebec*.
Bibliography: Jacob 1928a; Burgoyne 1929a; Morgan-Powell 1929b; Lismer 1930b, pp. 19–20; Robson 1932, repr. 209.

Reminiscent of Morrice's work, in the painting the muddy road leads us directly into the composition. Instead of Morrice's pearly pinks, however, A.Y. Jackson offers us a brown, overcast day only slightly brightened by the pale blue reflections on the snow and water. On occasion refined and elegant, it was almost as if Jackson deliberately set out to suppress this side of his art to achieve a certain austerity and vigour.

When this canvas was exhibited at the Spring Exhibition in Montreal in 1929, St. George Burgoyne (1929a) of the *Gazette* described the "tumble-down houses and a muddy undulating road up a steep ridge." Bridle (1928a) summed up Jackson's 1928 submissions to the Group show: "Some of his smaller [paintings] have a phenomenal sense of coldness, distance and inhabitation. He still uses

detail. When he paints a road it actually feels as though somebody had gone over it, and his houses look as though once they had been warm inside."

114
A.Y. Jackson (1882–1974)
Indian Home 1927 (see fig. 150)
Oil on canvas, 53.8 × 66.5 cm
Robert McLaughlin Gallery, Oshawa, gift of Isabel McLaughlin, 1987
Inscriptions: l.r., *A.Y. JACKSON*
Provenance: The artist, Toronto; Isabel McLaughlin, Toronto, 1933.
Exhibitions: Group 1928, no. 39, $350; London 1928, no. 117 *Indian Home (British Columbia)*; AAM Canadian 1928, no. 31; NGC 1929, no. 79, $400; AFA (2) 1930, no cat. no. *Indian House*, $300; Roerich 1932, no. 31; Group 1936, no. 125 *Indian Home* (incorrectly listed as property of the artist).
Bibliography: Brooker 1929a, p. 238, repr. 239.

A.Y. Jackson painted at least six canvases[1] from studies made during his trip to the Skeena River in 1926. Both the preparatory drawings in the National Gallery (17459, 17475, and 17486) and the oil sketch (fig. 151) show this house at Port Essington at the mouth of the Skeena with the mountains in the distance. There are no totem poles in the studies.[2] The painting is constructed to include generalized poles, similar to those he drew at Kispiox farther down the river, and he has centred the mountains behind the house. Free from the need to produce a documentary image, he delights in the treatment of the sky and foreground foliage.

1. At the 1927 show of West Coast art, Jackson exhibited *Gitsegyukla Village* (McMichael Canadian Art Collection, 1968.8.27), *Totem Poles, Hazelton* (collection unknown), and *Kispayaks Village* (cat. 115). He lists *Night, Skeena River* in a Montreal collection in 1933. In 1943 he painted a work titled *Souvenir of Kispayaks* (collection unknown). 2. My thanks to Sandra Dyck for bringing this to my attention.

115
A.Y. Jackson (1882–1974)
Kispayaks Village 1927 (see fig. 138)
Oil on canvas, 63.5 × 81.3 cm
Art Gallery of Greater Victoria (84.49), gift of David N. Ker, 1984
Inscriptions: l.r., *A Y JACKSON*
Provenance: The artist, Toronto; Dominion Gallery, Montreal, 1948. David N. Ker.
Exhibitions: West Coast Art 1927, no. 44; Buffalo 1928, no. 30 *Indian Village*; [Saskatoon OSA 1929, no cat. no. *Indian Village in B.C.* ?]; [Edmonton OSA 1930, no cat. no. *Kispiox on the Skeena* ?].
Bibliography: Barbeau 1928a, repr. opposite p. 70; Leechman 1928, repr. 333; Rochester Democrat and Chronicle [Nov. 1928], repr.; Barbeau 1932a, repr. 332.

Kispayaks Village was included in the 1927 exhibition of West Coast art, but amid the general interest in the aboriginal art and the works of Emily Carr, A.Y. Jackson's canvases went largely unnoticed. Related drawings in the National Gallery (17546, 17547) document the homes and poles, and the more faithful interpretation of the actual site in the painting may have been a reason for Marius Barbeau choosing it to reproduce in *The Downfall of Temlaham*.

116
Arthur Lismer (1885–1969)
Evening Silhouette, Georgian Bay 1928 (see fig. 155)
Oil on canvas, 80.3 × 100.8 cm
University College, University of Toronto, gift of H.S. Southam, Ottawa, c. 1948
Inscriptions: l.r., *A Lismer 28*
Provenance: The artist, Toronto; H.S. Southam, Ottawa, 1936.
Exhibitions: Group 1928, no. 47, $600, repr.; Calgary 1929, no. 93, $600; Roerich 1932, no. 35 *Evening – Georgian Bay*; Malloney Lismer 1935, no. 31 *Evening Silhouette, Georgian Bay* $600; Group 1936, no. 148.
Bibliography: J. Adeney 1928b, p. 43; N. Harris 1928a, repr.; Brooker 1929a, 248, repr. 249.

Fred Jacob (1928a) complained of Arthur Lismer's "restlessness," and Augustus Bridle (1928a) wondered if he wasn't "passing through a phase of sin in paint to come out presently stainless and serene like Harris." Yet in this painting Lismer vies with the expressive drama of Lawren Harris's *Ontario Hill Town* (cat. 95) in one of his most simple and concentrated paintings of Georgian Bay. When submitted for the 1928 RCA exhibition, it was refused by the jury.[1] Bertram Brooker admired it greatly, however, reproducing it in his *Yearbook* and acquiring one of the three related oil sketches for his own collection.[2]

1. Entry form for NGC 1929, NGC Arch., 5.5-Annual 1929. 2. Now in the McMichael Canadian Art Collection (1966.16.108). One other oil sketch is in the McMichael collection (1970.17.1), and one in a private collection. They were painted on Pine Island, Georgian Bay, in 1926.

117
Arthur Lismer (1885–1969)
Pines, Georgian Bay 1927 (see fig. 199)
Oil on canvas, 107.5 × 125 cm
University of Saskatchewan, Saskatoon
Provenance: Purchased from Saskatoon 1928.
Exhibitions: OSA 1927, no. 65, $600, repr.; CNE 1927, no. 160 *Pine Island*, $600, repr.; RCA 1927, no. 124 *Pines, Georgian Bay*, repr.; NGC 1928, no. 88; Saskatoon 1928, no. 48.
Bibliography: Grier 1927; Bridle 1927b; Telegram 18 March and 27 Aug. 1927, repr.; Toronto Daily Star 27 Aug. 1927; Laberge 1927; R.B.F. 1928a.

Dr. Walter Murray, the president of the University of Saskatchewan, took a keen interest in the work of Saskatchewan artists from the time of his arrival in Saskatoon from Halifax in 1908. His interest was no doubt intensified by his friendship with Norman Mackenzie of Regina, who wrote in 1914: "I am particularly fond of pictures and the pathetic attempts of travelling salesmen to inflict daubs on the respective Western towns makes me rather anxious to take advantage of anything good that comes our way, and goodness knows up to date this part of Canada has not had much opportunity to study art or collect pictures."[1] Murray first offered his support to Inglis Sheldon-Williams, Gus Kenderdine, and James Henderson, and in 1924 he purchased for the university two oil sketches by Lawren Harris and a small A.Y. Jackson canvas, *Mountain Ash*.[2] The university continued to collect over the next few years and, in 1928, from the Group show at

Nutana Collegiate, Murray purchased Lismer's *Pines, Georgian Bay*, the only sale.

When it was exhibited in the 1927 OSA exhibition, Bridle (1927b) described this painting as "the one with the dinosaurian trees trying to hold back a frontal attack of fawn-coloured clouds, with the insignificant horizon and a river away down near the bottom. So you look awhile. Which is the idea."

1. Mackenzie, Regina, to Murray, Saskatoon, 9 Jan. 1914, University of Saskatchewan Archives, Saskatoon, Presidential Papers Series I A–45. 2. OSA Minute Book 1916–31, 2 Dec. 1924, Arch. of Ont., MU2255. Canadian Bookman Jan. 1925 erroneously states fifteen sketches were purchased by the university from Small Pictures 1924.

118
F.H. Varley (1881–1969)
Red Rock and Snow 1927–28 (see fig. 176)
Oil on canvas, 86.5 × 101.9 cm
Power Corporation of Canada
Inscriptions: l.l., *F.H. Varley*
Provenance: John Vanderpant, Vancouver; by descent. Walter Klinkhoff Gallery, Montreal; purchased 1967.
Exhibitions: Group 1928, no. 61; Buffalo 1928, no. 52, $600; NGC 1931, no. 262; NGC Willingdon Arts Competition [Feb.] 1931.
Bibliography: Vancouver Daily Province 2 Dec. 1932.

During his first decade in Canada Fred Varley was primarily interested in painting figures. The Ontario landscape did not captivate him as that of British Columbia would, and before his departure he wrote: "My main object in going West is because I have the opportunity for study. I have not experimented for years & I want badly to try out many adventures in paint that have been caged in too long."[1] In July 1927 he and some art school students camped in Garibaldi Park in British Columbia, the experience fondly described by one camper: "Chill mists hang draped on Panorama Ridge and the East Bluff. The Castle Towers, the Sentinel, and Garibaldi itself loom in solemn array around the still lake. A cool breeze drifts down from Mimulus Creek, stirring the tree tops, and inspiring the quiet column of smoke from the campfire to activity. A few lone mosquitoes float above the camp, numb with the cold air" (Cianci 1928b, 44).

Stimulated by the new experiences and the landscape, Varley sent fifteen oil sketches and four remarkable canvases to the 1928 Group show: *Early Morning, Sphinx Mountain*; *The Cloud*; *Red Rock and Snow*; and *Mimulus, Mist and Snow*.[2]

1. Varley, Toronto, to Brown, Ottawa, 17 Aug. 1926, NGC Arch., 7.1-Varley. 2. Varley, Vancouver, to Brown, Ottawa, 18 Feb. 1928, NGC Arch., 7.1-Varley. Only eight sketches were included in the catalogue.

119
F.H. Varley (1881–1969)
Mimulus, Mist and Snow 1927–28 (see fig. 187)
Oil on canvas, 69.6 × 69.6 cm
London Regional Art and Historical Museums (72–A.117), gift of the Women's Committee and Mr. and Mrs. Richard Ivey, 1972
Inscriptions: l.r., *VARLEY*
Provenance: Estate of the artist; Jerrold Morris Gallery, Toronto, 1972.

Exhibitions: Group 1928, no. 62, $500; Buffalo 1928, no. 54 *Mist and Snow*, $500.
Bibliography: Telegram 18 Feb. 1928; Brunke 1928.

Of the four mountain canvases Varley exhibited in 1928, *Mimulus, Mist and Snow* was the smallest and the boldest in its abstraction of forms and use of colour. The mimulus and rocks are mere swirls of colour, which led one indignant visitor (Brunke 1928) to the 1928 Group exhibition to write in consternation: "I tried to make out this one myself last week and it only appealed to me as a mess of Chili sauce. It does seem a shame that the Art Gallery permits the hanging every year of this mess of 'Art' ... One wall would serve to show their ideas without having to clutter up the entire gallery with such exhibits."

120

Bertram Brooker (1888–1955)
Sounds Assembling 1928 (see fig. 167)
Oil on canvas, 91.7 × 112.3 cm
Winnipeg Art Gallery (L–80)
Provenance: The artist, Toronto; purchased by the Winnipeg School of Art, 1945.
Exhibitions: Group 1928, no. 65; Hart House, *Bertram Brooker Exhibition*, 14–30 March 1931.
Bibliography: N. Harris 1928a; Bridle 1928a; Jacob 1928a; Telegram 18 Feb. 1928; Salinger 1930n.

Bertram Brooker exhibited two canvases in the 1928 Group show, *Sounds Assembling* and *The Pinnacle*. Bridle (1928a) provided the most expressive description of the paintings: "The guest exhibitors are of varying degrees of insurgency; some of them still quite conventional – even to painting heads, houses and fences. Brooker is the only one who expresses the merely subjective. One of his is a peak of something between a gigantic ice cream cone and a new Broadway skyscraper: poles of light; the other what looks like a vast set of torpedo tubes supposed to represent something in music." Fred Jacob (1928a) recognized the relationship to Lawren Harris's paintings: "In the movement towards abstractions, Mr. Harris seems to have taken exactly the opposite path to other artists. He takes the material and transforms it into the nebulous. How different from Mr. B. Brooker. His painting *Sounds Assembling* gives form and shape to the abstract conception of what affects the ear. It is an ultra-modern conception of a picture, but clever and understandable. Mr. Brooker makes an abstraction of the unseeable; but Mr. Harris takes mountains and extracts from them their awe, presenting something almost like ghosts of mountains, remote and intangible."

The brass frame was made for the painting by Emanuel Hahn,[1] who acquired Brooker's *The Pinnacle*.[2]

1. Brooker, Toronto, to FitzGerald, Winnipeg, 20 Sept. 1945, UM FitzGerald, box 7. 2. Information from Mrs. Qennefer Browne. Present whereabouts unknown.

121

Charles Comfort (1900–1994)
Prairie Road 1925 (see fig. 197)
Oil on canvas, 116.8 × 86.4 cm
Hart House Permanent Collection, University of Toronto
Inscriptions: l.r., *Comfort '25*

Provenance: The artist, Toronto; gift of the Graduating Class of 1931.
Exhibitions: RCA 1925, no. 36 *Out West*; CNE 1926, no. 17a, $200; Group 1928, no. 67; Kingston OSA 1929, no cat. no.; Saskatoon OSA 1929, no cat. no.; Edmonton OSA 1930, no cat. no.; AFA (1) 1930, no. 10 *The Prairie Road*, $400; NGC 1931, no. 48.
Bibliography: Canadian Bookman Sept. 1926; J. Adeney 1928b; Jacob 1928a; Brooker 1928–30, 7 Sept. 1929; L. Mechlin 1930, p. 268.

First exhibited as *Out West*,[1] this painting's "extraordinary colour" (Jacob 1928a) was lauded by reviewers of the 1928 Group show. Wrote Jeanne Adeney (1928b, 44): "Outside the Group of Seven the strongest Canadian painter is, undoubtedly, Charles Comfort. No less modern than theirs, his work bears a living message and is warmly appreciated by public and critics alike. Because it fell to the lot of the Group of Seven to break with old traditions in Canada, and because Charles Comfort painted after this break and outside the Group, it may be his destiny to reap a harvest of their sowing. At any rate he seems to see his way clearly before him, unclouded by doubts, and his painting is a joy to the beholder. What can one say of that barren road in *Out West*, changed to a riot of glory by the setting sun?"

1. The change of title is documented in Comfort's "Chronological record of paintings," NAC, MG30 D81, box 21.

122

Edwin Holgate (1892–1977)
Lumberjack 1924 (see fig. 178)
Oil on canvas, 64.8 × 54.6 cm
Gallery Lambton, Sarnia, donated by the Sarnia Women's Art Association, 1956
Inscriptions: l.r., *E. Holgate*
Provenance: The artist, Montreal; A.Y. Jackson, Toronto, 1927; Women's Art Association, Sarnia 1928.
Exhibitions: RCA 1924, no. 93; Wembley 1925, no cat. no.; Paris 1927, no. 76 *Le bûcheron*, repr.; RCA 1927, no. 90 *Lumberjack*, $200, sold to A.Y. Jackson; Group 1928, no. 72, repr.; Saskatoon 1928, no. 62; Edmonton 1928, no. 36; AFA (1) 1930, no. 26, repr., loaned by the Women's Art Association, Sarnia; Group 1936, no. 96, repr.
Bibliography: Eric Brown 1927a, repr. 189; René-Jean 1927a, repr.; Denoinville 1927; Letondal 1927, repr.; Grier 1928, p. 23; N. Harris 1928a; Norbury 1928; Brooker 1929a, pp. 62, 85; Canadian Observer 12 April 1929; La Revue Populaire Jan. 1930, repr. 9; Art Digest mid–March 1930, repr. 5; Toronto Daily Star 20 March 1930, repr. 23; Salinger 1930L, repr. 6; L. Mechlin 1930, p. 270, repr. 265; Emmart 1930; Chicago Tribune 18 May 1930, repr. 8; Art News 7 June 1930, p. 6, repr. 8; St. Louis Post-Dispatch 27 July 1930, repr.; Davies 1932, repr. 19.

When Edwin Holgate returned from Paris in the summer of 1922 he painted a number of figure studies that reflected his interest in form and structure as derived from the work of Paul Cézanne. He was invited to participate in the exhibition the Group sent to the United States in 1923, but both Fred Varley and Lawren Harris objected to the inclusion of his paintings *Portrait* and *The Cellist*.[1] In sending their work abroad, they wanted an art that spoke of a distinctly Canadian experience. It was in 1924 that Holgate

began to treat Canadian "types" such as lumberjacks and loggers, first in woodcuts and then in his painting *Lumberjack*. In texture, colour, line, and density of composition there is an immediacy and directness in this work that reflects the Canadian character as defined by Harris (1928, 4): "This spirit is not precise: it lacks detail and finish, and is therefore considered somewhat crude by people polished with imported brushes."

1. Jackson, Baie-Saint-Paul, to N. Thomson, Toronto, postmarked 20 Sept. 1925, NAC MG30 D322, vol. 1, Jackson 1925.

123

Bess Housser (1890–1969)
Laurentian Village c. 1928 (see fig. 185)
Oil on canvas, 92.5 × 115.5 cm
Hart House Permanent Collection, University of Toronto
Inscriptions: l.r., *Bess Housser*
Provenance: Purchased from the artist, Toronto, 1931.
Exhibitions: [Group 1928, no. 73 *A Quebec Village*?]; [Saskatoon 1928, no. 64?]; [NGC 1929, no. 75, $300?]; [Detroit 1929, no. 83?]; AFA (1) 1930, no. 28 *Laurentian Village*, $300, repr.; AFA (2) 1930, no cat. no., $350.
Bibliography: N. Harris 1928a; Ottawa Evening Journal 22 Jan. 1929; Salinger 1930L, p. 9; Emmart 1930; Davenport Democrat 12 Dec. 1930; Davenport Daily Times 12 Dec. 1930.

Bess Housser began painting in 1924 at the instigation of Doris Mills. The two artists had an exhibition of their work, with Doris's sister Marion Huestis, at the Women's Art Association in Toronto in June 1925. One anonymous reviewer was quoted in the *Canadian Bookman*: "None of these ladies had handled a brush previous to a year ago. The results are both remarkable and significant ... The technical achievement alone is unusual ... There is no fumbling or awkwardness in the handling of the paint to interfere with the contemplation of the mood ... From viewing these pictures it would seem that women with something beautiful to express arrive at a clarity and serenity and easy spaciousness that is impossible to a man ... They seem to open a world of creative adventure peculiar to women ... They ... achieve an inner strength by fine feeling, by a conviction of beauty that relies almost solely on spirit rather than structure ... In a word these pictures are subjective and they equal, if they do not surpass, any similar attempts in that direction made in Canada" (quoted in B. Housser 1925f).

Housser exhibited two canvases in the 1928 Group show, *An Island, Lake Superior* and *A Quebec Village*,[1] the latter described by the *Telegram*'s writer as "a Quebec village in which very heavy masses of green bring out folding meadows to produce unconventional colour and pattern" (N. Harris 1928a). When shown in Ottawa it was praised for its achievement of "the real Canadian Winter atmosphere" (Ottawa Evening Journal 22 Jan. 1929). For this reason it is not certain whether this canvas was the one shown in 1928.

1. The 1928 Group canvas was the same size as this painting. See Bess Housser, entry form, NGC Arch., 5.5-Annual 1927.

124
Thoreau MacDonald (1901–1989)
Pine Tree Madonna 1926 (see fig. 186)
Oil on canvas, 30.4 × 25.7 cm
Private collection
Inscriptions: l.l., *THOREAU MACDONALD '26*; back of frame: u.l., on label, *PINE TREE MADONNA / by / THOREAU MACDONALD / GROUP OF SEVEN EXHIBITION Toronto Art / Gallery, February / 1928*, u.c., on label, *Manoir Richelieu Art Exhibition / 10 × 12" $250. / Pine-Tree Madonna*, u.r., on label, *Pine-Tree Madonna / Thoreau MacDonald*
Provenance: Doris Huestis Mills, Toronto, by 1931.
Exhibitions: Group 1928, no. 77, $150; Manoir Richelieu 1930, no. 345, $250.
Bibliography: N. Harris 1928a.

Thoreau MacDonald had been doing graphic work for a number of years when he exhibited his first paintings at the 1926 Group show. In 1928 he showed two religious works, *Winter Evening with Mary and Jesus* and *Pine Tree Madonna*. Critics appreciated their strange, whimsical character, calling them "primitive" (N. Harris 1928a) and "mystical" (Jacob 1928a). *Pine Tree Madonna* derives from Thoreau's decoration for St. Anne's Church (see fig. 78) and realizes his father's wish to Canadianize religious themes.

125
Mabel May (1884–1971)
Winter Landscape 1925 (see fig. 196)
Oil on canvas, 72.1 × 101.9 cm
Toronto-Dominion Bank
Inscriptions: l.r., *H.MABEL MAY*; verso: stamped c., *Pan American / Exhibition / … / 192 …*, u.c., torn label, *EXPOSITION PARK, LOS ANGELES, CAL., U.S.A. / ARTIST H. MABEL MAY / ADDRESS 434 ELM AVE. WEST … / TITLE LANDSCAPE / … TURN ADDRESS …*
Provenance: The artist, Montreal; Dominion Gallery, Montreal, c. 1950; Toronto-Dominion Bank, 1962.
Exhibitions: Los Angeles 1925, no. 233; [Group 1928, no. 79 *The Open Stream*, $250 ?]; [Quebec 1928, no cat. no. ?]; [NGC 1929, no. 107, $350 ?].

Mabel May painted for the Canadian War Memorials and was a charter member of the Beaver Hall Group. There is in her work a ruggedness of paint application combined with an almost naive decorative quality that is energetic and stimulating. This painting exemplifies the individuality of vision and freedom of spirit that the Group wished to support among Canadian artists.

126
Doris Mills (1894–1989)
Mountain Sunrays 1928 (see fig. 174)
Oil on canvas, 74.5 × 102 cm
McMichael Canadian Art Collection, Kleinburg, Ont. (1990.11.3), bequest of Doris Huestis Mills Speirs, Pickering, Ont., 1990
Inscriptions: l.r., *DORIS / HUESTIS / MILLS*; verso: on label in ink, *MOUNTAIN SUNRAYS / Exhibited in Group of Seven exhibition Art Gallery of Toronto / —opened Feb. 1928*, on label, typed, *ROBERT MCLAUGHLIN GALLERY / OSHAWA, ONTARIO / OCTOBER 12–31, 1971– / One Man Show of Doris Huestis / Mills Speirs*
Exhibitions: Group 1928, no. 82.

In 1925 A.Y. Jackson (quoted in B. Housser 1925f) articulated his understanding of the work of Bess Housser, Doris Mills, and Marion Huestis: "One of the problems of academic training in art is to keep the creative spirit alive. The exhibition at the Women's Art Association is rather a revelation of what can be accomplished by considering creative work of first importance … These vigorous, unconventional paintings by these young artists untrained in all the mysteries of technique and tradition make one realize that art has become such a complex affair that its purpose is lost sight of."

127
Kathleen Munn (1887–1974)
Composition 1928 (see fig. 166)
Oil on canvas, 51 × 60.8 cm
The Edmonton Art Gallery Collection (83.5), purchased with funds donated by the Women's Society of The Edmonton Art Gallery, 1983
Inscriptions: verso, across top before lining, *MUNN*
Provenance: Bertram Brooker, Toronto, c. 1929; estate of Bertram Brooker; Edmonton Art Gallery Foundation.
Exhibitions: Group 1928, no. 13 or 14.
Bibliography: Jacob 1928a; Telegram 18 Feb. 1928; N. Harris 1928a; Brooker 1929a, p. 268, repr. 269.

With persistence and courage Kathleen Munn continued to paint in a Cubist-influenced style for years in relative isolation. Paul Cézanne remained the model for Toronto's modern artists, who still had not confronted the lessons of Cubism and Henri Matisse. In Bertram Brooker, who purchased this canvas, Munn discovered an ally, and in the Société Anonyme exhibition of 1926–27 she found a reaffirmation of her interests and commitments. That exhibition included Franz Marc's *Deer*,[1] which may have been the inspiration for this canvas. Brooker (1929a, 268) wrote: "Miss Munn has for years been an earnest student of the most modern and the most ancient art, and fuses something from both in compositions that give her a thoroughly individual and unique place in the art of Canada."

1. Harold Tovell, a supporter of Munn, wrote to Katherine Dreier about purchasing this canvas, which was not for sale. Tovell, Toronto, to Dreier, [Danbury, Conn.], 11 April 1927, Beinecke Libr., K. Dreier correspondence, box 37. The Marc painting is in the Phillips Collection, Washington.

128
George Pepper (1903–1962)
Carl Schaefer in the North Country 1927 (see fig. 170)
Oil on wood, 37 × 31.6 cm
Estate of Carl Schaefer
Inscriptions: l.l., *G. PEPPER*; verso: u.l. in ink, *To my friend Carl, to bring / back those happy days on the French / and that our experiences at Tyson Lake / George*; u.l., by Carl Schaefer, *PAINTED / 1927 / EXHIBITED, INVITED CONTRIBUTOR / GROUP OF SEVEN EXHIBITION / ART GALLERY OF TORONTO / FEB. 1928 / CATALOGUE No. 87*; label, National Gallery of Canada, Ottawa / *Special Exhibition of Canadian Art 1929 / Title: Carl Schaefer in the North Country / Artist: George Pepper / Class: Oil / Return to: 251 Wellington St., Ottawa / Price: ;* back of frame: u.l. on label, by Carl Schaefer, *REFERENCE: "THE MAIL AND EMPIRE" / TORONTO / ARTICLE BY / FRED JACOB FEB. 18. 1928 / ON GROUP OF SEVEN EXHIBITION*
Provenance: Acquired from the artist.

Exhibitions: Group 1928, no. 87; NGC 1929, no. 132.
Bibliography: Jacob 1928a.

Lowrie Warrener had majored in sculpture under Emanuel Hahn at the Ontario College of Art, and it was Hahn, who had a cabin on the Pickerel River, who introduced Warrener to that region. In the summer of 1927 Carl Schaefer, Lowrie Warrener, and George Pepper camped on the French River (see fig. 205), and Pepper exhibited portraits of his two cohorts at the 1928 Group show. Set against the rocky landscape, this bust portrait of Schaefer recalls Holgate's *Lumberjack*, and the title clearly identifies the spirit of the venture.

129
Sarah Robertson (1891–1948)
The Blue Sleigh c. 1924 (see fig. 195)
Oil on canvas, 48.3 × 61 cm
Tom Thomson Memorial Art Gallery, Owen Sound, bequest of Norah Thomson de Pencier, 1974
Inscriptions: l.r., *S.M. ROBERTSON*
Provenance: F.B. Housser, Toronto, 1928; Norah Thomson, Toronto 1930.
Exhibitions: [AAM 1923, no. 186, $20 ?]; Wembley 1924, no. 204; RCA 1925, no. 188; NGC 1926, no. 141, $100; CNE 1926, no. 219, $150; Quebec 1927, no cat. no.; Group 1928, no. 89; Buffalo 1928, no. 45, loaned by F.B. Housser; AFA (1) 1930, no. 50, loaned by Miss Norah Thomson, Toronto.
Bibliography: Canadian Bookman Sept. 1926; Jacob 1928a; Rainey 1930; K. Clark 1930; Toronto Star Weekly 15 March 1930, repr. 13; Salinger 1930L, repr. 8; L. Mechlin 1930, p. 270, repr. 269; Chicago Tribune 18 May, 1930; Emmart 1930; Art News 7 June 1930, p. 6.

While not a member of the Beaver Hall Group, Sarah Robertson had studied with most of its members at the Art Association of Montreal under William Brymner. Her simplification of form and colour, possibly influenced by illustration of children's books from France, results in an effective, decorative image. It was the painting's freedom from academic literalness and its delicacy and naivety that attracted the Group artists, and led them to invite her to exhibit it in the 1928 show.

130
Albert H. Robinson (1881–1956)
Murray River Valley 1927 (see fig. 141)
Oil on canvas, 69.4 × 84.3 cm
Private collection
Inscriptions: l.r., *Albert h Robinson / 1927*
Provenance: Vincent Massey, Toronto, 1928; Laing Galleries, Toronto, 1966; private collection, Toronto; Sotheby's, Toronto, 6 Nov. 1991, lot 185.
Exhibitions: Group 1928, no. 93, $500; AAM 1928, no. 173, $500; CNE 1931, no. 467 *La Malbaie*, loaned by Vincent Massey; Massey 1934, no. 184.

A.Y. Jackson and Albert Robinson sketched at La Malbaie in March 1926 and 1927. Jackson found the landscape "good stuff, but not austere. The village is in a valley and I think things to be austere must silhouette, be either on the plains or on a hilltop but not the inside of a cup."[1] In 1927, the two artists were joined by Randolph Hewton. "While Hewton was here we sat round and talked and joshed Robinson and smoked till the room was blue," wrote Jackson, "but Robinson and I are more serious and have been trying hard to make art out of

obstinate material. It is fine stuff for naive treatment and we are too much trained in methods to forget. However very often punk sketches offer good motives for development."[2]

1. Jackson, La Malbaie, Que., to Norah Thomson, Toronto, 11 March [1926], NAC, MG30 D322, vol. 1, Jackson 1926. 2. Jackson to N. Thomson, 31 March [1927], NAC, MG30 D322, vol. 1, Jackson 1927.

131
Carl Schaefer (1903–1995)
Black Spruce, Pickerel River 1927 (see fig. 171)
Oil on pressed paper board, 35.5 × 30 cm
Estate of the artist
Inscriptions: l.l., *CARL SCHAEFER 1927*; verso, u.l., graphite, *"Black Spruce Pickerel River"* / *Sept. 1927* / *PICKEREL* / *RIVER*; c., graphite, *Trip with Lowrie Warrener* / *and George Pepper* / *Carl Schaefer* / 14½ × 11¾
Exhibitions: Manoir Richelieu 1930, no. 504, $100; [Young Canadians 1932, no. 350, $25 ?].

Carl Schaefer's two paintings in the 1928 Group show, *Grey Day* and *Dead Jack Pine*, have not been located, but they were characterized by the same linear decorative quality as this canvas. Only twenty-four years old when he first exhibited with the Group in 1928, Schaefer had, to date, mostly exhibited pen-and-ink drawings but few oils. The criticisms and support offered by J.E.H. MacDonald, A.Y. Jackson, Arthur Lismer and Lawren Harris were an important stimulus in Schaefer's career (G. Johnston 1986, 51–53).

132
Lowrie Warrener (1900–1983)
Northern Night 1928 (see fig. 173)
Oil on canvas, 60.5 × 92.5 cm
National Gallery of Canada, Ottawa (29464), gift of Rachel Warrener, Toronto, 1986
Inscriptions: l.r., *L. Warrener*; stretcher, u.l., *"NORTHERN NIGHT" $350.* / *LOWRIE WARRENER*
Provenance: Estate of the artist; Rachel Warrener, Toronto.
Exhibitions: Group 1928, no. 98, $350; Buenos Aires 1931, no cat. no.

Northern Night reinterprets the same subject as *Bats Fly Merrily* (cat. 105) from the 1926 show in a more severe form and with more dramatic colouring. In the face of academic pressure to turn out polished technicians, the Group chose to support individual expression and strength of spirit. "Amateurs" were again defined by Bertram Brooker (1928–30, 13 July 1929) as "those who have been somehow stirred by the beauty or austerity of this country and have attempted, not merely to copy realistically the scenes before them (in the manner of the amateur watercolour artists who are to be seen on every heath and hill in the older countries), but to capture somehow the mood and crystalize the larger rhythms of the Canadian landscape."

133
William J. Wood (1877–1954)
Self Study 1927 (see fig. 179)
Oil on canvas, 40 × 32.7 cm
Collection of John Hartman
Inscriptions: u.r., *W.J. WOOD.1927*
Provenance: Estate of the artist; artist's daughter, Alma Cordingley; John Hartman, 1973.
Exhibitions: Group 1928, no. 99.
Bibliography: Jacob 1928a.

W.J. Wood had been included in the 1923 show of the Group's work that was sent to the United States, but exhibited with the members in Toronto for the first time only in 1928. His self-portrait was appreciated by Fred Jacob (1928a): "Many persons will be pleased to see again the work of William Wood of Midland, whose painting has always been a unique example of self-expression, accomplished quite outside a sophisticated art environment. His *Self Study* is a very interesting piece of painting in spite of its awkwardness."

134
Franklin Carmichael (1890–1945)
The Whitefish Hills 1929 (see fig. 228)
Watercolour over graphite on wove paper, 50.8 × 68.5 cm
National Gallery of Canada, Ottawa (3949)
Inscriptions: l.r., *FRANK* / *CARMICHAEL* / *1929*
Provenance: Purchased from NGC 1931.
Exhibitions: Group 1930, no. 5, $200; CNE 1930, no. 259, $200; NGC 1931, no. 34; Group 1936, no. 2 repr.
Bibliography: C.C. MacKay 1930a.

The 1930 Group of Seven exhibition was presented at the Art Gallery of Toronto at the same time as the annual show of the Canadian Society of Painters in Water Colour. Frank Carmichael, who had been elected Secretary of the Water Colour society on its formation in 1925,[1] exhibited in both. In all, he had seventeen large and small watercolours in the show, affirming the Group's support of creative effort in all media.

1. Carmichael, Toronto, to Brown, Ottawa, 19 Dec. 1925, NGC Arch., 5.5-Annual 1926.

135
Franklin Carmichael (1890–1945)
The Bay of Islands 1930 (see fig. 222)
Watercolour on paper, 54.6 × 94.5 cm
Art Gallery of Ontario, Toronto (1328), gift from the Friends of Canadian Art Fund, 1930
Inscriptions: l.r., *FRANK* / *CARMICHAEL* / *1930*
Provenance: Purchased from Group 1930.
Exhibitions: Group 1930, no. 6, repr.; AGT Permanent 1935, no. 76; AGT Loan 1935, no. 223.
Bibliography: C.C. MacKay 1930a.

Frank Carmichael exhibited a small watercolour, *Bay of Islands*, in the 1930 Water Colour society show and a larger version in that year's Group exhibition (C.C. MacKay 1930a). The latter was purchased by the Friends of Canadian Art for the Art Gallery of Toronto.

136
Franklin Carmichael (1890–1945)
Wabagishik: Drowned Land 1929 (see fig. 201)
Watercolour and gouache over charcoal on wove paper, 51.8 × 69.8 cm
National Gallery of Canada, Ottawa (37158)
Inscriptions: l.r., *FRANK* / *CARMICHAEL* / *1929*; l.l., stamped (Carmichael estate stamp); u.l., *RS*
Provenance: Estate of the artist; by descent; purchased 1993.
Exhibitions: Group 1930, no. 14 *Drowned Land*, $150.

Frank Carmichael was the artist who most successfully translated the austerity of the northern landscape into watercolour. With a

clarity of light and simplicity of design he avoids atmospheric and overly decorative effects.

137
Emily Carr (1871–1945)
Kitwancool 1928 (see fig. 217)
Oil on canvas, 101.3 × 83.2 cm
Glenbow Museum, Calgary (56.23)
Inscriptions: l.l., *M. EMILY CARR*; stretcher, u.l., *KITWANCOOL* / *EMILY CARR*; u.c., on label in ink, *JUNE 9th 1928* / *BY EMILY CARR*
Provenance: The artist, Victoria; Emily Carr Trust, 1941; Glenbow Foundation, Calgary, 1956.
Exhibitions: Victoria, Island Arts and Crafts Society, 23–31 Oct. 1928, no. 79 *Kitwancool, Northern B.C.*, $200; Group 1930, no. 24 *June 9th 1928*, $250.

Although Emily Carr had painted sporadically in the twenties, it was without the intensity and commitment that had driven her before the First World War. Her contact with the Group artists in Toronto in 1927 was crucial for the renewal of her painting. Above all, she developed a strong affinity with Lawren Harris, as they both believed in the necessity of a spiritual purpose in their art.

Immediately on her return to Victoria from that trip, Carr re-examined her prewar subjects, reworking them in the new formal language she had seen in Harris's painting. In the summer of 1928, for the first time in sixteen years, she returned to the northern coastal villages and to the Skeena and Nass Rivers and, in late June or early July, visited the village of Kitwancool,[1] the site of recent protests by inhabitants over government incursions by surveyors.[2] On her return to Victoria, the Seattle artist Marc Tobey visited her. "He gave a short course of classes here in my studio, and I felt I got a tremendous lot of help from his criticisms. He was very keen on my summer's work, and his crits I feel will be very useful in the working out of many problems," she wrote.[3]

Carr's five paintings in the 1930 Group show ranged from the earliest, *Kitwancool*, exhibited under the curious title, transcribed from a label, of *June 9th 1928* (Shadbolt 1979, 203), to her most recent, *Western Canadian Forest* (AGO). They demonstrated the great advance in her work over the previous two years. In *Kitwancool*, Carr applies the Cubist-derived structural lessons learned from Tobey to the landscape and the sky, which falls like a curtain behind the poles. Though tentative and lacking in unity, the canvas nonetheless has a dynamism and energy derived from its bold experimentation in a new visual language.

1. Carr, Grenville, B.C., to Flora Burns, Victoria, 19 July [1928], B.C. Arch., Add. MSS 2786, box 1, file 4; and Carr, South Bay, B.C., to Eric and Maude Brown, 11 Aug. 1928, NGC Arch., 7.1–C. 2. "Indian Sent to Jail for Obstructing Survey," *Vancouver Daily Province*, 3 Sept. 1927. 3. Carr, Victoria, to E. Brown, Ottawa, 1 Oct. [1928], NGC Arch., 7.1–C.

138
Emily Carr (1871–1945)
Wood Interior 1929–30 (see fig. 216)
Oil on canvas, 106.8 × 69.9 cm
Robert McLaughlin Gallery, Oshawa, gift of Isabel McLaughlin, Toronto, 1987
Inscriptions: l.l., *M. Emily Carr*
Provenance: Isabel McLaughlin, Toronto, 1930.

Exhibitions: Group 1930, no. 21 *Forest*, $250; CNE 1930, no. 21b, $150; Roerich 1932, no. 8 *Wood Interior*; Atlantic City 1933, no. 6; CGP 1933, no cat. no.; Hamilton CGP 1934, no. 5.

In 1929 Lawren Harris wrote to Emily Carr: "Your work is very individual, and so far as I know, you have the feeling of the West Coast beyond anyone – and have and will find an equivalent for it in or through paint. How about leaving the totem alone for a year or more? I mean, the totem pole is a work of art in its own right and it is very difficult to use it in another form of art. But, how about seeking an equivalent for it in the exotic landscape of the Island and coast, making your own form and forms within the greater form … push the forms to the limit, in volume, plasticity and precision and relationships in one unified, functioning greater form which is the picture."[1]

In *Wood Interior*, realized from studies made at Port Renfrew in 1929, pastel shades illuminate a faceted interior surrounded by swirling planes. Form and movement combine in a linear, intersecting rhythm. In a poem Carr wrote 14 August 1929, she translated the image into words: "What seest thou? … Tangles of dense undergrowth, smothering, choking, struggling, in the distance receding plane after plane, rising, falling – warm and cold greens, gnarled stump of grey and brown … What feelest thou? The reality of growth and life and light, the sweetness of Mother Nature, the nearness of God, the unity of the universe, peace, content. What tastest thou? The full, pure joy of life …"[2]

1. Harris, Toronto, to Carr, Victoria, [1929], NAC, MG30 D215, vol. 2, Harris 1928–29. 2. E. Carr, "Renfrew 14 August 1929," B.C. Arch., Add. MSS 2181.

139
A.J. Casson (1898–1992)
Credit Forks 1930 (see fig. 231)
Watercolour over charcoal on paper, 46 × 56.5 cm
Art Gallery of Ontario, Toronto (1327), gift from Friends of Canadian Art Fund, 1930
Inscriptions: l.r., *A.J. CASSON*
Provenance: Purchased from Group 1930.
Exhibitions: Group 1930, no. 25; AGT Permanent 1935, no. 79; AGT Loan 1935, no. 224, dated c. 1929.
Bibliography: C.C. MacKay 1930a; Laberge 1930b.

A.J. Casson's lovely watercolour of these houses on the outskirts of Toronto was praised for its fresh colour. He exhibited seventeen watercolours in the Group show of 1930 and several more with the Water Colour society, of which he had been a charter member.

140
A.J. Casson (1898–1992)
Approaching Storm, Lake Superior 1929–30
(see fig. 229)
Watercolour over graphite on wove paper, 46.9 × 57 cm
National Gallery of Canada, Ottawa (3950)
Inscriptions: l.r., *A.J. CASSON*
Provenance: Purchased from NGC 1931.
Exhibitions: Group 1930, no. 34, $175; CNE 1930, no. 265, $175; NGC 1931, no. 41; Group 1936, no. 25.
Bibliography: F.M. Harris 1930; Eric Brown 1932, repr. 314; Sault Ste. Marie Star 31 March 1933.

In 1928 A.J. Casson made his first sketching trip to the north shore of Lake Superior. Bertram

Brooker met him on his return. "Until I actually saw the country," said Casson, "I always felt that Lawren Harris carried his Lake Superior paintings far beyond reality. The pools of light on the water and the shining bare trees in his canvases seemed intensified to such an extent that I could not feel that they were natural. But my first sight of the country in sunlight after a rainstorm and heavy fog, changed my mind completely. The great circular patches of light on the water were so bright that you couldn't look at them. And as for the bare trees, which caused people to talk about 'great snakes' a few years ago, they are thoroughly characteristic of the north shore – just as smooth and round and shiny as Harris paints them. He hasn't exaggerated anything a speck" (quoted in Brooker 1928–30, 24 Nov. 1928).

141
Lawren S. Harris (1885–1970)
Lighthouse, Father Point 1930 (see fig. 213)
Oil on canvas, 107.9 × 128.1 cm
National Gallery of Canada, Ottawa (5011), gift of the artist, Vancouver, 1960
Inscriptions: stretcher: u.c., *FATHER POINT LIGHT, QUE.*, u.r., *LAWREN HARRIS*
Exhibitions: Group 1930, no. 46, repr.; AFA (2) 1930, no cat. no., $1000; Dartmouth Harris 1931, no cat. no., $1000; Group 1936, hors cat.
Bibliography: Toronto Daily Star 3 April 1930, repr. 3; Salinger 1930i; Telegram 5 April 1930; C.C. MacKay 1930a; La Revue Populaire June 1930, repr. 68; Davenport Democrat 12 Dec. 1930; Davenport Daily Times 12 Dec. 1930; Mount 1931, repr. 6.

In the fall of 1929 Lawren Harris and A.Y. Jackson travelled by car to Gaspé and Rimouski. "It's a marvellous motor trip," wrote Jackson, "like Lake Superior country with a little less grandeur to it, strings of little villages all along the shore. I had no idea it was so populated. It's hard to paint, too scattered and much newer than the villages further up the river … Lawren's big bus goes like a bird."[1] Harris painted only one canvas from this trip, a symbolic interpretation of the lighthouse at Father Point.

Jehanne Biétry Salinger (1930i) found Harris's work the most impressive in the 1930 exhibition: "Harris is represented by some of his most complete compositions, which display an impressive unity of thought and spiritual direction. Almost like a symbol of his own work and perhaps of Canadian art, his *Lighthouse, Father Point, Quebec*, is the most simplified of his paintings and is designed with the most splendid sense of space relations. It also contains an element of spiritual power which makes of it one of his strongest works."

1. Jackson, Petite Madeleine, Que., to Norah Thomson, Toronto, postmarked 14 Oct. 1929, NAC, MG30 D322, vol. 1, Jackson 1929.

142
Lawren S. Harris (1885–1970)
Mountains and Lake 1929 (see fig. 255)
Oil on canvas, 92 × 114.8 cm
McMichael Canadian Art Collection, Kleinburg, Ont. (1970.1.1), gift of R.A. Laidlaw, Toronto, 1970
Provenance: Loan to Pickering College, Newmarket, Ont., 1936; Robert Rourke, Pickering College, Newmarket, 1949; Mrs. Robert Rourke, West Hartford, Conn.; purchased 1970 with proceeds of

sale of five L.S. Harris oil sketches donated by R.A. Laidlaw, Toronto.
Exhibitions: Group 1930, no. 49 *Mountain in Snow*, $600; NGC 1931, no. 103 *Lake and Mountain*, $700; Dartmouth Harris 1931, $750.
Bibliography: Toronto Daily Star 19 April 1930, repr. 22; Laberge 1930b.

W.J. Phillips (1926) summed up his interpretation of the Group's aesthetic: "The Group of Seven set themselves to interpret rather than reproduce and this they have done with a fine knowledge of form and great dignity of expression. The sheer beauty of their paintings is found in rhythm, often in colour. There is no warmth, little sentiment and no humour, but sobriety, even austerity, and grandeur in their paintings."

143
Lawren S. Harris (1885–1970)
Morning Light, Lake Superior c. 1927 (see fig. 212)
Oil on canvas, 87.6 × 101.6 cm
University of Guelph collection at the Macdonald Stewart Art Centre, Guelph, Ont. (UG 988.002), gift of Dr. Frieda Helen Fraser in memory of Dr. Edith Bickerton Williams, 1988
Inscriptions: verso: u.c., torn label, … ERY of TO … / BLACK AND WHITE EXHIBITION / April 1920 / From *E. Fraser* / 30 Heathdale Rd. / Catalogue No.; back of frame: u.c., *Box 14*, u.r., *58*
Provenance: The artist, Toronto; Dr. Frieda Fraser, Toronto, 1927.
Exhibitions: Group 1930, no. 58, loaned by Dr. Freda (*sic*) Fraser.

"Lawren Harris's north shore paintings are almost photographic in their realism," wrote Bertram Brooker (1928–30, 24 Nov. 1928). "He himself is not concerned with realism, and would thank nobody for calling his pictures photographic, but the fact remains that alongside his attempt to translate into paint the 'spirit' of the country there also goes on to his canvases a representation of the 'physiognomy' of the landscape that can be readily recognized by all who are familiar with it, no matter how much he 'simplified' it."

144
Prudence Heward (1896–1947)
At the Theatre 1928 (see fig. 211)
Oil on canvas, 101.6 × 101.6 cm
Montreal Museum of Fine Arts (1964.1497), purchase, Horsley and Annie Townsend Bequest, 1964
Inscriptions: l.r., *P. Heward / 1928*
Provenance: Estate of the artist; Continental Galleries, Montreal, 1964.
Exhibitions: RCA 1929, no. 97, $600; NGC 1930, no. 77; Group 1930, no. 59, $600; Montreal, W. Scott and Sons, from 19 April 1932, *Heward Exhibition*.
Bibliography: Nichol 1929; Morgan-Powell 1929c; A.V. Thomson 1929, p. 129; Telegram 27 Jan. and 5 April 1930; La Revue Populaire Jan. 1930, repr. 9; Harrold 1930; McCarthy 1930; Brooker 1928–30, 1 Feb. 1930; Armstrong 1930; Salinger 1930b and 1930c, p. 209; Laberge 1930b; Montreal Gazette 27 April 1932.

Bertram Brooker (1928–30, 1 Feb. 1930) delighted in the appearance of a modern, Canadian school of figure painters: "I feel that painters like Holgate and Prudence Heward, to name only two who are thought to be more influenced by Paris than Toronto, are achieving very individual

and very excellent results, whatever their influence." Pegi Nichol (1929) had another perception of Heward's work in her short notice on the 1929 Academy exhibition: "Intellect hiding behind a rather temporal subject appeared in Prudence Heward's picture of two women in a theater. Under a lovely texture of paint lay the old everlasting hills pattern. It was well organized and one wonders how it got in."

145

Edwin Holgate (1892–1977)
Paul, Dog Driver c. 1929 (see fig. 224)
Oil on canvas, 65.2 × 55.3 cm
Musée du Québec, Quebec City (38.14)
Inscriptions: l.r., *E. Holgate*
Provenance: Purchased from the artist, Montreal, 1938.
Exhibitions: RCA 1929, no. 102 *Paul, Trapper*, $300; NGC 1930, no. 85; Group 1930, no. 61, n.f.s., repr.; AFA (2) 1930, no cat. no., $350; Arts Club 1935, no. 7, $250.
Bibliography: Girard 1930a, p. 5; La Revue Populaire Jan. 1930, p. 8, repr. 9; Salinger 1930a, 1930b, 1930c, p. 211, 1930j, and 1930L, p. 7; Brooker 1928–30, 1 Feb. 1930; Toronto Star Weekly 8 Feb. 1930; Telegram 5 April 1930; *Canadian Homes and Gardens* VII:5 (May 1930), repr. 134; Davenport Democrat 12 Dec. 1930; Davenport Daily Times 12 Dec. 1930; Mount 1931, repr.; Seigneur Nov. 1933, repr.

"Edwin Holgate is a violent man, sharply realist," wrote Henri Girard (1930a), reviewing the 1929 Academy show. "He throws me off sometimes because his art pursues such raw contrasts and oppositions. But he affirms himself in such a decided and certain way that you can't help but admire him. He has, in any case, the excellent merit of sincerity. An Edwin Holgate canvas presents the artist directly; this is a man who ignores half-tones and paraphrases. He states his case straightforwardly, and too bad for you if your sensibility differs from his. A work like the portrait of Paul unquestionably offers openings for debate, but one must recognize its sincerity. This is a beautiful, and so rare, quality among our painters."

146

Edwin Holgate (1892–1977)
Nude 1930 (see fig. 230)
Oil on canvas, 64.8 × 73.6 cm
Art Gallery of Ontario, Toronto (1326), gift from Friends of Canadian Art Fund, 1930
Inscriptions: l.r., *E. Holgate*
Provenance: Purchased from Group 1930.
Exhibitions: Group 1930, no. 64 *Nude in the Open*; Group 1936, no. 92 *Nude in Landscape*.
Bibliography: Telegram 5 April 1930; Laberge 1930b; Morgan-Powell 1930.

Edwin Holgate showed two nudes in the 1930 Group show, *Nude in a Landscape*,[1] loaned by the National Gallery, and this painting, titled *Nude in the Open*. Both titles evoke the desired linkage between the figure and her environment. Salinger (1930j) captioned Holgate the new "Derain of Canada," and Bridle (1930b) acclaimed: "Holgate sets a new fashion in nudes – away from French decadence to the Laurentians for a background; splendidly painted nudes without cosmetics." Even Morgan-Powell (1930) lauded Holgate's "sound draughtsmanship and sound composition.

Clashing hues and distorted perspectives have not yet made their appeal to him."

The depiction of nude women was a repeated issue in the Toronto press, a sculpture by Alexander Archipenko and a painting by Max Weber having been removed from the Société Anonyme exhibition in 1927 *(Toronto Daily Star* 4 April 1927). John Russell's paintings at the CNE that same year attracted record crowds (*Telegram* 6 Sept. 1927), and roused a journalistic debate that continued into December. Holgate was the first to modernize what had been the subject of more traditional, academic painters. Yet, according to Bertram Brooker (in Deacon 1931, 94), Holgate's nudes "were the subject of complaint both in person and by correspondence for as long as a year after the show was taken down." The Friends of Canadian Art, nonetheless, purchased this painting for the Art Gallery of Toronto.

1. Lismer, Toronto, to McCurry, Ottawa, 8 April 1930, NGC Arch., 5.14-Buenos Aires; Salinger 1930i; Morgan-Powell 1930.

147

A.Y. Jackson (1882–1974)
The "Beothic" at Bache Post, Ellesmere Island 1929 (see fig. 214)
Oil on canvas, 81.6 × 102.1 cm
National Gallery of Canada, Ottawa (3711), gift of The Hon. Charles Stewart, Minister of the Interior, 1930, to commemorate the establishment on 6 August 1926 of Bache Peninsula post
Inscriptions: l.l., *A Y JACKSON*
Provenance: Gift of the artist to the Ministry of the Interior, 1930.
Exhibitions: NGC 1929, no. 89; Group 1930, no. 73, loaned by the NGC; Roerich 1932, no. 29; Quebec, Provincial Museum, Nov.–Dec. 1935; Group 1936, no. 100.
Bibliography: R.B.F. 1928b; Telegram 27 Jan. 1930; Harrold 1930; Art Digest 1 March 1930, repr.; Toronto Star Weekly 8 Feb. 1930; Glasgow Herald 4 March 1930; La Revue Populaire April 1930, repr. 13; Bridle 1930b; Salinger 1930j; J. Adeney 1931b; Telegram 7 March 1931; Webber 1932; Eric Brown 1932, repr. 314; Dick 1932, p. 280, repr. 279.

Replacing the antiquated SS *Arctic*, the SS *Beothic* made its first voyage north in 1926. Steel-hulled so it could cut through the ice, it enabled the RCMP to establish a post at Bache Peninsula on Ellesmere Island that first year. The internationally renowned Dr. Frederic Banting, co-discoverer of insulin, and A.Y. Jackson were among the passengers the following year. "It is not many years ago that the Canadian artist who sketched at Opeongo, Canoe Lake, or possibly even Muskoka, was considered a bit of a daredevil, and a dangerous technician to boot," observed a writer, possibly Barker Fairley, in the *Canadian Forum* (Nov. 1927). "But now we find the movement establishing its outpost on the North Shore, in the Rockies, and, to crown all, at remote points as far to the north of us as the Rockies are west. At a time when there seems to be no life left in landscape painting anywhere else in the world, when painters almost everywhere are making studies of rotten apples and antimacassars and blue horses and inventing theories of art to justify their having landed themselves in such a cul-de-sac, it is refreshing, nay it is wildly exhilarating, to reflect upon this

Canadian opportunity, this almost fabulous wealth of unexamined or half-examined landscape calling bird-like to the artist to come to it and make it his own."

148

Arthur Lismer (1885–1969)
The Glacier 1928 (see fig. 203)
Oil on canvas, 101.5 × 126.7 cm
Art Gallery of Hamilton (60-77-J), gift from the Women's Committee Fund, 1960
Inscriptions: l.l., *A. Lismer '28*
Provenance: The artist, Montreal; Laing Galleries, Toronto; purchased 1960.
Exhibitions: Group 1930, no. 88, $700 repr.; Malloney Lismer 1935, no. 10 *The Glacier, Moraine Lake*, $400.
Bibliography: Mail and Empire 6 March 1930, repr. 15; Salinger 1930j; Telegram 5 April 1930; Laberge 1930b.

Arthur Lismer made his first trip to the Rockies in 1928 and exhibited three mountain subjects at the 1930 Group show. In this canvas he takes the fluid, jewel-like paint of Fred Varley's *Mimulus, Mist and Snow* (cat. 119) and translates it into angular, interweaving forms glowing with an inward light.

Lismer (1927c, 18) wrote: "The world of appearances exists, as it does to the religious devotee, as a means of ecstasy. A stepping off place, as it were, into a world wherein the divine order of existence, the golden thread of pure design shines like a pathway of fire in the realm of the mind, and speculation on technical and objective things is replaced by aesthetic contemplation on the nature of beauty … Art arises from the spirit of adventure latent in man, and … a work of Art is like the life of man, full of struggles, difficulties and suffering, and to shape it [the artist] must leave the highway and break new paths."

149

Arthur Lismer (1885–1969)
Sunlight in a Wood 1930 (see fig. 218)
Oil on canvas, 91.4 × 101.6 cm
Art Gallery of Ontario, Toronto (2847), bequest of John M. Lyle, Toronto, 1946
Inscriptions: l.l., *A. Lismer 30*
Provenance: Purchased from the artist, Montreal, 1946, with funds bequeathed by John M. Lyle, Toronto.
Exhibitions: Group 1930, no. 92 *Sunlight in the Wood*, $600; AFA (2) 1930, no cat. no., $650; CNE 1931, no. 432 *Sunlight in the Woods*, $600; RCA 1931, no. 166, $600; Roerich 1932, no. 37 *Sunlight in a Wood*; Malloney Lismer 1935, no. 29, $600; Group 1936, no. 133.
Bibliography: Salinger 1930j; C.C. MacKay 1930a; Laberge 1930b; Burgoyne 1931c.

The paintings Arthur Lismer exhibited in 1930 mark a high point in his career. Independent of any market, not selling his work, he experimented with a boldness and freedom that challenged even his supporters. "The arid trees and tenacious rocks that cling to them; the glacier that goes to pieces under the sun; a forest interior with tree trunks that are pathetically bare and over which a raw light is pouring are the contributions of Arthur Lismer, not pleasing by any means, but brave attempts which, even when they fail, remain impressive" (Salinger 1930j).

150
J.E.H. MacDonald (1873–1932)
Clouds over Lake O'Hara 1930 (see fig. 226)
Oil on canvas, 106 × 134.5 cm
Musée d'art de Joliette, Quebec (1975.075)
Inscriptions: l.r., *J.E.H. MacDonald 1930*; verso: u.r.,
*Clouds over L. O'Hara, J.E.H. MacDonald / 30, no. 151,
33½ × 45*
Provenance: Estate of the artist; Mellors-Laing
Galleries, Toronto; Dominion Gallery, Montreal;
purchased by Dr. Alcide Ricard and Dr. Ed. Gervais
for the Séminaire de Joliette, 1947.
Exhibitions: Group 1930, no. 98 *O'Hara Shores, Rocky
Mountains*, $400; CNE 1930, no. 111, $950; NGC 1931,
no. 176, $350; [Roerich 1932, no. 42 *Lake O'Hara, Rocky
Mountains* ?]; [NGC MacDonald 1933, no. 45 *Lake
O'Hara* ?]; [Winnipeg 1933, no. 40 ?].
Bibliography: Telegram 5 April 1930.

J.E.H. MacDonald visited the Rocky Mountains
every year from 1924 to 1929, usually staying on
Lake O'Hara. In his diaries he noted the plant
life, the ever-changing weather, and the various
animals he encountered on his walks along the
trails to the nearby lakes and peaks. *Clouds over
Lake O'Hara* was worked up from a sketch paint-
ed 11 September 1929[1] on the south shore of the
lake. In the canvas the colour is heightened, the
forms are cleaner, and the whole glows with a
glorious light.

1. Sold at Sotheby's, Toronto, 30 Oct. 1990, lot 56,
repr. in catalogue.

151
J.E.H. MacDonald (1873–1932)
Dark Autumn, Rocky Mountains 1930 (see fig. 219)
Oil on canvas, 53.7 × 66.3 cm
National Gallery of Canada, Ottawa (4875)
Inscriptions: l.r., *J.E.H. MacDonald / 30*
Provenance: Estate of the artist; Thoreau
MacDonald, Toronto. Dominion Gallery, Montreal;
purchased 1948.
Exhibitions: Group 1930, no. 99, $150; NGC 1931,
no. 177, $175; RCA 1931, no. 174, $175; NGC 1932,
no. 165, $200; Roerich 1932, no. 41; NGC MacDonald
1933, no. 43; Winnipeg 1933, no. 41.
Bibliography: F.M. Harris 1930; Maxwell 1932, p. 20;
Calgary Herald 12 July 1933.

One New York reviewer welcomed the paintings
included in the Canadian exhibition organized
for the Roerich Museum and Boston: "Most of
the artists show a characteristic tendency to
respond to the remote and sterner moods of
nature which appeal more to the spirit than to
the senses … To the average American lover of
art this group of paintings by Canadian artists
… will be seen as a definite linking of the old
with the new – linking mountains and stone
that are older than history with the present-day
life of a nation that is still new, rugged and opti-
mistic" (Montreal *Gazette* 18 March 1932). A
protest came from Boston, however (J.W. Bell
1932): "One would think, on seeing an exhibi-
tion of Canadian art, installed with loud huzzas
in the Boston Museum of Art this week, that
'The Land of Snows' was a bleak dreary waste of
gaunt trees, stony ground and a paradise for imi-
tators of crazy William Blake … Won't you
send us, just once … samples of real Canadian
art I know so well – some of it a joy to live with;
some glimpses of Lake Louise, and something
like Sargent's *Lake O'Hara* – a feast forever.

Canada's painting grounds are the equal of any
in the world. These things by the Group are a
libel."

152
Thoreau MacDonald (1901–1989)
Northern Diver 1930 (see fig. 223)
Oil on canvas, 53.8 × 66.8 cm
Private collection
Inscriptions: l.r., *THOREAU MACDONALD / 30*
Provenance: Lawren Harris, Toronto; by descent.
Exhibitions: CNE 1930, no. 114, $120; NGC 1931, no. 182.

The present whereabouts of the canvas titled
White Falcon, exhibited by Thoreau MacDonald
in the 1930 Group show, is unknown. It and this
canvas were both in the collection of Bess and
Lawren Harris after 1934. Simple and direct in
their presentation, Thoreau's studies of animals
reflect his constant love of nature.

153
Mabel May (1884–1971)
From My Studio Window c. 1928 (see fig. 220)
Oil on canvas, 56.1 × 69.2 cm
Montreal Museum of Fine Arts (1959.1220), gift of
Dr. and Mrs. Max Stern, Montreal, 1959
Inscriptions: l.r., *H. MABEL MAY*
Provenance: The artist, Montreal; Dr. and Mrs. Max
Stern, Montreal, c. 1950.
Exhibitions: Group 1930, no. 101a, $500; CNE 1930,
no. 128a, $500; AFA (2) 1930, no cat. no., $600.
Bibliography: Laberge 1930b.

It was probably this painting A.Y. Jackson
referred to when he encouraged Sarah
Robertson to "paint a canvas from Lil's studio
window, the subject Henry did so well."[1]
Robertson, Lilias Torrance Newton, and
Henrietta Mabel May, known to her friends as
Henry, were all closely associated during the
twenties, offering each other mutual support
and stimulation. Decorative in its arrangement
of roofs, church dome, tree branches and falling
snow, this painting recalls the work of Albert
Robinson, though it is less refined and has a
sterner and more expressive surface.

1. Jackson, Toronto, to Robertson, [Montreal], post-
marked 20 Jan. 1930, NGC Arch., Robertson fonds.

154
Yvonne McKague (born 1898)
Rossport, Lake Superior 1929 (see fig. 221)
Oil on canvas, 61.6 × 76.6 cm
National Gallery of Canada, Ottawa (3704)
Inscriptions: l.l., *YVONNE McKAGUE*
Provenance: Purchased from NGC 1930.
Exhibitions: NGC 1930, no. 110; Group 1930, no. 104,
loaned by the NGC; Edmonton 1932, no. 30;
Camrose, Drumheller, Lamont, Banff, Canmore,
Lethbridge, Medicine Hat, Brooks, and Calgary,
Alberta, Oct. 1932–April 1933; Winnipeg 1933, no. 52;
Regina Grain Conference, July–Aug. 1933; Port Hope,
Ont., Trinity College School, Feb. 1934; Toronto,
Upper Canada College, March 1934.
Bibliography: Salinger 1930c, p. 211.

The example of the Group members attracted a
number of artists to the north shore of Lake
Superior. In 1929 Yvonne McKague and Isabel
McLaughlin sketched at Schreiber and at
Rossport. McKague (Y. Housser 1980, 28–29)
later described her first dawn at the latter site:

"Soon the sky showed a little light. Never will I
forget the glory of that sunrise … Lawren
Harris did it in some of his paintings. Every
now and then as the sun rose and penetrated the
mist it was as though a searchlight pinpointed
one composition after another. Shy spots of
light came on in the steep roofed houses and
sheds; vague shapes of men appearing carrying
lanterns near their fishing boats and drying fish
nets … I took off with my sketchbook and
paintbox and worked like mad … The shapes of
the steep-roofed houses, the 'tophat' silhouettes
of some of the off-shore islands were coming to
life in the ever changing light."

155
Lilias Torrance Newton (1896–1980)
Elise Kingman 1930 (see fig. 227)
Oil on canvas, 76.5 × 61.7 cm
Private collection
Exhibited in Ottawa only
Inscriptions: l.r., *Torrance Newton*
Provenance: Elise Kingman, Montreal.
Exhibitions: Group 1930, no. 116; Montreal, Watson
Art Galleries, *A.H. Robinson, L.T. Newton, F. Wyle*, Nov.
1931, no. 35 *Elise*.
Bibliography: Telegram 5 April 1930; Salinger 1931d.

An original member of the Beaver Hall Group,
Lilias Torrance Newton was invited to exhibit
with the Group of Seven in the show they sent
to the United States in 1923 and in the 1930 and
1931 exhibitions. Cool and classical in its treat-
ment of form, restrained in colouring, this por-
trait of a friend, Elise Kingman, marks a turning
point towards a greater severity in Newton's
painting. Included in her solo exhibition at the
Lyceum Club and Women's Art Association in
Toronto, it was described by Jehanne Biétry
Salinger (1931d) as "a striking portrait in which
the artist used elegant motives for a bit of psy-
chological fantasy … it indicates another possi-
bility in figure work which allows us to look
toward Montreal with confidence and interest."

156
F.H. Varley (1881–1969)
Vera 1930 (see fig. 200)
Oil on canvas, 81.8 × 66.7 cm
National Gallery of Canada, Ottawa (3712)
Inscriptions: l.r., *F-H / VARLEY / (thumbprint)*
Provenance: Purchased from NGC 1931.
Exhibitions: NGC 1930, no. 156, $750; NGC
Willingdon Arts Competition, [Feb.] 1930; Group
1930, no. 121; Edmonton 1931, no. 20, loaned by the
NGC; Saskatoon Industrial Exhibition, July–Aug.
1932; Cornwall Art Association, March 1934; London,
Western Fair, Sept. 1934; Maritime Art Association,
Oct. 1935–June 1936.
Bibliography: Brooker 1928–30, 1 March 1930; Ottawa
Citizen 3 May 1930; Ottawa Journal 3 May 1930.

Fred Varley's submissions to the 1930 Group
show differed greatly from his large mountain
landscapes of 1928. He sent five figure studies,
including this portrait of his student Vera
Weatherbie.[1] While this canvas shared the first
prize for painting with George Pepper in the
1930 Willingdon Arts Competition, the review-
ers of the 1930 Group show were less impressed.
Jehanne Biétry Salinger (1930j) commented:
"Varley is represented by a collection of mean-
ingless pictures of women which are after psy-
chic effects and are painted in sickly colours

which remind one of cheap candies." Augustus Bridle (1930b) also was struck by the colour: "Varley has invented a new shade of pink. One of his head portraits is suffused with it. Another portrait is a masterpiece of strong character in a face. But he is too many thousands of miles away from the rest of the group to be quite sure what they are doing. He has become almost an honorary member."

This would be the last year Varley would exhibit with the Group of Seven.

1. Varley, Seattle, to Brown, Ottawa, 8 July 1930, NGC Arch., 7.1-V.

157
André Biéler (1896–1989)
"Berlines," Quebec 1928 (see fig. 245)
Casein on canvas, 40.6 × 50.8 cm
André Biéler Inc.
Inscriptions: l.l., *ANDRE BIELER*
Provenance: Estate of the artist.
Exhibitions: AAM 1928, no. 20 *Les berlines, Québec*; NGC 1929, no. 11, $150; [Group 1931, no. 34 *The Sleighs* ?].

Among the new exhibitors Edwin Holgate brought to the Group of Seven was André Biéler. Having worked in Switzerland with his uncle, Biéler spent three years on the Île d'Orléans and took a studio in Montreal in 1930. While living at Sainte-Famille on the island, he would on occasion accompany the farmers to the market in Quebec City, crossing on the ice. Biéler's subject matter was entirely compatible with the regionalist interests of the Group, although the scale of the sleighs ("les berlines") in relation to the buildings puts the emphasis on the human presence rather than the environment (F.K. Smith 1988, 28).

Biéler also exhibited a painting from France at the Group's 1931 exhibition, an unlocated work titled *Guernes-sur-Seine*.

158
Bertram Brooker (1888–1955)
The St. Lawrence 1931 (see fig. 238)
Oil on canvas, 76.5 × 101.7 cm
National Gallery of Canada, Ottawa (16556), gift from the Douglas M. Duncan Collection, 1970
Inscriptions: l.r., *BERTRAM / BROOKER*; stretcher: u.r., (erased title) / *by B. BROOKER*, u.r., *B Brooker*
Provenance: Douglas M. Duncan, Toronto.
Exhibitions: Group 1931, no. 36; NGC 1933, no. 25, $200.

In the summer of 1931 Bertram Brooker and his family spent a holiday at Murray Bay. "At least one of the Murray Bay sketches should make a canvas," he informed LeMoine FitzGerald, "and on our way down by boat to Montreal, I saw something which I think should work up into a semi-abstract mountain thing that may be interesting." Later he wrote, "I hadn't painted anything since my return from Quebec, except the one canvas of the St. Lawrence ... which was invited for the show. Lawren [Harris] didn't like the trees in it, but was willing to hang it."[1] The painting was ignored by all the reviewers.

1. Brooker, Toronto, to FitzGerald, Winnipeg, 6 Aug. 1931 and 10 Jan. 1932, UM FitzGerald, box 7.

159
Franklin Carmichael (1890–1945)
Grace Lake 1931 (see fig. 240)
Oil on canvas, 101.6 × 122 cm
University College, University of Toronto
Inscriptions: l.r., *FRANK / CARMICHAEL / 1931*; verso: u.r., *FC* (monogram) / *1931*
Exhibitions: Group 1931, no. 38, $850; Roerich 1932, no. 5.
Bibliography: Harrold 1931.

The sketch (NGC 6450) for this canvas was painted only a few months before the Group's last exhibition. Successfully combining rich, earthy colour with Frank Carmichael's characteristic linear refinement, it merited the praise accorded him by E.W. Harrold (1931) writing for the *Ottawa Citizen*: "Frank Carmichael gathers force and individuality."

160
Emily Carr (1871–1945)
Red Cedar c. 1931 (see fig. 241)
Oil on canvas, 111 × 68.6 cm
Vancouver Art Gallery (54.7), gift of Ella Fell, Vancouver, 1954
Inscriptions: l.r., *EMILY CARR*
Provenance: Mrs. James Fell, Vancouver, 1942.
Exhibitions: [Group 1931, no. 45, $300 ?]; [NGC 1932, no. 36 ?]; Victoria, Island Arts and Crafts Society, 11–22 Oct. 1932, Modern Room, no. 4.

Emily Carr sent six canvases to the 1931 Group show, of which five were hung. "The sixth we did not hang because we felt it was not up to the others," wrote Lawren Harris. "One of mine went out for the same reason ... The little green yellow tree [cat. 161] we all liked best; then the red cedar – a fine thing."[1] Whether this canvas was the one exhibited in 1931 is not certain. It is possible that it was repainted in part at a later date or that Carr exhibited another painting with the same title (Shadbolt 1979, 213). The reviewers made no specific references to any of Carr's paintings.

1. Harris, Toronto, to Carr, Victoria, 6 December [1931], NAC, microfilm, MG30 D215, vol. 2.

161
Emily Carr (1871–1945)
The Little Pine 1931 (see fig. 242)
Oil on canvas, 112 × 68.8 cm
Vancouver Art Gallery (42.3.14), Emily Carr Trust
Inscriptions: l.r., *M.E. CARR*; verso: u.l., *The Little Pine / To: Emily Carr / 316 Beckley St / Victoria, B.C.*
Provenance: The artist, Victoria; Emily Carr Trust 1941.
Exhibitions: Group 1931, no. 46, $200.

"I see three phases in your work," wrote Lawren Harris to Emily Carr. "The first was shown in [1928] ... the spirit was there then in those works, but not so deep, so concentrated as in your later work. Second phase – Hart House has one, Isabel McLaughlin has one [cat. 138] ... These came to fruition in imaginative variety, in what you had experienced and desired to express ... Now, and for a year or so you enter a new phase, a deeper penetration into the life of nature."[1]

1. Harris, Toronto, to Carr, Victoria, 20 Dec. 1931, NAC, microfilm, MG30 D215, vol. 2.

162
Kathleen Daly (1898–1994)
Mackerel 1931 (see fig. 243)
Oil on canvas, 73.8 × 84 cm
National Gallery of Canada, Ottawa (37837), bequest of the artist, Toronto, 1994
Inscriptions: l.l., *K. DALY*; back of frame: u.c. in ink, *Tub of*, in black ink, "*MACKEREL*" / *KATHLEEN DALY / 16 TORRINGTON PLACE / OTTAWA*, in ink, *5364 Avenue Rd. / Toronto*
Exhibitions: Group 1931, no. 50, $75; [AAM 1932, no. 72 *Tubs of Mackerel* ?]; Ottawa Art Association, 9–14 May 1932, *Exhibition of Paintings, Etchings and Drawings by Kathleen Daly and George Pepper*, no. 6, $75.
Bibliography: Telegram 5 Dec. 1931; Harrold 1931.

Arthur Lismer and his family and Charles and Louise Comfort travelled to the Maritimes during the summer of 1930. The following year Kay Daly and her husband, George Pepper, followed. At Peggy's Cove, Daly found the subject for the two canvases she exhibited in the Group show in December: *Interior of Fish House, Peggy's Cove*,[1] and *Mackerel*, the latter almost a detail of the former. The Toronto reviewers nearly totally ignored the new invited contributors in their general discussion of the Group's supposed demise, but E.W. Harrold (1931) of the *Ottawa Citizen* praised Daly's lively realism and cold quality of light.

1. Sold at Sotheby's, Toronto, 11 May 1994, lot 228.

163
L.L. FitzGerald (1890–1956)
Doc Snyder's House 1931 (see fig. 239)
Oil on canvas, 74.9 × 85.1 cm
National Gallery of Canada, Ottawa (3993), gift of P.D. Ross, Ottawa, 1932
Inscriptions: l.l., *L.L. FITZGERALD 1931*
Provenance: Purchased from NGC 1932 with funds donated by P.D. Ross, Ottawa.
Exhibitions: Group 1931, no. 53, $500; NGC 1932, no. 60, $500; Roerich 1932, no. 13 (incorrectly as loaned by The Hon. Vincent Massey); Group 1936, no. 44.
Bibliography: Phillips 1931; McCormick 1932; Eric Brown 1932, repr. 315; Die Kunst Aug. 1933, repr. 347.

LeMoine FitzGerald's connection with the Group began when he had an exhibition at the Arts and Letters Club in February 1928. Fred Brigden, who had organized the show, informed FitzGerald that he would be invited to exhibit with the Group. "I think our friends of the Group of Seven have been quite intrigued by your viewpoint. It is something a little different from what they have been doing themselves but they recognize a kindred soul."[1] In a letter to MacDonald, FitzGerald declined. "It is very fine of the 'Group 7' to invite me to take part in their exhibition and I hope I may have the pleasure of joining at some future date again. I have always had the greatest interest in what you were doing and feel very sympathetic to your outlook and productions, even though the opportunity of seeing the various members' works have been comparatively few."[2]

FitzGerald showed two canvases in the 1930 exhibition, and sent three works to the 1931 show, *Farm Buildings*, *Prairie Farm*, and *Doc Snyder's House*. Having worked on the latter over two winters he wrote to Bertram Brooker: "The large winter picture is finished and I am almost tempted to say that it has some satisfying qualities,

that is if I don't look at it for any great length of time … it is a little more unified than some of the more recent ones in the last two or three years … The artist is most decidedly an optimist at all times, hopeful that the next one will be the supreme effort and so we live between the great heights and the greatest depths."[3]

Rejected by the Academy's jury for its 1931 exhibition,[4] the painting was bought for the National Gallery the following spring.

1. Brigden, Toronto, to FitzGerald, Winnipeg, 6 Feb. 1928, UM FitzGerald, box 7. 2. FitzGerald, Winnipeg, to J.E.H. MacDonald, Toronto, [Feb. 1928], NAC, MG30 D111, vol. 1. 3. FitzGerald, Winnipeg, to Brooker, Toronto, 13 June 1931, copy in UM FitzGerald, box 7. 4. Jackson, Toronto, to FitzGerald, Winnipeg, 30 Nov. 1931, UM FitzGerald, box 7.

164

Lawren S. Harris (1885–1970)
Mount Lefroy 1930 (see fig. 233)
Oil on canvas, 133.5 × 153.5 cm
McMichael Canadian Art Collection, Kleinburg, Ont. (1975.7), purchased 1975
Provenance: Estate of the artist; purchased from L.S.H. Holdings Ltd., 1975.
Exhibitions: Group 1931, no. 58 *Mountains, Massive Range Rocky Mountains*, $2000; Roerich 1932, no. 16; CNE 1932, no. 110, $1000, repr.; International 1933, no. 170.
Bibliography: Bridle 1932a; Canadian Bookman Sept. 1932; Canadian Homes and Gardens Sept. 1932, p. 20, and Oct. 1933, p. 29; Brooker 1932, p. 234; Sherburne 1933.

Lawren Harris sent his largest canvases since *Mountain Forms* of 1926 to the 1931 Group exhibition. These majestic, symbolic images dominated the show. E.W. Harrold (1931) wrote: "The most striking work is still being done by Lawren Harris. Seven years ago, Harris startled the art world with his *Above Lake Superior*. In this, Harris threw tradition to the wind. He did not paint a specific stretch of country so much as a summing up of a whole region. It was the region's 'soul'. The effect Harris's work has on the beholder is conflicting. One violently dislikes or likes it. But whatever one's reaction, one has to admit that his pictures have a strangely moving effect. They arouse queer emotions, because of the intensity of their feeling and the austerity of their conceptions."

One of Harris's most composed mountain canvases, worked up from at least three varying oil sketches,[1] *Mount Lefroy* evokes a spiritual aura, like praying hands reaching to the heavens. Yet, when the painting was shown at the Canadian National Exhibition, one exasperated writer could only say that it "and certain other modernistic efforts" seemed to be nothing short of monstrosities" (Canadian Bookman Sept. 1932).

1. All three sketches are in the McMichael Canadian Art Collection, Kleinburg, Ont. (1971.12; 1981.85.2; 1986.1).

165

Lawren S. Harris (1885–1970)
Icebergs, Davis Strait 1930 (see fig. 232)
Oil on canvas, 121.9 × 152.4 cm
McMichael Canadian Art Collection, Kleinburg, Ont. (1971.17), gift of Mr. and Mrs. H. Spencer Clark, Toronto, 1971

Provenance: Roberts Gallery, Toronto; Mr. and Mrs. H. Spencer Clark, Toronto.
Exhibitions: Group 1931, no. 59 *Icebergs, Smith Sound*, $1500; NGC 1932, no. 96; CNE 1933, no. 105, $1000, repr.; Pittsburgh 1935, no. 230 *Icebergs, Davis Strait*.
Bibliography: Harrold 1932a; Telegram 23 Jan. 1932; Dick 1932, pp. 280–81.

Icebergs, Davis Strait is the largest of Lawren Harris's Arctic canvases. In contrast to the centralized image of *Mount Lefroy*, two forms rise from the cold, blue water to the sky. This increasing purification of his art was not always appreciated by the Group's supporters, as expressed by Jehanne Biétry Salinger (1932a): "Harris, whose unfailing faith and aggressiveness had, for years, scandalized the morons, slowly retired to the sanctuary of an aristocratic spirituality where his understanding and aesthetic appreciation of human values suddenly froze as though under the spell of a magic wand, his voice ceased to speak, his heart ceased to beat, and his mountains, and his lakes, and his rocks, and his trees in their cold blue, green, or white garment did not seem to live anymore."

166

Lawren S. Harris (1885–1970)
Isolation Peak, Rocky Mountains 1930 (see fig. 253)
Oil on canvas, 106.7 × 127 cm
Hart House Permanent Collection, University of Toronto
Provenance: The artist, Vancouver; purchased with income from the Harold and Murray Wrong Memorial Fund, 1946.
Exhibitions: AFA (1) 1930, no. 18 *Isolation Peak*, $1000; Group 1931, no. 63, $750; NGC 1932, no. 98; Vancouver 1932, no. 43 *Isolation Peak, Rockies*.
Bibliography: L. Mechlin 1930, p. 267; Vancouver Sun 11 May 1932.

Fred Housser (1932, 183), in an emotional response, countered J.B. Salinger's estimation of Lawren Harris (see cat. 165): "Harris has always baffled his critics because they have been incapable or unwilling to follow him, and yet, no Canadian painter has had a more logical development. There are a chain of canvases marking every step of the way from *Above Lake Superior* to the Arctic pictures shown in the December exhibition. This chain traces the successful effort on the part of Harris to clarify more and more that stern but magnificent mood which he feels and loves in northern Nature and which unfortunately none of his critics ever contacted. I think he sees this mood in terms of spiritual and human values for which … he has the keenest appreciation and understanding. One may not like the mood, for it is certainly unfriendly to any cosmopolitan love of comfort and the side of life from which most of the art of Europe springs, but it is a mood which, if grasped and held, will help one to live like gods instead of slaves."

One of the two oil sketches for this smaller canvas is inscribed: "Isolated Peak above Yoho Valley, Rocky Mountains."[1]

1. This sketch is reproduced in C. Jackson 1991, p. 51. The second sketch is reproduced in Adamson 1978, p. 183. It has been suggested that the mountain is actually Mont des Poilus, near Isolated Peak in Yoho Park. G. Pole, Field, B.C., to McMichael Canadian Art Collection, Kleinburg, Ont., 12 Jan. 1933, Hart

House, University of Toronto, curatorial file for Harris, *Isolation Peak*.

167

Prudence Heward (1896–1947)
Girl under a Tree 1931 (see fig. 235)
Oil on canvas, 122.5 × 193.7 cm
Art Gallery of Hamilton (61.72.4), gift of the artist's family, 1961
Inscriptions: l.r., *P. Heward*
Provenance: Estate of the artist; by descent.
Exhibitions: Group 1931, no. 73; NGC 1932, no. 119; Montreal, W. Scott and Sons, from 19 April 1932, *Heward Exhibition*.
Bibliography: McCarthy 1931c and 1932a; Telegram 5 Dec. 1931; Harrold 1931; Montreal Gazette 27 April 1932; St. Catharines Standard 16 June 1932; Bridle and Golfer Oct. 1932, p. 1, repr. 2.

Prudence Heward exhibited two small canvases resultant from her recent studies in France, *Cagnes* and *Street in Cagnes*, and this large nude in the 1931 Group show. Only one reviewer, E.W. Harrold (1931), noted it, commenting on the "curious elements of modernism and classicism, and while it is not sensational, it is assertive."

A.Y. Jackson (1932a) situated Heward's work within the context of the growth of Canadian art: "Whether one styles her work as modern or not is of little moment — it is characterized by draughtsmanship of a high order, with spaces generously filled in. In some cases I would find the modelling of her figures too insistent — one becomes too conscious of the artist's understanding of planes and would feel happier if more was left to the imagination … It has been evident for some time that art in Canada is entering on a new phase — it essays to interpret the country more than ever before and at the same time is alive to present-day art developments abroad … the Canadian painters can no longer remain isolated; they will work with the idea of challenging opinions in New York or London, as well as Montreal and Toronto. During the last few years, Canadian exhibit[ions] have been going on almost continuously in various American cities, and the wider field in prospect is likely to spur the artist on to more daring and original efforts."

168

A.Y. Jackson (1882–1974)
Winter Evening, Quebec 1931 (see fig. 246)
Oil on canvas, 64.4 × 79.7 cm
Art Gallery of Hamilton (66.74.21), bequest of H.S. Southam, Esq., C.M.G., LL.D., Ottawa, 1966
Inscriptions: l.r., *A Y JACKSON*; verso: stamped c., Artist's Supply Co. Ltd. / 77 York St., Toronto
Provenance: The artist, Toronto; H.S. Southam, Ottawa.
Exhibitions: Group 1931, no. 89 *Ruisseau Jureux*, $400; NGC 1932, no. 135, $400; Roerich 1932, no. 30; London 1935, no. 58 *Cuisseau Jureux* [sic].
Bibliography: Harrold 1932a; Dick 1932, p. 280, repr. 281.

Frederick Banting, who accompanied A.Y. Jackson on several sketching trips in the late twenties, described how Jackson resolved the problem of freezing paint on cold, late winter days: "Alex has been painting from notes all day and has done three or four fine sketches. It is a fine method for one who knows how. It requires detailed observation and a memory for colour and tone. He makes a careful drawing and then

makes short-hand colour notes and it is remarkable how true he can hit the scene. It has the advantage that he can work indoors with warm plastic paint without being rushed instead of standing in the cold wind trying to place hard gummy paint. Colour and tone are important but design is the big thing in painting. Alex has about a dozen sketches which he is scratching out because they lack design, or are deficient in subject matter."[1]

In March 1931, Banting, Jackson and Randolph Hewton stayed at Saint-Irénée in Charlevoix County, walking to nearby villages on day trips. On their last day they visited Ruisseau-Jureux, a flag station "ten miles up hill all the way there and down hill almost all the way back,"[2] where Jackson sketched this composition.[3]

1. Banting, "Quebec trip 1930," 28 March 1930, UTL, ms. coll. 76, box 28B. 2. Banting, "Painting trip to St. Irenée, Quebec, 1931," 3 April 1931, UTL, ms. coll. 76, box 28B. 3. The oil sketch is in the Art Gallery of Hamilton (89.17).

169
A.Y. Jackson (1882–1974)
Night, Pine Island 1924 (see fig. 247)
Oil on canvas, 64.2 × 81.5 cm
National Gallery of Canada, Ottawa (18124), bequest of Dorothy Lampman McCurry, 1974, in memory of her husband Harry Orr McCurry, Director of the National Gallery of Canada, 1939–55
Inscriptions: l.l., *A Y JACKSON*; stretcher: t., *"NIGHT PINE ISLAND" A.Y. JACKSON / Price $400.⁰⁰*, u.l., *A.Y. JACKSON* (crossed out)
Provenance: The artist, Toronto; H.O. McCurry, Ottawa, 1933.
Exhibitions: [AGT Canadian 1926, no. 19 *Moonlight, Georgian Bay*, $350 ?]; [Rochester 1927, no. 15 *Night, Georgian Bay*, $350 ?]; [AGT Canadian 1927, no cat. no., $350 ?]; Group 1931, no. 90 *Night, Pine Island*, $450; AAM 1932, no. 132, $400; NGC 1933, no. 134; Group 1936, no. 112, loaned by H.O. McCurry.

In her premature postmortem on the Group of Seven, Jehanne Biétry Salinger (1932a) wrote: "Alone in his survival, and I might say in his renewed youth and wealth of inspiration, is Alex. Jackson, whom one might call the single survivor of The Group of Seven. He had fifteen canvases in the exhibition. Each of them was a new thing in itself and a successful thing." And Reta Myers (1931c) of Vancouver, quoting an eastern writer, exclaimed: "Fresh subjects, fresh interest, and decided technique has brought new interest to his work. He may have abandoned his wilderness, but he has created a whole symphony from the theme of life."

170
A.Y. Jackson (1882–1974)
Saint-Fidèle c. 1930 (see fig. 248)
Oil on canvas, 63.8 × 81.9 cm
Private collection, Quebec
Inscriptions: l.r., *A Y JACKSON*
Provenance: The artist, Toronto; Baron Byng High School, Montreal, c. 1931.
Exhibitions: Group 1931, no. 96 *St. Fidèle, Quebec*, loaned by Baron Byng High School, Montreal; Group 1936, no. 104.

A.Y. Jackson first visited Saint-Fidèle in 1926 with Edwin Holgate. "We went down for a

couple of days and liked it so well I am going back with Robinson," he wrote to Norah Thomson. "It is rather like St. Hilarion on top of a hill but overlooking the river for miles … not ancient but just a natural village where everyone did as they pleased and the pigs sun themselves on the front verandahs."[1] He returned in 1930 with Fred Banting. "It was a hard month to work, not many effects and more wind than was necessary and too much new snow and frozen paint."[2]

As E.W. Harrold (1931) commented, reviewing the 1931 Group show: "Jackson, it seems, has the roots of his artistic being still firmly embedded in the Quebec soil. More than half his pictures come from there, and they are all a delight."

1. Jackson, La Malbaie, Que., to N. Thomson, Toronto, 18 March [1926], NAC, MG30 D322, vol. 1, Jackson 1926. 2. Jackson, Petite Rivière, Que., to N. Thomson, Toronto, 1 April [1930], NAC, MG30 D322, vol. 1, Jackson 1930.

171
Arthur Lismer (1885–1969)
Harbour Life, Nova Scotia 1931 (see fig. 258)
Oil on canvas, 81.9 × 102.6 cm
Beaverbrook Art Gallery, Fredericton, gift of Lord Beaverbrook, 1959
Inscriptions: l.l., *A. Lismer '31*
Provenance: The artist, Montreal; Dominion Gallery, Montreal, 1955; Lord Beaverbrook.
Exhibitions: Group 1931, no. 99, $600; NGC 1932, no. 157, $750; Roerich 1932, no. 36; CNE 1932, no. 120, $600; Malloney Lismer 1935, no. 5 *In a Nova Scotia Harbour*, $500; Group 1936, no. 136 *A Nova Scotia Harbour*.
Bibliography: Harrold 1931; Canadian Homes and Gardens Sept. 1932, p. 21.

It was Bertram Brooker who noted that Arthur Lismer's Maritime paintings were more literal than usual,[1] and even Salinger (1932a) categorized him as "the now gentle painter of the Canadian wilds." The one exception was *Harbour Life, Nova Scotia*, in which the foreground post becomes the prime focus. The writer in *Canadian Homes and Gardens* (Sept. 1932, 21) was delighted with this work when it was exhibited at the Canadian National Exhibition, describing it as "a gay, animated fishing village scene, a vivid, swift impression, with all the business of docks, dories, anchors, ropes, deftly handled."

1. Brooker, Toronto, to FitzGerald, Winnipeg, 10 Jan. [1932], UM FitzGerald, box 7.

172
Yvonne McKague (born 1898)
Cobalt 1931 (see fig. 234)
Oil on canvas, 114.8 × 140 cm
National Gallery of Canada, Ottawa (3984)
Inscriptions: l.r., *YVONNE McKAGUE*
Provenance: Purchased from NGC 1932.
Exhibitions: Group 1931, no. 126; NGC 1932, no. 183, $450; Roerich 1932, no. 43, loaned by the NGC.
Bibliography: Bowler 1931; Webber 1932; Cochrane 1932; Eric Brown 1932, repr. 313; Gold Magazine Dec. 1933, repr.; Buckman 1934; North Bay Nugget 16 April 1934.

Like Lowrie Warrener (see cat. 105, 132), Yvonne McKague reworked an earlier subject for the 1931 Group show, eliminating much of the detail on

the horizon and in the buildings.[1] As Bertram Brooker wrote to LeMoine FitzGerald: "Yvonne McKague had a large canvas of Cobalt, very like the one that Hart House bought, but simplified and much finer."[2]

McKague first painted at Cobalt around 1926,[3] and the 1931 Group show included Northern Ontario mining subjects by Bess Housser and Isabel McLaughlin. A.Y. Jackson visited Cobalt the following autumn: "It's a higgley-piggeldy little town, slowly disintegrating, not a mine working. The great days when Cobalt was known as one of the great mining centres of the world are gone for good. Most of the mines are worked out and the others waiting until silver goes up enough in value to pay to take it out … the tin and tar paper and frame shacks are a little reminiscent of Hull."[4]

1. *Cobalt*, the first version, is repr. in Brooker 1929a, pl. XXX. That canvas (present whereabouts unknown) was 76.2 × 96.5 cm and was exhibited in the 1928 Group exhibition, see Entry Form-McKague, NGC Arch., 5.5–Annual 1929. 2. Brooker, Toronto, to FitzGerald, Winnipeg, 10 Jan. [1932], UM FitzGerald, box 7. 3. McKague exhibited *Miner's Shacks, Cobalt* at the 1926 RCA. See also Y. Housser 1980, pp. 21–27. 4. A.Y. Jackson, Cobalt, Ont., to Anne Savage, Montreal, 3 Oct. 1932, NAC, MG30 D374, vol. 1.

173
Isabel McLaughlin (born 1903)
Chestnut Branch 1931 (see fig. 215)
Oil on canvas, 51.4 × 48.9 cm
Private collection
Provenance: The artist; Col. and Mrs. R.S. McLaughlin, Oshawa, by 1936; by descent.
Exhibitions: Group 1931, no. 129, $150; NGC 1932, no. 189, $150; Roerich 1932, no. 44; AGT Young Canadians 1933, no. 2; Atlantic City 1933, no. 42; CGP 1933, no cat. no., $200; Hamilton CGP 1934, no. 26, $200; McLaughlin 1936, no. 317 *Chestnut Blossom*.
Bibliography: McCarthy 1931c.

In his article "The Amateur Movement in Painting" for the 1929 *Yearbook*, Fred Housser (in Brooker 1929a, 89–90) wrote: "Isabel McLaughlin, of Oshawa, a graduate of the Art Students' League, is one of the boldest young women painters we have. She is just beginning to exhibit. Her compositions are intensely modern in feeling … They are characterized by great thoroughness of search and real power, together with originality of expression and a fine structural sense." Painted two years later, *Chestnut Branch* confirms McLaughlin's individuality, and her unique sense of composition, firm design, and subtlety of colour appreciation. The inclusion of this canvas in the 1931 show confirms once again the strength of the Group's commitment to support new talent outside their own personal goals.

174
Lilias Torrance Newton (1896–1980)
Albert Robinson 1931 (see fig. 260)
Oil on canvas, 92 × 71 cm
Private collection
Inscriptions: l.l., *L. Torrance Newton*
Provenance: Albert Robinson, Montreal; Mrs. Albert Robinson, Toronto; by descent.
Exhibitions: Montreal, Watson Art Galleries, *A.H. Robinson, L.T. Newton, F. Wyle*, Nov. 1931, no. 34,

loaded by the sitter; Group 1931, no. 135; NGC 1932, no. 212.
Bibliography: Harrold 1932a; Ottawa Journal 21 Jan. 1932; Eric Brown 1932, repr. 320.

The subtly worked surface and rich colouring that characterize Newton's portrait of fellow artist Albert Robinson mark a further development in her work. From the more linear and classical treatment of *Elise Kingman*, she would concentrate more on texture and surface qualities in her portraits of the 1930s.

175
George Pepper (1903–1962)
Lighthouse 1931 (see fig. 254)
Oil on canvas laid down on hardboard, 111.8 × 142.2 cm
National Gallery of Canada, Ottawa (37842), bequest of Kathleen Daly, Toronto, 1994
Inscriptions: l.r., *G. PEPPER / 1931*; back of frame: t., *"LIGHTHOUSE" / GEORGE PEPPER 25 SEVERN ST. TORONTO*
Provenance: Estate of the artist; by descent.
Exhibitions: Group 1931, no. 136, $250; NGC 1932, no. 232; Roerich 1932, no. 45; CNE 1932, no. 138; Atlantic City 1933, no. 48; CGP 1933, no cat. no.; AAM 1935, no. 249, $250.
Bibliography: Harrold 1931; Montreal Gazette 7 March 1932; Lismer 1932c, p. 24; Brooker 1932, p. 234; Burroughs 1933.

While the Ottawa reviewer of the 1931 Group show, E.W. Harrold (1931), noted the advancement in scale and the influence of Lawren Harris in George Pepper's two submissions, the Toronto reviewers ignored his paintings. Yet Bertram Brooker (1932, 234) took special note of *Lighthouse* when it was exhibited at the Canadian National Exhibition in 1932: "Pepper's *Lighthouse* was an even more extreme example of this age-old, but lately neglected, simplicity. To anyone accustomed to the minute detail of recent realistic painting, this austere selection of the 'telling' aspects of a scene feels barren and freakish – and is promptly labelled 'modern' by those who are unaware that ancient art sprang from the same simplicity of outlook and severity of design."

176
Sarah Robertson (1891–1948)
Sulpician Seminary 1931 (see fig. 237)
Oil on canvas, 60.5 × 65.1 cm
Robert McLaughlin Gallery, Oshawa, gift of Isabel McLaughlin, 1987
Inscriptions: l.l., *Sarah Robertson*
Provenance: The artist, Montreal; Col. and Mrs. R.S. McLaughlin, Oshawa, c. 1934; Isabel McLaughlin, Toronto.
Exhibitions: Group 1931, no. 139; NGC 1932, no. 254, $150; Vancouver 1932, no. 98; Montreal, Sun Life Building, 8–23 Oct. 1932, *Independent Art Association*, no. 89, $100; Atlantic City 1933, no. 52; CGP 1933, no cat. no.; Hamilton CGP 1934, no. 28, $100; Montreal, W. Scott and Sons, May 1934, *Prudence Heward, Isabel McLaughlin, Sarah Robertson*; McLaughlin 1936, no. 325.
Bibliography: Lismer 1934a.

Arthur Lismer (1934a) reviewed an exhibition of the work of Prudence Heward, Sarah Robertson, and Isabel McLaughlin in May 1934: "Sarah Robertson is almost a veteran ... She has the wisdom of experience, and the experience to

change her wisdom into new and changing forms. There is one ... in this exhibition of a wall and trees of a Sulpician Monastery that recalls Morrice a little and yet has something entirely beautiful of its own ... Her landscapes are living examples that nature is a source and not a standard, and she has the courage to create landscapes and not copy them literally. They are adventurous and convincing statements that an artist only gets a fine design from nature if she brings that faculty to it."

177
Sarah Robertson (1891–1948)
Joseph and Marie-Louise 1929 (see fig. 192)
Oil on canvas, 61.6 × 66.2 cm
National Gallery of Canada, Ottawa (15545), bequest of Vincent Massey, 1968
Inscriptions: l.l., *S.M. Robertson*; stretcher: *Sarah M. Robertson / 1470 Fort St. / Winter Storm $100.*
Provenance: The Hon. Vincent Massey and Mrs. Massey, 1930.
Exhibitions: [CNE 1929, no. 1188 *Le Calvaire* ?]; AFA (1) 1930, no. 49 *Joseph and Marie-Louise*; Group 1931, no. 140, loaned by The Hon. Vincent Massey; NGC 1932, no. 252; Massey 1934, no. 183.
Bibliography: Hammond 1931.

Although it had been rejected by the Royal Canadian Academy, A.Y. Jackson was insistent that this painting be included in the exhibition organized by the American Federation of Arts for Washington.[1] There it was purchased by Vincent and Alice Massey.[2] Bertram Brooker was less enthusiastic about this particular work: "Sarah Robertson, an oldish Montreal painter, who has often contributed very simple, flattish things to the Group shows, had three slightly larger things than usual and greatly improved. One of a house, fields and sunny sky was quite ecstatic and exciting. Another of two people at a wayside crucifix had a little of the look of an illustration. The third – of a monastery – was the most distinguished."[3]

1. Jackson, Toronto, to Robertson, Montreal, postmarked 20 Jan. 1930, NGC Arch., Robertson fonds. 2. A. Massey, Washington, to [E. Brown], Ottawa, 12 March 1930, excerpt, NGC Arch., 5.4-American Federation of Arts 1930. 3. Brooker, Toronto, to FitzGerald, Winnipeg, 10 Jan. [1932], UM FitzGerald, box 7.

178
Anne Savage (1896–1971)
The Plough 1931–33 (see fig. 236)
Oil on canvas, 76.4 × 102.3 cm
Montreal Museum of Fine Arts (970.1652), gift of Arthur B. Gill, Montreal, 1970
Inscriptions: l.l., *ADSAVAGE*
Provenance: The artist, Montreal; The Hon. Vincent Massey and Mrs. Massey, 1934; estate of Vincent Massey; Sotheby and Co. (Canada) Ltd., 27 Oct. 1969, lot 165. Arthur B. Gill, Montreal.
Exhibitions: Group 1931, no. 144; NGC 1933, no. 244; Atlantic City 1933, no. 55; CGP 1933, no cat. no., $115; Hamilton CGP 1934, no. 31, $115; AAM 1934, no. 301; Massey 1934, no. 185.
Bibliography: Barbeau 1933b.

One of Anne Savage's largest canvases to date, *The Plough* was exhibited in the 1931 Group show and reworked by the artist before being exhibited in the first Canadian Group of Painters

show in Atlantic City in 1933.[1] In illustrating Adjutor Rivard's *Chez Nous*, Jackson drew a plough abandoned in a field for the final chapter. The book is a nostalgic account of the old ways and customs of the author's rural childhood and ends with the death of the farmer: "The ploughman who heeded not the sunrise neither sees the shadows lengthen" (Rivard 1924, 199). In a sketch by J.E.H. MacDonald,[2] a canvas by the American painter Grant Wood,[3] and a drawing by Thoreau MacDonald,[4] the abandoned plough in the foreground spoke of both nostalgia and change.

1. Jackson, Toronto, to Savage, Montreal, postmarked 9 Dec. 1931, and postmarked 24 Jan. 1932, and 22 Jan. [1933], and 19 May [1933], all NAC, MG30 D374, vol. 1. 2. *Plow and Field, Thornhill*, 1929, sold at Sotheby Parke Bernet (Canada) Ltd., Toronto, 18 Oct. 1976, lot 86. 3. *Fall Plowing*, 1931, The John Deere Collection, Moline, Illinois. 4. Cover for J.E.H. MacDonald 1933b.

179
Carl Schaefer (1903–1995)
House in the Wood 1931 (see fig. 257)
Oil on canvas, 81.9 × 102.2 cm
Estate of the artist
Inscriptions: l.l., *CARL SCHAEFER 31–*
Exhibitions: Group 1931, no. 145; Young Canadians 1932, no. 344, $200.

Of the artists supported and encouraged by the Group of Seven, one who would extend their vision in new directions in the thirties was Carl Schaefer. Having studied at the Ontario College of Art with Arthur Lismer and J.E.H. MacDonald, he assisted the latter with the decorations at St. Anne's Church, the Concourse Building, and the Claridge Apartments in Toronto. Schaefer's admiration for Lawren Harris is reflected in his interest in houses as symbols, but he is closer in spirit to MacDonald in his love of the rural environment and of tradition linked to place.

Water Colors; A Group of 18th Century Cotton and Linen Prints from France, England, Spain and East India; A Group of Portrait Heads by the French Sculptor, Charles Despiau; A Group of Etchings, Drypoints, Silverpoints and Pencil Drawings by Robert Fulton Logan; A Group of African Negro Sculpture, Buffalo Fine Arts Academy, Albright Art Gallery, Buffalo, Jan. 1928 (exhibition catalogue).

NGC 1928 *Annual Exhibition of Canadian Art*, National Gallery of Canada, Ottawa, 24 Jan.–28 Feb. 1928 (exhibition catalogue).

Group 1928 *Exhibition of Canadian Paintings by the Group of Seven and Etchings by Robert F. Logan*, Art Gallery of Toronto, 11–26 Feb. 1928 (exhibition catalogue).

OSA 1928 *Ontario Society of Artists: Fifty-sixth Annual Exhibition and Edmund Morris Memorial Exhibition*, Art Gallery of Toronto, 3 March–8 April 1928 (exhibition catalogue).

AAM 1928 *Art Association of Montreal: Forty-fifth Annual Spring Exhibition*, Montreal, 22 March–15 April 1928 (exhibition catalogue).

Leonardo 1928 *Paintings by Canadian Artists*, Leonardo Society, Montreal, April 1928.

London 1928 *Exhibition of Paintings, Drawings, Engravings and Sculpture by Artists Resident in Great Britain and the Dominions*, Imperial Institute, London, England, 2 April–30 June 1928 (exhibition catalogue).

Saskatoon 1928 *Group of Seven*, Nutana Collegiate Institute, Saskatoon, from 3 April 1928.

Buffalo Annual 1928 *Twenty-second Annual Exhibition of Selected Paintings by American Artists*, Buffalo Fine Arts Academy, Albright Art Gallery, Buffalo, 29 April–24 June 1928 (exhibition catalogue).

Quebec 1928 *Canadian Folk Song and Handicraft Festival: General Programme*, Château Frontenac, Quebec City, 24–28 May 1928 (exhibition catalogue).

CNE 1928 *Canadian National Exhibition: British, Spanish and Canadian Paintings; British and Canadian Sculpture; British, Mexican and Canadian Applied Art; International Graphic Art and Salon of Photography*, Toronto, 24 Aug.–8 Sept. 1928 (exhibition catalogue).

Western Tour 1928–29 *Vancouver Exhibition*, from 12 Aug. 1928 (exhibition list) / *New Westminster Provincial Exhibition*, B.C., Sept. 1928 / *Edmonton Museum of Arts Loan Exhibition*, 29 Oct.–3 Nov. 1928 (exhibition catalogue) / Calgary Public Museum, Dec. 1928 / Drumheller Public Library, Alta., Feb. 1929. [Catalogue numbers refer to the Edmonton catalogue.]

Buffalo 1928 *Exhibition of Paintings by Canadian Artists*, Buffalo Fine Arts Academy, Albright Art Gallery, Buffalo, 14 Sept.–14 Oct. 1928 (exhibition catalogue) / *Paintings by Canadian Artists*, Memorial Art Gallery, Rochester, N.Y., 14 Nov. 1928–6 Jan. 1929 (exhibition catalogue).

AAM Canadian 1928 *Exhibition of Contemporary Canadian Paintings*, Art Association of Montreal, 22 Sept.–14 Oct. 1928 (exhibition catalogue).

Edmonton 1928 *Edmonton Museum of Arts Loan Exhibition*, 29 Oct.–3 Nov. 1928 (exhibition catalogue).

RCA 1928 *Royal Canadian Academy of Arts: Fiftieth Annual Exhibition*, Art Gallery of Toronto, 29 Nov. 1928–8 Jan. 1929 (exhibition catalogue).

NGC 1929 *Annual Exhibition of Canadian Art; Exhibition by Members of the Society of Sculptors of Canada*, National Gallery of Canada, Ottawa, 28 Jan.–28 Feb. 1929 (exhibition catalogue).

Kingston OSA 1929 *Ontario Society of Artists: Loan Exhibition*, Kingston Arts and Music Club, Ont., after 7 Jan. 1929 (exhibition list).

OSA 1929 *Ontario Society of Artists: Fifty-seventh Annual Exhibition; Drawings by Bertram Brooker; Scissor-Cuts by Lisl Hummel Borsook*, Art Gallery of Toronto, 2–31 March 1929 (exhibition catalogue).

AAM 1929 *Art Association of Montreal: Forty-sixth Annual Spring Exhibition*, Montreal, 21 March–14 April 1929 (exhibition catalogue).

Calgary RCA 1929 *Art Loan Exhibit, Royal [Canadian] Academy of Arts*, Calgary Exhibition and Stampede, 8–13 July 1929 (exhibition catalogue) / Edmonton Exhibition, 15–20 July 1929 (exhibition catalogue).

CNE 1929 *Canadian National Exhibition: British, Danish and Canadian Paintings; British, Danish and Canadian Sculpture; British, Danish and Canadian Applied Art; American Mural Sketches; International Graphic Art and Salon of Photography*, Toronto, 23 Aug.–7 Sept. 1929 (exhibition catalogue).

Detroit 1929 *Women's International Exposition under the Auspices of the Detroit Federation of Women's Clubs*, Convention Hall, Detroit, 14–19 Oct. 1929 (exhibition catalogue).

Saskatoon OSA 1929 *Ontario Society of Artists Exhibition*, Nutana Collegiate Institute, Saskatoon, after 23 Oct. 1929 (exhibition list).

RCA 1929 *Royal Canadian Academy of Arts: Fifty-first Annual Exhibition*, Montreal, 21 Nov.–22 Dec. 1929 (exhibition catalogue).

Edmonton OSA 1930 *Ontario Society of Artists Exhibition*, Edmonton Museum of Arts, after 18 Jan. 1930 (exhibition list).

NGC 1930 *Annual Exhibition of Canadian Art*, National Gallery of Canada, Ottawa, 23 Jan.–28 Feb. 1930.

OSA 1930 *Ontario Society of Artists: Fifty-eighth Annual Exhibition*, Art Gallery of Toronto, 7–30 March 1930 (exhibition catalogue).

AFA (1) 1930 *Exhibition of Paintings by Contemporary Canadian Artists under the Auspices of the American Federation of Arts*, Corcoran Gallery of Art, Washington, D.C., 9–30 March 1930 (exhibition list) / Rhode Island School of Design, Providence, R.I., April 1930 / Baltimore Museum of Art, 4–28 May 1930 (exhibition catalogue) / Grand Central Galleries, New York City, June 1930 / Minneapolis Institute of Arts, July 1930 / City Art Museum, St. Louis, Mo., Aug. 1930 (exhibition catalogue).

AFA (2) 1930 *Exhibition of Paintings by Contemporary Canadian Artists under the Auspices of the American Federation of Arts*, University of Wisconsin, Madison, Nov. 1930 / Municipal Art Gallery, Davenport, Iowa, Dec. 1930 / Brooks Memorial Art Gallery, Memphis, Tenn., Jan. 1931 / Montclair Art Museum, N.J., Feb. 1931 / Amherst College, Mass., March 1931 (exhibition list).

London 1930 *Exhibition of Paintings, Drawings, Engravings and Sculpture by Artists Resident in Great Britain and the Dominions*, Imperial Institute, London, England, 5 April–28 June 1930 (exhibition catalogue).

Group 1930 *Exhibition of the Group of Seven, Canadian Society of Painters in Water Colour, Society of Canadian Painter-Etchers, The Toronto Camera Club*, Art Gallery of Toronto, 5–27 April 1930 (exhibition catalogue) / *Exhibition of Paintings and Drawings by the Group of Seven and by Other Artists Invited by Them to Contribute*, Art Association of Montreal, 3–18 May 1930 (exhibition catalogue).

Manoir Richelieu 1930 *First Annual Exhibition of Canadian Art*, Manoir Richelieu, Murray Bay, Que., July 1930 (exhibition catalogue).

CNE 1930 *Canadian National Exhibition: Canadian Paintings, Sculpture, Water Colours, Graphic and Applied Art; Architectural Exhibit and Salon of Photography*, Toronto, 22 Aug.–6 Sept. 1930 (exhibition catalogue).

Edmonton 1930 *Edmonton Museum of Arts Loan Exhibition*, 20–26 Oct. 1930 (exhibition catalogue).

RCA 1930 *Royal Canadian Academy of Arts: Fifty-first Annual Exhibition*, Montreal, Nov. 1930 (exhibition catalogue).

NGC Jackson-Harris 1930 *Catalogue of Arctic Sketches by A.Y. Jackson, R.C.A., and Lawren Harris*, National Gallery of Canada, Ottawa, 26 Nov.–8 Dec. 1930 / Art Association of Montreal, 31 Jan.–15 Feb. 1931.

Saskatoon 1930 *Exhibition of Paintings by the Art Association of Saskatoon, including Paintings by Members of the Royal Canadian Academy, the Ontario Society of Artists and the Group of Seven*, Memorial Art Gallery, Nutana Collegiate Institute, Saskatoon, 8–10 Dec. 1930 (exhibition catalogue) / Edmonton Museum of Arts, Jan. 1931 / Mount Royal College, Public Library, Calgary, 11–16 Feb. 1931 / Public Museum, Calgary, 16–28 Feb. 1931 / Women's Art Association of Saskatoon, 9 March–12 April 1931.

Eaton 1930 *Exhibition of Canadian Paintings*, Fine Art Galleries, T. Eaton Co., Toronto, c. 1930–31 (exhibition catalogue).

NGC 1931 *Annual Exhibition of Canadian Art: Exhibition by Members of the Society of Sculptors of Canada*, National Gallery of Canada, Ottawa, 15 Jan.–28 Feb. 1931 (exhibition catalogue).

Baltimore 1931 *First Baltimore Pan American Exhibition of Contemporary Paintings*, Baltimore Museum of Art, 15 Jan.–28 Feb. 1931 (exhibition catalogue).

Buenos Aires 1931 *British Empire Trade Fair*, Buenos Aires, Argentina, Feb.–April 1931 (exhibition list).

OSA 1931 *Ontario Society of Artists: Fifty-ninth Annual Exhibition; Contemporary French Prints*, Art Gallery of Toronto, from 6 March 1931 (exhibition catalogue).

AAM 1931 *Art Association of Montreal: Forty-eighth Spring Exhibition*, Montreal, 20 March–19 April 1931 (exhibition catalogue).

AGT Harris-Jackson 1931 *Exhibition of Contemporary British Water Colors; Wood Engravings by Clare Leighton, A.R.E.; Arctic Sketches by Lawren Harris and A.Y. Jackson, R.C.A.*, Art Gallery of Toronto, May 1931 (exhibition catalogue).

Dartmouth Harris 1931 *Lawren Harris Exhibition*, Dartmouth College, Hanover, N.H., June–Oct. 1931 (exhibition list).

Vancouver 1931 *Exhibition of Paintings and Photography: Contemporary British Water-Colors by Courtesy of the National Gallery, Ottawa; Sketches of the Canadian North by Lawren Harris, R.C.A. and A.Y. Jackson, R.C.A.; "Photograms of the Year,"* Vancouver Exhibition Association, 22–29 Aug. 1931 (exhibition catalogue).

CNE 1931 *Canadian National Exhibition: Scottish Paintings, Water Colours and Sculpture; British Paintings, Water Colours, Miniatures and Sculpture; British Graphic and Applied Art; Old Masters; Stained Glass Exhibit; Canadian Paintings, Water Colours, Sculpture, Graphic and Applied Art, and Salon of Photography*, Toronto, 28 Aug.–12 Sept. 1931 (exhibition catalogue).

Edmonton 1931 *Edmonton Museum of Arts Loan Exhibition*, 19–25 Oct. 1931 (exhibition catalogue).

RCA 1931 *Royal Canadian Academy of Arts: Fifty-second Annual Exhibition*, Montreal, 19 Nov.–20 Dec. 1931 (exhibition catalogue).

Group 1931 *Exhibition of Seascapes and Water-Fronts by Contemporary Artists and an Exhibition of the Group of Seven*, Art Gallery of Toronto, 4–24 Dec. 1931 (exhibition catalogue).

NGC 1932 *Seventh Annual Exhibition of Canadian Art*, National Gallery of Canada, Ottawa, 22 Jan.–23 Feb. 1932 (exhibition catalogue).

Roerich 1932 *Exhibition of Paintings by Contemporary Canadian Artists*, International Art Center of Roerich Museum, New York City, 5 March–5 April 1932 (exhibition catalogue) / *Exhibition of Contemporary Canadian Paintings*, Museum of Fine Arts, Boston, 8–27 April 1932 (exhibition catalogue) / Kalamazoo Museum and Art Institute, Mich., May 1932.

AAM 1932 *Art Association of Montreal: Forty-ninth Annual Spring Exhibition*, Montreal, 17 March–17 April 1932 (exhibition catalogue).

Vancouver 1932 *All-Canadian Exhibition,* Vancouver Art Gallery, May–July 1932 (exhibition catalogue).
CNE 1932 *Canadian National Exhibition: American Painting, Canadian Painting and Sculpture; British Water Colours, Graphic and Applied Art, Photography,* Toronto, 26 Aug.–10 Sept. 1932 (exhibition catalogue).
Edmonton 1932 *Edmonton Museum of Arts Loan Exhibition,* 22 Oct.–6 Nov. 1932 (exhibition catalogue).
RCA 1932 and **Young Canadians 1932** *Royal Canadian Academy of Arts: Fifty-third Annual Exhibition; Photography of Buildings Submitted for the Gold Medal and Other Awards of the Royal Architectural Institute of Canada; Exhibitions by Young Canadians; John Alfsen and Carl Schaefer,* Art Gallery of Toronto, 4–30 Nov. 1932 (exhibition catalogue)

International 1933 *College Art Association International 1933,* Worcester Art Museum, Mass., [Jan. 1933] / *International 1933,* Rockefeller Center, New York City, 5–26 Feb. 1933 / *College Art Association International 1933,* Cleveland Museum of Art, 8 March–8 April 1933 (exhibition catalogue). [Catalogue numbers refer to the Cleveland Museum of Art catalogue.]
AGT MacDonald 1933 *Modern French Paintings from Manet to Matisse; Water Colours by Contemporary American Painters; Memorial Exhibition of the Work of J.E.H. MacDonald, R.C.A.,* Art Gallery of Toronto, from 6 Jan. 1933 (exhibition catalogue).
AGT Young Canadians 1933 *Fourth Biennial Exhibition of Architecture and the Allied Arts, by the Members of the Toronto Chapter of the Ontario Association of Architects; Exhibitions by Young Canadians,* Art Gallery of Toronto, 3–26 Feb. 1933 (exhibition catalogue).
NGC 1933 and **NGC MacDonald 1933** *Annual Exhibition of Canadian Art; Memorial Exhibition of the Work of James E.H. MacDonald, R.C.A., 1873–1932,* National Gallery of Canada, Ottawa, 7 Feb.–6 March 1933 (exhibition catalogue). Part of the MacDonald memorial exhibition travelled to: Winnipeg Art Gallery, April–8 May 1933 / Vancouver Art Gallery, from c. 20 May / Calgary Exhibition and Stampede, 10–15 July 1933.

Winnipeg 1933 *Opening Exhibition of Paintings from Canadian National Gallery, Ottawa, and Contemporary American Water Color Drawings,* Winnipeg Art Gallery Association, from 22 April 1933 (exhibition catalogue).
Atlantic City 1933 *Paintings by the Canadian Group of Painters,* Heinz Art Salon, Heinz Ocean Pier, Atlantic City, summer 1933 (exhibition catalogue).
CNE 1933 *Canadian National Exhibition: American Painting, Canadian Painting and Sculpture, British Water Colours, Graphic and Applied Art, Photography,* Toronto, 25 Aug.–9 Sept. 1933 (exhibition catalogue).
AGT Forbes 1933 *Exhibition of Paintings by Kenneth Forbes, A.R.C.A., O.S.A; Paintings by Three American Painters, Robert Henri, Arthur B. Davies, and George Luks; Exhibition of "Times" Photographs,* Art Gallery of Toronto, Oct. 1933 (exhibition catalogue).
Edmonton 1933 *Edmonton Museum of Arts Annual Loan Exhibition 1933,* 19–31 Oct. 1933 (exhibition catalogue).
Toronto CGP 1933 *Exhibition of Paintings by Canadian Group of Painters,* Art Gallery of Toronto, from 3 Nov. 1933 (exhibition catalogue).
CGP 1933 *Canadian Group of Painters Canadian Clubs Tour,* Brantford, Ont., from 26 Nov. 1933 (exhibition list).

Montreal CGP 1934 *Exhibition of Paintings by Canadian Group of Painters,* Art Association of Montreal, 1–21 Jan. 1934 (exhibition catalogue).
Hamilton CGP 1934 *Canadian Group of Painters,* McMaster University, Hamilton, Feb. 1934 (exhibition list).
AAM 1934 *Art Association of Montreal: Fifty-first Annual Spring Exhibition,* Montreal, 19 April–13 May 1934 (exhibition catalogue).
Massey 1934 *Contemporary Paintings by Artists of the United States; Canadian Paintings, the Collection of Hon. Vincent and Mrs. Massey, and in the Print Room Scissor Cuts by René Kulbach,* Art Gallery of Toronto, Dec. 1934 (exhibition catalogue).

Malloney Jackson 1935 *Exhibition of Paintings: A.Y. Jackson, Fred S. Haines, Frank Carmichael, A.J. Casson,* J. Merritt Malloney Galleries, Toronto, 9–30 March [1935] (exhibition catalogue).
AAM 1935 *Art Association of Montreal: Fifty-second Annual Spring Exhibition,* Montreal, 21 March–14 April (exhibition catalogue).
Malloney Lismer 1935 *Exhibition of Paintings, Sketches and Drawings by Arthur Lismer, A.R.C.A., O.S.A., 'Canadian Group of Painters',* Galleries of J. Merritt Malloney, Toronto, 4–25 May 1935 (exhibition catalogue).
Arts Club 1935 *Summer Exhibition 1935,* Arts Club, Montreal, summer 1935 (exhibition list).
AGT Permanent 1935 *The Permanent Collection of Oil and Water Colour Paintings as Arranged for Exhibition, Summer, 1935; the Print Room: Contemporary British, American and Canadian Prints,* Art Gallery of Toronto, from 6 July 1935 (exhibition catalogue).
London 1935 *Western Art League Exhibition; 104 Color Prints by European Artists; 57 Paintings of French Canada,* Art Gallery, Queen's Park, London, Ont., 30 Sept.–5 Oct. 1935 (exhibition catalogue).
Edmonton 1935 *Edmonton Museum of Arts Twelfth Annual Exhibition,* Oct. 1935 (exhibition catalogue).
Pittsburgh 1935 *The 1935 International Exhibition of Paintings,* Carnegie Institute, Pittsburgh, 17 Oct.–8 Dec. 1935 (exhibition catalogue).
AGT Loan 1935 *Loan Exhibition of Paintings Celebrating the Opening of the Margaret Eaton Gallery and the East Gallery,* Art Gallery of Toronto, from 8 Nov. 1935 (exhibition catalogue).

McLaughlin 1936 *Ontario Society of Artists: Sixty-fourth Annual Exhibition; Canadian Paintings Collection of Mr. and Mrs. R.S. McLaughlin,* Oshawa, Art Gallery of Toronto, from 6 March 1936 (exhibition catalogue).
Group 1936 *Retrospective Exhibition of Painting by Members of the Group of Seven 1919–1933,* National Gallery of Canada, Ottawa, 20 Feb.–15 April 1936 / Art Association of Montreal, 17 April–3 May 1936 / Art Gallery of Toronto, 15 May–15 June 1936 (exhibition catalogue).

Bibliography

BOOKS AND ARTICLES, BY AUTHOR

A.
1922. "Hart House Theatre." *Canadian Forum* II:24 (Sept. 1922), pp. 753–56.
AAM (Art Association of Montreal)
Annual reports for the years 1900 to 1934.
1913a. *Catalogue of Pictures and Statuary in the Permanent Collections.* Montreal: Art Association of Montreal, 1913.
1913b. *Exhibition of Paintings and Drawings by John G. Lyman* (exhibition catalogue). Montreal: Art Association of Montreal, 1913.
A.C.D.
1931. "Fine Display of Water Colors at Exhibition Here." *Vancouver Daily Province,* 23 Aug. 1931.
Adam, James
1923. "The Portrait of Dr. Tory." *The Trail,* July 1923, pp. 6–7, frontispiece.
1924. "The Chancellor's Portrait." *The Trail* XVII:10 (1924), pp. 17–18.
Adams, T.D.
1992. "'Painting above Paint': Telling Li(v)es in Emily Carr's Literary Self-Portraits." *Journal of Canadian Studies* XXVII:2 (Summer 1992), pp. 37–48.
Adamson, Jeremy
1978. *Lawren S. Harris: Urban Scenes and Wilderness Landscapes 1906–1930* (exhibition catalogue). Toronto: Art Gallery of Ontario, 1978.
Addison, Ottelyn
1969. With Elizabeth Harwood. *Tom Thomson: The Algonquin Years.* Toronto: McGraw-Hill Ryerson, 1969.
1974. *Early Days in Algonquin Park.* Toronto: McGraw-Hill Ryerson, 1974.
Adeney, Jeanne
1927. "The Portrait Exhibition." *Canadian Bookman* IX:10 (Oct. 1927), pp. 294–95.
1928a. "The Galleries in January." *Canadian Bookman* X:1 (Jan. 1928), p. 5.
1928b. "The Group of Seven: Their 5th Annual Exhibition." *Canadian Bookman* X:2 (Feb. 1928), pp. 43–44.
1928c. "The 56th Annual O.S.A. Exhibition." *Canadian Bookman* X:3 (March 1928), pp. 79–80.
1928d. "Art Notes." *Canadian Bookman* X:11 (Nov. 1928), p. 344.
1929a. "Art Notes." *Canadian Bookman* XI:1 (Jan. 1929), p. 25.
1929b. "Art Notes." *Canadian Bookman* XI:4 (April 1929), pp. 98–99.
1930a. "Art Notes." *Canadian Bookman* XII:1 (Jan. 1930), p. 7.
1930b. "Art Notes." *Canadian Bookman* XII:12 (Dec. 1930), p. 252.
1931a. "Art Notes." *Canadian Bookman* XIII:1 (Jan. 1931), p. 18.
1931b. "Art Notes." *Canadian Bookman* XIII:3 (March 1931), p. 62.
Adeney, Marcus
1928. "Lawren Harris: An Interpretation." *Canadian Bookman* X:2 (Feb. 1928), pp. 42–43.

Adlow, Dorothy
1932. "Canadian Pictures in Boston." *Boston Monitor,* 16 April 1932.
Admirer of Canadian Art
1932. "Canadian Art and Artists Warmly Praised" (letter to the editor). *Montreal Daily Star,* 15 June 1932.
A.E.F.
1927. "Canadian Comes to Defense of Canada's Artists" (review of *A Canadian Art Movement* by F.B. Housser). *Vancouver Sunday Province,* 11 Sept. 1927, p. 4.
A.E.S.S.
1931. "Mr. Hammond's M.I.P. on Art" (review of *Painting and Sculpture in Canada* by M.O. Hammond). *Canadian Bookman* XIII:7 (July 1931), p. 140.
A Foreman
1928. "Pictures at the Fair" (letter to the editor). *Vancouver Daily Province,* 13 Aug. 1928, p. 7.
AGO (Art Gallery of Ontario)
1981. *Lawren Harris Ontario Landscapes* (exhibition catalogue). Toronto: Art Gallery of Ontario, 1981.
AGT (Art Gallery of Toronto)
Bulletins and annual reports for the years 1926 to 1934.
1948. *Lawren Harris Paintings 1910–1948* (exhibition catalogue). Toronto: Art Gallery of Toronto, 1948.
1950. *Arthur Lismer Paintings 1913–1949* (exhibition catalogue). Toronto: Art Gallery of Toronto, 1950.
1953. *A.Y. Jackson Paintings 1902–1953* (exhibition catalogue). Toronto: Art Gallery of Toronto, 1953.
1954. *F.H. Varley Paintings 1915–1954* (exhibition catalogue). Toronto: Art Gallery of Toronto, 1954.
ALC (Arts and Letters Club)
1913. *The Year Book of Canadian Art 1913.* Toronto: J.M. Dent & Sons, 1913.
Alexandre, Arsène
1927a. "La vie artistique." *Le Figaro* (Paris), 10 April 1927.
1927b. "Les Canadiens et le 'Primitivisme.'" *La Renaissance* (Paris), 15 April 1927.
Allen, Alexander Richard
1961. "Salem Bland and the Social Gospel in Canada." Master's thesis, University of Saskatchewan, 1961.
Allen, Jan
1993. *Bon Echo 'Dreams & Visions.'* Kingston, Ont.: Agnes Etherington Art Centre, 1993.
A Lover of Nature
1930. "Work of 'Group of Seven'" (letter to the editor). *Montreal Daily Star,* 14 May 1930.
A Lover of Real Art
1930. "The 'Group of Seven'" (letter to the editor). *Montreal Daily Star,* 24 May 1930.
A Lover of Truth and Beauty
1913. "The New Style of Painting" (letter to the editor). *Montreal Daily Witness* [2] April 1913.
Altmeyer, George
1976. "Three Ideas of Nature in Canada, 1893–1914." *Journal of Canadian Studies* XI:3 (Aug. 1976), pp. 21–36.
Amateur
1932. "Unfinished Pictures" (letter to the editor). *Ottawa Journal,* 29 Feb. 1932.

A.M.D.
1927. "Canadian Art Exhibit, Place de la Concorde." *Montreal Daily Star,* 7 May 1927.
Applehof, Ruth Stevens
1988. With Barbara Haskell and Jeffrey Hayes. *The Expressionist Landscape: North American Modernist Painting, 1920–1947* (exhibition catalogue). Birmingham, Ala.: Birmingham Museum of Art, 1988.
Armstrong, Isabel C.
1930. "All Schools Represented at National Art Exhibit." *Toronto Daily Star,* 1 Feb. 1930.
Art Association of Montreal
See under AAM.
Art Gallery of Ontario
See under AGO.
Art Gallery of Toronto
See under AGT.
Art Gallery of Windsor
1978. *A.J. Casson* (exhibition catalogue). Windsor, Ont.: Art Gallery of Windsor, 1978.
Art Lover
1919. "R.C.A. Art Exhibition" (letter to the editor). *Ottawa Journal,* 31 Dec. 1919.
Arts and Letters Club
See under ALC.
Ayers, Augustus
1922. "Spring Art Exhibition and the Status of Our Canadian Artists." *Montreal Daily Herald,* 1 April 1922.
Ayre, Robert
"Canadian Group of Painters." *Canadian Forum* XIV:159 (Dec. 1933), pp. 98, 100.
Bagnall, Frank
1933. "Canadian Artists' Show." *Saturday Night* XLVIII:50 (21 Oct. 1933), p. 16.
Baker, Victoria
1982. With Richard Dubé and François Tremblay. *Scenes of Charlevoix 1784–1950* (exhibition catalogue). Montreal: Montreal Museum of Fine Arts, 1982.
Ball, Helen
1916. "Trying to Understand Artists and Their Arts." *Toronto Daily News,* 11 March 1916, p. 4.
Banting, Frederick G.
1979. "Diary and Drawings of Eastern Arctic Expedition, 1927, with AY Jackson; Diary and Drawings of Western Arctic Expedition, 1928, with AY Jackson; Fifteen Drawings of Cobalt and Quebec." *Northward Journal,* 14/15 (1979), pp. 25–91.
Barbeau, C. Marius
1920a. Preface to *Chansons of Old French Canada with Accompaniments by Margaret Gascoine.* Quebec: Château Frontenac, 1920.
1920b. Preface to *Veillées du bon vieux temps, à la Bibliothèque Saint-Sulpice, à Montréal, les 18 mars et 24 avril 1919.* Montreal: G. Ducharme, 1920.
1923. *Indian Days in the Canadian Rockies.* Toronto: Macmillan, 1923.
1926. "Folk Songs of French Canada." In *Empire Club of Canada: Addresses Delivered to the Members during the Year 1925,* pp. 180–96. Toronto: Macoomb Press, 1926.

1928a. *The Downfall of Temlaham.* Toronto: Macmillan, 1928.
1928b. "Canadian Folk Songs as a National Asset." *Canadian Nation* I:1 (Feb. 1928), pp. 18–22.
1929. "Ancient Culture Vignettes Past." *Canadian National Railways Magazine* XV:7 (July 1929), pp. 13, 30–31, 33.
1930. "The Passing of John McCuish." *Canadian Forum* X:118 (July 1930), pp. 361–63.
1932a. "The Canadian Northwest: Theme for Modern Painters." *American Magazine of Art* XXIV:5 (May 1932), pp. 331–38.
1932b. "Tells Remarkable Story of Progress and Achievement." *Ottawa Citizen,* 27 July 1932.
1932c. "Canada Sets a Banquet of Art for the Imperial Conference." *Art Digest* VI:19 (1 Aug. 1932), pp. 3–4.
1932d. "Distinctive Canadian Art: National Gallery Organizes Characteristic Show for Conference." *Saturday Night* XLVII:39 (6 Aug. 1932), p. 3.
1932e. "L'art au Canada – Les progrès." *La Revue Moderne,* Sept. 1932, pp. 5, 9.
1932f. "Exotic Leanings of Art in Canada Was Handicap." *Ottawa Morning Citizen,* 1 Oct. 1932.
1933a. "The Best and Largest." *Ottawa Citizen,* 9 Feb. 1933.
1933b. "Canadian Art Goes Forward." *New Outlook* (Toronto), 1 March 1933.
1935. "Père Raquette." *La Presse* (Montreal), 27 April 1935.
1968. *Louis Jobin – Statuaire.* Montreal: Beauchemin, 1968.

Bayer, Fern
1981. "The 'Ontario Collection' and the Ontario Society of Artists Policy and Purchases, 1873–1914." *RACAR* VIII:1 (1981), pp. 32–54.
1984. *The Ontario Collection.* Toronto: Fitzhenry & Whiteside, for the Ontario Heritage Foundation, 1984.

Bayfield, A. Carolyn
1928. "Playing Its Part" (letter to the editor). *Calgary Albertan,* 16 April 1928.

B.B.
1921. "The Group of Seven Display Their Art to the Uncultured." *Toronto Star Weekly,* 21 May 1921, p. 12.

B.B.C.
1911. "A Departure in Art Criticism." *MacLean's,* May 1911, pp. 63–72.

Beatty, J.W.
1919. "'Expressionism'" (letter to the editor). *Toronto Globe,* 10 Sept. 1919, p. 6.

Béland, Mario
1985. *Marius Barbeau et l'art au Québec.* Quebec: Outils de recherche du Celat, 1985.
1986. *Louis Jobin, Master-Sculptor* (exhibition catalogue). Quebec: Musée du Québec, 1986.

Bell, H. Poynter
1927. "Landscape Prevails in Spring Exhibition of Association." *Montreal Daily Star,* 25 March 1927.
1930a. "The Fifty-first Exhibition of the Royal Canadian Academy." *Journal, Royal Architectural Institute of Canada* VII:1 (Jan. 1930), pp. 29–33.
1930b. "What about Canadian Art?" *Canadian Passing Show* (Montreal), Oct. 1930, p. 9.

Bell, J. William
1932. "Not Representative of Canada." *Montreal Daily Star,* 16 April 1932.

Bengough, J.W.
1919. "'Expressionism'" (letter to the editor). *Toronto Globe,* 8 Sept. 1919, p. 6.

Bertram, Anthony
1924. "The Palace of Arts, Wembley." *Saturday Review* (London), 7 June 1924.

B.H.S.
1928. "The Group of Seven." *Business Woman,* March 1928, pp. 17, 22, 38.

Bice, Megan
1990. *Light and Shadow: The Work of Franklin Carmichael* (exhibition catalogue). Kleinburg, Ont.: McMichael Canadian Art Collection, 1990.
1994. With Sharyn Udall. *The Informing Spirit: Art of the American Southwest and West Coast Canada, 1925–1945* (exhibition catalogue). Introduction by Charles Eldredge; essay by Ann Davis. Kleinburg, Ont.: McMichael Canadian Art Collection / Colorado Springs: Taylor Museum for Southwestern Studies, 1994.

Bissell, Claude
1981. *The Young Vincent Massey.* Toronto: University of Toronto Press, 1981.

Blanchard, Paula
1987. *The Life of Emily Carr.* Vancouver: Douglas & McIntyre, 1987.

Bland, Salem
1923. "Rev. Salem Bland Writes" (letter to the editor). *Saturday Night* XXXVIII:16 (24 Feb. 1923), p. 2.
1925. "The Group of Seven and the Canadian Soul" (signed "The Observer"). *Toronto Daily Star,* 31 Jan. 1925.
1927a. "F.B. Housser's Story of the Group of Seven" (signed "The Observer"). *Toronto Daily Star,* 11 Feb. 1927, p. 6.
1927b. "Modern Art and the Old Puritanism" (signed "The Observer"). *Toronto Daily Star,* 20 Sept. 1927.

Bloore, R.L.
1970. "The Group of Seven: Toronto and Ottawa, Then and Now." *artscanada* XXVII:4 (Aug. 1970), pp. 52–54.

B.M.G.
1922. "Carl Ahrens: The Authentic Interpreter." *Saturday Night* XXXVII:25 (22 April 1922), p. 3.

Boas, George
1931. "Pan-American in Baltimore." *Arts* XVII:6 (March 1931), pp. 408–11.

Bohan, Ruth L.
1982. *The Société Anonyme's Brooklyn Exhibition: Katherine Dreier and Modernism in America.* Ann Arbor, Mich.: UMI Research Press, 1982.

Bothwell, Austin
1925. "A Canadian Bookshelf" (review of *The Fine Arts in Canada* by Newton MacTavish). *Phoenix* (Saskatoon), 12 Dec. 1925.
1927. "A Canadian Art Movement." *Saskatchewan Teacher* [Feb. 1927].

Bottomley, M.K.
1926. "Early History of the Canadian Handicrafts Guild." *Supplement to the McGill News,* 1 (Dec. 1926), pp. 27–33.

Bouchard, Georges
1932. *The Renaissance of Rustic Arts.* Ottawa, 1932.

Bouchette, Bob
1932a. "Lend Me Your Ears." *Vancouver Sun,* 22 June 1932.
1932b. "In Defence of the Group of Seven." *Toronto Mail and Empire,* 7 July 1932.

Bovey, Patricia
1978. With Ann Davis. *Lionel LeMoine FitzGerald (1890–1956): The Development of an Artist* (exhibition catalogue). Winnipeg: Winnipeg Art Gallery, 1978.

Bowler, J.W.
1931. "Is Rather Critical of Some of the Exhibits at Art Gallery of Toronto" (letter to the editor). *Toronto Telegram,* 11 Dec. 1931, p. 6.

Boyanoski, Christine
1983. With John Hartman. *W.J. Wood: Paintings and Graphics* (exhibition catalogue). Toronto: Art Gallery of Ontario, 1983.

B.H.S.
1987. *Loring and Wyle: Sculptors' Legacy* (exhibition catalogue). Toronto: Art Gallery of Ontario, 1987.
1989. *Permeable Border: Art of Canada and the United States, 1920–1940* (exhibition catalogue). Toronto: Art Gallery of Ontario, 1989.

Bradshaw, Marion G.
1921. "Bernard McEvoy: A British Columbia Champion of Art Progress." *Saturday Night* XXXVII:6 (10 Dec. 1921), p. 5.

Braide, Janet
1979. *Anne Savage* (exhibition catalogue). Montreal: Montreal Museum of Fine Arts, 1979.

Breithaupt, Paul
1930. "History of the Art Students' League." *Etcetera* I:1 (Sept. 1930), pp. 28–30; I:2 (Oct. 1930), pp. 28–30; I:3 (Nov. 1930), pp. 30–33.

Brewster, Muriel
1925. "Canadian Mine of Hidden Treasure Has Been Discovered by a French-Canadian Dreamer." *Toronto Star Weekly,* 25 April 1925, p. 42.
1928. "Some Ladies Prefer Indians." *Toronto Star Weekly,* 21 Jan. 1928.

Bridges, Marjorie Lismer
1977. *A Border of Beauty: Arthur Lismer's Pen and Pencil.* Toronto: Red Rock Publishing, 1977.

Bridle, Augustus
1909. "The Drama of the Ward." *Canadian Magazine* XXXIV:1 (Nov. 1909), pp. 3–8.
1910. "A New Art Centre in Toronto." *Toronto Star Weekly,* 3 Sept. 1910, p. 16.
1911. "Points about Pictures: What Is Canadian Art Doing for Canada?" *Canadian Courier* IX:21 (22 April 1911), pp. 12, 27.
1912a. "A Season of Pictures." *Canadian Courier* XI:18 (30 March 1912), pp. 6–7.
1912b. "Arthur Heming the Trail Artist." *Toronto Globe,* 13 April 1912, p. 4.
1913. "Art in Little Pictures." *Canadian Courier* XIII:15 (15 March 1913), p. 8.
1916a. *Sons of Canada: Short Studies of Characteristic Canadians.* Toronto: J.M. Dent & Sons, 1916.
1916b. "The Arts and the War." *MacLean's,* Feb. 1916, pp. 17–20, 71–72.
1917. "The Country's Clear Call." *Canadian Courier* XXII:1 (2 June 1917), pp. 5–7.
1918. "Canadian Artists to the Front." *Canadian Courier* XXIII:10 (16 Feb. 1918), p. 7.
1919. "Home!" (unsigned). *Canadian Courier* XXIV:13 (29 March 1919), pp. 10–11 (illustrations by Arthur Lismer).
1920a. "Are These New-Canadian Painters Crazy?" *Canadian Courier* XXV:17 (22 May 1920), pp. 6, 10, 20.
1920b. "The Group of Seven in Canadian Art" (unsigned). *Christian Science Monitor,* 7 June 1920, p. 14.
1921a. "Unusual Art Cult Breaks Loose Again." *Toronto Daily Star,* 7 May 1921.
1921b. "Pictures! Pictures! Who'll Come an' Buy?" *Toronto Daily Star,* 16 Nov. 1921.
1922. "Pictures of the Group of Seven Show 'Art Must Take the Road.'" *Toronto Daily Star,* 20 May 1922.
1923a. "Exhibition Pictures Level of Democracy." *Toronto Daily Star,* 1 Sept. 1923, p. 26.
1923b. "Pictures Offer Contrast, Both Cubist and Funereal." *Toronto Daily Star,* 24 Nov. 1923, p. 2.
1923c. "Dedicated in Art Is St. Anne's Church." *Toronto Daily Star,* 17 Dec. 1923, p. 22.
1924. "Small Picture Show a Brilliant Success." *Toronto Daily Star,* 8 Nov. 1924.
1925. "'School of Seven' Exhibit Is Riot of Impressions" (unsigned). *Toronto Star Weekly,* 10 Jan. 1925.
1926a. "Six Varieties of Canadian Pictures at Art Gallery." *Toronto Star Weekly,* 6 Feb. 1926.

1926b. "Process and Pomp Ends Art Pageant Week of City." *Toronto Daily Star*, 8 Feb. 1926.

1926c. "Group of Seven Disdainful of Prettiness: New Art Aims at Sublimity" (unsigned). *Toronto Daily Star*, 6 May 1926.

1926d. "Group of Seven Betray No Signs of Repentance." *Toronto Star Weekly*, 8 May 1926.

1926e. "British Artist Lauds Canada's Seven Group." *Toronto Daily Star*, 18 Dec. 1926.

1927a. "The Art Gallery Makes Use of Free Good Music." *Toronto Daily Star*, 5 Feb. 1927, p. 8.

1927b. "Progressive Group Takes Hold of Ontario Artists." *Toronto Daily Star*, 5 March 1927.

1927c. "Greatest Portrait Galaxy in America at Gallery." *Toronto Daily Star*, 6 Oct. 1927.

1928a. "Group of Seven Display Their Annual Symbolisms." *Toronto Daily Star*, 8 Feb. 1928.

1928b. "Seven Group Again Lead Ghost Dance of Palette" (unsigned). *Toronto Daily Star*, 18 Feb. 1928.

1928c. "Royal Canadian Academy Opens Here This Evening." *Toronto Daily Star*, 29 Nov. 1928.

1930a. "New Model Pictures Make Entries Record." *Toronto Daily Star*, 6 March 1930, p. 7.

1930b. "All Space Is Occupied for Art Gallery's Opening." *Toronto Daily Star*, 3 April 1930.

1931a. "Brooker's Nude Was Crated by Decision of Majority." *Toronto Daily Star*, 14 March 1931.

1931b. "Group of Seven Rumored as Seceding from O.S.A." *Toronto Daily Star*, 5 Dec. 1931, p. 4.

1932a. "Even Nudes Were Hot at 'Ex' Private Show." *Toronto Daily Star*, 26 Aug. 1932, p. 34.

1932b. "Variety and Ability Mark R.C.A. Display." *Toronto Daily Star*, 4 Nov. 1932.

1933a. "Canada and France Rivals at Gallery." *Toronto Daily Star*, 6 Jan. 1933.

1933b. "Two Distinct Art Worlds Now Visible at Gallery" (unsigned). *Toronto Daily Star*, 14 Jan. 1933.

1933c. "New Democracy Seen in Latest Paintings." *Toronto Daily Star*, 3 Nov. 1933.

1933d. "New 'Group' of Painters Challenged to Be Human." *Toronto Daily Star*, 4 Nov. 1933.

1934a. "Jackson's North Show Arouses Enthusiasm." *Toronto Daily Star*, 17 March 1934.

1934b. "Massey's Canadiana Feature at Gallery." *Toronto Daily Star*, 7 Dec. 1934.

1940. "New MacDonald Biography Misses His 'Pagan Appeal.'" *Toronto Daily Star*, 21 Dec. 1940.

1945. *The Story of the Club.* Toronto: Arts and Letters Club, 1945.

Brigden, F.H.

1923. With E. Wyly Grier, Fred Haines, A.Y. Jackson, C.W. Jefferys, J.E.H. MacDonald, and Herbert Palmer). "Our Artists' Duty to the Empire Exhibition" (letter to the editor). *Toronto Mail and Empire*, 27 Sept. 1923. Reprinted in *Toronto Daily Star*, 27 Sept. 1923; *Ottawa Citizen*, 28 Sept. 1923; *Montreal Gazette*, 28 Sept. 1923; *Winnipeg Free Press*, 29 Sept. 1923.

1925. "A Comedy of Errors" (signed F.H.B.). *Canadian Bookman* VII:8 (Aug. 1925), p. 137.

1927. "The Academy Exhibition." *Journal, Royal Architectural Institute of Canada* IV:1 (Jan. 1927), pp. 19–26.

Brinton, Christian

1926. *Modern Art at the Sesqui-Centennial Exhibition.* New York: Société Anonyme, 1926.

Broder, Bride

1929. "Canadians and Canadian Art." *Toronto Mail and Empire*, 28 Feb. 1929.

Brooke, Janet M.

1989. *Discerning Tastes: Montreal Collectors 1880–1920* (exhibition catalogue). Montreal: Montreal Museum of Fine Arts, 1989.

Brooker, Bertram

1925. "Conrad's View of Life." *Canadian Forum* V:55 (April 1925), pp. 207, 208, 210.

1926a. "Canada's Modern Art Movement." *Canadian Forum* VI:69 (June 1926), pp. 276–79.

1926b. "A Group of Seven Sponsors an Amateur Attitude in Art." *Canadian Passing Show* (Montreal), Dec. 1926, pp. 6, 7, 41.

1928–1930. "The Seven Arts." *Ottawa Citizen*, weekly column, 22 Oct. 1928–21 June 1930, 6 Sept.–22 Nov. 1930.

1929a. *Yearbook of the Arts in Canada, 1928–1929* (ed.). Toronto: Macmillan, 1929.

1929b. "Mr. Brooker Replies" (letter to the editor). *Winnipeg Tribune*, 27 Sept. 1929.

1929c. "Readers Forum: Mr. Brooker Replies" (letter to the editor). *Winnipeg Tribune*, 12 Dec. 1929.

1930a. "Mysticism Debunked." *Canadian Forum* X:114 (March 1930), pp. 202–03.

1930b. "Correspondence" (letter to the editor). *Winnipeg Free Press Evening Bulletin*, 7 April 1930.

1932. "A Review of the Arts at the Canadian National Exhibition, 1932." *Journal, Royal Architectural Institute of Canada* IX:10 (Oct. 1932), pp. 232–34.

Brown, Elizabeth

1985. *A Wilderness for All: Landscapes of Canada's Mountain Parks 1885–1960* (exhibition catalogue). Banff: Whyte Museum of the Canadian Rockies, 1985.

Brown, Eric

1911. "E. Wyly Grier." *Canadian Magazine* XXXVII:2 (June 1911), pp. 165–71.

1912. "The National Art Gallery of Canada." *Toronto Globe*, 4 May 1912.

1913a. "The National Art Gallery of Canada at Ottawa." *Studio* LVIII (Feb. 1913), pp. 15–21. Reprinted in *International Studio* XLIX:193 (March 1913), pp. 15–21.

1913b. "Canada and Her Art." In *Canadian National Problems*, pp. 171–76. Philadelphia: American Academy of Political and Social Science, 1913.

1915. "Studio Talk: Ottawa." *Studio* LXIV:265 (April 1915), pp. 206–12.

1916. "The National Gallery." *MacLean's*, July 1916, p. 34.

1917a. "Landscape Art in Canada." In *Art of the British Empire Overseas*, ed. Charles Holme, pp. 3–8. London: The Studio, 1917.

1917b. "Studio Talk: Ottawa." *Studio* LXXI:291 (June 1917), pp. 32–38.

1918a. "Canada's Purchases at Toronto" (unsigned). *Christian Science Monitor*, 15 April 1918.

1918b. "The Joint Canadian Show" (unsigned). *Christian Science Monitor*, 23 April 1918.

1919a. "Art and Art Galleries" (letter to the editor). *Ottawa Citizen*, 3 Dec. 1919.

1919b. "The Royal Canadian Academy at Toronto" (unsigned). *Christian Science Monitor*, 22 Dec. 1919.

1920. "The Royal Canadian Academy Exhibition" (unsigned). *Christian Science Monitor*, 13 Dec. 1920.

1921a. "Ontario Artists Exhibit in Toronto" (unsigned). *Christian Science Monitor*, 28 March 1921.

1921b. "Canadian Art and the Canadian National Gallery" (signed C.I.S.). *Winnipeg Free Press* 2 July 1921, p. 15.

1922. "An Art Movement in Canada – The Group of Seven" (signed E.). *Christian Science Monitor*, 31 July 1922.

1923. "The Canadian Art Exhibition" (letter to the editor). *Ottawa Citizen*, 12 Sept. 1923.

1925. *Canadian Art and Artists: A Lecture.* Ottawa: National Gallery of Canada, 1925.

1926. "'Those Pictures' – Mr. Brown Replies." *Ottawa Journal*, 13 March 1926.

1927a. "La jeune peinture canadienne." *L'Art et les Artistes*, 75 (March 1927), pp. 181–95.

1927b. "Canadian Art in Paris." *Canadian Forum* VII:84 (Sept. 1927), pp. 360–61.

1928a. "Ottawa Hits Back!" (letter to the editor). *Western Tribune* (Vancouver), 29 Sept. 1928.

1928b. "Explanation by National Gallery" (letter to the editor). *Calgary Herald*, 26 Dec. 1928.

1930. "'Get Art Out of the Cellar' – It Is Out, Claims Director" (letter to the editor). *Toronto Telegram*, 27 Sept. 1930.

1932. "Canada's National Painters." *Studio* CIII:471 (June 1932), pp. 311–23.

Brown, F. Maude

1927a. "Canadian Art in the Making." *Canadian Homes and Gardens* IV:6 (June 1927), pp. 38, 58, 60.

1927b. "Canadian Art in Paris." *Canadian Homes and Gardens* IV:8 (Aug. 1927) pp. 20, 56.

1946. "Eric Brown: His Contribution to the National Gallery." *Canadian Art* IV:1 (Nov. 1946), pp. 8–15, 32–33.

1964a. *Breaking Barriers: Eric Brown and the National Gallery.* Ottawa: Society for Art Publications, 1964.

1964b. "I Remember Wembley." *Canadian Art* XXI:4 (July/Aug. 1964), pp. 210–13.

Brown, J. Lewis

1932. "Canadian Artist Wins International Applause." *Bridle and Golfer*, Dec. 1932, pp. 20–21.

Brown, Milton

1963. *The Story of the Armory Show.* The Joseph H. Hirshhorn Foundation, 1963.

Browne, A.

1926. "Dictatorship in Art" (letter to the editor). *Toronto Daily Star*, 3 Dec. 1926.

Brunke, Frederick C.

1928. "'Mess of Chili Sauce' Is Description of One Work of Art" (letter to the editor). *Toronto Telegram*, 23 Feb. 1928, p. 30.

Buckman, Edward

1934. "Cobalt and the Artists" (letter to the editor). *Gold Magazine*, April 1934.

Burgoyne, St. George

1913a. "Local Artists' Work" (unsigned). *Montreal Gazette*, 19 Feb. 1913.

1913b. "Spring Exhibition at Art Gallery" (unsigned). *Montreal Gazette*, 26 March 1913.

1913c. "The Spring Exhibition at the Montreal Art Gallery" (signed "Palette"). *Saturday Mirror* (Montreal), 29 March 1913.

1913d. "Pictures Seen by Twelve Thousand" (unsigned). *Montreal Gazette*, 11 April 1913.

1913e. "In Local Pictures" (unsigned). *Montreal Gazette*, 15 April 1913.

1918. "War-Time Note in Academy Pictures" (unsigned). *Montreal Gazette*, 22 Nov. 1918.

1919. "Pictures of War at Art Gallery" (unsigned). *Montreal Gazette*, 28 Oct. 1919.

1920a. "War's Last Phase Shown in Paint." *Montreal Gazette*, 30 Sept. 1920.

1920b. "Art of Canadians Well Represented" (unsigned). *Montreal Gazette*, 19 Nov. 1920.

1922a. "Exhibits Drawn from Wide Area" (unsigned). *Montreal Gazette*, 21 March 1922.

1922b. "High Standard Set by R.C.A. Pictures" (unsigned). *Montreal Gazette*, 17 Nov. 1922, p. 9.

1922c. "Thirteen Hundred Visited Galleries" (unsigned). *Montreal Gazette*, 4 Dec. 1922.

1925. "Fine Work Marks R.C.A. Exhibition" (unsigned). *Montreal Gazette*, 20 Nov. 1925.

1926. "Canadian Artist's Versatility Shown" (unsigned). *Montreal Gazette*, 6 Dec. 1926.

1927. "R.C.A. Exhibition Nearing Jubilee" (unsigned). *Montreal Gazette*, 25 Nov. 1927.

1928. "Art Association Holds Exhibition" (unsigned). *Montreal Gazette*, 10 Oct. 1928.

1929a. "Spring Exhibition at Art Galleries." *Montreal Gazette*, 22 March 1929.

1929b. "R.C.A. Show Opened with Private View" (unsigned). *Montreal Gazette*, 22 Nov. 1929.

1930a. "Artists Follow Lead" (unsigned). *Montreal Gazette*, 23 April 1930.
1930b. "Exhibition of Art." *Montreal Gazette*, 26 April 1930.
1930c. "Group of Seven Showing Works" (unsigned). *Montreal Gazette*, 7 May 1930.
1931a. "Arctic Sketches Show" (unsigned). *Montreal Gazette*, 28 Jan. 1931.
1931b. "Sketches Exhibited of Canadian Arctic" (unsigned). *Montreal Gazette*, 2 Feb. 1931.
1931c. "Wide Range of Art in R.C.A. Exhibition" (unsigned). *Montreal Gazette*, 20 Nov. 1931.
1938. "A.Y. Jackson Plies His Able Brush from Georgian Bay to Baffin Island." *Montreal Gazette*, 22 Jan. 1938.
1939. "Montreal Press 'Ignored' Art Show by Printing Columns of Comment." *Montreal Gazette*, 14 Jan. 1939.

Burke, Eustella
1927. "The O.S.A. 1927 Spring Show." *Canadian Homes and Gardens* IV:4 (April 1927), pp. 100, 102.

Burnham, Constance
1924. "Harsh Lines Distinguish Canadian Art." *Sentinel* (Milwaukee), 2 Feb. 1924.

Burr, W.H.
1928. "A Little of Everything: The Group of Seven." *Toronto Daily Star*, 19 April 1928.

Burroughs, Carlyle
1933. "Canadian Art at Atlantic City." *New York Herald*, 4 June 1933.

Butterfield, J.
1927. "The Common Round." *Vancouver Daily Province*, 18 Aug. 1927, p. 6.
1928. "The Common Round: Some Pertinent Questions." *Vancouver Daily Province*, 27 Sept. 1928.

Callahan, Maggie
1982. *Lionel LeMoine FitzGerald: His Drawings and Watercolours* (exhibition catalogue). Edmonton: Edmonton Art Gallery, 1982.

Cameron, Don
1928. "Canada's New Art." *Border Cities Star* (Windsor, Ont.), 3 Dec. 1928.

Canadian Annual Review
1924. *Canadian Annual Review of Public Affairs 1923.* Toronto: Canadian Review Co., 1924.

Canadian Art Club
1911. *The Canadian Art Club 1907–1911.* [Toronto: Canadian Art Club, 1911.]

Canadian Drawings
1925. *Canadian Drawings by Members of the Group of Seven.* Toronto: Rous & Mann, 1925.

Canadian Forum Reproductions
1928. *Canadian Forum Reproductions: A Series of Canadian Drawings, Series No. 1.* Toronto, 1928.

Canadian National Railways
1927. *Jasper National Park.* Montreal: Canadian National Railways, 1927.
1929. *Canadian National Railways Magazine* XV: 7 (July 1929).

Canadian Society of Graphic Art
1931. *The Canadian Graphic Art Year Book.* Toronto: Ryerson [1931].

Cardin, Clarisse
1947. *Bio-bibliographie de Marius Barbeau.* Montreal: Éditions Fides, 1947.

Carmichael, Franklin
1978. "A Portfolio of Drawings." *Boréal*, 11/12 (1978), pp. 35–58.

Carr, Emily
1929. "Modern and Indian Art of the West Coast." *Supplement to the McGill News* X:3 (June 1929), pp. 18–22.
1966. *Hundreds and Thousands: The Journals of Emily Carr.* Toronto: Clarke, Irwin & Co., 1966.
1993. *The Emily Carr Omnibus.* Introduction by Doris Shadbolt. Vancouver: Douglas & McIntyre, 1993.

Carver, Humphrey
1931. "Exhibition at the Toronto Art Gallery." *Canadian Forum* XI:130 (July 1931), pp. 379–80.

C.C.C.
1919. "The Art League of Toronto." *The Rebel* IV:2 (Nov. 1919), pp. 87–88.

Chalmers, D.A.
1928a. "Toronto Exhibits at B.C. Art Gallery Attract Attention." *Vancouver Daily Province*, 3 Feb. 1928.
1928b. "Not Responsible for Pictures" (letter to the editor). *Vancouver Daily Province*, 14 Aug. 1928, p. 5.

Chalmers, W.C.
1926a. "Those Pictures" (letter to the editor). *Ottawa Journal*, 2 March 1926.
1926b. "Those Pictures" (letter to the editor). *Ottawa Journal*, 11 March 1926.

Charlesworth, Hector
1892. "Art in Canada To-Day." *Lake Magazine* I (Aug. 1892), pp. 57–61.
1911. "The O.S.A. Exhibition" (unsigned). *Saturday Night* XXIV:26 (8 April 1911), p. 25.
1914. "The Little Picture Show" (unsigned). *Saturday Night* XXVII:18 (14 Feb. 1914), p. 21.
1916. "Pictures That Can Be Heard: A Survey of the Ontario Society of Artists' Exhibition." *Saturday Night* XXIX:23 (18 March 1916), pp. 5, 11.
1917a. "Good Pictures at O.S.A. Exhibition." *Saturday Night* XXX:24 (24 March 1917), p. 2.
1917b. "A Master of the Luminous." *Saturday Night* XXXI:4 (10 Nov. 1917), p. 7.
1918a. "Carl Ahrens: A National Asset." *Saturday Night* XXXI:12 (5 Jan. 1918), p. 3.
1918b. "Toronto's New Art Gallery." *Saturday Night* XXXI:27 (20 April 1918).
1918c. "Archibald Browne's Landscapes." *Saturday Night* XXXII:1 (19 Oct. 1918), p. 7.
1919a. "Painter-Etchers and Others" (unsigned). *Saturday Night* XXXII:31 (17 May 1919), p. 3.
1919b. "Reflections." *Saturday Night* XXXII:48 (13 Sept. 1919), p. 2.
1919c. "Reflections." *Saturday Night* XXXIII:9 (13 Dec. 1919), p. 2.
1920. "Reflections." *Saturday Night* XXXV:47 (18 Sept. 1920), p. 2.
1921a. "Music and Drama." *Saturday Night* XXXVI:25 (16 April 1921), pp. 6–7.
1921b. "The Front Page." *Saturday Night* XXXVI:49 (8 Oct. 1921), p. 1.
1921c. "Impressions of the Royal Canadian Academy." *Saturday Night* XXXVII:4 (26 Nov. 1921), p. 5.
1921d. Editorial. *Saturday Night* XXXVII:8 (24 Dec. 1921), pp. 1–2.
1922a. "Past and Present among the Painters." *Saturday Night* XXXVII:22 (1 April 1922), p. 3.
1922b. "Music and Drama." *Saturday Night* XXXVII:33 (17 June 1922), p. 6.
1922c. "The National Gallery a National Reproach." *Saturday Night* XXXVIII:6 (9 Dec. 1922), p. 3.
1922d. "Xmas Picture Exhibitions." *Saturday Night* XXXVIII:7 (16 Dec. 1922), p. 3.
1922e. "Mr. Charlesworth's Reply." *Saturday Night* XXXVIII:19 (23 Dec. 1922), p. 2.
1922f. "Mr. Charlesworth Replies" (letter to the editor). *Ottawa Citizen*, 27 Dec. 1922, p. 14.
1922g. "And Still They Come! Aftermath of a Recent Article on the National Gallery." *Saturday Night* XXXVIII:8 (30 Dec. 1922), p. 3.
1923a. "The O.S.A. Exhibition." *Saturday Night* XXXVIII:20 (24 March 1923), p. 3.
1923b. "True Canadian Landscape." *Saturday Night* XXXVIII:23 (14 April 1923), p. 3.
1923c. "Pictures at National Exhibition." *Saturday Night* XXXVIII:43 (8 Sept. 1923), p. 3.
1923d. "Canada's Art at Empire Fair." *Saturday Night* XXXVIII:44 (15 Sept. 1923), p. 1.
1923e. "Royal Canadian Academy." *Saturday Night* XXXIX:2 (1 Dec. 1923), p. 5.
1924a. "O.S.A. Annual Exhibition." *Saturday Night* XXXIX:19 (29 March 1924), p. 3.
1924b. "Canadian Pictures at Wembley" (unsigned). *Saturday Night* XXXIX:26 (17 May 1924), p. 1.
1924c. "Canadian Pictures at Wembley" (unsigned). *Saturday Night* XXXIX:28 (31 May 1924), p. 3.
1924d. "Freak Pictures at Wembley" (unsigned). *Saturday Night* XXXIX:43 (13 Sept. 1924), p. 1.
1924e. "Canadian Painting for Taft Gallery" (signed H.C.). *Saturday Night* XXXIX:50 (1 Nov. 1924), p. 3.
1924f. "Canada and Her Paint Slingers" (unsigned). *Saturday Night* XXXIX:51 (8 Nov. 1924), p. 1.
1925a. *Candid Chronicles.* Toronto: Macmillan, 1925.
1925b. "The Group System in Art." *Saturday Night* XL:10 (24 Jan. 1925), p. 3.
1925c. "Many Picture Displays." *Saturday Night* XL:14 (21 Feb. 1925), p. 3.
1925d. "Ontario Society of Artists." *Saturday Night* XL:17 (14 March 1925), p. 3.
1926a. "A Magnificent Home of Art." *Saturday Night* XLI:12 (6 Feb. 1926), p. 5.
1926b. "Toronto and Montreal Painters." *Saturday Night* XLI:27 (22 May 1926), p. 3.
1926c. "Summer Shows at Toronto Art Gallery." *Saturday Night* XLI:40 (21 Aug. 1926), p. 3.
1926d. "Canada's War Memorial Pictures." *Saturday Night* XLI:47 (9 Oct. 1926).
1928. "Portraits by Richard Jack, R.A." *Saturday Night* XLIII:11 (28 Jan. 1928), p. 5.
1929. "Art Survey" (review of *Yearbook of the Arts in Canada, 1928–1929* by Bertram Brooker). *Saturday Night* XLV:2 (23 Nov. 1929).
1938. "The History of 'Saturday Night.'" *Saturday Night* LIII:9 (1 Jan. 1938), pp. 14–15, 18 (C.W. Jefferys drawing p. 1).

Chassé, Charles
1927. "L'exposition canadienne à Paris." *Le Figaro Hebdomadaire* (Paris), 13 April 1927.

Chauvin, Jean
1928. *Ateliers: Études sur vingt-deux peintres et sculpteurs canadiens.* Montreal: Louis Carrier & Cie., 1928.
1931. "Mexican Art Today." *Canadian Forum* XI:126 (March 1931), pp. 214–16.
1933. "Diego Rivera avait raison." *Le Canada*, 9 Jan. 1933. Reprinted in *Ottawa Citizen*, 24 Jan. 1933, "Diego Rivera Was Right."

Chavance, René
1927. "Une exposition d'art canadien s'ouvre demain au Jeu de Paume." *Liberté* (Paris), 11 April 1927.

Choate, Richard F.
1929. "Newcomers' Art Prominent in Exhibition at Gallery." *Toronto Mail and Empire*, 4 March 1929.

Choquette, Robert
1928. "Le Festival de la Chanson." *La Revue Moderne* IX:8 (June 1928), p. 1.

Cianci, Vito S.
1927. "Editorial." *Paint Box* II (June 1927), pp. 5–6.
1928a. "Artists – and Others." *Paint Box* III (June 1928), pp. 13–15.
1928b. "Morning on the Black Tusk Meadows." *Paint Box* III (June 1928), pp. 44, 63.

Citizen
1930. "Canadian Art" (letter to the editor). *Toronto Daily Star*, 12 June 1930.

Clark, Gregory
1914a. "Canadian Collectors Fail to Appreciate Canadian Art." *Toronto Star Weekly*, 31 Oct. 1914, p. 10.

1914b. "Why Canadian Art Is Not Popular with Collectors." *Toronto Star Weekly*, 21 Nov. 1914, p. 10.
1914c. "Canadian Artists Must Cut Loose from Old World Ideals." *Toronto Star Weekly*, 2 Dec. 1914.
1919. "Visiting the Canadian Art Academy Exhibition with Snivers the Plumber." *Toronto Star Weekly*, 13 Dec. 1919, p. 9.

Clark, Ken
1930. "Canadian Art Show Delayed in Opening Due to Taft's Death." *Montreal Gazette*, 10 March 1930.

Clive, Katharine
1931a. "The Canadian Galatea Comes to Life." *Canadian Homes and Gardens* VIII:2 (Feb. 1931), pp. 17–19, 51.
1931b. "The Canadian Galatea Comes to Life: Part II." *Canadian Homes and Gardens* VIII:3 (March 1931), pp. 35, 78.

C.M.
1919. "The Canadian War Memorials." *American Magazine of Art* X:8 (June 1919), pp. 289–90.

Coburn, F.W.
1920. Review of exhibition. *Boston Herald*, 19 Dec. 1920.

Cochrane, Albert Franz
1932. "Canadian Art." *Boston Transcript*, 9 April 1932.

Cole, Douglas
1978. "Artists, Patrons and Public: An Enquiry into the Success of the Group of Seven." *Journal of Canadian Studies* XIII:2 (Summer 1978), pp. 69–78.

Colgate, William G.
1933a. Editorial (unsigned). *Bridle and Golfer* VI:1 (March 1933), p. xx.
1933b. "Art: The Stencil School and Others." *Bridle and Golfer* VI:9 (Nov. 1933), pp. 14–15, 35.
1943. *Canadian Art: Its Origin and Development.* Toronto: Ryerson, 1943.
1954. *The Toronto Art Students' League: 1886–1904.* Toronto: Ryerson, 1954.

Comfort, Charles F.
1930. "The Art Reviewed." *Skyscraper*, 1 Dec. 1930, pp. 4, 7.

Constable, W.G.
1953. "Eric Brown as I Knew Him." *Canadian Art* X:3 (Spring 1953), pp. 114–19.

Cook, Ramsay
1974. "Landscape Painting and National Sentiment in Canada." *Historical Reflections* I:2 (Winter 1974), pp. 263–83.

Cowan, James A.
1925. "Hymie, Solly and a Pair of Truck-Drivers Take Part-Time Job as High Art Critics." *Toronto Telegram*, 31 Jan. 1925.

Cox, Kenyon
1913. "Futurism in Art." *Saturday Night* XXVI:44 (9 Aug. 1913), p. 7.

Coy, Helen
1982. *FitzGerald as Printmaker: A Catalogue Raisonné of the First Complete Exhibition of the Printed Works* (exhibition catalogue). Winnipeg: University of Manitoba Press, 1982.

C.P.S.
1925. "Art, Music and Drama." *Varsity* (University of Toronto), 30 Sept. 1925, p. 2.

Craven, Thomas
1926. "Northern Art" (review of *The Fine Arts in Canada* by Newton MacTavish). *New York Herald Tribune Books*, 2 May 1926, p. 13.

Crisp, A.
1933. "Tempest among the Artists." *Ottawa Journal*, 17 Jan. 1933.

Cunliffe, Guy S.
1931. "Nude Painting Sent to Cellar as Artists' Exhibition Opens Creating First-rate Mystery." *Toronto Mail and Empire*, 7 March 1931.

Currie, Ada F.
1928. "The Vanderpant Musicales." *Paint Box* III (June 1928), p. 48.

Dale, E.A.
1921. "Matsuo, The Pine Tree." *Canadian Forum* I:4 (Jan. 1921), pp. 114–16.

Dalton, W.
1928. "Real Art at Exhibition" (letter to the editor). *Vancouver Daily Province*, 29 Aug. 1928.

Daniels, Lisa
1990. *Lowrie L. Warrener* (exhibition catalogue). Sarnia, Ont.: Sarnia Public Library and Art Gallery, 1990.

Darling, David
1980. With Douglas Cole. "Totem Pole Restoration on the Skeena, 1925–30: An Early Exercise in Heritage Conservation." *B.C. Studies*, 47 (Fall 1980), pp. 29–48.

Darroch, Lois E.
1981. *Bright Land: A Warm Look at Arthur Lismer.* Toronto: Merritt Publishing, 1981.

Davidson, Margaret F.
1969. "A New Approach to the Group of Seven." *Journal of Canadian Studies* IV:4 (Nov. 1969), pp. 9–16.

Davies, Blodwen
1926. "Canada's First Art School." *Canadian Magazine* LXVI:5 (Dec. 1926), pp. 14–15, 36.
1930a. *Paddle and Palette: The Story of Tom Thomson.* Toronto: Ryerson, 1930.
1930b. "A National Picture Show." *Saturday Night* XLV:12 (1 Feb. 1930), p. 3.
1930c. "'Here's Canada!'" *New Outlook* CI:15 (26 Feb. 1930), pp. 202, 207.
1930d. "Need Not Look to Europe for Art Expression" (letter to the editor). *Toronto Telegram*, 10 May 1930.
1930e. "Canadian Women of Brush and Chisel." *Chatelaine*, June 1930, pp. 9, 42–43.
1930f. "Two Toronto Artists Going into Arctic." *Toronto Star Weekly*, 21 June 1930.
1930g. "Young Pirates Hunt Late Artist's Canoe." *Toronto Star Weekly*, 9 Aug. 1930.
1930h. "Tom Thomson and the Canadian Mood." *New Outlook*, 27 Aug. 1930, pp. 826, 836.
1931a. "Annual Canadian Art Show." *Saturday Night* XLVI:13 (7 Feb. 1931), p. 3.
1931b. "Stock-taking in the Arts in Canada." *New Outlook*, 18 Feb. 1931, p. 153.
1932. "The Canadian Group of Seven." *American Magazine of Art* XXV:1 (July 1932), pp. 13–22.
1935. *A Study of Tom Thomson.* Toronto: Discus Press, 1935.
1967. *Tom Thomson: The Story of a Man Who Looked for Beauty and for Truth in the Wilderness.* Vancouver: Mitchell Press, 1967.

Davis, Ann
1971. "A Study of the Group of Seven." Ottawa: National Historic Sites Service, 1971.
1973. "The Wembley Controversy in Canadian Art." *Canadian Historical Review* LIV:1 (March 1973), pp. 48–74.
1974. "An Apprehended Vision: The Philosophy of the Group of Seven." Ph.D. diss., York University, Toronto, 1974.
1982. *A Distant Harmony: Comparisons in the Painting of Canada and the United States of America* (exhibition catalogue). Winnipeg: Winnipeg Art Gallery, 1982.
1990. *The Logic of Ecstasy: Canadian Mystical Painting 1920–1940* (exhibition catalogue). London, Ont.: London Regional Art and Historical Museums, 1990.
1992. *The Logic of Ecstasy: Canadian Mystical Painting 1920–1940.* Toronto: University of Toronto Press, 1992.

Deacon, William Arthur
1929. "Arts Year Book Praised as Courageous Effort by W.A.D. Who Writes in It." *Ottawa Citizen*, 9 Dec. 1929.
1931. With W. Reeves. *Open House.* Ottawa: Graphic Publishers, 1931.

Debrisay, Mary A.
1928. "Native Art" (letter to the editor). *Vancouver Daily Province*, 16 Aug. 1928.

Denison, Merrill
1923a. "The Omniscienta." *Canadian Bookman* V:1 (Jan. 1923), pp. 9–10.
1923b. "The Arts and Letters Players." *Canadian Bookman* V:2 (Feb. 1923), pp. 31–32.
1923c. "Hart House Theatre." *Canadian Bookman* V:3 (March 1923), pp. 61–63.
1923d. *The Unheroic North: Four Canadian Plays.* Toronto: McClelland & Stewart, 1923.
1926. "Story of an Art Movement" (review of *A Canadian Art Movement* by F.B. Housser). *Toronto Globe*, 18 Dec. 1926.
1927. "The Group of Seven" (review of *A Canadian Art Movement* by F.B. Housser). *Willison's Monthly* II:8 (Jan. 1927), p. 293.
1928. "No More Pyrotechniques at Painting Exhibitions." *Toronto Daily Star*, 22 Dec. 1928.
1929. "The Complete Hotel." *Canadian National Railways Magazine* XV:7 (July 1929), pp. 1, 3, 42.
1934a. "Wins Fame as Painter." *Border Cities Star* (Windsor, Ont.), 25 Jan. 1934.
1934b. "Art War Rages for 22 Years over Lawren Harris' Paintings." *Sudbury Star*, 27 Jan. 1934.

Denoinville, G.
1927. "Exposition d'art canadien." *Le Journal des Arts* (Paris), 30 April 1927.

Deveu, Elsie
1931. "But Is It Art?" (letter to the editor). *Vancouver Daily Province*, 6 Sept. 1931.

Devlin, E.W.
1932. "At the National Gallery." *Ottawa Citizen*, 17 Feb. 1932.

Dewan, Janet
1994. "M.O. Hammond of Toronto." *History of Photography* XVIII:1 (Spring 1994), pp. 64–77.

D.G.
1926. "Philadelphia Notes." *American Magazine of Art* XVII:12 (Dec. 1926), p. 652.

D.G.M.
1932. "A Modern Art Group" (letter to the editor). *Toronto Mail and Empire*, 14 May 1932.

Dick, Stewart
1928a. "Canada's Primitive Arts." *Saturday Night* XLIII:10 (21 Jan. 1928), p. 2.
1928b. "The National Gallery of Canada: Tom Thomson." *Saturday Night* XLIII:42 (1 Sept. 1928), p. 5.
1928c. "The Canadian National Gallery: The Group of Seven and Others." *Saturday Night* XLIII:48 (13 Oct. 1928), p. 5.
1929. "East and West." *Saturday Night* XLIV:12 (2 Feb. 1929), p. 5.
1932. "Canadian Landscape of To-Day." *Apollo* XV (June 1932), pp. 279–82.

Dickson, Helen
1931. "The Vancouver School of Decorative and Applied Art." *Canadian Forum* XII:135 (Dec. 1931), pp. 102–03.

Djwa, Sandra
1976. "The *Canadian Forum*: Literary Catalyst." *Studies in Canadian Literature*, 1 (Winter 1976), pp. 7–25.
1977. "'A New Soil and a Sharp Sun': The Landscape of a Modern Canadian Poetry." *Modernist Studies: Literature & Culture 1920–1940* II:2 (1977), pp. 3–17.
1987. *The Politics of the Imagination: A Life of F.R. Scott.* Toronto: McClelland & Stewart, 1987.

Donegan, Rosemary
1987. *Industrial Images* (exhibition catalogue). Hamilton: Art Gallery of Hamilton, 1987.

Donovan, Peter [pseudonym: P.O'D.]
1911. "An Exhibition by Carl Ahrens." *Saturday Night* XXV:2 (21 Oct. 1911), p. 25.
1912. "That National Gallery of Ours." *Saturday Night* XXVI:12 (28 Dec. 1912), pp. 4–5.

1913. "A Big Show of Little Pictures." *Saturday Night* XXVI:20 (8 March 1913), p. 6.
1916. "Arting among the Artists." *Saturday Night* XXIX:26 (8 April 1916), p. 5. Reprinted in *Over 'ere and Back Home*, pp. 287–96 (Toronto: McClelland & Stewart, 1922).
1919a. "The Connosoor." *Saturday Night* XXXII:24 (29 March 1919), p. 5.
1919b. "The Spirit of the Club." *The Lamps*, Dec. 1919, pp. 46–52.

Dorne, F.H.
1925. "Feeling versus Training." *Canadian Bookman* VII:7 (July 1925), p. 121.

Dramatic Cricket
1920a. "The Dedication of the Temple." *The Rebel* IV:4 (Jan. 1920), pp. 163–65.
1920b. "The Chester Mystery Play." *The Rebel* IV:5 (Feb. 1920), pp. 206–08.

Dreier, Katherine S.
1926. *Modern Art*. New York: Société Anonyme, 1926.
1927. *Lecture on Modern Art, Toronto, April 14th, 1927.* [New York: Société Anonyme, 1927.]

Duval, Paul
1951. *Alfred Joseph Casson*. Toronto: Ryerson Press, 1951.
1965. *Group of Seven Drawings*. Toronto: Burns and MacEachern, 1965.
1972. *Four Decades: The Canadian Group of Painters and Their Contemporaries*. Toronto: Clarke, Irwin & Co., 1972.
1978. *The Tangled Garden*. Scarborough: Cerebrus/Prentice Hall, 1978.

D.W.W.
1920. "Of Artists and Art-Galleries." *The Rebel* IV:6 (March 1920), pp. 241–43.

Dyonnet, E.
1920. "For Art in Canada" (letter to the editor). *Ottawa Journal*, 13 Jan. 1920.
1922. "R.C.A.'s Appreciation" (letter to the editor). *Montreal Gazette*, 4 Dec. 1922.

Eckhardt, Ferdinand
1958. *L.L. Fitzgerald 1890–1956: A Memorial Exhibition* (exhibition catalogue). Ottawa: National Gallery of Canada, 1958.

Eden
1931. Letter to the editor. *Vancouver Star*, 29 Aug. 1931.

Edison, Margaret E.
1973. *Thoreau MacDonald: A Catalogue of Design and Illustration*. Toronto: University of Toronto Press, 1973.

Eglington, Guy C.
1920. "Hart House, University of Toronto." *International Studio* LXXII:24 (Nov. 1920), pp. v–xi.

E.M.B.
1928. "Writer Speaks Up for Pictures on Exhibition Here" (letter to the editor). *Toronto Telegram*, 29 Feb. 1928.

Emma
1922. "Pictures, Hanging, Judging" (letter to the editor). *Montreal Daily Star*, 25 April 1922.

Emmart, A.D.
1930. "Galleries Cover Wide Range Now." *Baltimore Morning Sun*, 11 May 1930.

Evans, Victoria
1986. "Bertram Brooker's Theory of Art as Evinced in His 'The Seven Arts' Columns and Early Abstractions." *Journal of Canadian Art History* IX:1 (1986), pp. 28–44.

Fair Play
1930. "'Group of Seven' Methods" (letter to the editor). *Montreal Daily Star*, 4 June 1930.

Fairbairn, Margaret L.
1913. "Five Canadian Artists Gain Distinction" (signed M.L.A.F.). *Toronto Star Weekly*, 8 March 1913.
1916. "Some Pictures at the Art Gallery" (signed M.L.A.F.). *Toronto Daily Star*, 11 March 1916, p. 5.
1917. "Virility Is the Note in Paintings of 1916" (signed M.L.A.F.). *Toronto Daily Star*, 9 March 1917, p. 17.
1919a. "Younger Artists Come to the Front" (signed M.L.A.F.). *Toronto Daily Star*, 8 March 1919.
1919b. "Among the Studios: Notes of Art World" (signed M.L.F.). *Toronto Daily Star*, 10 Nov. 1919, p. 9.
1919c. "New Academicians and Associates of R.C.A" (signed M.L.A.F.). *Toronto Star Weekly*, 6 Dec. 1919, p. 12.
1920a. "Society of Artists' Annual Exhibition" (signed M.L.F.). *Toronto Daily Star*, 6 March 1920.
1920b. "Some Fine Paintings at O.S.A. Exhibition" (signed M.L.F.). *Toronto Daily Star*, 20 March 1920.
1920c. "New and Interesting Pictures on View" (signed M.L.F.). *Toronto Daily Star*, 10 May 1920.
1920d. "Triumphs of the War Shown by Pictures" (signed M.L.F.). *Toronto Daily Star*, 28 Aug. 1920.
1920e. "Cities of Canada See Good Pictures" (signed M.L.F.). *Toronto Daily Star*, 4 Dec. 1920, p. 25.
1921a. "Tom Thomson Pleases with Canadian Scenes" (signed M.L.F.). *Toronto Daily Star*, 22 Jan. 1921.
1921b. "Ontario Artists Have Splendid Exhibition" (signed M.L.F.). *Toronto Daily Star*, 4 March 1921.
1922a. "Doings of the Day in the World of Art" (signed M.L.F.). *Toronto Star Weekly*, 1 April 1922, p. 5.
1922b. "Four Years of Work on View at Art Gallery" (signed M.L.F.). *Toronto Star Weekly*, 20 May 1922, p. 16.
1922c. "Throng Art Galleries, View Many Paintings" (signed M.L.F.). *Toronto Star Weekly*, 18 Nov. 1922.
1923a. "Art in Winnipeg Takes on New Life" (signed M.L.F.). *Toronto Star Weekly*, 1 April 1923.
1923b. "Academy Pictures Draw Lovers of Art" (signed M.L.F.). *Toronto Star Weekly*, 1 Dec. 1923, p. 11.
1924. "All Paintings So Good Hard to Know the Best" (signed M.L.F.). *Toronto Daily Star*, 8 March 1924.
1925. "Artists Give Expression without Being Imitative" (signed M.L.F.). *Toronto Daily Star*, 9 Jan. 1925.
1926a. "Some Fine Portraits Are Shown by O.S.A" (signed M.L.F.). *Toronto Daily Star*, 13 March 1926.
1926b. "Modern Canadian Art Charms Tourists" (signed M.L.F.). *Toronto Star Weekly*, 21 Aug. 1926.
1926c. "Many Fine Pictures at Academy Exhibit" (signed M.L.F.). *Toronto Daily Star*, 18 Nov. 1926.
1926d. "Four Exhibitions in Toronto Art Gallery" (signed M.L.F.). *Toronto Daily Star*, 4 Dec. 1926.

Fairley, Barker
1919a. "Algonquin and Algoma" (signed B.F.). *The Rebel* III:6 (April 1919), pp. 279–82.
1919b. "Canadian War Pictures." *Canadian Magazine* LIV:1 (Nov. 1919), pp. 3–11.
1919c. "At the Art Gallery" (signed B.F.). *The Rebel* IV:3 (Dec. 1919), pp. 123–28.
1920a. "Hart House Pictures" (letter to the editor). *Varsity* (University of Toronto), 2 Feb. 1920, p. 2.
1920b. "Tom Thomson and Others" (signed B.F.). *The Rebel* IV:6 (March 1920), pp. 244–48.
1920c. "Studio Talk: Toronto" (signed B.F.). *Studio* LXXIX:325 (April 1920), pp. 77–78. Reprinted in *International Studio* LXX:279 (May 1920), pp. 77–78.
1920d. "A Peep at the Art Galleries." *Canadian Forum* I:1 (Oct. 1920), pp. 19–21.
1921a. "Some Canadian Painters: Lawren Harris." *Canadian Forum* I:9 (June 1921), pp. 275–78.
1921b. "Studio Talk: Toronto" (signed B.F.). *Studio* LXXXII:343 (Oct. 1921), pp. 166–70.
1921c. "Artists and Authors." *Canadian Forum* II:15 (Dec. 1921), pp. 460–63.
1922a. "Year '22 Give Picture?" *Varsity* (University of Toronto), 16 Jan. 1922, p. 2.
1922b. "Some Canadian Painters: F.H. Varley." *Canadian Forum* II:19 (April 1922), pp. 594–96. Reprinted in *The Trail*, Dec. 1922, pp. 5–8.
1923a. Review of *Contrasts* by Lawren Harris. *Canadian Forum* III:28 (Jan. 1923), pp. 120, 122.
1923b. "Studio Talk: Toronto" (signed B.F.). *Studio* LXXXVI:364 (July 1923), pp. 54–58.
1924. "Wild Geese." *Canadian Forum* IV:41 (Feb. 1924), p. 143.
1925. "The Group of Seven." *Canadian Forum* V:53 (Feb. 1925), pp. 144–47.
1927. "The Group of Seven" (unsigned review of *A Canadian Art Movement* by F.B. Housser). *Canadian Forum* VII:77 (Feb. 1927), p. 136.
1937. "J.E.H. MacDonald." In *Catalogue: A Loan Exhibition of the Work of J.E.H. MacDonald R.C.A.* (exhibition catalogue). Toronto: Mellors Galleries, 1937.

Farr, Dorothy
1981. *J.W. Beatty: 1869–1941* (exhibition catalogue). Kingston, Ont.: Agnes Etherington Art Centre, 1981.
1990. *Urban Images: Canadian Painting* (exhibition catalogue). Kingston, Ont.: Agnes Etherington Art Centre, 1990.

Farrell, Alish
1983. "Emily Carr's Vision of the Real." *Queen's Quarterly* XC:3 (Fall 1983), pp. 746–55.

Fegdal, Charles
1927. "Exposition d'art canadien." *Le Jour* (Paris), 29 May 1927.

Fidoe, Frank W.
1932. "Primitive Daubs" (letter to the editor). *Ottawa Citizen*, 5 Feb. 1932.

Fierins, Paul
1927. "L'exposition d'art canadien." *Journal des Débats* (Paris), 11 April 1927.

Fletcher, Allan J.
1989. "Industrial Algoma and the Myth of Wilderness: Algoma Landscapes and the Emergence of the Group of Seven 1918–1920." Master's thesis, University of British Columbia, 1989.

Flood, John
1977. "Northern Ontario Art: A Study in Line Drawings." *Boréal*, 9 (1977), pp. 2–11.
1978a. "Northern Ontario Art, Part II: A.J. Casson, A Study in Pencil Sketches." *Boréal*, 10 (1978), pp. 4–8.
1978b. "Northern Ontario Art, Part III: Franklin Carmichael and Herman Voaden." *Boréal*, 11/12 (1978), pp. 5–8.
1980. "Yvonne McKague Housser: Northern Moments." *Northward Journal*, 16 (1980), pp. 10–20.
1982. "Lowrie Warrener." *Northward Journal*, 25 (1982), pp. 10–28.

Flood, W.J.
1930. "Ottawa's Artists." *Ottawa Citizen*, 12 March 1930.

Foley, Roy
1924. "Canadian Art at Institute a Bit Neutral." *Telegram* (Milwaukee), 17 Feb. 1924.

Forrest, Kevin
1981. *The Paintings of Frederick Nicholas Loveroff* (exhibition catalogue). Regina: Norman Mackenzie Art Gallery, 1981.

Fosbery, Ernest
1926. "Those Pictures" (letter to the editor). *Ottawa Journal*, 9 March 1926.
1927a. "As to Certain Myths" (letter to the editor). *Ottawa Journal*, 2 Feb. 1927. Reprinted in *Saturday Night* XLII:13 (12 Feb. 1927), p. 3.
1927b. "Those Pictures" (letter to the editor). *Ottawa Journal*, 16 Feb. 1927.
1927c. "Names One Great Canadian Picture Missing from List and Artists Wondering Why." *Ottawa Journal*, 25 Feb. 1927.
1930. "Landscape Painting in Canada." *Canadian Geographical Journal* I:4 (Aug. 1930), pp. 279–89.
1932a. "The Artists' Complaint" (letter to the editor). *Ottawa Journal*, 15 Dec. 1932.
1932b. "Artists at Odds" (letter to the editor). *Toronto Globe*, 23 Dec. 1932.

1933. "The Revolt against National Gallery's Ways" (letter to the editor). *Ottawa Journal*, 24 Jan. 1933.

Fryer, Stanley
1931. "Correspondence" (letter to the editor). *Journal, Royal Architectural Institute of Canada* VIII:1 (Jan. 1931), p. 22.

Fulford, Robert
1969. "A Night with Art Lovers." *Saturday Night* LXXXIV:1 (Jan. 1969), pp. 9–10.
1987. "Old Heck." *Saturday Night* CII:11 (Nov. 1987), pp. 7–8, 10–11.
1992. "Cross Currents." *Toronto Globe and Mail*, 25 Nov. 1992, section A, p. 14.

Gadsby, H.F.
1913. "The Hot Mush School or Peter and I." *Toronto Daily Star*, 12 Dec. 1913, p. 6.

Gagen, R.F.
1922. "Early Days in Canadian Art." *Canadian Forum* II:18 (March 1922), pp. 560–62.

Gagnon, François-M.
1976. "Painting in Quebec in the Thirties." *Journal of Canadian Art History* III:1/2 (Fall 1976), pp. 2–20.

Gagnon Pratte, France
1993. With Éric Etter. *Le Château Frontenac*. Quebec: Éditions Continuité, 1993.

Gibbon, John Murray
1920. "The Foreign Born." *Queen's Quarterly* XXVII:4 (April/May/June 1920), pp. 331–51.
1923. "European Seeds in the Canadian Garden." *Proceedings and Transactions of the Royal Society of Canada*, 3rd series, XVII (1923), section II, pp. 119–29.
1927. *Canadian Folk Songs Old and New*. Toronto: J.M. Dent & Sons, 1927.
1938. *Canadian Mosaic*. Toronto: McClelland & Stewart, 1938.
1939. *New World Ballads*. Toronto: Ryerson, 1939.

Gigeroff, Alex K.
1955. "Nude Controversy Painters Outline Personal Attitude." *Varsity* (University of Toronto), 11 Jan. 1955.

Gill, William
1930. "Painting Lake O'Hara" (letter to the editor). *Montreal Daily Star*, 3 June 1930.

Gillson, A.H.S.
1930. "The Group of Seven: The Artist, Why and Whither?" *Canadian Passing Show* (Montreal), Sept. 1930, pp. 15, 24–25, 42.

Girard, Henri
1930a. "Suzor Coté, l'exemple –" *La Revue Moderne* XI:3 (Jan. 1930), pp. 5, 55.
1930b. "Les 'Sept' à Montréal." *La Revue Moderne* XI:10 (Aug. 1930), p. 8.
1934. "Le mois artistique." *Le Canada*, 9 Feb. 1934.

G.K.M.
1930. "Art, Music and Drama." *Varsity* (University of Toronto), 5 Nov. 1930, p. 2.

Glynn, William
1929. "A Man with a Plan but Little to Say." *Canadian Magazine* LXXII:4 (Oct. 1929), p. 21.

Goldie, Terence
1977. "A National Drama and a National Dramatist: The First Attempt." *Canadian Drama* III:1 (Spring 1977), pp. 9–19.

Gordon, Alfred
1922. "Canadian Culture?" (letter to the editor). *Canadian Forum* II:18 (March 1922), pp. 558–59.

Gorham, Deborah
1977. "Flora MacDonald Denison, Canadian Feminist." In *A Not Unreasonable Claim: Women and Reform in Canada, 1880s–1920s*, ed. Linda Kealey, pp. 47–70. Toronto: Women's Press, 1977.

Gorman, W.J.
1934. "Grab Samples." *Northern Miner*, 5 April 1934.

Gow, J.L.
1922. "The Artist as Critic" (letter to the editor). *Ottawa Citizen*, 29 Dec. 1922.

Grace, Sherrill E.
1984. "A Northern Modernism, 1920–1932: Canadian Painting and Literature." *Literary Criterion* XIX:3 and 4 (1984), pp. 104–24.
1985. "'The Living Soul of Man': Bertram Brooker and Expressionist Theatre." *Theatre History in Canada* VI:1 (Spring 1985), pp. 3–22.
1992. "Re-introducing Canadian 'Art of the Theatre': Herman Voaden's 1930 Manifesto." *Canadian Literature*, 135 (Winter 1992), pp. 51–63.

Grafly, Dorothy
1926. "The Palace of Arts: Sesquicentennial in Retrospect." *American Magazine of Art* XVII:12 (Dec. 1926), pp. 630–38.

Graham, Jean
1932a. "Among Those Present: XXII. Mr. Arthur Lismer, A.R.C.A." *Saturday Night* XLVII:28 (21 May 1932), p. 5.
1932b. "Among Those Present: XXIV. Mr. Archibald G. Barnes, O.S.A., R.P., R.O.I., R.I." *Saturday Night* XLVII:30 (4 June 1932), p. 5.
1932c. "Among Those Present: XXVII. Mr. Arthur Heming." *Saturday Night* XLVII:33 (25 June 1932), p. 5.
1932d. "Among Those Present: XXIX. Mr. John Russell." *Saturday Night* XLVII:35 (9 July 1932), p. 5.
1932e. "Among Those Present: XXX. Mr. Kenneth Forbes, A.R.C.A." *Saturday Night* XLVII:37 (23 July 1932), pp. 11, 15.
1932f. "Among Those Present: XLIV. Mr. E. Wyly Grier, P.R.C.A." *Saturday Night* XLVIII:2 (19 Nov. 1932), p. 11.

Grant, E.C.
1926. "Canadian Art." *Ottawa Journal*, 19 Feb. 1926.

Gray, Margaret, with Margaret Rand and Lois Steen
1976a. *A.J. Casson*. Canadian Artists 1. [Toronto]: Gage, 1976.
1976b. *Charles Comfort*. Canadian Artists 2. [Toronto]: Gage, 1976.
1977. *Carl Schaefer*. Canadian Artists 3. [Toronto]: Gage, 1977.

Greenaway, C.R.
1924. "Lawrence Skey's Byzantine Defiance a Triumph of Toronto Artists." *Toronto Star Weekly*, 19 Jan. 1924.
1927a. "Jackson Says Montreal Most Bigoted City." *Toronto Daily Star*, 10 Sept. 1927.
1927b. "Painter Says Canada Does Not Appreciate Arctic Possessions." *Toronto Daily Star*, 10 Sept. 1927.
1927c. "Must Protect Eskimo Race from Extinction A.Y. Jackson Insists." *Toronto Daily Star*, 12 Sept. 1927.

Greenshields, E.B.
1904. *The Subjective View of Landscape Painting, with Special Reference to J.H. Weissenbruch and Illustrations from Works of His in Canada*. Montreal: Desbarats, 1904.
1906. *Landscape Painting and Modern Dutch Artists*. New York: Baker & Taylor, 1906.

Greig, E.R.
1919. "The Art Gallery of Toronto." *The Lamps*, Dec. 1919, pp. 68–69.

Grier, E. Wyly
1912. "The Impressionists." *Church Life*, 3 Oct. 1912, p. 8.
1913a. "The Craze of the Cubist." *Canadian Courier* XIII:22 (3 May 1913), p. 11.
1913b. "Canadian Art." *Church Life*, 18 Dec. 1913, pp. 16–17.
1915. "Canada National Gallery and Its Recent Purchases" (unsigned). *Christian Science Monitor*, 17 Nov. 1915.
1918. "Toronto's New Art Museum" (unsigned). *Christian Science Monitor*, 23 April 1918.
1926a. "Two Views of Canadian Art, Addresses by Mr. Wyly Grier, R.C.A., O.S.A., and A.Y. Jackson,

R.C.A., O.S.A." In *Empire Club of Canada: Addresses Delivered to the Members during the Year 1925*, pp. 97–105. Toronto: Macoomb Press, 1926.
1926b. "Inaugural Exhibition at the Art Gallery of Toronto" (unsigned). *Christian Science Monitor*, 8 March 1926.
1926c. "Canadian Painters Portray Variety of Scenes and Themes" (unsigned). *Christian Science Monitor*, 16 April 1926.
1927. "The Ontario Society of Artists" (unsigned). *Christian Science Monitor* [March 1927].
1928. "Forty-Ninth Exhibition of the Royal Canadian Academy." *Journal, Royal Architectural Institute of Canada* V:1 (Jan. 1928), pp. 19–24.
1929. "A Painter of Portraits." *Canadian Magazine* LXXII:5 (Nov. 1929), pp. 5, 32.
1930a. "Modern English Painting" (letter to the editor). *Times* (London), 11 Aug. 1930.
1930b. "Pictures at the Canadian National Exhibition." *Canadian Forum* XI:122 (Nov. 1930), pp. 62–64.
1931a. "Survey of Canadian Art" (review of *Painting and Sculpture in Canada* by M.O. Hammond). *Toronto Globe*, 3 Jan. 1931.
1931b. "Painters and Photography" (letter to the editor). *Toronto Daily Star*, 5 May 1931.
1933. "Statement by R.C.A. President regarding Protest to Government." *Journal, Royal Architectural Institute of Canada* X:4 (April 1933), p. 78.

Grier, Louis
1895. "A Painter's Club." *The Studio* V (June 1895), pp. 110–12.

Griesbach, Emma [pseudonym: "Diana"]
1919. "An Hour and a Half in the Art World." *Farmers' Sun* (Toronto), 10 Dec. 1919.
1920. "In a Studio." *Farmers' Sun* (Toronto), 4 Dec. 1920.
1921. "A Little about Pictures." *Farmers' Sun* (Toronto) [March 1921], p. 6.

Groves, Naomi Jackson
1968. *A.Y.'s Canada: Pencil Drawings by A.Y. Jackson*. Toronto: Clarke, Irwin & Co., 1968.
1982a. *A.Y. Jackson: The Arctic 1927*. Moonbeam, Ont.: Penumbra Press, 1982.
1982b. *Young A.Y. Jackson: Lindsay A. Evans' Memories 1902–1906* (ed.). Ottawa: Edahl Productions, 1982.
1988. *One Summer in Quebec: A.Y. Jackson in 1925, A Family View*. Kapuskasing, Ont.: Penumbra Press, 1988.

Gurd, Norman
1925. "Development of an Idea" (letter to the editor). *Canadian Bookman* VII:2 (Feb. 1925), p. 33.

G.W.
1913. "Remembers the 'Horrible Woman'" (letter to the editor, under the heading: "Post-Impressionism: What Julius Meier-Graeffe Really Thinks of It"). *Montreal Daily Star*, 16 April 1913.

Hambleton, Jack
1932. "Great Canadian Artist Drew Inspiration from Algoma." *Sault Ste. Marie Star*, 30 Nov. 1932.

Hamilton, C.F.
1926. "'Those Pictures': The Young Artists." *Ottawa Journal*, 13 March 1926.

Hammond, M.O.
1914. "Art and Artists" (unsigned). *Toronto Globe*, 21 Nov. 1914.
1916. "Extremes Meet at O.S.A. Show" (unsigned). *Toronto Globe*, 11 March 1916, p. 8.
1918. "Academy Opens in New Gallery" (unsigned). *Toronto Globe*, 6 April 1918.
1919a. "O.S.A. Annual Exhibition" (unsigned). *Toronto Globe*, 8 March 1919, p. 8.
1919b. "Canada's Noble Story Recorded in Colors." *Toronto Globe*, 23 Aug. 1919, p. 19.
1919c. "Art and Artists" (unsigned). *Toronto Globe*, 21 Oct. 1919, p. 10.

1919d. "Great Variety Marks Annual Academy Show" (unsigned). *Toronto Globe*, 21 Nov. 1919.
1919e. "National Flavor in Canadian Art" (unsigned). *New York Sun*, 25 Nov. 1919.
1920a. "Many Pictures by Canadians on Exhibition" (unsigned). *Toronto Globe*, 6 March 1920.
1920b. "Art and Artists" (unsigned). *Toronto Globe*, 11 May 1920, p. 10.
1920c. "The Futurist Paintings at Ex. Defended" (unsigned). *Toronto Globe*, 2 Sept. 1920.
1920d. "Art and Artists" (unsigned). *Toronto Globe*, 2 Dec. 1920, p. 22.
1921a. "Canadian Art of High Order" (unsigned). *Toronto Globe*, 15 March 1921.
1921b. "Art and Artists" (unsigned). *Toronto Globe*, 9 May 1921, p. 12.
1921c. "Progress of Canadian Art Splendidly Demonstrated at Annual Academy Show" (unsigned). *Toronto Globe*, 18 Nov. 1921.
1921d. "Artists Given Laurel Crown" (unsigned). *Toronto Globe*, 19 Nov. 1921.
1922a. "Retrospective Exhibition of Ontario Artists" (signed M.O.H.). *Toronto Globe*, 13 Feb. 1922.
1922b. "Society of Artists Win Proud Success." *Toronto Globe*, 14 March 1922.
1922c. "Ontario Society of Artists Constantly Adding Recruits" (signed M.O.H.). *Toronto Globe*, 21 March 1922.
1922d. "Salon of 'Group of Seven' Reflects Canadian Impulse to Glimpse beyond Skyline" (signed M.O.H.). *Toronto Globe*, 10 May 1922.
1923a. "Art and Artists" (unsigned). *Toronto Globe*, 12 March 1923.
1923b. "Work of Canadian Painters at Royal Academy of Arts Is of Satisfactory Quality" (unsigned). *Toronto Globe*, 24 Nov. 1923.
1924a. "Artists of Ontario Exhibit Their Work" (unsigned). *Toronto Globe*, 8 March 1924.
1924b "Art and Artists" (unsigned). *Toronto Globe*, 8 July 1924.
1925a. "Art and Artists" (unsigned). *Toronto Globe*, 12 Jan. 1925.
1925b. "Totems to National Gallery" (signed M.O.H., review of *The Fine Arts in Canada* by Newton MacTavish). *Toronto Globe*, 5 Dec. 1925.
1926a. "Many Beautiful Pictures, Work of Ontario Artists, on View at Art Gallery" (unsigned). *Toronto Globe*, 6 March 1926.
1926b. "Portrait Painting in Canada." *Canadian Homes and Gardens* III:5 (May 1926), pp. 20–21, 54.
1926c. "Chansons of French Canada Echo through Art Gallery" (unsigned). *Toronto Globe*, 14 May 1926.
1927a. "Strong Encouragement Is Given by Exhibition to All Creative Arts." *Toronto Globe*, 27 Aug. 1927, p. 16.
1927b. "Scenes in Frozen North Depicted by Artist's Brush" (unsigned). *Toronto Globe*, 22 Sept. 1927.
1928a. "Art and Artists" (unsigned). *Toronto Globe*, 13 Feb. 1928.
1928b. "Art and Artists" (unsigned). *Toronto Globe*, 14 Feb. 1928, p. 14.
1928c. "Many Fine Examples of Art Are Now on View at Gallery" (unsigned). *Toronto Globe* [5] March 1928.
1930a. *Painting and Sculpture in Canada*. Toronto: Ryerson, 1930.
1930b. "Leading Canadian Artists: Lawren Harris." *Toronto Globe*, 26 July 1930.
1930c. "Leading Canadian Artists: A.Y. Jackson." *Toronto Globe*, 23 Aug. 1930.
1930d. "Art and Artists" (unsigned). *Toronto Globe*, 6 Sept. 1930.
1931. "Art and Artists" (unsigned). *Toronto Globe*, 5 Dec. 1931.

1932a. "Canadian Artists Have Large Place in Fine Exhibition." *Toronto Globe*, 5 March 1932.
1932b. "Art and Artists." *Toronto Globe*, 5 Nov. 1932.
1932c. "J.E.H. MacDonald, Art College Head, Dies after Illness" (unsigned). *Toronto Globe*, 28 Nov. 1932.

Harper, J. Russell
1971. *Carl Schaefer Retrospective Exhibition: Paintings from 1926 to 1969* (exhibition catalogue). Montreal: Sir George Williams University [1971].

Harris, Bess
1969. With R.G.P. Colgrove. *Lawren Harris*. Toronto: Macmillan, 1969.

Harris, Frank Mann
1926. "Feeding Our Artistic Soul." *Toronto Star Weekly*, 13 Feb. 1926.
1930. "Seven Group Makes Whoopee in Gloom of Rain and Sleet." *Toronto Daily Star*, 7 April 1930, p. 29.

Harris, Lawren S.
1911a. "Heming's Black and White." *The Lamps* I:1 (Oct. 1911), p. 11.
1911b. "The R.C.A. Reviewed" and "Carl Ahrens' Pictures." *The Lamps* I:2 (Dec. 1911), p. 9.
1911c. "Palmer's Work." *The Lamps* I:2 (Dec. 1911), p. 12.
1914. "The Federal Art Commission" (letter to the editor). *Toronto Globe*, 4 June 1914.
1922. *Contrasts: A Book of Verse*. Toronto: McClelland & Stewart, 1922.
1923. "Winning a Canadian Background." *Canadian Bookman* V:2 (Feb. 1923), p. 37.
1924a. "The Greatest Book by a Canadian and Another." *Canadian Bookman* VI:2 (Feb. 1924), p. 38.
1924b. "Sir Edmund Walker." *Canadian Bookman* VI:5 (May 1924), p. 109.
1924c. "The Philosopher's Stone." *Canadian Bookman* VI:7 (July 1924), p. 163.
1925a. "Gandhi." *Canadian Forum* V:55 (April 1925), p. 213.
1925b. "Dr. M'Avoy's Fight to Save Glace Bay from Starvation." *Toronto Daily Star*, 25 April 1925, p. 12.
1925c. "Artist and Audience." *Canadian Bookman* VIII:12 (Dec. 1925), pp. 197–98.
1926a. "Review of the Toronto Art Gallery Opening." *Canadian Bookman* VIII:2 (Feb. 1926), pp. 46–47.
1926b. "Revelation of Art in Canada." *Canadian Theosophist* VII:5 (15 July 1926), pp. 85–88.
1927a. "Modern Art and Aesthetic Reactions: An Appreciation." *Canadian Forum* VII:80 (May 1927), pp. 239–41.
1927b. "Strength." *Canadian Theosophist* VIII:5 (15 July 1927), p. 104.
1927c. "The Nudes at the C.N.E." *Canadian Forum* VIII:85 (Oct. 1927), pp. 391–92.
1928. "Creative Art and Canada." *Supplement to the McGill News* X:1 (Dec. 1928), pp. 1–6. Reprinted in *Yearbook of the Arts in Canada, 1928–1929*, ed. B. Brooker, pp. 177–86 (Toronto: Macmillan, 1929).
1929. "The Art Students League." *Canadian Forum* IX:105 (June 1929), pp. 302–03.
1931. "Science and the Soul." *Canadian Theosophist* XII:10 (15 Dec. 1931), pp. 298–300.
1932a. "Leader of Group of Seven Rises to Make a Few Remarks on a Current Topic." *Toronto Telegram*, 16 Dec. 1932.
1932b. "Denies Claim to Infallibility on Canadian Art in Terms That Are Vigorous if Not Artistic" (letter to the editor). *Toronto Telegram*, 20 Dec. 1932.
1933a. "Theosophy and Art." *Canadian Theosophist* XIV:5 (15 July 1933), pp. 129–32.
1933b. "Theosophy and Art." *Canadian Theosophist* XIV:6 (15 Aug. 1933), pp. 161–66.
1933c. "An Epitome of Europe." *Canadian Theosophist* XIV:7 (Sept. 1933), p. 220.

1933d. Review of *Four Handsome Negresses* by Herbert Baptist. *Canadian Theosophist* XIV:7 (15 Sept. 1933), pp. 219–20.
1933e. "Theosophy and the Modern World." *Canadian Theosophist* XIV:9 (15 Nov. 1933), pp. 281–88.
1933f. "Different Idioms in Creative Art." *Canadian Comment* II:12 (Dec. 1933), pp. 5–6, 32.
1934. "The Armaments Racket." *Canadian Theosophist* XV:4 (June 1934), pp. 125–26.
1948. "The Group of Seven in Canadian History." In *The Canadian Historical Society, Report of the Annual Meeting Held at Victoria and Vancouver June 16–19, 1948*, ed. R.A. Preston. Toronto: University of Toronto Press, 1948.
1954. "The Story of the Group of Seven." In *Group of Seven* (exhibition catalogue), pp. 9–12. Vancouver: Vancouver Art Gallery, 1954.
1964. *The Story of the Group of Seven*. Toronto: Rous & Mann, 1964.
1987. "Fallacies about Art." *Canadian Literature*, 113/114 (Summer/Fall 1987), pp. 128–43.

Harris, Norman
1927. "'Circus' Pictures at Exhibition People Say Nudes Poor Taste." *Toronto Telegram*, 3 Sept. 1927.
1928a. "Group of Seven Exhibit." *Toronto Telegram*, 11 Feb. 1928, p. 18.
1928b. "Canada Has Fine Artists." *Toronto Telegram*, 30 Nov. 1928.

Harrold, E.W.
1924. "Group of Seven' Exhibition" (signed E.W.H.). *Ottawa Citizen*, 1 March 1924, p. 7.
1925. "Langdon Kihn" (signed E.W.H.). *Ottawa Citizen*, 13 March 1925.
1927. "Exhibition of Contemporary Canadian Art Has Resulted in Fine Picture Collection" (unsigned). *Ottawa Citizen*, 12 Jan. 1927.
1928. "Third Annual Exhibition of Canadian Art at the Gallery" (signed E.W.H.). *Ottawa Citizen*, 25 Jan. 1928.
1929. "'Year Book of the Arts in Canada' Is Provocative Survey of Trends." *Ottawa Citizen*, 23 Nov. 1929.
1930. "Painters of Canada Going In More for Figure and Vigorous Portraiture" (signed E.W.H.). *Ottawa Citizen*, 24 Jan. 1930.
1931. "Seventh Group of Seven Show" (signed E.W.H.). *Ottawa Morning Citizen*, 29 Dec. 1931.
1932a. "Seventh Annual Exhibition of Canadian Art Opening" (unsigned). *Ottawa Citizen*, 21 Jan. 1932.
1932b. "Daly-Pepper Exhibition Is Worth Seeing" (signed E.W.H.). *Ottawa Evening Citizen*, 10 May 1932.
1933a. "National Gallery's Eighth Annual Exhibition Opened" (signed E.W.H.). *Ottawa Citizen*, 9 Feb. 1933.
1933b. "Memorial Exhibition at National Gallery of Works of Late J.E.H. MacDonald, R.C.A." (signed E.W.H.). *Ottawa Citizen*, 10 Feb. 1933.

Hart, E.J.
1983. *The Selling of Canada: The CPR and the Beginnings of Canadian Tourism*. Banff: Altitude Publishing, 1983.

Haverson, Jessie
1921. "Group of Seven, Canadian Artists, to Have Exhibit at Albright Art Gallery." *Buffalo Courier*, 31 July 1921.

Haviland, Richard H.
1938. "Arthur Henry Heming, O.S.A." *Montreal Standard*, 13 Aug. 1938.

Hawker, R.W.
1991. "Frederick Alexie: Euro-Canadian Discussions of a First Nations' Artist." *Canadian Journal of Native Studies* XI:2 (1991), pp. 229–52.

Haycock, Maurice
1970. "A Northern Tribute to A.Y. Jackson." *North* XVII:5 (Sept./Oct. 1970), pp. 38–41.

Hayward, Victoria
1922. "Jobin – The Woodcarver." *Canadian Magazine* LX:2 (Dec. 1922), pp. 91–100.

1926. "Woodcarving Crowned as a Canadian Art." *Toronto Star Weekly*, 19 June 1926. Reprinted in *Victoria Daily Colonist*, 1 Aug. 1926, p. 23.

H.B.C.
1926. "Rochdale Art Gallery." *Rochdale Observer* (England), 8 May 1926.

Hembroff-Schleicher, Edythe
1978. *Emily Carr: The Untold Story*. Saanichton, B.C.: Hancock House, 1978.
1981. *The Modern Room* (exhibition catalogue). Victoria: Emily Carr Gallery, Provincial Archives of British Columbia, 1981.

Heming, Arthur
1933. "The National Gallery" (letter to the editor). *Ottawa Journal*, 30 Jan. 1933. Reprinted in *Toronto Mail and Empire*, 1 Feb. 1933.

Henderson, W.B.
1926. "A Travesty" (letter to the editor). *Ottawa Journal*, 20 March 1926.

Hendricks, Bessie
1921a. "Canadian Painters' Work on View at Art Institute." *Indianapolis News*, 9 April 1921.
1921b. "'Group of Seven' Canada Artists." *Indianapolis News*, 16 April 1921.
1921c. "Canadian Group Paintings: Javanese and Other Exhibits." *Indianapolis News*, 23 April 1921.

Herriott, Ted
1993. *Sunday Morning with Cass: Conversations with A.J. Casson*. Mississauga, Ont.: Purpleville Publishing, 1993.

Hewton, Randolph S.
1926. "Another Impenitent" (letter to the editor). *Toronto Daily Star*, 27 Nov. 1926.

Hill, Charles C.
1975. *Canadian Painting in the Thirties* (exhibition catalogue). Ottawa: National Gallery of Canada, 1975.
1976. *John Vanderpant Photographs* (exhibition catalogue). Ottawa: National Gallery of Canada, 1976.

Hind, C. Lewis
1924a. "Life and I." *Daily Chronicle* (London), 30 April 1924.
1924b. "Art and Artists: Canadian Landscape Painters at Wembley." *International Interpreter* III:8 (24 May 1924), pp. 249–50.
1924c. *Landscape Painting from Giotto to the Present Day: II*. London: Chapman & Hall, 1924.

Hipp, T. Christie
1927. "Fine Art Section of Vancouver Exhibition." *Vancouver Sunday Province*, 14 Aug. 1927, p. 3.

Hodkinson, Ian
1992. *Arthur Lismer's Drawings for the Humberside Mural: Development of a Grandiose Patriotic Theme* (exhibition catalogue). Kleinburg, Ont.: McMichael Canadian Art Collection, 1992.

H.O.L.
1928. "The Group of Seven Again" (letter to the editor). *New Western Tribune* (Vancouver), 27 Oct. 1928.

Holgate, Edwin
1947. "Prudence Heward." *Canadian Art* IV:4 (Summer 1947), pp. 160–61.

Housser, Bess
1922. "Art in Canada" (letter to the editor). *Canadian Forum* II:20 (May 1922), p. 621.
1924a. "Introducing a New Topic." *Canadian Bookman* VI:6 (June 1924), p. 137.
1924b. "What the Critics Are Saying at Wembley." *Canadian Bookman* VI:7 (July 1924), p. 159.
1924c. "In the Realm of Art." *Canadian Bookman* VI:8 (Aug. 1924), p. 185.
1924d. "In the Realm of Canadian Art." *Canadian Bookman* VI:11 (Nov. 1924), p. 238.
1925a. "In the Realm of Art." *Canadian Bookman* VII:2 (Feb. 1925), p. 33.
1925b. "In the Realm of Art." *Canadian Bookman* VII:3 (March 1925), p. 54.

1925c. "In the Realm of Art." *Canadian Bookman* VII:4 (April 1925), p. 70.
1925d. "In the Realm of Art." *Canadian Bookman* VII:5 (May 1925), p. 87.
1925e. "In the Realm of Art." *Canadian Bookman* VII:6 (June 1925), p. 101.
1925f. "In the Realm of Art." *Canadian Bookman* VII:7 (July 1925), p. 121.
1925g. "In the Realm of Art." *Canadian Bookman* VII:8 (Aug. 1925), p. 137.
1925h. "In the Realm of Art: The J.E.H. MacDonald Exhibition." *Canadian Bookman* VII:11 (Nov. 1925), p. 186.
1926. "In the Realm of Art." *Canadian Bookman* VIII:1 (Jan. 1926), pp. 33–34.

Housser, Frederick Broughton
1923a. "Carl Sandburg." *Canadian Forum* III:31 (April 1923), p. 210.
1923b. "Idealism in Canada." *Canadian Bookman* V:4 (April 1923), p. 94.
1925a. "Ideas of a Painter." *Canadian Bookman* VII:4 (April 1925), p. 70.
1925b. "The Russian Exhibition." *Canadian Bookman* VII:5 (May 1925), p. 87.
1926a. *A Canadian Art Movement: The Story of the Group of Seven*. Toronto: Macmillan, 1926.
1926b. "Those Pictures" (letter to the editor). *Ottawa Morning Journal*, 1 April 1926.
1926c. "The Group of Seven Exhibition." *Canadian Bookman* VIII:6 (June 1926), pp. 179–80.
1927a. "Art, the Initiator." *Canadian Theosophist* VIII:2 (15 April 1927), pp. 21–26.
1927b. "What Canadian Artists Are Doing." *London Free Press* (Ont.), 2 June 1927.
1927c. "Some Thoughts on National Consciousness." *Canadian Theosophist* VIII:5 (15 July 1927), pp. 81–83.
1928. "Thoughts on a Trip West." *Canadian Theosophist* IX:8 (15 Oct. 1928), pp. 225–27.
1929a. "A Recent Visitor from India." *Canadian Theosophist* X:1 (15 March 1929), pp. 21–23.
1929b. "Theosophy and America." *Canadian Theosophist* X:5 (15 July 1929), pp. 129–131.
1930a. "Art National and Universal." *Canadian Student* XII:6 (March/April 1930), pp. 180–82.
1930b. "Tibet Today." *Canadian Theosophist* XI:1 (15 March 1930), pp. 10–11.
1930c. "A Task for Theosophists." *Canadian Theosophist* XI:3 (15 May 1930), pp. 77–79.
1930d. "Walt Whitman and North American Idealism." *Canadian Theosophist* XI:4 (15 June 1930), pp. 103–06.
1930e. "Walt Whitman and North American Idealism." *Canadian Theosophist* XI:5 (15 July 1930), pp. 136–40.
1931. "Creative Art Criticism" (review of *Men of Art* by Thomas Craven). *Canadian Forum* XI:130 (July 1931), pp. 384–85.
1932. "The Group of Seven and Its Critics." *Canadian Forum* XII:137 (Feb. 1932), pp. 183–84.
1933. "Art Shows the Way." *Gold Magazine*, Dec. 1933.

Housser, Yvonne McKague
1980. "'Mining Country,' North Shore of Lake Superior." *Northward Journal*, 16 (1980), pp. 15–29.

H.R.W.
1913. "'Behind the Scenes'" (letter to the editor, under the heading: "Post-Impressionism: What Julius Meier-Graeffe Really Thinks of It"). *Montreal Daily Star*, 16 April 1913.

Hubbard, R.H.
1968. *Vincent Massey Bequest: The Canadian Paintings* (exhibition catalogue). Ottawa: National Gallery of Canada, 1968.

Hughes, Katharine
1932. "Contemporary Canadian Paintings Form

Striking Exhibition at Museum." *Boston Herald*, 9 April 1932.

Humphrey, Ruth
1974. "Maria Tippett, 'A Paste Solitaire in a Steel Claw Setting: Emily Carr and Her Public': A Reply." *B.C. Studies*, 23 (Fall 1974), pp. 47–49.

Hunter, E. Robert
1940. *J.E.H. MacDonald: A Biography and Catalogue of His Work*. Toronto: Ryerson, 1940.
1941. "Thoreau MacDonald." *Maritime Art* II:2 (Dec. 1941), pp. 44–49.
1954. "J.E.H. MacDonald." *Educational Record* LXXX:3 (July–Sept. 1954), pp. 157–62.

Hurdalek, Marta
1983. *The Hague School: Collecting in Canada at the Turn of the Century* (exhibition catalogue). Toronto: Art Gallery of Ontario, 1983.

H.W.M.K.
1925. Review of exhibition. *Architect*, 22 May 1925.

Inconstant Reader
1929. "Preferences." *Canadian Forum* X:111 (Dec. 1929), pp. 87–88.

Innes, John
1928. *From Trail to Rail: The Epic of Transportation*. Vancouver: Hudson's Bay Company [1928].

It Is To Laugh
1930. "No Praise for the Group of Seven" (letter to the editor). *Toronto Telegram*, 26 April 1930.

J.A.A.
1927. "Art." *Canadian Bookman* IX:6 (June 1927), p. 184.

Jackson, A.Y.
1912. "Who Committed the Spring Exhibition" (letter to the editor). *Montreal Daily Herald*, 27 May 1912.
1914. "Canada's Artists and Foreign Art" (signed "Cadmium"). *Toronto Globe*, 14 May 1914.
1919a. "Figure versus Landscape" (signed "Smoke Lake"). *The Rebel* III:3 (Jan. 1919), pp. 111–12.
1919b. "Art and Craft" (signed "Ajax"). *The Rebel* III:4 (Feb. 1919), pp. 158–59.
1919c. "Foreword." *Catalogue of an Exhibition of Paintings by the Late Tom Thomson, March 1 to March 21, 1919* (exhibition catalogue). Montreal: The Arts Club, 1919.
1919d. "A Volunteer" (signed "Ajax"). *The Rebel* III:6 (April 1919), pp. 256–57.
1919e. "Canadian and Foreign Art" (letter to the editor, signed "Canadian Artist"). *Toronto Globe*, 31 May 1919.
1919f. "The Vital Necessity of the Fine Arts." *Canadian Courier* XXIV:24 (30 Aug. 1919), p. 7.
1919g. "An Aesthetic Standard" (signed "Ajax"). *The Rebel* IV:1 (Oct. 1919), p. 43.
1919h. "Dutch Art in Canada: The Last Chapter" (signed "Ajax"). *The Rebel* IV:2 (Nov. 1919), pp. 65–66.
1919i. "Canadian Art" (letter to the editor). *Toronto Globe* [after 20 Nov. 1919].
1919j. "The War Memorials: A Challenge." *The Lamps*, Dec. 1919, pp. 75–78.
1920. "Things Are Looking Up" (signed "Ajax"). *The Rebel* IV:5 (Feb. 1920), p. 196.
1921. "Sketching in Algoma." *Canadian Forum* I:6 (March 1921), pp. 174–75.
1922a. "The Allward Memorial" (letter to the editor). *Canadian Forum* II:18 (March 1922), p. 559.
1922b. "A Policy for Art Galleries." *Canadian Forum* II:21 (June 1922), p. 660, 662.
1922c. "The Septuagenarian and Art" (letter to the editor). *Montreal Gazette*, 8 Dec. 1922.
1922d. With R.F. Gagen and P.H. Robson. "Is 'The National Gallery a National Reproach'?" (letter to the editor), *Toronto Mail and Empire*, 19 Dec. 1922.
1922e. "An Artist's Reply to Critic" (letter to the editor). *Ottawa Citizen*, 21 Dec. 1922.
1923. "The Problem of the Canadian Painter" (signed M.E.). *Canadian Bookman* V:2 (Feb. 1923), p. 33.

1924. "Canadian Art at Wembley" (letter to the editor, signed "Rose Madder"). *Toronto Daily Star*, 23 May 1924.

1925a. "Artists in the Mountains." *Canadian Forum* V:52 (Jan. 1925), pp. 112–14.

1925b. "In the Realm of Art." *Canadian Bookman* VII:6 (June 1925), p. 101.

1925c. "Early Quebec Wood Carving Now in Toronto." *Canadian Bookman* VII:11 (Nov. 1925), p. 186.

1926a. "Two Views of Canadian Art: Addresses by Mr. Wyly Grier, R.C.A., O.S.A., and A.Y. Jackson, R.C.A., O.S.A." In *Empire Club of Canada: Addresses Delivered to the Members during the Year 1925*, pp. 105–13. Toronto: Macoomb Press, 1926.

1926b. "Montreal Pictures in Toronto" (letter to the editor). *Montreal Gazette*, 22 Feb. 1926, p. 12.

1926c. "Art in Toronto." *Canadian Forum* VI:66 (March 1926), pp. 180, 182.

1926d. "Those Pictures: More Opinions" (letter to the editor). *Ottawa Journal*, 20 March 1926.

1926e. "War Pictures Again." *Canadian Bookman* VIII:11 (Nov. 1926), p. 340.

1926f. "Canadian Art Has Received Well-Earned Commendation: Are 'Old Material'" (letter to the editor). *Toronto Daily Star*, 29 Nov. 1926.

1927a. "As to Certain Myths" (letter to the editor). *Ottawa Morning Journal*, 10 Feb. 1927.

1927b. "Canadian Artist Honored" (letter to the editor, signed "Maple Leaf"). *Toronto Daily Star*, 5 May 1927.

1927c. "Winter Sketching." *Supplement to the McGill News* VIII:3 (June 1927), pp. 29–30.

1927d. "'Group of Seven' Painter Answers Sir John Collier." *Toronto Daily Star*, 15 Sept. 1927.

1927e. "Mr. Russell and Other Artists" (letter to the editor). *Toronto Mail and Empire* [after 3 Nov. 1927].

1927f. "Up North." *Canadian Forum* VIII:87 (Dec. 1927), pp. 478–80.

1927g. "Rescuing Our Tottering Totems." *MacLean's*, 15 Dec. 1927, pp. 23, 37.

1929a. "The Emigrant's Stone" (letter to the editor). *Canadian Forum* IX:100 (Jan. 1929), p. 143.

1929b. "There Is Still Snow in Quebec." *Tangent* [1929].

1929c. "The Royal Canadian Academy." *Canadian Mercury*, Feb. 1929, p. 54.

1932a. "Paintings by Prudence Heward Placed on Exhibition in Montreal." *Montreal Daily Star*, 27 April 1932.

1932b. "Wild Art in Mild West" (letter to the editor). *Toronto Mail and Empire*, 14 July 1932.

1932c. "What's Wrong with the Academic Painter?'" (letter to the editor). *Toronto Mail and Empire*, 16 Dec. 1932.

1932d. "Modern Art No 'Menace.'" *Saturday Night* XLVIII:6 (17 Dec. 1932), p. 3.

1933a. "J.E.H. MacDonald." *Canadian Forum* XIII:148 (Jan. 1933), pp. 136–38.

1933b. "More Art Experts" (letter to the editor). *Toronto Mail and Empire*, 2 Jan. 1933.

1933c. "Why Always the Group of Seven?" (letter to the editor). *Toronto Mail and Empire*, 6 Feb. 1933.

1943. "Dr. MacCallum: Loyal Friend of Art." *Saturday Night* LIX:14 (11 Dec. 1943), p. 19.

1949. "Sarah Robertson: 1891–1948." *Canadian Art* VI:31 (Spring 1949), pp. 125–26.

1954. "William J. Wood 1877–1954." *Canadian Art* XI:3 (Spring 1954), p. 115.

1955. "Arthur Lismer." *Educational Record* LXXXI:1 (Jan.–March 1955), pp. 11–17.

1957. "Box-car Days in Algoma." *Canadian Art* XIV:4 (Summer 1957), pp. 136–41.

1958. *A Painter's Country: The Autobiography of A.Y. Jackson*. Toronto: Clarke, Irwin & Co., 1958. Revised edition 1967.

Jackson, Christopher

1991. *Lawren Harris, North by West: The Arctic and Rocky Mountain Paintings of Lawren Harris 1924–1931* (exhibition catalogue). Calgary: Glenbow Museum, 1991.

Jacob, Fred

1917a. "Canadian Artists in Khaki." *Saturday Night* XXX:22 (3 March 1917), p. 3.

1917b. "Canadian Artists Do Vigorous Work" (unsigned). *Toronto Mail and Empire*, 10 March 1917, p. 4.

1919a. "Picture Gallery Is Riot of Color" (unsigned). *Toronto Mail and Empire*, 10 March 1919.

1919b. "The New Canadian Art" (unsigned). *Toronto Mail and Empire*, 10 May 1919.

1919c. "Canada at War Shown in Pictures" (unsigned). *Toronto Mail and Empire*, 19 June 1919.

1919d. "More Paintings of War Activities" (unsigned). *Toronto Mail and Empire*, 20 Oct. 1919, p. 10.

1919e. "Broad Treatment in the Paintings" (unsigned). *Toronto Mail and Empire*, 25 Nov. 1919, p. 2.

1920a. "Beauty of North Shown in Color" (unsigned). *Toronto Mail and Empire*, 14 Feb. 1920.

1920b. "The Canadian Algonquin School" (unsigned). *Toronto Mail and Empire*, 21 Feb. 1920.

1920c. "Plenty of Vigor in Canadian Art" (unsigned). *Toronto Mail and Empire*, 6 March 1920.

1920d. "The Ontario Society of Artists" (unsigned). *Toronto Mail and Empire*, 20 March 1920.

1920e. "Seven Artists Invite Criticism" (unsigned). *Toronto Mail and Empire*, 10 March 1920.

1920f. "Pictures Show War's Last Phase" (unsigned). *Toronto Mail and Empire*, 23 Aug. 1920.

1920g. "People Startled by Radical Art" (unsigned). *Toronto Mail and Empire*, 4 Sept. 1920.

1920h. "Wealth of Color Seen in Paintings" (unsigned). *Toronto Mail and Empire*, 18 Dec. 1920, p. 5.

1921a. "Plenty of Vigor in Canadian Art" (unsigned). *Toronto Mail and Empire*, 12 March 1921.

1921b. "Group of Seven Hold Exhibition" (unsigned). *Toronto Mail and Empire*, 16 May 1921.

1921c. "Canadian Academy Full of Interest" (unsigned). *Toronto Mail and Empire*, 21 Nov. 1921.

1922a. "Ontario Art Shown in the Making" (unsigned). *Toronto Mail and Empire*, 11 Feb. 1922.

1922b. "Art Society Reaches Half-Century Mark" (unsigned). *Toronto Mail and Empire*, 25 March 1922.

1922c. "How Canadian Art Got Its Real Start" (unsigned). *Toronto Sunday World*, 9 April 1922, magazine section.

1922d. "The Group of Seven" (unsigned). *Toronto Mail and Empire*, 6 May 1922, p. 20.

1922e. "Group of Seven Not So Extreme" (unsigned). *Toronto Mail and Empire*, 13 May 1922.

1922f. "Drama and Music" (unsigned). *Toronto Mail and Empire*, 10 June 1922, p. 15.

1923a. "Ontario Painters Do Striking Work" (unsigned). *Toronto Mail and Empire*, 10 March 1923.

1923b. "Small Pictures on Exhibition" (unsigned). *Toronto Mail and Empire*, 29 Oct. 1923.

1923c. "Contrasted Styles in Canadian Art" (unsigned). *Toronto Mail and Empire*, 26 Dec. 1923, p. 5

1924. "Ontario Painters Doing Vital Work" (unsigned). *Toronto Mail and Empire*, 17 March 1924.

1925a. "In the Art Galleries" (unsigned). *Toronto Mail and Empire*, 31 Jan. 1925, p. 14.

1925b. "In the Art Galleries" (unsigned). *Toronto Mail and Empire*, 14 March 1925.

1925c. "The Stage." *Canadian Forum* V:58 (July 1925), pp. 316, 318.

1926a. "Pictures Look Well in Larger Gallery" (unsigned). *Toronto Mail and Empire*, 1 March 1926.

1926b. "New Member Is Added to the Group of Seven" (unsigned). *Toronto Mail and Empire*, 8 May 1926.

1926c. "A Canadian Replies." *Canadian Bookman* VIII:7 (July 1926), pp. 220–21.

1926d. "Canada's Own Christmas Cards." *Canadian Homes and Gardens* III:12 (Dec. 1926), pp. 33–35, 108.

1927a. "In the Art Galleries" (unsigned review of *A Canadian Art Movement* by F.B. Housser). *Toronto Mail and Empire*, 22 Jan. 1927.

1927b. "Radical Painters Showing Their Work" (unsigned). *Toronto Mail and Empire*, 5 March 1927.

1927c. "In the Art Galleries" (unsigned). *Toronto Mail and Empire*, 19 March 1927.

1927d. "Canada's Artists Develop a National Consciousness." *Toronto Mail and Empire*, 1 July 1927.

1927e. "Art of Portraiture Ancient and Modern." *Toronto Mail and Empire*, 6 Oct. 1927.

1928a. "In the Art Galleries." *Toronto Mail and Empire*, 18 Feb. 1928.

1928b. "The Leonard Picture Fund." *Canadian Homes and Gardens* V:3 (March 1928), pp. 37, 60–64.

1928c. "Youth Is Prominent at the Art Gallery." *Toronto Mail and Empire*, 3 March 1928.

Jefferys, Charles W.

1911a. "MacDonald's Sketches." *The Lamps* I:2 (Dec. 1911), p. 12.

1911b. "Tendencies in Art." *The Lamps* I:2 (Dec. 1911), p. 16.

Jewell, Edward Alden

1930. "New Books on Art" (review of *Yearbook of the Arts in Canada* by B. Brooker). *New York Times*, 30 March 1930.

Jewett, Eleanor

1930. "Current Exhibits in East." *Chicago Tribune*, 18 May 1930, part 8, p. 4.

J.H.M.

1926. "Pictures by Canadian Artists." *Manchester Guardian*, 28 Aug. 1926.

J.M.B.

1932. "At the W.S.A." *Winnipeg Free Press*, 19 March 1932.

Johnson, Main

1921. "Wednesday Talks: Cheese and Fireworks." *Toronto Daily Star*, 3 Aug. 1921, p. 4.

Johnston, Frank

1924a. "Art." *Winnipeg Mirror*, 5 April 1924.

1924b. "Art and Music." *Winnipeg Mirror*, 25 April 1924.

1924c. "Art." *Winnipeg Mirror*, 10 May 1924.

1924d. "Art." *Winnipeg Mirror*, 17 May 1924.

1924e. "Art Notes." *Winnipeg Mirror*, 7 June 1924.

1927. "Modern Art and Aesthetic Reactions: An Objection." *Canadian Forum* VII:80 (May 1927), pp. 241–42.

Johnston, George

1979. "Carl Schaefer: The French and Pickerel River Drawings, 1926–1933." *Northward Journal*, 13 (1979), pp. 19–22.

1986. *Carl: Portrait of a Painter, Carl Schaefer*. Moonbeam, Ont.: Penumbra Press, 1986.

Johnston, Robert

1931. "Canadian Forum Covers" (letter to the editor). *Canadian Forum* XI:130 (July 1931), pp. 397–98.

Johnstone, Ken

1965. "The Last Tyrant of Taste." *MacLean's*, 24 March 1965, pp. 24, 52–55.

Jones, Hugh G.

1934. With Edmund Dyonnet. *History of the Royal Canadian Academy of Arts*. Montreal: Royal Canadian Academy of Arts, 1934.

Jones, John T.

1923. "Snobs and Gushers." *The Trail*, April 1923, pp. 6–8.

Kahn, Gustav

1927. "L'exposition de l'art canadien, musée du Jeu de Paume." *Mercure de France*, 1 May 1927.

Kean, A.D.

1930. "Cowboy Sees Gallery Acquires Art Taste." *Toronto Daily Star*, 28 April 1930.

Kelly, Gemey

1982. *Arthur Lismer: Nova Scotia, 1916–1919* (exhibition

catalogue). Halifax: Dalhousie Art Gallery, Dalhousie University, 1982.

1990. *J.E.H. MacDonald, Lewis Smith, Edith Smith: Nova Scotia* (exhibition catalogue). Halifax: Dalhousie Art Gallery, Dalhousie University, 1990.

Kerr, Estelle M.

1916a. "At the Sign of the Maple." *Canadian Courier* XIX:12 (19 Feb. 1916), p. 13.

1916b. "At the Sign of the Maple: Concerning Art in Canada." *Canadian Courier* XIX:17 (25 March 1916), p. 13.

1916c. "At the Sign of the Maple: Concerning Canadian Art." *Canadian Courier* XIX:22 (29 April 1916), pp. 27, 29.

1916d. "Artists in War-Time." *Canadian Courier* XX:8 (22 July 1916), pp. 10–11.

1916e. "The New Theatre Movement." *Canadian Courier* XX:17 (23 Sept. 1916), pp. 13, 17.

1916f. "Concerning Canadian Art." *Canadian Courier* XX:19 (7 Oct. 1916), pp. 15, 28.

1916g. "Concerning Canadian Art." *Canadian Courier* XX:24 (11 Nov. 1916), p. 15.

1916h. "Bilingualism in Art." *Canadian Courier* XXI:3 (16 Dec. 1916), p. 15.

1917a. "Municipal Art Galleries." *Canadian Courier* XXI:21 (21 April 1917), pp. 15–16.

1917b. "Art Notes." *Canadian Courier* XXII:3 (16 June 1917), p. 13.

1918. "Art in War-Time." *Canadian Courier* XXIII:6 (5 Jan. 1918), pp. 15, 24.

Key, Archibald

1932. "Parallels, and an Expatriate." *Canadian Forum* XII:142 (July 1932), pp. 384–85.

King, Basil

1922. "Authors and Artists" (letter to the editor). *Canadian Forum* II:16 (Jan. 1922), pp. 491–92.

Kirker, Ena

1927. "The Woman Who Put Charm into a Public Library." *Canadian Magazine* LXVIII:3 (Sept. 1927), pp. 32, 41.

Kirkpatrick, Andrea F.

1986. "The Portraiture of Frederick H. Varley, 1919 to 1926." Master's thesis, Queen's University, Kingston, Ont., 1986.

1987. "A Newly Discovered Portrait by F.H. Varley." *RACAR* XIV:1–2 (1987), pp. 128, 159–62.

Koltun, Lily

1984. *Private Realms of Light* (ed.). Toronto: Fitzhenry & Whiteside, 1984.

Konody, P.G.

1918. "The Canadian War Memorials." *Colour* IX:2 (Sept. 1918), pp. 25–41.

1919a. *Art and War: Canadian War Memorials.* London: Colour Ltd., 1919.

1919b. "Canada in War to Be Seen on Canvas." *New York Sun*, 3 June 1919.

1919c. "'Expressionism'" (letter to the editor). *Toronto Globe*, 9 Sept. 1919, p. 6.

1919d. "Canadian War Memorial Pictures at Art Gallery Show Great War Clearly." *Montreal Daily Herald*, 8 Nov. 1919, p. 2.

1925. "Art and Artists: The Palace of Arts at Wembley." *Observer* (London), 24 May 1925.

1927. "Art and Artists." *Observer* (London), 24 April 1927.

Kucheray, D.

1978. "Artist Remembers Dumbells, Group of 7." *London Evening Free Press* (Ont.), 2 Nov. 1978.

Laberge, Albert

1910. "L'exposition de peintures." *La Presse* (Montreal), 26 Jan. 1910, p. 10.

1913a. "Ouverture de l'exposition de peintures à la Galerie des Arts" (unsigned). *La Presse* (Montreal), 26 March 1913, p. 8.

1913b. "Au Salon de peinture à la Galerie des arts" (unsigned). *La Presse* (Montreal), 29 March 1913, p. 16.

1918. "Superbe travail des artistes canadiens" (unsigned). *La Presse* (Montreal), 22 Nov. 1918.

1921. "Au fil de l'heure" (unsigned). *La Presse* (Montreal), 20 Jan. 1921.

1925a. "Ouverture du Salon de l'Académie royale" (unsigned). *La Presse* (Montreal), 20 Nov. 1925.

1925b. "Toiles remarquables par les peintres de Toronto" (unsigned). *La Presse* (Montreal), 23 Nov. 1925.

1927. "Appréciation de quelques toiles du Salon des artistes canadiens." *La Presse* (Montreal), 3 Dec. 1927.

1930. "Exposition de peintures par le Groupe des Sept de Toronto" (unsigned). *La Presse* (Montreal), 5 May 1930.

1931. "Ouverture du Salon de l'Académie canadienne." *La Presse* (Montreal), 18 Nov. 1931.

Lacombe, Michele

1982. "Theosophy and the Canadian Idealist Tradition: A Preliminary Exploration." *Journal of Canadian Studies* XVII:2 (Summer 1982) pp. 100–18.

Laliberté, A.

1984. *Les artistes de mon temps.* Montreal: Le Boréal, 1984.

L'Allier, Pierre

1993. With Esther Trépanier. *Adrien Hébert* (exhibition catalogue). Quebec: Musée du Québec, 1993.

Lamb, Robert J.

1988. *The Canadian Art Club 1907–1915* (exhibition catalogue). Edmonton: Edmonton Art Gallery, 1988.

Lamonde, Yvan

1986. With Esther Trépanier. *L'avènement de la modernité culturelle au Québec.* Quebec: Institut québécois de recherche sur la culture, 1986.

Lampman, Archibald

1932. "Group of Seven 'Jazz Band of Art,' Says John Russell." *Toronto Telegram*, 26 Sept. 1932, p. 17.

Landry, Pierre B.

1990. *The MacCallum-Jackman Cottage Mural Paintings.* Ottawa: National Gallery of Canada, 1990.

1994. *Catalogue of the National Gallery of Canada, Canadian Art: Volume Two / G–K.* With Claire Champ. Ottawa: National Gallery of Canada, 1994.

Langton, W.A.

1927. "A Canadian Art Movement." *Willison's Monthly* III:2 (July 1927), pp. 66–73.

Larisey, Peter

1974. "Nationalist Aspects of Lawren S. Harris's Aesthetics: A Portfolio of Landscapes by Lawren S. Harris." *Bulletin* (National Gallery of Canada), 23 (1974), pp. 3–16.

1993. *Light for a Cold Land: Lawren Harris's Work and Life — An Interpretation.* Toronto: Dundurn Press, 1993.

Lauder, Brian

1976. "Two Radicals: Richard Maurice Bucke and Lawren Harris." *Dalhousie Review*, Summer 1976, pp. 307–18.

Lee, Rupert

1924. "Canadian Pictures at Wembley." *Canadian Forum* IV:47 (Aug. 1924), pp. 338–39.

1925. "Canadian Art at Wembley." *Canadian Forum* V:60 (Sept. 1925), pp. 368–70.

Lee, Thomas R.

1956a. *Albert H. Robinson: "The Painter's Painter."* Montreal, 1956.

1956b. "Bertram Brooker 1888–1955." *Canadian Art* XIII:3 (Spring 1956), pp. 286–91.

Leechman, Douglas

1928. "Native Canadian Art of the West Coast." *Studio* XCVI:428 (Nov. 1928), pp. 331–33.

Leek, Walter

1928. With John K. Matheson. "Exhibition Pictures" (letter to the editor). *Vancouver Daily Province*, 14 Aug. 1928, p. 5.

Letondal, Henri

1927. "Lettre de Paris: La jeune peinture canadienne en France." *La Patrie* (Montreal), 5 May 1927.

Leyland, James

1928. "Correspondence: Attitude of Art Gallery on Group of Seven." *Vancouver Daily Province*, 2 Sept. 1928.

1930. "Vancouver Art Dealer Criticizes Art School Exhibit" (letter to the editor). *Vancouver Sun*, 30 April 1930.

Lismer, Arthur J.

1919a. "Art and the Average Canadian." *Canadian Courier* XXIV:9 (1 Feb. 1919), p. 13.

1919b. "Modernism in Art" (letter to the editor). *Toronto Globe*, 12 Sept. 1919.

1919c. "The Canadian War Memorials." *The Rebel* IV:1 (Oct. 1919), pp. 40–42.

1920. "Art Education and Art Appreciation." *The Rebel* III:5 (Feb. 1920), pp. 208–11.

1925a. "Canadian Art." *Canadian Theosophist* V:12 (15 Feb. 1925), pp. 177–79.

1925b. "Art a Common Necessity." *Canadian Bookman* VII:10 (Oct. 1925), pp. 159–60. Reprinted in part in *Edmonton Journal*, 14 Nov. 1925.

1926a. *A Short History of Painting, with a Note on Canadian Art.* Toronto: Andrews Bros., 1926.

1926b. "Canadian Art Has Received Well-Earned Commendation" (letter to the editor). *Toronto Daily Star*, 29 Nov. 1926.

1926c. "The Art Gallery of Toronto." *Journal, Royal Architectural Institute of Canada* III:2 (March/April 1926), pp. 65–72.

1927a. "Canadian Art." In *Addresses Delivered before the Canadian Club of Toronto: Season of 1926–27*, pp. 168–77. Toronto: Warwick Bros. & Rutter, 1927.

1927b. "Art and Life." In *Foundations: Building the City of God*, 2nd series, pp. 67–76. Toronto: Student Christian Movement of Canada, 1927.

1927c. "Possession and Creation." *O.C.A. Students' Annual*, May 1927, pp. 18–20.

1928a. "Canadian Art Should Interpret Environment." *Journal, Royal Architectural Institute of Canada* V:1 (Jan. 1928), p. 29.

1928b. "Artists Must Have Room for Progress." *Varsity* (University of Toronto), 20 Feb. 1928, pp. 1, 4.

1928c. "The Value, Meaning and Place of Art in Education." *Dalhousie Review* VIII (Oct. 1928), pp. 378–89.

1929a. "The Little Theatres: Stage Settings for High Schools." *Canadian Forum* IX:104 (May 1929), pp. 292–93.

1929b. "Education: Education through Art." *Canadian Forum* IX:106 (July 1929), pp. 346–47.

1929c. "Mr. Lismer Discusses Architecture as a School Subject" (letter to the editor). *Journal, Royal Architectural Institute of Canada*, VI:10 (Oct. 1929), pp. 375, xxvi.

1930a. "The Beginning of Art Education." *Tangent*, May 1930, pp. 26–28. Reprinted in *Etcetera* I:1 (Sept. 1930), pp. 12–13.

1930b. *Canadian Picture Study.* Toronto: Art Gallery of Toronto, 1930.

1932a. "The World of Art." *Canadian Comment* I:2 (Feb. 1932), pp. 25–26.

1932b. "World of Art." *Canadian Comment* I:3 (March 1932), pp. 20–21.

1932c. "World of Art." *Canadian Comment* I:4 (April 1932), pp. 24–25.

1932d. "World of Art." *Canadian Comment* I:6 (June 1932), pp. 31–32.

1932e. "World of Art." *Canadian Comment* I:7 (July 1932), pp. 20–21.

1932f. "Canadian Painters Offended." *Toronto Mail and Empire*, 18 July 1932.

1932g. "World of Art." *Canadian Comment* I:8 (Aug. 1932), p. 21.
1932h. "Art in Canada." *Twentieth Century* I:1 (Nov. 1932), pp. 8–11.
1932i. "Art in Canada." *Twentieth Century* I:2 (Dec. 1932), pp. 6–8.
1932j. "Art in Canada." *Twentieth Century* I:3 (Dec. 1932), pp. 9–11.
1932k. "Art Agitation." *Toronto Mail and Empire*, 17 Dec. 1932.
1932L. "Fifth Column." *Ottawa Citizen*, 29 Dec. 1932.
1932m. "The World of Art." *Canadian Comment* I:12 (Dec. 1932), p. 30.
1932n. "National Gallery and Artists" (letter to the editor). *Toronto Mail and Empire*, 30 Dec. 1932.
1933a. "Art in Canada." *Twentieth Century* I:4 (Jan. 1933), pp. 17–19.
1933b. "The World of Art." *Canadian Comment* II:1 (Jan. 1933), p. 31.
1933c. "Painter of Canada's Solemn Lands: Memorial Show Proves Greatness of Late J.E.H. MacDonald." *Saturday Night* XLVIII:11 (21 Jan. 1933), p. 3.
1933d. "Art in Canada." *Twentieth Century* I:5 (Feb. 1933), pp. 22–25.
1933e. "The World of Art." *Canadian Comment* II:2 (Feb. 1933), pp. 23, 32.
1933f. "Art in Canada." *Twentieth Century* I:6 (Feb. 1933), pp. 13–15.
1933g. "Art in Canada." *Twentieth Century* I:7 (March 1933), pp. 13–15.
1933h. "Art in Canada." *Twentieth Century* I:8 (March 1933), pp. 17–20.
1933i. "The World of Art." *Canadian Comment* II:3 (March 1933), pp. 28, 32.
1933j. "Art in Canada." *Twentieth Century* I:9 (April 1933), pp. 25–26.
1933k. "The World of Art." *Canadian Comment* II:4 (April 1933), p. 25.
1933L. "J.E.H. MacDonald, R.C.A." *Tangent*, April 1933, pp. 2–4.
1933m. "Art in Canada." *Twentieth Century* I:10 (May 1933), pp. 33–37.
1933n. "The World of Art." *Canadian Comment* II:5 (May 1933), pp. 26, 29–30.
1933o. "Art in Canada." *Twentieth Century* I:10 (June 1933), pp. 27–30.
1933p. "The World of Art." *Canadian Comment* II:6 (June 1933), pp. 22, 31–32.
1933q. "Art in Canada." *Twentieth Century* I:12 (July 1933), pp. 37–39.
1933r. "The World of Art." *Canadian Comment* II:7 (July 1933), pp. 25, 32.
1933s. "Mural Painting." *Journal, Royal Architectural Institute of Canada* X:7 (July 1933), pp. 127–35.
1933t. "Art at the World's Fair." *Canadian Comment* II:10 (Oct. 1933), pp. 5–6.
1933u. "Art in Canada." *Twentieth Century* II:1 (Nov. 1933), pp. 29–33.
1933v. "November Exhibitions." *Bulletin* (Art Gallery of Toronto), Nov. 1933.
1933w. "The Van Horne Collection." *Canadian Comment* II:12 (Dec. 1933), p. 24.
1934. "Works by Three Canadian Women." *Montreal Daily Star*, 9 May 1934.
1954. "Tom Thomson (1877–1917): Canadian Painter." *Educational Record* LXXX:3 (July–Sept. 1954), pp. 170–75.

London, T. W. B.
1930. "B.C. Art League Thanks Vancouver Sun for Editorials and News on Discrimination" (letter to the editor). *Vancouver Sun*, 30 Jan. 1930.

Longden, Major A. A.
1924. "Overseas Empire Art at Wembley." *The Field* (London), 22 May 1924.

Longstreth, T. Morris
1933. "When Canadian Art 'Arrived' in Europe." *Saturday Night* XLVIII:22 (8 April 1933), p. 15.
1934. "The Paintings of J.E.H. MacDonald." *Studio* CVIII:496 (July 1934), p. 43.

Lord, Barry
1967. "Georgian Bay and the Development of the September Gale Theme in Arthur Lismer's Painting, 1912–21." *Bulletin* (National Gallery of Canada) V:1–2 (1967), pp. 28–38.

Loring, F.
1933. "Eric Brown Champion of Canadian Art." *Toronto Mail and Empire*, 13 Feb. 1933.

Lover of Art
1928. "Criticism of Painting at Art Gallery Is Approved by Art Lover" (letter to the editor). *Toronto Telegram*, 22 Feb. 1928, p. 28.

Lowery, Susan J.
1985. "The Art Gallery of Toronto, Pattern and Process of Growth: 1872 to 1966." Master's thesis, Concordia University, Montreal, 1985.

Lowrey, Carol
1985. "Within the Sanctum: Newton MacTavish as Art Critic." *Vanguard* XIV:9 (Nov./Dec. 1985), pp. 11–14.

Luckhart, Grace
1928. "The Group of Seven." *Vancouver Daily Province*, 16 Aug. 1928, p. 6.

Luckyj, Natalie
1983. *Visions and Victories: 10 Canadian Women Artists 1914–1945* (exhibition catalogue). London, Ont.: London Regional Art Gallery, 1983.
1986. *Expressions of Will: The Art of Prudence Heward* (exhibition catalogue). Kingston, Ont.: Agnes Etherington Art Centre, 1986.

Lyle, John M.
1931. "Fifty-first Annual Exhibition, Royal Canadian Academy of Arts." *Journal, Royal Architectural Institute of Canada* VIII:1 (Jan. 1931), pp. 4–10.

Lyman, F. Gold
1913. "Post Impressionists May Be Misjudged as Ruskin Did Whistler" (letter to the editor). *Montreal Daily Herald*, 1 April 1913, p. 6.

Lyman, John
1913a. "Mr. John G. Lyman Writes in Defence of Post-Impressionism" (letter to the editor). *Montreal Daily Star*, 3 May 1913.
1913b. "Mr. John G. Lyman in Defence of Post-Impressionism" (letter to the editor). *Montreal Daily Star*, 17 May 1913.
1932. "Canadian Art" (letter to the editor). *Canadian Forum* XII:140 (May 1932), pp. 313–14.
1939. "Art." *Montrealer*, 1 May 1939.

M. A.
1922. "The R.C.A. Exhibition" (letter to the editor). *Montreal Gazette*, 8 Dec. 1922.

Macbeth, Madge
1922. "The National Gallery of Art." *Saturday Night* XXXVII:11 (14 Jan. 1922), p. 21.
1926. "The All Canadian Exhibition of Paintings at Ottawa." *Saturday Night* XLI:17 (13 March 1926), p. 25.

MacCallum, H.R.
1933. "The Group of Seven: A Retrospect." *Queen's Quarterly* XL:2 (May 1933), pp. 242–52. Reprinted in *Imitation and Design and Other Essays by Reid MacCallum*, ed. William Bissett (Toronto: University of Toronto Press, 1953).

MacCallum, J.M.
1918. "Tom Thomson: Painter of the North." *Canadian Magazine* I:5 (March 1918), pp. 375–85.

MacDermot, T.W.L.
1932. "T.M.'s Cover Designs" (letter to the editor). *Canadian Forum* XII:144 (Sept. 1932), p. 476.

MacDonald, Dick
1973. *Mugwump Canadian: The Merrill Denison Story.* Montreal: Content Publishing, 1973.

MacDonald, James Edward Hervey
1913. "The Hot Mush School: In Rebuttal of H.F.G" (letter to the editor). *Toronto Daily Star*, 20 Dec. 1913, p. 23.
1916a. "The O.S.A. Exhibition" (letter to the editor, signed "Pictor"). *Toronto Globe*, 15 March 1916, p. 6.
1916b. "Bouquets from a Tangled Garden" (letter to the editor). *Toronto Globe*, 27 March 1916, p. 4.
1916c. "A Notable Exhibition of Decorative Art." *Toronto Globe*, 8 May 1916, p. 7.
1917a. "A Landmark of Canadian Art." *The Rebel* II:2 (Nov. 1917), pp. 45–50.
1917b. "A Hash of Art." *The Rebel* II:3 (Dec. 1917), pp. 90–93.
1918a. "Art Crushed to Earth." *The Rebel* II:4 (Jan. 1918), pp. 150–53.
1918b. "Art and Our Friend in Flanders." *The Rebel* II:5 (Feb. 1918), pp. 182–86.
1918c. "A Whack at Dutch Art." *The Rebel* II:6 (March 1918), pp. 256–60.
1918d. "Francis Ledwidge Killed in Action." *The Rebel* III:1 (Oct. 1918), p. 2.
1918e. "The Terrier and the China Dog." *The Rebel* III:2 (Dec. 1918), pp. 55–60.
1919a. "Mentioned in Dispatches" (signed J.M.). *The Rebel* III:5 (March 1919), pp. 205–07.
1919b. "The Aesthetes." *The Rebel* III:5 (March 1919), p. 226.
1919c. "The Canadian Spirit in Art." *Statesman* (Toronto) I:35 (22 March 1919), pp. 6–7.
1919d. "The War Memorials Pictures" (letter to the editor). *Toronto Globe*, 5 Sept. 1919, p. 6.
1919e. "Below the Rapid." *The Rebel* IV:2 (Nov. 1919), p. 66.
1919f. "A.C.R. 10557." *The Lamps*, Dec. 1919, pp. 33–39.
1919g. "Men and Mary (Court Street)." *The Lamps*, Dec. 1919, p. 60.
1920a. "A Happy New Year for Art." *The Rebel* IV:4 (Jan. 1920), pp. 155–60.
1920b. "The Lost Village." *The Rebel* III:6 (March 1920), pp. 262–63.
1923. "The Choir Invisible." *Canadian Forum* III:28 (Jan. 1923), pp. 111–13.
1924. "A Glimpse of the West." *Canadian Bookman* VI:11 (Nov. 1924), pp. 229–31.
1925a. "Interior Decorations of St. Anne's Church, Toronto." *Journal, Royal Architectural Institute of Canada* II:3 (May/June 1925), pp. 85–93.
1925b. "Art, Indoors and Out." *Canadian Forum* VI:63 (Dec. 1925), pp. 77–78.
1926. "The Toronto Grange in April." *Canadian Bookman* VIII:5 (May 1926), pp. 157–58.
1928a. "Some Books on Art." *Canadian Forum* VIII:88 (Jan. 1928), pp. 505–06.
1928b. "In Memoriam – Fred Jacob." *Canadian Forum* VIII:94 (July 1928), p. 705.
1928c. "Tolstoy and His Centenary." *Canadian Forum* VIII:95 (Aug. 1928), p. 742.
1929a. "City of Future Brilliant with Gold Color." *Toronto Telegram*, 26 Feb. 1929.
1929b. "The Little Theatres: The Players' Revue." *Canadian Forum* IX:103 (April 1929), p. 256.
1931. "Art." In *Trails to Success*, ed. John Henderson and Alfred H. Allen. Toronto: Macmillan, 1931, pp. 94–104.
1933a. *Village and Fields: A Few Country Poems by J.E.H. MacDonald.* Thornhill, Ont.: Woodchuck Press, 1933.
1933b. *West by East and Other Poems by J.E.H. MacDonald.* Toronto: Ryerson, 1933.
1979. *J.E.H. MacDonald: Sketchbook, 1915–1922.* Introduction by Hunter Bishop. Facsimile edition.

Moonbeam, Ont.: Penumbra Press, 1979.
1980. "Scandinavian Art." *Northward Journal*, 18/19 (1980), pp. 9–35.
1989. *J.E.H. MacDonald: The Barbados Journal 1932.* Introduction by John Sabean. Kapuskasing, Ont.: Penumbra Press, 1989.

MacDonald, Thoreau
1927. "O.S.A. Exhibition" (unsigned). *Canadian Forum* IX:3 (March 1927), p. 78.
1929a. "Canada and Russia" (letter to the editor). *Canadian Forum* IX:104 (May 1929), p. 292.
1929b. "Local Improvement" (letter to the editor). *Canadian Forum* X:110 (Nov. 1929), p. 69.
1931. "Repetition" (letter to the editor). *Canadian Forum* XI:129 (June 1931), pp. 356–57.
1932. "Decline of the Group of Seven." *Canadian Forum* XII:136 (Jan. 1932), p. 144.
1944. *The Group of Seven.* Toronto: Ryerson, 1944.
1977. "Le Groupe des Sept." *Boréal*, 9 (1977), pp. 11–17.
1980. *Notebooks: Thoreau MacDonald.* Moonbeam, Ont.: Penumbra Press, 1980.

MacKay, Alice
1927. "The Second Annual Exhibition of Canadian Art." *Canadian Homes and Gardens* IV:4 (April 1927), pp. 32, 52, 54.

MacKay, C.C.
1930a. "Group of Seven." *Saturday Night* XLV:22 (12 April 1930), p. 15.
1930b. "Canadian Academy's Jubilee." *Saturday Night* XLVI:2 (22 Nov. 1930), p. 5.
1931a. "O.S.A. Sticks to Its Formulas." *Saturday Night* XLVI:18 (14 March 1931), p. 10.
1931b. "The World of Art." *Saturday Night* XLVI:26 (9 May 1931), p. 15.

MacLean, Margaret
1919. "'Cubist Monstrosities'" (letter to the editor). *Toronto Globe*, 5 Sept. 1919, p. 6.

MacMillan, Ernest
1925. "Folk Songs of French Canada." *Canadian Forum* VI:63 (Dec. 1925), pp. 79–80, 82.

Macpherson, Mary-Etta
1929. "Canadian Art in Review." *Canadian Homes and Gardens* VI:2 (Feb. 1929), pp. 20–21.

MacTavish, Newton
1908a. "The Front Window" (unsigned). *Canadian Magazine* XXX:5 (March 1908), pp. 480–83.
1908b. "The Front Window" (unsigned). *Canadian Magazine* XXXI:1 (May 1908), pp. 94–96.
1910. "Within the Sanctum" (signed "The Editor"). *Canadian Magazine* XXXIV:3 (Jan. 1910), pp. 299–301.
1911. "A Renaissance of Art in Canada." *Art and Progress* II:11 (Sept. 1911), pp. 318–25.
1918. "Some Canadian Painters of the Snow." *Studio* LXXV:307 (Oct. 1918), pp. 78–82.
1924. "Fine Arts from Canada" (unsigned). *Canadian Magazine* LXIII:3 (July 1924), pp. 132–44.
1925a. *The Fine Arts in Canada.* Toronto: Macmillan, 1925.
1925b. "John Murray Gibbon, Apostle of Silence." *Canadian Magazine* LXIV:1 (Feb. 1925), pp. 11, 29.
1931. "The Development of the Fine Arts in Canada." In *Canada Year Book, 1931*, pp. 995–1009. Ottawa: King's Printer, 1931. Published as a pamphlet under the same title (Ottawa: Dominion Bureau of Statistics, F.A. Acland, 1931).
1938. *Ars Longa.* Toronto: Ontario Publishing Co., 1938.

Mann, Addison
1926. "Those Pictures" (letter to the editor). *Ottawa Journal*, 17 March 1926.

Martinesen, Hanna
1984. "The Scandinavian Impact on the Group of Seven's Vision of the Canadian Landscape." *Konsthistorisk Tidskrift* LIII (1984), pp. 1–17.

Mason, Lawrence
1926. "Art and Artists" (signed L.M.). *Toronto Globe*, 14 May 1926, p. 20.
1927. "The National Gallery of Canada at Ottawa." *Toronto Globe*, 12 Nov. 1927.

Massey, Vincent
1922. "The Prospects of a Canadian Drama." *Queen's Quarterly* XXX:2 (Oct./Nov./Dec. 1922), pp. 194–212.
1926. *Canadian Plays from Hart House Theatre: I* (ed.). Toronto: Macmillan, 1926.
1929. "Address by the Hon. Vincent Massey." *Journal, Royal Architectural Institute of Canada* VI:2 (Feb. 1929), pp. 38–39, 68.
1930. "Art and Nationality in Canada." *Proceedings of the Royal Society of Canada*, 1930, Appendix B, pp. lix–lxxii.

Masson, H.L.
1930. "'Real Art'" (letter to the editor). *Ottawa Morning Citizen*, 21 April 1930.

Matheson, J.
1928a. "Exhibition and the Art Gallery Pictures." *Vancouver Daily Province*, 30 Sept. 1928.
1928b. "How Exhibition Obtained Its Pictures." *Vancouver Daily Province*, 21 Oct. 1928.

Maxwell, W.S.
1932a. "Fifty-second Annual Exhibition, Royal Canadian Academy of Arts." *Journal, Royal Architectural Institute of Canada* IX:1 (Jan. 1932), pp. 14–21.
1932b. "Canadian Artists Protest" (letter to the editor). *Montreal Gazette*, 13 Dec. 1932.

May, Ella
1913. "'Critics Ignorant,' Says 'Futurist' Supporter." *Montreal Daily Herald*, 27 March 1913.

McCarthy, Pearl
1930. "National Gallery Marks Jubilee by Impressive Canadian Display." *Toronto Mail and Empire*, 24 Jan. 1930.
1931a. "Works of Ontario Artists Offer Display Catholicity." *Toronto Mail and Empire*, 7 March 1931.
1931b. "New Contribution to Canadian Art." *Toronto Mail and Empire*, 5 May 1931.
1931c. "Group of Seven Seen in New Adventures." *Toronto Mail and Empire*, 5 Dec. 1931, p. 5.
1932a. "National Gallery Opening Reveals Decided Progress in Art Work of Dominion." *Toronto Mail and Empire*, 22 Jan. 1932.
1932b. "Conservatives Hold Art Show Spotlight." *Toronto Mail and Empire*, 4 March 1932.
1932c. "Attractive Exhibit by Canadian Artists." *Toronto Mail and Empire*, 7 June 1932.
1932d. "Royal Academy Exhibition Is Broadly Representative." *Toronto Mail and Empire*, 4 Nov. 1932.
1932e. "Group of Seven Loses Member." *Toronto Mail and Empire*, 28 Nov. 1932.
1933a. "Moderns of French School Vie with MacDonald Works." *Toronto Mail and Empire*, 6 Jan. 1933.
1933b. *Toronto Mail and Empire*, 28 Oct. 1933.
1933c. "Canadian Group Canvases Explore New Territories." *Toronto Mail and Empire*, 3 Nov. 1933.
1934. "A.Y. Jackson Gives Exhibit of Work." *Toronto Mail and Empire*, 27 Feb. 1934.

McCurry, H.O.
1923a. "Canadian Pictures for England" (letter to the editor). *Ottawa Morning Journal*, 11 Oct. 1923.
1923b. "Explains Situation re Art Exhibition" (letter to the editor). *Vancouver World*, 24 Oct. 1923.
1928. "Now Ottawa Speaks" (letter to the editor). *Vancouver Sunday Province*, 9 Sept. 1928, p. 9.

McDougall, Anne
1977. *Anne Savage: The Story of a Canadian Painter.* Montreal: Harvest House, 1977.

McEvoy, Bernard [pseudonym: "Diogenes"]
1897. *Away from Newspaperdom and Other Poems.* Toronto: G. Morang, 1897.

1927a. "B.C. Society of Fine Arts." *Vancouver Daily Province*, 12 June 1927.
1927b. "Street Corners." *Vancouver Sunday Province*, 21 Aug. 1927, p. 11.
1928a. "B.C. Society of Fine Arts." *Vancouver Daily Province*, 28 April 1928.
1928b. "Modern Art." *Vancouver Daily Province*, 3 May 1928.
1931. "Visit to Art Gallery at Hastings Park." *Vancouver Star*, 29 Aug. 1931.

M.C.J.
1913. "Mr. Lyman Shows Clever Pictures at the Gallery." *Montreal Daily Star*, 21 May 1913.

McLaren, J.W.
1931. "Canadian Forum Covers" (letter to the editor). *Canadian Forum* XI:130 (July 1931), p. 397.

McLeish, John A.B.
1955. *September Gale: A Study of Arthur Lismer of the Group of Seven.* Toronto: J.M. Dent & Sons, 1955.

M'Cormick, W.B.
1932. "Canadian Art." *New York American*, 22 March 1932.

M.D.
1922. "The R.C.A. Exhibition" (letter to the editor). *Montreal Gazette*, 4 Dec. 1922.

Mechlin, Carol
1931. "The Pan-American Exhibition." *American Magazine of Art* XXII:4 (April 1931), p. 283. Reprint of article from *Washington Star*, 25 Jan. 1931.

Mechlin, Leila
1930. "Paintings by Contemporary Canadian Artists." *American Magazine of Art* XXI:5 (May 1930), pp. 262–70.

Mellen, Peter
1970. *The Group of Seven.* Toronto: McClelland & Stewart, 1970.

Mellor, John
1983. *The Company Store: James Bryson McLachlan and the Cape Breton Coal Miners 1900–1925.* Toronto: Doubleday, 1983.

Meredith, Marjorie
1928. "A Group of Seven." *Vancouver Daily Province*, 1 Sept. 1928, p. 19.

Meszaros, Cheryl
1990. "Visibility and Representation: Saskatchewan Art Organizations prior to 1945." Master's thesis, Queen's University, Kingston, Ont., 1990.

Middleton, J.E.
1932. "J.E.H. MacDonald: An Appreciation." *Supplement to "The Lamps,"* Dec. 1932.

Miller, Edward F.
1928. Letter to the editor. *Vancouver Sunday Province*, 19 Aug. 1928, magazine section, p. 10.

Miller, Marion Huestis
1928. "A Three Day Camp in India." *Canadian Forum* IX:97 (Oct. 1928), pp. 10–11.

Miller, Muriel
1983. *Famous Canadian Artists.* Peterborough, Ont.: Woodland Publishing, 1983.

Miller, William
1928a. "Correspondence: More about Pictures" (letter to the editor). *Vancouver Daily Province*, 16 Aug. 1928, p. 14.
1928b. "Paris Interest in Futurist Art Is on the Wane" (letter to the editor). *Vancouver Morning Star*, 14 Sept. 1928.

Milligan, Doris
1931. "In World of Art." *Vancouver Sun*, 17 Oct. 1931.
1932. "Art Notes." *Vancouver Sun*, 27 Aug. 1932.

Millman, J.M.
1924. "Canadian Art: A Reasoned Appreciation." *Mercury* (Leicester), 3 Dec. 1924.

Mills, Allen
1979. "The *Canadian Forum* and Socialism,

1920–1934." *Journal of Canadian Studies* XIII:4 (Winter 1978–79), pp. 11–27.

Mills, W. Gordon
1925. "Art at the Canadian National Exhibition." *Canadian Bookman* VII:9 (Sept. 1925), pp. 152–53.
1926. "A Subscriber Writes of the Group Show." *Canadian Bookman* VIII:6 (June 1926), p. 180.
1985. *Timber Line and Other Poems.* Toronto: Natural Heritage, 1985.

Milne, David
1933a. "'The War': An Artist's View." *Ottawa Citizen*, 6 Jan. 1933.
1933b. "An Art Squabble." *Ottawa Journal*, 9 Jan. 1933.
1933c. "Should Clarify Its Position." *Toronto Mail and Empire*, 12 Jan. 1933.
1933d. "The National Gallery." *Ottawa Journal*, 31 Jan. 1933.
1933e. "Art and Artists." *Toronto Mail and Empire*, 14 Feb. 1933.
1933f. "Purchase of Works of Art by the Nation." *Winnipeg Free Press*, 18 Feb. 1933.

Mitchell, Roy
1919. *Shakespeare for Community Players.* Illustrated by J.E.H. MacDonald. Toronto: J.M. Dent & Sons, 1919.
1929. *Creative Theatre.* New York: John Day, 1929.
1932. "The Spirit of Modern Art." *Canadian Theosophist* XIII:6 (15 Aug. 1932), pp. 161–68.

MMFA (Montreal Museum of Fine Arts)
1963. *John Lyman* (exhibition catalogue). Montreal: Montreal Museum of Fine Arts, 1963.

Montague, Dewar
1913. "The Classic Commonplace." *MacLean's*, May 1913, pp. 31–39.

Montague, Ian
1969. *An Uncommon Fellowship: The Story of Hart House.* Toronto: University of Toronto Press, 1969.

Montreal Museum of Fine Arts
See under MMFA.

Moogk, Peter N.
1975. "Réexamen de l'École des arts et métiers de Saint-Joachim." *Revue d'Histoire de l'Amérique Française* XXIX:1 (June 1975), pp. 3–29.

Moore, Harry N.
1924a. "Canadian Pictures Cause Row." *Times and Star* (Saint John, N.B.), 19 May 1924. Reprinted in *Edmonton Journal*, 19 May 1924; *Calgary Herald*, 19 May 1924; *Montreal Daily Star*, 19 May 1924; *Toronto Daily Star*, 19 May 1924; *Ottawa Evening Citizen*, 19 May 1924; *Halifax Chronicle*, 20 May 1924.
1924b. "Canadian Artist Defends Exhibit." *Edmonton Journal*, 20 May 1924.

Morehouse, Lucille E.
1921a. "Exhibit by Seven Canadian Artists Will Open Today." *Indianapolis Sunday Star*, 10 April 1921.
1921b. "Canadian Artists' Masterful Work Is Displayed Here." *Indianapolis Sunday Star*, 17 April 1921.
1921c. "'The West Wind' Powerful Canvas in Fine Display." *Indianapolis Sunday Star*, 24 April 1921.

Morgan-Powell, S.
1913a. "Art Association Spring Exhibition Shows Notable Features." *Montreal Daily Star*, 25 March 1913.
1913b. "Art and the Post-Impressionists." *Montreal Daily Star*, 29 March 1913.
1913c. "A Reply to Mr. H. Mortimer-Lamb" (letter to the editor, under heading: "Post-Impressionism: What Julius Meier-Graeffe Really Thinks of It"). *Montreal Daily Star*, 16 April 1913.
1913d. "Some Post-Impressionist Thoughts on the Post-Impressionist Movement." *Montreal Daily Star*, 10 May 1913.
1913e. "Essays, Fugues, Adventures and Improvisations." *Montreal Daily Star*, 23 May 1913.
1918. "A Few Notable Canvases, but a Lower Average." *Montreal Daily Star*, 23 Nov. 1918, p. 1.

1919a. "Canadian War Memorials on Canvas Vivid." *Montreal Daily Star*, 29 Oct. 1919.
1919b. "War Memorial Pictures on View at Art Gallery: Further Details of a Remarkable Exhibition." *Montreal Daily Star*, 7 Nov. 1919, p. 30.
1920a. "War Memorials Exhibition at the Art Gallery." *Montreal Daily Star*, 28 Sept. 1920.
1920b. "Royal Canadian Academy's 42nd Exhibition Open." *Montreal Daily Star*, 19 Nov. 1920.
1922a. "Portraits at Exhibition Are Outstanding Feature." *Montreal Daily Star*, 27 March 1922.
1922b. "A Final Glance Around the Art Exhibition Here." *Montreal Daily Star*, 12 April 1922.
1922c. "Royal Canadian Academy Show Is Not Sensational." *Montreal Daily Star*, 22 Nov. 1922.
1922d. "The Royal Canadian Academy Exhibition." *Montreal Daily Star*, 24 Nov. 1922.
1925a. "Forty-seventh R.C.A. Exhibition Now Open at the Art Galleries." *Montreal Daily Star*, 20 Nov. 1925.
1925b. "Academy Exhibition Canvases That Have Attracted Attention." *Montreal Daily Star*, 16 Dec. 1925.
1926a. "Spring Exhibition at Art Galleries Is an Indifferent Show." *Montreal Daily Star*, 7 April 1926.
1926b. "Books" (review of *A Canadian Art Movement* by F.B. Housser). *Montreal Daily Star*, 31 Dec. 1926.
1927. "Forty-ninth Annual R.C.A. Exhibition at Art Galleries Here." *Montreal Daily Star* [25 Nov. 1927].
1928a. "Canadian West Coast Art on Exhibition by the Art Association." *Montreal Daily Star*, 1 March 1928.
1928b. "Canadian Pictures by Contemporary Painters at the Art Association." *Montreal Daily Star*, 11 Oct. 1928.
1928c. "The Group of Seven Again." *Montreal Standard*, 27 Oct. 1928.
1929a. *Memories That Live.* Toronto: Macmillan, 1929.
1929b. "The Spring Exhibition." *Montreal Daily Star*, 22 March 1929.
1929c. "R.C.A. Exhibition." *Montreal Daily Star*, 22 Nov. 1929.
1930. "The School of Seven." *Montreal Daily Star*, 7 May 1930. Reprinted in *Canadian Forum* X:118 (July 1930), p. 384.
1931. "Pictures on View." *Montreal Daily Star*, 2 Feb. 1931.

Morin, Leo-Pol
1930. *Papiers de musique.* Montreal: Librairie d'Action canadienne-française, 1930.

Morrin, Peter
1986. *The Advent of Modernism: Post-Impressionism and North American Art, 1900–1918* (exhibition catalogue). With Judith Zilczer and William C. Agee. Atlanta: High Museum of Art, 1986.

Morrison, Ann
1991. "Canadian Art and Cultural Appropriation: Emily Carr and the 1927 Exhibition of Canadian West Coast Art – Native and Modern." Master's thesis, University of British Columbia, 1991.

Mortimer-Lamb, Harold
1908. "The Art of Curtis Williamson." *Canadian Magazine* XXXII:1 (Nov. 1908), pp. 65–71.
1911a. "Studio Talk: Montreal." *Studio* LII:216 (March 1911), pp. 159–60.
1911b. "Studio-Talk: Montreal." *Studio* XLIV:174 (Aug. 1911), pp. 164–67.
1913a. "Post-Impressionism Creates Much Discussion Locally" (letter to the editor). *Montreal Daily Star*, 7 April 1913.
1913b. "Art and Art Critics" (letter to the editor). *Montreal Daily Star*, 19 April 1913.
1913c. "Some Notes on Understanding and the Appreciation of Art." *Montreal Daily Herald*, 26 Nov. 1913.
1915a. "Studio Talk: Montreal." *Studio* LXV:269 (Aug. 1915), pp. 212–13.

1915b. "Canadian Artists and the War." *Studio* LXV:270 (Sept. 1915), pp. 259–64.
1916. "Studio Talk: Montreal." *Studio* LXVII:275 (Feb. 1916), pp. 62–70.
1917. "The Thirty-eighth Exhibition of the Royal Canadian Academy of Arts." *Studio* LXX:287 (Feb. 1917), pp. 30–39.
1918. "Art Criticism and the Star" (letter to the editor). *Montreal Daily Star*, 28 Nov. 1918.
1919a. "Studio Talk: Montreal." *Studio* LXXVI:314 (May 1919), pp. 149–51.
1919b. "Studio Talk: Montreal." *Studio* LXXVII:316 (July 1919), pp. 119–26.
1922a. "The Modern Art Movement in Canada." *Vancouver Daily Province*, 15 Sept.
1922b. "Group of Seven Attracts Artists." *Victoria Daily Colonist*, 22 Sept. 1922.
1922c. "Modern Art in Canada and the Group of Seven." 8 Oct. 1922 (unidentified clipping, National Gallery of Canada Library, documentation file, Group of Seven).
1925a. "National Art Board Is Arraigned for Neglect of West." *Vancouver Daily Province*, 8 Feb. 1925.
1925b. "National Art Question" (letter to the editor). *Vancouver Daily Province*, 22 March 1925.
1928a. "More about the Pictures" (letter to the editor). *Vancouver Daily Province*, 14 Aug. 1928, p. 9.
1928b. "Mr. Lamb's Rejoinder" (letter to the editor). *Vancouver Daily Province*, 29 Aug. 1928, p. 24.
1930. "Vancouver Art Students Capture Laurels." *Vancouver Star*, 28 April 1930.
1932a. "The Modern Art Movement in Canada." *Vancouver Daily Province*, 15 Sept. 1932.
1932b. "British Columbia Art." *Saturday Night* XLVI-II:4 (3 Dec. 1932), p. 21.

Mount, Nora S.
1931. "The Group of Seven." *Bulletin of the Montclair Art Museum* II:1 (Feb. 1931), pp. 1–3.

Mount, R. J.
1914. "Art and Artist." *Montreal Daily News*, 16 Sept. 1914.

M.T.
1921. "Art." *Buffalo Evening News*, 24 Sept. 1921.

Murray, Joan
1971. *The Art of Tom Thomson.* Toronto: Art Gallery of Ontario, 1971.
1982. With Robert Fulford. *The Beginning of Vision: The Drawings of Lawren Harris.* Vancouver: Douglas & McIntyre, with Mira Godard Editions. 1982.
1983. *Isabel McLaughlin: Recollections.* Oshawa, Ont.: Robert McLaughlin Gallery, 1983.
1984a. *The Best of the Group of Seven.* Edmonton: Hurtig, 1984. Reprint by McClelland & Stewart, Toronto, 1993.
1984b. *Daffodils in Winter: The Life and Letters of Pegi Nicol MacLeod, 1904–1949.* Moonbeam, Ont.: Penumbra Press, 1984.
1986. *The Best of Tom Thomson.* Edmonton: Hurtig, 1986.
1994a. *Northern Lights: Masterpieces of Tom Thomson and the Group of Seven.* Toronto: Key Porter, 1994.
1994b. *Origins of Abstraction in Canada: Modernist Pioneers.* Oshawa: Robert McLaughlin Gallery, 1994.

Myers, Reta W.
1930. "In the Domain of Art." *Vancouver Daily Province*, 26 Oct. 1930.
1931a. "In the Domain of Art." *Vancouver Daily Province*, 4 Oct. 1931.
1931b. "Art Gallery Opening Marks Epoch in Vancouver." *Vancouver Daily Province*, 5 Oct. 1931.
1931c. "In the Domain of Art." *Vancouver Daily Province*, 6 Dec. 1931, p. 5.
1932a. "In the Domain of Art." *Vancouver Daily Province*, 24 Jan. 1932.
1932b. "In the Domain of Art." *Vancouver Daily Province*, 28 Feb. 1932.

1932c. "Art of Canada Comes to Vancouver." *Vancouver Daily Province*, 8 May 1932.
1932d. "Art Gallery Display Is of Exceptional Merit." *Vancouver Daily Province*, 12 May 1932.
1932e. "In the Domain of Art." *Vancouver Daily Province*, 14 Dec. 1932.

Nasgaard, Roald
1984. *The Mystic North: Symbolist Landscape Painting in Northern Europe and North America 1890–1940* (exhibition catalogue). Toronto: University of Toronto Press / Art Gallery of Ontario, 1984.

National Gallery of Canada
See under NGC.

NGC (National Gallery of Canada)
Annual reports for the years 1920–21 through 1933–34.
1924a. *A Portfolio of Pictures from the Canadian Section of Fine Arts*. [Ottawa: National Gallery of Canada, 1924.]
1924b. *Press Comments on the Canadian Section of Fine Arts, British Empire Exhibition*. [Ottawa: National Gallery of Canada], 1924.
1925. *Press Comments on the Canadian Section of Fine Arts, British Empire Exhibition 1924–1925*. [Ottawa: National Gallery of Canada], 1925.
1963. *Lawren Harris Retrospective Exhibition 1963* (exhibition catalogue). Ottawa: National Gallery of Canada, 1963.

Nichol, Pegi [Nicol]
1929. "R.C.A. Impressions" (letter to the editor). *Ottawa Citizen*, 4 Dec. 1929.

Nicholson, Edward J.
1970. *Brigdens Limited: The First One Hundred Years*. Toronto: Brigdens, 1970.

Nicol, R.
1927. "Strongly Defends Art Exhibit, Particularly Group of 7" (letter to the editor). *Vancouver Sunday Province*, 21 Aug. 1927, p. 10.

Norbury, F.H.
1928. "National Gallery Pictures and Work of 'Group of Seven' Make Up Unusual Collection." *Edmonton Journal*, 29 Oct. 1928.
1929. "Art Subjects and Objects." *Edmonton Journal*, 23 Nov. 1929.
1932a. "Arthur Lismer to Speak to Edmonton Art Lovers." *Edmonton Journal*, 11 March 1932.
1932b. "Canada Has Developed National School of Art." *Regina Leader Post*, 16 March 1932.

Norcliffe, Glen
1992. With P. Simpson-Housley. *A Few Acres of Snow: Literary and Artistic Images of Canada* (ed.). Toronto: Dundurn Press, 1992.

Nutt, E.S.
1929. "Development in Canadian Art." *London Morning Free Press* (Ont.), 12 April 1929.

Ogden, J. Williams
1928. "Correspondence: Art at the Exhibition" (letter to the editor). *Vancouver Daily Province*, 13 Aug. 1928, p. 7.
1930. "Protests against One-Man Tribunal to Select B.C. Pictures for Show" (letter to the editor). *Vancouver Sun*, 1 Feb. 1930.

Olmsted, J.M.D.
1926. "Art in the Southwestern States." *Canadian Forum* VI:64 (Jan. 1926), pp. 117–18.

One of the Moderns
1913. "Bear Futurists If Only to Save Us from Bores of Repetition" (letter to the editor). *Montreal Daily Herald*, 3 April 1913, p. 7.

Onlooker
1928. "Canadian Art Interests" (letter to the editor). *Montreal Daily Star*, 29 Sept. 1928.

Ontario Society of Artists
See under OSA.

OSA (Ontario Society of Artists)
Annual reports for the years 1900 to 1934.

1911. *Notes on Pictures at the O.S.A. Exhibition*. [Toronto, 1911.]

Ostiguy, Jean-René
1982. *Modernism in Quebec Art, 1916–1946* (exhibition catalogue). Ottawa: National Gallery of Canada, 1982.
1986. *Adrien Hébert*. Saint-Laurent: Éditions du Trécarré, 1986.

Pantazzi, Sybille
1966. "Book Illustration and Design by Canadian Artists 1890–1940." *Bulletin* (National Gallery of Canada) IV:1 (1966), pp. 6–24.
1969. "Group of Seven: Early Magazine Drawings." *Canadian Antiques Collector* IV:2 (Feb. 1969), pp. 22–23.
1977. "A Picture Frame by J.E.H. MacDonald." *RACAR* IV:1 (1977), pp. 32–35.

Panton, L.A.C.
1920. "Wyly Grier and British Art" (letter to the editor). *Toronto Daily Star*, 15 Dec. 1920.
1932. "Canadian Art" (letter to the editor). *Toronto Mail and Empire*, 2 Aug. 1932.
1933. "The Exhibition of the Royal Canadian Academy." *Journal, Royal Architectural Institute of Canada* X:1 (Jan. 1933), pp. 7–12.

Parke-Taylor, Michael
1988. *In Seclusion with Nature: The Later Work of L. LeMoine FitzGerald, 1942 to 1956* (exhibition catalogue). Winnipeg: Winnipeg Art Gallery, 1988.

Parrott, Doris
1928. "Exhibition – Canada's 'Group of Seven.'" *Calgary Herald*, 8 Dec. 1928.

P.E.
1920. "The Alchemist." *The Rebel* III:6 (March 1920), pp. 237–40.

Peck, M.A.
1929. *Sketch of the Activities of the Canadian Handicraft Guild and of the Dawn of the Handicraft Movement in the Dominion*. Montreal: Canadian Handicraft Guild, 1929.

Pelletier, Georges
1918. "Le retour au terroir." *Le Devoir* (Montreal), 23 Jan. 1918.

Pepall, Rosalind
1986a. *Building a Beaux-Arts Museum*. Montreal: Montreal Museum of Fine Arts, 1986.
1986b. "The Murals in the Toronto Municipal Buildings: George Reid's Debt to Puvis de Chavannes." *Journal of Canadian Art History* IX:2 (1986), pp. 142–63.

Pfaff, L.R.
1978. "Portraits by Lawren Harris: Salem Bland and Others." *RACAR* V:1 (1978), pp. 21–27.
1984. "Lawren Harris and the International Exhibition of Modern Art: Rectifications to the Toronto Catalogue (1927), and Some Critical Comments." *RACAR* XI:1–2 (1984), pp. 79–96.

Phillips, Walter Joseph
1926. "Art and Artists" (review of *A Canadian Art Movement* by F.B. Housser). *Winnipeg Tribune*, 31 Dec. 1926.
1927. "Art and Artists." *Winnipeg Tribune*, 12 March 1927.
1930. "Art and Artists" (unsigned). *Winnipeg Tribune*, 22 Nov. 1930.
1931. "Art and Artists" (unsigned). *Winnipeg Tribune*, 19 Dec. 1931.
1932a. "Art and Artists." *Winnipeg Tribune*, 16 Jan. 1932.
1932b. "Art and Artists." *Winnipeg Tribune*, 10 Dec. 1932.
1933. "Art and Artists." *Winnipeg Tribune*, 25 Feb. 1933.
1940. "The Art of Arthur Heming." *Beaver*, Sept. 1940, pp. 25–29.

Pierce, L. Bruce
1971. *Thoreau MacDonald: Illustrator, Designer, Observer of Nature*. Toronto: Norflex, 1971.

Pierce, Lorne
1928. "Picturing Personalities: A Study of E. Wyly Grier, R.C.A., O.S.A." *Canadian Magazine* LXX:1 (July 1928), pp. 22–23.

Porter, C.G.
1923. "Jack Innes: Painter, Poet and Newspaper Man." *Saturday Night* XXXIX:1 (24 Nov. 1923), p. 2.

Potter, G.R.L.
1926. "'Jazz' in Pictures" (letter to the editor). *Ottawa Journal*, 10 March 1926.

Préfontaine, Fernand
1918a. "Le sujet en art." *Le Nigog* I:2 (Feb. 1918), pp. 44–48.
1918b. "L'art et 'Le Nigog.'" *Le Nigog* I:4 (April 1918), pp. 121–23.
1918c. "La mare aux grenouilles: L'art et le régionalisme." *Le Nigog* I:11 (Nov. 1918), pp. 376–78.

Price, A.M.
1931. "Vancouver Hardly Grown-up Enough to Judge New Art" (letter to the editor). *Vancouver Star*, 29 Aug. 1931.

Pringle, Gertrude
1926. "Tom Thomson, the Man." *Saturday Night* XLI:21 (10 April 1926), p. 5.

Pyper, C.B.
1929. "An Eastern Critic." *Winnipeg Tribune*, 17 Sept. 1929.
1933. "On Art." *Winnipeg Tribune*, 2 May 1933.

Radford, J.A.
1894. "Canadian Art Schools, Artists and Art." *Canadian Magazine* II:5 (March 1894), pp. 462–66.
1907. "Canadian Art and Its Critics." *Canadian Magazine* XXIX:6 (Oct. 1907), pp. 513–19.
1922. "Nation's Pictures Should Come West Art Critic States." Dec. 1922 (unidentified clipping, National Gallery of Canada Library, documentation file, NGC General 1922–23).
1923. "The National Gallery and B.C. Art League" (letter to the editor). *Saturday Night* XXXVIII:13 (3 Feb. 1923), p. 2.
1926. "Art Notes from Here and There." *Vancouver Sun*, 24 Dec. 1926.
1927a. "Art Notes from Near and Far." *Vancouver Sun*, 12 March 1927.
1927b. "Art Notes from Far and Near." *Vancouver Sun*, 22 March 1927.
1930a. "Artists Slighted by Ottawa" (letter to the editor). *Vancouver Sun*, 14 Jan. 1930.
1930b. "B.C. Art Societies Wholly Ignored." *Vancouver Sun*, 16 Jan. 1930.
1930c. "National Art Gallery Trustees Not Fair with People of Canada: Is His Contention" (letter to the editor). *Vancouver Sun*, 21 Jan. 1930.
1930d. "B.C. Pictures for Ottawa." *Vancouver Sun*, 30 Jan. 1930.
1931a. "Queer Enormities Seen by Art Critic at Exhibition." *Vancouver Star*, 26 Aug. 1931.
1931b. "New Art Gallery Offers Wide Choice in Subjects." *Vancouver Star*, 5 Oct. 1931.
1931c. "Oils in New Gallery Draw High Tribute." *Vancouver Star*, 8 Oct. 1931.
1932a. "'Modernistic Bunk' Attacked by Critic." *Vancouver Star*, 9 Feb. 1932.
1932b. "Grotesque Fantasies." *Vancouver Sun*, 14 June 1932.
1932c. "Alex. Young Jackson." *Vancouver Sun*, 10 Dec. 1932.
1932d. "Favoritism." *Vancouver Sun*, 20 Dec. 1932.
1932e. "Boycotting the Art Gallery." *Toronto Mail and Empire*, 28 Dec. 1932.

Rainey, Ada
1930. "Pictures Show Canadian Art of High Order." *Washington Post*, 9 March 1930.

R.B.
1919. "The Players Club, Hart House Theatre and the University." *The Rebel* IV:2 (Nov. 1919), pp. 80–82.
R.B.
1927. "Chronique des arts." *L'Action Française* (Paris), 14 April 1927.
R.B.F.
1927. "Color Studies of Habitant Life and Scenery." *Ottawa Journal*, 12 Jan. 1927.
1928a. "National Artists in a Fine Display." *Ottawa Journal*, 25 Jan. 1928.
1928b. "170 Paintings Seen in National Gallery Annual Exhibition." *Ottawa Journal*, 28 Jan. 1928.
R.B.M.
1926. "Local Artists Have Pictures Purchased to be Hung in Canadian National Gallery." *Ottawa Journal*, 22 Jan. 1926.
RCA (Royal Canadian Academy of Arts)
1883. *Records of the Founding of the Royal Canadian Academy by His Excellency the Marquis of Lorne and Her Royal Highness The Princess Louise 1879–80.* Toronto: Globe Printing, 1883.
Annual reports for the years 1900 to 1934.
Read, Helen Appleton
1924. "Triple Group at Brooklyn Museum." *Brooklyn Daily Eagle*, 25 May 1924, section B, p. 2.
Reade, R.C.
1926. "They Have Taken Photography and Wrung Its Neck." *Toronto Star Weekly*, 22 May 1926.
Reader
1928. "Correspondence" (letter to the editor). *Vancouver Sunday Province*, 26 Aug. 1928.
R.E.H.
1927. "Art, Music and Drama." *Varsity* (University of Toronto), 17 Oct. 1927, p. 2.
Reid, Dennis
1968. "Lawren Harris." *artscanada* XXV:5 (Dec. 1968), pp. 9–16.
1969. *The MacCallum Bequest and the Mr. and Mrs. H.R. Jackman Gift* (exhibition catalogue). Ottawa: National Gallery of Canada, 1969.
1970. *The Group of Seven* (exhibition catalogue). Ottawa: National Gallery of Canada, 1970.
1971. *A Bibliography of the Group of Seven.* Ottawa: National Gallery of Canada, 1971.
1973. *Bertram Brooker.* Ottawa: National Gallery of Canada, 1973.
1975. *Tom Thomson: The Jack Pine.* Masterpieces in the National Gallery of Canada, 5. Ottawa: National Gallery of Canada, 1975.
1976. *Edwin Holgate.* Ottawa: National Gallery of Canada, 1976.
1979. *Our Own Country Canada.* Ottawa: National Gallery of Canada, 1979.
1982. *Alberta Rhythm: The Later Work of A.Y. Jackson* (exhibition catalogue). Toronto: Art Gallery of Ontario, 1982.
1985a. *Atma Buddhi Manas: The Later Work of Lawren S. Harris* (exhibition catalogue). Toronto: Art Gallery of Ontario, 1985.
1985b. *Canadian Jungle: The Later Work of Arthur Lismer* (exhibition catalogue). Toronto: Art Gallery of Ontario, 1985.
1989. *The Group of Seven: Selected Watercolours, Drawings and Prints from the Collection of the Art Gallery of Ontario* (exhibition catalogue). Toronto: Art Gallery of Ontario, 1989.
René-Jean
1927a. "L'exposition d'art canadien et ses beaux paysages." *Comœdia* (Paris), 10 April 1927.
1927b. "Une exposition canadienne." *Petit Provençal* (Marseilles), 13 April 1927.
1927c. "Devant l'exposition canadienne." *Comœdia* (Paris), 14 April 1927.

Reynald
1935. "Le canadianisme de A.-Y. Jackson." *La Presse* (Montreal), 16 Nov. 1935.
R.G.D.
1931. "Ban on Nudes" (letter to the editor). *Toronto Daily Star*, 14 March 1931.
Rhoades, Guy E.
1927. "West Coast Indian Art." *Saturday Night* XLIII:5 (18 Dec. 1927), p. 3.
1932. "Figure Painters Feature of Show." *Montreal Gazette*, 5 Nov. 1932. Reprinted in *Winnipeg Free Press*, 5 Nov. 1932.
Richmond, Leonard
1925. "Canadian Pictures at Wembley." *Studio* LXXXIX:182 (Jan. 1925), pp. 16–22.
1926. "A Portfolio of Drawings by Members of the Canadian Group of Seven." *Studio* XCI:397 (April 1926), pp. 244–47.
Rimstead, Roxanne
1991. "'Klee Wyck': Redefining Region through Marginal Realities." *Canadian Literature*, 130 (Fall 1991), pp. 29–59.
Rivard, Adjutor
1924. *Chez Nous (Our Old Quebec Home).* Toronto: McClelland & Stewart, 1924.
R.K.H.
1929. "University Extension and the Little Theatre." *Canadian Forum* X:119 (Nov. 1929), p. 70.
R.M.
1924. "Canada's Art." *Glasgow News*, 24 Dec. 1924.
Roberts, Charles G.D.
1929. "Poetry and Big Business." *Toronto Telegram*, 26 March 1929.
Robertson, Nancy E.
1965. *J.E.H. MacDonald, R.C.A., 1873–1932* (exhibition catalogue). Toronto: Art Gallery of Toronto, 1965.
Robins, J.D.
1927. "Songs of French Canada" (review of *Canadian Folk Songs* by John Murray Gibbon). *Canadian Forum* VII:82 (July 1927), pp. 313–14.
Robinson, Gilbert de B.
1981. *Percy James Robinson (1873–1953): Classicist, Artist, Teacher, Historian.* Toronto: University of Toronto Press, 1981.
Robinson, Noel
1926. "The Star Window." *Vancouver Morning Star*, 20 Dec. 1926.
1927. "The Star Window." *Vancouver Morning Star*, 20 Jan. 1927.
Robinson, Percy J.
1918. "Royal Canadian Academy and the Ontario Society of Artists Exhibition." *Toronto Mail and Empire*, 30 March 1918.
1923. "The Group of Seven." *Acta Victoriana* XLVII:4 (Jan. 1923), pp. 7–12.
1926. "The O.S.A. Exhibition." *Canadian Forum* VI:67 (April 1926), p. 223.
1966. *The Georgian Bay.* Toronto, 1966.
Robson, Albert H.
1932. *Canadian Landscape Painters.* Toronto: Ryerson, 1932.
1937. *J.E.H. MacDonald.* Toronto: Ryerson, 1937.
1938. *A.Y. Jackson.* Toronto: Ryerson, 1938.
Rorke, Louise Richardson
1920. "The Canadian War Memorial Pictures." *Canadian Countryman*, 18 Sept. 1920.
1921. "Canadian Winters as Portrayed by Canadian Artists." *Canadian Countryman*, 10 Dec. 1921, pp. 25, 56.
Rosenberg, James N.
1920. "Ghosts: The Exhibition of the New Society." *International Studio* LXXII:285 (Dec. 1920), pp. lix–lxii.
Royal Canadian Academy of Arts
See under RCA.

R.S.
1918. "In the Art Gallery." *The Rebel* III:2 (Dec. 1918), pp. 78–79.
1925. "Art: The Royal Canadian Academy." *McGill Fortnightly Review* I:1 (21 Nov. 1925), p. 14.
Rufus
1930. "The 'Group of Seven'" (letter to the editor). *Montreal Daily Star*, 29 May 1930.
Russell, G. Horne
1923a. "Royal Canadian Academy's Answer." *Ottawa Citizen*, 8 Sept. 1923, p. 2.
1923b. "Academy Objects to Trustees' Action" (letter to the editor). *Montreal Daily Star*, 10 Sept. 1923.
1923c. "Artists Oppose Mode of Selection" (letter to the editor). *Montreal Gazette*, 10 Sept. 1923.
1923d. "Art at the British Empire Exhibition" (letter to the editor). *Saturday Night* XXXVIII:44 (15 Sept. 1923), p. 2.
1923e. With William Hope and Edmond Dyonnet. "Royal Canadian Academy of the Arts" (letter to the editor). *Toronto Daily Star*, 29 Sept. 1923. Reprinted in *Montreal Daily Star*, 1 Oct. 1923; *Ottawa Citizen*, 2 Oct. 1923.
1924. "Canadian Pictures at Wembley" (letter to the editor). *Daily Telegraph* (London), 2 June 1924.
Russell, Peter
1966. *Nationalism in Canada* (ed.). Toronto: McGraw-Hill, 1966.
Rutter, Frank
1926. "Canadian Art at Manchester, England." *Christian Science Monitor*, 20 Sept. 1926.
St. Anne's Church
1987. *St. Anne's Church 1862–1987.* Toronto: St. Anne's Church, 1987.
Salinger, Jehanne B.
1929a. "Pictures at Art Gallery Cover Period of 965 Years." *Toronto Mail and Empire*, 6 Nov. 1929, p. 8.
1929b. "Comment and Digressions on Art." *Canadian Forum* X:11 (Dec. 1929), pp. 90–91.
1930a. "Canada Splendidly Launched in Career of National Art." *London Morning Advertiser* (Ont.), 25 Jan. 1930.
1930b. "Art Consciousness Aroused by Canada by National Gallery." *North Bay Nugget*, 15 Feb. 1930. Reprinted in *Regina Star*, 5 March 1930, "Art Consciousness Being Aroused in Canada through the National Gallery."
1930c. "Comment on Art." *Canadian Forum* X:114 (March 1930), pp. 209–11.
1930d. "Ontario Society of Artists Opens Annual Show To-night." *Toronto Mail and Empire*, 7 March 1930.
1930e. "Canadian Paintings in U.S. Earn Critics High Praise." *Vancouver Daily Province*, 10 March 1930.
1930f. "Canadian Art Is Applauded by United States Experts." *Toronto Star Weekly*, 15 March 1930, p. 13.
1930g. "Women Sculptors Prominent at O.S.A." *Toronto Mail and Empire*, 22 March 1930.
1930h. "A Prophet of Beauty" (review of *Heart of Asia* by Nicholas Roerich). *Canadian Forum* X:115 (April 1930), p. 259.
1930i. "All-Canadian Art Exhibition Opens Tonight at Toronto." *Montreal Gazette*, 4 April 1930.
1930j. "Freedom Fills Work by Group of Seven." *Toronto Mail and Empire*, 4 April 1930.
1930k. "Comments on Art." *Canadian Forum* X:116 (May 1930), pp. 287–88.
1930L. "Peinture et littérature: L'exposition d'art canadien aux États-Unis." *La Revue Populaire* XXIII:5 (May 1930), pp. 6–9.
1930m. "Exhibition by Arthur Lismer Is Featured at Grange Studios." *Toronto Mail and Empire*, 13 May 1930.
1930n. "The Work of Bertram Brooker." *Canadian Forum* X:117 (June 1930), pp. 331–32.

1930o. Review of *Elijah* by Bertram Brooker. *Canadian Forum* X:117 (June 1930), p. 342.

1930p. "The Academy Show." *Canadian Forum* XI:123 (Dec. 1930), pp. 101–02.

1931a. "One More Exhibition." *Canadian Forum* XI:127 (April 1931), pp. 261–62.

1931b. "Far North Is Pictured by Two Artists." *Regina Leader Post*, 1 May 1931.

1931c. "Paintings Depict Canadian Arctic." *Montreal Gazette*, 1 May 1931.

1931d. "Art Comment." *Canadian Forum* XI:129 (June 1931), p. 341.

1931e. "Comment on Art." *Canadian Forum* XII:135 (Dec. 1931), p. 102.

1931f. "Group of Seven Begins Expansion." *Toronto Mail and Empire*, 7 Dec. 1931.

1932a. "Comment on Art: The Group of Seven." *Canadian Forum* XII:136 (Jan. 1932), pp. 142–43.

1932b. "A Canadian Parallel in Art." *Canadian Forum* XII:139 (April 1932), pp. 266–67.

1932c. "Criticism and the Seven" (letter to the editor). *Canadian Forum* XII:139 (April 1932), p. 277.

Sanger, Peter
1987. "Finding D'Sonoqua's Child: Myth, Truth and Lies in the Prose of Emily Carr." *Antigonish Review*, 69–70 (1987), pp. 210–39.

Schaefer, Carl
1979a. "Painting Expeditions North, 1926 and 1927: Lower French/Pickerel River." *Northward Journal*, 13 (1979), pp. 51–57.

1979b. "A Portfolio of Drawings." *Northward Journal*, 13 (1979), pp. 23–49.

Semple, F. G.
1932. "In the Name of Art" (letter to the editor). *Ottawa Journal*, 1 Feb. 1932.

Septuagenarian
1922. "Academy of Arts Exhibition" (letter to the editor). *Montreal Gazette*, 2 Dec. 1922.

Shadbolt, Doris
1971. *Emily Carr* (exhibition catalogue). Vancouver: Vancouver Art Gallery, 1971.

1979. *The Art of Emily Carr*. Vancouver: Douglas & McIntyre, 1979.

1990a. *Emily Carr*. Vancouver: Douglas & McIntyre, 1990.

1990b. "The Dark Spirit of Emily Carr." *Canadian Forum* LXVIV:790 (June 1990), pp. 7–9.

Sharman, Lyon
1922. "Canadian Culture: To the Editor." *Canadian Forum* II:17 (Feb. 1922), pp. 525–26.

Shaul, Sandra
1982. *The Modern Image: Cubism and the Realist Tradition*. Edmonton: Edmonton Art Gallery, 1982.

Sherburne, E. C.
1933. "An International Show for 1933." *Christian Science Monitor*, 20 Feb. 1933.

Sibley, C. Lintern
1913. "Spring Art Exhibition: Native vs. Foreign Talent." *Montreal Daily Witness*, 17 March 1913.

Siddall, Catherine D.
1987. *The Prevailing Influence: Hart House and the Group of Seven, 1919–1953* (exhibition catalogue). Oakville, Ont.: Oakville Galleries, 1987.

Simms, H. A.
1929. "Appreciates Canadian Art" (letter to the editor). *Toronto Globe*, 29 March 1929.

Sinclair, Jennifer Oille
1989. "Bertram Brooker and Emergent Modernism" (ed.). *Provincial Essays* VII (1989).

Sinclair, John D.
1925. "Gandhi" (letter to the editor). *Canadian Forum* V:57 (June 1925), p. 270.

Sisler, Rebecca
1980. *Passionate Spirits: A History of the Royal Canadian Academy of Arts, 1880–1980*. Toronto: Clark, Irwin & Co., 1980.

Smith, A.J.M.
1926. "Two Poems." *McGill Fortnightly Review* I:4 (9 Jan. 1926), p. 30.

Smith, Frances K.
1980. *André Biéler: An Artist's Life and Times*. Toronto: Merritt Publishing, 1980.

1988. *André Biéler in Rural Quebec* (exhibition catalogue). Kingston, Ont.: Agnes Etherington Art Centre, 1988.

Smith, George L.
1974. *Norman Gurd and the Group of 7*. Sarnia, Ont.: Sarnia Central Collegiate, 1974.

Société Anonyme
1972. "Its Why and Its Wherefore." In *Selected Publications: Société Anonyme* (Vol. 1: Documents). New York: Arno Press, 1972. Originally published as a pamphlet, 1920.

Somerville, Henry
1924a. "Russell Claims Art Selection Too Restricted." *Toronto Daily Star*, 19 May 1924.

1924b. "Says It's Pretty Small." *Ottawa Evening Citizen* [c. 19 May 1924].

1924c. "'Revival of Argument Is Really Indecent.'" *Toronto Daily Star*, 20 May 1924.

1924d. "British Critics Say Canada Developing Own Virile Art." *Toronto Daily Star*, 27 May 1924.

1924e. "British Art Critics Laud Vigor of Canadian Painting." *Toronto Daily Star*, 4 July 1924.

1930. "Several Styles of Canadian Art in British Show." *Toronto Daily Star*, 5 April 1930, p. 3.

Soucy, Donald
1993. With Harold Pearse. *The First Hundred Years: A History of the Nova Scotia College of Art and Design*. Fredericton: University of New Brunswick Faculty of Education / Halifax: Nova Scotia College of Art and Design, 1993.

Southam, H.S.
1930. "Chairman of Art Gallery Trustees Says No Discrimination in Exhibition" (letter to the editor). *Vancouver Sun*, 6 Feb. 1930.

Spectator
1931. "Who Shall Define Art, Correspondent Asks Mr. Radford" (letter to the editor). *Vancouver Daily Province*, 1 Sept. 1931.

Spence, Charles
1932. "'Group of Seven' Productions Are Declared to Be a 'Joke on a Suffering Nation' – Supports Telegram's Stand" (letter to the editor). *Toronto Telegram*, 21 Dec. 1932.

Spencer, H. Zella
1929. "A Visit to the Canadian Exhibition of Art." *U.F.A.* (Calgary), 15 Feb. 1929.

Sproatt, H.
1926. "Academy Not Responsible" (letter to the editor). *Toronto Daily Star*, 4 Dec. 1926.

Sproxton, Birk
1980. *Sounds Assembling: The Poetry of Bertram Brooker* (ed.). Winnipeg: Turnstone Press, 1980.

Stacey, Robert
1980. "A Contact in Context: The Influence of Scandinavian Landscape Painting on Canadian Artists before and after 1913." *Northward Journal*, 18/19 (1980), pp. 36–56.

1981. "C.W. Jefferys." *Northward Journal*, 20 (1981), pp. 7–50.

1983. *The Hand Holding the Brush: Self Portraits by Canadian Artists* (exhibition catalogue). London, Ont.: London Regional Art Gallery, 1983.

1986. *Western Sunlight: C.W. Jefferys on the Canadian Prairies* (exhibition catalogue). Saskatoon: Mendel Art Gallery, 1986.

1988. With Liz Wylie. *Eight/Twenty: 100 Years of the Nova Scotia College of Art and Design* (exhibition catalogue). Halifax: Art Gallery of Nova Scotia, 1988.

Stansfield, Herbert H.
1925. "Portraits at the OSA." *Canadian Forum* V:56 (May 1925), pp. 239–42.

Stevens, Mrs. K.
1928. Letter to the editor. *Vancouver Sunday Province*, 19 Aug. 1928, magazine section, p. 10.

Stevenson, O.J.
1927. *A People's Best*. Toronto: Musson, 1927.

Stevenson, R.A.M.
1886. "Art in Canada." *Magazine of Art* IX (Nov. 1886), p. 516–20.

Stoughton, Arthur Alexander
1922. "Winnipeg Art Topics." *Winnipeg Free Press*, 28 Jan. 1922.

Stringer, Arthur
1910. "Arthur Heming Illustrator." *Canadian Courier* VII:18 (2 April 1910), p. 12.

1913. "Arthur Stringer's New York Letter." *Saturday Mirror* (Montreal), 8 March 1913, p. 13.

Student in Arms
1922. "The R.C.A. Exhibition" (letter to the editor). *Montreal Gazette*, 4 Dec. 1922.

Sutnik, Maia-Mari
1989. *Photographs by Charles Macnamara and M.O. Hammond: Pictorial Expressions in Landscape and Portrait* (exhibition catalogue). Essays by Janet Dewan and Martin Hunter. Toronto: Art Gallery of Ontario, 1989.

Swift, S.C.
1922. "Canadian Culture?" (letter to the editor). *Canadian Forum* II:17 (Feb. 1922), pp. 524–25.

Symonds, A.
1929. "Art School Exhibition Shows Lack of True Artistic Feeling." *New Western Tribune* (Vancouver), 29 June 1929.

Tapson, Clarice
1930. "Modernists Big Aid to Real Art, Says Conservative Mr. Grier." *Border Cities Star* (Windsor, Ont.), 2 Dec. 1930.

Taylor, Dorothy G.
1925. "Wembley's Palace of Arts." *New Westminster British Columbian*, 31 Aug. 1925.

1928. "The Art Gallery." *New Westminster British Columbian*, 6 Sept. 1928.

Teitelbaum, Matthew
1991. "Sighting the Single Tree, Sighting the New Found Land." In *Eye of Nature*, ed. by Daina Augaitis and Helga Pakasaar, pp. 71–78. Banff: Walter Phillips Gallery, 1991.

Tenody, K. Janet
1983. "F.H. Varley: Landscapes of the Vancouver Years." Master's thesis, Queen's University, Kingston, Ont., 1983.

The Dean
1927. "A Canadian Art Movement." *Montreal Standard*, 12 Feb. 1927.

Thiébault-Sisson
1927a. "Une exposition d'art canadien au Jeu-de-Paume." *Le Temps* (Paris), 25 March 1927.

1927b. "Art et curiosité." *Le Temps* (Paris), 12 April 1927.

Thom, Ian M.
1981. *Franklin Carmichael Watercolours* (exhibition catalogue). Victoria: Art Gallery of Greater Victoria, 1981.

1984a. *A.J. Casson: Early Works* (exhibition catalogue). Kleinburg, Ont.: McMichael Canadian Art Collection, 1984.

1984b. *Franklin Carmichael: Prints* (exhibition catalogue). Kleinburg, Ont.: McMichael Canadian Art Collection, 1984.

1985. *The Cartoons of Arthur Lismer: A New Angle on*

Canadian Art (exhibition catalogue). Toronto: Irwin Publishing, with the McMichael Canadian Collection, 1985.

1989. *The Prints of Edwin Holgate* (exhibition catalogue). Kleinburg, Ont.: McMichael Canadian Art Collection, 1989.

Thompson, John Herd
1985. With Allan Seager. *Canada 1922–1939: Decades of Discord.* Toronto: McClelland & Stewart, 1985.

Thomson, A.V.
1930. "The Academy Show." *Canadian Forum* X:112 (Jan. 1930), pp. 128–29.

Thomson, Norah
1928. "Illustrated Books That Interpret the Canadian Spirit." *Publishers' Weekly* CXIII:25 (23 June 1928), pp. 2516–20.

Tilney, F.C.
1928. "Prints by J. Vanderpant, F.R.P.S." *Photographic Journal,* June 1928, pp. 243–44.

Tippett, Maria
1974a. "'A Paste Solitaire in a Steel Claw Setting': Emily Carr and Her Public." *B.C. Studies,* 20 (Winter 1973–74), pp. 3–12.
1974b. "Who 'Discovered' Emily Carr?" *Journal of Canadian Art History* I:2 (Fall 1974), pp. 30–34.
1975. "In Reply." *B.C. Studies,* 24 (Winter 1974–75), p. 89.
1977a. "Emily Carr's Klee Wyck." *Canadian Literature,* 72 (Spring 1977), pp. 49–58.
1977b. With Douglas Cole. *From Desolation to Splendour: Changing Perceptions of the British Columbia Landscape.* Toronto: Clarke, Irwin & Co., 1977.
1979. *Emily Carr: A Biography.* Toronto: Oxford University Press, 1979.
1982. With Douglas Cole. *Phillips in Print: The Selected Writings of Walter J. Phillips on Canadian Nature and Art* (ed.). Winnipeg: Manitoba Record Society, 1982.
1984. *Art at the Service of War: Canada, Art and the Great War.* Toronto: University of Toronto Press, 1984.

Tooby, Michael
1991. *Our Home and Native Land: Sheffield's Canadian Artists* (exhibition catalogue). Sheffield: Mappin Art Gallery, 1991.
1992. *The True North: Canadian Landscape Painting 1896–1939* (exhibition catalogue). London: Lund Humphries, with the Barbican Art Gallery, 1992.

Topham, Thurston
1924. "Canadian Art in Britain" (letter to the editor). *Montreal Daily Star,* 6 Dec. 1924.

Town, Harold
1977. With David P. Silcox. *Tom Thomson: The Silence and the Storm.* Toronto: McClelland & Stewart, 1977.

Trant, Patrick
1989. *A Small Tribute to TM.* Thornhill, Ont., 1989.

Traquair, Ramsay
1920. "The Royal Canadian Academy." *Canadian Forum* I:3 (Dec. 1920), pp. 83–85.
1921. "Studio Talk: Montreal." *International Studio* LXXIII:288 (March 1921), pp. 81–82.
1923. "Studio Talk: Montreal." *Studio* LXXXV:361 (April 1923), pp. 236–39.

Trépanier, Esther
1987. "Un nigog lancé dans la mare des arts plastiques." In *Le Nigog* (Archives des lettres canadiennes, Tome VII). Montreal: Éditions Fides, 1987, pp. 239–67.
1989. "Deux portraits de la critique d'art des années vingt: Albert Laberge et Jean Chauvin." *Journal of Canadian Art History* XII:2 (1989), pp. 141–73.
1991. "La peinture et la question du régionalisme dans l'Entre-deux-guerres." *Québec Studies,* 12 (Spring/Summer 1991), pp. 115–26.

Trudel, Jean
1992. "Aux origines du Musée des beaux-arts de Montréal." *Journal of Canadian Art History* XV:1 (1992), pp. 31–62.

Truth
1913. "Primal Academism as Best Name for Futurist School" (letter to the editor). *Montreal Daily Herald,* 29 March 1913.

Tupper, Charles
1887. *Report of Sir Charles Tupper, G.C.M.G., C.B., Executive Commissioner, on the Canadian Section of the Colonial and Indian Exhibition at South Kensington 1886.* Appendix to the Report of the Minister of Agriculture for 1886. Ottawa: MacLean, Roger & Co., 1887.

Turner, Percy Moore
1922. "Painting in Canada." *Canadian Forum* III:27 (Dec. 1922), pp. 82, 84.

Underhill, Frank H.
1936. "False Hair on the Chest." *Saturday Night* LI:48 (3 Oct. 1936), pp. 1, 3.

Usmiani, Renate
1987. "Roy Mitchell: Prophet in Our Past." *Theatre History in Canada* VII:2 (Fall 1987), pp. 147–68.

Van Gogh, Lucy
1933. "The World of Art: 'Canadian Group.'" *Saturday Night* XLIX:4 (2 Dec. 1933), p. 24.

Vanderpant, John
1927. "Appreciates the Art Exhibition." *Vancouver Daily Province,* 18 Aug. 1927, p. 17.
1928a. "Artery." *Paint Box* III (June 1928), pp. 46, 55.
1928b. "Correspondence: Art and Criticism" (letter to the editor). *Vancouver Daily Province,* 17 Aug. 1928.
1928c. "Tradition in Art." *Photographic Journal,* Nov. 1928, pp. 447–51.

Varley, Christopher
1979. *F.H. Varley.* Ottawa: National Gallery of Canada, 1979.
1981. *F.H. Varley: A Centennial Exhibition* (exhibition catalogue). Edmonton: Edmonton Art Gallery, 1981.

Varley, Frederick Horsman
1927a. "Takes Issue with 'Art Notes' on Recent Criticism of Canada's 'Group of Seven'" (letter to the editor). *Vancouver Sun,* 22 March 1927.
1927b. "Room 27 Speaking." *Paint Box* II (June 1927), pp. 23–24.
1928. *Paint Box* III (June 1928), p. 12.

Varley, Peter
1983. *Frederick H. Varley.* Toronto: Key Porter, 1983.

Vaughan, E.
1931. "From One Critic to Another" (letter to the editor). *Vancouver Daily Province,* 13 Sept. 1931.

Veni, Vidi, Fugi
Letter to the editor. *Toronto Telegram,* 4 April 1932.

Venne, Emile
1935. "Peintures de M. A.Y. Jackson." *La Renaissance,* 23 Nov. 1935.

Veritas
1924a. "Canadian Art at Wembley" (letter to the editor). *Montreal Daily Star,* 20 Aug. 1924.
1924b. "Canadian Art at Wembley" (letter to the editor). *Montreal Daily Star,* 2 Dec. 1924.

Vipond, Mary
1974. "National Consciousness in English-Speaking Canada in the 1920's: Seven Studies." Ph.D. diss., University of Toronto, 1974.
1980. "The Nationalist Network: English Canada's Intellectuals and Artists in the 1920s." *Canadian Review of Studies in Nationalism* VII:1 (Spring 1980), pp. 32–52.

Voaden, Herman
1928. "A National Drama League." *Canadian Forum* IX:99 (Dec. 1928), pp. 105–06.
1930. *Six Canadian Plays* (ed.). Toronto: Copp Clark, 1930.
1978. "Wilderness: A Play of the North." *Boréal,* 11/12 (1978), pp. 10–20.

1980. "Towards a Canadian Drama: A View from the Thirties." *Canadian Theatre Review,* Fall 1980, pp. 10–17.
1982. "Symphony: A Drama of Motion and Light for a New Theatre." *Canadian Drama* VIII:1 (1982), pp. 74–83.

Wagner, A.
1983. "'A Country of the Soul': Herman Voaden, Lowrie Warrener and the Writing of *Symphony.*" *Canadian Drama* IX:2 (1983), pp. 203–19.
1984. "Herman Voaden's Symphonic Expressionism." Ph.D. diss., University of Toronto, 1984.
1985. "Herman Voaden's 'New Religion.'" *Theatre History in Canada* VI:2 (Fall 1985), pp. 187–201.
1991. "Herman Voaden and the Group of Seven: Creating a Canadian Imaginative Background in Theatre." *International Journal of Canadian Studies,* 4 (Fall 1991), pp. 145–64.
1993. *A Vision of Canada: Herman Voaden's Dramatic Works* (ed.). Toronto: Simon and Pierre, 1993.

Walker, B.E. [Sir Edmund]
1922. "To the Editor of the Globe: Recent Criticism of National Gallery." *Toronto Globe,* 15 Dec. 1922. Reprinted in *Toronto Mail and Empire,* 19 Dec. 1922; *Saturday Night* XXXVIII:10 (23 Dec. 1922), p. 2, "Canada's National Gallery," with reply by Hector Charlesworth.
1923a. "Only Naming Artists to Act as Judges" (letter to the editor). *Toronto Daily Star,* 11 Sept. 1923.
1923b. "Sir Edmund Walker's Letters re the British Empire Exhibition." *Saturday Night* XXXVIII:45 (22 Sept. 1923), p. 2.

Walker, Doreen
1975. "'Instruction Pour Establir les Manufacture': A Key Document in the Art History of New France." *Journal of Canadian Art History* II:1 (Summer 1975), pp. 1–18.

Walton, Paul H.
1990. "The Group of Seven and Northern Development." *RACAR* XVII:2 (1990), pp. 171–208.
1992. "Beauty My Mistress: Hector Charlesworth as Art Critic." *Journal of Canadian Art History* XV:1 (1992), pp. 84–107.

Watson, Homer
1923. "Canadian Art at British Empire Exhibition" (letter to the editor). *Saturday Night* XXXVIII:47 (6 Oct. 1923), p. 2.

Watson, Jennifer
1982. *Albert H. Robinson: The Mature Years* (exhibition catalogue). Kitchener-Waterloo, Ont.: Kitchener-Waterloo Art Gallery, 1982.
1984. *Carl Ahrens as Printmaker* (exhibition catalogue). Kitchener-Waterloo, Ont.: Kitchener-Waterloo Art Gallery, 1984.

Watson, Scott
1991. "Disfigured Nature: The Origins of the Modern Canadian Landscape." In *Eye of Nature,* ed. by Daina Augaitis and Helga Pakasaar, pp. 103–12. Banff: Walter Phillips Gallery, 1991.
1994. "Race, Wilderness, Territory and the Origins of Modern Canadian Landscape Painting." *Semiotext(e) Canadas* VI:2 (1994), pp. 93–104.

Watson, William R.
1912. "Post-Impressionism." *Montreal Gazette,* 30 March 1912.
1913. "[…] in Local Pictures." *Montreal Gazette,* 16 April 1913.
1922. "On a Portrait in a Spring Art Exhibition." *Montreal Daily Star,* 5 April 1922.

Wayling, Thomas
1930. "'Beothic' Off for North with Party to Study Arctic Flora, Fauna, Eskimo." *Toronto Mail and Empire,* 1 May 1930.

W.C.C.
1926. "Canadian Pictures" (letter to the editor). *Ottawa Journal*, 4 Oct. 1926.
Webber, John E.
1932. "New York Letter." *Saturday Night* XLVII:19 (19 March 1932), p. 12.
Wells, Kenneth
1932a. "Art and Artists." *Toronto Telegram*, 3 Dec. 1932.
1932b. "Art and Artists." *Toronto Telegram*, 17 Dec. 1932.
1932c. "Art and Artists." *Toronto Telegram*, 24 Dec. 1932, p. 7.
1932d. "Art and Artists." *Toronto Telegram*, 31 Dec. 1932.
1933a. "Art and Artists." *Toronto Telegram*, 14 Jan. 1933, p. 7.
1933b. "Art and Artists." *Toronto Telegram*, 6 Feb. 1933.
1933c. "Art and Artists." *Toronto Telegram*, 11 Feb. 1933, p. 5.
1933d "Art and Artists." *Toronto Telegram*, 18 Feb. 1933, p. 14.
1933e. "Art and Artists." *Toronto Telegram*, 25 Feb. 1933, p. 12.
1933f. "Canadian Group of Painters Takes Dominion Bow Here." *Toronto Telegram*, 3 Nov. 1933.
1933g. "Art and Artists." *Toronto Telegram*, 4 Nov. 1933.
1933h. "Art and Artists." *Toronto Telegram*, 25 Nov. 1933.
1933i. "Art and Artists." *Toronto Telegram*, 16 Dec. 1933, p. 5.
1934a. "Art and Artists." *Toronto Telegram*, 3 Feb. 1934.
1934b. "Art and Artists." *Toronto Telegram*, 3 Feb. 1934.
1934c. "Art and Artists." *Toronto Telegram*, 3 March 1934.
W.G.M.
1926. "The Group of Seven Exhibition." *Canadian Bookman* VIII:6 (June 1926), pp. 179–80.
W.H.D.
1920. "Pictures by Canadians." *Boston Transcript*, 15 Dec. 1920, p. 12.
White, William
1985. *Ernest Hemingway, Dateline: Toronto* (ed.). New York: Scribner's, 1985.
W.H.K.
John Inns: Painter of the Canadian West. Vancouver: Rose, Cowan & Latta Ltd., n.d.
Wilkinson, J.
1924. "Canadian Art at Wembley" (letter to the editor). *Saturday Night* XXXIX:29 (7 June 1924), p. 2.
Willard, Reta D.
1927. "Prairie School Memorial to War Heroes Takes Form of Canadian Art Gallery." *Vancouver Daily Province*, 23 Jan. 1927.
Wilson, J.
1926a. "Those Pictures" (letter to the editor). *Ottawa Journal*, 12 March 1926.
1926b. "The Diploma Room" (letter to the editor). *Ottawa Journal*, 20 March 1926.
Wistow, David
1982. *Tom Thomson and the Group of Seven.* Toronto: Art Gallery of Ontario, 1982.
Wood, E.W.
1933. "The National Gallery." *Ottawa Citizen*, 11 March 1933.
Woodcock, George
1980. "Nationalism and the Canadian Genius." *artscanada* XXXVI:4 (Dec. 1979/Jan. 1980), pp. 2–10.
Wrenshall, H.E.
1920a. "A Northland Painter." *Toronto Sunday World*, 22 Feb. 1920.
1920b. "Art Notes." *Toronto Sunday World*, 21 May 1920.
Wrenshall, Irene B.
1914a. "The Field of Art." *Toronto Sunday World*, 8 Feb. 1914, p. 13.
1914b. "The Field of Art." *Toronto Sunday World*, 20 April 1914.
1914c. "Never in European Gallery but He's One of Canada's Great Painters." *Toronto Sunday World*, 7 June 1914, section III, p. 3.
W.S.M.
1924. "Art, Music and Drama." *Varsity* (University of Toronto), 13 Feb. 1924, 2.
Wyte, Florence
1928. "Art and Its Judges" (letter to the editor). *Toronto Mail and Empire*, 29 March 1928.
Zemans, Joyce
1973. "The Art and Weltanschauung of Bertram Brooker." *artscanada* XXX (Feb./March 1973), pp. 65–68.
1986. "The Microcosmic / The Macrocosmic: Arthur Lismer and Lawren Harris." *Vanguard* XV:1 (March 1986), pp. 12–17.
1988. With Elizabeth Burrell and Elizabeth Hunter. *Kathleen Munn, Edna Taçon: New Perspectives on Modernism in Canada* (exhibition catalogue). Toronto: Art Gallery of York University / Éditions du GREF, 1988.
Zillah
1913. "The New Style of Painting" (letter to the editor). *Montreal Daily Witness*, [2] April 1913.

UNATTRIBUTED ARTICLES

1899
Toronto Globe. "Mr. Arthur Heming." 3 June 1899, pp. 1, 4.

1900
Toronto Globe. "Philistines." 16 March 1900.

1907
Canadian Courier. "Canadian Art Progress." II:21 (19 Oct. 1907).

1910
Morning Post (Liverpool). "Royal Canadian Academy." 4 July 1910.
Art Chronicle. "Canadian Art at Liverpool." 30 July 1910, p. 192.
Toronto Globe. "Curator of the National Gallery." 10 Sept. 1910.
Canadian Courier. "Tolstoi and Canada." VIII:26 (26 Nov. 1910), p. 6.

1911
The Lamps. "The Sketch Easel." I:2 (Dec. 1911), p. 12.

1912
Montreal Daily Herald. "Art Show Looks as if the Hanging Show Slept." 15 March 1912.
Owen Sound Sun. "Local Man's Experience in Northern Woods." 27 Sept. 1912.

1913
Toronto Daily Star. "Canvas and Easel, Brush and Pencil." 25 Jan. 1913, p. 6.
Montreal Daily Star. "Montreal Boys Achieve Success with Paintings." 20 Feb. 1913.
Toronto Star Weekly. "Five Canadian Artists Gain Distinction." 8 March 1913.
Montreal Daily Herald. "Futurist Pictures Cause Stir at Spring Art Exhibit." 26 March 1913.
Montreal Daily Witness. "Post Impressionists Shock Local Art Lovers at the Spring Art Exhibition." 26 March 1913.
Montreal Daily Herald. "Artists Divided over 'Art' Shown by the Futurists." 28 March 1913.
Montreal Daily Witness. "Big Crowds at Art Gallery, Cubists' Exhibition Next?" 7 April 1913.
Montreal Daily Witness. "Art Exhibition Soon to Close." 16 April 1913.
Montreal Daily Witness. "Art Exhibition Attracted 28,000." 21 April 1913.
Montreal Daily Witness. "More Post-Impressionism at the Art Gallery." 21 May 1913.
Canadian Courier. "Impressionism in Montreal." XIII:26 (31 May 1913), p. 22.
Toronto Mail and Empire. "Artists Give Sketch to National Gallery." 8 Nov. 1913.
Toronto Daily News. "Artists to Present Picture to Gallery." 8 Nov. 1913.

1914
Toronto Globe. "Chronicles of a Day – Nationalism in Art." 15 Jan. 1914, p. 5.
Canadian Courier. "The New Style in Pictures." XV:11 (14 Feb. 1914), p. 11.
Toronto Daily Star. "Where the Artists Work by Northern Light – Model Studios Will Develop Natural Art." 28 Feb. 1914.
Fort William Daily Times-Journal. "The Very First 'Little Picture Show.'" 14 March 1914, p. 2.
Fort William Daily Times-Journal. "Critic Praises 'Picture Show.'" 21 March 1914, p. 2.
Canadian Courier. "Two Noteworthy Canadian Landscapes." XV:18 (4 April 1914), p. 13.
Toronto Globe. "National Gallery Will Encourage Art." 28 May 1914.
Montreal Daily Star. "Scholarship Is Given to Canada to Promote Arts." 21 July 1914.

1915
Montreal Gazette. "Third Montreal Artist for Front." 29 June 1915.
Saturday Night. "Canadian Artists' Contribution." XVIII:41 (24 July 1915), p.3.
Varsity (University of Toronto). "New Names on Staff of Arts Departments." 4 Oct. 1915, p. 1.

1916
Toronto Mail and Empire. "Ontario Artists Do Daring Work." 11 March 1916, p. 5.
Toronto Daily Star. "The New Schools of Art." 16 March 1916, p. 3.
Canadian Courier. "Painters and Pictures." XIX:16 (18 March 1916), p. 14.
Canadian Courier. "Imagine the Colours in These." IX:17 (25 March 1916), p. 11.

1917
Owen Sound Sun. "Pictures by Sydenham Boy Worth Seeing." 10 April 1917.
Montreal Gazette. "Will Paint Battle Fields in Europe." 4 Sept. 1917.
Saturday Night. "Politicians' Silly Jibes at Painters." XXX:49 (22 Sept. 1917), pp. 1–2.
Toronto Globe. "Erect Cairn to Artist's Memory." 3 Oct. 1917.
Ottawa Citizen. "Speaker Advocates Subsidies to Art." 31 Oct. 1917.
Canadian Courier. "When War Came to Halifax … As Seen by the Artist." XXIII:5 (29 Dec. 1917), pp. 10–11.

1918
The Rebel. "Why Is an Artist?" II:4 (Jan. 1918), pp. 133–35.
Montreal Gazette. "Canadian Artists May Go Overseas." 5 Jan. 1918.
Toronto Daily Star. "Canadian Artists to the Fighting Line." 24 Jan. 1918.
Toronto Star Weekly. "Toronto's New Art Museum at the Historic Old Grange." 20 April 1918, p. 7.
Canadian Courier. "Halifax Rebuilding: Sketches by Arthur Lismer." XXIII:18 (8 June 1918), p. 17.

Saturday Night. "Canadian War Memorials." XXXII:2 (26 Oct. 1918), p. 25.
Christian Science Monitor. "Canadian War Art to Order." 4 Nov. 1918.

1919

The Rebel. "Art and the Undergraduate." III:4 (Feb. 1919), pp. 145–46.
Christian Science Monitor. "Canadian War Memorials Exhibit." 10 Feb. 1919, p. 14.
Edmonton Journal. "Showing Canada's National Gallery by Travelling Exhibition." 24 Feb. 1919.
Toronto Daily News. "Glorious Color Runs Riot in Artists' Work This Year." 7 March 1919, p. 6.
Toronto Telegram. "Noisy Chaos of Color." 8 March 1919.
Toronto Daily Star. "Pictures Rejected, Action Criticized." 26 March 1919, p. 7.
Montreal Gazette. "A Painter of the Wilds." 28 March 1919.
Toronto Daily Star. "Etchings Predominate at Art Exhibition." 3 May 1919, p. 5.
The Equity (Shawville, Que.). "Canadian Art." 29 May 1919.
New York Herald. "Canada's War Art Show Has Lesson for This Country." 8 June 1919.
Art Quarterly (Milwaukee Art Institute). "May and June Canadian Collection." 13 (July 1919), p. 11.
Saturday Night. "Appertaining to Rev. Salem G. Bland." XXXII:38 (5 July 1919), p. 1.
Montreal Gazette. "War Pictures May Evoke Criticism." 16 July 1919.
Toronto Daily Star. "The Canadian National Exhibition Poster Is Now Being Distributed." 21 July 1919.
Saturday Night. "Canada's War Memorial Pictures Which Will be Shown at the Canadian National Exhibition at Toronto." XXXII:43 (9 Aug. 1919), p. 25.
Toronto Globe. "Notes and Comments." 1 Sept. 1919, p. 6.
Canadian Courier. "Editorial." XXIV:25 (13 Sept. 1919), p. 10.
Canadian Bookman. "Art and War Memorials." I:3 (Oct. 1919), p. 40.
The Rebel. "Editorial." IV:1 (Oct. 1919), p. 3.
Montreal Daily Herald. "Finest Pictures of the Great War Are on Exhibit in the Canadian War Memorial." 15 Nov. 1919.
Toronto Daily Star. "Notable Pictures in the Art Exhibition." 20 Nov. 1919.
The Lamps. "Sculpture and the War." Dec. 1919, pp. 83–85.

1920

Canadian Courier. "Canada's Underground Theatre." XXV:7 (3 Jan. 1920), p. 18.
Montreal Gazette. "Sounds like Talk of Vexed Artist." 9 Jan. 1920.
Varsity (University of Toronto). "Weird and Beautiful Pictures Adorn Walls." 28 Jan. 1920, p. 1.
The Rebel. "Editorial: A Conjecture regarding Canadian Art." IV:5 (Feb. 1920), pp. 185–86.
Toronto Daily Star. "Memorial Exhibition to Artist of North." 18 Feb. 1920.
Montreal Gazette. "Govt. Buys Six Can. Paintings." [10] April 1920.
Saturday Night. "Carl Ahrens Leaving Canada." XXXIV:31 (15 May 1920), p. 3.
Canadian Theosophist. Obituary of Flora M. Denison. I:5 (15 July 1920), p. 77.
Toronto Sunday World. "New War Pictures for Toronto Fair." 14 Aug. 1920.
Canadian Courier. "Editorial: More Canadian War Pictures." XXV:23 (15 Aug. 1920), p. 7.
Toronto Star Weekly. "More Shocks in Store for Ordinary Folk at 'Ex' Art Gallery." 28 Aug. 1920.

Toronto Daily Star. "Canada Leads in War Memorial Paintings." 30 Aug. 1920.
Toronto Sunday World. "Canadian War Memorial Paintings at Exhibition." 5 Sept. 1920.
Vancouver Daily Province. "Formation of Art School Planned." 19 Sept. 1920.
Montreal Daily Herald. "Canadian War Art Exhibition." 25 Sept. 1920.
Canadian Forum. Editorial. I:1 (Oct. 1920), p. 3.
Ottawa Citizen. "Canadian Art and National Gallery." 2 Oct. 1920.
Montreal Daily Herald. "Art Gallery's War Pictures Artistic Treat to Visitors." 9 Oct. 1920.
Montreal Gazette. "To Study in Paris." 29 Oct. 1920.
Canadian Forum. Editorial. I:2 (Nov. 1920), p. 37.
Montreal Herald Illustrated. "Royal Canadian Academy Forty-second Exhibition." 19 Nov. 1920.
Canadian Forum. "Editorial." I:3 (Dec. 1920), p. 69.
Toronto Daily Star. "Cities of Canada See Good Pictures." 4 Dec. 1920, p. 25.
Boston Post. "Canadian Painters Exhibit at Museum." 6 Dec. 1920.

1921

Canadian Forum. Editorial. I:4 (Jan. 1921), p. 101.
Fort William Daily Times-Journal. "Canadian Artists Show Their Pictures Here." 7 Jan. 1921, p. 1.
Toronto Globe. "Sarnia Women Start Museum with War Fund." 10 Jan. 1921.
Fort William Daily Times-Journal. "The Public Library and National Art." 12 Jan. 1921, p. 2.
Fort William Daily Times-Journal. "Nature on Canvas at Art Show in Library." 15 Jan. 1921, p. 3.
Fort William Daily Times-Journal. "Canadian Artists." 18 Jan. 1921, p. 4.
Montreal Gazette. "Public Profession of Artistic Faith." 18 Jan. 1921, p. 5.
Edmonton Bulletin. " 'Group of Seven' Newest Movement in Canadian Art." 4 March 1921, p. 4.
Blade (Toledo, Ohio). "Canadian Art Is Exhibited." 5 March 1921.
Times (Toledo, Ohio). "News of the Art World." 6 March 1921.
Edmonton Bulletin. "Art Exhibition Opens To-day in MacKay Avenue School – Large Number of Exhibitors." 28 March 1921, p. 4.
Edmonton Journal. "As I Was Saying." 2 April 1921.
Montreal Gazette. "Art Mission of National Art Gallery." 19 April 1921.
Winnipeg Tribune. "Modern Canadian Painting Equal to World's Best, Says Director of Art Gallery." 11 June 1921.
Canadian Theosophist. "A Comrade Passes." II:4 (15 June 1921), pp. 57–58.
Regina Leader. "School of Art in Canada Has High Standard." 15 June 1921.
Victoria Daily Colonist. "Work of National Gallery of Canada." 19 June 1921.
Vancouver Daily World. "Director Lauds Modern School." 21 June 1921.
Vancouver Daily Province. "National Art Is Evolving." 21 June 1921.
Vancouver Daily Province. "By the Way in Art." 25 June 1921.
Victoria Daily Colonist. "Have Painters but Lack Appreciation." 26 June 1921.
La Patrie (Montreal). "Directeur de la Galerie des arts." 24 Aug. 1921.
Toronto Mail and Empire. "Canadian Art in the West." 3 Sept. 1921, p. 18.
Buffalo Express. "Three New Exhibits at the Gallery." 10 Sept. 1921.
Buffalo Courier. "Albright Gallery Opens New Exhibit." 11 Sept. 1921.

Ottawa Citizen. "The Promise of Canadian Art." 14 Sept. 1921.
Buffalo Evening News. "Art." 24 Sept. 1921.
Ottawa Evening Citizen. "Art and Common Life." 4 Oct. 1921.
Saturday Night. "Francis H. Johnston, A.R.C.A., O.S.A." XXXVI:49 (8 Oct. 1921), p. 3.
Winnipeg Tribune. "Leader of 'Free' Artists Exhibits Painting in Winnipeg Gallery." 15 Oct. 1921.
Winnipeg Free Press. "Winnipeg's Aid to Canadian Art." [17] Oct. 1921.
Bulletin of the Minneapolis Institute of Arts. "Exhibition of Canadian Paintings." X:9 (Dec. 1921), p. 70.

1922

Academy Notes (Buffalo). "The 'Group of Seven' Canadian Paintings." XVII:1 (Jan.–June 1922), pp. 39–41.
Varsity (University of Toronto). "Art Collection for Hart House." 11 Jan. 1922, p. 1.
Winnipeg Community Builder. "Many Splendid Pictures in Johnston Exhibit." 11 Jan. 1922.
Muskegon Chronicle. "Hackley Art Gallery." 14 Jan. 1922.
Academy Notes (Buffalo). " 'The Group of Seven' Canadian Paintings." XVII:1 (Jan.–June 1922), pp. 39–41.
Canadian Forum. Editorial. II:17 (Feb. 1922), p. 516.
Winnipeg Free Press. "Art Gallery Notes." 18 Feb. 1922.
Ottawa Journal. "Fine Pictures Added to National Gallery." 18 Feb. 1922.
Ottawa Citizen. "A Canadian Artist." 22 Feb. 1922.
Peterborough Examiner. "Exhibition of Group of Seven Holds Interest." 6 March 1922.
Toronto Telegram. "Says Schools of Art Are But an Abomination." 11 March 1922.
Montreal Daily Herald. "Canadian School Is Well Represented at the Art Exhibition." 25 March 1922.
Montreal Daily Herald. "The Story and Origin of Art Exhibits in Montreal." 25 March 1922.
Ottawa Citizen. "Criticism of National Gallery." 30 April 1922.
Canadian Forum. Editorial. II:20 (May 1922), p. 614.
Canadian Farmer (Toronto). Editorial. 27 May 1922.
Toronto Sunday World. "The Group of Seven." 28 May 1922, p. 3.
Toronto Telegram. "Hart House Players Please in 'The Tempest' Convocation Week." 7 June 1922.
London Advertiser (Ont.). "Pictures Delight Art Lovers at Western Fair." 13 Sept. 1922.
Victoria Daily Colonist. "Group of Seven Attracts Artists." 22 Sept. 1922.
Canadian Forum. "A Mood of Georgian Bay." III:25 (Oct. 1922), p. 15.
Toronto Globe. "Candid Critic Talks of Art." 9 Nov. 1922.
Varsity (University of Toronto). "Hart House Pictures." 24 Nov. 1922, p. 2.
Montreal Gazette. "Tree Branch like Stick of Licorice." 24 Nov. 1922.
Montreal Gazette. "The R.C.A. Exhibition." 4 Dec. 1922.
Regina Daily Post. "New Paintings for Canadian Gallery." 5 Dec. 1922.
Montreal Gazette. "The Art Gallery Sunday Opening." 8 Dec. 1922.
Winnipeg Free Press. "Frank H. Johnston Exhibition One of Year's Local Art Events." 9 Dec. 1922.
Montreal Standard. "New Editors for Art Committee." 9 Dec. 1922.
Montreal Gazette. "Balaam among the Pictures." 15 Dec. 1922.
Ottawa Evening Journal. "The National Gallery." 16 Dec. 1922.
Vancouver Daily Province. "By the Way in Art." 18 Dec. 1922.

Edmonton Journal. "The National Art Gallery."
22 Dec. 1922.
Calgary Herald. "National Gallery." 23 Dec. 1922.
Hamilton Spectator. "An Art Debate." 28 Dec. 1922.

1923
Ottawa Citizen. "Add New Trustees National Gallery."
3 Jan. 1923.
[*Sarnia Observer.*] "Sarnia Paintings Warmly Praised by
Canadian Artist." 6 March 1923.
Toronto Telegram. "Tonic in O.S.A. Pictures."
10 March 1923.
Sarnia Observer. "Art Exhibition Opens Tomorrow
Public Library." 23 March 1923.
Saturday Night. "Notes of Gallery and Studio."
XXXVIII:26 (5 May 1923), p. 2.
Montreal Gazette. "Canadian Artist at Paris." 9 May 1923.
Montreal Gazette. "Canadian Artists Asked to Exhibit."
10 May 1923.
La Patrie (Montreal). "Les artistes canadiens appelés à
exposer leurs œuvres à l'exposition de Londres."
11 May 1923.
The Hook (Vancouver). "Who Are These Pictures for
Anyway?" 25 May 1923.
Victoria Daily Colonist. "A Canadian Artist." 29 May 1923.
Canadian Forum. "The New Cover." V:6 (June 1923),
p. 152.
Ottawa Citizen. "Canadian Artists' Opportunity."
7 June 1923.
Toronto Daily Star. "Group of Seven Are Invited to
States." 30 June 1923.
Toronto Globe. "Nice Display of Art Is Seen This
Season At Exhibition Rooms." 31 Aug. 1923, p. 12.
Ottawa Citizen. "National Gallery and the Academy
Are at Variance." 4 Sept. 1923, p. 3.
Ottawa Citizen. "R.C.A. Circular Is Inexact, Trustees of
Gallery State." 5 Sept. 1923.
Toronto Sunday World. "War of Canada's Artists Leads
to Threat of British Empire Exhibition Boycott."
23 Sept. 1923, pp. 1, 2.
Montreal Gazette. "Canadian Pictures." 24 Sept. 1923.
Toronto Daily Star. "Ask Canada's Artists to Support
Exhibition." 27 Sept. 1923.
Ottawa Citizen. "Appeal to Artists' Loyalty."
28 Sept. 1923.
Montreal Gazette. "Canadian Art at the Empire
Exhibition." 28 Sept. 1923.
Vancouver Daily World. "The World's Window." 28 Sept.
1923, p. 4.
Toronto Daily Star. "Royal Canadian Academy of Arts."
29 Sept. 1923.
Winnipeg Free Press. "Canadian Artists and the Empire
Exhibition." 29 Sept. 1923.
Toronto Sunday World. "Canadian Artists in Battle Array:
Issue between Toronto and Montreal." 30 Sept. 1923.
Toronto Sunday World. "Montrealers Hysterical Is
Toronto View." 30 Sept. 1923.
Montreal Gazette. "Canadian Art and the Empire
Exhibition." 1 Oct. 1923.
Saturday Night. "Canadian Art at British Empire
Exhibition." XXXVIII:47 (6 Oct. 1923), p. 2.
Toronto Sunday World. "Expose by Sunday World of
Boycott Threat Rouses Ire of Academy Die-Hards."
7 Oct. 1923, pp. 1, 3.
Varsity (University of Toronto). "Mr. Varley Will
Begin Classes in Art Monday." 26 Oct. 1923, p. 1.
Bulletin of the Minneapolis Institute of Arts. "Canadian
Painting Exhibition." XII:8 (Nov. 1923), pp. 59–60.
Minneapolis Journal. "Definite Aim in Canadian Group."
11 Nov. 1923.
Toronto Telegram. "Academy and Freak 'Art.'" 22 Nov. 1923.
Toronto Globe. "First and Second Awards Won in
Painting Contest by MacDonald and Varley."
24 Nov. 1923.

Vancouver World. "Blow at Local Artists." 26 Nov. 1923.
Toronto Telegram. "Group of Seven Triumphs."
30 Nov. 1923.
Montreal Daily Star. "Quebec Will Not Enter Plans for
Laurier Statue." 30 Nov. 1923.
Toronto Globe. "Innovations in a City Church."
15 Dec. 1923.
Toronto Globe. "Church Eulogized, Rector Is Praised, at
Fine Reopening." 17 Dec. 1923.

1924
Canadian Forum. Editorial. IV:40 (Jan. 1924),
pp. 102–03.
Toronto Star Weekly. "Canada Has Given Birth to a New
and National Art." 26 Jan. 1924.
Varsity (University of Toronto). "Art, Music and
Drama." 31 Jan. 1924, p. 2.
Varsity (University of Toronto). "The Ottawa Group."
4 Feb. 1924, p. 2.
Canadian Forum. Editorial. IV:42 (March 1924), p. 165.
Ottawa Citizen. "Group of Seven Exhibitions." 1 March
1924, p. 7.
Edmonton Gateway. "To Make Portrait of Chancellor."
4 March 1924, p. 1.
Hamilton Spectator. "Ontario Art." 13 March 1924.
Edmonton Morning Bulletin. "Art Is Defined by Lecturer."
27 March 1924.
Edmonton Journal. "Sees Vision of Golden Age of
Expression on the Horizon." 27 March 1924.
Canadian Farmer (Toronto). "What Do You Think?"
29 March 1924.
Morning Post (London). "Palace of Arts."
22 April 1924.
Montreal Standard. "Canadian Artists at Wembley."
26 April 1924.
Hamilton Spectator. "Canadian Artist." 6 May 1924.
Times (London). "Palace of Arts." 6 May 1924.
Edmonton Gateway. "Portrait of Chancellor Stuart to Be
Presented." XIV:21 (14 May 1924).
Hamilton Spectator. "Praises Canadian Art."
14 May 1924.
Canadian Theosophist. "Canadian Art." V:3 (15 May
1924), p. 46.
Ottawa Citizen. "Canadian Art at Wembley."
17 May 1924.
Ottawa Morning Journal. "Say That Criticisms without
Foundation." 20 May 1924.
Ottawa Journal. "Canadian Art." 21 May 1924.
Toronto Daily Star. "Exhibit at Wembley Not a
Restricted One." 21 May 1924.
Times (London). "Empire Art at Wembley, Dominion
Contrasts." 28 May 1924.
Toronto Telegram. "Uphold Canadian Artists."
30 May 1924.
Toronto Mail and Empire. "Canadian Art Exhibit
Belittled by Canadian." 31 May 1924.
Saturday Review (London). "The Palace of Arts at
Wembley." 31 May 1924.
Art News. "Canadian Pictures." XXII:34 (31 May 1924),
p. 10.
Canadian Forum. Editorial. IV:45 (June 1924),
pp. 260–61.
New York Evening Post. "Canadian Artists Show Work in
Exhibition at Museum – Notes of the Art Galleries."
7 June 1924, section 5, p. 7.
New York Times Magazine. "The World of Art." 8 June
1924, pp. 12–13.
Montreal Daily Star. "British Praise Canadian Artists."
10 June 1924.
Saturday Night. "Portrait of Dr. Daniel McIntyre."
XXXIX:32 (28 June 1924), p. 12.
Brooklyn Museum Quarterly. "Group Exhibition of
Paintings by Contemporary Canadian Artists." XI:3
(July 1924), pp. 104–08.

Toronto Daily Star. "Says Paintings from Canada Are
Most Vital of Century." 5 July 1924.
Ottawa Journal. "British Critics Praise Highly Canada's
Art Exhibits at Wembley." 16 July 1924.
Montreal Gazette. "Favors Revision of Canada's Art."
18 Aug. 1924.
Toronto Daily Star. "Canadian 'Art.'" 20 Aug. 1924, p. 6.
Toronto Sunday World. "Canada Rightly Proud of Her
Younger Artists." 31 Aug. 1924.
Canadian Bookman. "Sarnia's Collection of Canadian
Paintings: Reactions to a Show." VI:9 (Sept. 1924),
p. 201.
Canadian Forum. "The 'Seven' and the 'Star.'" IV:48
(Sept. 1924), pp. 358–59.
Toronto Daily Star. "Art, Science and Critics." 4 Sept.
1924, p. 6.
Canadian Forum. "The Seven and the Star." V:49 (Oct.
1924), pp. 5–6.
Toronto Star Weekly. "One Canadian Artist Deserts
Extremist 'School of Seven.'" 5 Oct. 1924.
Toronto Star Weekly. "Johnston Never Member of the
Group of Seven." 11 Oct. 1924.
Barrie Observer. "A.Y. Jackson, the Canadian Artist
Mounts to Fame." 24 Oct. 1924.
Toronto Daily Star. "Once Painted Designs on Tomato
Can Labels." 25 Oct. 1924.
Edmonton Journal. "Rare Treat Awaits Public in
Collection of Pictures on Exhibition in Macdonald."
30 Oct. 1924.
Toronto Globe. "Claims Distinction for Art of Canada."
4 Nov. 1924.
Toronto Telegram. "O.S.A. Show Not Dead One."
8 Nov. 1924.
Leicester Mail. "Canadian Pictures." 12 Nov. 1924.
Winnipeg Free Press. "The Art of Canada."
20 Nov. 1924.
Ottawa Journal. "Royal Arts Academy." 20 Nov. 1924.
Ottawa Journal. "National Atmosphere Produced in
the Paintings at the Academy: Opening Night
Brilliant Occasion." 21 Nov. 1924.
Ottawa [Citizen]. "Royal Canadian Academy Opens at
the National Gallery Here." 21 Nov. 1924.
Ottawa Journal. "Progress in Art." 25 Nov. 1924.
Canadian Forum. "A 'Jackson' in the National Gallery."
V:51 (Dec. 1924), p. 70.
Toronto Telegram. "British Art Leads World Says K.K.
Forbes." 9 Dec. 1924.
Glasgow Bulletin. "Canadian Art." 29 Dec. 1924.

1925
Birmingham Daily Mail. "Fine Exhibition at
Birmingham Art Gallery." [Jan. 1925.]
Canadian Bookman. "The Small Picture Show." VII:1
(Jan. 1925), p. 16.
Canadian Forum. "The 'Group of Seven' Exhibits."
V:52 (Jan. 1925), p. 102.
Toronto Telegram. "Back to Intelligibility." 12 Jan. 1925.
Birmingham Gazette. "Canadian Art." 30 Jan. 1925.
Sarnia Observer. "Famous Picture Owned in Sarnia
Goes to England." 31 Jan. 1925.
Toronto Daily Star. "If Cow Can Stay in Parlor Then
Why Can't Bull Moose?" 26 Feb. 1925, p. 29.
Toronto Daily Star. "Empire Club Hears Views of Two
Artists on Art." 26 Feb. 1925, p. 1.
Toronto Daily Star. "Must Study Figure to Develop Art
– Grier." 26 Feb. 1925, p. 29.
Toronto Telegram. "Advice to Group of Seven."
27 Feb. 1925.
Toronto Globe. "Opposing Views on Art Are Heard by
Empire Club." 27 Feb. 1925.
Toronto Mail and Empire. "Rival Schools of Art Stoutly
Championed." 27 Feb. 1925.
Standard (Kingston, Ont.). "Buying Canadian
Pictures." 3 March 1925.

La Presse (Montreal). "Au pays du Temlaham." 28 March 1925.

Toronto Daily Star. "Star Opens Relief Fund to Help Miners' Families." 30 March 1925, p. 1.

London Advertiser (Ont.). Review of exhibition. 4 April 1925.

Montreal Daily Star. "Describe Indians." 6 April 1925.

La Presse (Montreal). "L'exposition de l'œuvre de H. L. Kihn." 6 April 1925.

Sunday Times (London). "Art at Wembley." 10 May 1925.

Winnipeg Free Press. "Canadian Pictures at Wembley Show." 23 May 1925.

Ottawa Journal. "Canadian Art." 25 May 1925.

Ottawa Citizen. "Snow in Canadian Art." 30 May 1925.

Journal, Royal Architectural Institute of Canada. II:3 (May–June 1925), p. 82.

Saturday Night. "What Is the Matter with Wembley?" XL:36 (25 July 1925), p. 1.

Canadian Forum. "Canadian Pictures at Wembley." V:60 (Sept. 1925), p. 357.

Vancouver Daily Province. "Art School to Be Opened Thursday." 30 Sept. 1925.

Vancouver Sun. "New Arts School Begins Activity." 2 Oct. 1925.

Vancouver Sun. "Art for Vancouver." 15 Nov. 1925.

Varsity (University of Toronto). "Rural Quebec Has Artistic Interests Unique in Canada." 18 Nov. 1925, p. 1.

Times (London). "Art Exhibitions: Canadian Landscapes at Whitechapel." 25 Nov. 1925.

Montreal Gazette. "Showing Works by Canadian Artists." 5 Dec. 1925.

1926

Canadian Bookman. "Canadian Art in the U.S." VIII:1 (Jan. 1926), p. 33.

Canadian Forum. "The Chronicles of a Contented Man" (review of *Candid Chronicles* by Hector Charlesworth). VI:64 (Jan. 1926), pp. 120–21.

Willison's Monthly. "MacTavish's History of the Fine Arts in Canada." I:8 (Jan. 1926), p. 291.

Guelph Mercury. "Fine Painting Is Unveiled at O.A. College." 9 Jan. 1926.

Toronto Globe. "Generous Gift by Citizen Perpetuates Memory of Son." 16 Jan. 1926, p. 13.

Toronto Daily Star. "Variety Marks Display of Canadian Paintings." 21 Jan. 1926, p. 32.

Canadian Forum. "A Great Show." VI:65 (Feb. 1926), p. 137.

Toronto Daily Star. "Tom Thomson's Aged Father Typifies Son's Rugged Scenes." 4 Feb. 1926.

Toronto Mail and Empire. "Fine Canadian Canvas for the Art Gallery." 10 Feb. 1926.

Collingwood News (Ont.). "Tribute to Tom Thomson, Artist." 20 Feb. 1926.

Ottawa Journal. "Forward Protest Toronto Paintings." 23 Feb. 1926.

Bury Guardian (England). "Canadian Art." 27 Feb. 1926.

Vancouver Daily Province. "Vancouver's Art School Trains Latent Talent of Youth of City." 27 Feb. 1926, p. 3.

Canadian Bookman. "Activities in the Art Gallery of Toronto." VIII:3 (March 1926), p. 92.

Toronto Telegram. "O.S.A. Opens in Gallery." 5 March 1926.

Barrie Examiner. "The Development of Canadian Art." 11 March 1926.

Ottawa Citizen. "Blazing Trails in Art." 17 March 1926.

Montreal Daily Star. "French Influence on Canadian Art." 23 March 1926.

Montreal Daily Star. "Schools of Art and Architecture in Early Period of Canada." 23 March 1926.

Montreal Gazette. "Private View Held at Art Exhibition." 27 March 1926.

Quality Street (Toronto). "Paris – The Magnet." April 1926, pp. 9–10, 24.

Mail and Empire. "Folk Songs Found in French Canada." 14 May 1926.

Toronto Telegram. "Ancient School of Art." 15 May 1926.

Toronto Telegram. "Does Lawren Harris Dip His Brush in the Crucible That Forms Canada?" 29 May 1926.

Canadian Forum. "Art in French Canada." VI:69 (June 1926), pp. 265–66.

Manchester Guardian. Review of *The Fine Arts in Canada* by Newton MacTavish. 14 June 1926.

World Wide (Montreal). "Canadian Artists Target of Criticism." 19 June 1926.

Canadian Forum. "Books" (includes review of *The Fine Arts in Canada* by Newton MacTavish). VI:70 (July 1926), pp. 312–13.

Canadian Bookman. "Impressions of Canadian Art." VIII:7 (July 1926), p. 220.

Times Literary Supplement. "Art in Canada" (review of *The Fine Arts in Canada* by Newton MacTavish). 15 July 1926.

Yorkshire Post. "Canadian Art at the Bradford Gallery." 23 July 1926.

Yorkshire Observer. "Canadian Art: Exhibition at Cartwright Hall." 23 July 1926.

Vancouver Sun. "Accepts Post as Painting Teacher." 31 July 1926.

Canadian Bookman. "Some Notes on Art." VIII:8 (Aug. 1926), p. 256.

Spectator (London). Review of *The Fine Arts in Canada* by Newton MacTavish. 13 Aug. 1926.

Connoisseur. "The Connoisseur Bookshelf" (review of *The Fine Arts in Canada* by Newton MacTavish). LXXVI:301 (Sept. 1926), pp. 51–52.

Canadian Bookman. "The Art Gallery at the Canadian National Exhibition." VIII:9 (Sept. 1926), p. 283.

Toronto Telegram. "Diwan Visits Gallery." 1 Sept. 1926.

Manchester City News. "Canadian Pictures." 4 Sept. 1926.

Toronto Daily Star. "Mr. F.H. Varley." 4 Sept. 1926.

Canadian Bookman. "The Critics on Canadian Art." VIII:10 (Oct. 1926), pp. 302–03.

Ottawa Journal. "Canadian Art Abroad." 1 Oct. 1926.

Vancouver Daily Province. "Indian Literature Is Lecture Theme." 23 Oct. 1926.

Toronto Daily Star. "Low-Tone Tyranny Gone from Academy." 19 Nov. 1926.

Toronto Daily Star. "Hanging Committee Sits in Judgement in Toronto." 20 Nov. 1926, p. 5.

Toronto Daily Star. "Painters Demand the Head of Art Dictator of Canada." 20 Nov. 1926, p. 15.

Vancouver Sun. "School of Art Needed." 27 Nov. 1926.

Toronto Telegram. "Support Good Artists." 27 Nov. 1926, p. 27.

Toronto Daily Star. "Criticism of Art Director Is Effectively Disposed Of." 1 Dec. 1926.

Toronto Daily Star. "New Volume Vigorously Champions Group of Seven." 11 Dec. 1926, p. 27.

Toronto Daily Star. "Paint Canada's History upon Walls of School Is Proposed by Artist." 13 Dec. 1926.

Toronto Mail and Empire. "Adventurers in Art Stand by Their Guns." 14 Dec. 1926.

Vancouver Sun. "Eulogizes New School of Artists." 15 Dec. 1926.

Vancouver Daily Province. "Significance of Art, Lecture Theme." 15 Dec. 1926.

Vancouver Star. "Victorian Art Depreciated in Varley Lecture." 15 Dec. 1926.

1927

Canadian Bookman. "A Canadian Art Movement" (review of *A Canadian Art Movement* by F.B. Housser). IX:1 (Jan. 1927), p. 16.

Canadian Bookman. "Lismer at the Canadian Club." IX:1 (Jan. 1927), p. 11.

Canadian Bookman. "The R.C.A." IX:1 (Jan. 1927), p. 11.

Winnipeg Free Press. "Canada's Art Academy Exhibits." 11 Jan. 1927.

Canadian Theosophist. "Fellows and Friends" (review of *A Canadian Art Movement* by F.B. Housser). VII:11 (15 Jan. 1927), p. 239.

Halifax Chronicle. "Brilliant Gathering at Art Exhibit." 15 Jan. 1927.

Montreal Daily Herald. "Newest Canadian Art Movement Reveals Strength" (review of *A Canadian Art Movement* by F.B. Housser). 21 Jan. 1927.

Ottawa Journal. "Literature and Life: A Booklovers' Corner" (review of *A Canadian Art Movement* by F.B. Housser). 29 Jan. 1927, p. 19.

Toronto Daily Star. "Many Painters Study Music as the Art of Democracy." 29 Jan. 1927, p. 7.

Canadian Bookman. "Art Galleries." IX:2 (Feb. 1927), p. 45.

Toronto Daily Star. "New Young Toronto Artist Paints Subjective Group." 5 Feb. 1927, p. 8.

Varsity (University of Toronto). "Absence of Creed Is Mark of Artist." 11 Feb. 1927, pp. 1, 4.

Rochester Democrat and Chronicle and Rochester Herald. "Exhibitions at Art Gallery and Mechanics' Institute." 13 Feb. 1927.

Rochester Democrat and Chronicle and Rochester Herald. "Art Exhibits Now on View Have Exceptional Interest." 20 Feb. 1927.

Toronto Telegram. "R.C.A. Protests Modern Choices for Paris Show." 21 Feb. 1927.

Toronto Daily Star. "Ottawa Artists to Protest the Selection of Pictures." 24 Feb. 1927.

Rochester Times-Union. "Canadian Portrays Desolation." 25 Feb. 1927.

Ottawa Journal. "Declares No Group of Seven Can Represent Art of Country." 25 Feb. 1927.

Ottawa Journal. "Names One Great Canadian Missing from List and Artists Wondering Why." 25 Feb. 1927.

Toronto Telegram. "Evolution and Revolution at Annual O.S.A. Exhibition." 5 March 1927.

Winnipeg Free Press. "Art for Mercy's Sake!" 8 March 1927.

Times (Toledo, Ohio). "Mountain Canvas on Exhibit at Museum." 13 March 1927.

Toronto Telegram. "Ontario Society of Artists in Their Fifty-fifth Exhibition Reveal Distinct Art Groups." 18 March 1927.

Toronto Daily Star. "Paintings of Nudes Consigned to Cellar." 4 April 1927.

Rappel (Paris). "Dans les galeries." 12 April 1927.

Intransigeant (Paris). "M. Doumergue inaugure l'exposition canadienne." 12 April 1927.

Toronto Globe. "Have We a New Art?" 14 April 1927.

Comoedia (Paris). "À propos de l'exposition des Canadiens." 16 April 1927.

Toronto Telegram. "Lawren Harris, of the School of Seven." 22 April 1927.

Halifax Daily Star. "Canadian Art in Paris." 25 April 1927.

Canadian Bookman. "Classifying Canadian Art." IX:5 (May 1927), p. 137.

Canadian Homes and Gardens. "Summer Home of Horne Russell, P.R.C.A." IV:5 (May 1927).

Toronto Daily Star. "Author of Canadian Art Places Canada Art First." 14 May 1927.

The Paintbox. "Editorial." II (June 1927), p. 5.

Canadian Bookman. "Art." IX:6 (June 1927), p. 184.

Sault Ste. Marie Star. "Canadian Artists Exhibit Widely." 2 June 1927.

Vancouver Daily Province. "Modern Note Is Dominant at Art Show." 12 June 1927.

Standard (St. Catharines, Ont.). "Canadian Painting Has Been Purchased for Luxembourg." 14 June 1927.

Canadian Bookman. "Art: Artist-Explorer." IX:7 (July 1927), p. 216.

Winnipeg Free Press. "To Paint Arctic Scenes." 5 July 1927.

Toronto Globe. "Retires from Post in College of Art." 6 July 1927.

Toronto Mail and Empire. "Call of the North Strong This Year." 11 July 1927.

Telegram (St. John's, Nfld.). "Artist Seeks New Inspiration in Polar Regions." 18 July 1927. Reprinted in *Regina Post*, 30 July 1927.

Edmonton Journal. "Canadian Artists' Work Is Exhibited." 19 July 1927.

Toronto Telegram. "Charming Studies Arrest Eye in 'Ex' Art Galleries." 27 Aug. 1927.

Toronto Daily Star. "C.N.E. Pictures This Year Galaxy of High Average." 27 Aug. 1927, p. 3.

Toronto Telegram. "Line-up Crowds Art Gallery Many Pictures Are Sold." 6 Sept. 1927.

Toronto Mail and Empire. "Pictures, Good and Bad." 9 Sept. 1927.

Toronto Daily Star. "Pictures on Exhibit Are Being Purchased." 10 Sept. 1927.

Montreal Daily Star. "Montreal Dubbed Most Bigoted City by Toronto Artist." 13 Sept. 1927.

Toronto Daily Star. "Stupid Slander Is Reply to Criticism at Montreal." 13 Sept. 1927, p. 27.

Vancouver Star. "Citizens Urged to Continue Efforts for Art Gallery." 14 Sept. 1927.

Toronto Globe. "Bertram Forsyth, Theatrical Artist, Dies in New York." 17 Sept. 1927, p. 1.

Toronto Daily Star. "Far North Sketches Shown at Gallery." 21 Sept. 1927.

Montreal Standard. "Who Bit Mr. Jackson?" 24 Sept. 1927.

Toronto Daily Star. "Says Montreal Appreciates Art but Not the School of Seven 'Art.'" 27 Sept. 1927.

Montreal Gazette. "English Artist Arrives in City." 25 Oct. 1927.

Canadian Forum. "Adventure in Art." VIII:86 (Nov. 1927), p. 424.

Toronto Mail and Empire. "Says Canadian Art Falls Flat in Paris." 2 Nov. 1927.

Toronto Daily Star. "Is Paris 'Arty'? Do Admirals Talk Art? Grave Matters in A.Y. Jackson–Russell Row." 9 Nov. 1927.

Ottawa Citizen. "To Hold Unique Exhibition of Paintings and Handicrafts at National Gallery." 10 Nov. 1927.

Saturday Night. "Canadian Women in the Public Eye: Lilias T. Newton." XLII:52 (12 Nov. 1927), p. 35.

Montreal Daily Star. "Canadian Art Is Power in Home." 21 Nov. 1927.

Montreal Gazette. "Patriotism Aided by Canadian Art." 21 Nov. 1927.

Ottawa Citizen. "Canada Should Listen to Voice of Youth Urges Lecturer on Art of This Country." 22 Nov. 1927.

Montreal Gazette. "Canada Should be Artistically Free." 23 Nov. 1927.

Edmonton Journal. "An Artist and Alberta." 24 Nov. 1927.

Canadian Bookman. "The Art Students' League." IX:12 (Dec. 1927), p. 373.

London Free Press (Ont.). "Group of Seven Hurt by Miss Dick's Scorn." 11 Dec. 1927.

Ottawa Evening Citizen. "Canadian Art Status as Snake in Ireland." 14 Dec. 1927.

Toronto Daily Star. "Big Game Hunter's Thrill Is Explained by Artist." 14 Dec. 1927.

Hamilton Herald. "Group of Seven Are Indignant." 15 Dec. 1927.

1928

Canadian Homes and Gardens. "The Royal Canadian Academy of Arts at Montreal." V:1 (Jan. 1928), pp. 64, 66.

Toronto Daily Star. "Art of B.C. Aborigines Deemed Equal to Aztecs." 9 Jan. 1928.

Ottawa Evening Citizen. "Ottawa's Interest in Art." 9 Jan. 1928.

Toronto Mail and Empire. "Arts Abandoned with Beliefs of Paganism." 11 Jan. 1928.

Toronto Globe. "West Coast Indian Art." 12 Jan. 1928.

Ottawa Morning Journal. "National Gallery Gets Noted Work." 17 Jan. 1928.

Montreal Daily Star. "Toronto Artist Says Canadian Critics Are Doing Little for Art." 17 Jan. 1928.

Montreal Daily Star. "Some Misconceptions." 18 Jan. 1928.

Victoria Daily Colonist. "Indian Art Is Fine Heritage." 25 Jan. 1928.

Toronto Daily Star. "Miss Juliette Gaultier." 25 Jan. 1928, p. 1.

Toronto Daily Star. "Art Gallery Stages Indian, Eskimo Songs." 26 Jan. 1928, p. 9.

Toronto Mail and Empire. "Music in Our Town." 28 Jan. 1928, p. 20.

Canadian Forum. "West Coast Indian Art." VIII:89 (Feb. 1928), p. 525.

Toronto Daily Star. "Captures Vivid Reality in Northern Snow Scenes." 4 Feb. 1928.

Toronto Daily Star. "High Tribute Paid to Group of Seven." 14 Feb. 1928.

Montreal Gazette. "Art of Western Indian Reviewed." 18 Feb. 1928.

Toronto Telegram. "Junk Clutters Art Gallery Walls while Real Paintings Are Hidden in Cellar." 18 Feb. 1928.

Montreal Gazette. "Native Art Makes Fine Exhibition." 22 Feb. 1928.

Toronto Daily Star. "Skies Prove Big Mystery – Mountains Ice Cream Cones." 27 Feb. 1928.

Canadian Forum. "The Canadian Scene." VIII:90 (March 1928), p. 561.

Echoes. "West Coast Indian Art Shown in Various Art Galleries in the Dominion." March 1928, p. 13.

Toronto Telegram. "Variety Marks O.S.A. Annual at Art Gallery." 3 March 1928.

Saskatoon Daily Star. "Art Lovers Flock to View Paintings by 'Group of Seven.'" 4 April 1928.

Montreal Gazette. "By Canadian Artists." 30 April 1928.

Toronto Daily Star. "College of Art Changes." 23 June 1928.

Photographic Journal. "The John J. Vanderpant and J. Harold Leighton Exhibitions." July 1928 [pp. 291–92].

Vancouver Sunday Province. "Canadian Art Represented at Fair." 12 Aug. 1928, p. 20.

Winnipeg Free Press. "The National Gallery." 14 Aug. 1928, p. 5.

Vancouver Daily Province. "The Group of Seven." 15 Aug. 1928, p. 6.

Hamilton Herald. "Group of Seven Pictures." 22 Aug. 1928.

Vancouver Daily Province. "'Group of Seven' Exhibit under Heavy Fire" (letters to the editor from J. Williams Ogden, "Reader," "Observer," and Lionel Haweis). 26 Aug. 1928.

Winnipeg Free Press. "The National Gallery." 5 Sept. 1928.

Montreal Chronicle. "Western Art Critics." 10 Sept. 1928.

Toronto Telegram. "Encouraging Canadian Art." 11 Sept. 1928, p. 6.

Vancouver Morning Star. "The Group of Seven." 11 Sept. 1928.

Buffalo Evening News. "Canadian Exhibit at Art Gallery." 15 Sept. 1928.

Ottawa Morning Citizen. "The Art War on the Coast." 22 Sept. 1928.

Toronto Telegram. "National Gallery Pleads 'Not Guilty' to Charge." 22 Sept. 1928.

Times Globe (Saint John, N.B.). "The Group of Seven." 2 Oct. 1928.

Ottawa Evening Journal. "A Storm over Art." 8 Oct. 1928.

Montreal Gazette. "'Group of Seven' to Be Exhibited." 19 Oct. 1928.

Toronto Mail and Empire. "Warn Edmonton of Toronto Art." 19 Oct. 1928.

Beacon-Herald (Stratford, Ont.). "Artist Learned to Sketch as He Worked as Checker." 20 Oct. 1928.

Toronto Globe. "National Gallery and Group of Seven Will Show Pictures." 20 Oct. 1928, p. 25.

Edmonton Journal. "Many Gems among National Gallery Pictures to Be Seen at Museum of Arts Exhibition." 26 Oct. 1928.

Montreal Standard. "The Group of Seven Again." 27 Oct. 1928.

Toronto Daily Star. "Group of Seven Again Held Up to Ridicule." 3 Nov. 1928.

Toronto Daily Star. "Ontario Artists Travel Far to Get Material for Work." 19 Nov. 1928.

Vancouver Daily Province. "The National Gallery." 28 Nov. 1928.

Toronto Mail and Empire. "Canadian Academy Exhibition Strikes More Modern Note." 30 Nov. 1928, p. 8.

Rochester Democrat and Chronicle. "Paintings of Canadian Artist Group in Art Gallery Exhibit." [Nov. 1928.]

Bulletin (Memorial Art Gallery, Rochester). "The November–December Exhibition." I:2 (Dec. 1928), pp. 3–5.

Calgary Herald. "'Group of Seven' Returns to City." 6 Dec. 1928, p. 12.

1929

Canadian Forum. "Picture Week." IX:100 (Jan. 1929), pp. 114–15.

Beaver, Canada First (Toronto). "Canadian Painters Quit Aping British and Dutch." 3 Jan. 1929.

Calgary Herald. "Art Critic Reviews 'Group of Seven.'" 16 Jan. 1929.

Toronto Telegram. "Canada Shows Fine Spirit in Art." 22 Jan. 1929.

Ottawa Evening Journal. "Exhibition at National Gallery Is One of the Best Ever Held Here." 22 Jan. 1929.

Construction. "The Claridge Apartments, Toronto." XXII:3 (March 1929), pp. 89–96.

Recorder and Times (Brockville, Ont.). "Leading Painter Criticizes Royal Canadian Academy." 4 March 1929.

Toronto Telegram. "Art and Poetry in Building Construction." 26 March 1929.

Canadian Observer. "Holgate Picture Added to Sarnia Art Collection." 12 April 1929.

Toronto Mail and Empire. "Hart House Acquires Tom Thomson Painting." 18 April 1929.

Construction. "The Concourse Building, Toronto." XXII:5 (May 1929), pp. 137–44.

Hamilton Herald. "Group of Seven Lead." 15 May 1929.

Canadian Homes and Gardens. "Rubble Stone in an Early Canadian Design." XI:6 (June 1929), p. 31.

New Western Tribune (Vancouver). "Vancouver Exhibition Owes Debt to 'Group of Seven.'" 29 June 1929.

Canadian National Railways Magazine. "Bring Natives to Make Totems." XV:8 Aug. 1929, p. 45.

Canadian Passing Show (Montreal). "Canadian Artist Adapts Totem Pole as Motive." Aug. 1929, pp. 25–26.

Toronto Telegram. "Found Canada Loyal to Empire." 9 Sept. 1929.

Canadian Homes and Gardens. "A Canadian Interpretation of the Modern Spirit." VI:10 (Oct. 1929), pp. 40–41.

La Revue Populaire. "Le Château Laurier: Le Salon totémique." XXII:10 (Oct. 1929), pp. 55–58.

Montreal Gazette. "R.C.A. President Is E. Wyly Grier." 20 Nov. 1929.
Winnipeg Tribune. "Art and Artists." 23 Nov. 1929.
Canadian Bookman. "Art in Skyscrapers." XI:12 (Dec. 1929), p. 282.
Winnipeg Free Press. "The Arts in Canada." 2 Dec. 1929.
Montreal Gazette. "Canadian Rockies Inspires Painter." 2 Dec. 1929.
Toronto Star Weekly. "Chief of Art Academy Used Father as Model." 21 Dec. 1929.

1930
La Revue Populaire. "Chronique d'art: Le Salon d'automne." XXIII:1 (Jan. 1930), pp. 7–10.
Canadian Forum. "A Prize for a Play." X:112 (Jan. 1930), p. 147.
Vancouver Sun. "B.C. Artists Slighted." 17 Jan. 1930.
Vancouver Sun. "Art Taxation without Representation." 20 Jan. 1930.
Toronto Telegram. "Fifth Display Canadian Art Ready to Show." 23 Jan. 1930. Reprinted in *Toronto Globe,* 24 Jan. 1930, "Canadian Tradition Inspires New Art."
Montreal Daily Star. "Special Showing of Canadian Paintings in American Cities." 27 Jan. 1930.
Toronto Daily Star. "Group of Seven Is Stupid Is Artist's Criticism." 1 Feb. 1930.
Toronto Star Weekly. "Despite Origin's Obscurity Canadian Art Has Arrived." 8 Feb. 1930.
La Revue Populaire. "Chronique d'art" (review of *Yearbook of the Arts in Canada 1928–1929* by B. Brooker). XXIII:3 (March 1930), pp. 12–13.
Toronto Star Weekly. "Dominion's Pioneer Art Organization Is Opening 58th Annual Exhibition on March 7th." 1 March 1930.
Art Digest. "Two Significant Pictures from Canada's Annual Exhibition." IV (1 March 1930), p. 32.
Glasgow Herald. "Canadian Art." 4 March 1930.
Hamilton Herald. "Canadian Art." 5 March 1930.
Toronto Daily Star. "Artists from Canada to Exhibit at Capitol." 8 March 1930, p. 4.
Montreal Daily Star. "Canadian Artists' Work Is Praised." 11 March 1930.
Sudbury Star. "Canadian Art Not 'Advanced.'" 15 March 1930.
Toronto Daily Star. "French Influence in Canadian Art Culturist States." 15 March 1930, p. 22.
Toronto Daily Star. "Toronto Pictures Travel Province." 15 March 1930, p. 22.
Art Digest. "Canadian Pictures at Corcoran 'Sing a Saga of the North.'" IV:12 (mid-March 1930), pp. 5–6.
Ottawa Journal. "James E. MacDonald Gives Lecture Here on Constable's Works." 18 March 1930.
La Revue Populaire. "Chronique d'art: Le Salon annuel d'art canadien." XXIII:4 (April 1930), pp. 11–13.
Victoria Daily Colonist. "On Way East to Attend Exhibition of Her Work." 1 April 1930.
Montreal Gazette. "Keen Interest Was Shown in Exhibit." 1 April 1930.
Toronto Daily Star. "Group of Seven Hold Exhibition at Toronto Art Gallery." 3 April 1930, p. 3.
Toronto Telegram. "Group of 7, Now 8, Steadies as Youthfulness Turns Mature." 5 April 1930.
Toronto Daily Star. "Group of Seven Exhibit as Seen by Six-bit Critic." 7 April 1930, p. 29.
Toronto Daily Star. "Hart House Quartet Play among Pictures." 7 April 1930, p. 4.
Toronto Daily Star. "Toronto Lumberman Assails School of Seven Exhibition." 10 April 1930, pp. 1–2.
Saturday Night. "Group of Seven." XLV:22 (12 April 1930), p. 4.
Toronto Daily Star. "Criticism Is Minimized by College of Art Head." 15 April 1930, p. 3.

Toronto Daily Star. "Figures in Group of Seven Controversy." 15 April 1930, p. 3.
Ottawa Evening Citizen. "Now Represents Spirit of Canadian Art." 24 April 1930.
Toronto Telegram. "No Praise for Group of Seven." 26 April 1930.
Toronto Daily Star. "'Holy Smoke' and 'Lonely Mountain.'" 28 April 1930.
Montreal Standard. "Exhibition of Paintings and Drawings Opened Today at Art Gallery." 3 May 1930.
Ottawa Morning Journal. "Results Are Given Willingdon Arts 1929 Competitions." 3 May 1930.
Ottawa Citizen. "Willingdon Arts Competition Has Proven Success." 3 May 1930.
Vancouver Star. "City Artists' Work Honored." 15 May 1930.
Toronto Telegram. "'Group of Seven' Portrait Painter at Work Here." 17 May 1930.
Montreal Gazette. "Hon. V. Massey on Trend of Art in Canada." 23 May 1930.
Montreal Daily Star. "New Era in Canadian Art Dawning, Massey Claims." 23 May 1930.
Saturday Night. "A Gracious Artist." XLV:29 (31 May 1930).
Toronto Daily Star. "Tom Thomson Memoir to Come Out Soon." 31 May 1930.
La Revue Populaire. "Chronique d'art: Les expositions." XXIII:6 (June 1930), pp. 67–69.
Canadian Forum. "The Group of Seven." X:117 (June 1930), p. 314.
Victoria Times. "Art in Canada." 6 June 1930.
Art News. "Grand Central Galleries Show Contemporary Canadian Painting." XXVIII:36 (7 June 1930), pp. 6–8.
Seattle Times. "Famous Artist Is Added to Institute." 6 July 1930.
Cala (San Francisco). "Varley's Art Shown Here in Fall." 12 July 1930.
Toronto Telegram. "Remember Woods Artist." 19 July 1930.
Seattle Star. "Art Lecture Sponsored by Club." 25 July 1930.
St. Louis Post-Dispatch. "Paintings by Contemporary Canadian Artists, to Be Shown Next Month in St. Louis at the City Art Museum." 27 July 1930.
St. Louis Post-Dispatch. "Canadian Exhibit at Art Museum." 1 Aug. 1930.
Toronto Mail and Empire. "Totem Pole Honors Tom Thomson's Ideal." 18 Aug. 1930.
Toronto Globe. "Bark Canoe Carries Memorial Flowers." 19 Aug. 1930.
Vancouver Star. "Toronto to See Works of B.C. Artists." 25 Sept. 1930.
Natural Resources Canada. "1930 Season One of Great Activity in Canada's Arctic." IX:11 (Nov. 1930), pp. 1–2.
Journal, Royal Architectural Institute of Canada. "The New Chateau Laurier, Ottawa." VII:11 (Nov. 1930), pp. 393–411.
Toronto Mail and Empire. "Fifty Years of Freedom Achieved by Art Academy." 8 Nov. 1930.
Montreal Daily Star. "Art Exhibition Is Opened in Toronto." 8 Nov. 1930.
Montreal Daily Star. "R.C.A. Exhibition." 23 Nov. 1930.
Ottawa Evening Citizen. "Arctic Sketches at National Gallery." 27 Nov. 1930.
Ottawa Journal. "Canadian Artists Exhibit Pictures of Arctic Regions." 27 Nov. 1930.
Democrat (Davenport, Iowa). "Exhibition of Canadian Art Is Attraction." 12 Dec. 1930.
Daily Times (Davenport, Iowa). "Paintings of Canadian Artists on Exhibit at Art Gallery Here Have Brilliant Color Effects of North." 12 Dec. 1930.

1931
Canadian Forum. "Repetition in Art." XI:124 (Jan. 1931), p. 127.
Toronto Mail and Empire. "Land of Polar Bears Revealed in Pictures." 6 Jan. 1931.
Toronto Mail and Empire. "Lawren Harris Wins Museum of Art Prize." 16 Jan. 1931.
Montreal Daily Star. "Famous Portraitist Citizen of Montreal." 17 Jan. 1931.
London Morning Free Press (Ont.). "Growth of Canadian Art." 20 Jan. 1931.
Winnipeg Free Press. "Art in Canada." 4 Feb. 1931.
Ottawa Evening Citizen. "Suspicious." 24 Feb. 1931.
Toronto Daily Star. "'Nudes in Landscape' Causes Art Dispute.'" 7 March 1931.
Toronto Telegram. "Subtle, Arresting Quality Seen at O.S.A. Exhibition." 7 March 1931.
Montreal Gazette. "Painting Removed from Ontario Show." 9 March 1931.
Toronto Daily Star. "British Art Expert Praises School of 7." 21 March 1931.
American Magazine of Art. "The Baltimore Pan-American." XXII:4 (April 1931), pp. 280–88.
Canadian Homes and Gardens. "A Canadian Artist's Modern Home." VIII:4 (April 1931), p. 40.
Toronto Mail and Empire. "Scandinavian Art Akin to Canadian." 18 April 1931, p. 5.
Canadian Geographical Journal. "A Portfolio of Paintings of Canadian Scenes." II:6 (June 1931), pp. 455–62.
Canadian Forum. "West Coast Indian Art." XI:130 (July 1931), p. 366.
Vancouver Daily Province. "In the Domain of Art." 2 Aug. 1931.
Vancouver Star. "Crowds Flock to Fair Art Show." 27 Aug. 1931.
Vancouver Star. "Puzzle Pictures Attract Crowds." 28 Aug. 1931.
Vancouver Star. "Vancouver Hardly Grown-up Enough to Judge New Art." 29 Aug. 1931.
Vancouver Daily Province. "When Is a Cow Not a Cow?" [Aug.-Sept. 1931.]
Vancouver Daily Province. "Who Shall Define Art, Correspondent Asks Mr. Radford." 1 Sept. 1931.
Vancouver Daily Province. "But Is It Art?" 6 Sept. 1931.
Vancouver Sun. "New Art Gallery Opened Today." 5 Oct. 1931.
Vancouver Daily Province. "H.A. Stone Named Art Gallery Head." 7 Nov. 1931.
Montreal Daily Star. "Canadian Artists Are Well Represented at R.C.A. Exhibition." 20 Nov. 1931.
Apollo. "Canadian Art, Foundations of a National School." XIV (Dec. 1931), pp. 326–27.
Montreal Standard. "Paintings Show Big Advance on Those of Last Exhibition." 5 Dec. 1931.
Toronto Telegram. "Seascapes Are Pronounced in Art Gallery Exhibit." 5 Dec. 1931, p. 3.
Vancouver Sun. 6 Dec. 1931.
Montreal Gazette. "New Epoch Is Seen in Canadian Art." 7 Dec. 1931.

1932
Ottawa Journal. "Splendid Works of Canadian Art Exhibited at National Gallery." 21 Jan. 1932.
Toronto Telegram. "Local Artists Display Works." 23 Jan. 1932.
Sherbrooke Record. "The Pictures Which Live and 'Grow upon You.'" 29 Jan. 1932.
Montreal Daily Herald. "Art at Ottawa." 5 Feb. 1932.
Calgary Herald. "Prominent Artist Praises Work of Many Westerners." 5 March 1932.
Montreal Gazette. "N.Y. Has Exhibition of Canadian Art." 7 March 1932.
Montreal Gazette. "Modernistic Art Is Severely Scored." 16 March 1932.

Montreal Gazette. "New Yorkers View Art from Canada." 18 March 1932.
Toronto Globe. "Canadian Paintings Win Lovers of Art in New York City." 21 March 1932.
Saskatoon Morning Star-Phoenix. "Strong Appeal Made for Canadian Artists by Well Known Painter." 22 March 1932.
Edmonton Journal. "West More 'Art Conscious' than East, Finds Visitor." 23 March 1932.
Edmonton Bulletin. "Arthur Lismer Concludes Inspiring Lecture Series." 26 March 1932.
Vancouver Sun. "Art That Stimulates." 31 March 1932.
Canadian Homes and Gardens. "Around the Galleries." IX:4 (April 1932).
Victoria Times. "Should Foster National Art." 1 April 1932.
Toronto Telegram. "Can. Artists' Current Show." 16 April 1932.
Ottawa Morning Journal. "Dr. MacTavish Resigns as Director of Gallery." 23 April 1932.
Montreal Gazette. "Prudence Heward Shows Paintings." 27 April 1932.
Toronto Telegram. "Artistic Impressions by Ontario Artist." 30 April 1932.
Toronto Globe. "Increase Planned in Art Extension." 5 May 1932.
Toronto Daily Star. "Lismer in Vancouver Lauds Group of Seven." 7 May 1932.
Vancouver Sun. "All Canadian Artists' Pictures on Exhibition." 11 May 1932.
Vancouver Sun. "National Art Show Abuses Protested." 31 May 1932.
Montreal Daily Star. "Who Best Represents Canadian Art？" 8 June 1932.
St. Catharines Standard. "Prudence Heward's Exceptional Talent." 16 June 1932.
Vancouver Sun. "Art or Lunacy." 17 June 1932.
Vancouver Sun. "Has Art Gone Mad." 25 June 1932.
Vancouver Sunday Province. "Our Art Gallery." 3 July 1932.
Toronto Daily Star. "Gallery Wastes $1,000,000 Says Artist Asking Inquiry." 7 July 1932.
Toronto Mail and Empire. "Vancouver Is Pretty Severe on the Modernists." 12 July 1932.
Toronto Daily Star. "Morality Men Do Not Object to C.N.E. Nudes." 18 Aug. 1932.
Toronto Daily Star. "Call Group of Seven Copyists of U.S. Man." 27 Aug. 1932, p. 4.
Canadian Bookman. "A Layman at the Art Show." XIV:8 (Sept. 1932), p. 100.
Canadian Homes and Gardens. "Canadian Art at the C.N.E." IX:9 (Sept. 1932), pp. 20–21.
Labour Leader. "The Group of Seven." 16 Sept. 1932.
Bridle and Golfer. "Modernistic in Tone." Oct. 1932, pp. 1–2.
Toronto Daily Star. "Artist Terms Business Men Dullest in Creation." 7 Oct. 1932.
Montreal Gazette. "Lilias T. Newton Shows Portraits." 18 Oct. 1932.
Toronto Globe. "Child Art in Canada Needs Aid." 20 Oct. 1932.
Toronto Globe. "Royal Canadian Academy Prepares for Show." 1 Nov. 1932.
Toronto Telegram. "New Names on Roster of Artists Whose Work Academy Has Accepted." 5 Nov. 1932.
Toronto Telegram. "Horrors and Experiments Deck Walls at R.C.A. Show." 8 Nov. 1932.
Toronto Daily Star. "Principal of O.C.A. Again Active in Art." 26 Nov. 1932.
Toronto Telegram. "Death Takes Fine Painter and Teacher." 28 Nov. 1932.
Toronto Telegram. "Art College Head Honored in Death." 29 Nov. 1932.
Border Cities Star (Windsor, Ont.). "Group of 7 Is Mourning." 29 Nov. 1932.

London Free Press (Ont.). "Group of Seven Honors Leader." 29 Nov. 1932.
Owen Sound Sun-Times. "J.E.H. MacDonald Widely Mourned by Art Lovers." 29 Nov. 1932.
Canadian Homes and Gardens. "The Royal Canadian Academy." IX:12 (Dec. 1932), pp. 21–23, 42.
Vancouver Sun. "Varley Pictures Attract Crowds." 2 Dec. 1932.
Vancouver Daily Province. "Varley Works Are Inspiring." 2 Dec. 1932.
Saturday Night. "First Death in Group of Seven." XLVIII:4 (3 Dec. 1932), p. 1.
Toronto Daily Star. "Fellow Club-Men Are Buried upon Same Day This Week." 3 Dec. 1932.
Ottawa Journal. "Artists Boycott National Gallery until Radical Reform Takes Place." 8 Dec. 1932.
Varsity (University of Toronto). "Art, Music and Drama." 12 Dec. 1932, pp. 1, 4.
Toronto Telegram. "'Unearned Infallibility' Yourself Mr. Harris." 16 Dec. 1932.
Toronto Mail and Empire. "Franklin Carmichael on Art School Staff." 17 Dec. 1932.
Ottawa Citizen. "Sees Patronage and Politics in Petition on Art." 19 Dec. 1932.
Vancouver Sun. "Radford Stand on Art Praised." 24 Dec. 1932.
Ottawa Citizen. "Montreal Artists Defend National Gallery Policy." 29 Dec. 1932.

1933

La Presse (Montreal). "Encore les artistes." 9 Jan. 1933.
Toronto Mail and Empire. "Grier Denies Rumor Picture Ban Lifted." 9 Jan. 1933.
Toronto Telegram. "Development of Typical Canadian Art Is Important." 10 Jan. 1933.
Toronto Telegram. "Lismer Speaks on French Art." 10 Jan. 1933.
Montreal Gazette. "Canadian Painting Is Forging Ahead." 19 Jan. 1933.
Toronto Telegram. "Art Exhibition Recalls Genius J.E. MacDonald." 21 Jan. 1933.
Toronto Globe. "Friends Honor Canadian Artist." 21 Jan. 1933.
Montreal Gazette. "Group of Seven Issues Statement Defending Aims." 31 Jan. 1933.
Vancouver Sun. "'Humbugs: Illusions.'" 20 Feb. 1933.
Toronto Globe. "Jackson Resignation Accepted by Academy." 20 Feb. 1933.
Montreal Gazette. "Canadian Artists Form New Group." 21 Feb. 1933.
Ottawa Morning Citizen. "'Group of Seven' Bows to Broader New Art Society." 21 Feb. 1933.
Toronto Telegram. "Painters Form Canadian Body to Foster Idea." 21 Feb. 1933, p. 29.
Montreal Daily Star. "Art and Artists in Canada." 22 Feb. 1933.
Toronto Telegram. "Canadian Art Has Big Field." 14 March 1933, p. 14
The Tatler (London). "Mr. Arthur Heming's Dramatic Pictures." 22 March 1933.
Sault Ste. Marie Star. "'Autumn in Algoma' in National Gallery." 31 March 1933.
Hamilton Spectator. "Academy President Lauds Local Artists." 7 April 1933.
Winnipeg Tribune. "Arthur Lismer Urges Native Form of Art." 2 May 1933.
Winnipeg Free Press. "Noted Artist of Toronto Lectures to Large Group." 2 May 1933.
Winnipeg Mirror. "Mr. Lismer Speaks on Canadian Art." 6 May 1933.
Journal, Royal Architectural Institute of Canada. "The Royal Canadian Academy of Arts." X:6 (June 1933), p. 116.
Telegraph (Sheffield). "Sheffield Artist's Success in Canada." 12 June 1933.

Canadian Forum. "Painting and Pickles." XIII:154 (July 1933), p. 366.
Toronto Daily Star. "Canadian Picture Exhibit Is Atlantic City Feature." 10 July 1933.
Calgary Herald. "MacDonald Memorial Collection Includes Many Fine Canvases." 12 July 1933.
Die Kunst. "Moderne Malerei in Kanada." LXVII (Aug. 1933), pp. 343–47.
Ottawa Journal. "Canadian Art Is Shown Abroad." 25 Aug. 1933.
Canadian Homes and Gardens. "Around the Galleries." X:10 (Oct. 1933), pp. 28–29, 47.
The Seigneur. "Acadian Cover." V:5 (Nov. 1933).
Toronto Globe. "'Canadian Group' Formed by Artists." 4 Nov. 1933, p. 14.
Gold Magazine. "'The Best Old Town I Know': Painting by Yvonne McKague." Dec. 1933.
Brantford Expositor. "Mr. F.B. Housser on Canadian Art." 1 Dec. 1933.
Christian Science Monitor. "Native Canadian Art Carves Niche in World Culture in Two Decades." 28 Dec. 1933.

1934

Ottawa Citizen. "Here's an Artist Who Agrees with People but Who also Does Exactly as He Pleases." 24 March 1934.
North Bay Nugget. "Her Brush Missed the Spirit." 16 April 1934.
Winnipeg Saturday Review. "Art and Artists." 25 Aug. 1934.

MANUSCRIPT SOURCES

AGO Arch. (Art Gallery of Ontario Archives, Toronto)
Art Gallery of Toronto, correspondence files.
Art Gallery of Toronto, exhibition files.
Art Gallery of Toronto, minutes of Council and annual meetings 1925–26, 1927–28, 1929–30.
Art Gallery of Toronto, scrapbooks, education: "Educational Work," vol. 1.
Art Museum of Toronto, letters.
Art Museum of Toronto, minute book 1900–1925.
Art Museum of Toronto, scrapbook 1900–1925.
C.W. Jefferys papers.
Arthur Lismer papers.
Edmund Morris Canadian Art Club papers.
W.J. Wood papers.
Albright Arch. (Albright-Knox Art Gallery Archives, Buffalo, N.Y.).
Exhibition records, R.G. 3:1, box 28, folder 3: "Canadian Group of Seven," Sept. 1921.
Exhibition records, R.G. 3:1, box 4, folder 14: "Sesquicentennial Exposition," 1926.
Exhibition records, R.G. 3:1, box 34, folder 22: "Canadian Artists," Sept. 1928.
ALC Arch. (Arts and Letters Club Archives, Toronto)
Minute books of Executive Committee, Oct. 1913–Oct. 1926 and Oct. 1926–Jan. 1932.
Scrapbooks.
Arch. of Ont. (Archives of Ontario, Toronto)
E. Wyly Grier papers (MU8223–29).
M.O. Hammond papers (MU1289–95).
Ontario Society of Artists papers (MU2250–60).
B.C. Arch. (British Columbia Archives and Records Service, Victoria)
Flora Burns papers (Add. MSS 2786).
Phyllis Inglis—Emily Carr collection (Add. MSS 2181).
H. Mortimer-Lamb papers (MS 2834).
Beinecke Libr. (Beinecke Rare Book and Manuscript Library, Yale University, New Haven)
Société Anonyme collection.

Boston Arch. (Boston Museum of Fine Arts Archives)
Scrapbooks, exhibition file: "Group of Seven Canadian Artists," Dec. 1920.
Brooklyn Arch. (Brooklyn Museum Archives)
Records of the Office of the Director (William Henry Fox, 1913–33), file 865, "Canadian Group of Seven," 1924.
CGH (Canadian Guild of Handicrafts Quebec, Montreal)
M.A. Peck, "The Canadian Handicrafts Guild and the New Settler" (typescript).
CMC (Canadian Museum of Civilization, Hull, Que.)
Marius Barbeau collection: Correspondence and Northwest Coast files.
Corcoran Arch. (Corcoran Gallery Archives, Washington, D.C.)
Exhibition file: "Paintings by Contemporary Canadian Artists," March 1930.
CP Arch. (Canadian Pacific Archives, Montreal)
Folksong and handicraft festivals (file C-178).
John Murray Gibbon (file B-07.15-G).
Publicity department photographs.
Detroit Arch. (Detroit Institute of Arts Archives)
Exhibition file: "Group of Seven," June 1921.
Gallery Lambton Arch. (Gallery Lambton, Sarnia, Ont.)
Sarnia Women's Conservation Art Association papers.
Indianapolis Libr. (Indianapolis Museum of Art Library)
Scrapbooks, exhibition file: "Group of Seven Canadian Artists," April 1921.
Mackenzie Arch. (Mackenzie Art Gallery, Regina)
McCord Arch. (McCord Museum of Canadian History Archives, Montreal)
Clarence Gagnon papers.
A.Y. Jackson letters.
J.E.H. MacDonald papers.
McLaughlin Arch. (Robert McLaughlin Gallery, Oshawa, Ont.)
Canadian Group of Painters papers.
Transcript of Joan Murray interview with Barker Fairley, 4 June 1979.
McMichael Coll. (McMichael Canadian Art Collection Library, Kleinburg, Ont.)
Arthur Lismer papers.
Christopher Varley's research notes on F.H. Varley.
J.E.H. MacDonald papers.
Memorial Libr. (Memorial Art Gallery Library, Rochester, N.Y.)
Exhibition file and scrapbooks: "Canadian Group of Seven," Jan. 1921.
Exhibition file and scrapbooks: "Canadian Paintings," Feb. 1927.

Milwaukee Arch. (Milwaukee Art Museum Archives)
Scrapbooks, exhibition file: "Paintings by Canadian Artists," May 1919.
Scrapbooks, exhibition file: "Paintings by a Group of Canadian Artists," Feb. 1924.
MMFA Arch. (Montreal Museum of Fine Arts Archives)
Art Association of Montreal exhibition registers.
Art Association of Montreal scrapbooks.
Arts Club papers.
Arthur Lismer papers.
Muskegon Libr. (Muskegon Museum of Art Library, Mich.)
Scrapbook, exhibition file: "Group of Seven," Jan. 1922.
NAC (National Archives of Canada, Ottawa)
Augustus Bridle fonds (MG30 D354).
Emily Carr fonds, microfilmed from original in B.C Archives (MG30 D215).
Brooke Claxton fonds (MG32 B5).
Blodwen Davies fonds (MG30 D38).
Department of Public Works papers (RG11, vol. 1653).
Lawren S. Harris fonds (MG30 D208).
Sir Wilfrid Laurier fonds (MG26 G).
Arthur Lismer fonds (MG30 D184).
Newton McFaul MacTavish fonds (MG30 D278).
J.E.H. MacDonald fonds (MG30 D111).
Thoreau MacDonald fonds (MG30 D112).
Massey Family fonds (MG32 A1).
Harry Orr and Dorothy McCurry fonds (MG30 D186).
G.R. Parkin fonds (MG30 D77).
Norah de Pencier fonds (MG30 D322).
Royal Canadian Academy of Arts fonds (MG28 I126).
Anne Savage fonds (MG30 D374).
Carl Schaefer fonds (MG30 D171).
Tom Thomson fonds (MG30 D284).
William Robinson Watson fonds (MG30 D310).
NGC Arch. (National Gallery of Canada Archives, Ottawa)
Interviews on Group of Seven by Ann Davis for Parks Canada.
Dr. James MacCallum fonds.
Sarah Robertson fonds.
Homer Watson fonds.
Watson Art Gallery fonds.
North York Libr. (North York Public Library, Canadiana Collection, Ont.)
Newton McFaul MacTavish papers.
Nutana Arch. (Nutana Collegiate Institute, Saskatoon)
Memorial Art Gallery correspondence.
Queen's Arch. (Queen's University Archives, Kingston, Ont.)

André Biéler papers (coll. 2050).
Merrill Denison papers (coll. 2056).
Lorne Pierce papers (coll. 2001a).
Lorne and Edith Pierce Collection of Canadian Manuscripts (coll. 2001b).
St. Louis Arch. (St. Louis Art Museum Archives, Mo.)
Exhibition file: "Paintings by Contemporary Canadian Artists," Aug. 1930.
Toledo Libr. (Toledo Museum of Art Library, Ohio)
Exhibition file: "Group of Seven Canadian Artists," March 1921.
Exhibition file: "Paintings by Contemporary Canadian Artists," March 1927.
UMA (University of Manitoba, Department of Archives and Special Collections, Elizabeth Dafoe Library, Winnipeg)
Bertram Brooker collection (MSS16).
UM FitzGerald (University of Manitoba, L.L. FitzGerald Study Collection, Winnipeg)
L.L. FitzGerald papers.
URA (University of Regina Archives)
Norman Mackenzie papers (88-10).
UTA (University of Toronto Archives)
Hart House papers (A73-0050).
Hart House Theatre papers (A75-0009).
UTL (University of Toronto, Thomas Fisher Rare Book Library)
Frederick G. Banting papers (ms coll. 76).
Thoreau R. MacDonald papers (ms coll. 180).
James Mavor papers (ms coll. 119).
Carl Schaefer Collection of Thoreau MacDonald (ms coll. 240).
Doris Speirs Collection of Thoreau MacDonald (uncatalogued).
Sir Edmund Walker papers (ms coll. 1).
UWL (University of Waterloo Library, Doris Lewis Rare Book Room, Ont.)
M. Edna Breithaupt collection.
Catherine Breithaupt Bennett papers.
Florence Clement papers.
Breithaupt Hewetson Clark collection.
VAG Arch. (Vancouver Art Gallery Archives)
Vancouver Arch. (Vancouver City Archives)
B.C. Art League papers (Add MSS 168).
B.C. Society of Fine Arts papers (Add MSS 171).
Worcester Arch. (Worcester Art Museum Archives, Mass.)
Exhibition files: "Group of Seven Canadian Artists," 7–28 Nov. 1920.
Exhibition files: "Canadian Artists," 6–27 April 1924.
YUA (York University Archives, North York, Ont.)
Herman Voaden papers.

Index

Photograph Credits

Photographs have been provided by the owners or custodians of the works reproduced, except for the following (listed by fig. no.):

Art Gallery of Ontario, Toronto 62

Art Gallery of Ontario, The E.P. Taylor Research Library and Archives, Toronto 28, 43, 57, 112, 135, 153, 256

Canadian Pacific Archives, Montreal 142, 143

City of Toronto Archives, Globe and Mail 249 (28439)

Manitoba Archives, Edmund Morris collection, Winnipeg 11

McMichael Canadian Art Collection Archives, Kleinburg, Ont. 35

Metropolitan Toronto Reference Library 137

Musée du Québec, Quebec City, Patrick Altman 245

National Archives of Canada, Ottawa 3 (C98559), 9 (C86701), 98 (PA 122343), 169 (PA 188441), 189 (PA 125403), 191 (PA 188202)

National Gallery of Canada, Ottawa 1, 12, 14, 15, 20, 24–26, 29–31, 34, 36, 47, 48, 53, 58–60, 65, 66, 72, 78, 79, 84, 88, 92, 93, 96, 100–02, 107, 109–11, 115, 117, 132, 133, 136, 138, 141, 144, 147, 150, 155, 159, 160, 164, 165, 170–72, 177–79, 186, 187, 193, 203–05, 209, 210, 215, 216, 223, 225, 235, 237, 240, 246, 253, 257, 259, 260

National Gallery of Canada Archives, Ottawa, courtesy Galerie Dominion, Montreal 196, 258

National Gallery of Canada, Richard-Max Tremblay, Montreal 94, 186, 226, 227, 248

National Library of Canada, Ottawa 188, 190, 207, 208

University of Toronto Archives 5 (94–19), 81–83 (collection A75–0009)

Vancouver Public Library 175 (DP26053)

Worcester Art Museum, Massachusetts 69

York University Archives, Herman Voaden papers, North York, Ont., photograph Allan Sangster 206